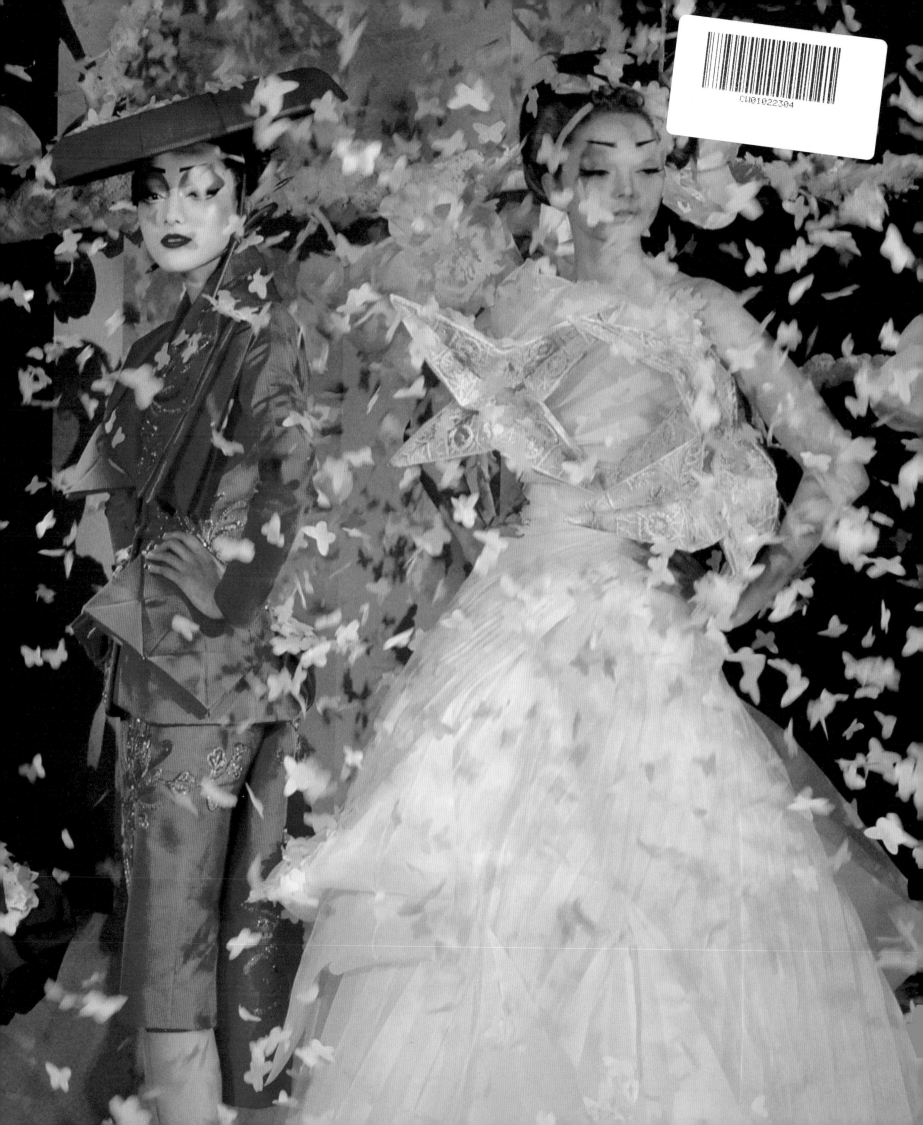

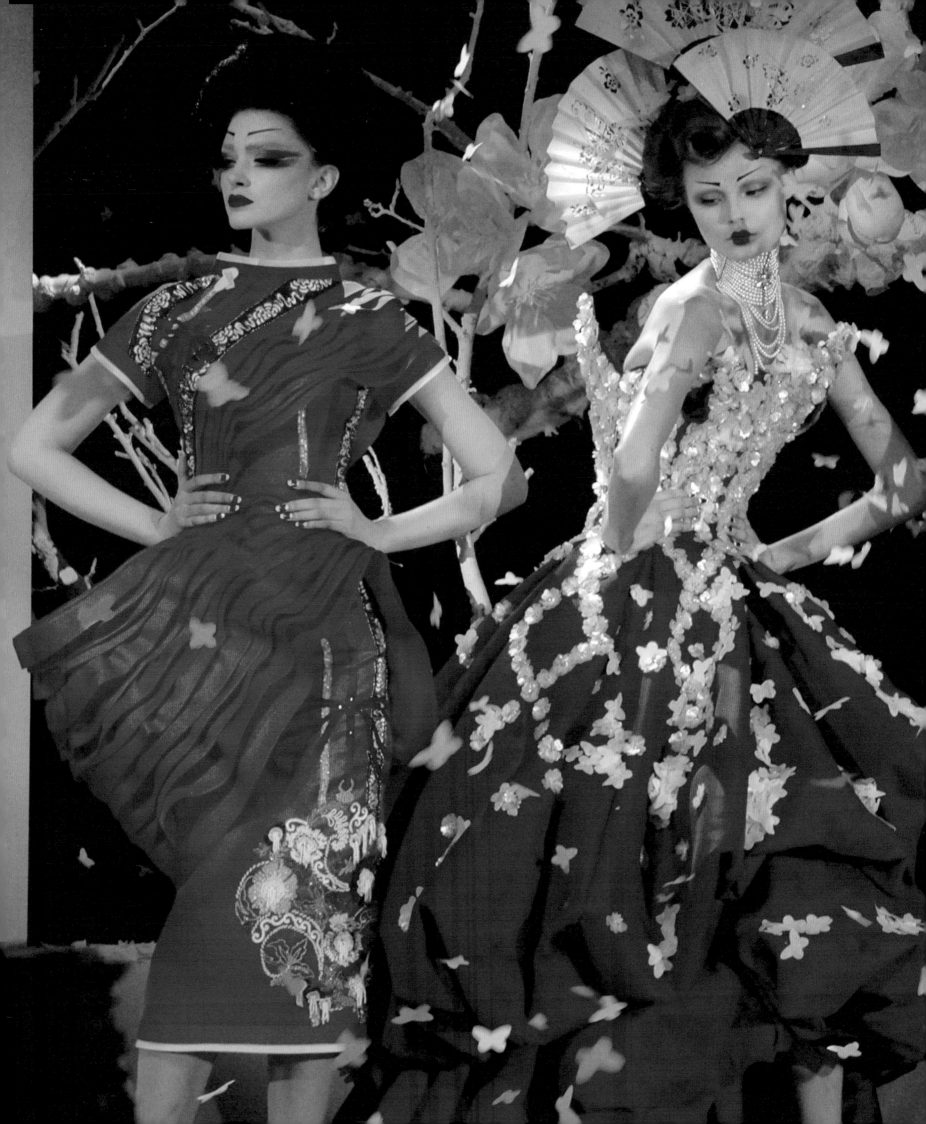

CATWALKING

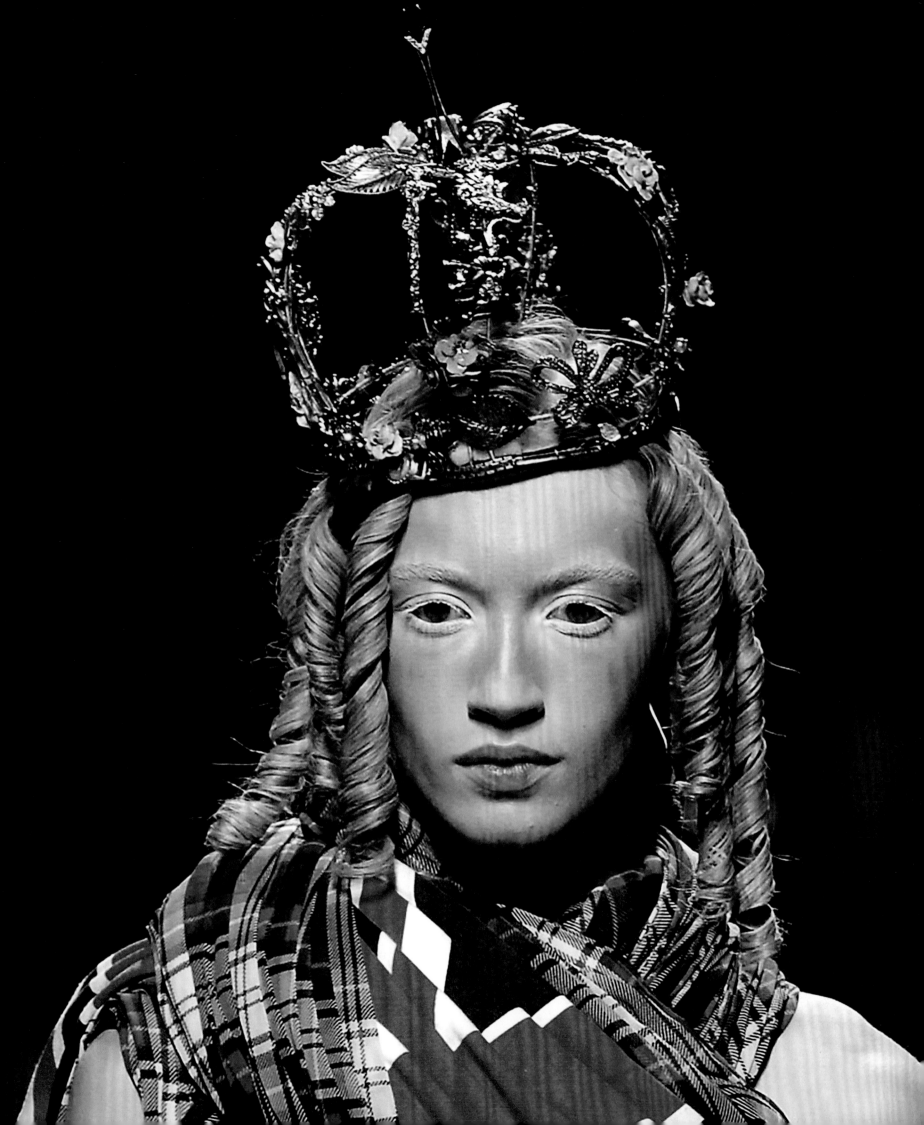

Photographs by Chris Moore

CATWALKING

Words by Alexander Fury

Published in 2017 by
Laurence King Publishing Ltd
361–373 City Road, London,
EC1V 1LR, United Kingdom
T +44 (0)20 7841 6900
F + 44 (0)20 7841 6910
enquiries@laurenceking.com
www.laurenceking.com

This book was produced by
Laurence King Publishing Ltd, London

A catalogue record for this book is available
from the British Library

ISBN: 9781786270634

Senior Editor: Charlotte Selby
Design: BLOK
www.blokdesign.co.uk
Photographs curated by Maxine Millar

Printed in China

Endpapers:
**John Galliano for
Christian Dior**
Spring/Summer 2007
Haute Couture, Paris

Page 2–3:
Marc Jacobs
Autumn/Winter 2007
New York

Previous page:
Comme des Garçons
Spring/Summer 2006
Paris

Page 10:
Chris Moore in 2016
Photo by Jonas Gustavsson

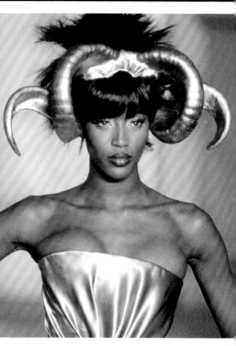
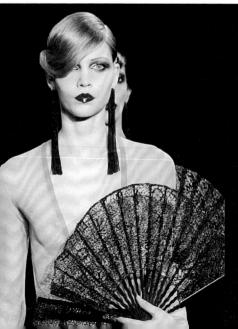

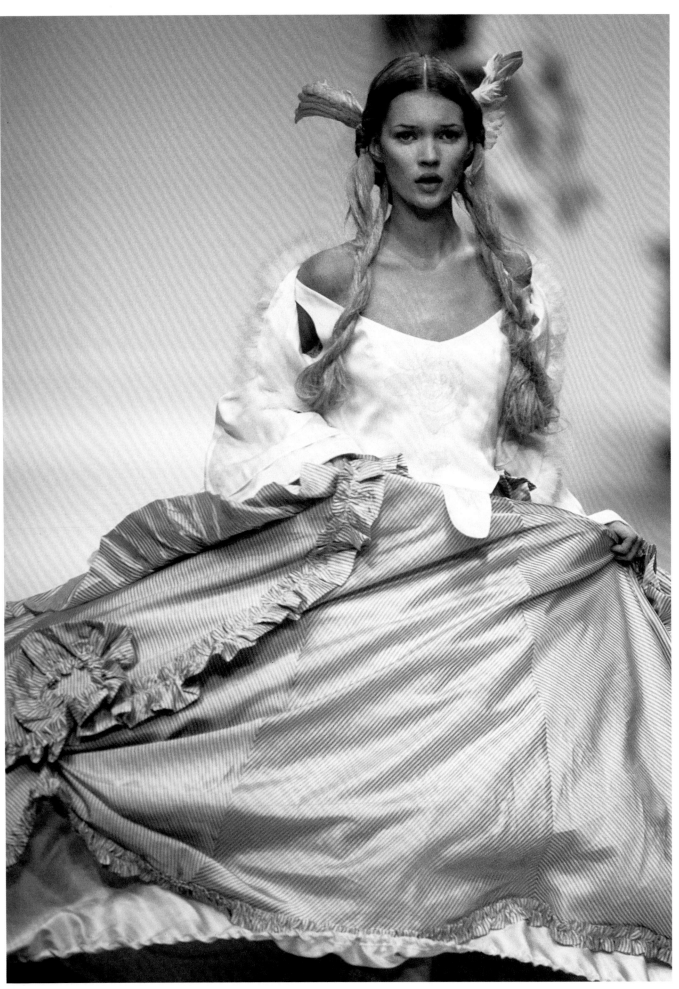

John Galliano
Spring/Summer 1994
Paris

Foreword

The catwalk is a moment in time – you see the clothes and the models – Chris Moore has seen them all. From graduates to grand salons, *mise en scène* to concealed details and cuts, each collection has a different story to tell and Chris is always there to capture the moment.

The catwalk has to speak for the designer without words, to present your collection and showcase the energy and attitude in an instant. Chris Moore is the eye that shows it to the world and this book charts his journey as well as the evolution of fashion.

John Galliano
Paris, 2017

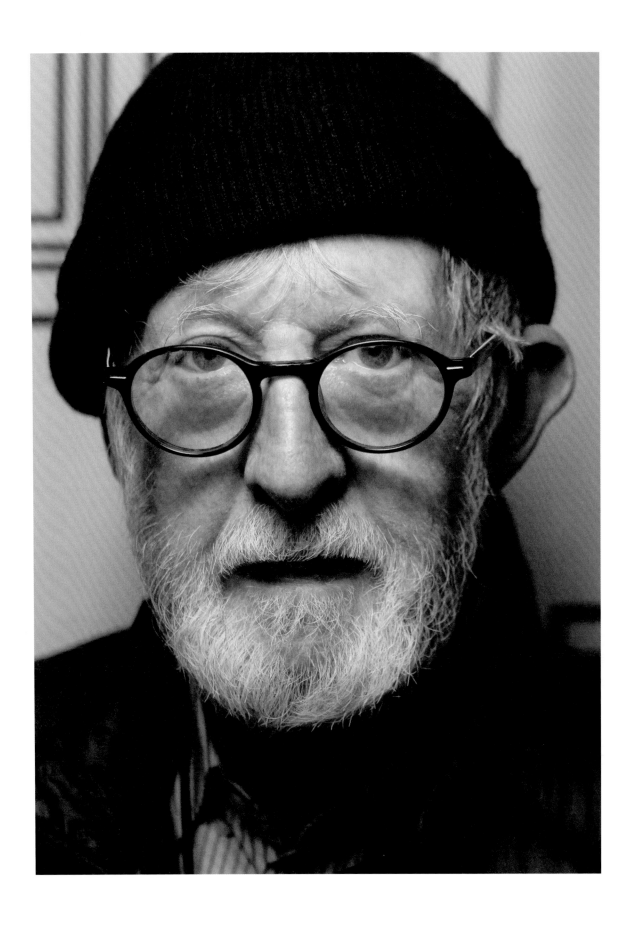

A Note from Chris

The term 'catwalk photographer' was not something I heard until the late 1980s. There were photographers, of course, who amongst other things covered the catwalk shows twice a year, but the label as such was fashion jargon that came in roughly the same time as another well-know term: supermodel.

At first, I wanted to shrug off the implication of this total dedication – after all I still did other work from my studio in London, besides catwalk photography. But I too came to realise that the catwalk scene had grown such in strength and proportions that others, as well as myself, were being drawn in completely.

My early days at *Vogue* had created an appetite for the curious, often otherworldliness, of 'style', and the people who had it. As the catwalk scene evolved it seemed to me to be a magnet for the weird and the wonderful, a travelling circus of flamboyance and innovation, taking me to the great cities of western culture, where I would learn about food and fashion, and see exclusive spaces inside iconic architecture. Gabrielle 'Coco' Chanel's rue Cambon salon or her gilded residential suite at the Ritz Hotel, Giorgio Armani's personal theatre, countless grand ball rooms, palaces and parks and bustling around them a host of fashion's royalty, subjects and slaves.

I chose my vantage point long ago and stayed there.

Words were never my thing, and although a career in photography came to me quite by accident, pictures gave me a natural voice. I realise fortunately – many decades on – that the diary I would fail to keep is instead told through the visual records of negatives and transparencies residing in the hundreds of cardboard boxes in my archive.

Finally I owe a great debt of thanks to my friend Suzy Menkes, who shared this adventure with me for over 25 years as we worked alongside each other at the *International Herald Tribune*. I would not have gained access to many of the privileged vantage points that delivered countless winning shots were it not for her true appreciation and knowing importance of the visual, and her solidarity with me in the face of adversities.

When I think of archives, I think of the cheese analogy: good quality ingredients coming together before being placed on a shelf in a cool dark place for a decent spell of time. Sample too soon and the flavour is not fully realised. Having reached a good degree of maturity, the time seems right to roll out this sampling of my own.

Chris Moore
London, 2017

'Fashion gets in your blood.'

Chris Moore

'I am a camera,' said Christopher Isherwood in *Goodbye To Berlin*, 'with its shutter open, quite passive, recording, not thinking.' Is that the impression given of photojournalism, of photographers capturing the reality of a real-life event, mute and receptive, recording only facts without opinion or interpretation? Perhaps. If so, where do we place the catwalk photographer, a witness to the reality of an unreal event? In fashion, people are 'models' – a form of doublespeak, whose semiotics simultaneously mean a representation, rather than a reality, and an example to be followed, as well as a body whose purpose is to display clothing. They don't walk, they 'catwalk', in attire that is not clothing, but 'fashion'. Enter a fashion show and you are entering a fantasy, a simulacrum, a performance without a plot.

What is the role of photographers, then, in recording this heightened reality? They cannot merely record, without thinking. It is their role to capture the mood, to evoke the message of the medium, to communicate. If the fashion writer's role is that of translator, to transform images into words and semaphore a designer's message, then the catwalk photographers are the eyes of fashion. We can see only what they see.

Generations of fanatics have experienced and continue to experience fashion through the eyes of Chris Moore. Moore is the man who invented the notion of the catwalk photographer in the 1960s, when catwalk shows as we know them had only just begun. His work was revolutionary, at a time when fashion was being revolutionized: charting the emergence of designer ready-to-wear in the 1960s and 1970s, Chris Moore was present for the true birth of the modern notion of the 'catwalk', and our contemporary idea of the fashion show. His work, in turn, continues to epitomize the enduring idea of catwalk photography.

Collecting that work together – imagery that spans half a century, and documents the greatest designers of that period – offers an unparalleled and complete vision of the malleable and constantly changing world of international high fashion. Arranged chronologically by decade, these photographs bear witness to the transformation of the industry over the past 60 years – indeed, to the invention of a new identity for fashion today, once cloistered and secret, now basking in the light of millions of flash bulbs, beamed instantly around the globe. Moore's body of work charts the evolution of contemporary fashion in its natural habitat, the catwalk.

Moore is a delicate, sparrow-like man, now in his eighties. British-born and London-based, he bears a striking resemblance to his transatlantic counterpart, the late Bill Cunningham. Indeed, Bill and Chris photographed each other through the 1970s and 1980s in their respective perches alongside the catwalk, as they both became familiar faces on the fast-developing four-city fashion circuit. If Cunningham is widely credited with creating the notion of the 'street style' photographer, Moore must be given his due for defining that of the catwalk photographer. His images were used ceaselessly by newspaper fashion editors, first in black and white, then colour, to ring in the changes for generations of readers; today they populate a profusion of websites. Both Moore and Cunningham inspired legions of imitators, and even new originals. But both were there first.

Moore has seen more fashion than, perhaps, anybody else on earth. Starting in the mid-1960s, he covered the Parisian haute couture from outside the houses of Courrèges, Dior and Balmain – the era before cameras were permitted inside those hallowed halls – as well as their London counterparts. But he also captured the first shows by a rising generation of ready-to-wear designers – Emmanuelle Khanh, Sonia Rykiel, Karl Lagerfeld and Kenzo Takada – challenging the status quo of the couture establishment. Through the inexorable rise of ready-to-wear during the 1970s, the blockbuster, crowd-pleasing spectacles of the 1980s and 1990s, until today, Moore has documented it all, pinpointing for posterity the fleeting moments of each and every catwalk show. He has attended thousands, has taken millions of pictures. The scope of his experience is unparalleled.

Moore invented his medium, reacting to the ever-shifting tectonic plates of the volatile fashion industry and the emergence of ready-to-wear as the dominant fashion force. That created the catwalk, superseding the salon as a stage for designers to perform upon. Until the 1960s, fashion shows were decidedly quiet affairs, staged in those staid salons in silence, to intimate groups of clients and press, with photography banned. Yet, as designer ready-to-wear emerged as an economic and creative force, the salon doors were forced open. Fashion began to be staged, for an appreciative international audience eager to consume. Many bought the clothes; but many more pored over the deluge of imagery produced from the new breed of fashion extravaganza.

Indeed, to examine Moore's work is to chart the development of an entire industry. Arching across fashion's modern creation in the late twentieth century, through to its contemporary incarnation in the nascent twenty-first, Moore has documented the greatest change since Charles Frederick Worth invented haute couture and put the first designer name on a label in the middle of the nineteenth century. That change is the rise of ready-to-wear – the mass-manufactured – and the true idea of fashion for the everyman, or woman. Broadening their appeal meant designers had to broaden their audience, prising open the salon doors and allowing the public to see fashion, live for the first time. Moore's camera was the first: his imagery brought fashion to the masses, as never before. His images represent the democratization of fashion.

Moore's camera also highlights the influence of technology, hitherto underestimated in the development of fashion image-making. The power of the internet has been hurrahed and abhorred, but the development of camera technology and newsprint – from

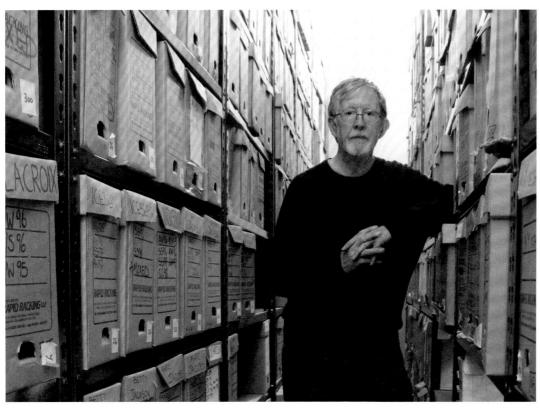

Left:
Chris Moore with his photography archive, 2016, Newcastle.

Below:
The *New York Times* style photographer Bill Cunningham (centre) with designer and stylist Judy Blame (far left). Taken during the collections Autumn/Winter 1984, New York

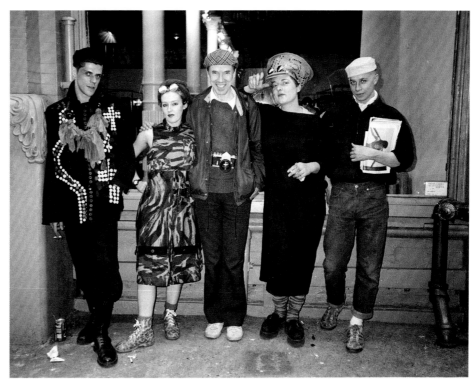

'I call this the three flashes,' says Moore of this shot of Catherine Deneuve at **Yves Saint Laurent** Autumn/Winter 1994 Haute Couture, Paris

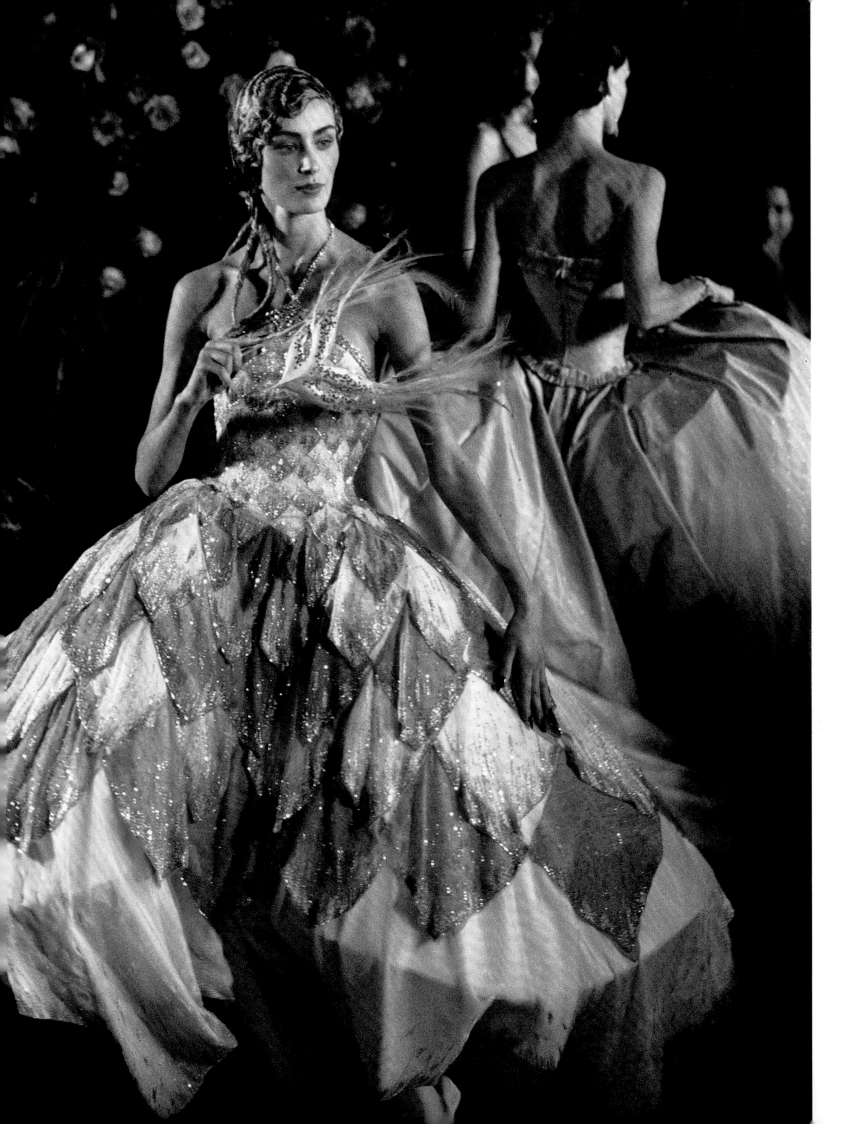

black and white to colour, to autofocus and digital – has also changed the manner in which we see fashion. Photographers who once thronged the flanks of the catwalk, chasing the ever-moving models in the hope of capturing a focused image, now perch at its apex. The models walk towards them, because the show is now orchestrated for the cameras: not for the audience in the room, but for the huddled masses who pore over imagery from afar.

In the late twentieth century, fashion became a spectator sport, soon to be pushed to extremes of theatricality. Ironically, alongside the rise of designers' widely available ready-to-wear clothing, the fashion show became an image-making tool, not merely a vehicle for selling dresses.

Image-making requires an image-maker. Moore is the premier catwalk photographer, shooting for publications and for the fashion houses themselves, recording the collections as they revved up to breakneck pace and began to proliferate across the newly formed axis of New York, London, Milan and Paris. But Moore is, in himself, also a fashion editor: cropping and shaping our view of the fashion industry, capturing ephemeral moments, fixing them for eternity. His work gives permanence to the fundamentally temporal.

Moore named his company Catwalking in 1996, trade marking the word, which fast became a verb to describe the intricate, highly choreographed walk of fashion models on the catwalk. In American parlance, it's called a runway – but 'catwalk' has a special resonance, the perfect description of the feline prowl of models, legs crossing in front, sometimes to such a degree that it appears as if they shouldn't be travelling anywhere at all.

Millions of images are produced around the biannual catwalk shows – womenswear, menswear and haute couture – but Moore's have dominated for decades. Just as his company is named after the definition of that model-esque walk, so his images have defined the meaning of 'catwalking' today. It is Moore who captured the bug-eyed models, startled in startling white, of André Courrèges's 1960s' 'Space Age' collections. He caught Thierry Mugler's inter galactic queens in padded spacesuits and metallic make-up, John Galliano's histrionic tango dancers and steam engines for Christian Dior. He photographed the infamously exposed flesh of Alexander McQueen's 'bumsters' from his 'Highland Rape' collection; two years later he charted McQueen's first haute couture show for the esteemed house of Givenchy. He was there for designers' debuts and swan songs. Off the catwalk, Moore's prolific lens made sideways glances at the universe around the stage of the catwalk: Yves Saint Laurent in a clinch with Catherine Deneuve and occasionally, the models backstage, like Degas's dancers captured before a performance.

Moore's work is a testament to the time in which it was created. Each of his images not only captures a single moment, one dress, a model in motion, but also it encapsulates fashion as a whole, the ever-fluctuating landscape, the minor movement of styles

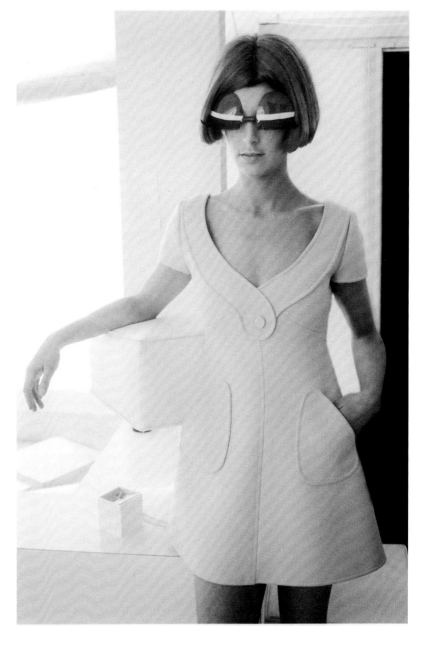

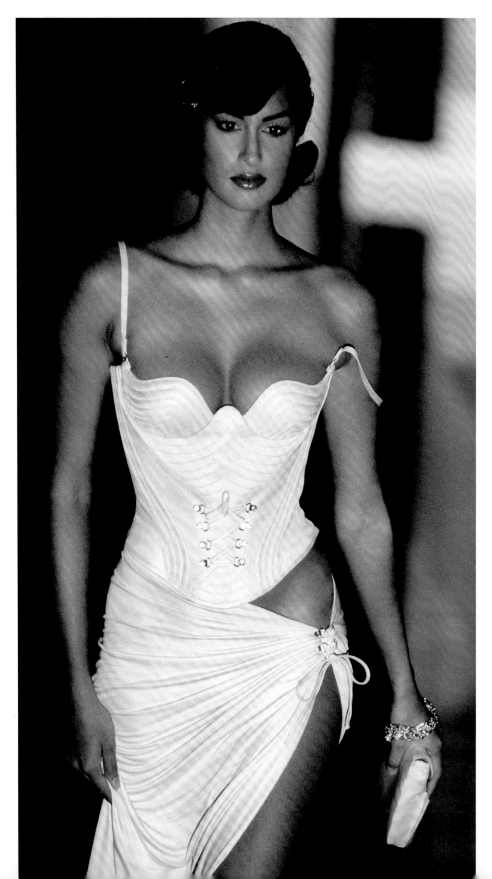

and the major shifts in cultural consciousness. Moore's recording frequently veers from the stage of the catwalk to the front-row cast of supporting characters – the fashion editors, stylists and celebrities whose presence is a necessary validation for the event, and who frequently frame perceptions of each designer and their clothes. He documents the terrain of fashion, the panorama of the catwalk – indeed, the attire of those alongside throws designers' work into relief, in retrospect reflecting if a designer is defining the moment, missing the mark or, perhaps, a portent of things to come.

Sometimes the images speak of a wider context. Today's front row peppered with the glow of smartphones reflects the ceaseless democratization of both fashion and technology, and the new demands of social media and the internet – a shift in fashion as great as the slamming open of the salon doors, and again Moore has been not only an observer of, but also an active participant in it.

Today, fashion is about immediacy: live streaming, showing to sell, click-baiting and hyperlinking. How best to reflect that? In the clothes on our back. Moore places fashion in context – first and foremost the context of the catwalk, its natural home, but then beyond. His view is the view. He is always recording, but never passive, constantly thinking.

I remember seeing my first Moore image – of the supermodel Linda Evangelista, prancing through a gas station set in a saturated, limoncello cloud of tulle. It was a John Galliano dress from Spring/Summer 1995, but Moore captured far more than simply the dress, or indeed the girl. Evangelista is, indeed, the main event, caught at the apex of the image, a great candyfloss cloud, like an overstuffed macaron exploding. But the audience's reactions are just as telling: hands clamped to mouths, eyes shining, the background fading out, their focus – and ours – entirely on Linda. One audience member snaps a picture at the same time as Moore, trying to capture an identical instant.

It's what we, in the trade, call a 'fashion moment'. Most of us are lucky if we witness half a dozen in a lifetime. Chris Moore's entire career has been about capturing those moments, the moments that elude everyone else, but which have come to define the identity of the fashion world.

Here they are.

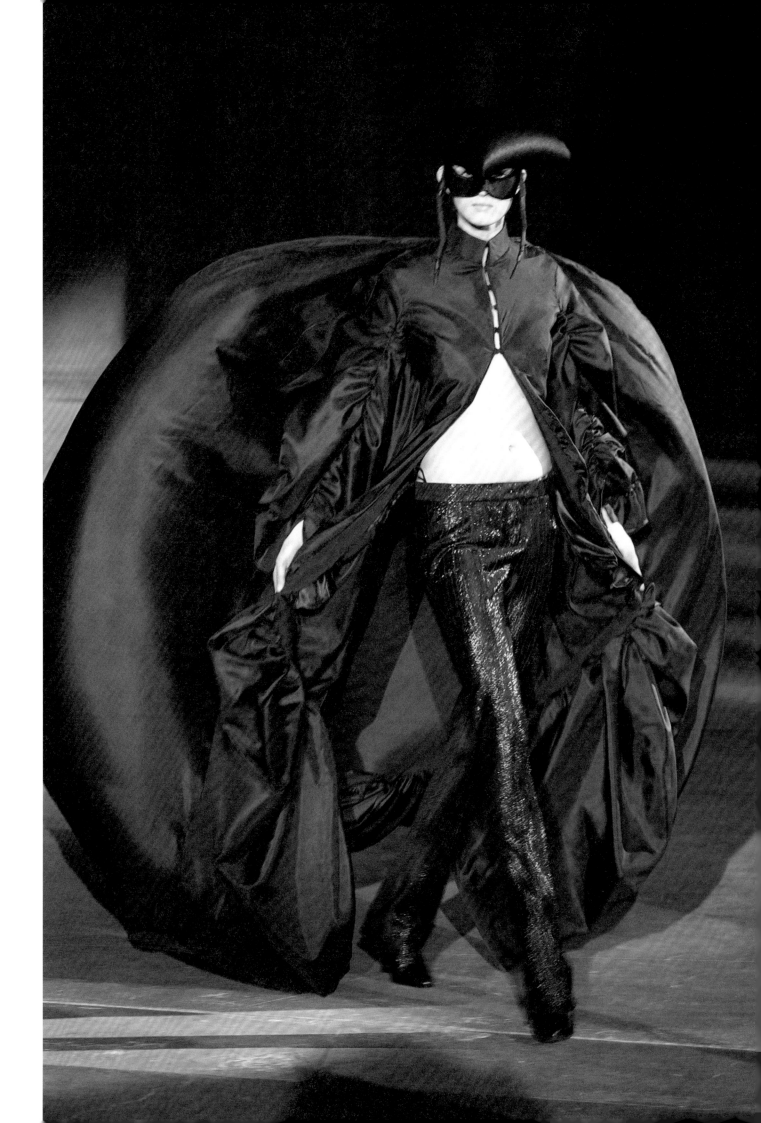

This page:
Thierry Mugler
Autumn/Winter 1995
Paris

Overleaf:
John Galliano
Spring/Summer 1995
Paris

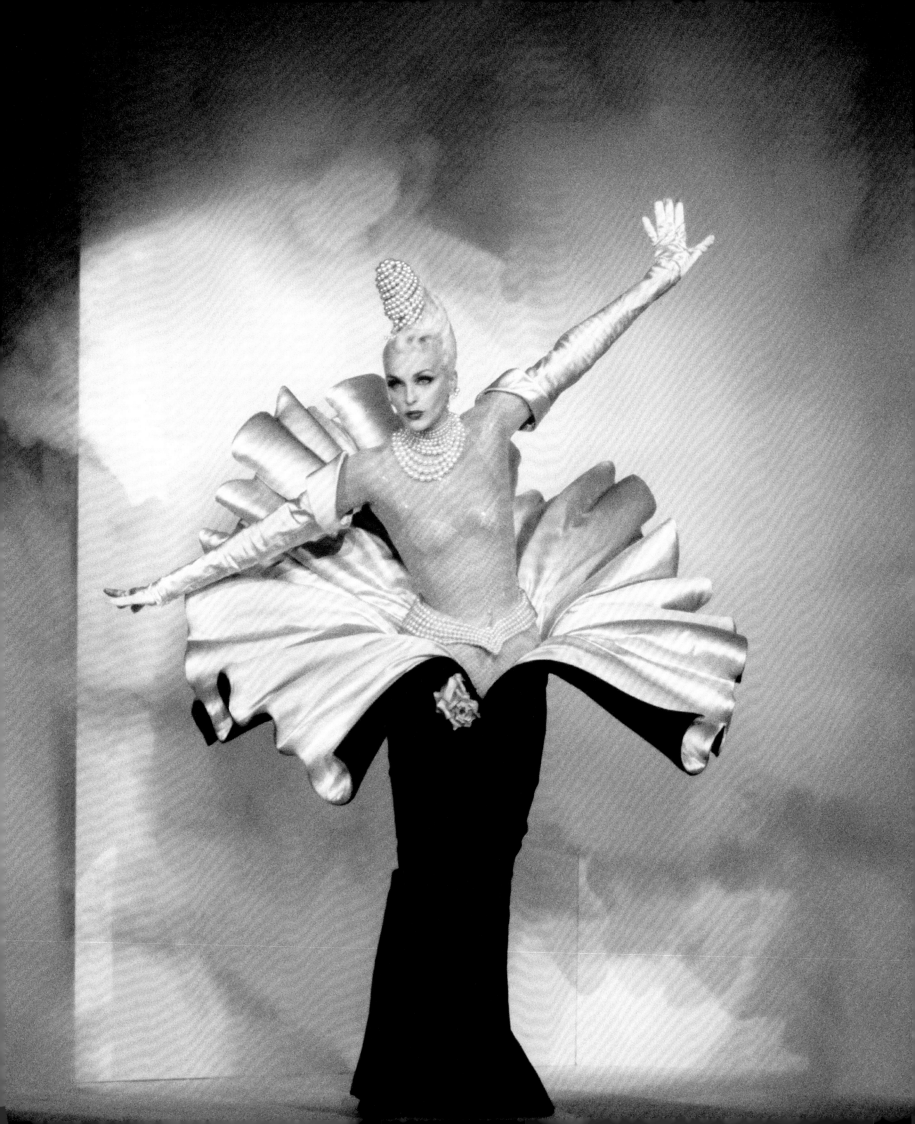

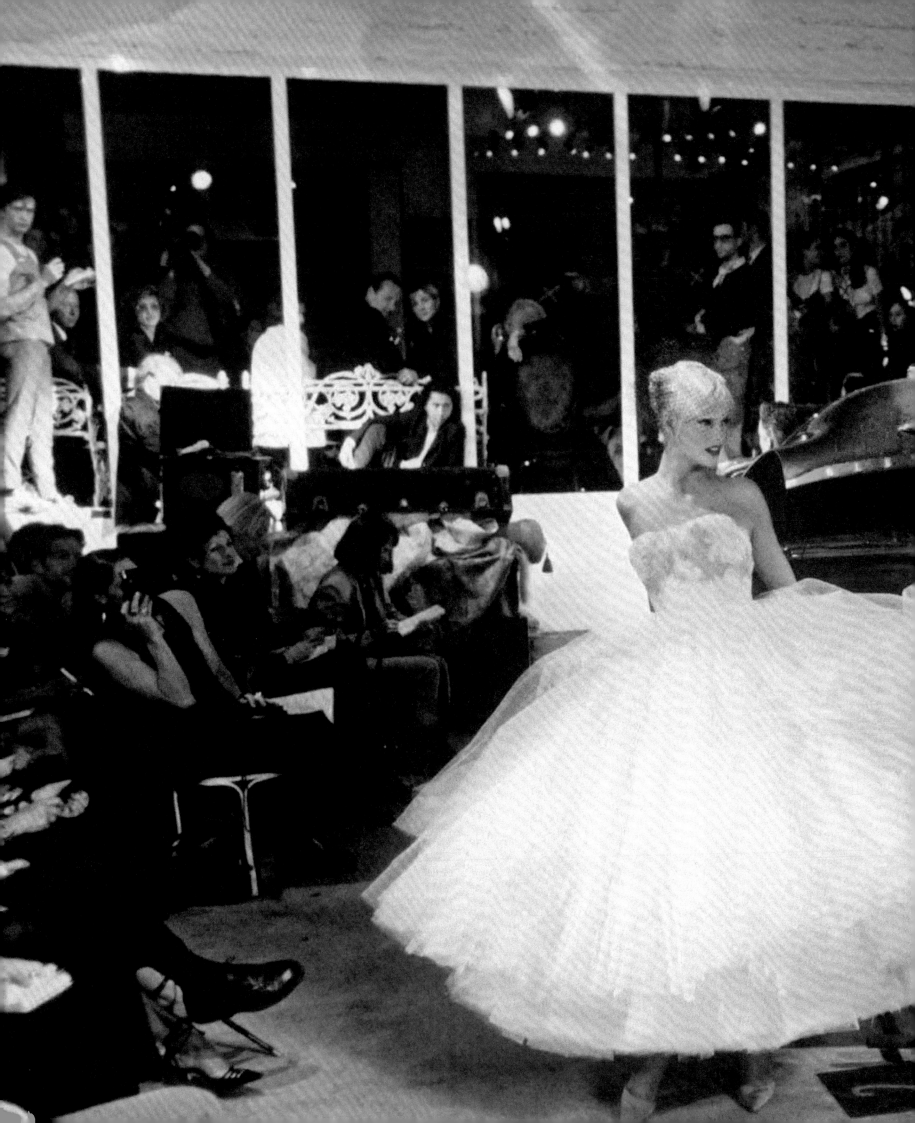

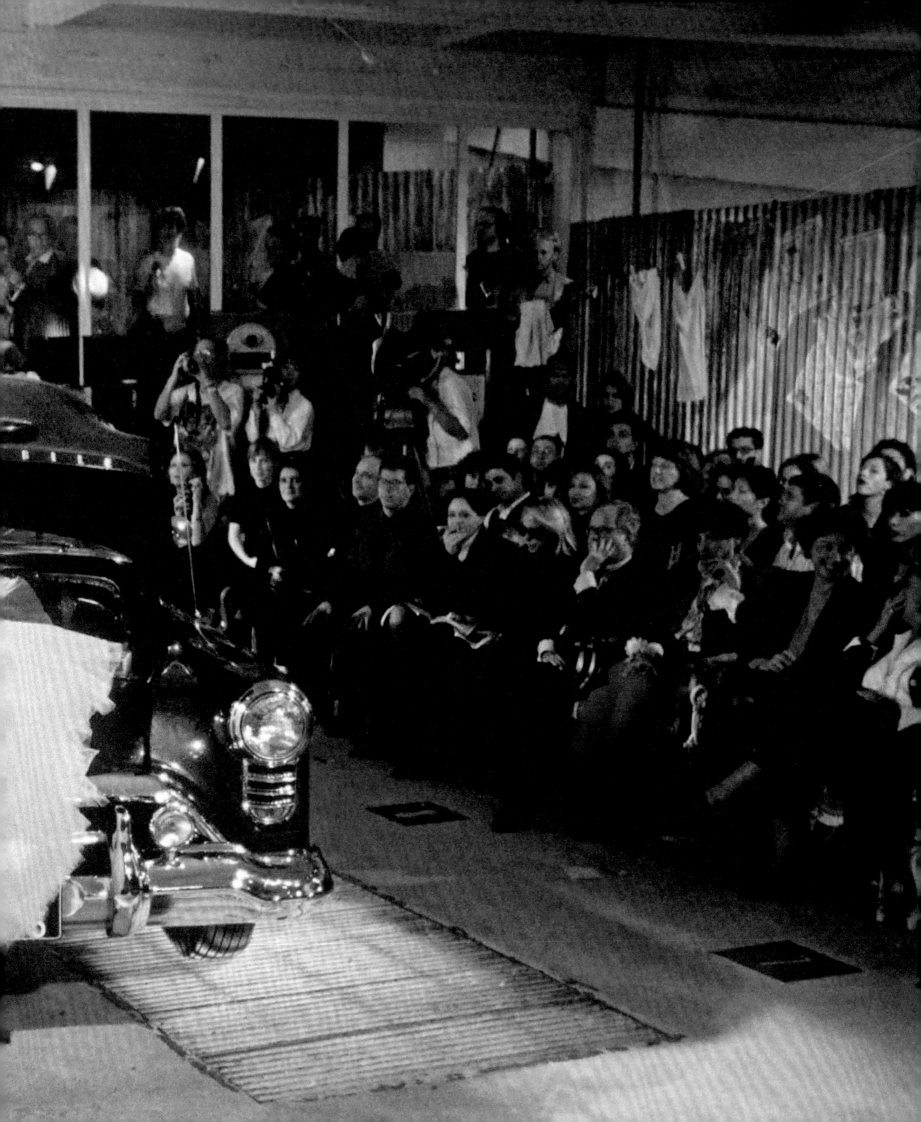

The Early Years

1954–1969

'My first wife, who was a journalist, used to cover the couture in Paris. They didn't have "shows" then – they would never allow any photographer in. But you could go after and they would have clothes that you could photograph. So that's what I did.'

Chris Moore

Chris Moore wasn't interested in fashion, really. Born in March 1934 in the Byker district of Newcastle Upon Tyne in northeast England and coming to London aged four in 1938, Moore was at first interested in the mechanics of image-making, as opposed to that of glamour. His early childhood didn't expose him to fashion; his father was a butcher, his mother a cook. But the power of the camera – its technical processes and its ability to create imagery – was an early fascination. 'When I was about 12 or 11, my sister had a Leica and she was taking photographs and developing films. I got really hooked on that,' Moore says. That was in the mid 1940s, photographic cameras having become more readily available and affordable in the 1930s. Rather than an alien thing – complex to operate, cumbersome to manoeuvre, a specialist contraption to be regarded with suspicion and even fear – cameras began to be used by the everyman to document family life. The introduction of 35mm film and lightweight, easily handheld cameras such as the Leica opened photography up to new audiences. Some, like Moore and his sister – 12 years his elder – even experimented with printing and development processes. Moore became fixated on the technicalities of photography, and its possibilities for creation.

'I was more interested in the images than the photography,' says Moore. 'Later on I got a camera of my own, called an Agfa Karat, spelled with a "K". Then I just took pictures of the surrounds of where I lived at the time. They were just snapshots really, I can't say I was being artistic … but I was always interested in images, images always interested me.' Those post-war snapshots didn't survive. In mid-century London, art school wasn't an option for most – particularly working-class teenagers like Moore, even those with an interest in the subject. Moore wanted to study art, but failed the entrance examinations. 'I was absolutely hopeless at Maths and English,' he allows. 'I think I'm probably a bit dyslexic – I can't spell a word, so I find it very difficult to write. So photography, I find really wonderful.'

As a result, Moore left school in 1949 aged 15, and worked as a messenger in a solicitor's office: a means to an end, rather than his life's calling. The following year he took his first steps to translate his burgeoning photographic fascination into employment – albeit not yet a career. At the behest of his father, he joined a photographic studio just off Fleet Street in London, named Gee & Watson Limited, on Shoe Lane. 'They made blocks – plates that went into journals,' says Moore, describing a technical printing process to mass-produce imagery, in which Gee & Watson specialized. An advertisement from February 1940 trumpets the varieties expertise under Gee & Watson's roof: Process Engravers, Typesetters, Stereotypers, Electrotypers – alongside Artists and Photographers. The building was a hub, of practical technique but also of creativity. 'I arrived thinking I was going to work in the block makers, but I was ushered into a photographic studio,' says Moore. 'That's like being put into heaven really, for me.'

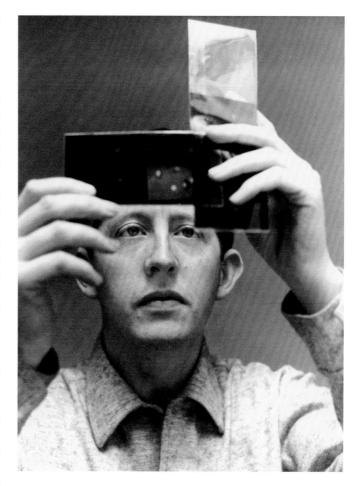

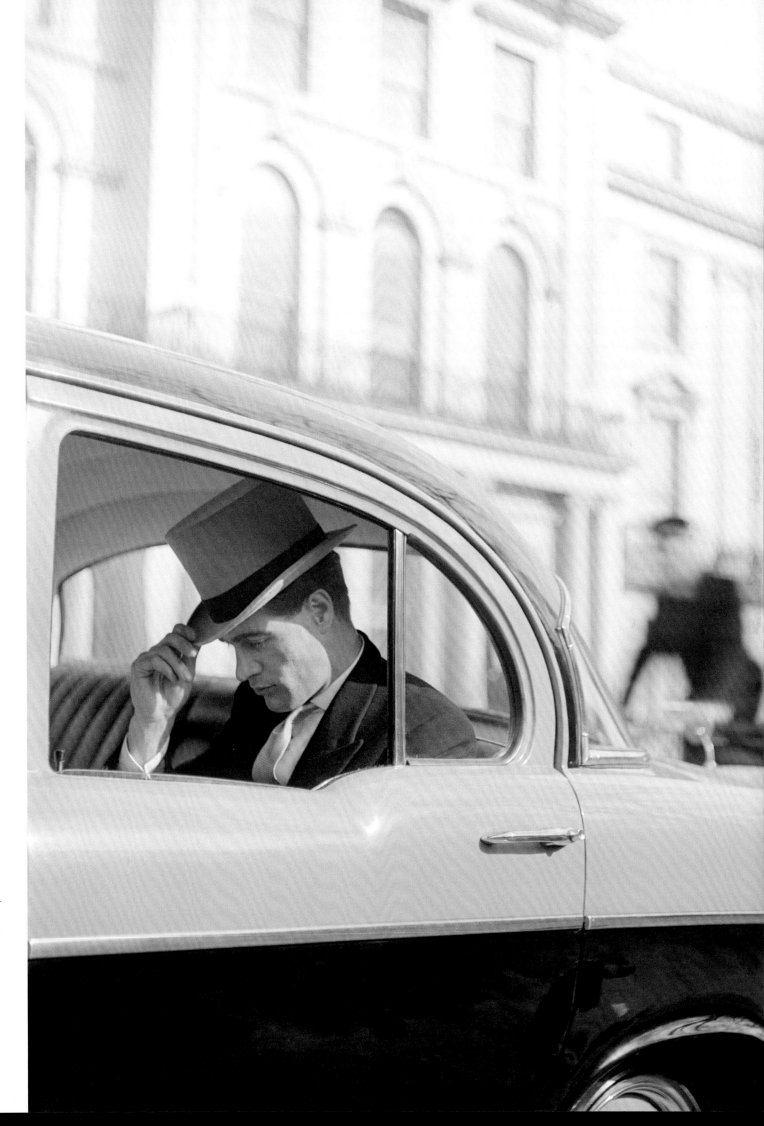

Opposite:
Chris Moore, self-portrait,
1964, London

Right:
An image taken by Chris
Moore for the magazine
British Millinery. It was for
this magazine that Moore
was first commissioned to
cover the London couture
collections. 1959, London

Previous page:
Clive
Autumn/Winter 1967
Haute Couture, London

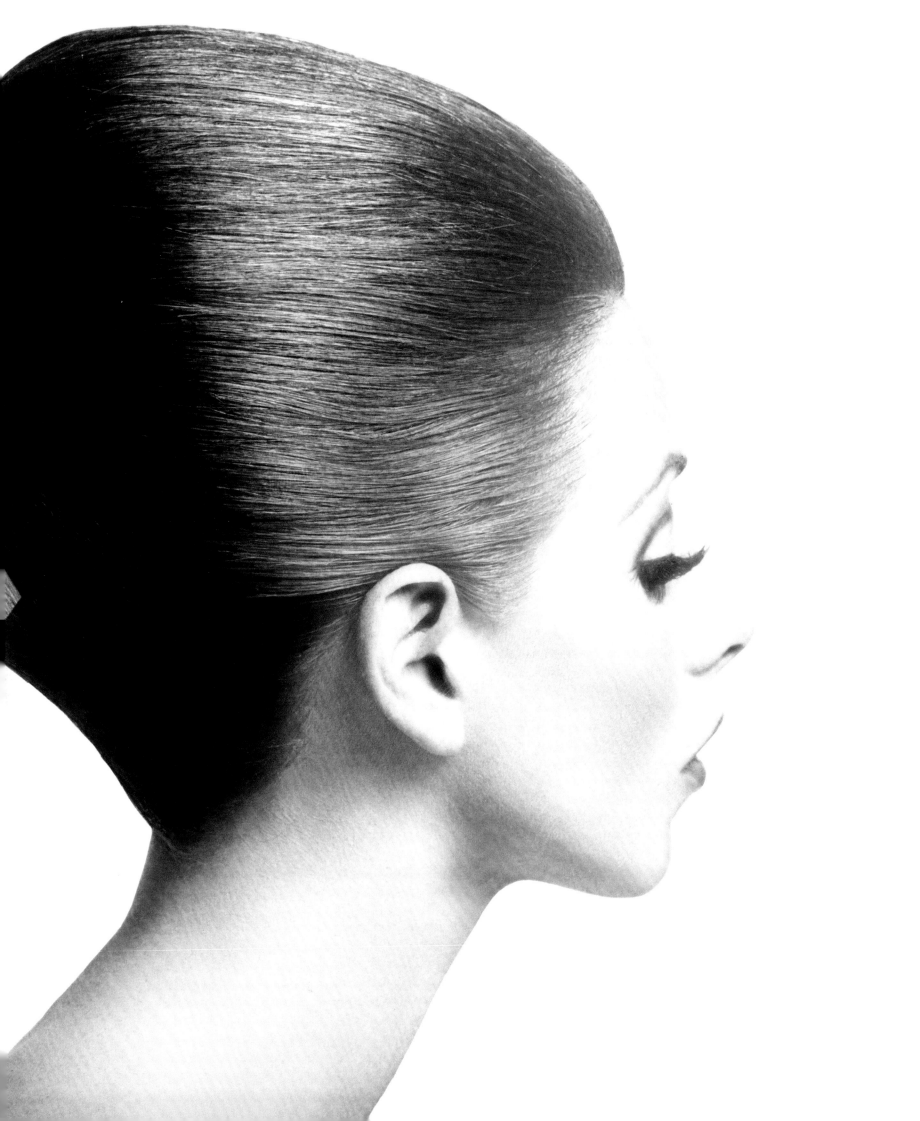

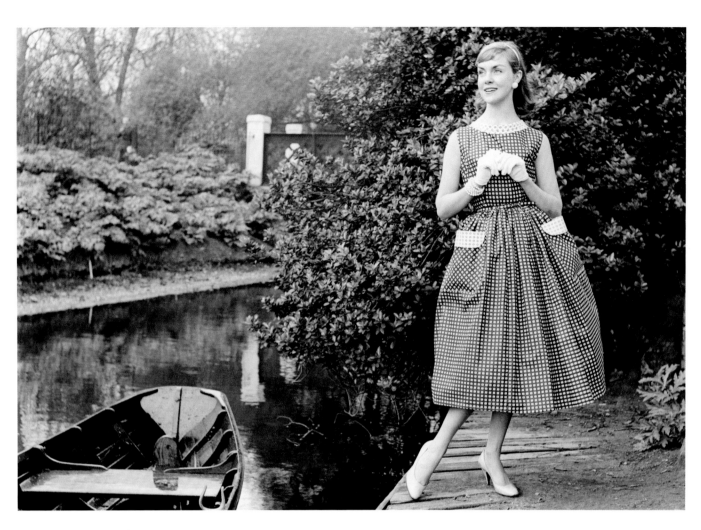

Left:
She magazine,
editorial, 1959, London

Opposite:
Marimekko advertorial
image, 1961, Helsinki

Previous page:
An editorial image featuring
hair by Rose Evansky, a
leading hairstylist of the
1950s and 1960s, who
invented the blow-dry
hairstyle in 1962. Chris
Moore's training at British
Vogue gave both these
early studio-based images
and later catwalk reportage
work an editorial eye.
Evansky, 1964, London

Moore's time at Gee & Watson cemented his decision to work in photography, and unexpectedly directed him towards his future in fashion. He also worked alongside another future star, the nascent photographer Terence Donovan. 'He left before me,' comments Moore. 'And went straight up into the sky!' Moore's Gee & Watson work was by no means fashion-focused: he photographed still lifes – tins of biscuits and the like – for a variety of publications. 'But it was learning one's craft,' Moore emphasizes. Indeed, at Gee & Watson, Moore grappled with the tools of the trade old and new, including the technicalities of plate cameras (still in use late into the twentieth century), alongside the duplication and printing of images. The latter is a skill that he still highlights as incredibly important. 'I'm absolutely fascinated by the technology,' he says. 'I think it is like a painter wanting to know which paint works best. I think a photographer needs to do that.'

Images of the young Moore show a clean-cut, dutiful young man: the eager apprentice. He soaked up a knowledge of photography, indulging his passion. Indeed, those images are self-portraits, so their depiction of a near-teenager captivated by a photographic negative reflects Moore's own image of himself. He set up a still-life studio in his bedroom, to photograph portraits and experiment with lighting, printing and processing in his own time, exploring the artistic possibilities of the medium with his new-found know-how.

It was only when he was aged 20 that Moore's path first truly intersected with fashion. He moved to British *Vogue*'s in-house studio, as a photographic assistant, a giant leap from Fleet Street into the world of high fashion – albeit to Soho's Shaftesbury Avenue, rather than Hanover Square. The Vogue Studio was just above the Queen's Theatre, on the corner of Wardour Street, and was used by photographers shooting for Condé Nast titles, including *Vogue* and *House & Garden* (then a relatively new publication, launched only in 1947). 'It is fascinating, because I came from a very sort of humble background, and then suddenly I was in this great, sophisticated place,' says Moore. 'Even the fact that Brewer Street Market, which was around the corner, had peppers. Well, I'd never seen a pepper, or an artichoke. I was the English provincial boy, suddenly among all these exotic things. It was wonderful, because I asked questions of everybody. I learned a lot.'

In contrast to current photographic practice, where an assistant is coupled with a photographer to learn the trade and eventually branch out alone, at Vogue Studio a group of assistants were employed to work interchangeably, albeit alongside the leading fashion photographers of the time: Clifford Coffin, Henry Clarke, Cecil Beaton, Norman Parkinson. Moore insists that role came about by accident, as opposed to by design or through any specific interest in fashion, over photography. Even at this point, he confesses to having little fascination with that world. 'When I was at Vogue Studio, people would ask, "Oh, so you're interested in fashion?" And I would answer, "I don't know",' he says. 'But I think that grew; the interest in fashion did rub off on me.'

That much was, perhaps, inevitable. *Vogue* in the mid 1950s was the crucible of contemporary fashion: to be 'in vogue' was to occupy a position at the centre of the fashion firmament, at the pinnacle of the industry. Moore's exposure, as a budding photographer, to the world of style that roamed the halls of British *Vogue*, proved pivotal.

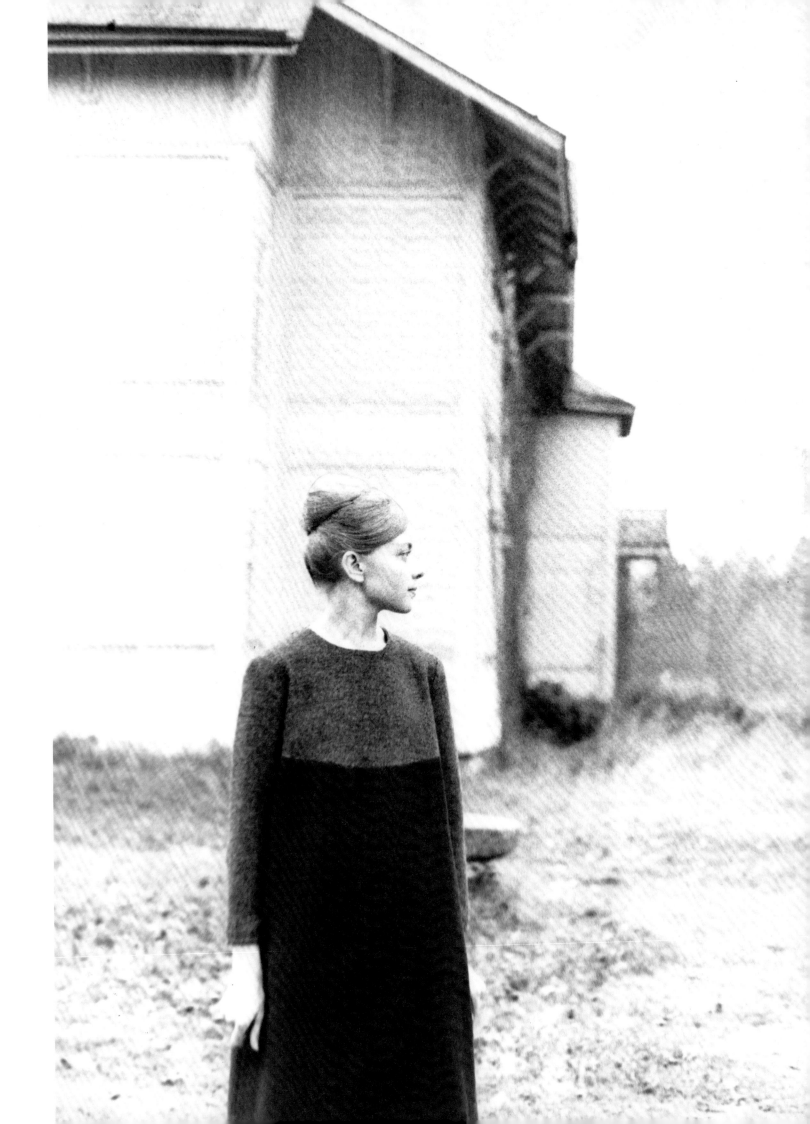

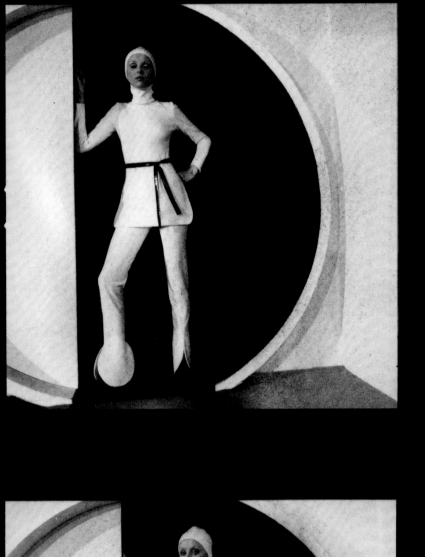
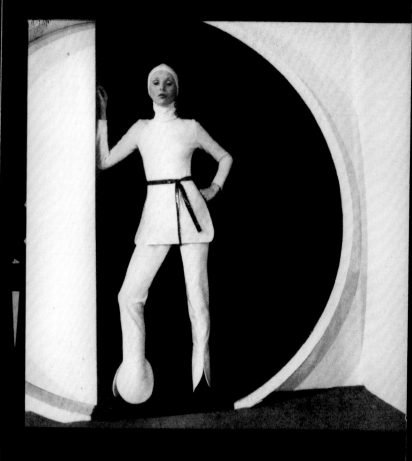
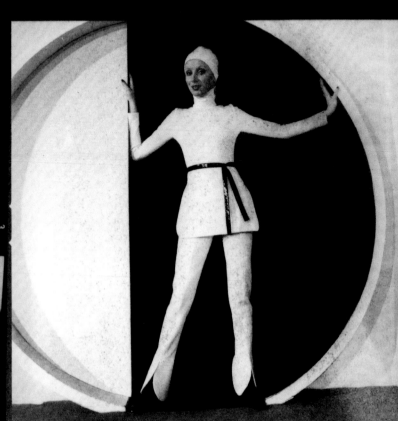
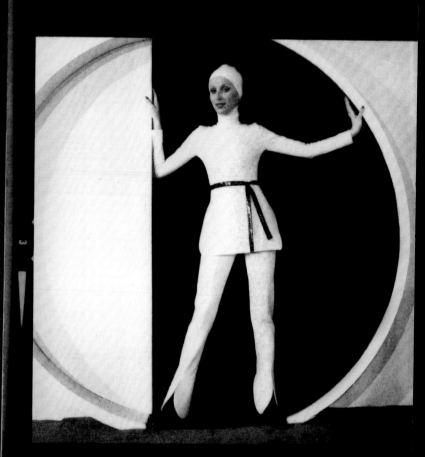

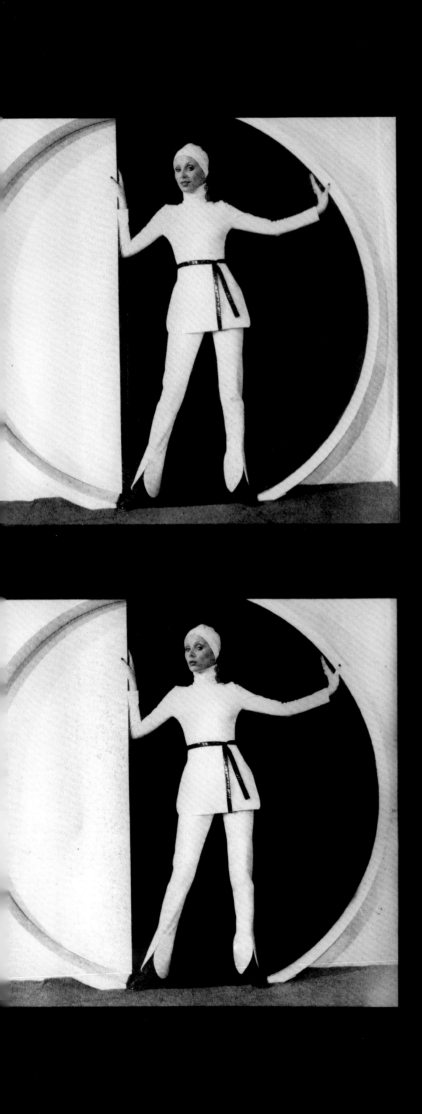

'I shot Cardin from the word go, really,' says Moore, who states that his catwalk career began with the Paris Haute Couture collections of 1967. 'In the 1960s and '70s Cardin really was the big trendsetter. He was one of the first to let us into the salons. A real modern thinker, [and] it showed in the clothes, too.'

Pierre Cardin
Spring/Summer 1967
Haute Couture, Paris

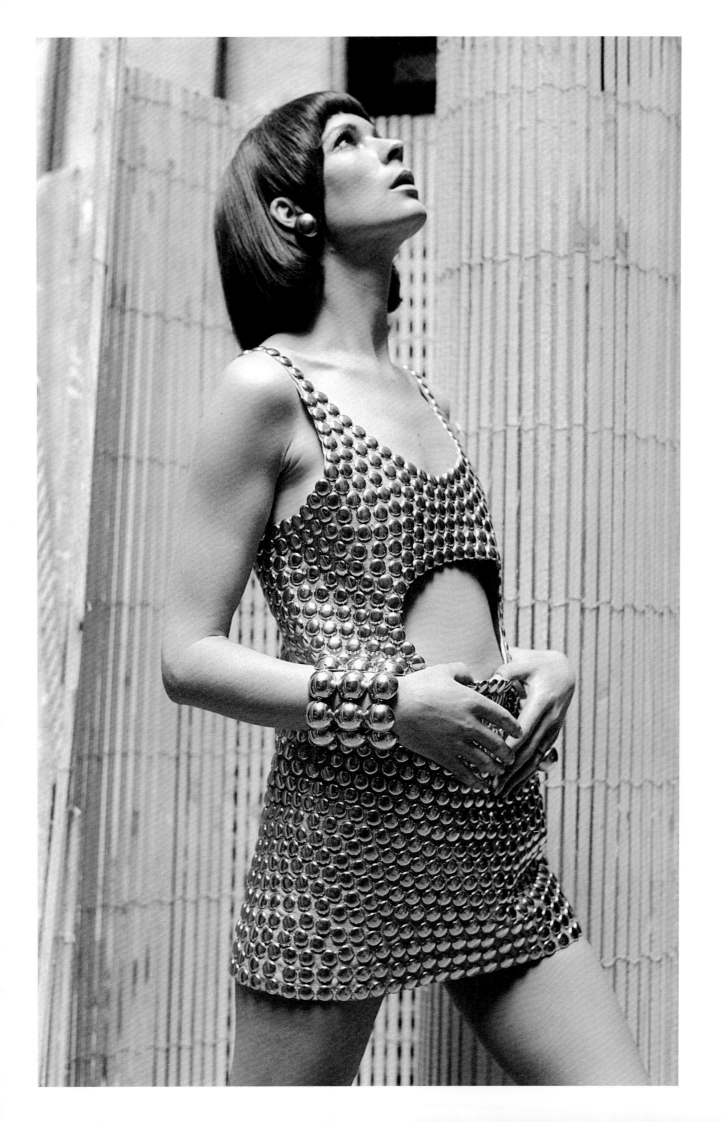

As the 1960s unfolded,
Moore documented the
rising stars of the Paris
scene. Modernists, such
as Paco Rabanne – whose
clothes were created from
unconventional materials,
such as plastic or metal
plates connected with
chain-links, as opposed
to fabric – were more
receptive to the new idea
of catwalk photography
than old-school names.
In the 1960s Moore
was never permitted to
photograph the clothes
of couture houses
Balenciaga or Givenchy.

Paco Rabanne
Autumn/Winter 1968
Haute Couture, Paris

Far left:
Emanuel Ungaro
Autumn/Winter 1968
Haute Couture, Paris

Left:
Mary Quant
Autumn/Winter 1968
London

Opposite:
Emanuel Ungaro
Autumn/Winter 1967
Haute Couture, Paris

Vogue offered a young working-class man like Moore a close acquaintance with – if not exactly an entrée into – not only fashion but also a glittering world of high society. 'I had a wonderful trip with Henry Clarke to Sicily. That was an eye-opener for this rather provincial, uneducated assistant,' he says. 'It was with Fiona Campbell-Walter, who later became Baroness Thyssen, I think, and Elsa Martinelli, who became a film star. She taught me how to eat spaghetti. I'll always be thankful to her.' On another shoot, Moore recalls Clarke styling the model Suzy Parker's hair. 'Then, models mostly did their own make-up. There weren't any stylists then. They didn't exist.' Moore recalls the difference between the photographers' various talents: Cecil Beaton shot with given light, rather than tweaking or reconfiguring and his contemporary Clifford Coffin 'brought his own light from America', recalls Moore. 'It was a ring light, a tungsten ring light. I remember he wanted music, and so I brought my record player in. I can remember the music we played: Johnny Dankworth, "It's the Talk of the Town". It was that sort of era. It was fascinating, all of it.'

Vogue was a learning experience for Moore: he likens it, today, to art school. Certainly, in assisting the greats of the day, Moore was first-hand witness not only to photographic technique but also to the work of leading designers and models, the entire universe of fashion. Moore himself, however, stayed away from the camera. 'The one thing they did tell you when you went to become an assistant was, "Don't imagine you're ever going to become a *Vogue* photographer,"' he says. Instead, Moore's daily work was manual labour: assembling sets, loading 5x4 inch film slides. 'General dogs-body' is how he characterizes his role. He can't recall taking an image within the Vogue Studio himself. 'That', he declares, 'was rather frowned upon.'

Indeed, the pecking order was emphasized, even as the 1960s began to swing and young, working-class photographers – like Donovan, and David Bailey – began to break through onto *Vogue*'s rarefied pages, shattering a glass ceiling few had perceived. 'I could be a jazz musician, an actor or a car thief,' said Bailey. 'They – from Mars, or wherever they are – said I wouldn't be a fashion photographer, because I didn't have my head in a cloud of pink chiffon.'

Moore's experience established an editorial eye: rather than roving reportage, he had photographed still lifes off Fleet Street, and watched as photographers captured the static, highly stylized poses of mannequins at *Vogue*. Although an interest in fashion had been piqued – 'subconsciously', he says today – Moore moved from Condé Nast to the photographic agency Camera Press, primarily motivated by finance. He married his first wife, Jackie Moore, a fashion journalist, when he was 20. They had met during Moore's time at Gee & Watson: she was the knitting editor of *Woman's Weekly*; Moore was responsible for the still lifes created to illustrate her articles. When they married shortly after, his wages at *Vogue* weren't enough to support them both, prompting him to branch out. He photographed models, but usually without a fashion slant: to illustrate general interest articles, rather than fashion shoots. 'I knew what I wanted to do was take photographs,' he says, plainly.

What Moore perceived as a restrictive contract with Camera Press motivated him to break out on his own, founding a company in his own name and creating imagery under his own direction. He was just 21. Given his *Vogue* training, which understandably swung towards fashion from its earliest point, Moore photographed decidedly old-school imagery, for trade magazines, such as *British Millinery*. He would shoot 60 hats in two hours, a self-confessed hack job against a pale Colorama, in a small studio in Soho.

The notion of the 'catwalk photographer', which Moore would come to define, had yet to emerge. In part, that was because the catwalk itself had yet to develop: in the late 1950s, the fashion system was still dictated by haute couture, governed by draconian rules and regulations and centred on Paris. Possibly above and beyond all other rules, photography was banned in the salons of couture houses, sacrosanct spaces guarded jealously by the industry's governing body, the Chambre Syndicale de la Haute Couture. Established in 1868 at the behest of Charles Frederick Worth, to regulate and standardize the then burgeoning new haute couture industry, the Chambre Syndicale monitored and enforced rules prohibiting the publication of images, in an effort to prevent piracy. Haute couture made the lion's share of its money not by sales to private clients, but through licensing designs to department stores for reproduction, so a leaked design could spell financial ruin for a couturier. Newspapers and magazines reporting on the shows would use either official sketches or censored images, or wait until approximately three months after a collection's debut to present images of the clothes to the public at large.

Official rules against photography were coupled with general disdain for the press, which many couturiers merely endured rather than embraced. Especially extreme were the reactions of Cristóbal Balenciaga and his protégé Hubert de Givenchy, who, from 1957, opted to show four weeks after their peers. Their clothes were unveiled to journalists and editors a mere 24 hours before their delivery dates, denting their press coverage in an ostensible attempt to combat piracy. Simultaneously, it demonstrated many couturiers' distaste for publicity – particularly that of Balenciaga, who gave his first (and only) interview after his couture house closed in 1968.

In the fashion industry of the late 1950s and early 1960s, there was no space for any such thing as a 'catwalk photographer': the presentation of couture clothing to press was simply not photographed. However, just as attitudes towards fashion photographers began to shift in the late 1950s, to open the playing field to talents as diverse as Donovan and Bailey, fashion as a whole began to shift. Younger talent began to emerge: in 1957 Christian Dior – the couturier whose 1947 'New Look' had 'saved France', and whose couture house, by 1949, accounted for an enormous 75 per cent of French fashion exports and 5 per cent of all French export revenue – died of a heart attack, aged 52. His empire was inherited by his delicate 21-year-old assistant, Yves Saint Laurent, who followed an acclaimed debut in spring 1958 with a series of controversial collections, radical and uncompromising in their youth. In 1950 another former Dior assistant, a 28-year-old Franco-Italian named Pierre Cardin, opened his couture house, making a name for himself with bubble-shaped dresses and unusual, modernist cuts. By 1959 he was sufficiently radical to attempt a collection of 'ready-to-wear' clothing for the department store Le Printemps, causing the Chambre Syndicale to expel him from its august ranks. And in 1961 André Courrèges and his parter and future wife Coqueline Barrière founded Maison Courrèges, with seed capital from their former employer, Balenciaga.

In the mid-1960s, André Courrèges was fashion's pioneer – he designed cosmonaut-influenced clothing, with sharp, modern lines that retrospectively define the optimism and modernism of the era. 'The most exciting, the most extraordinary,' says Moore. Following widespread copying of his designs after his 1965 'Space Age' collection, Courrèges retreated from showing on the couture schedule. When he returned in 1967, Moore captured his designs on colour film, which was still rare. This was his first season photographing the French haute couture

André Courrèges
Autumn/Winter 1967
Haute Couture, Paris

These younger couturiers designed progressive, youth-orientated clothes: Saint Laurent was fired from Dior in 1960 for producing a collection inspired by the black-clad Existentialists who peopled the Left Bank of Paris. The keynote garment of the show was a leather jacket – or *blouson noir,* synonymously a colloquialism for hooligans on the Boulevard Saint-Germain. *Blousons noirs* were more likely to intimidate or mug a couture client than to appear on their back. But the experimentation of Saint Laurent, Cardin and Courrèges was indicative of shifting attitudes not just to fashion, but also to the dissemination of its imagery. In short, modern fashion was about to be born.

It wasn't just born in Paris, though. Moore was – and still is – based in the vibrant centre of London: he established Christopher Moore Limited in Soho in 1964, with his home above his studio on Soho Street. He bore witness to the explosion of London's vibrant ready-to-wear scene, centred on the boutiques of neighbouring Carnaby Street and the King's Road and extending into Kensington, the home of Mary Quant and Biba. None of these, however, were viewed as 'high fashion' – that label was restricted to London's couture practitioners, chief among whom were Norman Hartnell and Hardy Amies, both dressmakers to the Queen by the end of the 1950s. Those couture houses, however, were followers rather than leaders, developing styles laid down by their Parisian counterparts. Moore, meanwhile, was focusing on an editorial career, on studio shots and posed models – including a selection of clothes from those British couturiers – for clients including newspapers such as the *Guardian* and the *Express,* and *British Millinery.* For the last publication, Moore recorded the work of the young British couture house Clive, designed by Clive Evans and presented in a salon in Hanover Square from 1964. A largely forgotten name now, Clive designed couture that, oddly, bridged the gap between the establishment and the mood of 'Swinging London', attracting clients including the socialite Lee Radziwill and the dancer Cyd Charisse with its combination of old-school technique and fashionable new shapes (miniskirts rode high up the thigh). But Moore was recording clothes in a manner akin to his *Vogue* mentors, as opposed to capturing the dynamic speed of a fashion show in live action. In the mid 1960s, catwalks still did not exist – in London, Paris or anywhere else.

Just as couture was still the zenith of fashion, so Paris was the undisputed centre of that industry. Despite fashion shows staged in Rome and Florence – the latter notably catapulting the Italian designer Valentino Garavani to fame at his debut in 1962 – and the rise of both couture and ready-to-wear trades around New York's Seventh Avenue and London's Mayfair, Paris was the absolute focus of both creative and commercial forces in the industry. 'No other nation can match,' *Time* magazine had declared in 1957, in a story that ran with a cover image of Christian Dior himself. 'No other people have been willing to devote so much time and thought to their clothes.'

Moore first went to Paris in 1967, to cover the spring haute couture presentations. As a freelance journalist, his wife had access to those shows, and she encouraged Moore to follow her, to document the clothes – although not the events. Moore was not allowed into the salons during the presentation of the couture collections; no photographers were, bar those employed by fashion houses, such as the German-born Willy Maywald, whose imagery has become indelibly associated with the designs of Christian Dior in the 1940s and 1950s. But even Maywald tended to document Dior dresses in a context more akin to an editorial shoot – framed by sprays of roses on the staircase of the Dior couture house at 30 Avenue Montaigne, or famously on the banks of the Seine, where house model Renée posed in Dior's 1947 Bar suit.

'I think she [Jackie] just wanted me there for company, but I had to do something,' Moore recalls, with typical modesty, of these first trips to the couture shows. But what he ended up doing, in Paris in the 1960s, was becoming one of the first photographers to record fashion live, as it happened. Rather than capturing fashion months after its original unveiling in an alien editorial setting, Moore's work pinned down fashion at the source: the houses of 1960s Paris.

The context was vital – and, for Moore, a thrilling element. 'When I was an assistant at *Vogue,* I remember that somebody said, "the collections are coming out,"' he recalls. 'I thought that was fascinating: that there would be a time of year when there would be

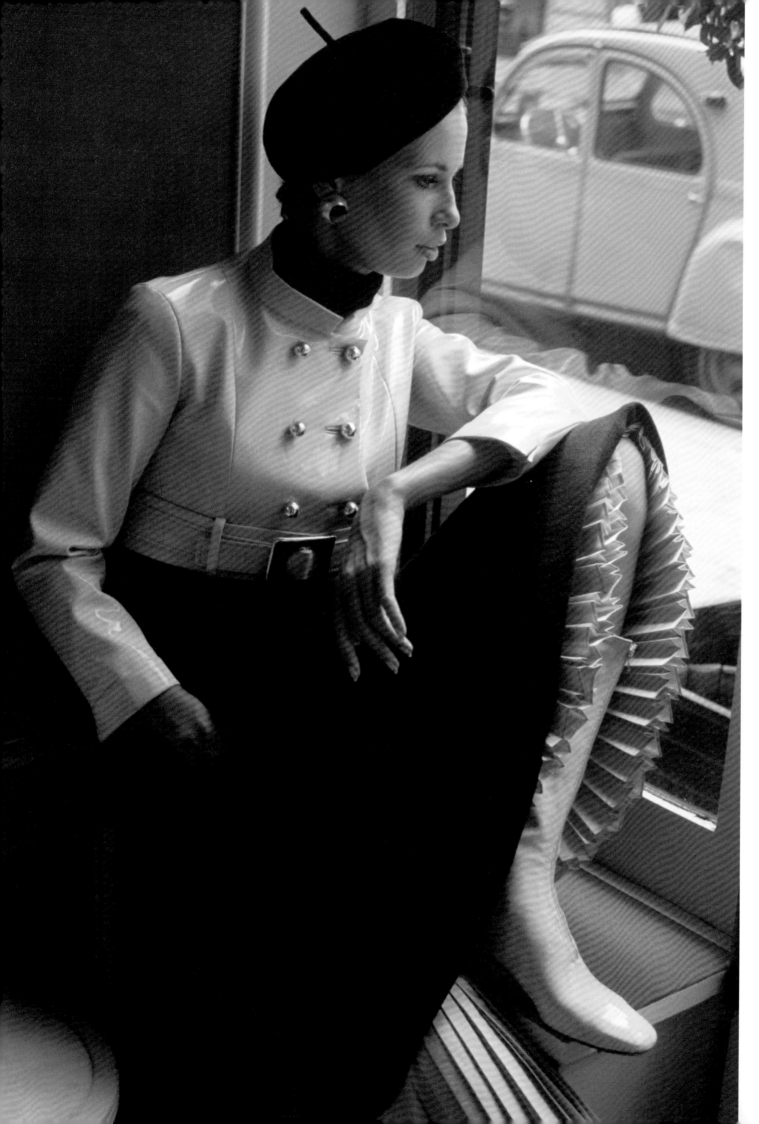

Alongside the new
generation of couturiers,
and a fresh wave of
London talent, Moore also
photographed outfits from
established Paris houses.
Lanvin, then designed
by Jules-François Crahay
(between 1963 and 1983),
was an early advocate.

Lanvin
Autumn/Winter 1967
Haute Couture, Paris

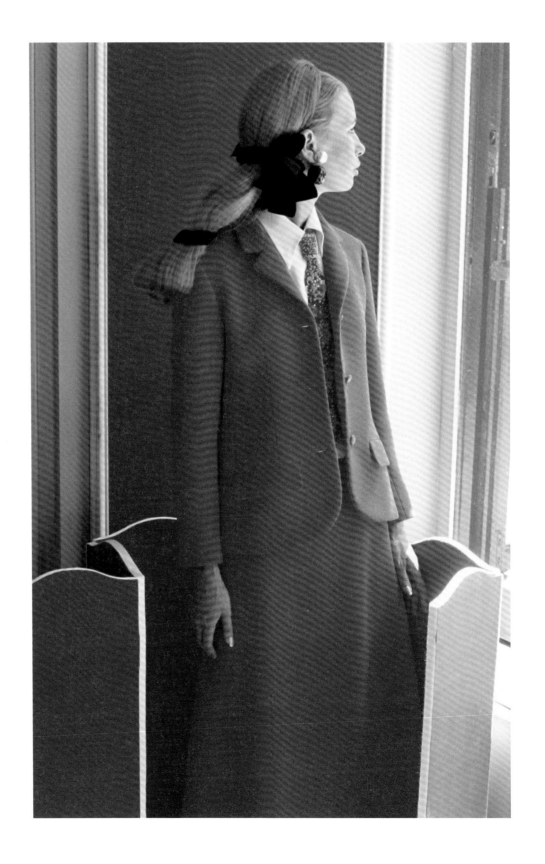

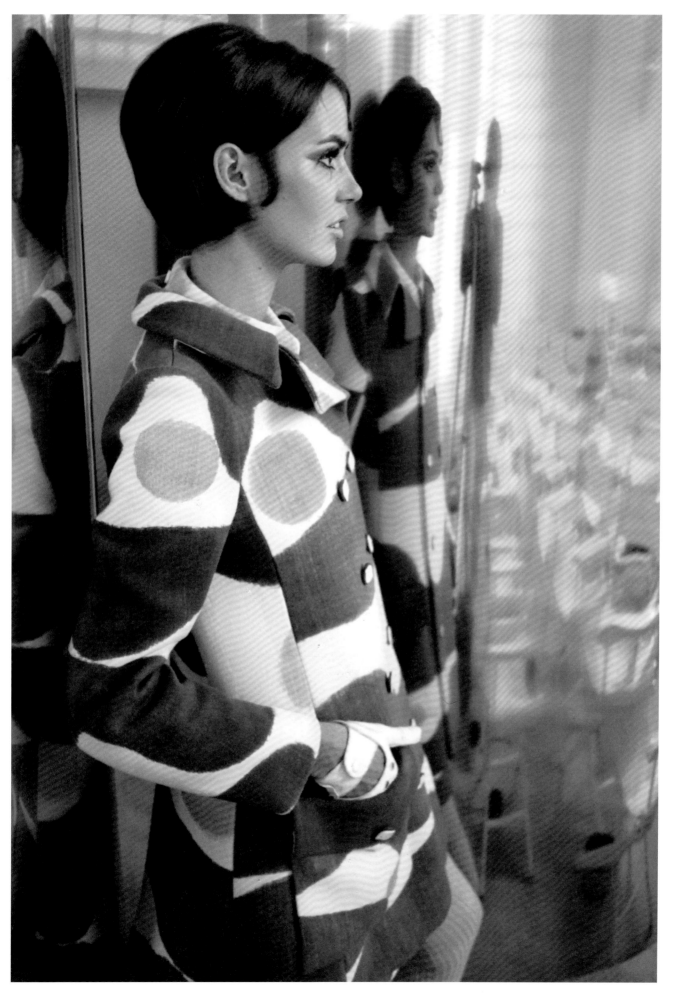

While younger couturiers – such as Emanuel Ungaro, who trained at Balenciaga and opened his own house in 1965 – invited Moore into their salons to take images, more established names kept their distance. Moore photographed models in the street, or in hotels or apartments, to record their collections.

Left:
Emanuel Ungaro
Autumn/Winter 1968
Haute Couture, Paris

Opposite:
Chanel
Autumn/Winter 1968
Haute Couture, Paris

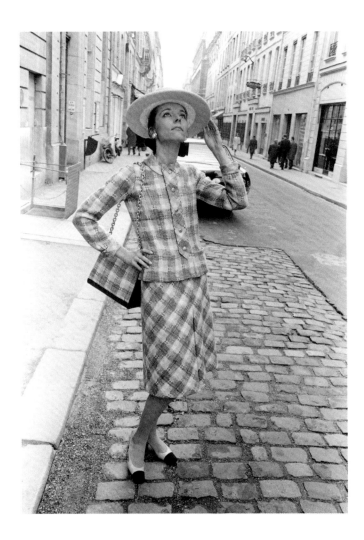
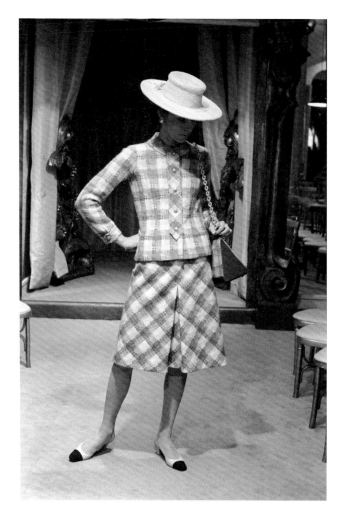

"collections". It became a sort of compulsion. There have been occasions, very few occasions, when I didn't get to cover those shows, and you feel like you're missing something terribly important.'

Moore's images were published, alongside Jackie Moore's writing, in British magazines and periodicals including the *Draper's Record*. Fusing fashion with real-life events, this marked Moore's first step into the industry proper.

But the catwalk remained elusive. 'They would never allow any photographer into a show,' Moore says, emphatically. 'But you could go after the show and they would have a number of garments that they would let you photograph. I'd take them out on the street.' The industry standard was five outfits, available to be released to the press. The models were even paid a fee for their time: the equivalent of £4 in French Francs. Moore's earliest work is notable for its lack of the recognizable catwalk of today: models are instead caught on the street or, occasionally, posed in studios. The images are markedly still, with none of the dynamic movement that is characteristic of his catwalk imagery.

But times had begun to change. By the mid 1960s Moore was one of a clutch of photographers capturing models on the street in their couture clothes. 'We'd call it the Croydon Camera Club,' he laughs. 'In other words, there would be a girl, and there'd be perhaps five photographers taking pictures.' And while certain houses – Balenciaga and Givenchy, Gabrielle 'Coco' Chanel, Dior under a new but conservative designer named Marc Bohan – continued to bar their doors to photographers, others began to challenge the century-old strictures of the Chambre Syndicale.

All this chimes with the mood of the times: rebellion, radicalism, revolution. It was an upheaval of social mores in which fashion's shifts – the highest in profile, and hemline, being the miniskirt – reflected the rapidly transforming ideals of the times. The 1960s transformed the twentieth century – it's when the world became modern. It's also when fashion became modern. In the 1940s and 1950s, fashion's mood was reactionary: Dior's ironically monikered 'New Look', with its Victorian expanse of skirt and constrained waist, made an unusual bedfellow with art's championing of Abstract Expressionism, or the bold, futuristic lines of mid-century Modernism.

In the next decade, fashion set the pace. Man walked on the moon in 1969, but woman did so in 1965, via the space-age salons of Courrèges, couture's relentless futurist. Incidentally, they beat Stanley Kubrick's *2001: A Space Odyssey* (1968) by three years. Moore was invited inside, to photograph Courrèges's models in situ, in the house's all-white space on Rue François Premier, kitted out 'with the modernity of a moonship'. The power of those images still resonates, of models in brief gabardine dresses, eyes concealed by goggles, surrounded by blinding white space. It looked like the future – stereotypically, but also in terms of a model in a designer environment.

'Courrèges was the bombshell in the sixties, I think,' says Moore. 'He really was. He was sort of the whole fresh approach.' The approach wasn't just aesthetic – it was also ideological, in terms of Moore's image-making. Courrèges kicked open the salon door, inviting photographers inside. Suddenly, others scrambled

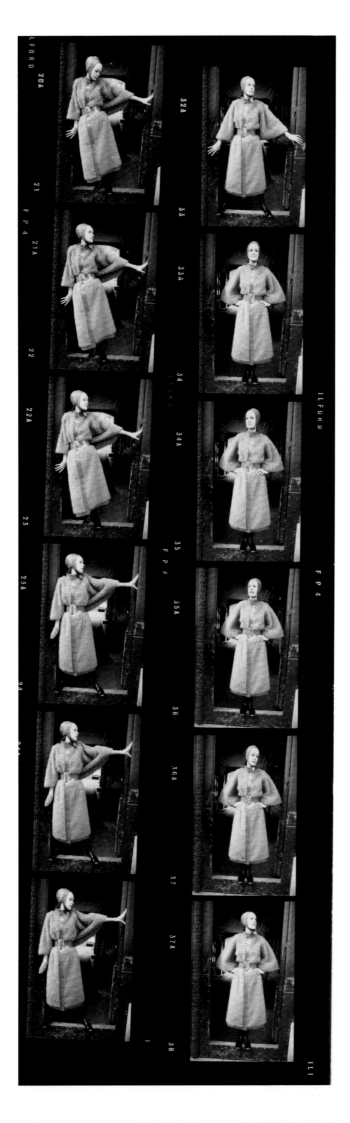

to follow, including staid houses such as Lanvin, and upstarts like Emanuel Ungaro, the former assistant to Courrèges and Balenciaga, who opened his own house the same year as Courrège space-age triumph. The limitations of outfits were the same – Moore and the handful of other photographers documenting the collections would be given access to very few models – and only after the presentations to clientele and press were complete, but the move in from the street signified a new acceptance of photography by a fresh generation of couture stars.

Moore was now shooting his own fashion images, albeit impromptu, unposed and improvised. In broader terms, his images chimed with the mood of the times, with the de-formalizing of fashion that would come to characterize the 1960s, when models became young and active and wore energetic, emancipated clothing. They increasingly wore ready-to-wear rather than haute couture, the clothes designed and sold direct by Mary Quant and Biba in London, and in France under the labels Cacharel and Chloé. The latter, founded by Gaby Aghion in 1952 (there was no 'Chloé' – Aghion merely liked the curvilinear shape of the letters that composed the name), staged its first fashion shows in 1957, impromptu events in the Left Bank eateries Café des Flores and Brasserie Lipp; but it pre-dated the true emergence of Parisian prêt-à-porter by a clear decade.

It is Yves Saint Laurent who is credited with the introduction of ready-to-wear to high fashion, opening a boutique in the Saint-Germain neighbourhood of Paris on 26 September 1966. That's the Left Bank of the city – the Rive Gauche, which Saint Laurent added to the title of the new venture, to emphasize its geographical position as separate from the couturier's *maison* in the Rue Spontini, an upmarket road in the 16th arrondissement, close to the homes of France's wealthiest financiers and industrialists. That was the Right Bank, and the right side of the river, which means a great deal in Parisian culture; by contrast, the Rive Gauche represented the anti-establishment, anti-fashion, anti-tradition. Saint Laurent was all those things, when he and his business partner Pierre Bergé struck a licensing deal with the French manufacturer C. Mendès to create his Rive Gauche clothes.

Before Saint Laurent, Parisian couturiers offered only 'boutique' lines, generally sold from small shops in their houses, which offered watered-down versions of their haute couture creations. They were seen as distinctly inferior. Saint Laurent's Rive Gauche, by contrast, was a creative exercise. The clothes were luxurious; not couture, granted, but with a new, polished elan, and appeal. It was a phenomenal success: by four o'clock on its first day of business, the boutique had sold $24,000 worth of clothing. By October that year, Saint Laurent himself was said to be 'desperate' – because the manufacturers couldn't keep up with demand for his ready-to-wear clothing.

Where Saint Laurent ventured, others followed. Cardin had been experimenting with the idea, and in 1967 both the young Emanuel Ungaro and Yves Saint Laurent's former employer, Christian Dior, launched their own lines. So did the 'bomb-shell' Courrèges, led by André and his wife, Coqueline – they prophetically titled it 'Couture Future'. That is what ready-to-wear proved to be: the future of fashion.

It was also a simple means to capitalize: 'When we went to America in 1965, we discovered we were being terribly ripped off,' recalled Coqueline Courrèges (née Barrière), in 2001. 'To see our ideas being copied made André furious. André decided that we would not be copied any more because we were going to copy

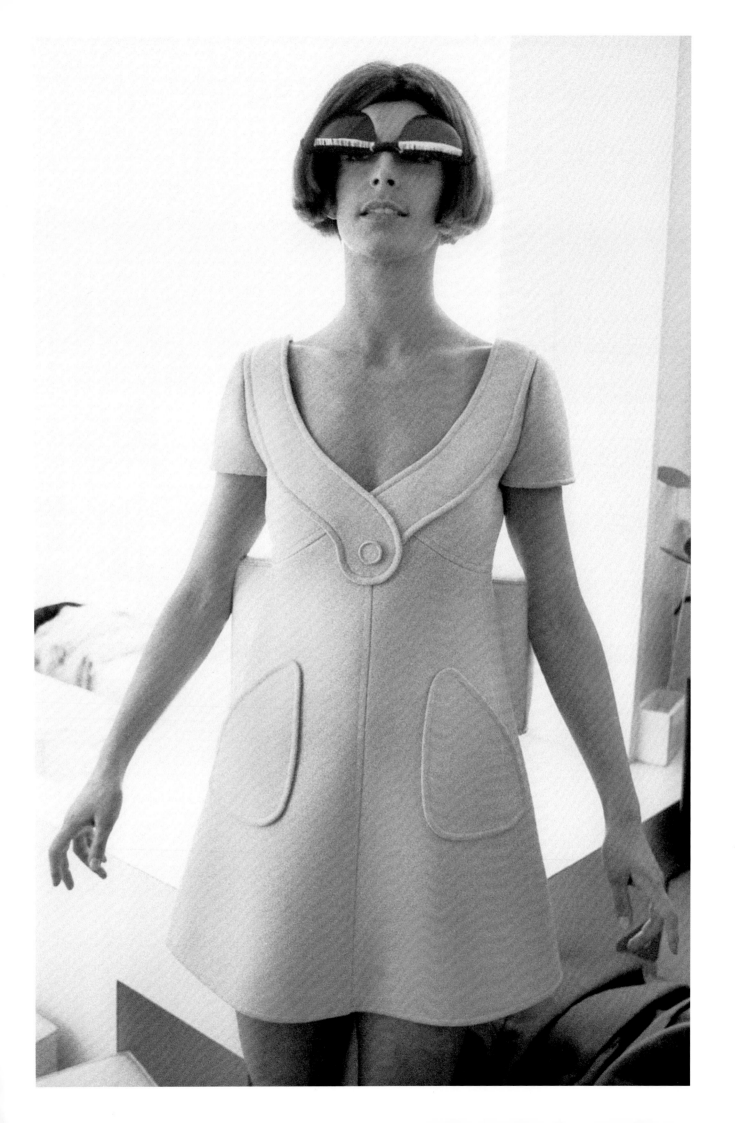

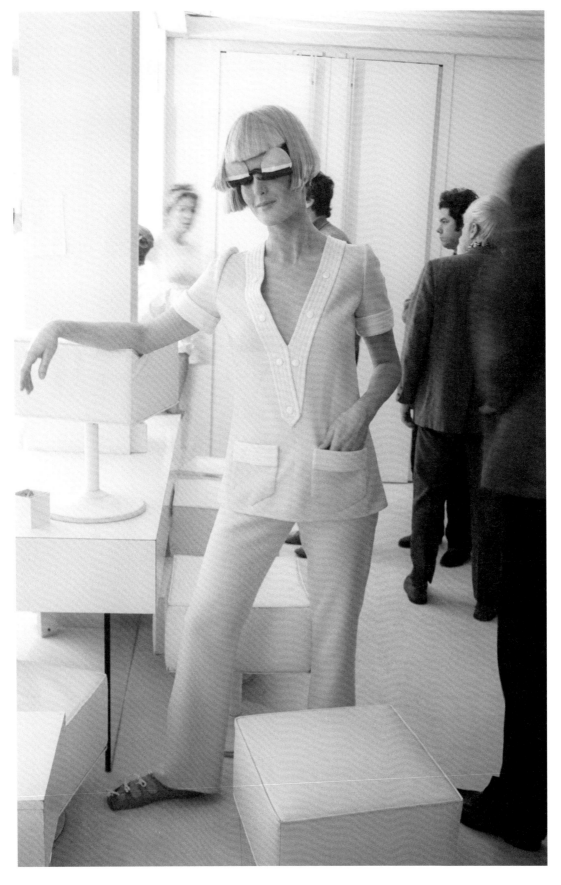

Moore vividly recalls the setting of the Courrèges salon, where he was permitted to record these images, which epitomize the space-age look with which Courrèges made his name: 'It was on the Rue François Premier in Paris – it still is today. And it was white; the seats you sat on, the walls, the salon, it was all white. Modern. It was very modern of them to let me in, as well, to take those images. Progressive.'

André Courrèges
Autumn/Winter 1968
Haute Couture, Paris

Alongside the final
published shot, Moore
would shoot a series of
different takes and provide
the publication with contact
sheets, like these originals.

André Courrèges
Spring/Summer 1968
Haute Couture, Paris

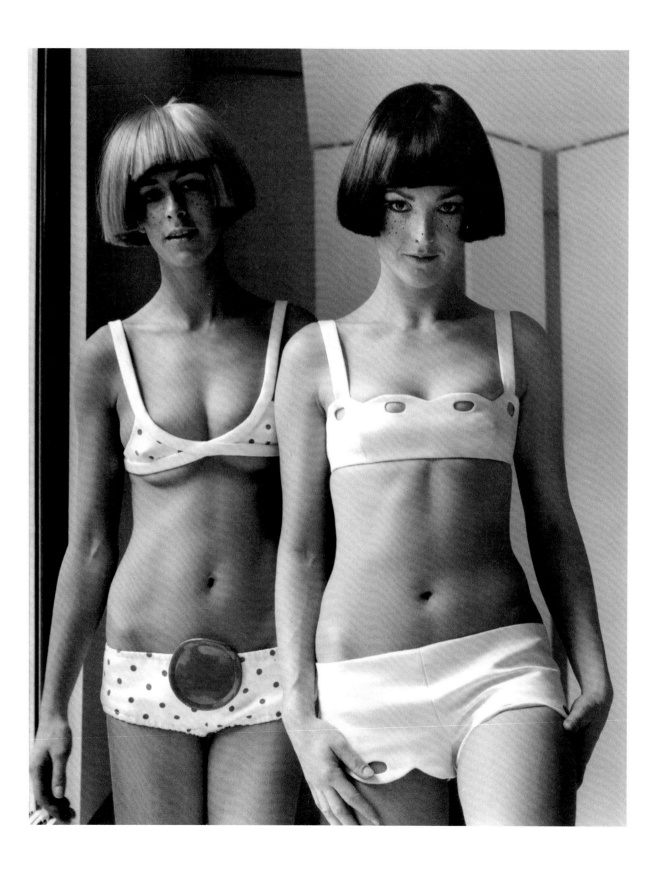

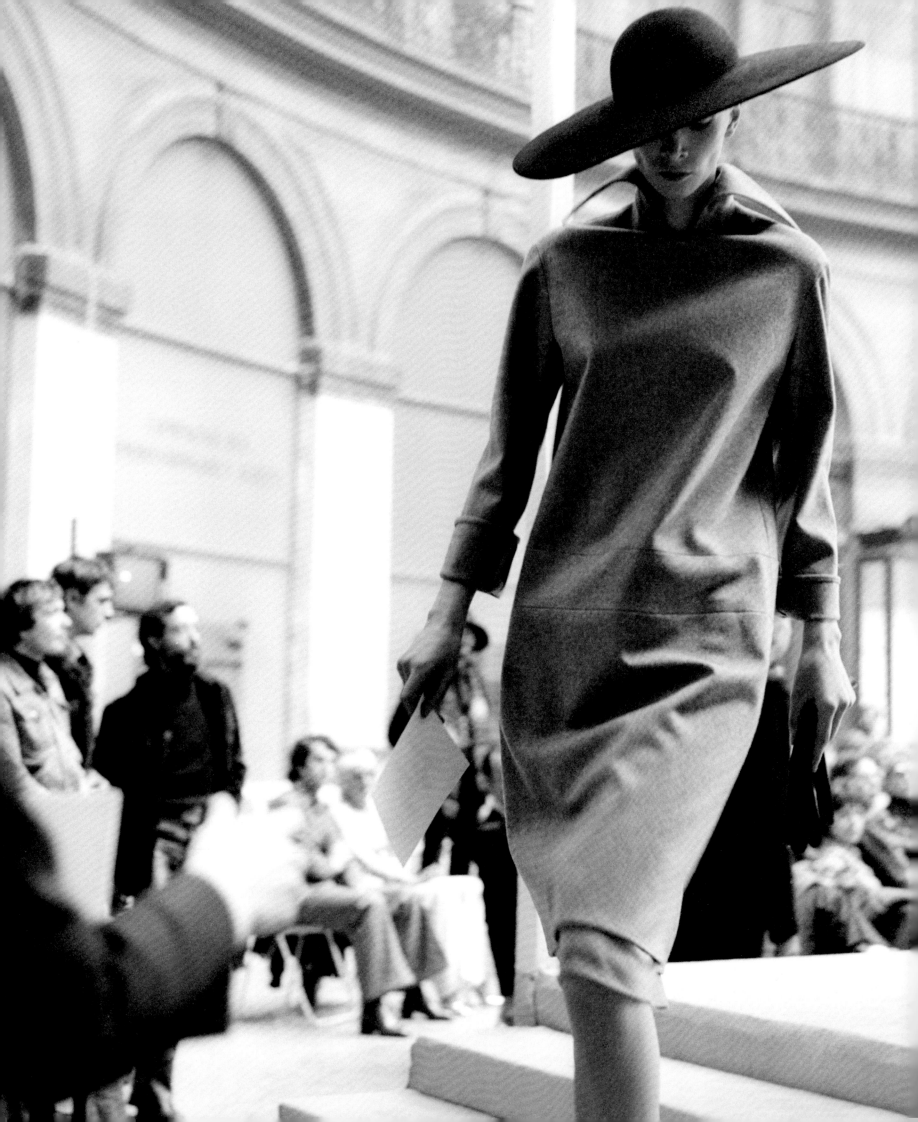

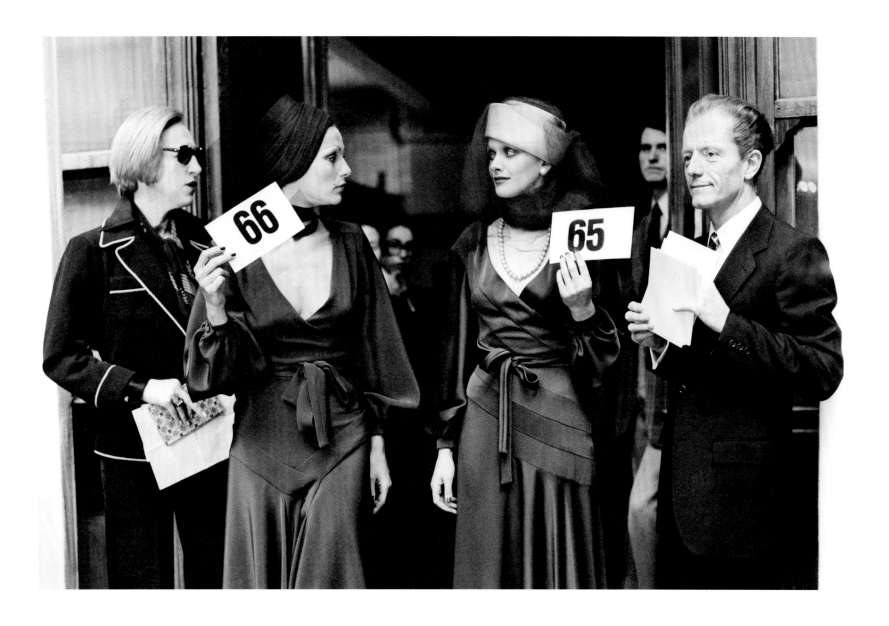

ourselves.' Despite its status as the first true ready-to-wear line, Saint Laurent Rive Gauche also included trickle-down variations of couture originals, such as the designer's Pop Art dresses – embellished with lips, cartoon faces and hearts – from his Autumn/ Winter 1966 collection. Those were haute couture, but they seemed to have been created with ready-to-wear dissemination in mind. 'No one copies Saint Laurent better than Saint Laurent,' declared the *New York Times*.

'At that time they did just think we were spies,' comments Moore, of the continuing reluctance of many of the old guard to allow photographers into their early ready-to-wear presentations. But, increasingly, the urge to publicize their wares overtook the instinct to protect originality. In 1967, both Balenciaga and Givenchy returned to the couture schedule, alongside the rest of the Paris houses – although they still refused to permit photography. The

following year Balenciaga closed his salons, declaring: 'Why do you want me to continue? There is no one left to dress.' Perhaps he was lamenting not the loss of a privileged, moneyed elite to purchase his clothes, but the demand for couture as a whole. Clients had now begun to buy ready-to-wear instead of haute couture: the first customer at the Rive Gauche shop in 1966 was Catherine Deneuve, the French actress and fanatical supporter of Yves Saint Laurent (man, and label). She bought ready-to-wear miniskirts, and asked for them to be made even shorter. The 1960s were changing everything – hemlines weren't the only thing transformed in the fashion industry.

For Moore, ready-to-wear marked the true start of his career – and of the idea of the 'catwalk photographer' as a whole. 'That's what really opened up the whole industry, to catwalking,' he says today.

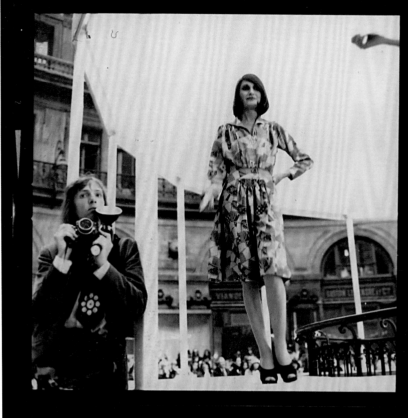
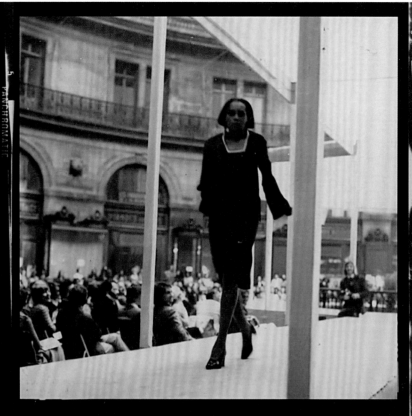
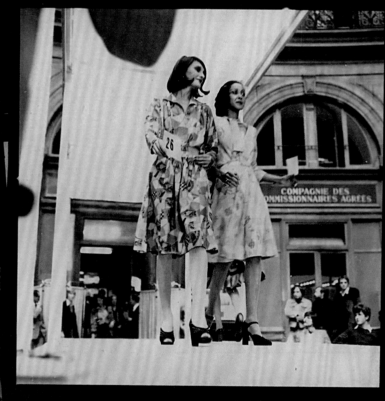
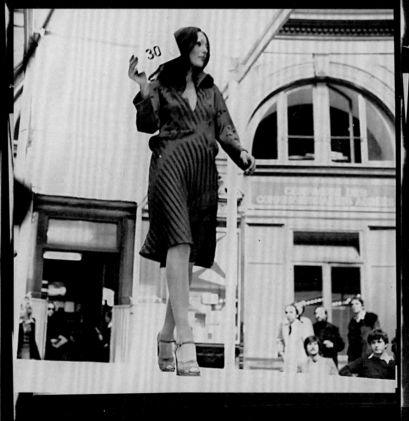

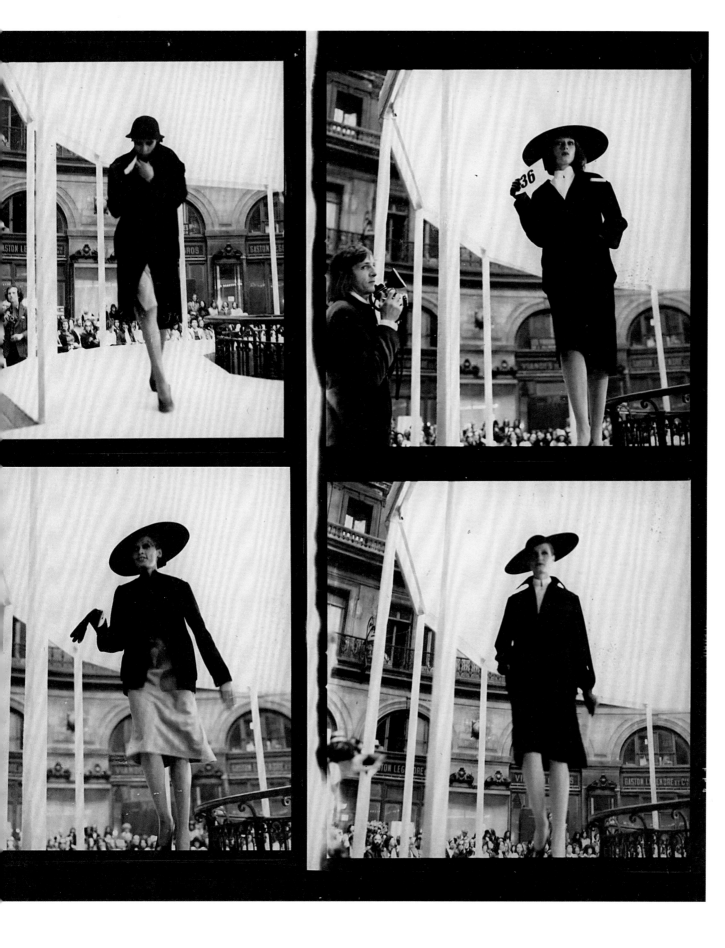

By the end of the 1960s, true catwalk shows had begun to develop to showcase designers' mass-manufactured ready-to-wear lines. 'The early ready-to-wear shows ... they had numbers. It might even not have music,' Moore remembers. 'They hadn't worked out what it was all about.' Models carrying couture-style namecards are flanked by the designer Andrée Putman and Didier Grumbach (previous page), whose family company, C. Mendès, manufactured designer ready-to-wear, including Yves Saint Laurent's Rive Gauche line.

This page and previous:
Various designers
Spring/Summer 1968
Paris

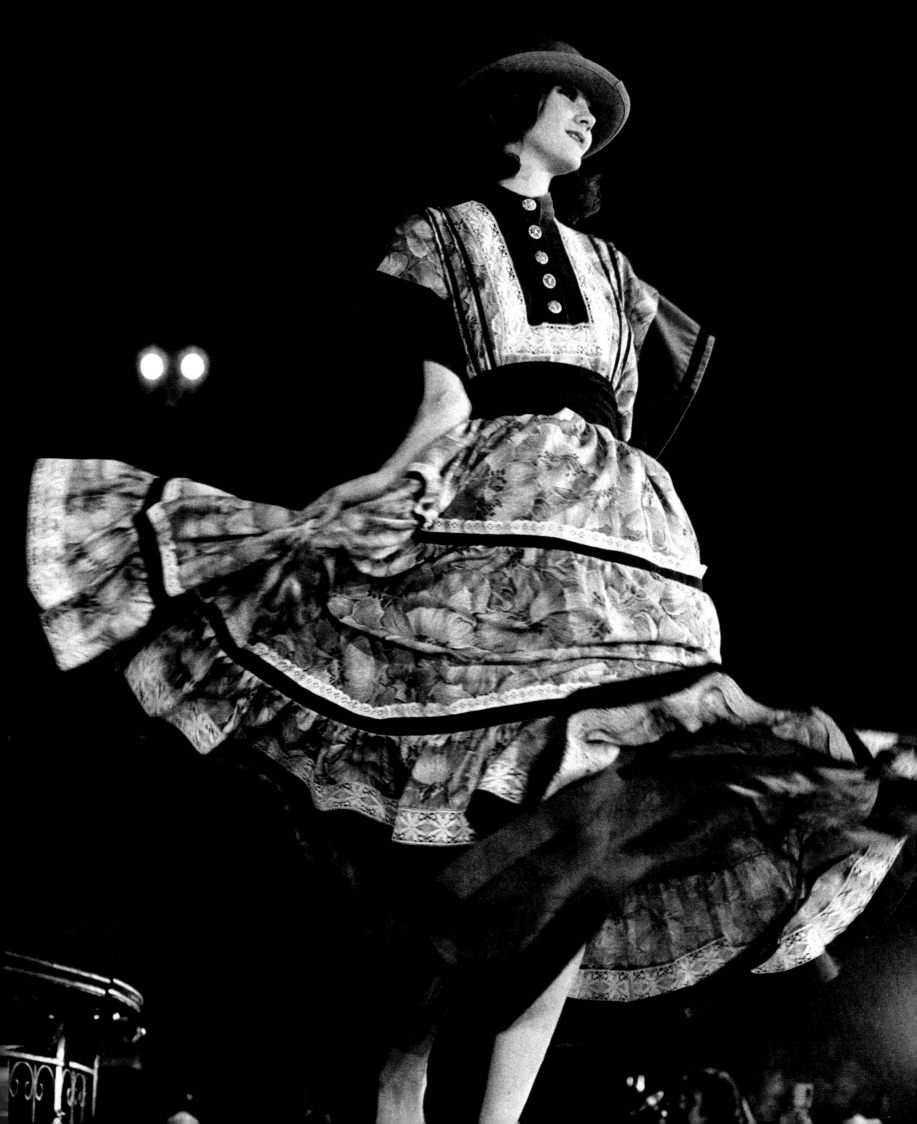

The Birth of the Catwalk

1970–1979

> *'Saint Laurent, Courrèges, Cardin ... They were much more open than the couture. The couturiers had to open up because of the ready-to-wear. If there hadn't been ready-to-wear ...'*
>
> Chris Moore

Chris Moore's career would fuse two key elements of his early years and training: Fleet Street and fashion; the immediacy of newsprint journalism fused with the considered eye of a *Vogue* fashion photographer. Moore's combination of these two elements was unique, and unprecedented – certainly, it couldn't have emerged any earlier than the 1960s, when fashion was still enthralled by the cosseted haute couture presentations of Paris, where photography was strictly forbidden.

By the early 1970s, however, a revolution had taken place. Just as social mores had been thrown into upheaval with the sexual revolution of the 1960s, fashion's hitherto sacrosanct restrictions and rigidly imposed hierarchy were exploded. Fashion echoed social changes, with the breakdown of class systems and restrictions across the board. The most notable symptom was the demise of haute couture as an industry leader: by 1971 the French prêt-à-porter, or ready-to-wear, industry was worth $480 million, with over $100 million in exports alone the previous year. The growth was exponential: in 1968 the exports for ready-to-wear across France came to only $38 million, despite including lines from houses as diverse as Dior, André Courrèges and the mighty market leader Saint Laurent's Rive Gauche. By 1977 the leading 23 French fashion houses earned more than $1 billion in ready-to-wear and accessories.

And haute couture? 'It has become a museum,' said Yves Saint Laurent in 1971, by which time the number of his ready-to-wear Rive Gauche boutiques had ballooned to 41 globally. The former great white hope of haute couture railed against the trade, dubbing it 'a refuge for people who do not dare to look life in the face and who are reassured by tradition'. That year, Saint Laurent pulled the plug on his couture shows, presenting them to clients only and closing their ranks to both press and store buyers. He wanted to save the publicity – and department-store budgets – for his biannual ready-to-wear shows, where, he said, his spectacular statements would henceforth be made. He staged his first Rive Gauche catwalk show in October of the same year, showing a total of 300 pieces to an elated press. Pierre Cardin followed suit, and in 1972 Nina Ricci shelved its January couture show to focus instead on ready-to-wear. All three returned to showing haute couture shortly afterwards, but their statements carried weight. Confidence had shifted from haute couture to ready-to-wear. By 1977 the only French couturier without a ready-to-wear range was Grès.

This was not just a revelation, but a revolution in French fashion – 'as important as the revolution brought about by Christian Dior in 1947 with his "New Look"', said *Le Monde* in July 1969 of Saint Laurent's focus on the creative importance of ready-to-wear. In fact, it was more important. Dior's 'New Look' changed how women dressed, for a period – it changed the outline of their silhouette, but was then swept away. What Saint Laurent did – aided and abetted by the legion of designers who followed him – was

to reinvent the rules of the fashion business. After ready-to-wear exploded, the industry would never be the same again.

In 1966, on the eve of the launch of Rive Gauche, newspapers such as the *New York Times* were still reporting on the bestselling Paris couture copies in New York department stores – key pieces by Balenciaga and Dior, and Chanel suits. But couture, it seemed, was already dying: between the establishment of Rive Gauche in September 1966 and the end of 1967, the number of couture houses fell from 37 to 19. Yet still manufacturers and department stores paid not only to reproduce their own licensed versions of the clothes on show, but also to attend the salon shows. Those were, incidentally, presented multiple times, on a selection of models known collectively as a *cabine* and unique to each couture house. The Chambre Syndicale rules dictated that couture houses must give their clients 45 opportunities a season for a private show, in an edict set by the Vichy Government during World War II and ratified by Parliament after the war. (The practice persisted until the 1980s, when Dior and the newly founded house of Christian Lacroix screened videotapes, but traditionalists like Madame Grès would archaically show 'Tuesdays and Thursdays starting September 1 until mid-October'.)

More than merely buying, however, those manufacturers and stores – and the press, too – looked to couture to lead the way, to ring the changes. The tale of Dior's spectacular 'New Look' in 1947 – of American buyers who skipped Dior's showing to sail back to New York early, only to turn around when they hit Ellis Island to return and see Europe's fashion revolution – kept buyers attending eagerly, and anxiously. They paid around $3,000 to each couture house for the privilege. When Yves Saint Laurent barred buyers from his couture show in 1971, his line-for-line copies could still be found, under licence, at a number of American department stores, including Ohrbach's and Lord & Taylor, I. Magnin of San Francisco, Bergdorf Goodman, Bonwit Teller and Marshall Field of Chicago.

But within a few years, buyers en masse stopped paying their fees, attending the couture shows and licensing the clothing. Instead of couture's small-scale January and July salon showings, buyers frequented the ready-to-wear shows across town – and purchased their fashions there. In the spring of 1971, a full six months ahead of even Yves Saint Laurent, the French ready-to-wear industry showed its autumn/winter collections over ten days, mostly at the gargantuan Porte de Versailles exhibition hall off the Boulevard Périphérique on the edge of Paris, or at the Hilton by the Champs-Élysées. Shows had taken place close to the Bois de Boulogne, in the Palais des Congrès at the Porte Maillot, which seated around 1,000; later in the decade, they would oscillate between those venues and a myriad more, including the Hotel Intercontinental, a dance hall named the Salle Wagram, and the Bourse de Commerce.

Left:
Chanel
Autumn/Winter 1970
Haute Couture, Paris

Previous page:
Kenzo
Spring/Summer 1974
Paris

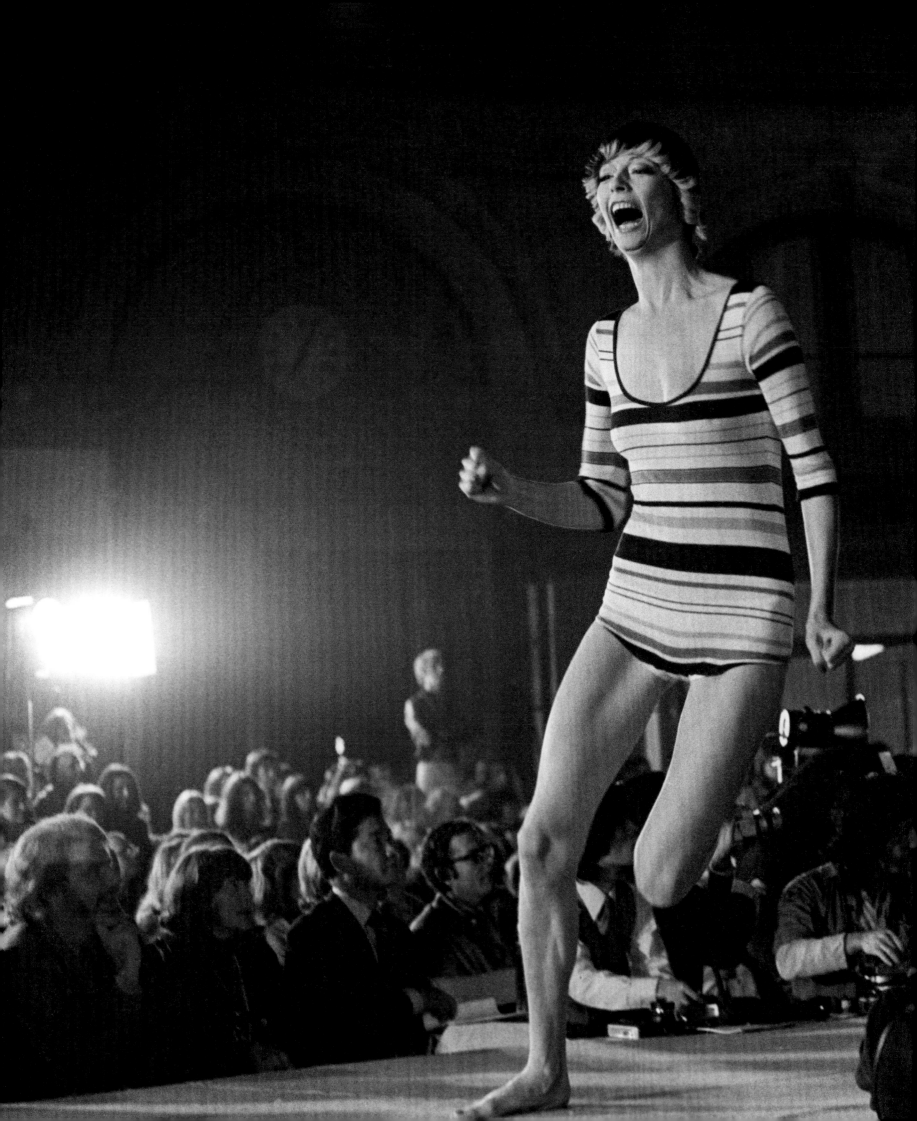

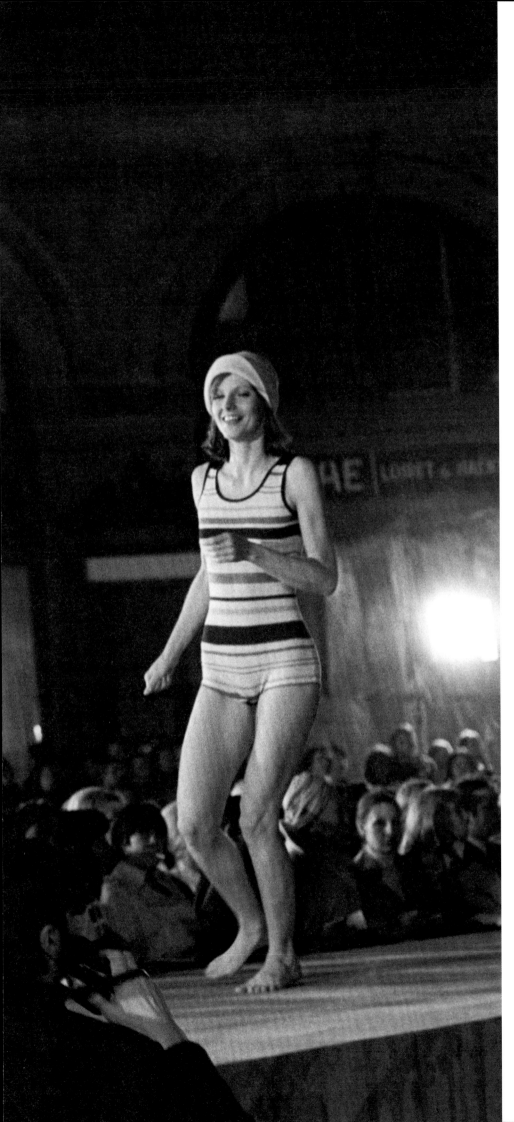

Kenzo
Spring/Summer 1973
Paris

'They kept constantly trying to find a centre that everything could be shown at,' recalls Moore. 'At Porte Maillot there was a place where they started showing ready-to-wear. Then suddenly we all had to go out to Porte de Versailles ... then of course the Carousel [du Louvre] got built, and we were all going to see everything there. Of course the designers didn't want to. A lot of them didn't want to show there.' The fashion critic Bernadine Morris called the oscillation between venues by 1977 'wearisome'. The problem underlined twin points: the relative youth and hence disorderly conduct of Parisian prêt-à-porter versus the well-organized couture schedule, and the increased importance of the former at the expense of the latter.

The problem of organization was tackled head on in 1973, when Pierre Bergé, co-founder and CEO of Yves Saint Laurent, created a ready-to-wear equivalent of the Chambre Syndicale, the Groupement Mode et Création, to organize the burgeoning calendar officially. The Groupement also hitched together a hitherto disparate group of designers, allying the ready-to-wear of couture houses such as Saint Laurent, Cardin and Dior with pure ready-to-wear specialists, whose numbers were booming. Chief among them was Karl Lagerfeld, who had designed Chloé since 1963. By the early 1970s his clothes were setting trends internationally, imitated by mass-manufacturers and haute couture alike. They also weren't particularly cheap: 'his clothes are almost as expensive as made to order,' said Morris in 1975, citing the example of dresses retailing for $800 against an haute couture base rate of around $1,000 at the time. Kenzo Takada launched his label 'Jap' (later 'Jungle Jap') in Paris in 1970; Sonia Rykiel founded her ready-to-wear line of 'poor boy' sweaters in 1968.

But even as prêt-à-porter became legitimized, there were distinctions between it and the more exclusive realms of haute couture. The phrase 'fashion designer' wasn't used; in France, there were *couturiers* and *stylistes*, the term given to ready-to-wear designers. Later, it would be supplanted by a more evocative

moniker: *créateur*. But, in the late 1960s, it indicated a certain snobbishness, emphasizing how low in the pecking order the ready-to-wear was placed, even with Saint Laurent's phenomenal success.

The same attitude was apparent in 1971, when five American designers showed clothes at the Palais de Versailles alongside five French couturiers. It would be, all assumed, an easy win for French polish over American commercialism, but the clothes of the American labels – Bill Blass, Stephen Burrows, Anne Klein, Oscar de la Renta and Halston – caused a sensation. They not only looked young, but also were both easy, and ready, to wear. It felt like a gauntlet thrown down to the Parisian elite, a glimpse of the future – exactly the word Saint Laurent had used to describe ready-to-wear in French *Elle* in 1967.

The transformation of the fashion industry necessitated a transformation of the fashion show. Ready-to-wear wasn't haute couture; it was less precious, less fussy, younger, freer. It was a revolution and, like France's revolution two centuries before, its clarion cry was *liberté, égalité, fraternité* – on your back. That revolution extended to the perception of those clothes, the relationship of fashion to media, and the entire business as a result.

For Moore, as designer ready-to-wear emerged as an economic and creative force, the sacrosanct salon doors of haute couture were forced open. 'There was a crisis with the couture houses,' he says. 'They suddenly realized that they were losing something, they were losing out, so they had to do something.'

The year 1971 – in which Saint Laurent (temporarily) pulled the plug on his haute couture presentations – is the one Moore also identifies as the launch of the true Paris ready-to-wear shows. 'There were some catwalk shows in the sixties,' recalls Moore. 'Terrible things. They didn't always have music. They sometimes would go on forever ...' The lack of music recalled the couture shows of old, where models paraded with numbered cards through stuffy couture salons, a practice sometimes aped by the emerging ready-to-wear. But, rapidly, the new designers began to show in new ways – with music, dancing, an enthusiasm never before seen in the presentation of fashion.

That was the beginning of the notion of the catwalk. 'It was when Cacharel and people like that decided to put on shows – before then, it didn't exist,' says Moore. 'With that having been successful, the couture houses decided they would have to do it as well, otherwise they would lose out. They weren't getting the press.'

What the couture houses were losing out on was not only sales (as customers defected to purchase ready-to-wear, particularly for daytime clothes), but also coverage. The riotous presentations of Saint Laurent, Chloé and Kenzo's 'Jungle Jap' stole attention. Rather than presented to intimate groups of clients in low-key salons that barely seated 50, fashion began to be staged, for an appreciative international audience eager to consume. In the April 1973 shows alone, there were tightrope walkers, Crazy Horse cabaret girls,

tangoing models, jugglers and fireworks animating the Autumn/Winter collections. By the end of the decade, a new breed of fashion showman had emerged, epitomized by the flashy productions being staged by Claude Montana and Thierry Mugler, and the furore over a flashy new young French designer, a former assistant of Cardin named Jean Paul Gaultier. Many bought the clothes, but many more pored over the deluge of imagery produced from the new breed of fashion extravaganza. Nevertheless, for all their fantasy, the ready-to-wear shows seemed far more approachable than the haute couture. 'It seemed more real,' says Moore, mirroring the declarations of women of the time who could suddenly buy this fashion, rather than its ersatz imitators.

With the new approach and new shows came new models, including Pat Cleveland, Marie Helvin and Jerry Hall, ready-to-wear stars who changed the modelling game. They appeared across the board, in shows for Kenzo, Lagerfeld and Saint Laurent, as well as a myriad other labels. Like the clothes, they seemed, if not everyday, certainly more approachable than the traditionally glacial couture mannequins, stiff and formal, presenting their clothes in silence. This wasn't fashion to be treated with the precious prissiness of haute couture, so the new models danced and sang, twirled and allowed their individual personalities to shine through, giving life to the clothes. The *cabine* was dead and buried. 'Before they arrived on the scene, the models were just house models, girls who had good bodies,' says Moore. 'Not necessarily wonderful faces.' But the 1970s modelling superstars transcended the catwalk, dashing from show to show and appearing in magazine editorials and advertising spreads. In 1977, Hall was the 'face' of Yves Saint Laurent's Opium fragrance campaign; that year the perfume outsold Chanel No. 5.

The ready-to-wear revolution wasn't just happening in Paris. By 1975 the city that had stood at the pinnacle of all matters sartorial for 300 years had major new competition. Milan began presenting biannual ready-to-wear collections in 1975, superseding Florence and Rome as the Italian fashion capital. The latter two cities were tied to custom-made clothing; Milan was founded in manufacturing. The same year, Giorgio Armani established his eponymous brand; Gianfranco Ferré was founded in 1974 and the Gianni Versace label in 1978 (although Versace had been designing clothes since 1972 to great acclaim under the labels Callaghan, Genny and Complice). With the added influence of labels like Krizia and Missoni, Milan's clout resulted in rising sales. Between 1977 and 1981, the city's ready-to-wear exports doubled, to $40 million.

And the shows in Milan were well-organized – the opposite of the 'wearisome' Parisian staging. 'When Milan first started, the Principe di Savoia showed one show, and the Palace, the hotel on the opposite side of the street, showed the other,' says Moore. 'You would walk across from one side to the other. Lunchtime at the Principe they had a buffet that was open to everyone,

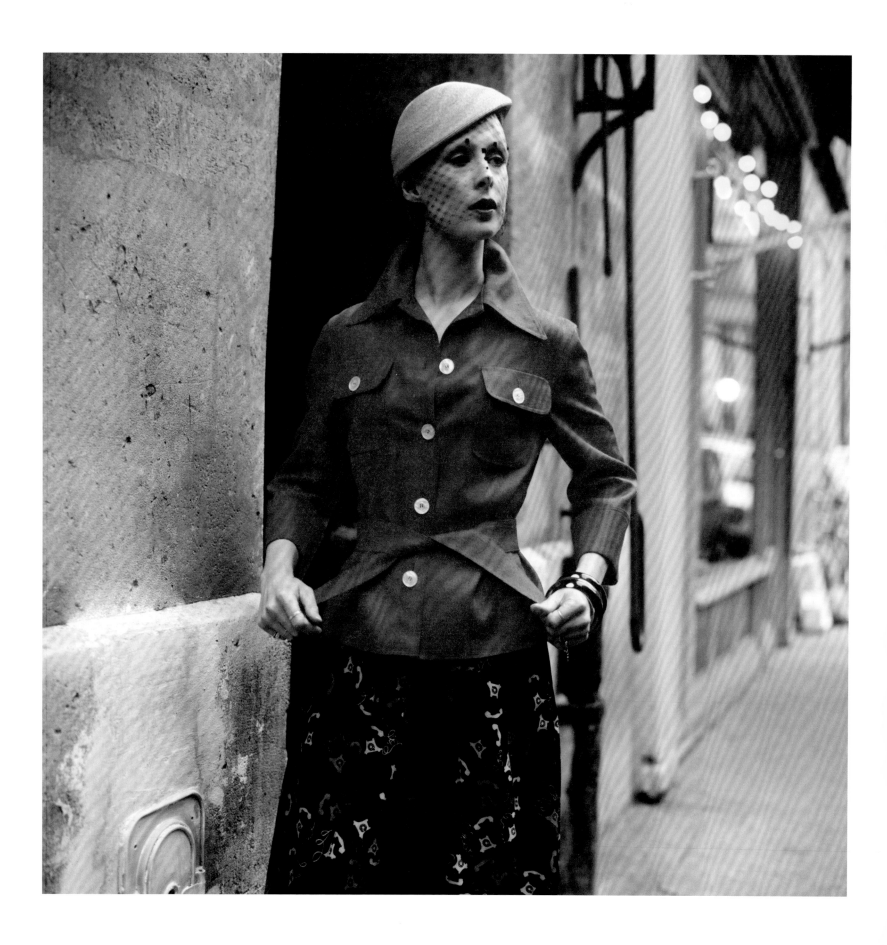

The Birth of the Catwalk

Opposite:
Chloé
Spring/Summer 1973
Paris

Below:
Cacharel
Spring/Summer 1975
Paris

photographers as well.' Milan's organization was hell-bent on wooing the fashion press and buyers, to invest in their talent. The city rose rapidly, to become a serious challenge to the fashion supremacy of Paris in less than a decade.

Another challenge arose across the Atlantic; the aforementioned New York designers who so impressed French audiences at Versailles were only a warning shot. Calvin Klein, Ralph Lauren, Geoffrey Beene and a plethora of other labels emerged from Seventh Avenue, offering a wealth of choice to customers, all focused on ready-to-wear. In London, the 1960s success of Mary Quant and Biba was augmented by new designers working in ready-to-wear rather than couture; Clive Evans, ironically, was one of the final few – 'the last flowering on the tree of British couture,' said the *Times*'s fashion editor Prudence Glynn in 1972. In his place, talents like Bill Gibb, Zandra Rhodes, Jean Muir and Ossie Clark emerged, focusing their attention solely on ready-to-wear. They staged extravaganzas, and stole headlines both from Paris in general and from haute couture in particular.

The press rushed to chart these emerging designers and new fashion cities. 'New York was the last one,' says Moore, of the gradual, organic development of the ready-to-wear show circuit in the 1970s. 'I went there in '79. I was already doing Milan – I'm not absolutely certain what year we started in Milan. Milan had been going a few seasons before I went. Paris was really first, then London, then Milan, then New York.' Nevertheless, despite the growing importance of those fashion capitals – and the fact that Moore and his fellow catwalk photographers attended increasing numbers of shows across all four – Paris remained the most important. It was perhaps inevitable: since Louis XIV, the city had been perceived as the heartland of matters sartorial, in the same way that New York is the centre of the contemporary art market, and London the world's key financial hub. It was an Englishman, Charles Frederick Worth, who founded the concept of haute couture in the mid nineteenth century – but he came to Paris to do it. In the 1970s the grip loosened, but was still there. 'I always found Paris somehow the best,' comments Moore. 'I mean Paris can be as dull as hell, but it's always something. There will always be something in Paris.'

Where did that leave haute couture, though? Scrambling to keep up, even by the start of the 1970s, with ready-to-wear in its infancy. Designer ready-to-wear emerged to satisfy a demand. Women didn't want to wear haute couture – which, alongside its prohibitive expense, was perceived as fuddy-duddy and staid by younger generations – yet mass-manufactured clothes were seen as shoddy and sub-par. They were, however, convenient: bought off the rack, rather than requiring the numerous fittings necessitated by made-to-measure clothing. The new ready-to-wear labels offered the best of both worlds – the innovation characteristic of haute couture, and the ease of the mass-market. Talking of Yves

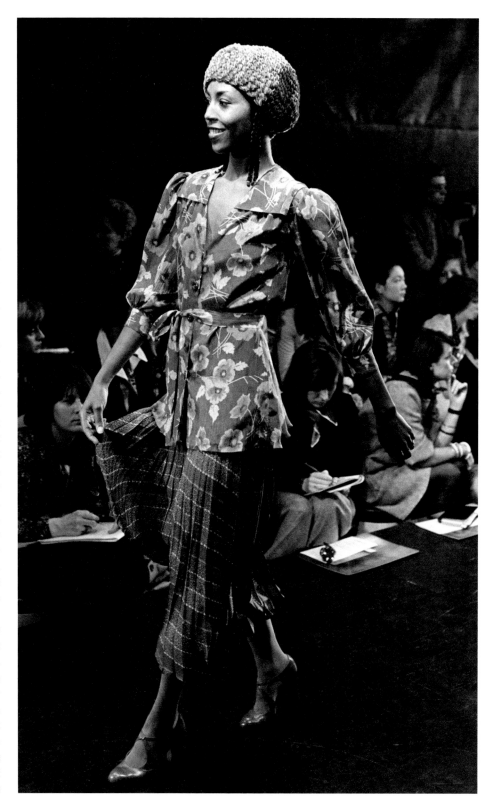

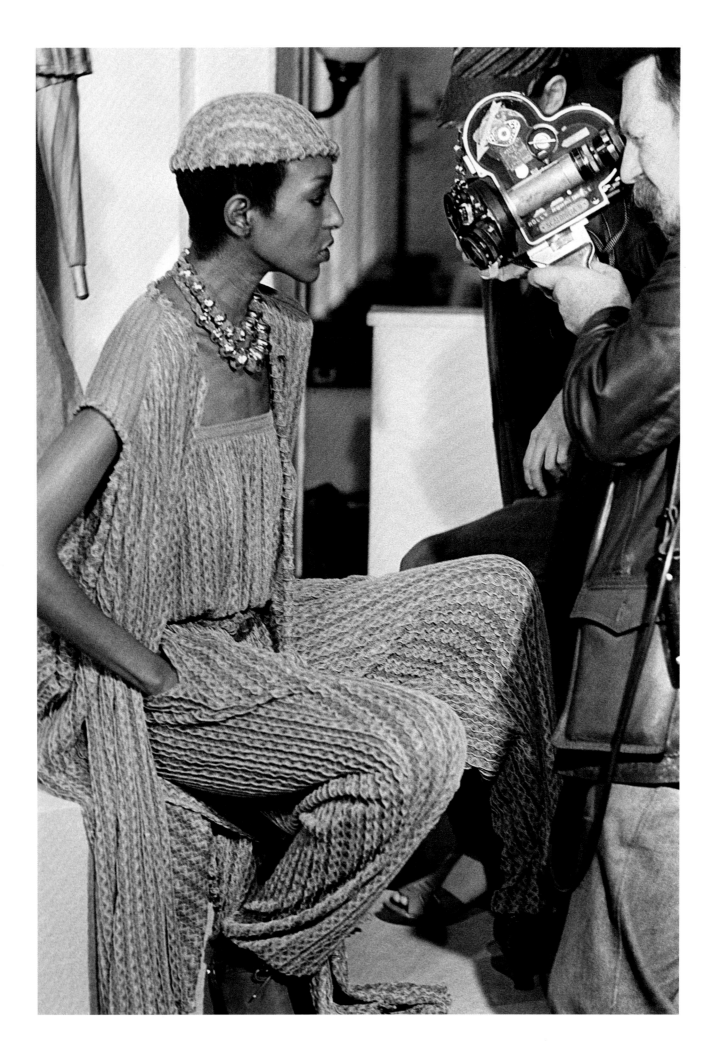

Opposite:
Missoni
Spring/Summer 1979
Milan

Below:
Kenzo
Spring/Summer 1973
Paris

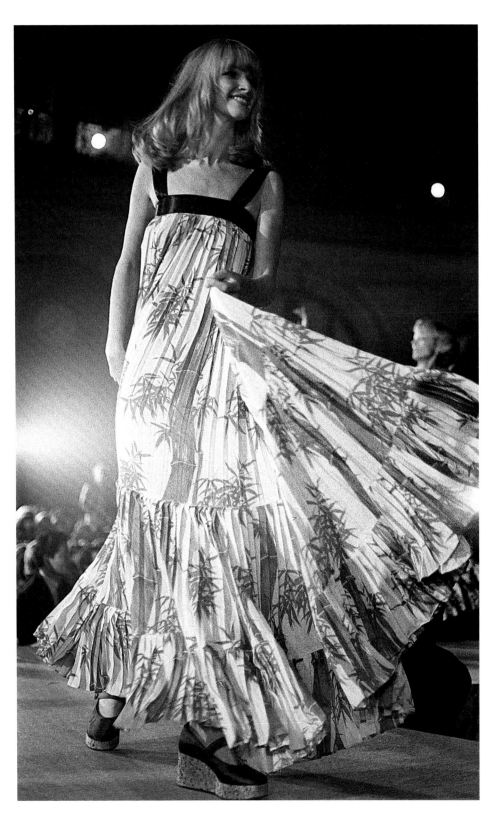

Saint Laurent's Rive Gauche, Pierre Bergé commented, 'It was the first time a great couturier had designed ready-to-wear and given it as much thought as haute couture.' Saint Laurent was, indeed, the first – but not the last.

Other events hit haute couture hard. In January 1971 Gabrielle 'Coco' Chanel died; in March of the following year, Cristóbal Balenciaga passed away. Although neither were current leaders, whose absence affected the lines of contemporary fashion in any great way, Balenciaga died four years after closing his haute couture house, and Chanel's early innovations were now established enough to be called 'classic' – the symbolism was heavy. An old way was dying, literally, and a new breed emerging. The July 1970 haute couture collections had already illustrated that shift: André Courrèges, who jockeyed with Saint Laurent and Cardin for pole position as French fashion's leader, had invited 900 members of the press to view his collection. Even Chanel had opened her salons for what would prove to be her final collection. For the first time, she invited press photographers inside to document the clothes – and among them was Moore.

For Moore, this time was a revelation. 'I used to try to cover those shows, but I was never invited in at that time,' he recalls. 'You'd ask at the door. Couture started to show the same way, inasmuch as there was a show that they would actually let photographers in, to photograph.'

The shift in attitude was charted by the press at the time. 'The secrecy and the coyness about showing the couture clothes are disappearing as the houses try to get the greatest exposure for their wares,' noted Bernadine Morris in the *New York Times*, of those shows in 1970. 'Like toothpaste or tires, they're selling a product, and the more people who hear the message, the greater the chances for acceptance.'

The disappearance of that secrecy and coyness, however, was gradual. 'They were paranoid,' says Moore. 'But I remember a rag trader in Great Portland Street saying, "Can you let me have your contact sheets?" I didn't let him have the contacts, but I was approached. So they were probably right to be paranoid. But it was inevitable, there was no way they were going to stop people seeing the stuff. If people wanted to see it, they'd see it.'

The energy is palpable in Moore's images from this period. Nothing could be more different than these shots and the staid couture poses of the 1960s – inside the salon, or out. The ever well-behaved haute couture couldn't compare to Sonia Rykiel's sweater girls, piling down the mirrored staircase of her Left Bank boutique; nor to the riotous energy of Kenzo's models, swirling metres of pleated skirts and careening about the catwalk. And there they are: the catwalks. Raised above the audience, like stages for performances, with models – Jerry, Marie, Pat – as the leading ladies. A performance is exactly what fashion became in the 1970s, acted out for a new global audience of millions.

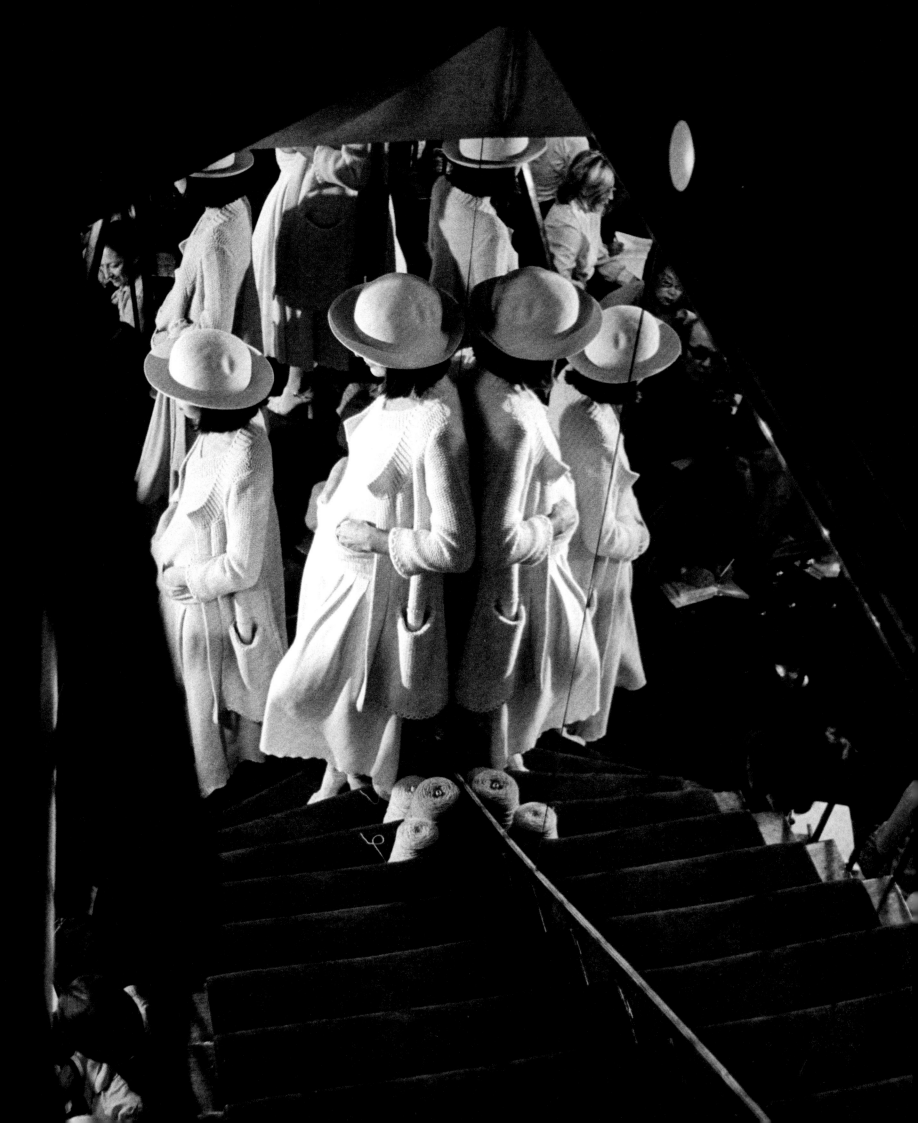

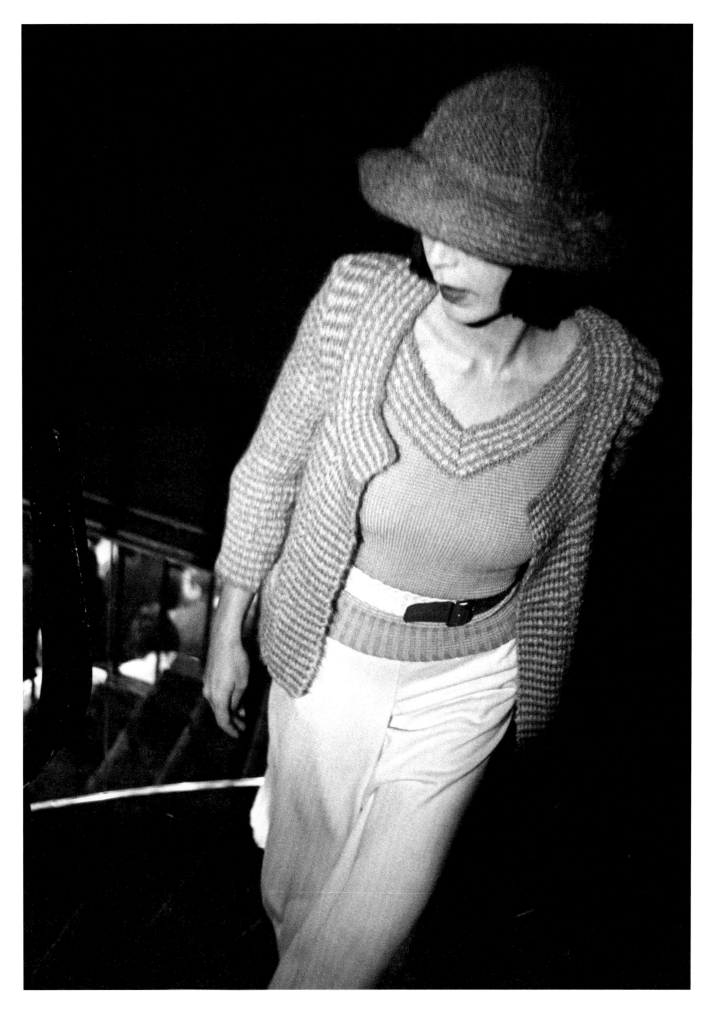

Sonia Rykiel was a leading figure of early French ready-to-wear, famed for her 'poor boy' sweaters, skinny-ribbed with high armholes and inside-out seams. Like that of Saint Laurent, her business was based on the Left Bank, and in the 1970s she began to show her collections in her Saint-Germain-des-Prés boutique, with its signature mirrored staircase.

Sonia Rykiel
Spring/Summer 1974
Paris

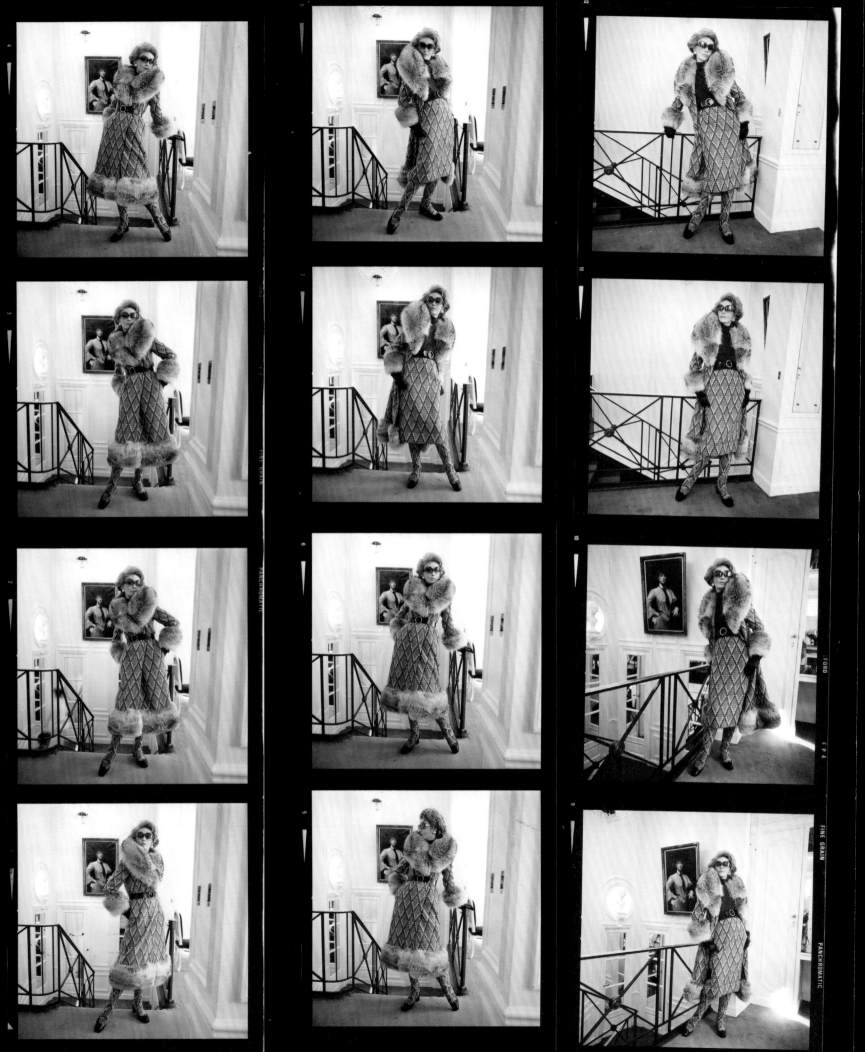

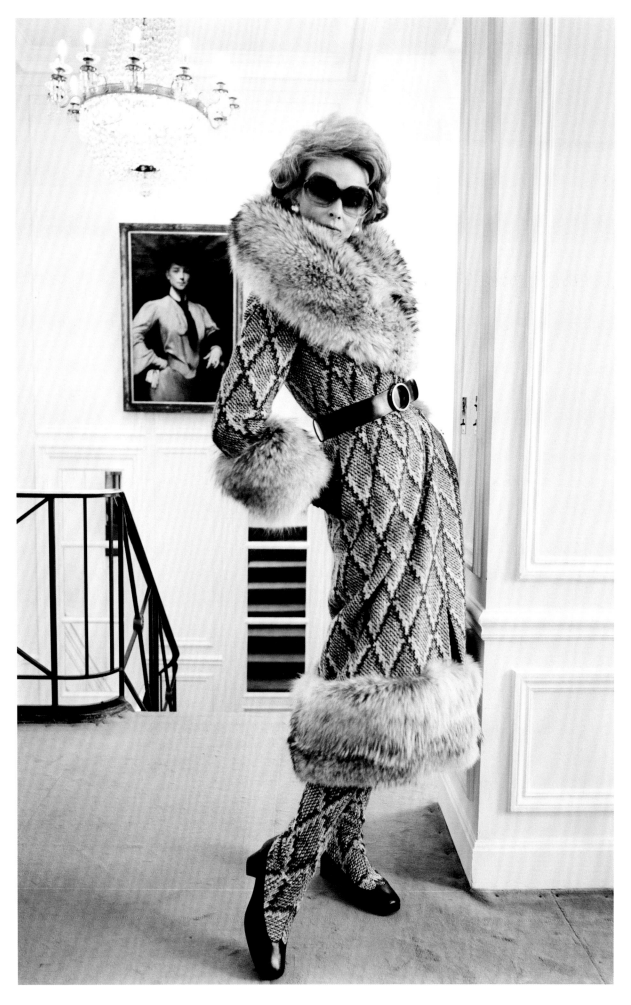

When a model failed to arrive at the House of Balmain for an haute couture presentation in 1971, the salon's then directrice, Ginette Spanier, took over as a model at the last minute. 'She looked terrific. Despite her years she didn't think anything of stepping in for a much younger woman,' remembers Moore. 'It was probably the first time that I understood that style was more than just the clothes, it was how you worked a look and projected yourself in the clothes that mattered; but, crucially, that fashion was for anyone who cared to be stylish.'

Balmain
Autumn/Winter 1971
Haute Couture, Paris

In the early 1970s, reflecting
the relative youth of catwalk
photography, Moore was
still commissioned by both
designers and publications
to capture collections in
shoots akin to editorial.
The resulting images
recall his work of the mid
1960s, before haute couture
shows became available
to be photographed.

Pierre Cardin
Autumn/Winter 1972
Haute Couture, Paris

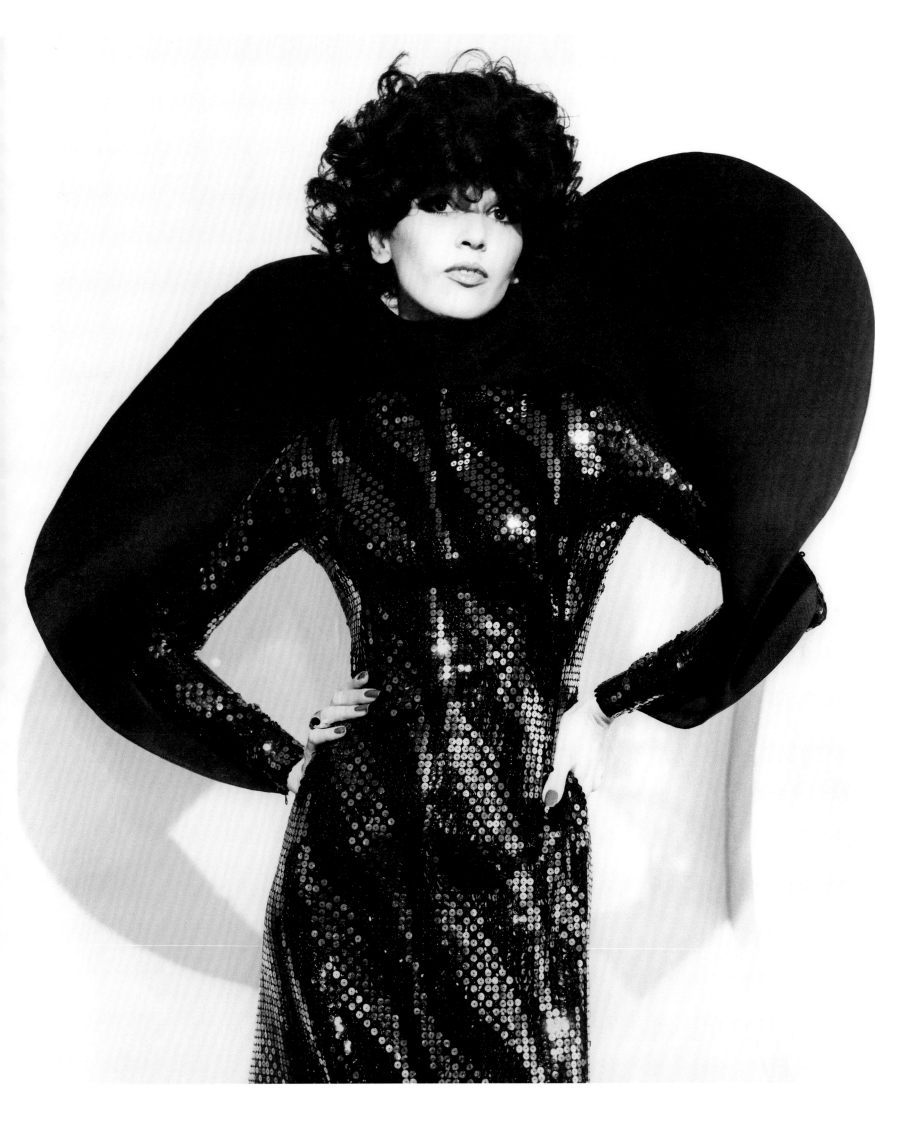

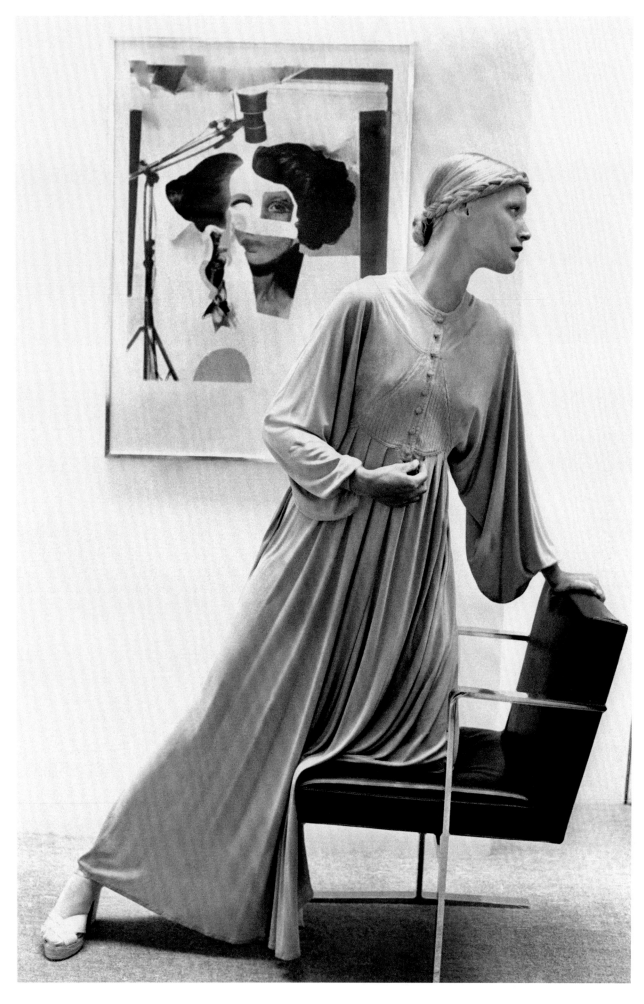

Left:
Jean Muir
Spring/Summer 1972
London

Opposite:
Hardy Amies
Spring/Summer 1973
Haute Couture, Paris

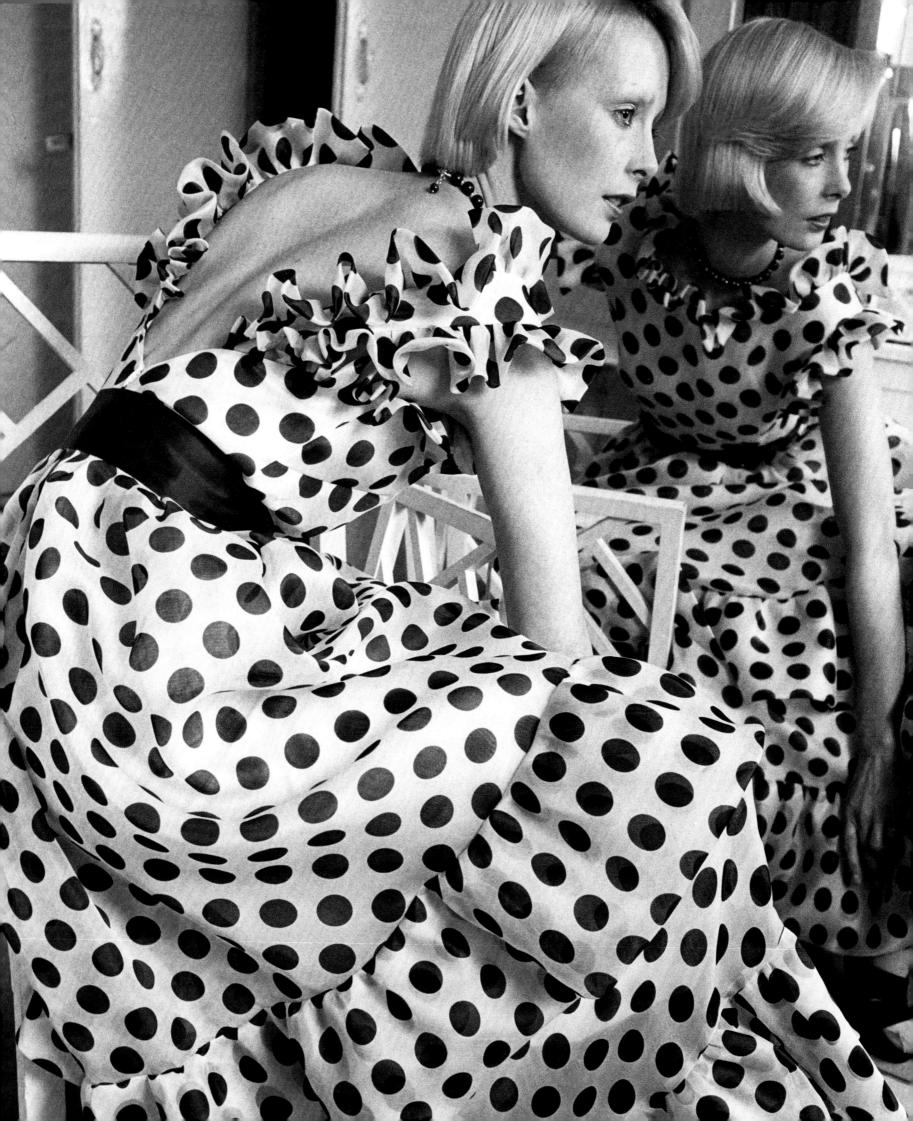

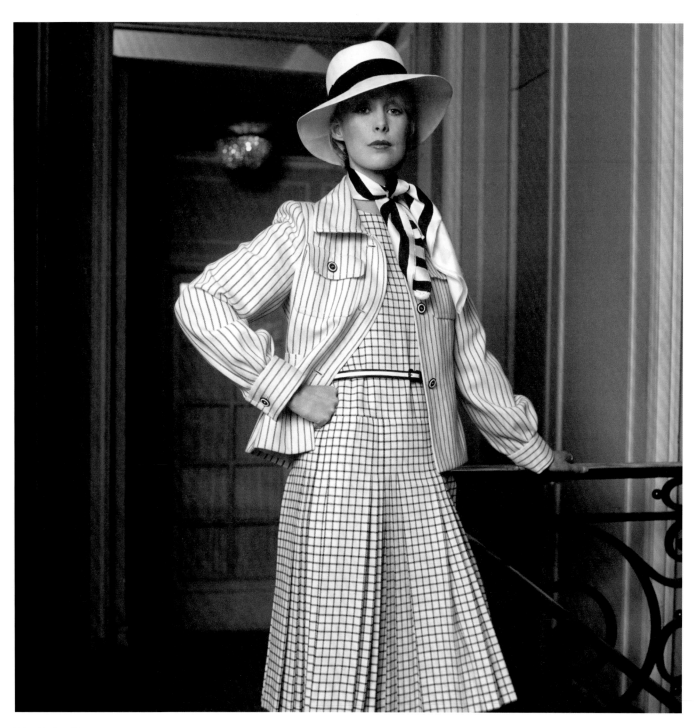

**Marc Bohan for
Christian Dior**
Spring/Summer 1973
Haute Couture, Paris

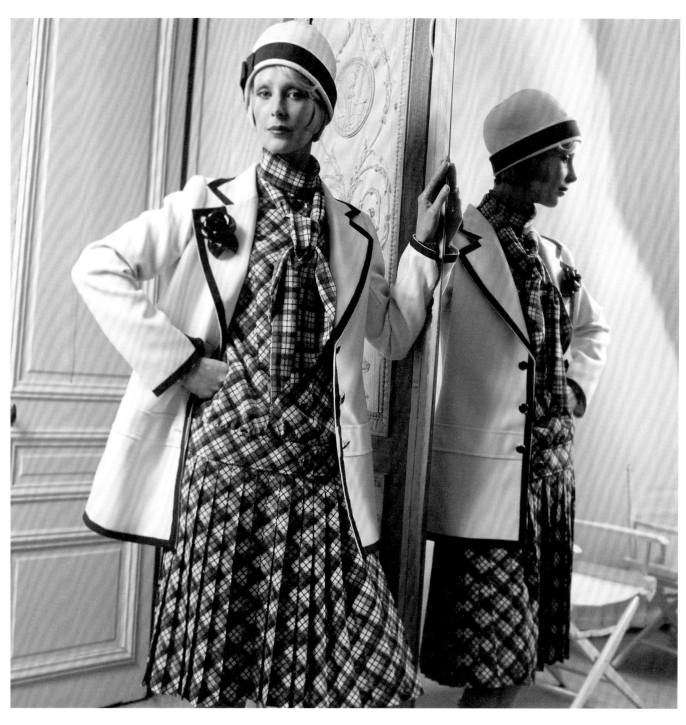

Emanuel Ungaro
Spring/Summer 1973
Haute Couture, Paris

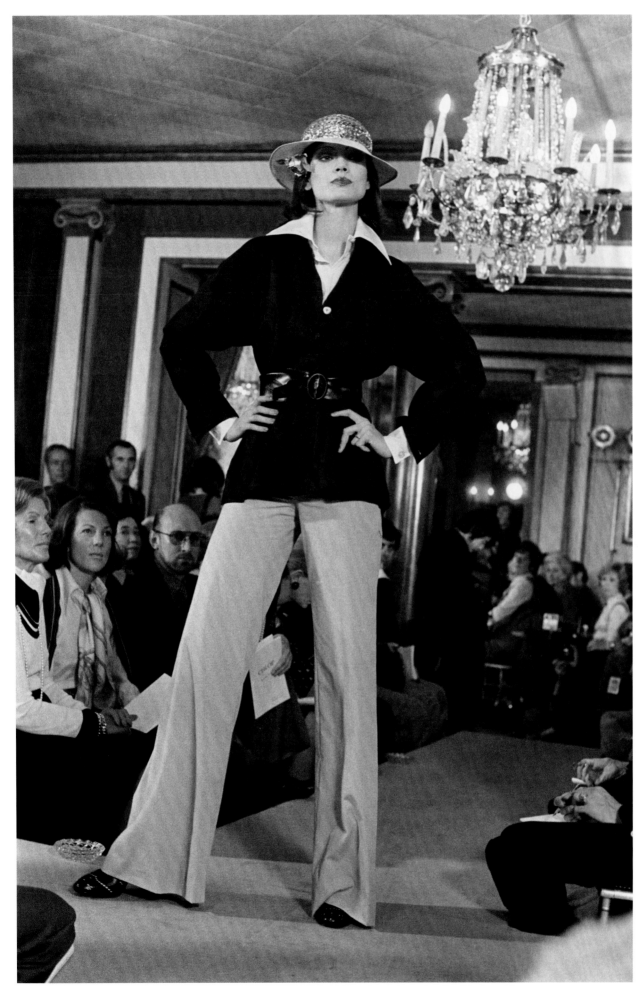

Left:
Chloé
Spring/Summer 1974
Paris

Opposite:
Kenzo
Spring/Summer 1974
Paris

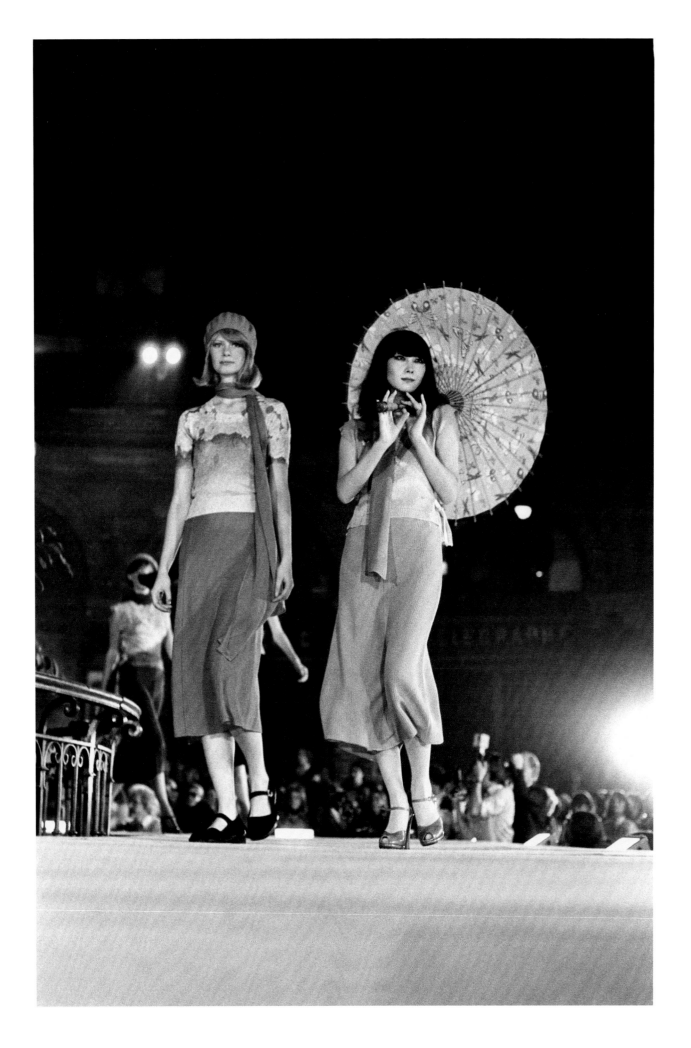

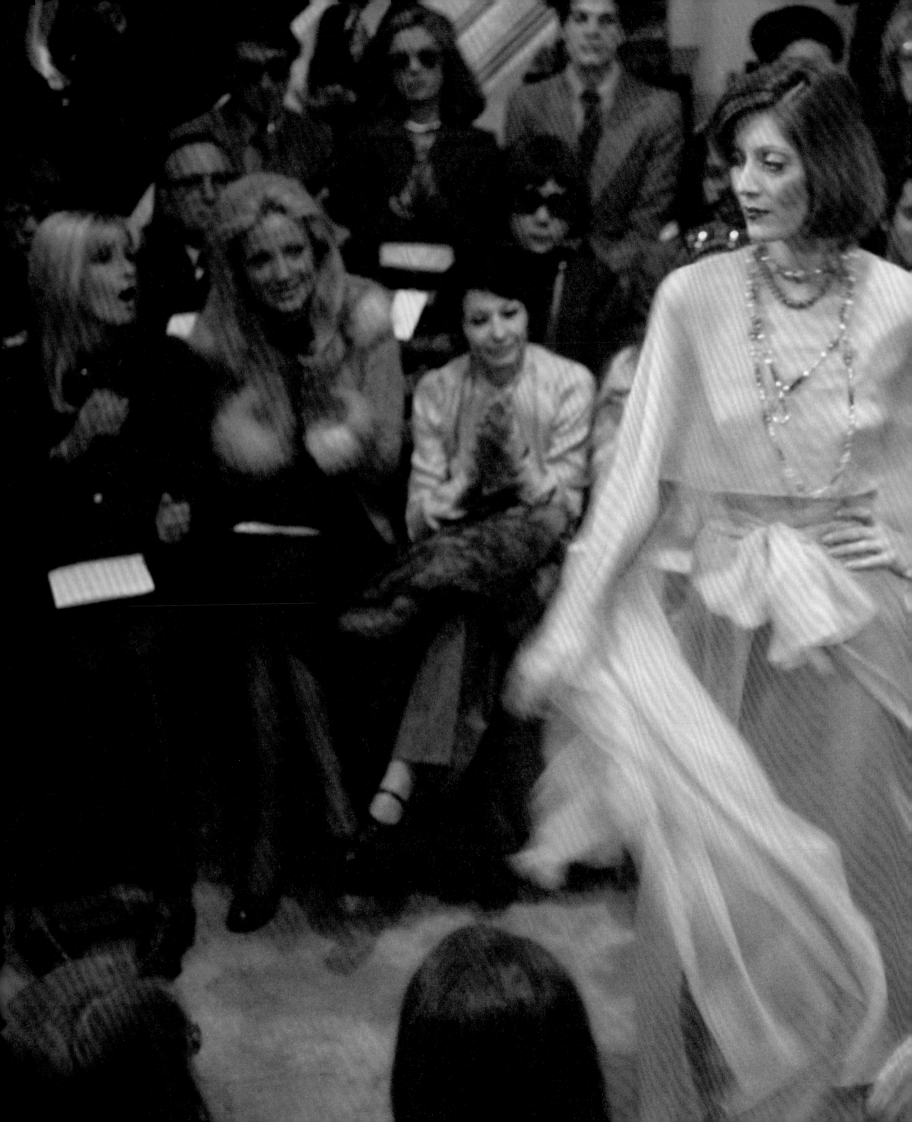

By 1974, Yves Saint Laurent was already a legend of French fashion. Dubbed the saviour of Dior on his debut in 1958, following the death of the founder a year earlier, he began rapidly to rebel, and in doing so reinvented twentieth-century fashion. 'I was as excited by Yves Saint Laurent as all the journalists were,' says Moore. 'He was making magic.' Saint Laurent presented radical designs such as trouser suits, peacoats, art-inspired dresses and 1940s revival looks, and he bared breasts for the first time in a couture salon. In the 1970s Moore and the small group of catwalk photographers were finally allowed into the intimate couture salons of Saint Laurent, on Rue Spontini, to record these groundbreaking collections live. Here, a model takes her turn, and overleaf, Saint Laurent takes his bow.

This page and overleaf:
Yves Saint Laurent
Spring/Summer 1974
Haute Couture, Paris

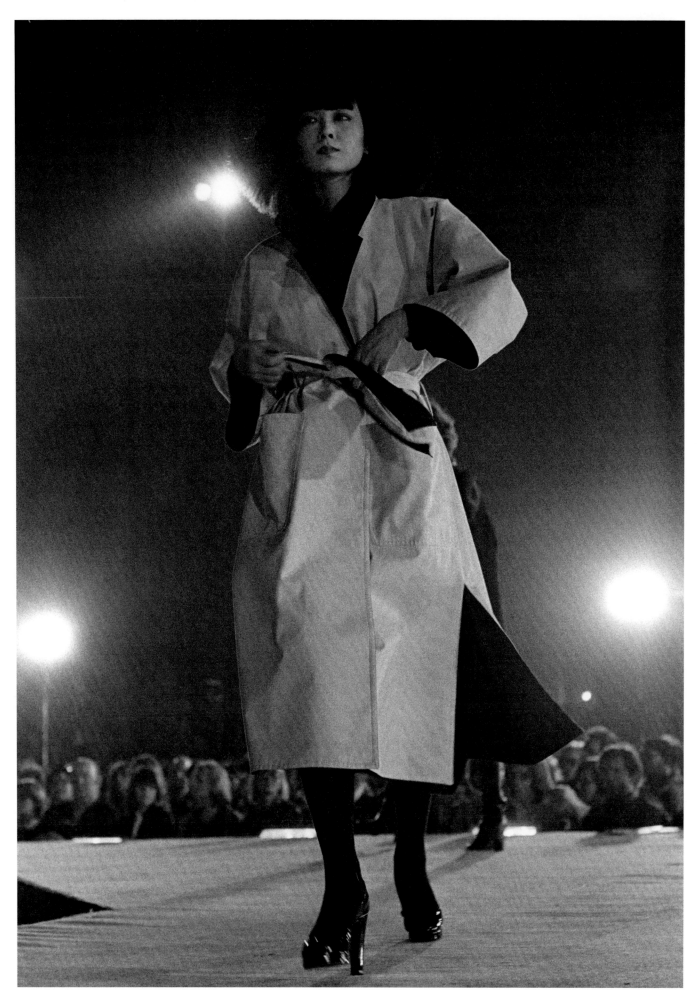

In the late 1970s Moore met the war photographer Don McCullin one season shooting the collections for the *Sunday Times*. He remembers: '[McCullin] said to me, "Do you know, it's easier to be a war photographer than it is to do this job?" It was weird, that it was so difficult. They seemed to want the photographers, yet also, to not want them.'

Left:
Kenzo
Autumn/Winter 1975
Paris

Opposite:
Emmanuelle Khanh
Spring/Summer 1976
Paris

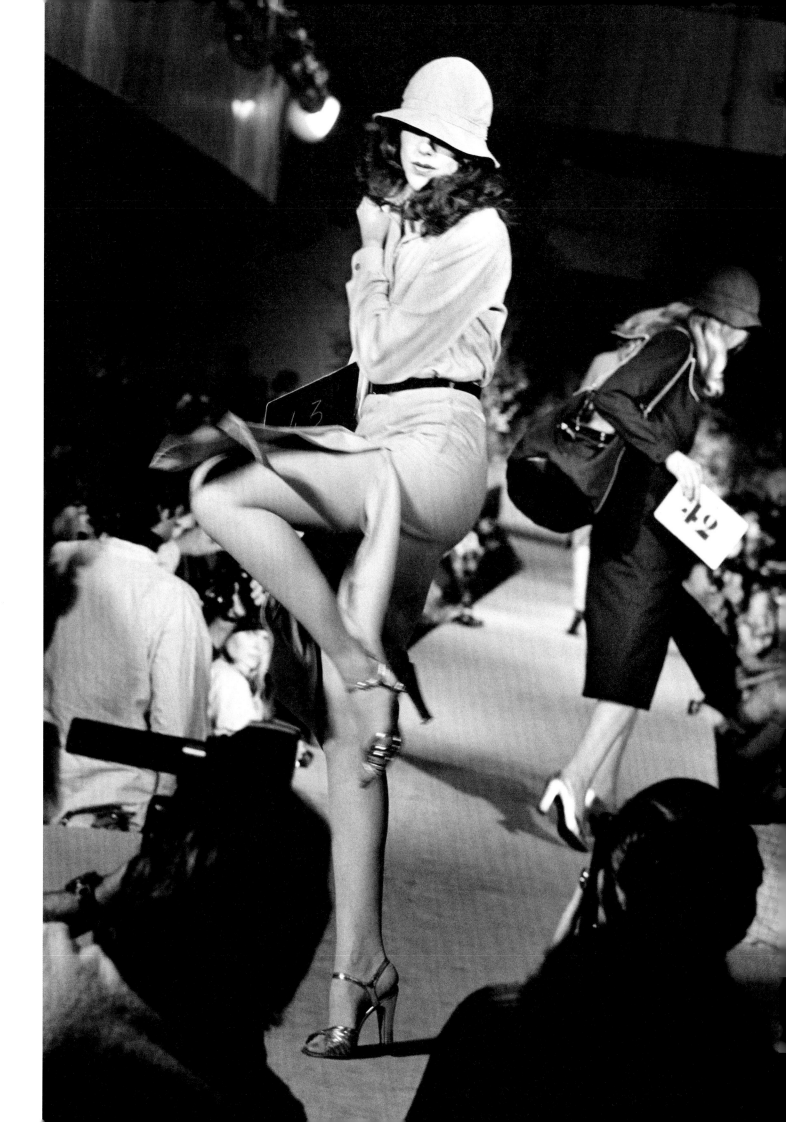

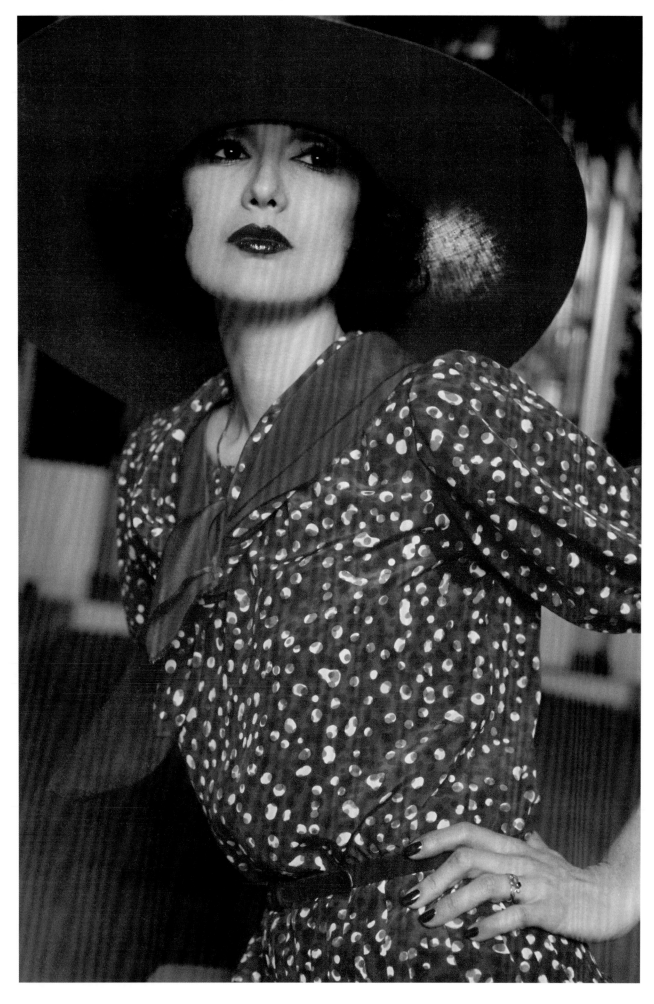

Photographing ready-to-wear was a different challenge, Moore recalls: 'The first Dior ready-to-wear show I went to, there was no podium for photographers. I was by a fireplace, in the salon of the Grand Hotel [in Paris]; some other photographers climbed on the fireplace. There was another grand fireplace at the Hotel Intercontinental; I think I've worked from the mantelpiece, too, at times.'

Left:
Marc Bohan for Christian Dior
Spring/Summer 1975
Paris

Opposite:
Yves Saint Laurent
Autumn/Winter 1975
Haute Couture, Paris

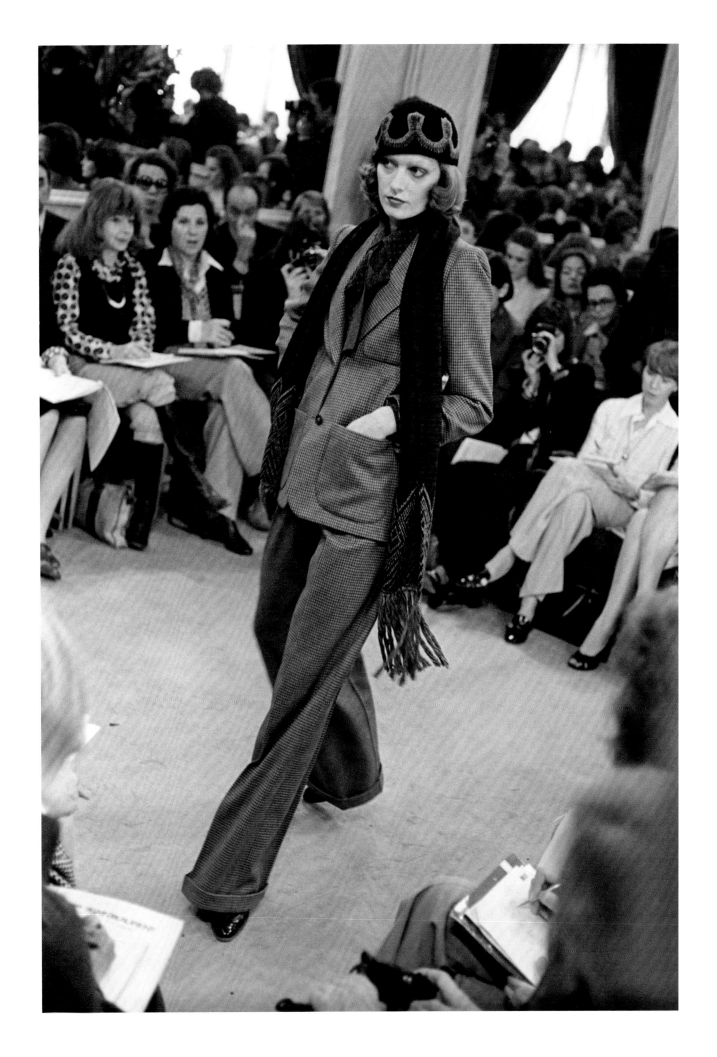

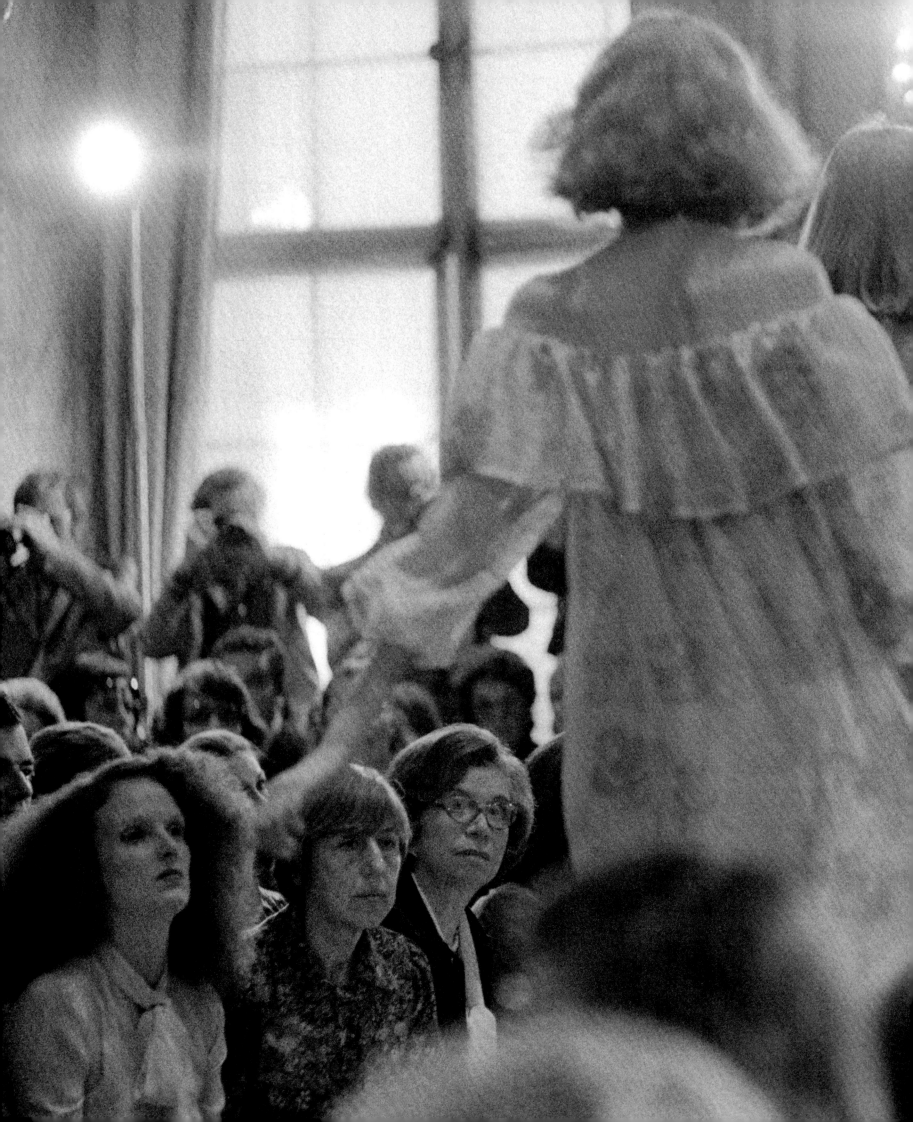

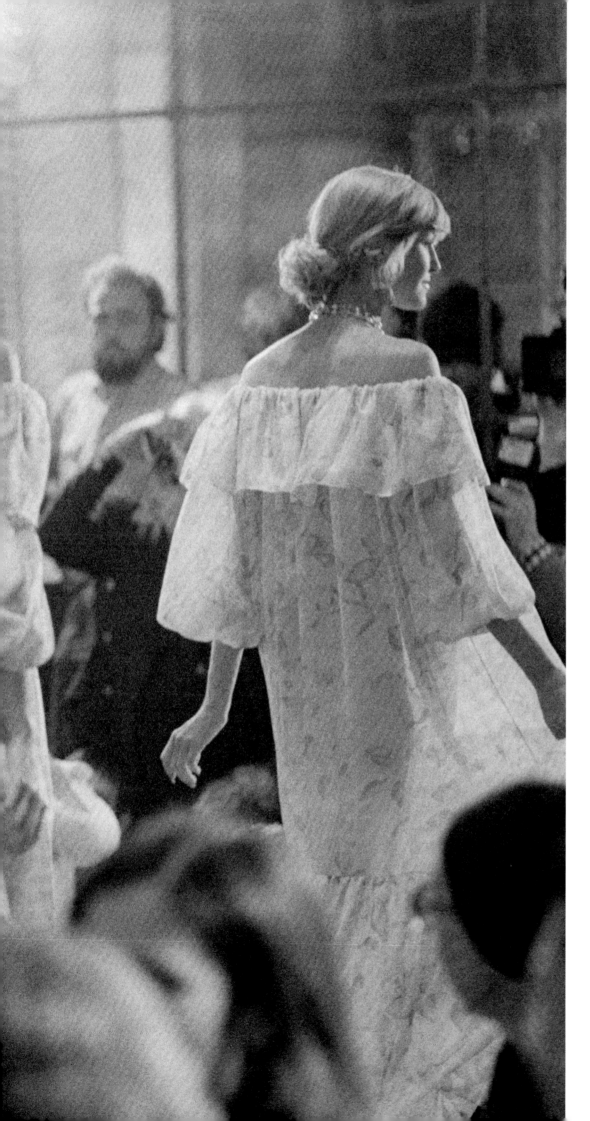

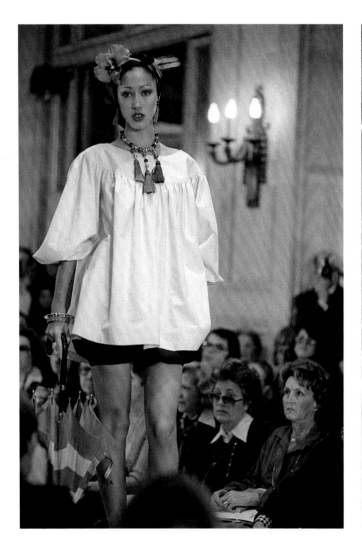

By the end of the 1970s,
Paris fashion faced
competition as catwalk
shows emerged in both
America and Italy. In Milan,
the high concentration of
clothing manufacturers
and factories caused a new
fashion week to spring up,
including the slick knitwear
of Mariuccia Mandelli's
Krizia label, and the
sharp tailoring of a young
Milanese designer named
Giorgio Armani.

Opposite left:
Yves Saint Laurent
Spring/Summer 1977
Haute Couture, Paris

Opposite right:
Krizia
Autumn/Winter 1976
Milan

Left:
Giorgio Armani
Autumn/Winter 1977
Milan

'Shows were a lot smaller in this decade than in the 1980s,' says Moore – as his images of tiny rooms, crammed with spectators, testify. 'They would often have more than one show, because the place was small. I suppose there were probably about 100–150 people at a time, and it would have been spread through a number of rooms, because there was a string of rooms. In the early days, they would never have thought of setting up podiums for the photographers.' As the decade progressed, however, shows became bigger and more spectacular, and the catwalk began to rise.

Left:
Chloé
Autumn/Winter 1973
Paris

Opposite:-
Yves Saint Laurent
Autumn/Winter 1979
Paris

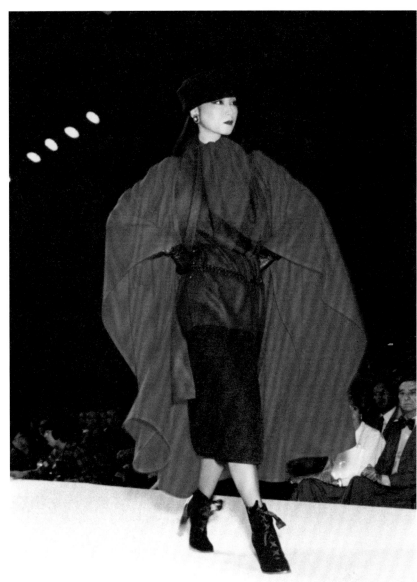

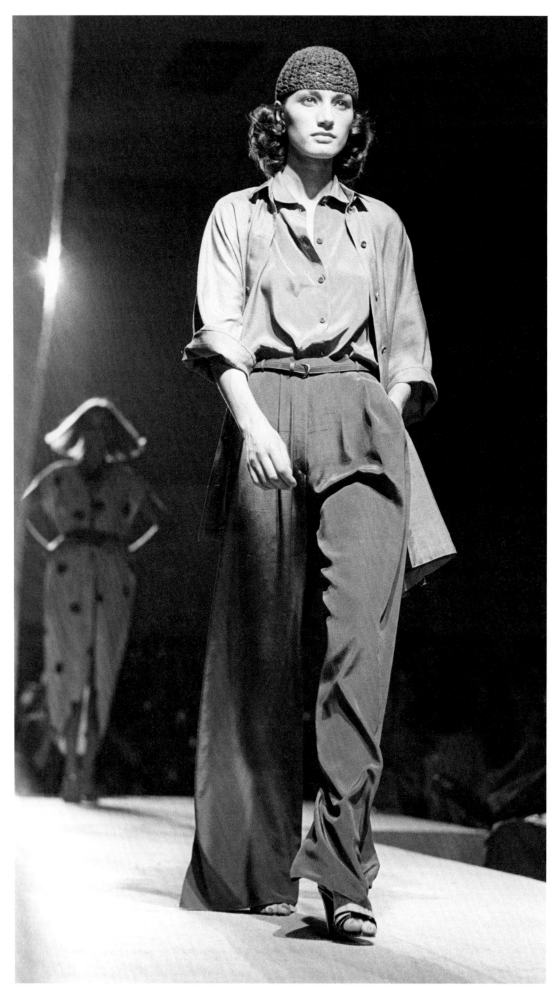

Left:
Geoffrey Beene
Spring/Summer 1979
New York

Opposite:
Chloé
Spring/Summer 1979
Paris

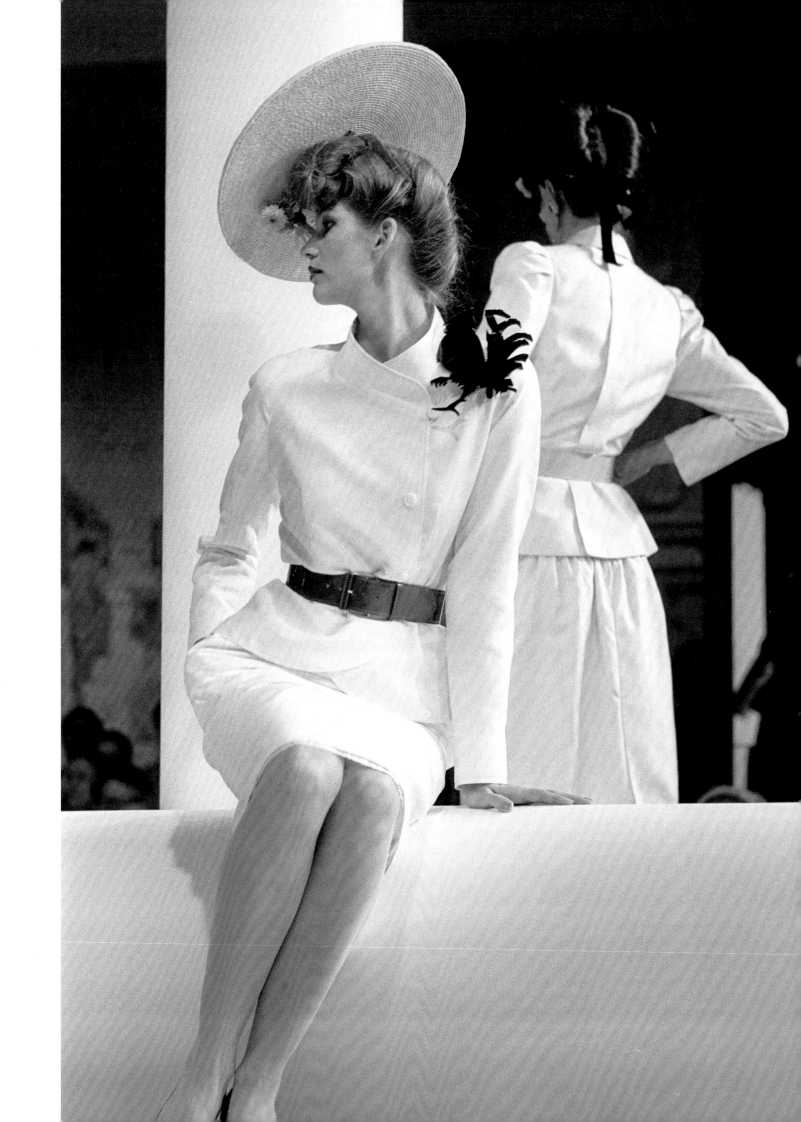

The audience of a fashion
show was as interesting,
to Moore, as the clothing
on the catwalk. By the
late 1970s, flamboyant
characters – such as the
Italian fashion editor
Anna Piaggi, seen here
– had begun to emerge
from the ranks, and
Moore documented them
eagerly. 'I was interested
in the people watching
at the shows from the
very start,' he says. 'They
always made themselves
look extraordinary. It's a
moment in time I like
to catch.'

Above:
Anna Piaggi (left) at
Krizia
Autumn/Winter 1976
Milan

Opposite:
Anna Piaggi (left)
and Hebe Dorsey at
Yves Saint Laurent
Autumn/Winter 1979
Haute Couture, Paris

From left to right:
Mandy Clapperton,
Grace Coddington and
Cathy Phillips at
Balmain
Autumn/Winter 1977
Haute Couture, Paris

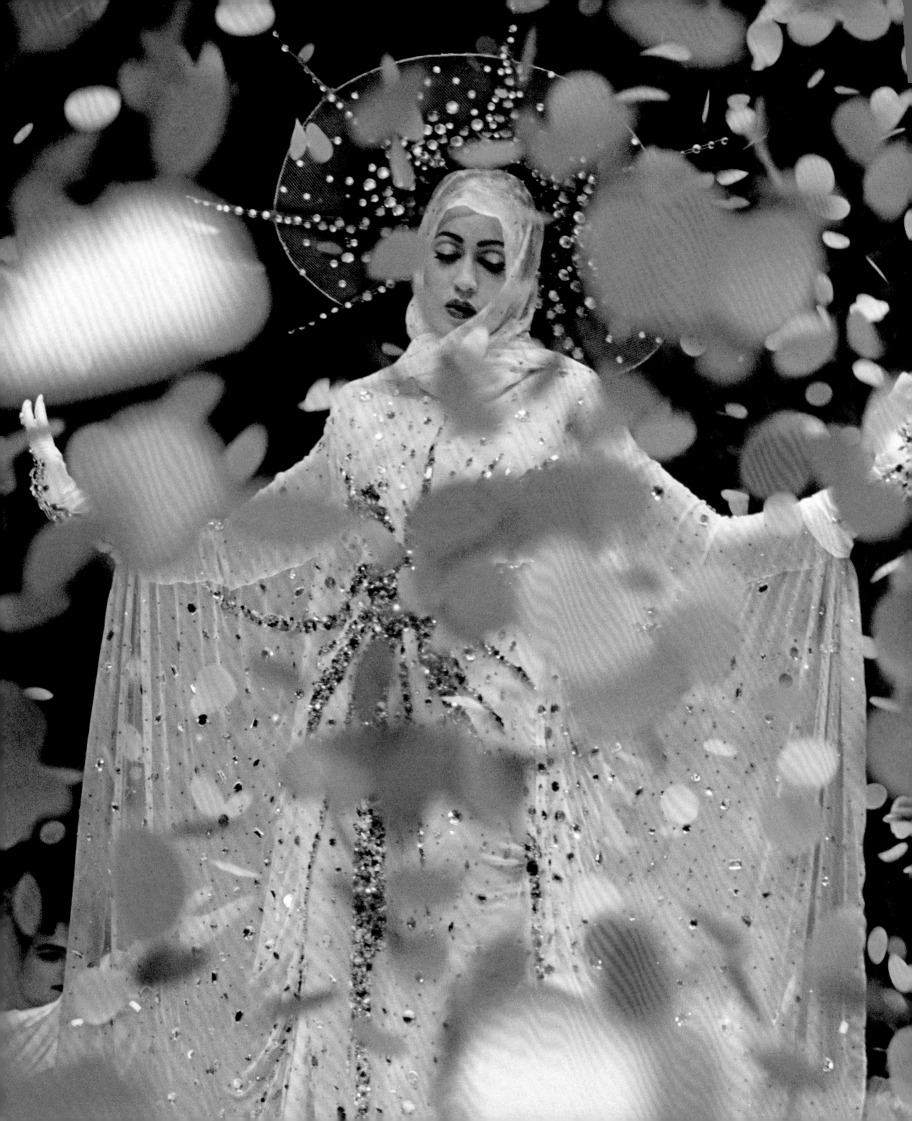

Four-City Circus

1980–1989

'If you're a designer, a show is like the final picture on the canvas.'

Chris Moore

To look at the fashion world in 1970 and again in 1980 is to see an industry transformed. But, rather than murky behind-the-scenes dealings or infinitesimal shifts perceived only by insiders, the transformation took place centre stage. In fact, it was *about* the stage – about the rise, physically and metaphorically, of the catwalk, and the ever-increasing importance of the fashion show.

If the major fashion story of the 1970s – the inexorable rise of ready-to-wear – was an industry shift that gave way to the birth of the catwalk show proper, from 1980 onwards those shows were the arena that would give birth to the industry's key changes. The major stories of the decade – fashion's underground going overground, the emergence of the Japanese designers Rei Kawakubo and Yohji Yamamoto, the launch of London Fashion Week, the ostensible revival of haute couture – all emerged from the catwalk. The decade's signature silhouette of aggressively short skirts, cinched waists and preternaturally pronounced shoulders also originated there. It was a round riposte to the 1970s, where the designers' early proposition of midi-skirts was roundly rejected by women at large, and where the street stole a march on high fashion. In the 1980s, the catwalk was king.

Punk, arguably the 1970s' most important and lasting influence on fashion, originated not in Parisian haute couture, or even ready-to-wear, but from a small, highly stylized London shop. Based at 430 King's Road in Chelsea, it was reinvented under various names but was particularly impactful under the name and label Seditionaries, between 1976 and 1979. Both the shop and the label were led by the music impresario Malcolm McLaren and his partner Vivienne Westwood, who themselves were capitalizing on ideas and aesthetic notions from small groups of musicians and hangers-on in both that city and, more prominently, New York. Punk had nothing to do with fashion, but its visuals were quickly co-opted by avant-garde designers such as Zandra Rhodes in London and Jean Paul Gaultier in Paris. Even more established names, such as Claude Montana, borrowed from its rich language (Montana's fetishistic black leather has clear roots in Punk).

With the dawn of the 1980s, a shift was palpable. In 1981 Westwood and McLaren, under the label World's End, opted to show on a catwalk for the first time, a conscious step into an elite system they had previously abhorred and railed against. Or was it? In the 1980s the catwalk became not a symbol of the rebellion of ready-to-wear against couture tradition, nor a vehicle of the establishment; rather, it was transformed into the only way that clothes were shown. There was something strikingly egalitarian about that, for all the elitism that runs rife in fashion. The subcultural, even 'anti-fashion' styles of designers such as Westwood, Kawakubo, Gaultier or, in Milan, the irreverent Franco Moschino shared an arena with the designers who defined the contemporary silhouette – Montana and Armani – and the staid, bourgeois but continuing world of Parisian haute couture. Indeed, in 1983 the avant-garde Westwood

would show on a Tokyo catwalk alongside Montana, the Italian Gianfranco Ferré and New York's Calvin Klein. The catwalk wasn't a melting pot – it was simply where, and how, you showed fashion: the 1980s transformed the catwalk into its natural environment.

The 1970s was a decade of relentless, boundless experimentation in modes of fashion presentation. Models sipped from hip flasks in couture salons, slunk through the vistas of boutiques or nightclubs, or whirled like dervishes on catwalks; sometimes they clutched numbered cards, like couture models of old; mostly they were backed by music, whether amped-up arias or thumping disco. But, in the 1980s, things settled. A pattern emerged; a style. In Paris, shows moved to a semi-permanent set-up of tents pitched in the Tuileries gardens or the Cour Carrée in the eastern branch of the Louvre museum; in Milan, around a third of designers used the Fiera, a high-tech space northwest of the city. Others began to show in custom-built showrooms and amphitheatres, emblems of the success of the booming Italian ready-to-wear businesses. In London, shows were staged in Olympia exhibition centre to the west of the city centre, while in New York designers showed in hotels, studios and, in the case of the young designer Stephen Sprouse, at the New York nightclub the Ritz, on East 11th Street.

The venues may have been varied, but the format was cemented: spotlights trained on every look; music at dangerous decibel levels (from Montana's signature Wagner dirges to pop anthems at Chanel); and always a raised catwalk with the designer's name writ large at the back, to differentiate it from all the other shows that looked so very similar. The term 'catwalk' had been in use since the 1940s to describe the narrow walkway down which fashion models progressed, but it was only in the 1980s that the fashion catwalk evolved from a simple path to a recognized object or structure: the stage on which the biannual fashion collections would be performed.

The importance of performance in the identity of 1980s fashion is vital. The notion did not apply only to the models' behaviour – although, with the likes of Jerry Hall, Marie Helvin and Pat Cleveland still prominent at the start of the decade, and others, including Marpessa Hennink, Violeta Sanchez and Katoucha Niane (known, like Madonna, by her first name only), emerging as new stars, modelling in the 1980s was as much about showing off as it was about showing the clothes. Rather, the theatrical dimension of the catwalk demanded much more from the designers, and from their garments. 'To make sure their clothes are not lost on the vast runways of the tent city set up for the fashion shows ... designers assault the eye with outlandish accessories and the ear with music,' moaned Bernadine Morris in the *New York Times*, of the Paris Autumn/Winter collections of 1984. 'The result is that any sense of reality in the clothes themselves is lost.'

Morris was an observer whose career spanned the industry B.C. – 'Before Catwalking' – and hence contextualized the spec-

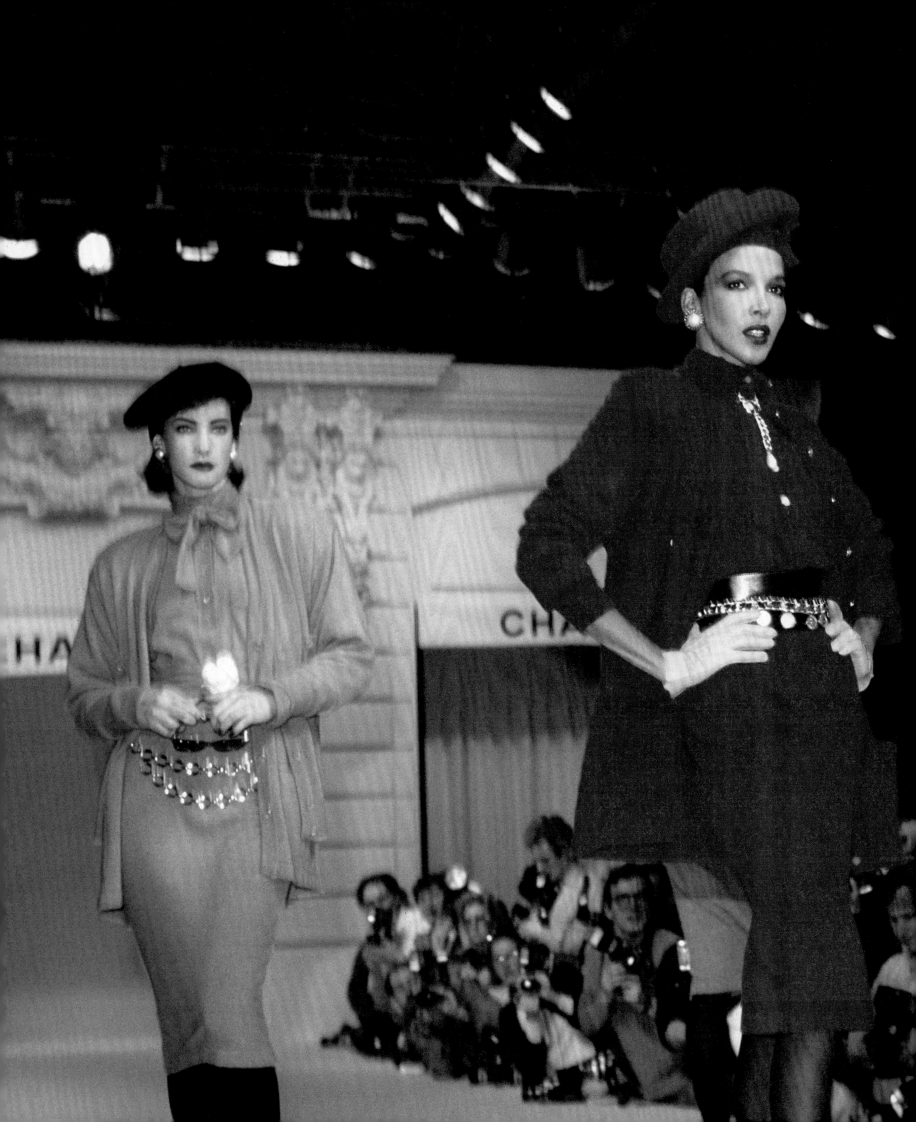

Page 100:
Thierry Mugler
Autumn/Winter 1984
Paris

Previous page:
Bill Blass
Spring/Summer 1987
New York

This page:
Chanel
Spring/Summer 1986
Paris

tacular productions of the 1980s as rising from the earlier, simpler purpose of fashion shows: to show fashion. The 1980s snipped off the extraneous opening noun of that former moniker, leaving us with merely a 'show'. Reality went out of the window.

Was it coincidence that, in this new era of high fashion on a high-up podium, the exaggerated, shoulder-padded styles of 1940s screen sirens were revived? Fashion was playing to the back row; Christian Lacroix, a darling of the era lauded by publications including *Women's Wear Daily* and the *New York Times*, declared, 'Everything has to be a kind of caricature to register; everything must be larger than life.' That was undoubtedly true of Lacroix's clothes, designed first for the haute couture branch of the house of Jean Patou between 1981 and the spring of 1987, and thereafter under his own name. Under both, his style was characterized by a riot of strident colours, bubbled volumes and high-impact accessories that shifted fashion's aesthetic compass. Lacroix was the rule, rather than the exception: besides the influence his styles had in the latter half of the decade, he was the poster child for a postmodern approach to fashion, scrambling decades and aesthetics into a kind of stylistic soup that registered on the big stage of the ever-demanding 1980s catwalk.

Lacroix was the ringleader – but his was the general mood of a great swathe of 1980s fashion. In Paris, Montana and Thierry Mugler exaggerated 1940s' dimensions to cartoonish proportions, as if dressing comic-book heroines; in London, the designer Antony Price – who had dressed Roxy Music in the 1970s – based collections on Marvel heroes. Price, and Mugler and Montana, staged enormous productions that seated not hundreds but thousands of spectators. In 1984 Mugler erected the catwalk for his Autumn/Winter show inside Zenith, a venue newly built to stage rock concerts: he invited 2,000 guests, and sold tickets to another 4,000. The show itself was a cast-of-thousands affair, featuring models in angel wings, on sleighs, and posing as Madonna and Child set to the low-key strains of Mozart's Requiem and Handel's *Messiah*. There was, of course, also some fashion.

By the start of the 1980s, Chris Moore's position as the leading chronicler of the new high-fashion habitat of the catwalk was established. In 1981 he moved his business from London's West End to Clerkenwell, an area then boasting the highest concentration of photography-based operations in the world by square mile, and a quarter-mile from Fleet Street, the heart of British print journalism. Moore was providing catwalk images to companies across the world – *W* and *The Face* magazines, the *Sunday Times* and *Observer* newspapers. His images were used in the fashion coverage of as many as five daily newspapers simultaneously. Moore was more than just a go-to lensman; he was a catwalk anthropologist who, like Morris, had documented fashion 'B.C.' in the 1960s; charted the catwalk evolution in the 1970s; and now witnessed their full flowering in the 1980s.

In essence, what Moore saw was the birth of the fashion circus – the four-city catwalk show system that still exists today. That was consolidated only in 1984, when the first official London Fashion Week was staged. The same year, a young Saint Martin's School of Art student called John Galliano showed his graduation collection, inspired by French dandy rebels of the eighteenth century, emphasizing the importance of London in the biannual ready-to-wear shows. 'People thought a lot of London,' says Moore. 'It was a shining star, I suppose. Vivienne Westwood, of course, was great at that time. And BodyMap.' He pauses. 'There were lots of mediocre ones as well.' But Moore saw and documented them all, good and bad.

The swell to four fully fledged fashion weeks necessitated more photographers, as did the booming number of labels launched in those cities. 'When I began, there were 15,' Moore says of the photographers whose profession it was to chart the international collections. 'In the seventies it went up to, I would say, 200. But in the eighties it was mad. It was 300, 400.'

As the visibility and accessibility of fashion increased – in the absolute reverse of the haute couture system, photographers were suddenly permitted into shows, and clothes suddenly available to buy – media interest boomed. Newspapers ran fashion bigger and bolder, leading with images that captured the atmosphere of the shows, not just the lines of the clothes. Sometimes – as with Mugler – the clothes could seem like an afterthought. Video cameras began to infiltrate, all the better for catching the epic nature of this new fashion-as-theatre. And photographers were placed front and centre.

The set-up of 1980s' catwalk shows is well-known and much parodied, and even today the shorthand for 'fashion show' is a towering white podium characteristically flanked by those

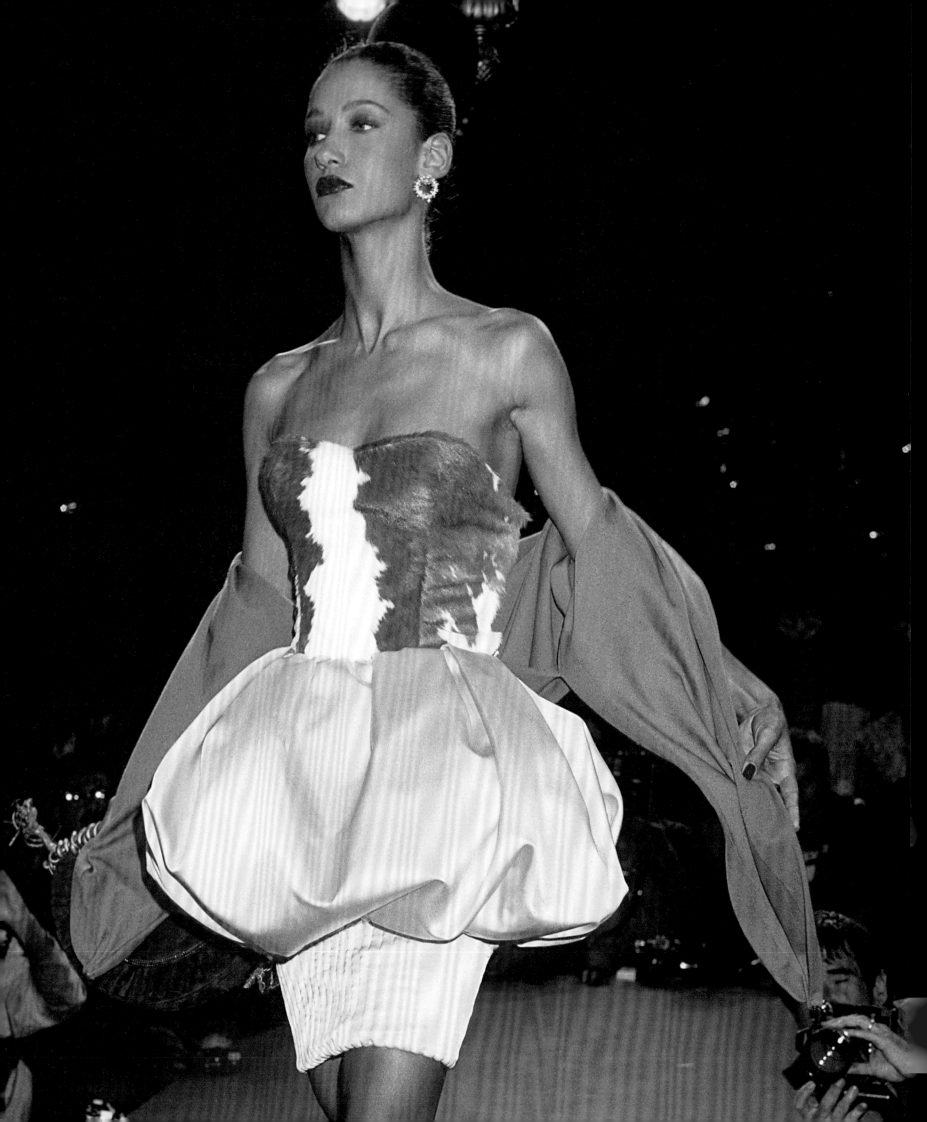

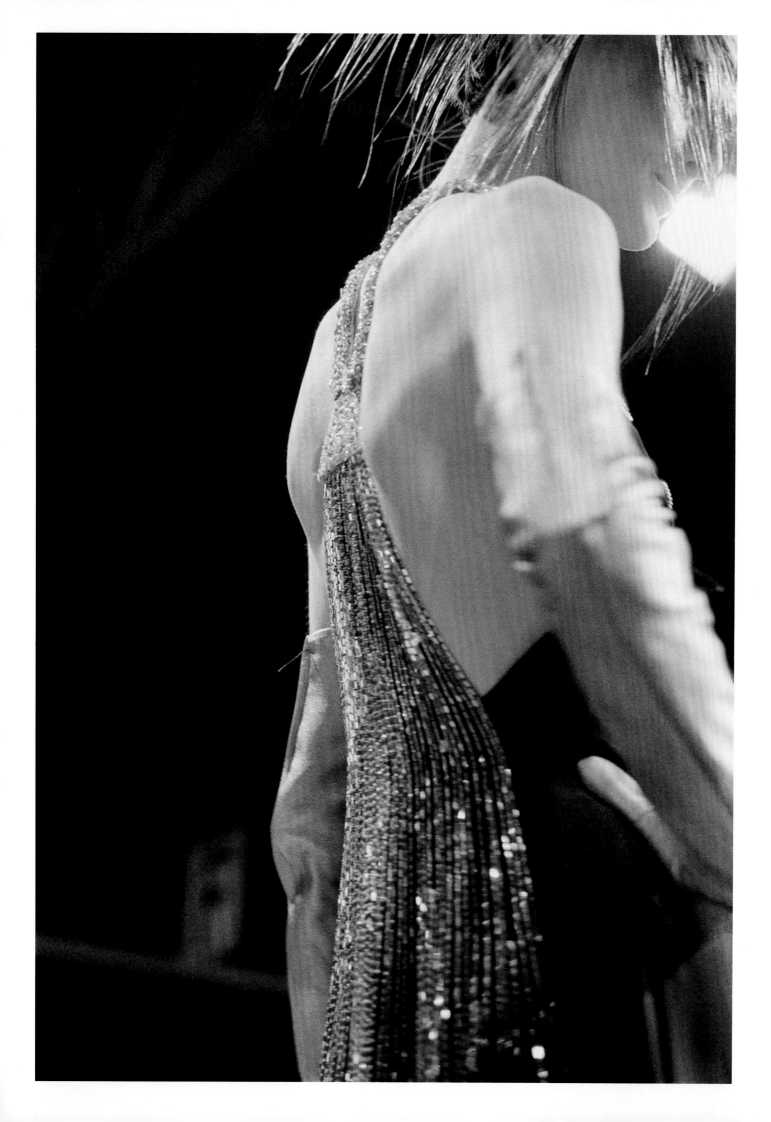

Opposite:
Chloé
Autumn/Winter 1983
Paris

Overleaf:
Yannis Vlamos
(centre left) at
Nina Ricci
Autumn/Winter 1986
Paris

hundreds of photographers. Established in the late 1970s, that typical set-up would persist until the mid-1990s. It created an immediately identifiable 'look' when translated to those innumerable photographers' images: the model at an angle, towering above the viewpoint, frequently capturing a swathe of backdrop (and many of the other photographers). The fantasy of fashion collided with the real world on the catwalk.

'The designers and all the people who put on the show didn't realise the nuisance that photographers would become, especially as there were more and more along the side of the catwalk to get in the way of the journalists,' remarks Moore. The real front row, in the 1980s, belonged to the fashion photographers, positioned between the seated audience and the models. The raised catwalk was a necessary device, to elevate the models – and the clothes, the point of the whole thing – above the photographers' heads, for the audience to see.

'They got fed up with us, seeing us jack-in-the-box, get up and sit down,' says Moore. He's referring to the technique of not only capturing the models, but also inhabiting that new fashion environment: Moore and his fellow photographers would crouch at the base of the catwalk, leaping to their feet to photograph each model. It was a synchronized, highly physical exertion, practised hundreds of times daily and thousands of times every season.

The development of the catwalk, rather than the development of photographic technology, necessitated that positioning. 'You had to photograph a moving object, which you often didn't have to do before,' explains Moore. 'In a period before the automatic focus, you had to let the model walk into focus, because to try to focus on a moving object is too difficult. You set the camera to something like four or five, four metres say, and you were invariably sat at the side of the catwalk.'

It wasn't just the movement: the pace of the 1980s catwalk required new methods to capture every look – which, in Moore's eyes, was not merely a challenge but an absolute necessity. 'I used to work with two cameras: one black-and-white, one colour. You would stand up rapidly as the models came towards you, and shoot, and then sit down. Then when they came back, because you'd be sat at the side but probably in the middle [of the length of the catwalk], you would perhaps use the other camera to get some colour. You just learn these techniques. The camera was a 35mm Nikon, the standard lens. Perhaps one with an 18mm lens, and of course you had to load the film.' Occasionally, if employed by a fashion house to shoot imagery for their own use, Moore might be afforded the luxury of an assistant with a camera 'body' already loaded, only changing the lens during the rapid-fire retinue of models' looks. 'But that was a luxury you couldn't have for every show,' he remarks, ruefully. 'You could possibly go through ten rolls of film.'

Multiply Moore's account by the hundreds of photographers now swamping every show, and there was a sudden, remarkable deluge of imagery – a tidal wave of fashion. Although Moore was the first, he was a reluctant pioneer. Ask him when he decided to become a catwalk photographer, and the response is sharp: 'I didn't decide. Everyone else decided. That was where the demand was. Indeed, the birth of the true catwalk had created an insatiable demand for fashion pictures.

Despite the competition, the excitement over other fashion capitals' creativity and the serious commercial threat of the fast-expanding Milanese designer labels, Paris consolidated its position as the centre of the fashion world in the 1980s. It did so by two means, both focused on the primacy of the catwalk: by spectacularly reviving its haute couture tradition and, conversely, by ushering in the strikingly new.

In the early 1980s, Paris welcomed overseas designers, allowing Yohji Yamamoto and Kawakubo's Comme des Garçons to show on their schedule (Westwood also showed there for a single season in 1983, at the Angelina tea room). Originally, the Japanese designers had wanted to show in London, but the capital's lack of organization meant Paris stole a march (both first showed in Europe in 1981, two years before London Fashion Week was founded). Kawakubo and Yamamoto caused a sensation, and were acclaimed and reviled in equal measure, for clothes that were insensitively dubbed 'post-Hiroshima' or 'bag lady'. The critics referenced the distressed layers of clothes, sometimes randomly punched with tears; when Kawakubo showed oversized sweaters pocked with holes – created by loosening the screws of knitting machines to produce intentional 'errors' of gaps in the knit – she ironically called the collection 'Lace'. That, technically, is what these clothes were: fabric with holes, just like the Chantilly or Valenciennes varieties, but also different.

Kawakubo and Yamamoto challenged the conventions of dress – Western conventions. Rather than creating clothes composed of numerous specially shaped pieces, 'tailored' to the body beneath, they created wide, flat-cut clothes, more akin to the kimono. Their idea of wrapping bodies in layers of fabric also finds a kinship with traditional occidental modes of dress. Even the approach to make-up was unconventional: Kawakubo's first show used blotches of dark hues across the models' cheeks or forehead, like bruises, because the designer didn't see why colour should be confined to eyes or lips. In these stark shows, the models in their black clothes dramatic against the catwalk like living Japanese pictograms, the Japanese designers unveiled something that had never been seen before in Paris.

Paris's revival of haute couture, on the other hand, harked back to a post-war golden age, when the city's influence was unquestioned. The fêted ready-to-wear clothes of Mugler and Montana also echoed that period – and, in their demanding shapes, close fit and complex design, they were perhaps closer to the tradition

of haute couture than the hitherto easy-to-make ready-to-wear when it emerged in the 1970s. Karl Lagerfeld, formerly the ready-to-wear designer for the label Chloé, showed his first haute couture collection for Chanel in January 1983. History has been rewritten to say that Lagerfeld's first show was a revolution, but that wasn't the case. Contrast his debut with the collection from July 1982 created by Jean Cazaubon and Yvonne Dudel, former assistants of Chanel who had designed the line since her death in 1971. There are few great differences: the tweeds, the pearls, the chains, the boater hats and two-tone shoes, the codes of Chanel. But the attitude had been transformed, as had the applications of these codes. The leitmotif look was of the model Inès de La Fressange, soon to become Chanel's 'face', in a black crêpe-de-chine dress, embroidered with fake jewellery by Maison Lesage. 'It's a good thing Coco Chanel is dead because she would not have understood,' commented Hebe Dorsey of the *International Herald Tribune*, of the early days of Lagerfeld's Chanel revolution. The haute couture takeover was, ironically, staged in the salons of 31 Rue Cambon itself – a couture bastion, stormed.

Lagerfeld, alongside Christian Lacroix, was the great leader of the couture revival in the 1980s. Yves Saint Laurent and Emanuel Ungaro were also popular – but Lagerfeld and Lacroix used the catwalk as the main tool to express their ideas. Crafting intricate haute couture dresses to swaddle rich clients wasn't the goal; crafting an image was. 'We don't make a profit from the couture,' said Pierre Bergé of Yves Saint Laurent, boldly. 'But it's not a problem. It's our advertising budget.' This wasn't just a media revival, though: according to the Fédération Française de la Couture du Prêt-à-Porter des Couturiers et des Créateurs de Mode, sales of haute couture rose from 100 million francs in 1980 to 301 million francs in 1987. Nevertheless, contrasting those figures with the perceived publicity value of the couture shows its real worth: between the announcement of his departure from the house of Patou in February 1987 and the launch of his own label in July, Christian Lacroix was estimated to have netted $4 million worth of editorial publicity. It also explains why, after the stock market

crash of 1987 and the ensuing recession put a damper on fashion's party years, haute couture persisted, even as the sales powering the much-vaunted and publicized boom flagged.

There is a deeper meaning to all this. The philosopher Guy Debord discussed the 'spectacle' of modern society as 'a social relationship between people that is mediated by images', and what better summarizes that idea of image taking precedence over reality than the revival of Paris haute couture? In the 1990s, the sociologist Jean Baudrillard argued controversially that the Gulf War functioned as a virtual war, a war on no fronts other than 'the depthless, ephemeral plane of the CNN broadcasts'. In a similar manner, haute couture, by the 1980s, was shown purely through video and photographs – at least, to the general public. Unlike ready-to-wear, where physical garments *could* become available, to touch if not to buy, haute couture clothing was entirely inaccessible. These clothes were restricted to the backs of the few thousand women worldwide with the wealth to afford it (around 2,000 by the 1980s, dipping from a post-war high of 30,000) and to the editorial pages of fashion magazines. Anna Wintour, then the new, young editor of 1980s American *Vogue* (she was just 38 when appointed to the role), put Lacroix haute couture on the cover of her first issue, in November 1988. The mixing of an embroidered velvet Lacroix jacket with the 'reality' of stonewashed denim jeans caused a sensation. But only a few outfits were ordered, or indeed photographed by magazines, from the haute couture shows. More often than not, their life was brief, restricted to fashion's natural habitat of the catwalk. That was visible live, for a few hundred invited guests – but most probably, you'd encounter these clothes confined to the images created by Moore and his army of contemporaries, relentlessly recording this perfect postmodern fashion.

Back in the 1960s, that inaccessibility was couture's ultimate undoing. But in the 1980s, with the catwalk as the new power broker, it was the perfect medium for fashion. It was all about image, all about spectacle. All about the final picture, not the final product.

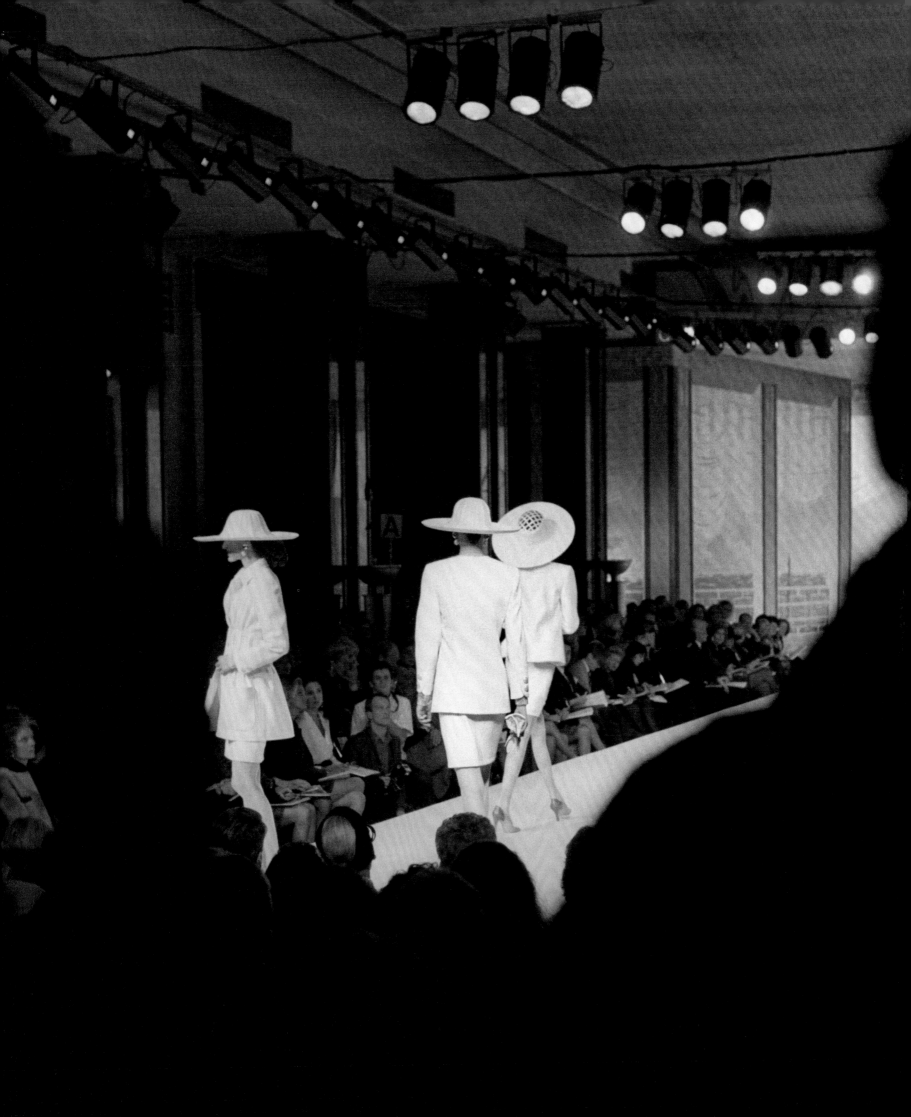

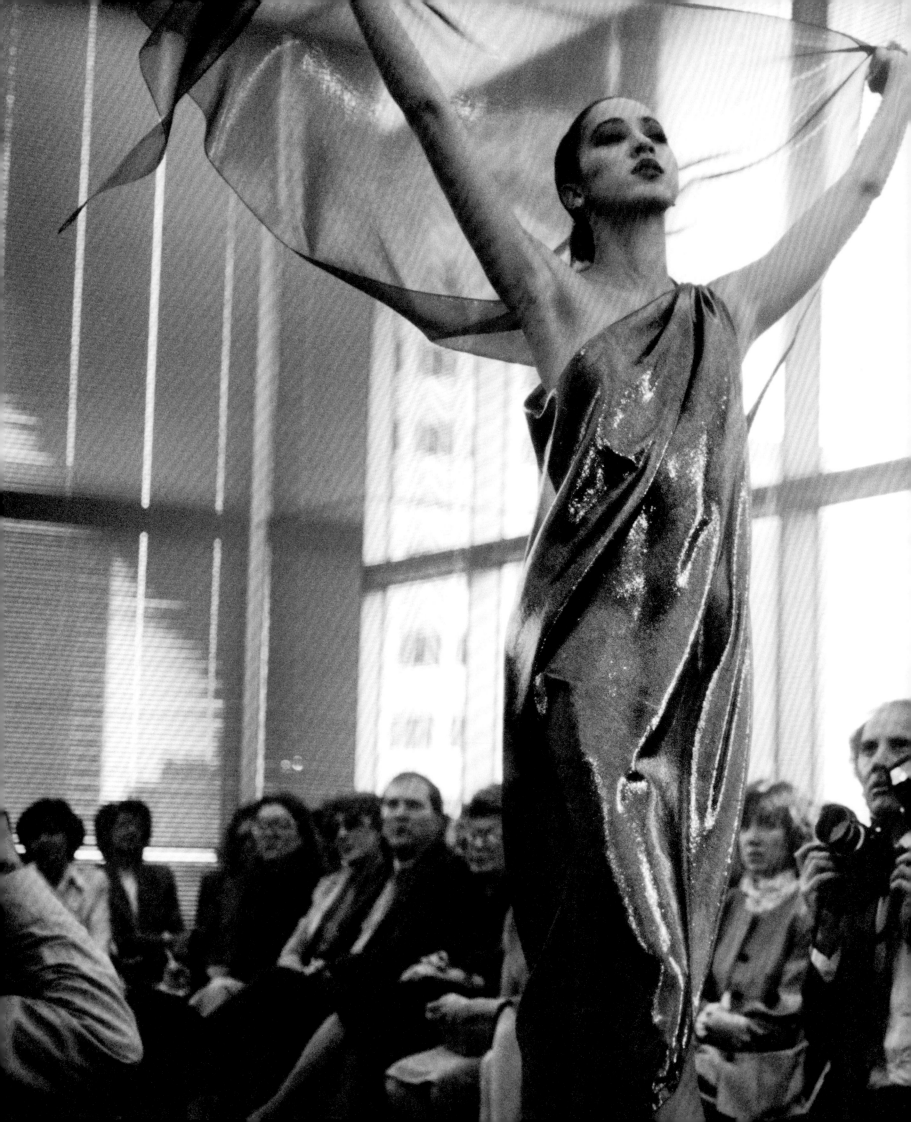

This page:
Halston
Autumn/Winter 1982
New York

Overleaf:
Giorgio Armani
Spring/Summer 1980
Milan

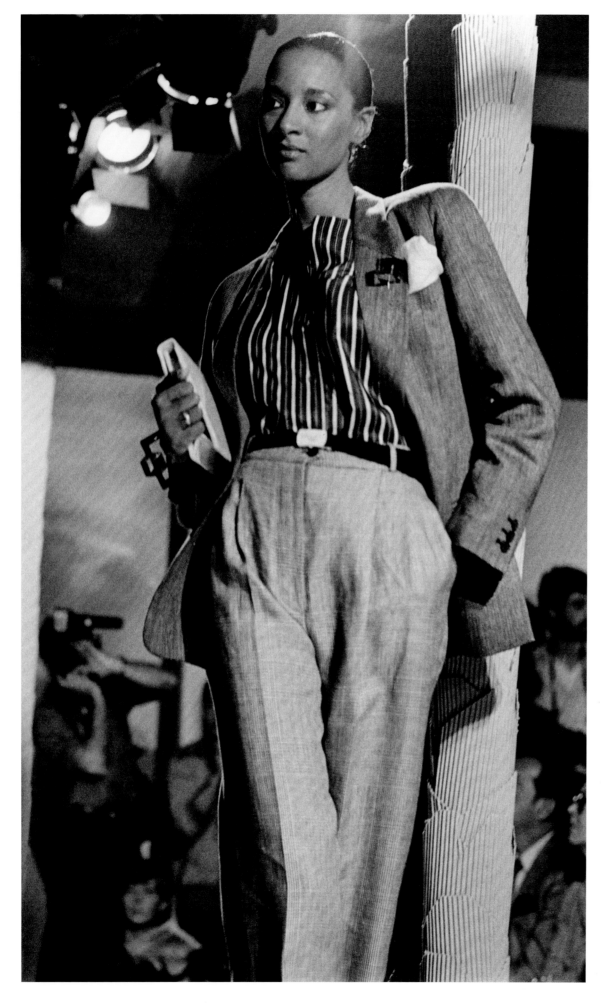

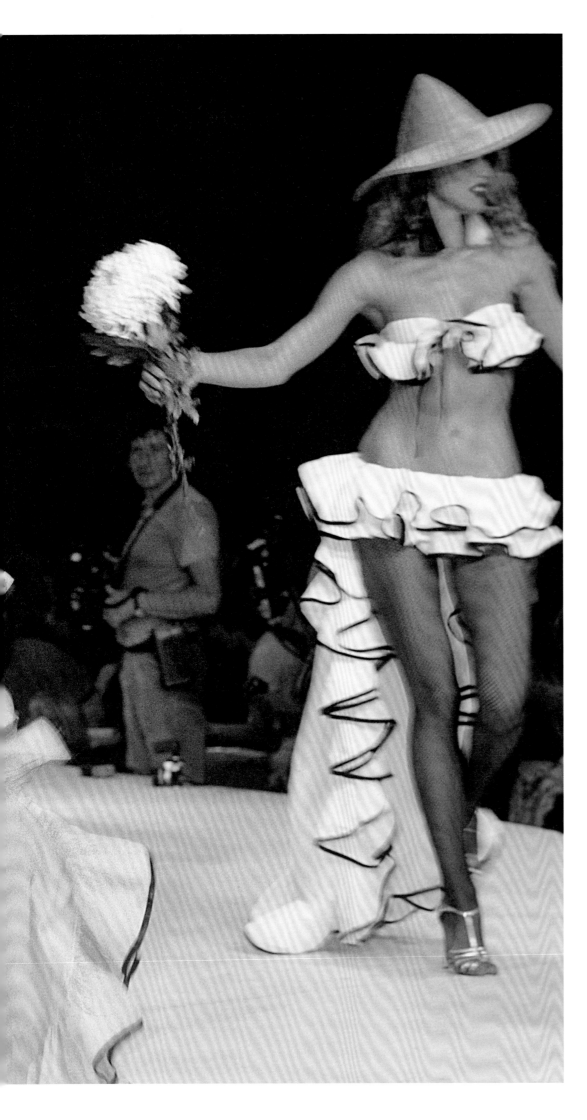

Yves Saint Laurent
Spring/Summer 1980
Paris

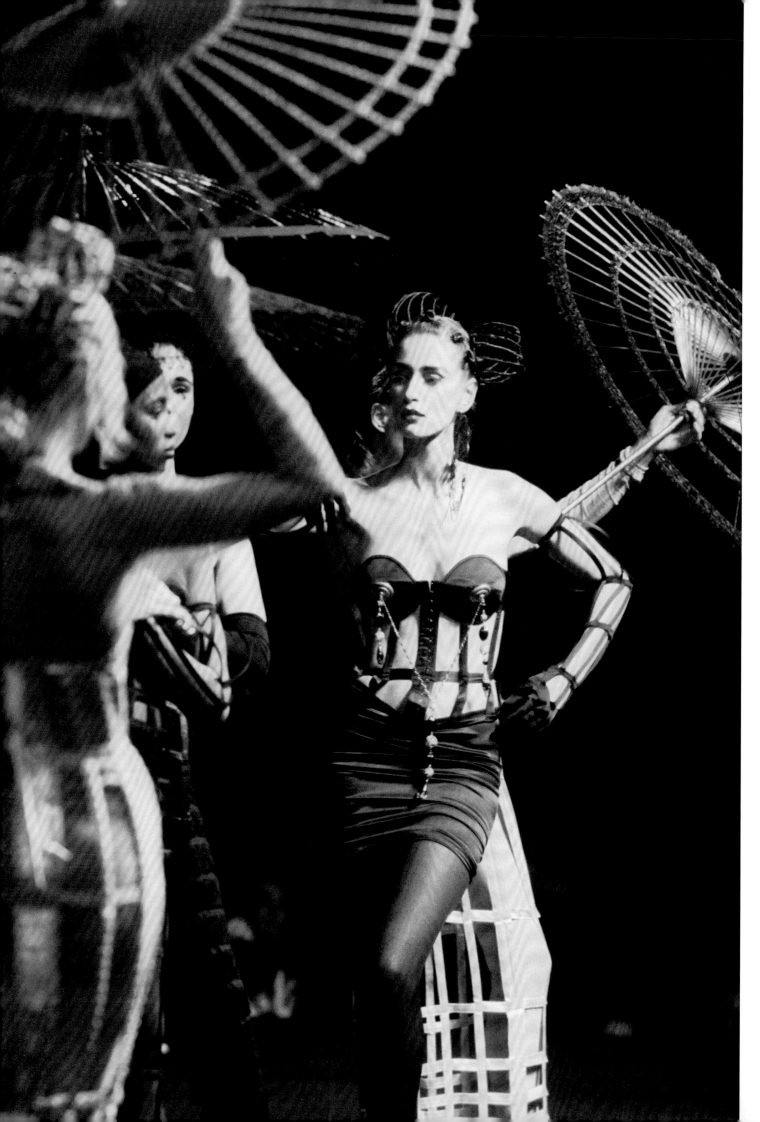

'I loved those early shows. A definite thrill, an experience,' recalls Moore of Jean Paul Gaultier, the *enfant terrible* of French fashion who leapt to international prominence in the 1980s. His high-octane shows were some of the decade's most acclaimed and spectacular, 'a very exciting audio-visual experience', according to Moore. They also helped to re-establish Paris as a must-see fashion capital, against Milanese dominance. The clothes were witty and funny, with signature reinvented corsets, while traditional tailoring was sliced open and radically reworked. Gaultier presented an alternative to the French fashion establishment, so frequently seen as bourgeois and stuffy. He was proof of new life and fresh blood in French fashion.

Jean Paul Gaultier
Spring/Summer 1989
Paris

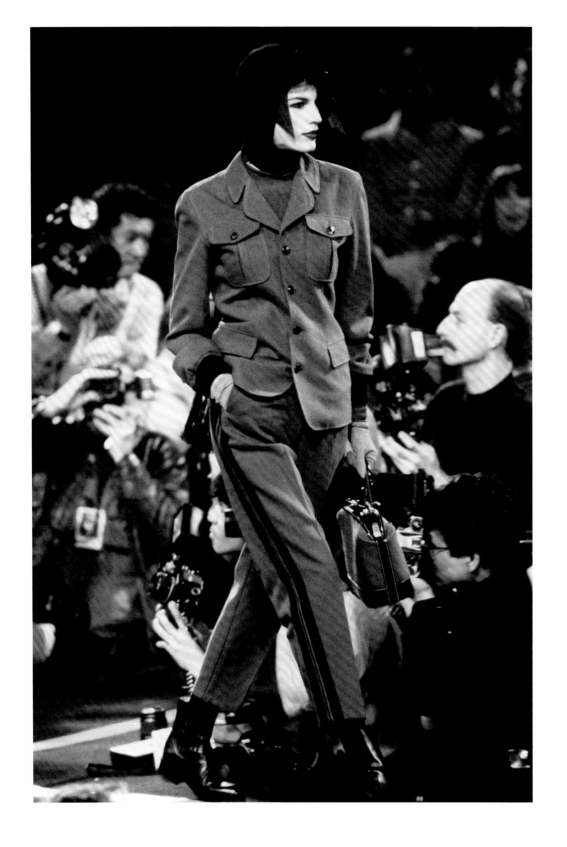

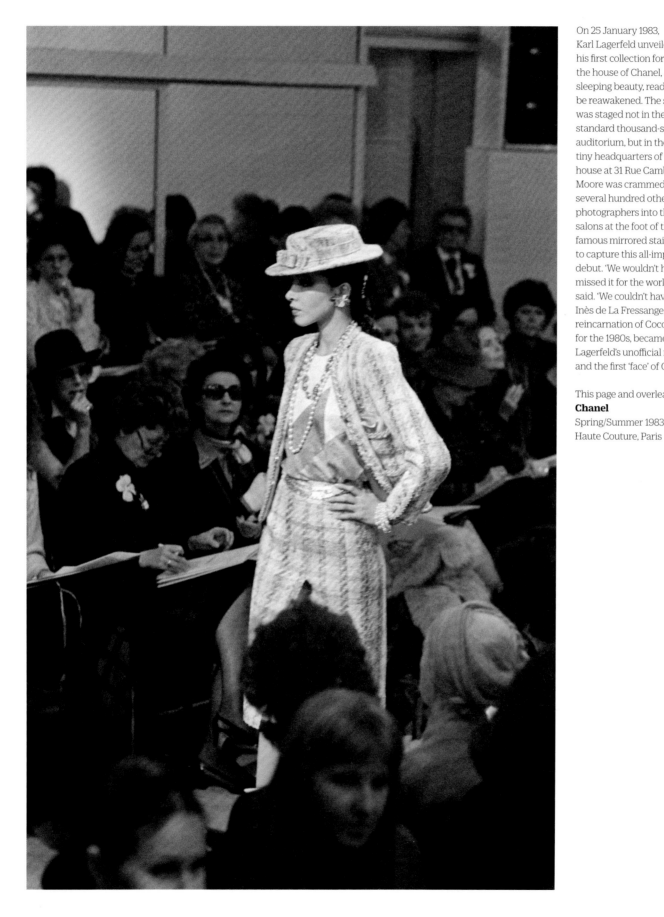

On 25 January 1983, Karl Lagerfeld unveiled his first collection for the house of Chanel, a sleeping beauty, ready to be reawakened. The show was staged not in the then standard thousand-seat auditorium, but in the tiny headquarters of the house at 31 Rue Cambon, Moore was crammed with several hundred other photographers into the salons at the foot of the famous mirrored staircase to capture this all-important debut. 'We wouldn't have missed it for the world,' he said. 'We couldn't have!' Inès de La Fressange, a reincarnation of Coco for the 1980s, became Lagerfeld's unofficial muse and the first 'face' of Chanel.

This page and overleaf:
Chanel
Spring/Summer 1983
Haute Couture, Paris

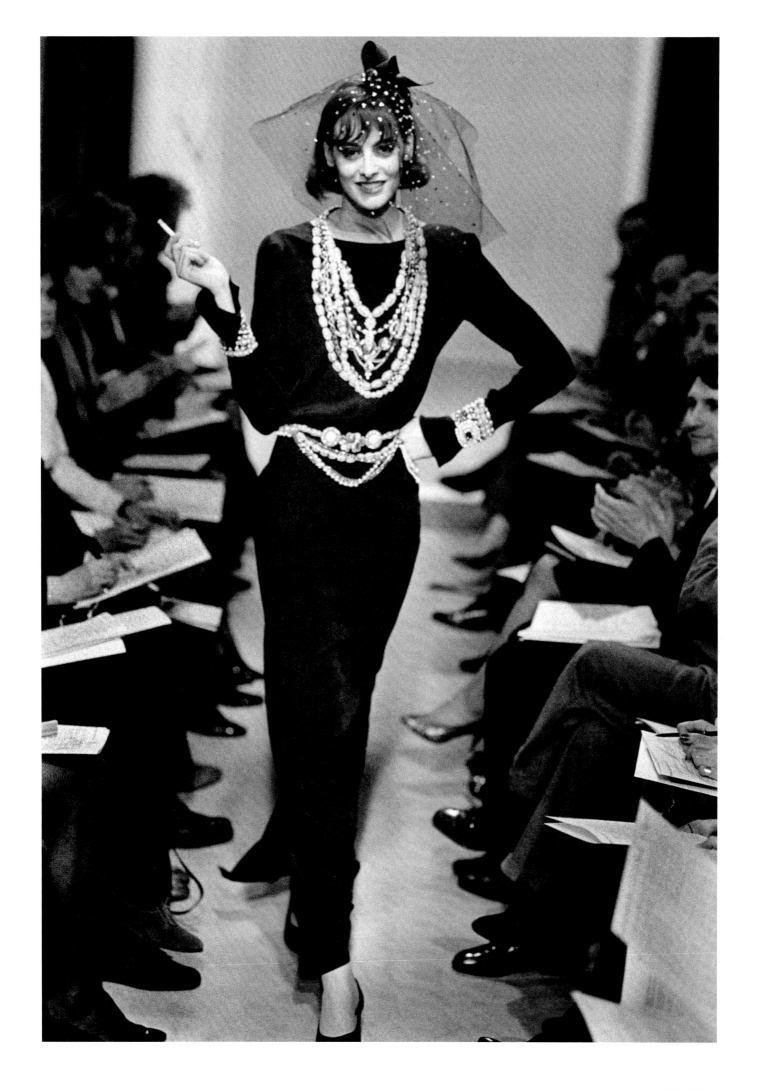

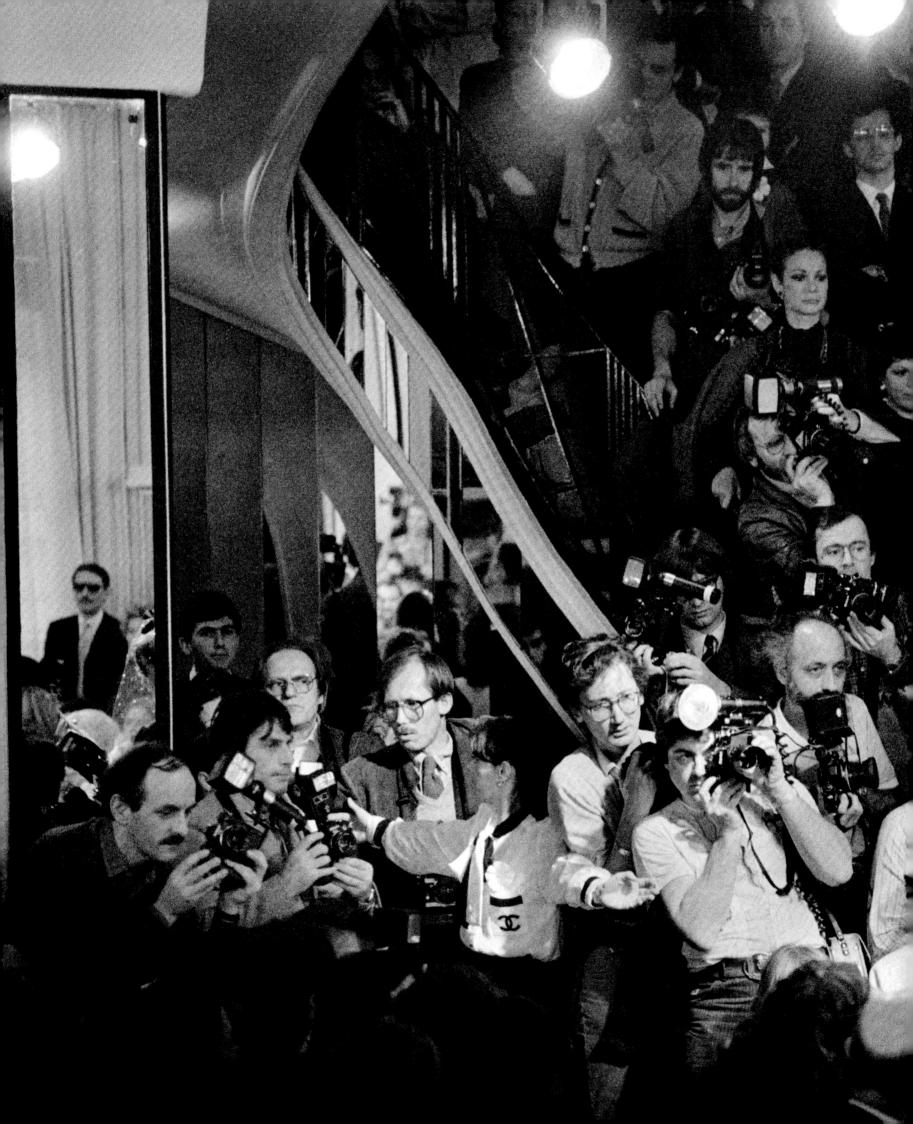

CHRIS MOORE

CHANEL AW 87

♯♯♯O HC

CHANEL

CHANEL

AW 90

Chanel Aw 91

Chanel

Chris Moore

CHANEL

SS92

CHANEL
SPRING/SUMMER 93

CHANEL

AW 92

Chanel ss94

♯♯ 97

CHRIS MOORE

CHANEL
AW 94

CHRIS MOORE

CHANEL SS 97

♯♯♯O

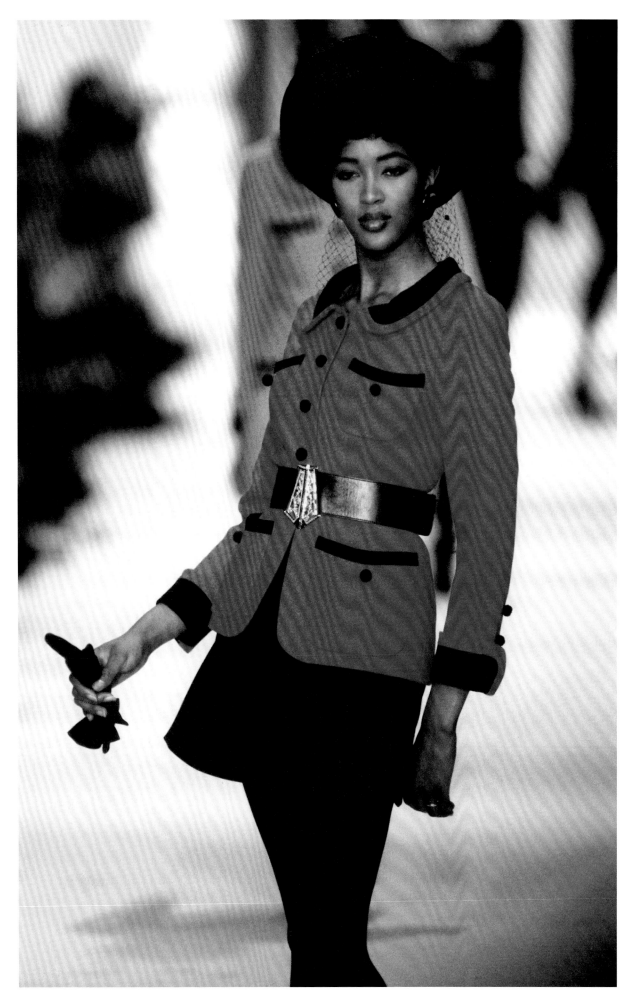

Chanel's blueprint for the 1980s was established in Karl Lagerfeld's first haute couture collection: using the symbols of the house (tweed, camellias, dripping pearls) to invent a new future. But in fact, Lagerfeld's revitalization of Chanel has proved *the* blueprint – and benchmark – for every designer revival since. Lagerfeld's constant innovation can best be measured by his riffs on and reiterations of the classic Chanel tweed cardigan jacket, braid-trimmed and weighted at the hem with a chain and introduced by Gabrielle Chanel in the 1950s. Lagerfeld's reinventions number in the thousands. To borrow one of his own maxims, it is always, but never, the same.

Chanel
Autumn/Winter 1989
Paris

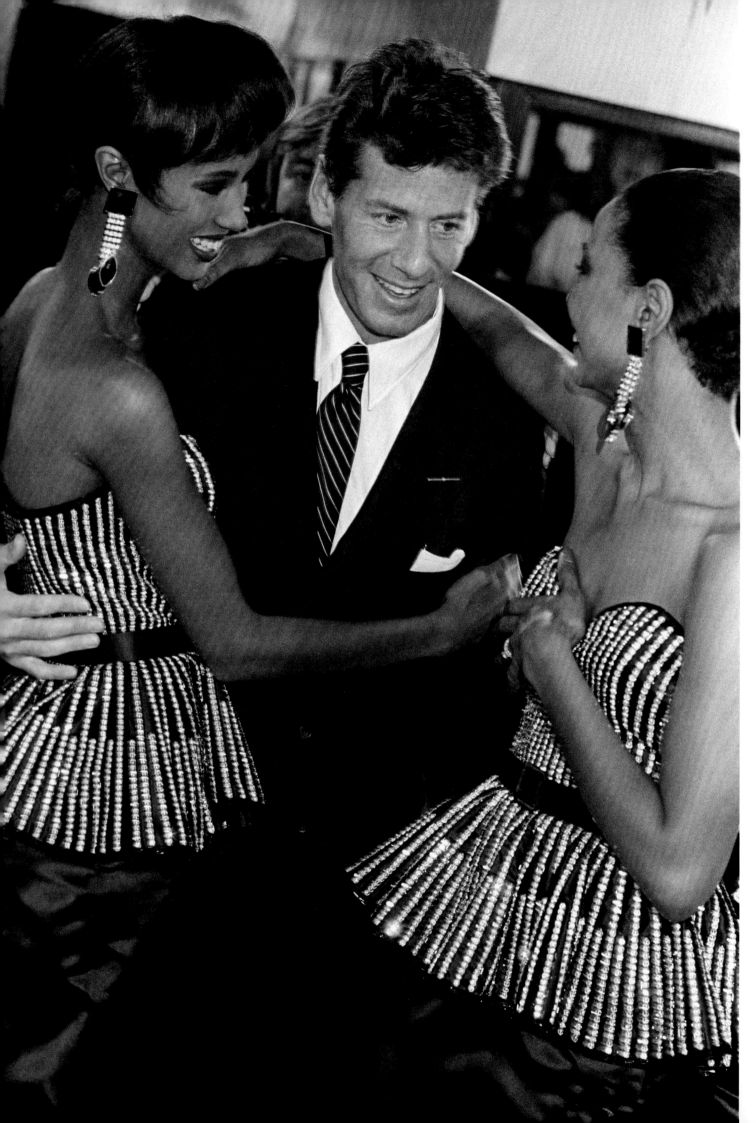

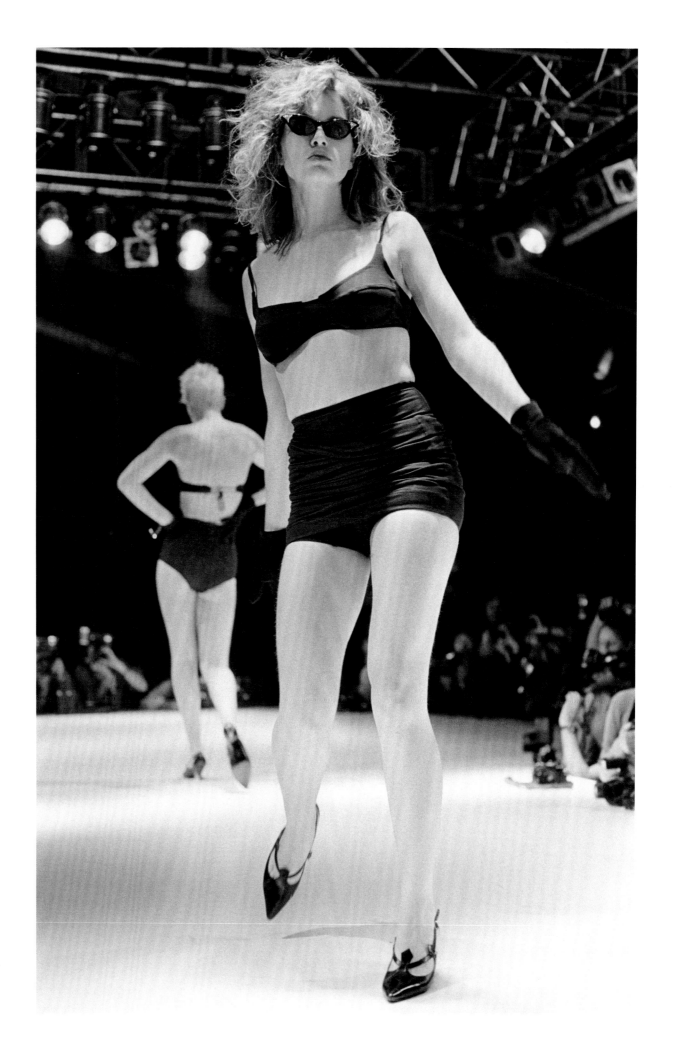

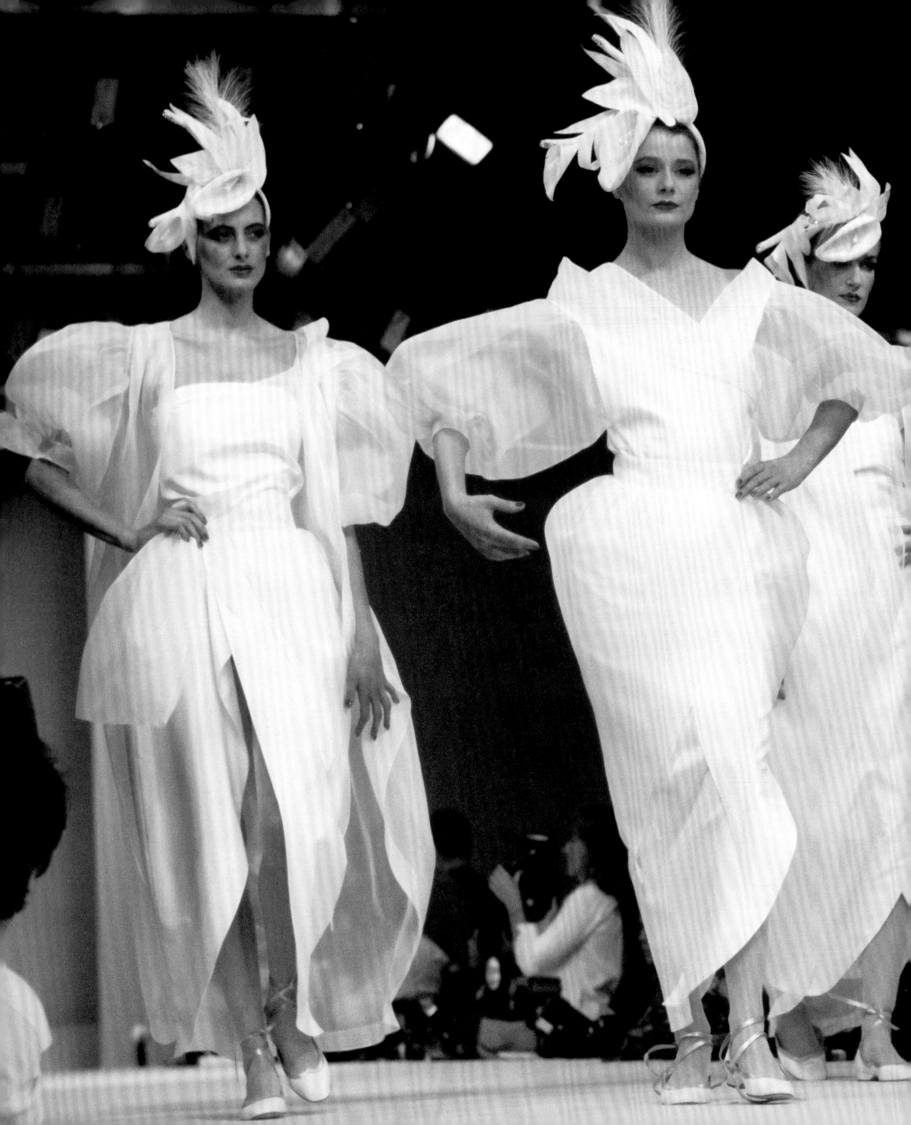

Claude Montana founded his fashion house in 1979, and his signature silhouette of wide, assertive shoulders above handspan waists was the definitive fashion statement of the 1980s. Born to a Catalonian father and a German mother, he showed a distinctive combination of rigour and passion – not to mention expertise with leather – that won him legions of supporters. His dramatic, powerful shows were staged with Wagnerian opera music and models marching in phalanxes intricately choreographed by Montana himself. 'The 1980s were really his era,' observes Moore.

Claude Montana
Spring/Summer 1983
Paris

Alongside Montana,
Thierry Mugler was the
most influential French
designer of the decade.
Their silhouettes were
similar, with giant shoulders
and tightly cinched midriffs,
but Montana's poised
drama was replaced with
playful insouciance by
Mugler, whose collections
walk a fine line between
high fashion and high camp.
He was also a consummate
showman, staging catwalk
shows as cast-of-thousands
spectaculars for thousands
of spectators, with vignettes
perfectly designed to
maximize the impact of
catwalk photography and
the new medium of video.

This page:
Thierry Mugler
Autumn/Winter 1983
Paris

Overleaf:
Valentino
Autumn/Winter 1983
Milan

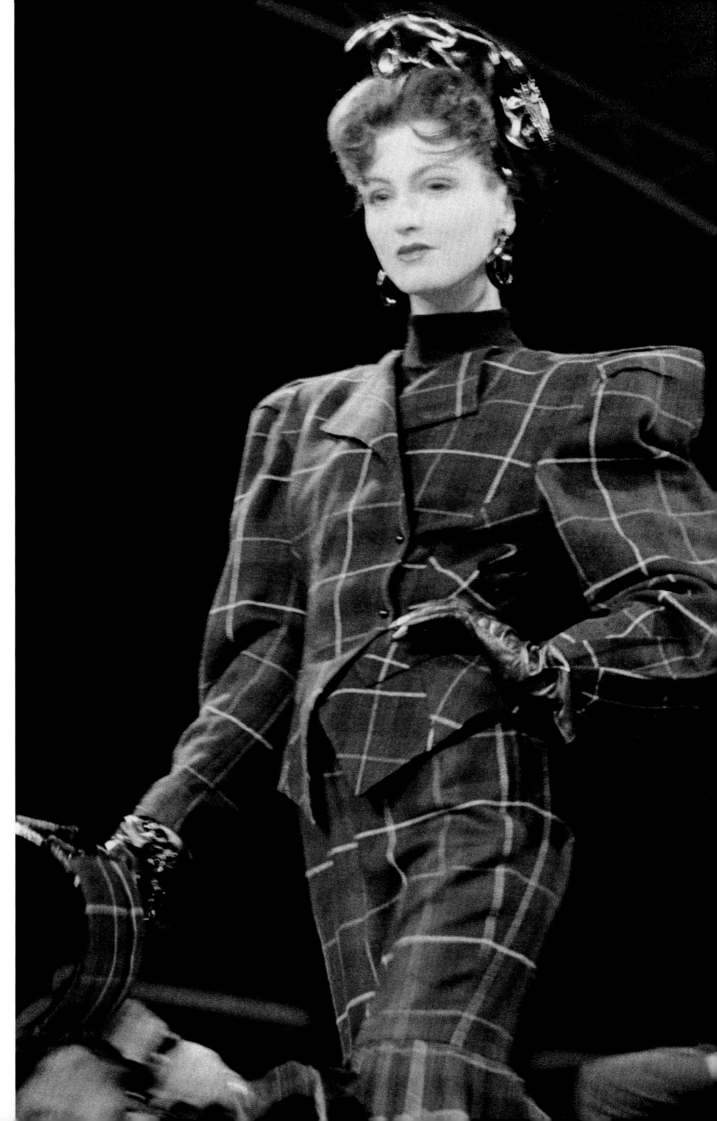

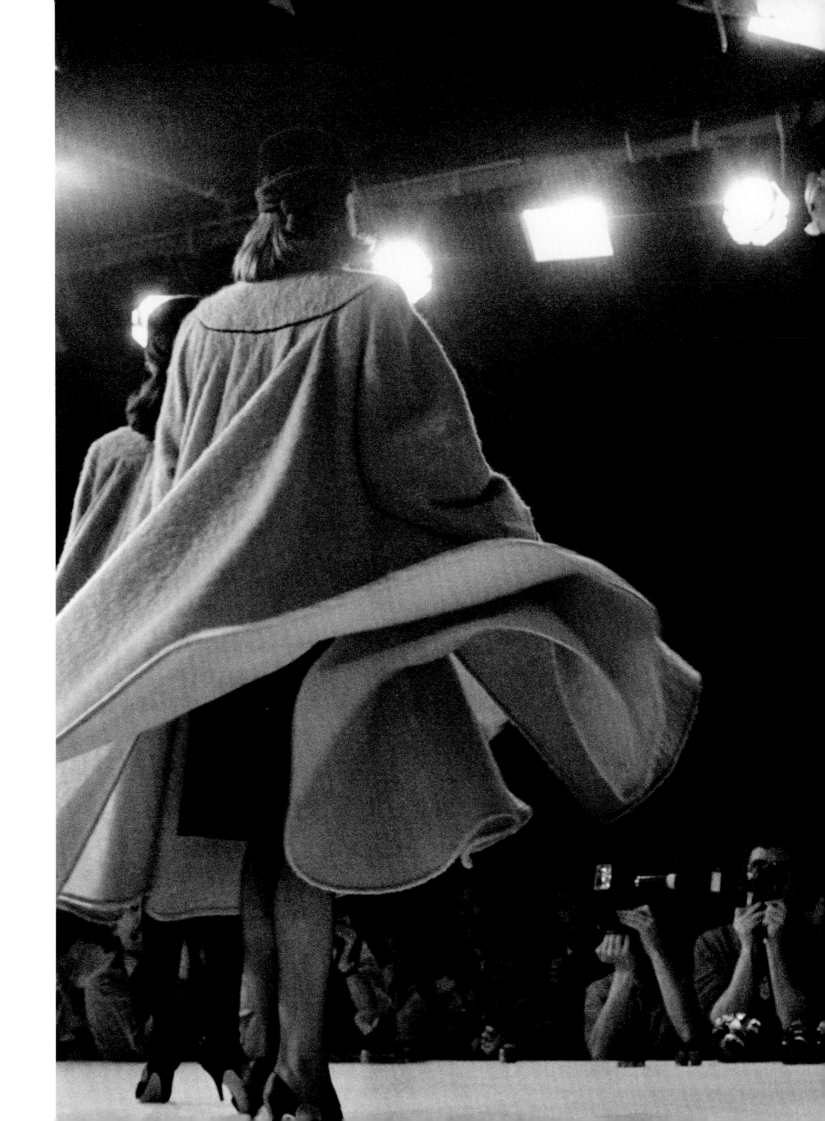

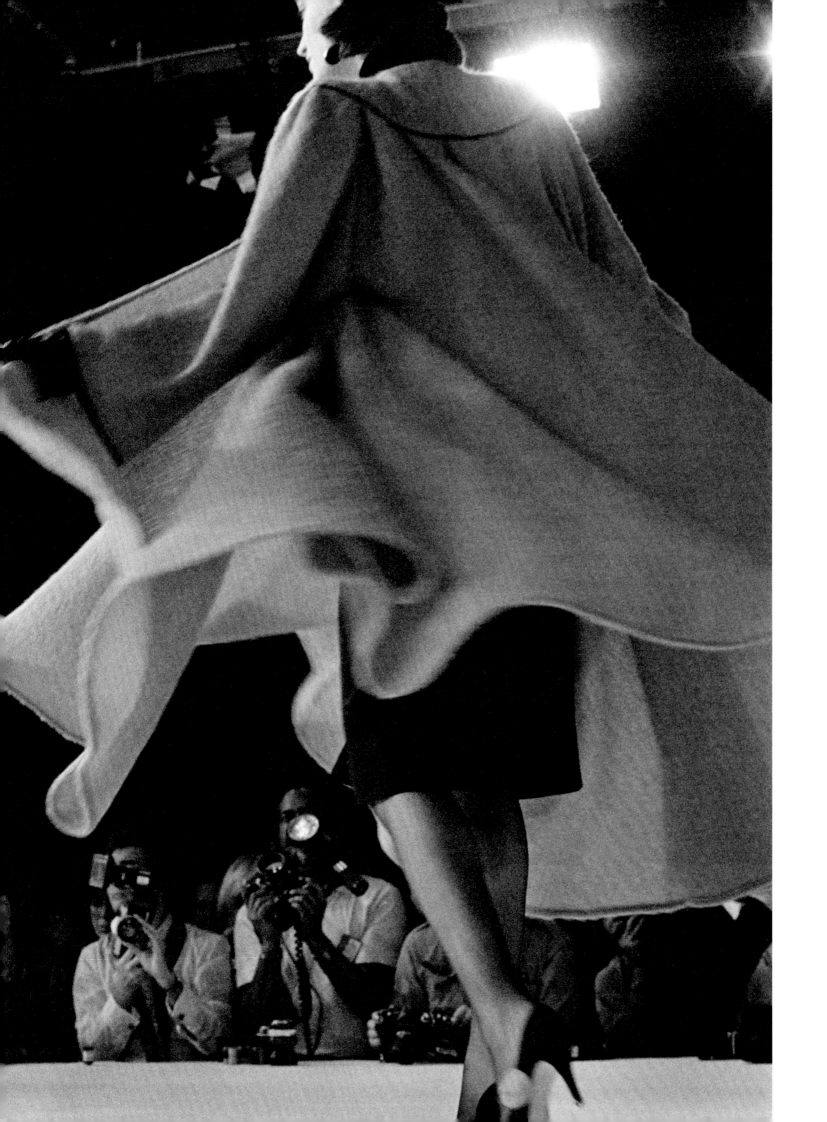

CHRISTY TURLINGTON

Valentino SS87 · VAL SS88 · Valentino Au89 · Valentino IBMY

Cm © Chris Moore · 7E F/W 92 · VALENTINO F/W 92 · SS92 VAL · Eva · Val AW93 · CHRIS MOORE · VALENTINO SS 95

91 82 · VALENTINO SPRING/SUMMER 95 @ CHRIS MOORE · SHALOM · VALENTINO FALL 95 CHRIS MOORE · 3104 3009 VALENTINO FALL 97 CHRIS MOORE · 1786 VALENTINO SPRING/SUMMER 97 CHRIS MOORE

VALENTINO S/S 98 CHRIS MOORE · D8003 VALENTINO H.C SPRING 98 CHRIS MOORE · Claudia Schiffer · F/W98 VALENTINO · VALENTINO FALL 98 CHRIS MOORE

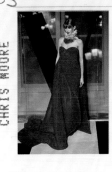
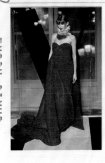
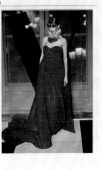

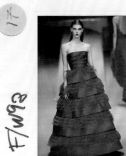
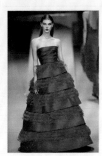
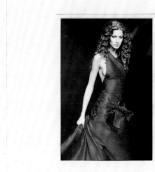

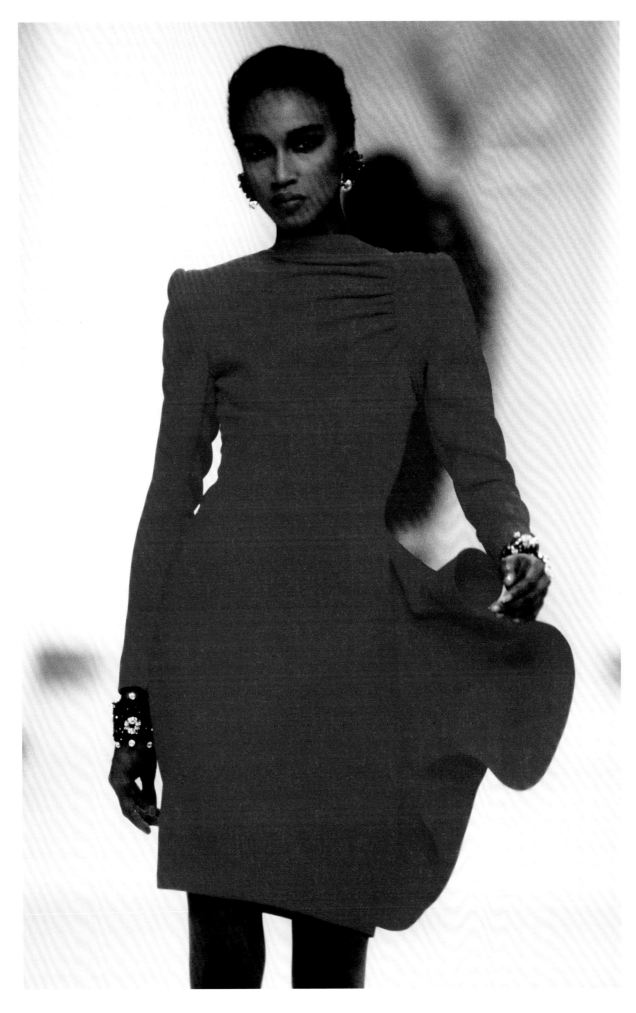

Valentino Garavani's elegant, feminine and occasionally ostentatious designs were fixtures of 1980s fashion. They were often executed in his signature Valentino Red – a juicy, lipstick scarlet that appeared at least once in each of his shows and, coincidentally, coordinated perfectly with the party political hue of then American First Lady Nancy Reagan, whom he prominently dressed and socialized with. His clothes didn't lead fashion, but nevertheless they summarize a certain subcategory of sparkling cocktail attire that emerged as a fashion force during the economic boom of the 1980s. Despite the emergence of Milan as a fashion force, and the Rome base of the label, Valentino presented his haute couture and ready-to-wear lines in Paris (showing his first collection in 1975, he was an early advocate of prêt-à-porter catwalk shows). His work was so representative of the time that he even lent his name to a particular type of woman: 'Val's Gals' was a witticism coined by the industry bible *Women's Wear Daily* to brand a distinct breed of well-heeled socialite with a rapacious lust for Valentino's flattering ruffles and flounces.

Valentino
Autumn/Winter 1989
Paris

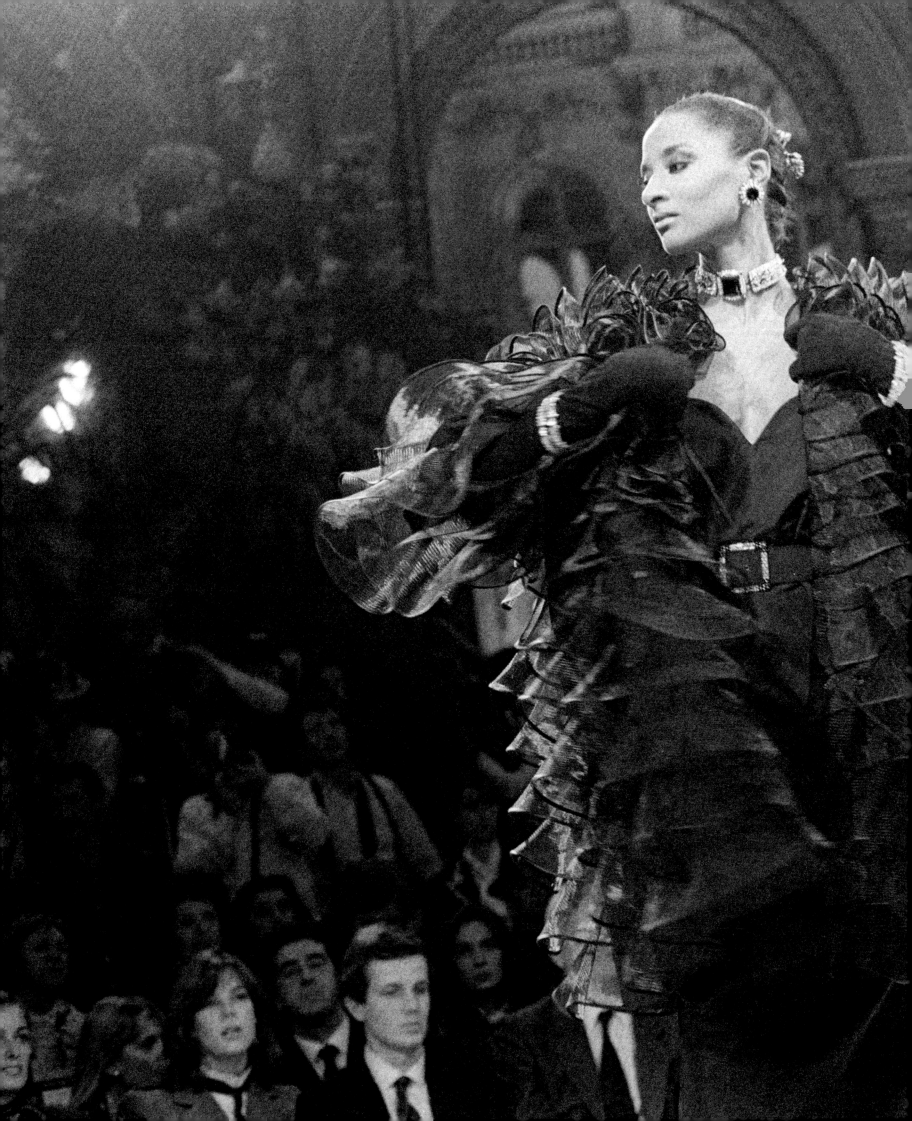

This page:
Jean Paul Gaultier
Autumn/Winter 1984
Paris

Overleaf:
Thierry Mugler
Autumn/Winter 1984
Paris

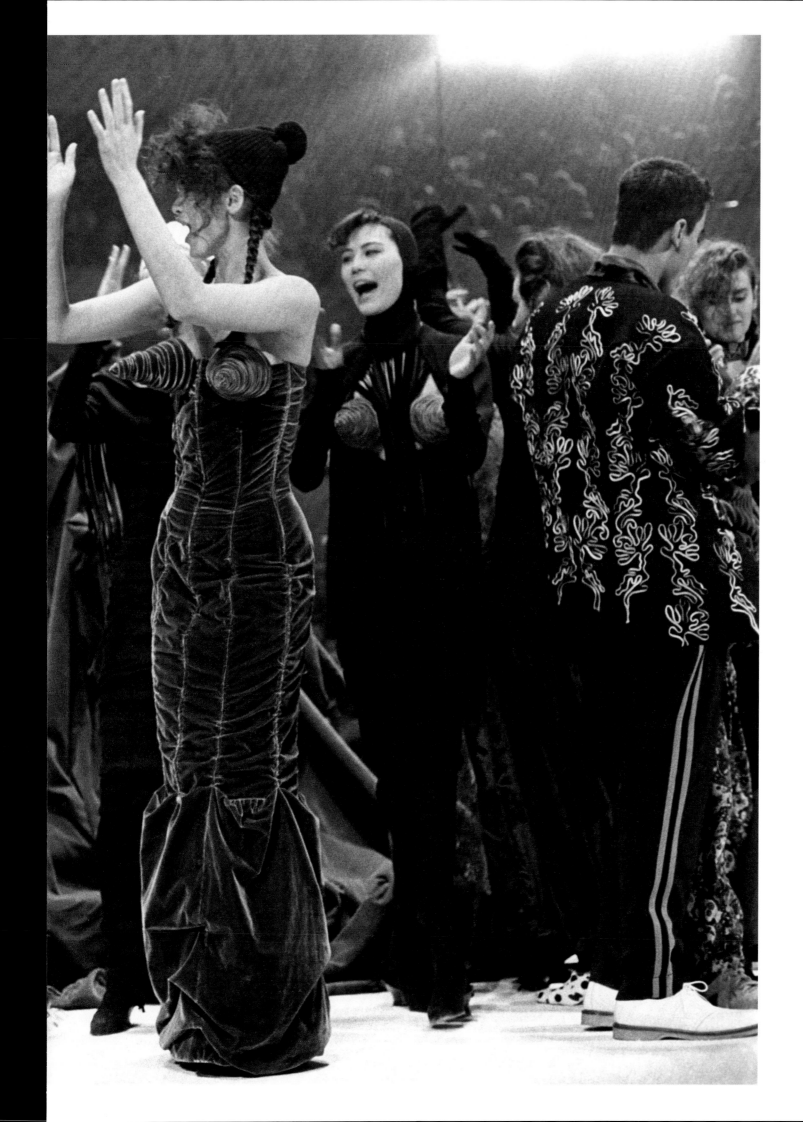

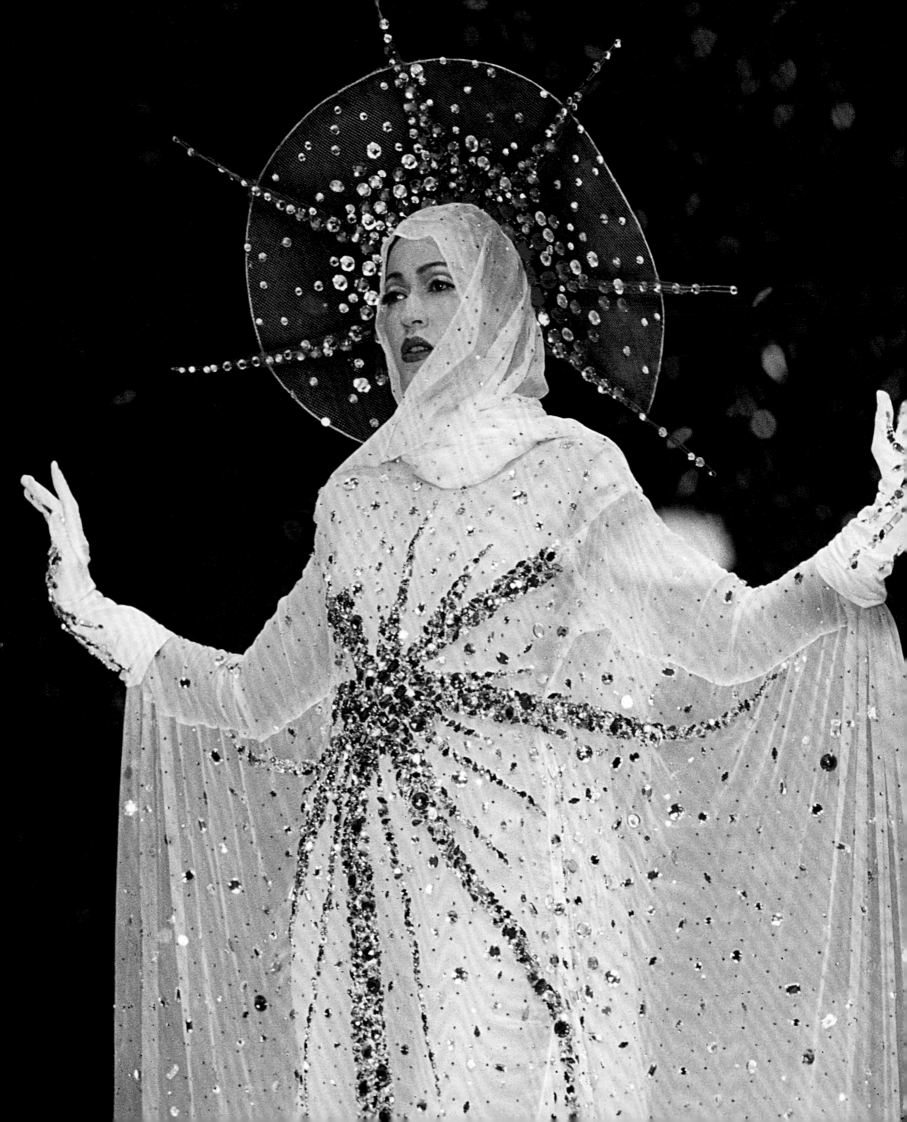

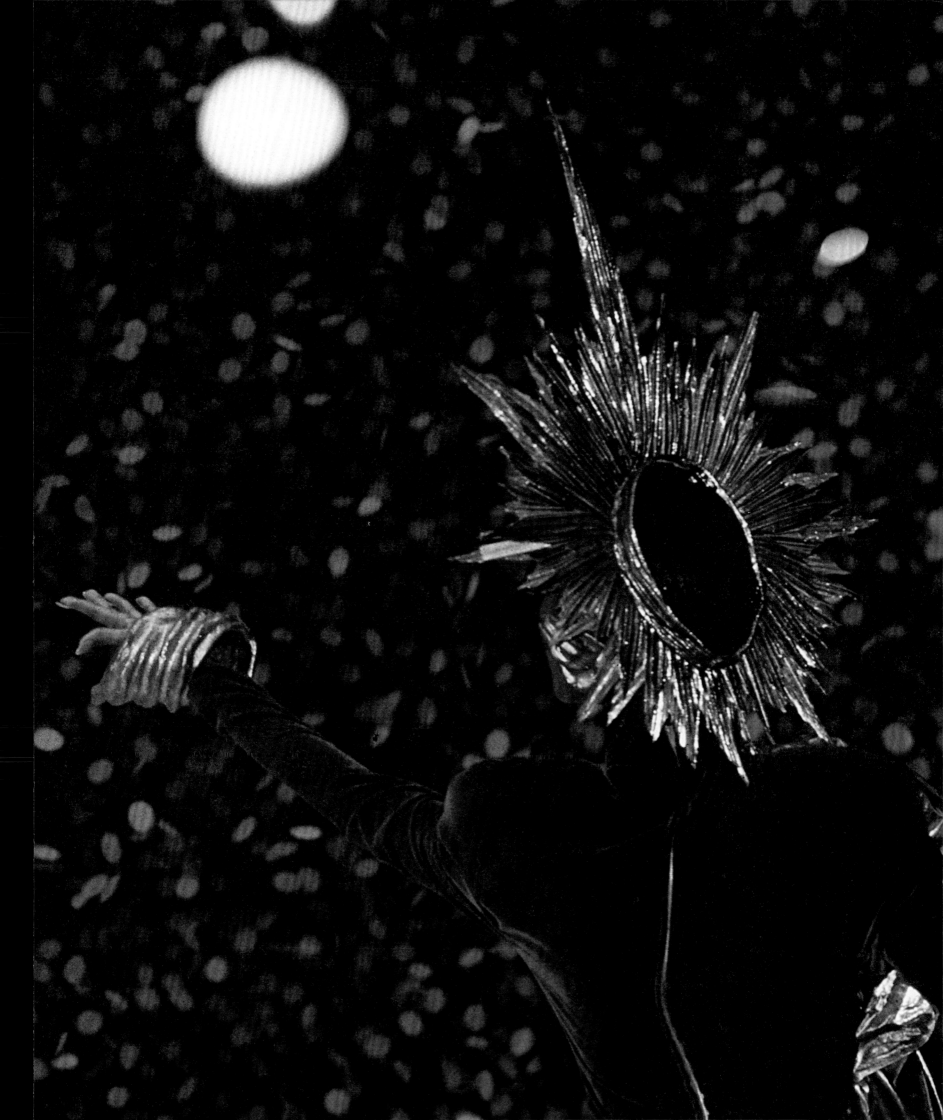

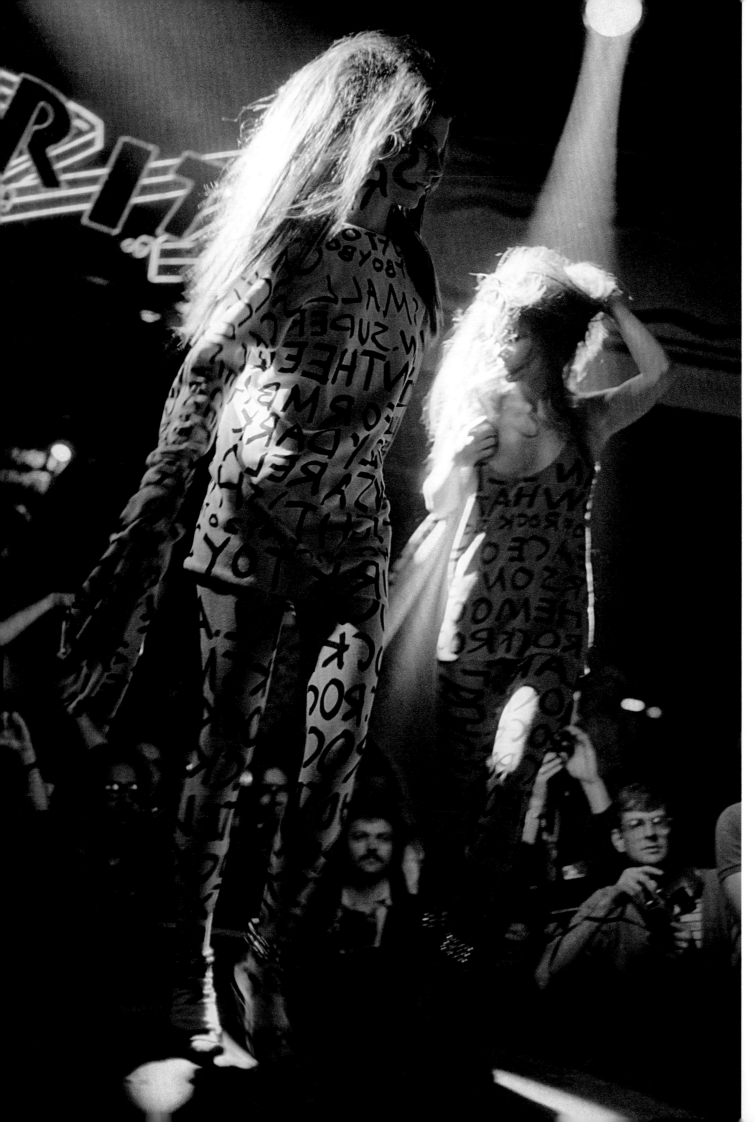

Frequently, Moore recalls the technical challenges of a fashion show as vividly as its creativity or its encapsulation of the fashion zeitgeist. 'That was a difficult show to shoot,' he says of Stephen Sprouse's Autumn/Winter 1984 collection, 'because he kept turning the lights out. On and off, on and off.' In that semi-darkness in New York's East Village Ritz Club, an audience of 1,700 watched Sprouse's debut show, including Andy Warhol and Debbie Harry.

Stephen Sprouse
Autumn/Winter 1984
New York

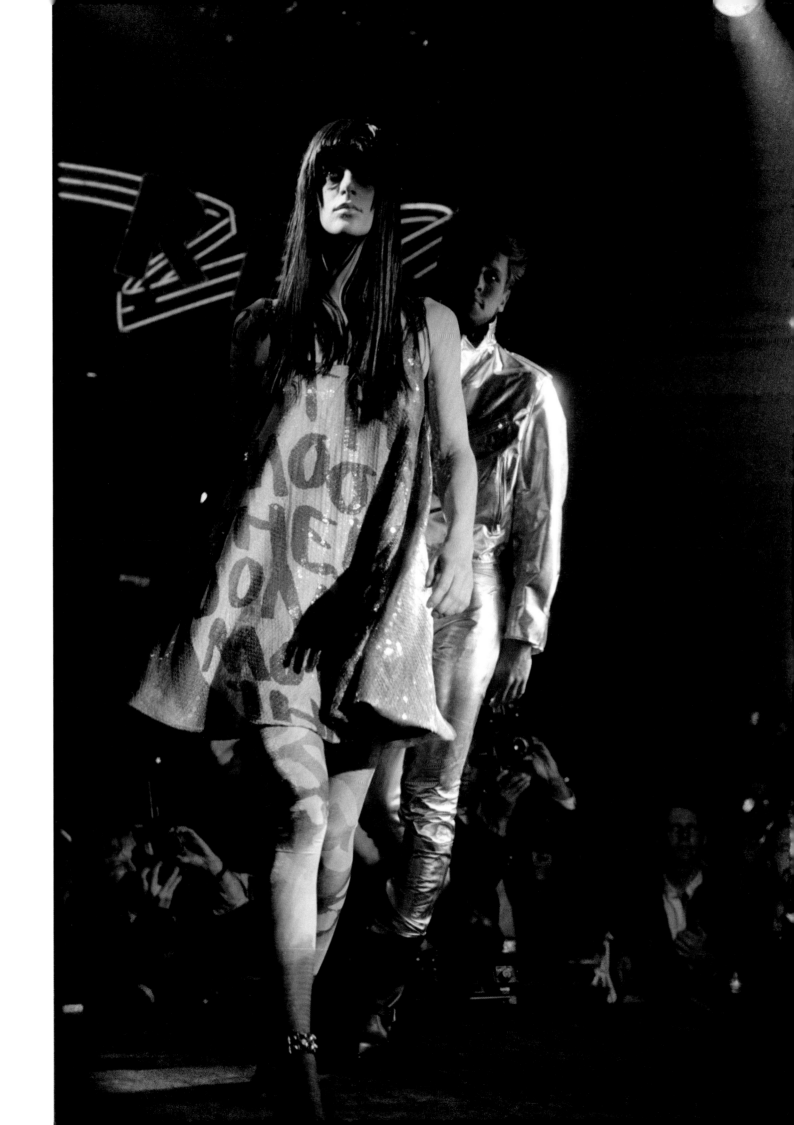

'I remember Issey Miyake shows, in the past, really made the hair stand up on the back of my neck,' says Moore. 'Beautiful, really. I do get moved sometimes by shows. I do find I'm almost in tears.'

Issey Miyake
Autumn/Winter 1989
Paris

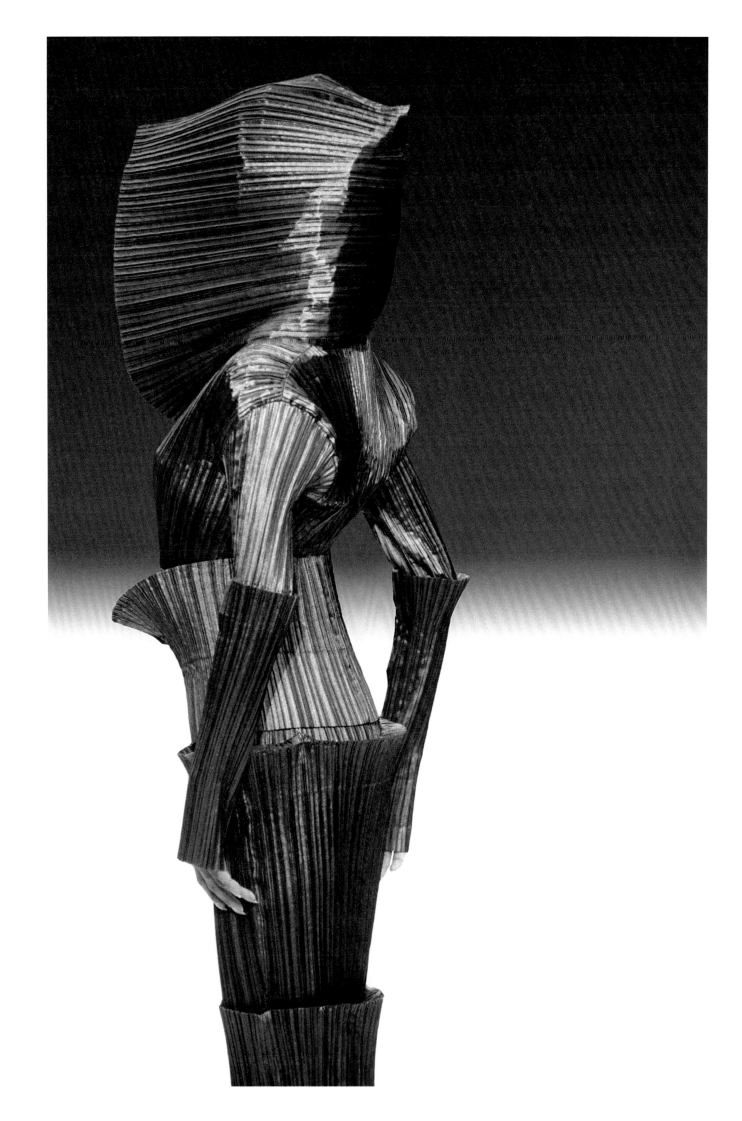

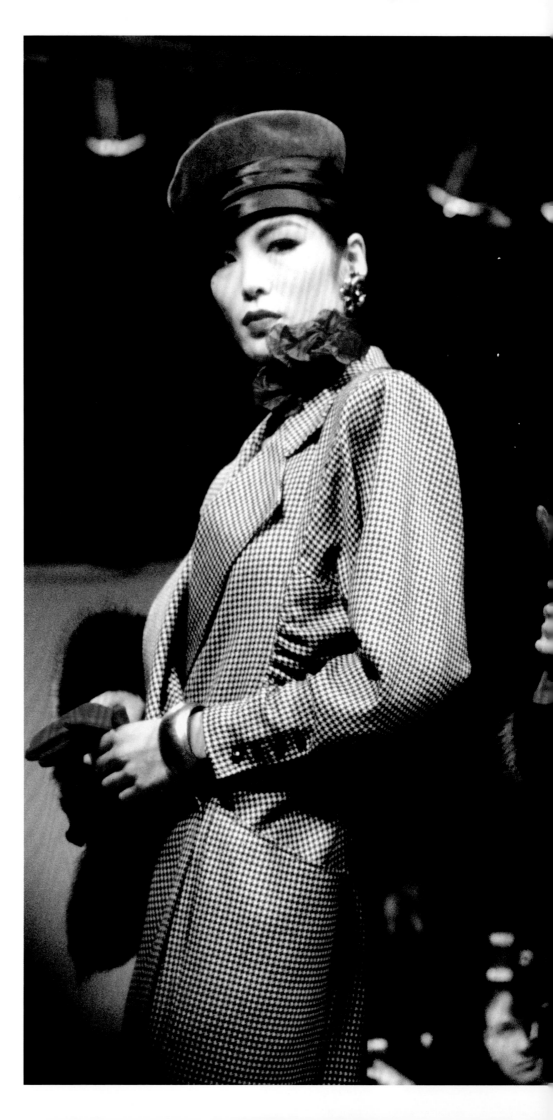

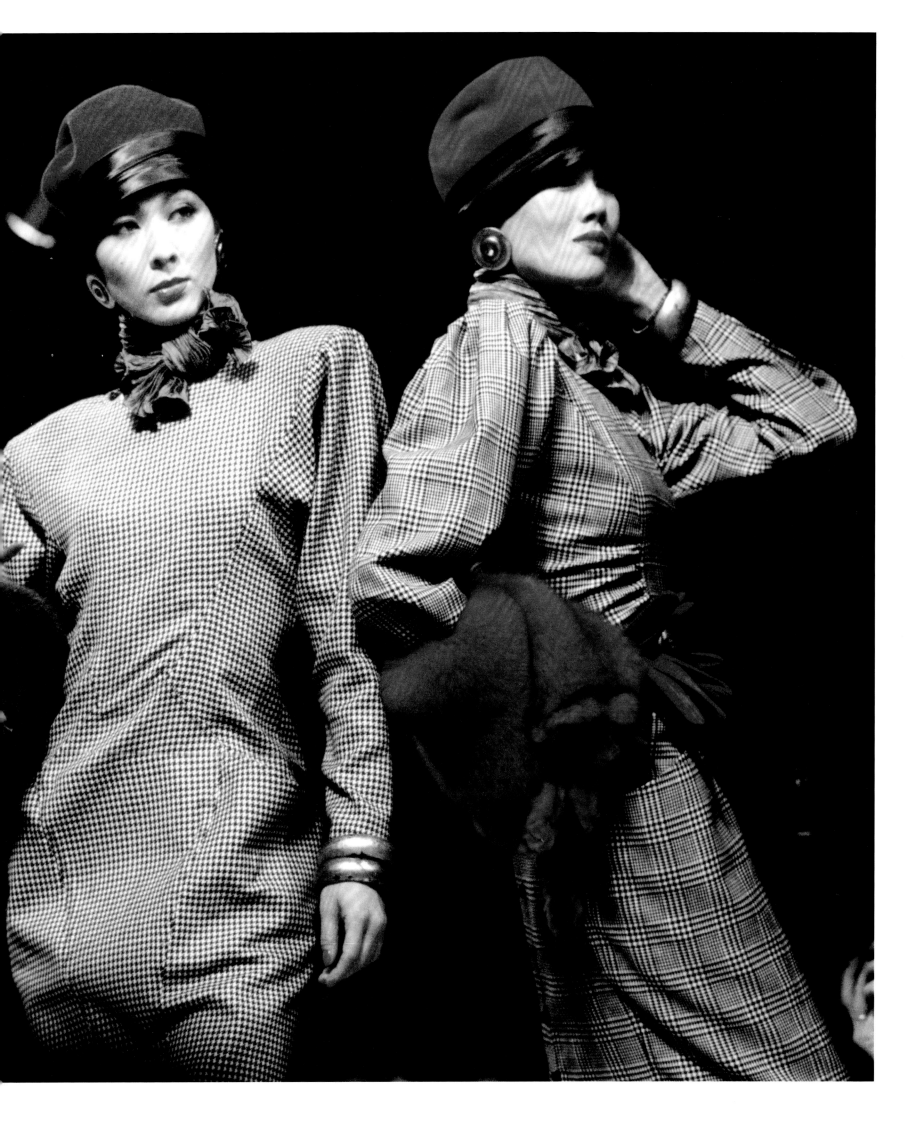

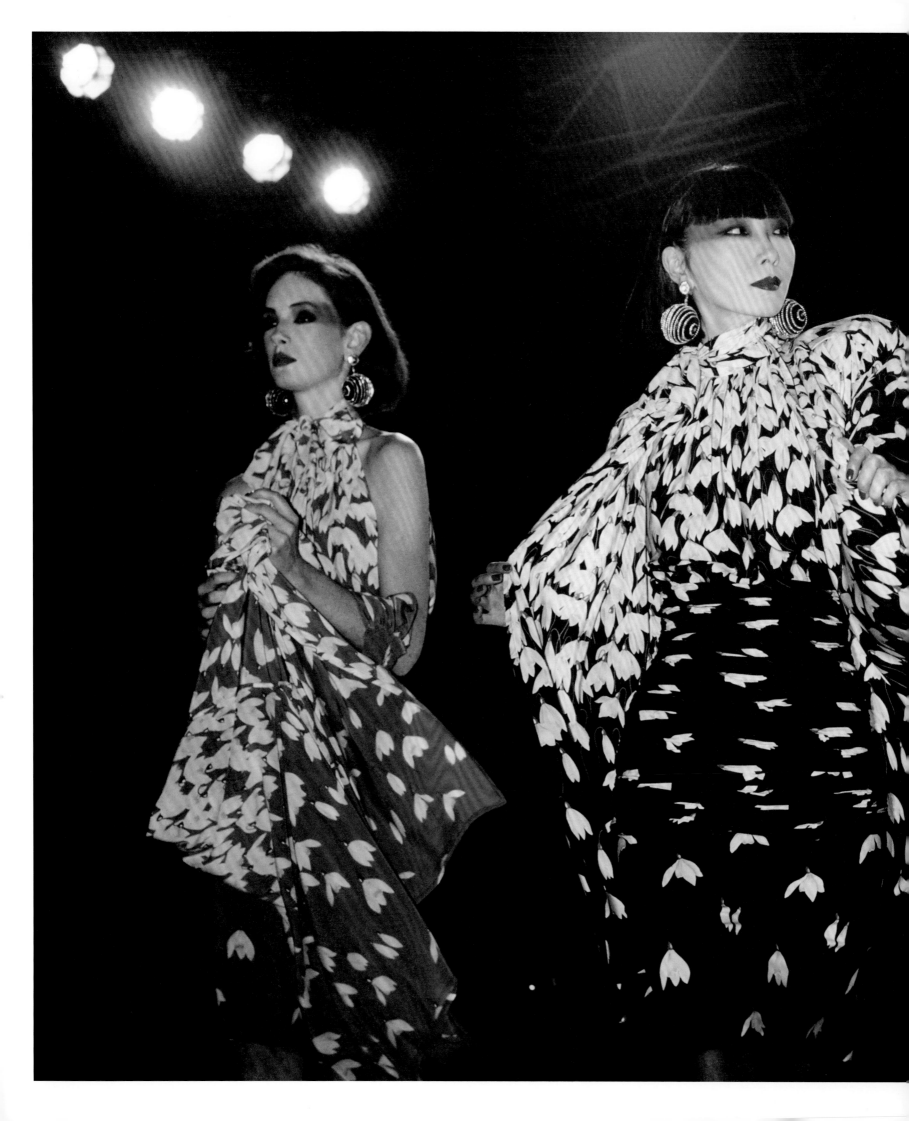

Catwalk photography can be a dangerous profession: during the pressure-cooker period of the international collections, tempers easily become frayed. 'When we were all down the side of the catwalk with the cameras, I can remember someone walking down and kicking the cameras out of the way,' says Moore. 'There was such an animal reaction from all the photographers, it was absolutely incredible. I have never heard such a roar of displeasure. They wanted to tear this man apart.'

Valentino
Spring/Summer 1985
Paris

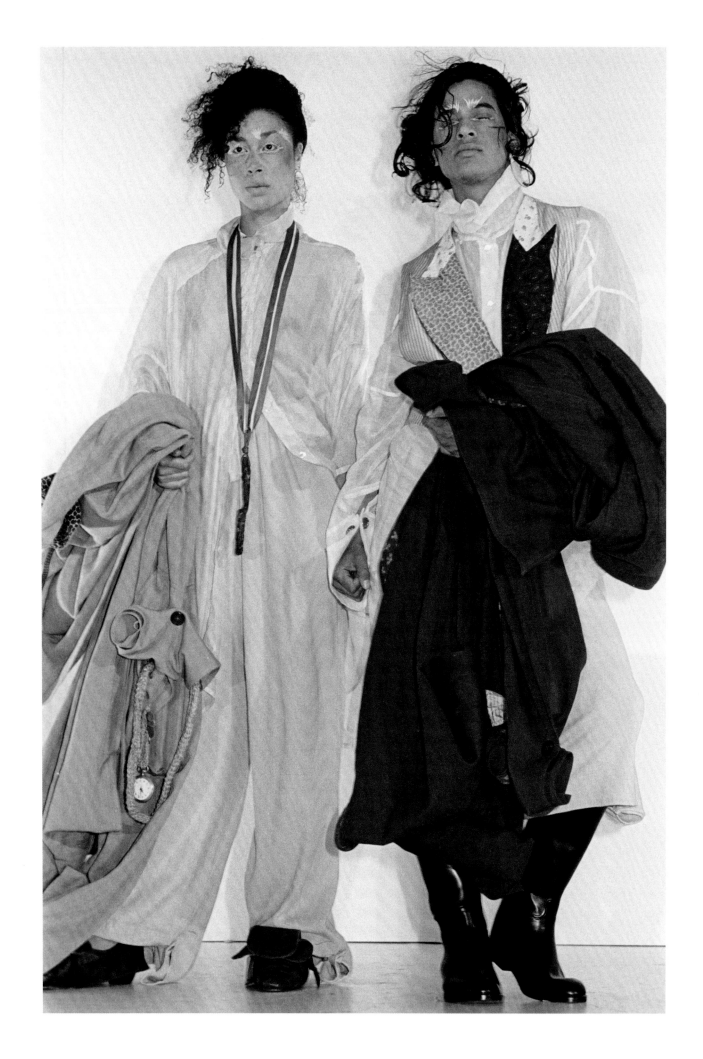

Never has a graduation collection garnered so much attention as that of John Galliano, a 1984 BA student at London's Saint Martin's School of Art. He was catapulted into the international limelight by this degree show, named 'Les Incroyables' after a miscreant band of aristocratic rebels in Revolutionary France, and influenced by the vibrant London club culture. The collection, which was featured in the windows of the London boutique Browns, launched Galliano's career. Moore was there, recording the scene of one of fashion's most extraordinary debuts, and the birth of one of its most original designers.

John Galliano
Saint Martin's Graduation
Collection, June 1984
London

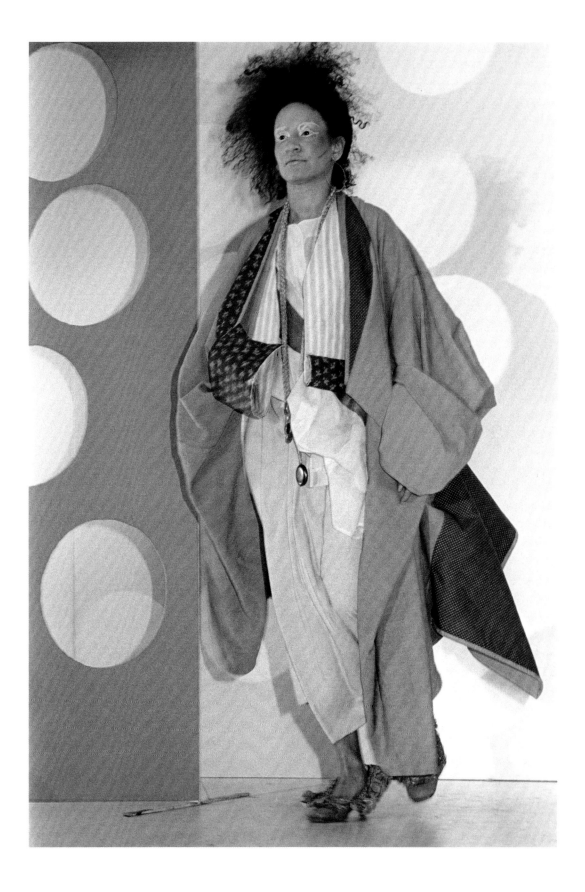

'London was exciting. It was not as polished as Milan or Paris,' comments Moore, 'but here was where the excitement was. The new things. Everyone was looking to British designers, to the London shows. It was a shining star, London in the 1980s.' Here, Moore captures the frenetic energy of BodyMap's 1985 show, entitled 'Barbie Takes a Trip Around Nature's Cosmic Curves', featuring choreography (and a modelling cameo) by Michael Clark (far right).

BodyMap
Autumn/Winter 1985
London

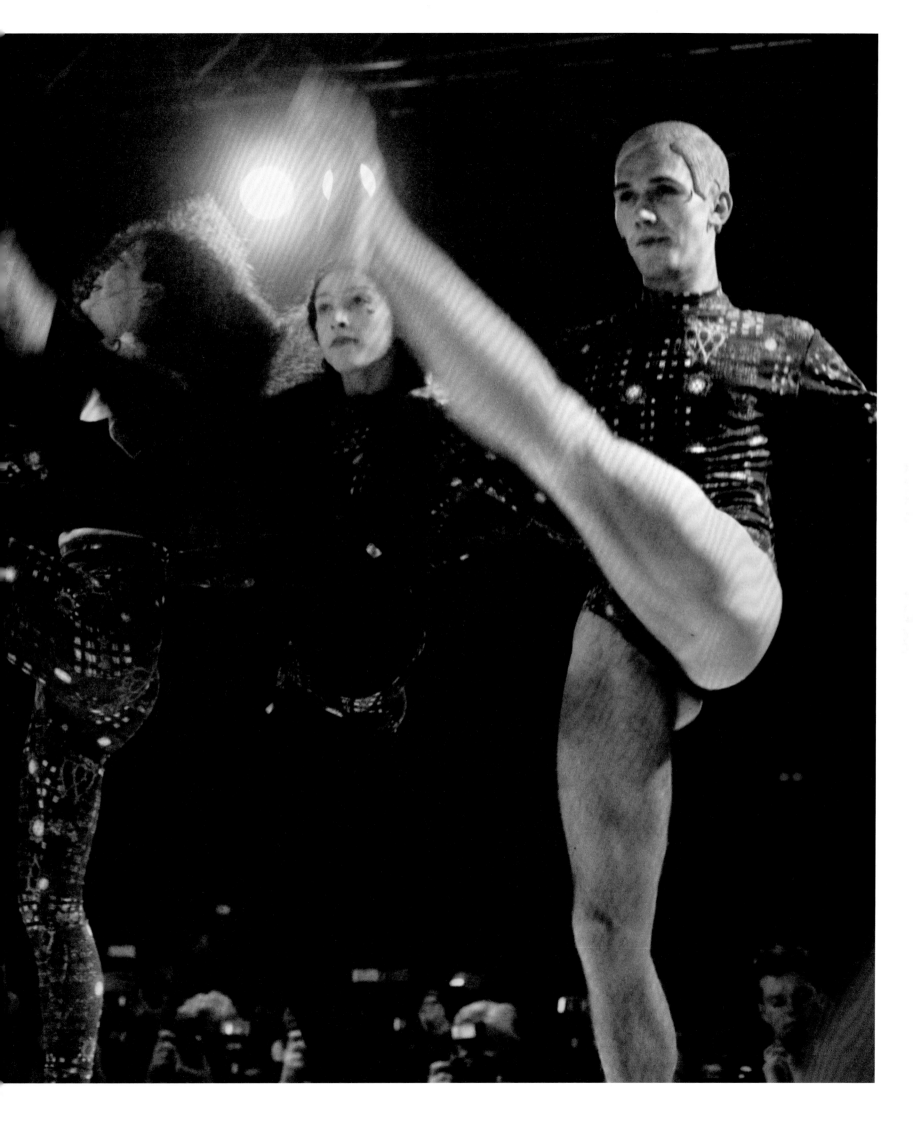

This page and overleaf:
Thierry Mugler
Autumn/Winter 1986
Paris

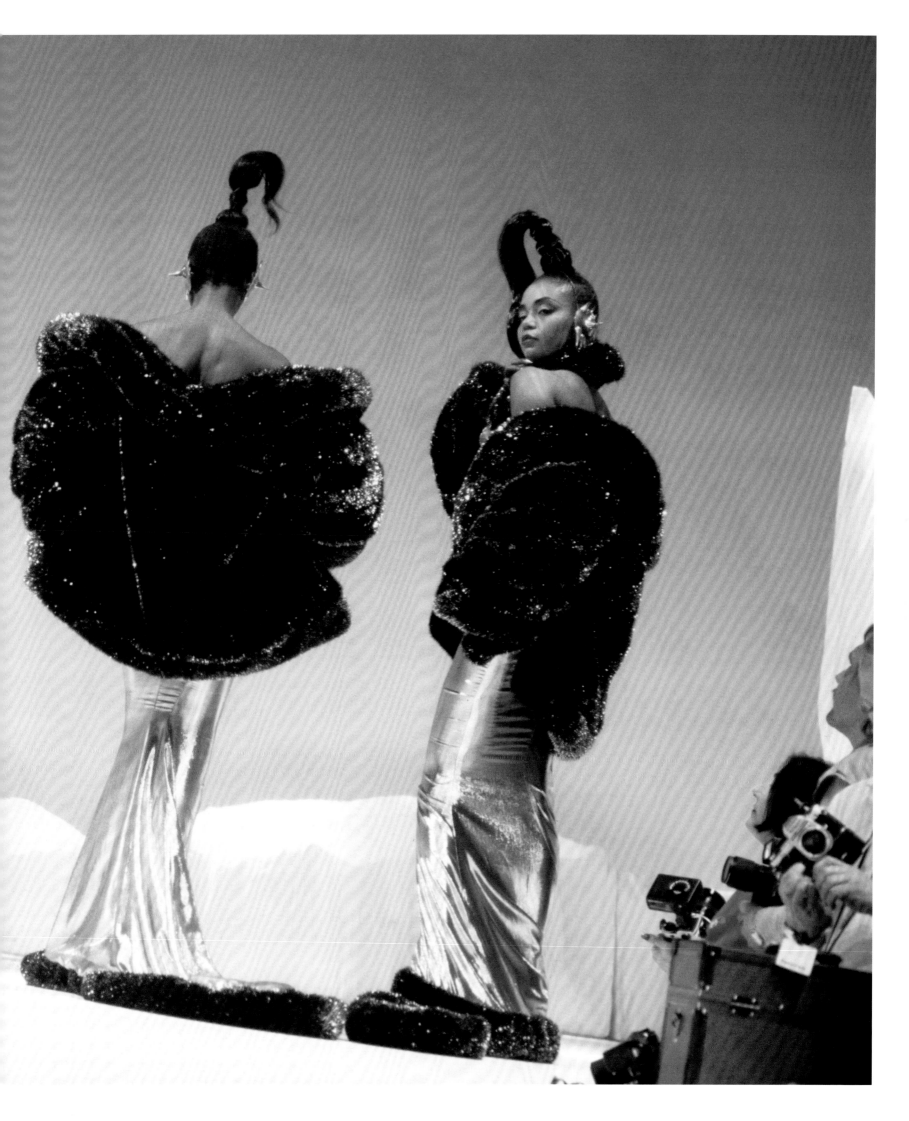

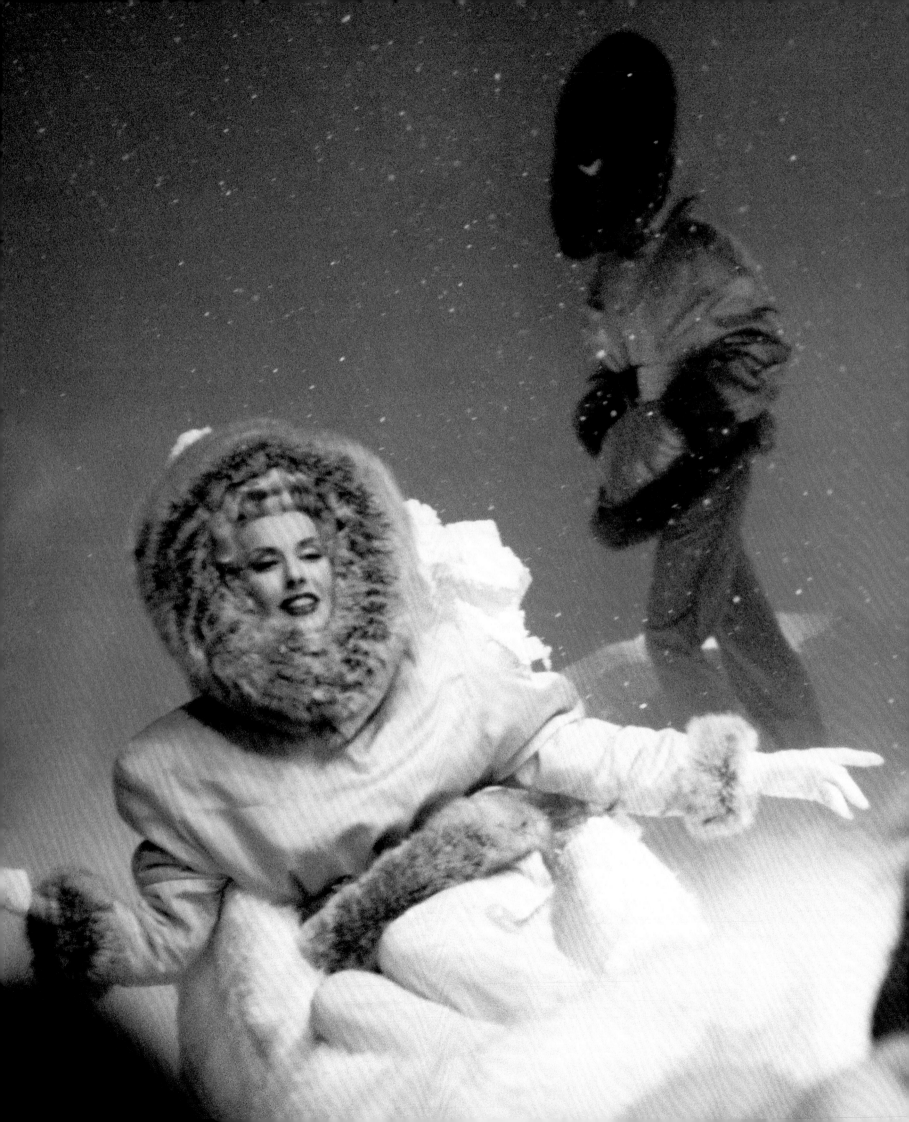

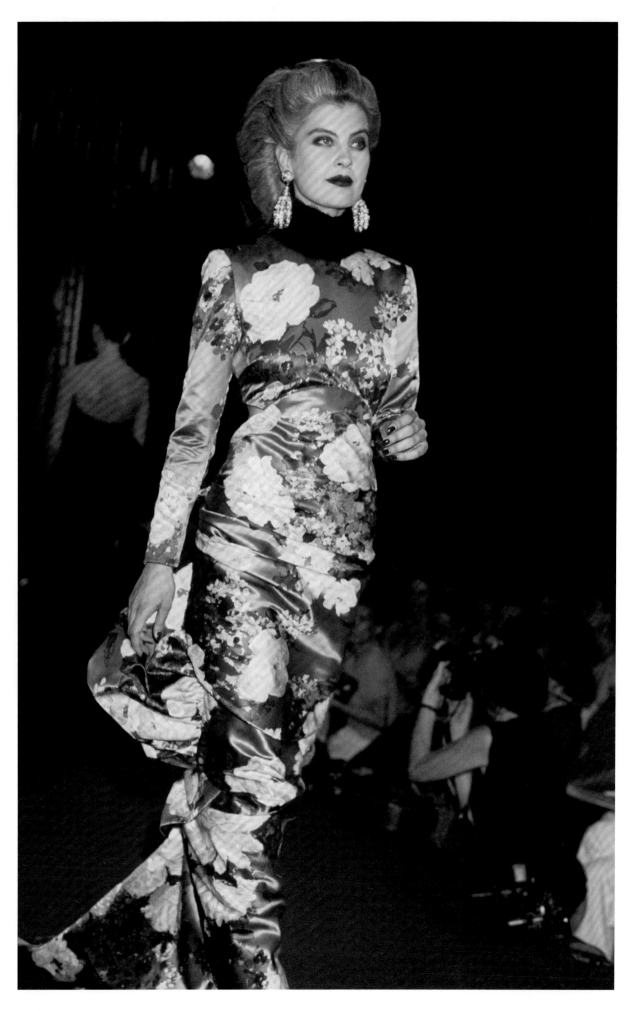

Left:
Jean Patou
Autumn/Winter 1986
Haute Couture, Paris

Opposite:
Antony Price
Autumn/Winter 1980
London

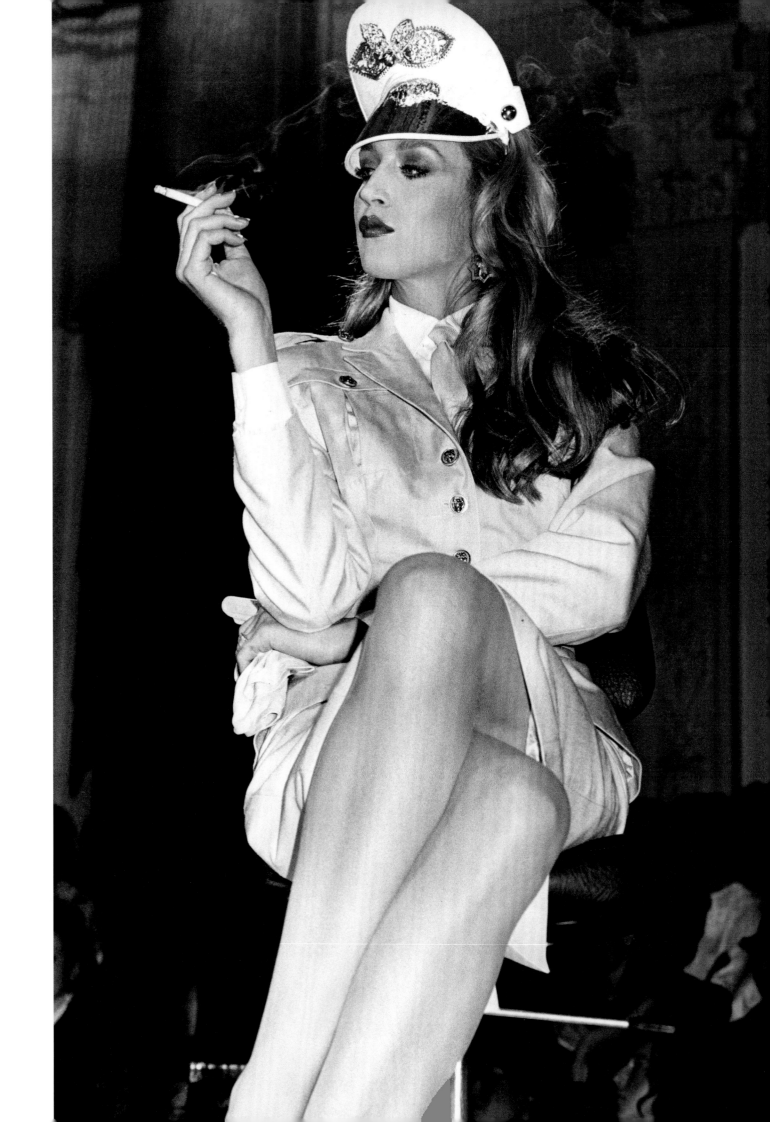

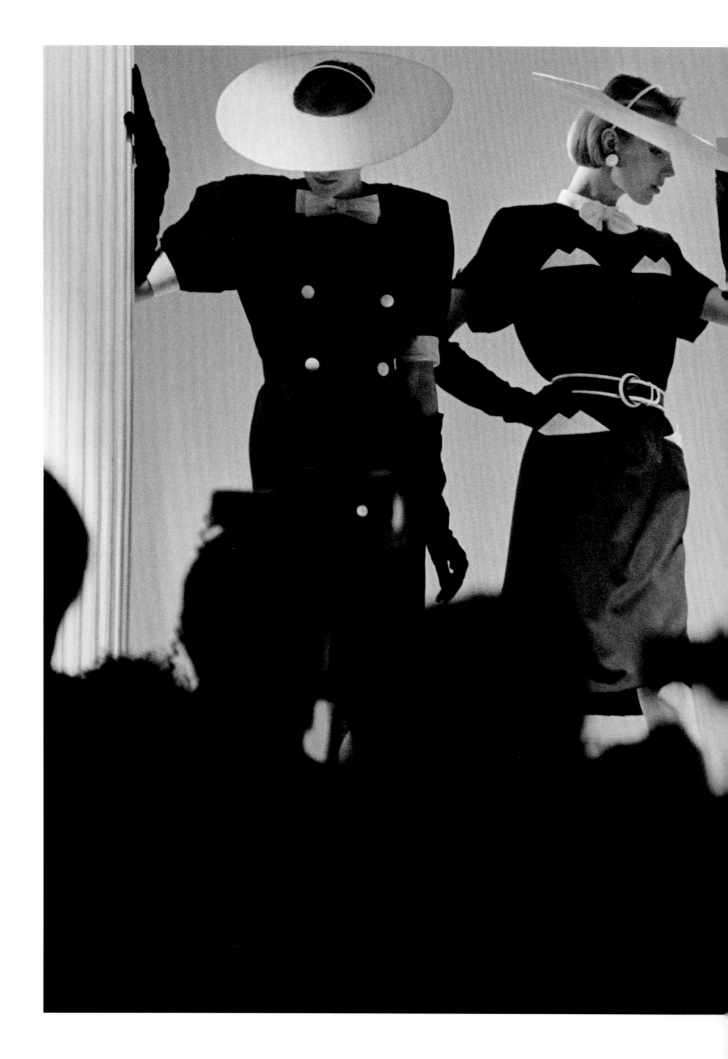

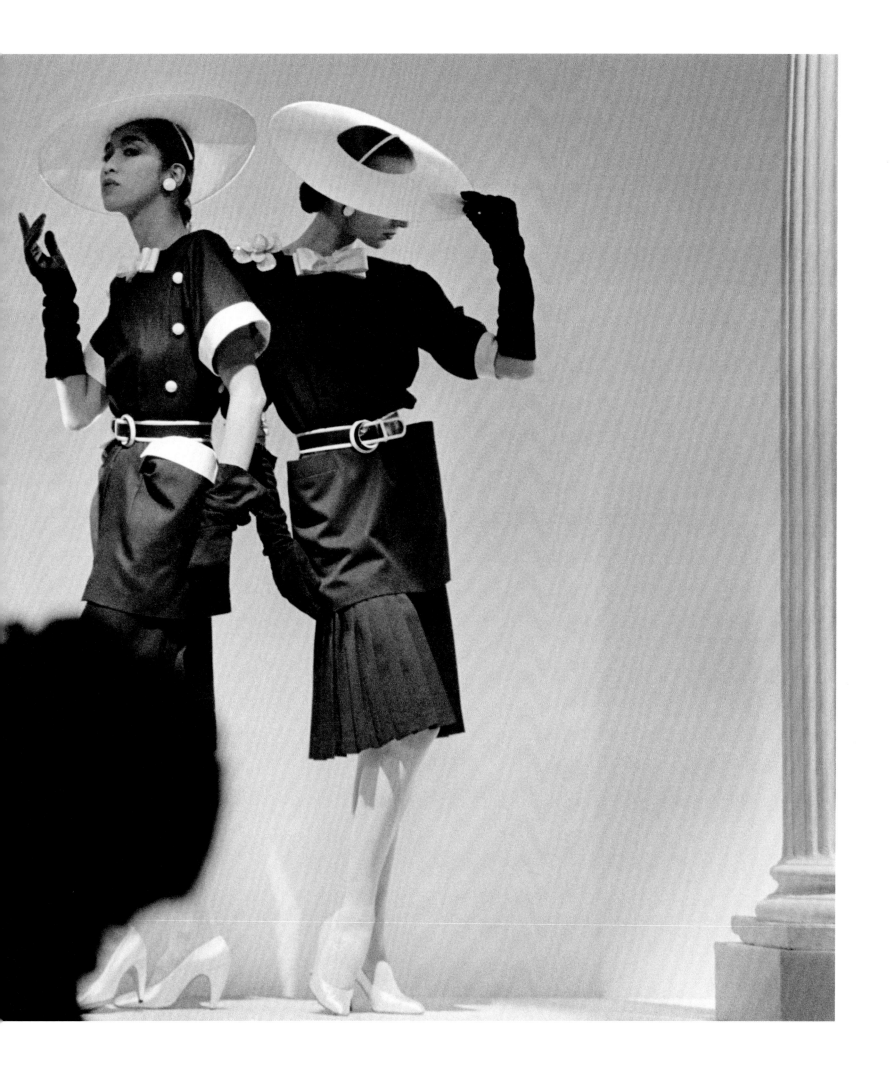

Versace
Autumn/Winter 1986
Milan

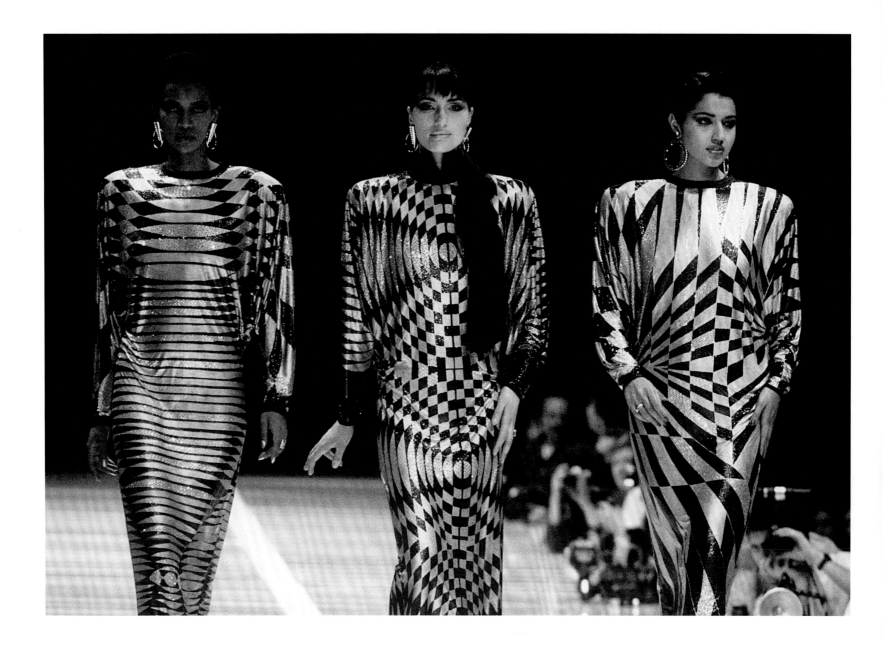

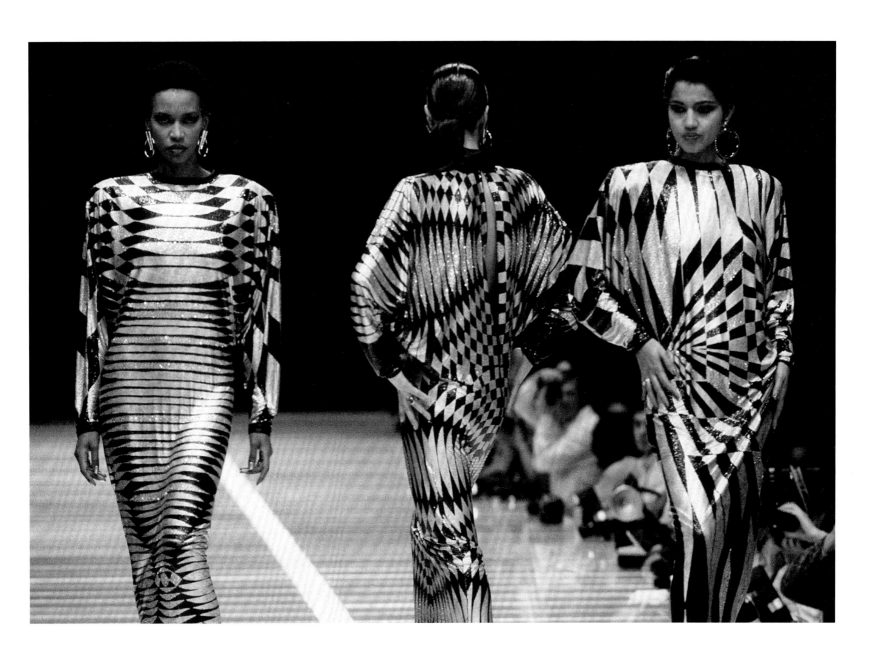

Below:
Katharine Hamnett
Autumn/Winter 1985
London

Opposite:
Jean Paul Gaultier
Autumn/Winter 1987
Paris

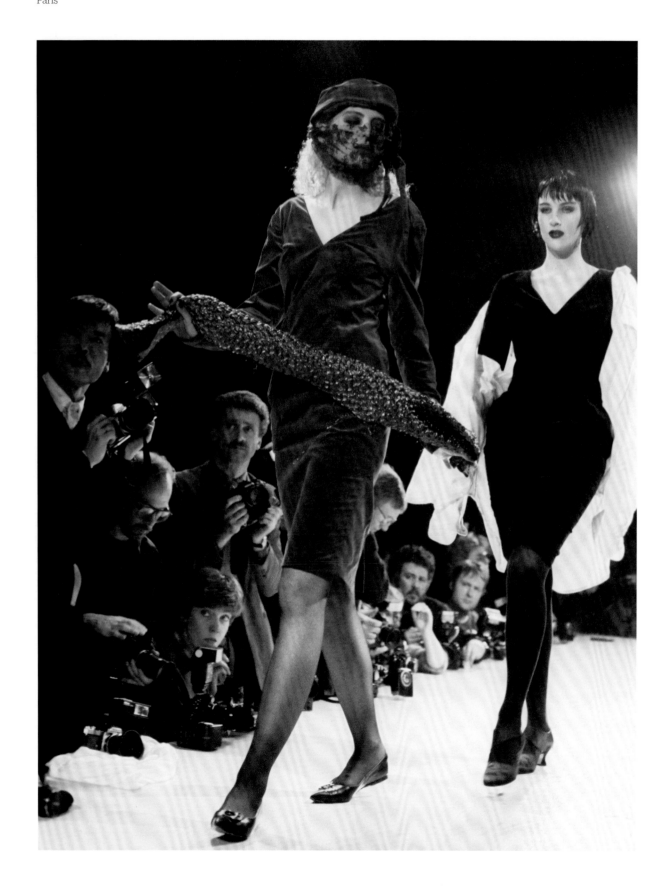

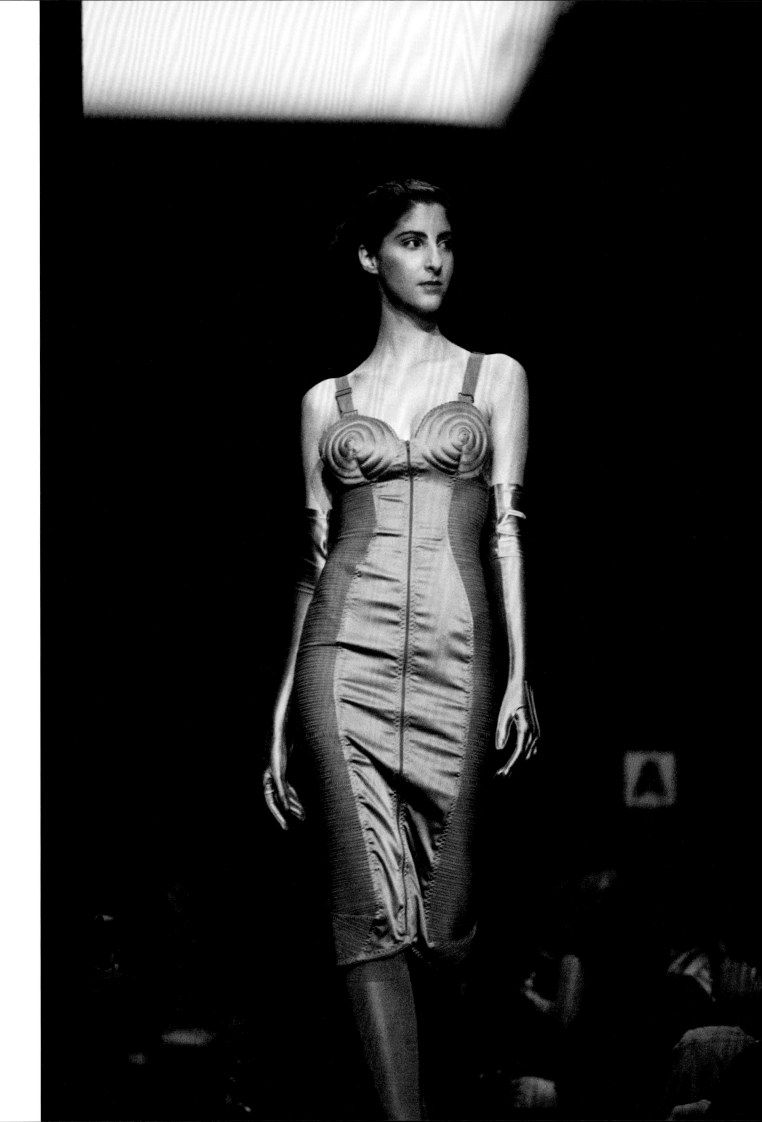

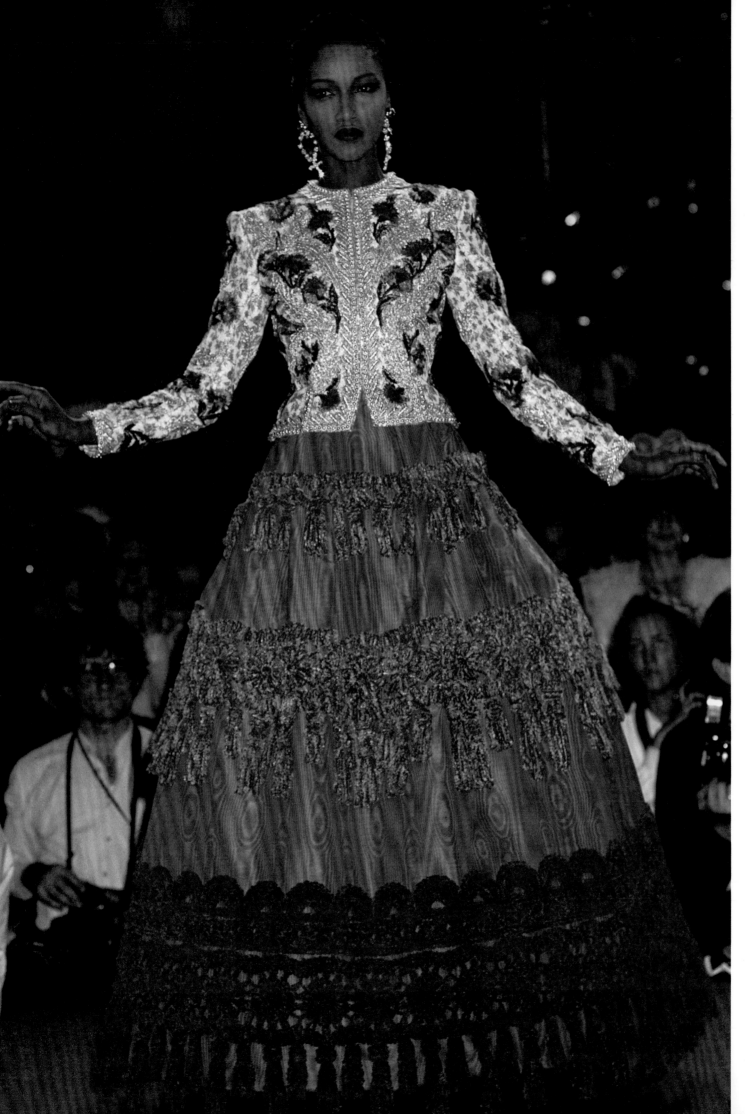

In the 1980s Christian Lacroix was the darling of the fashion industry. Born in Arles in the south of France, and trained as a museum curator before following a love of fashion into the industry, he brought to the catwalk his region's unique sense of colour and a whimsical historical slant courtesy of his unconventional education. His clothes, with their odd proportions and arcane accessories – baroque jewellery, Victorian bonnets, Louis-heeled shoes – brought a touch of the ludicrous to a strait-laced fashion world. It wasn't all fun and games, though: Lacroix's revival of crinolines and eighteenth-century frills and ruffles, along with his interest in haute couture as, in his own words, 'a laboratory for ideas', was enormously important during the latter half of the 1980s, offering a stylistic touchstone. When Lacroix opened his own house in 1987, after six years as head designer of Jean Patou, it was with as much fanfare and expectation as the launch of Yves Saint Laurent in 1961. 'Lacroix was the hot ticket,' agrees Moore. 'The first time I came across him was at Patou. There was something special about everything he did.'

Left:
Christian Lacroix
Autumn/Winter 1987
Haute Couture, Paris

Opposite:
Christian Lacroix
Autumn/Winter 1988
Haute Couture, Paris

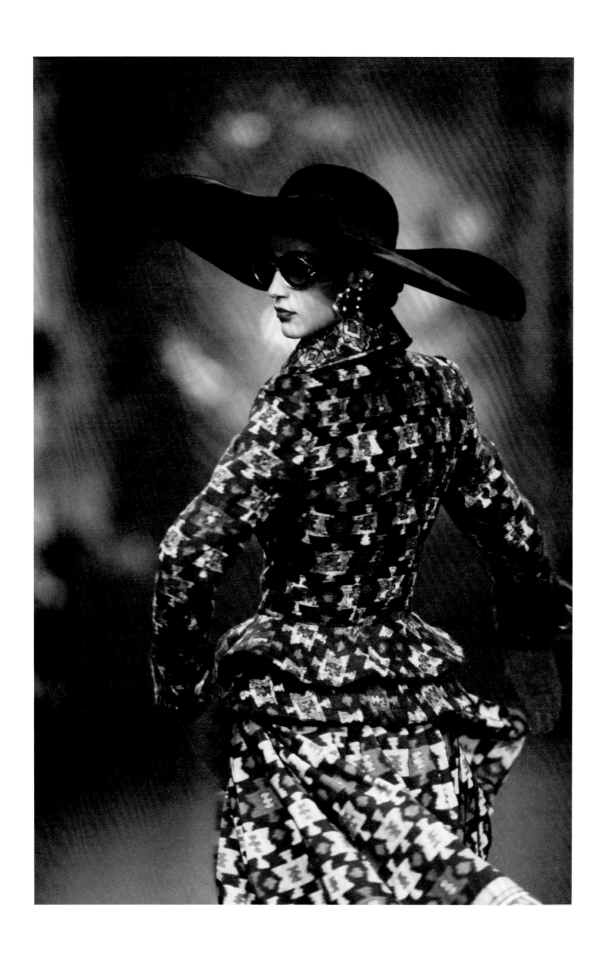

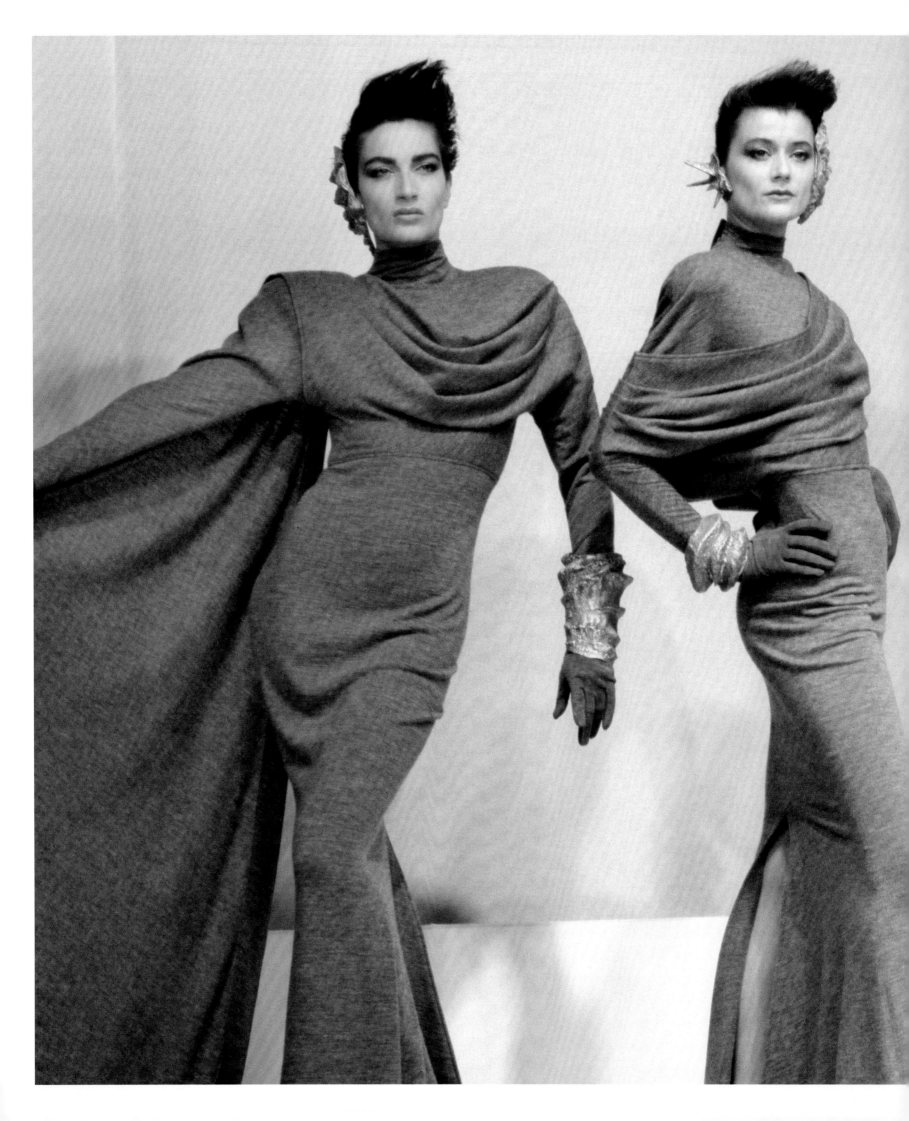

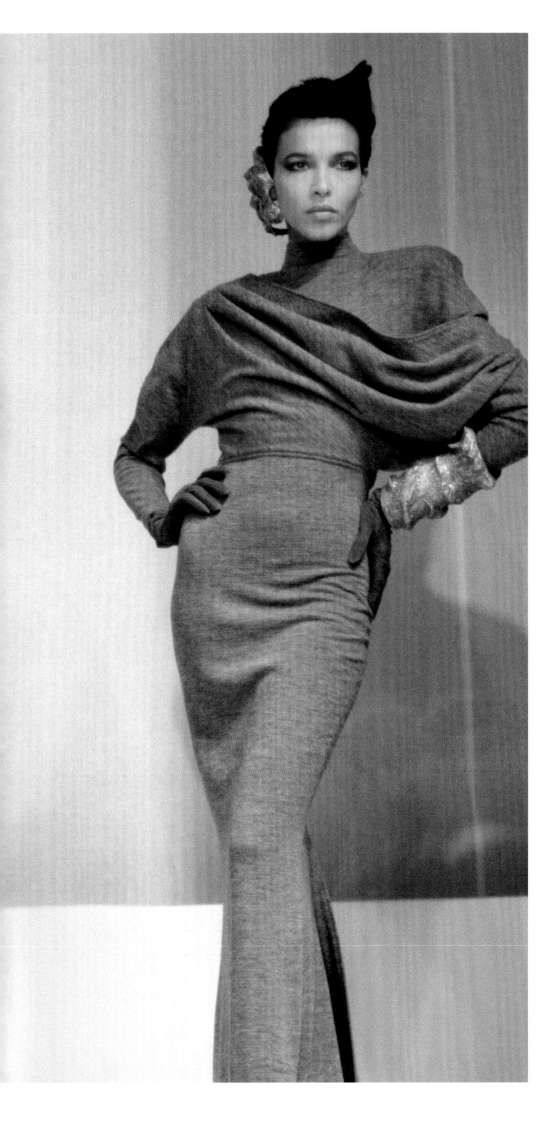

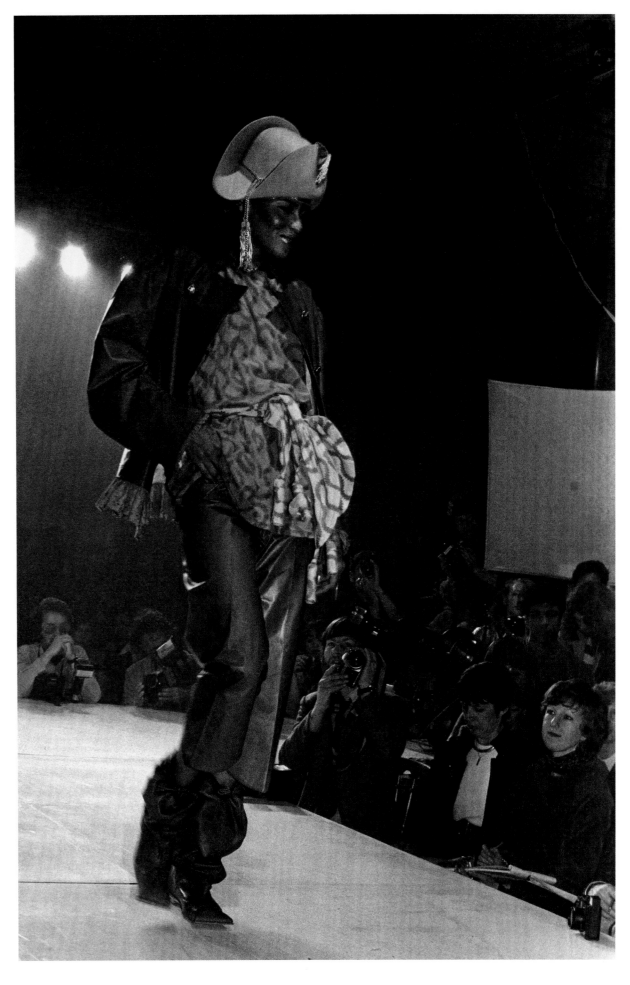

By the 1980s, fashion had fragmented. There was no single style, but rather style tribes that allowed the avant-garde work of designers such as Vivienne Westwood to exist on the same stage as the establishment, which included Emanuel Ungaro. These were two extremes of 1980s fashion: street smart and couture polish.

Left:
World's End
Autumn/Winter 1981
London

Opposite:
Emanuel Ungaro
Autumn/Winter 1987
Paris

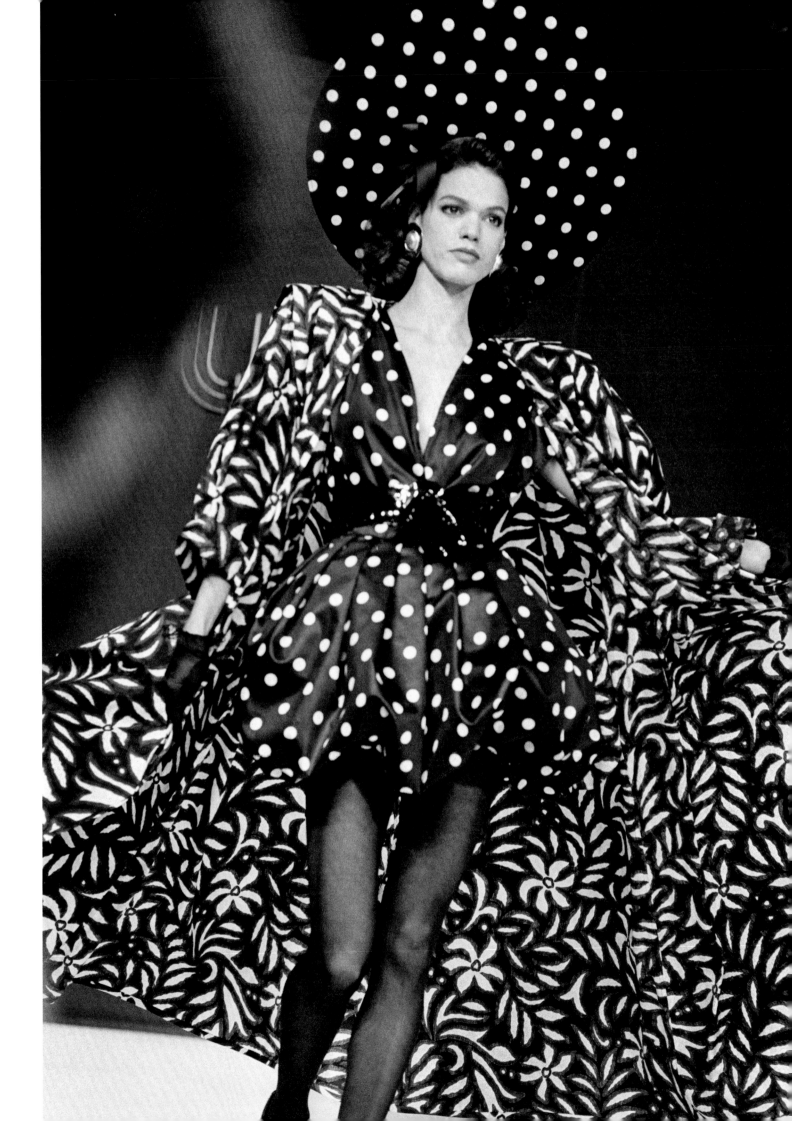

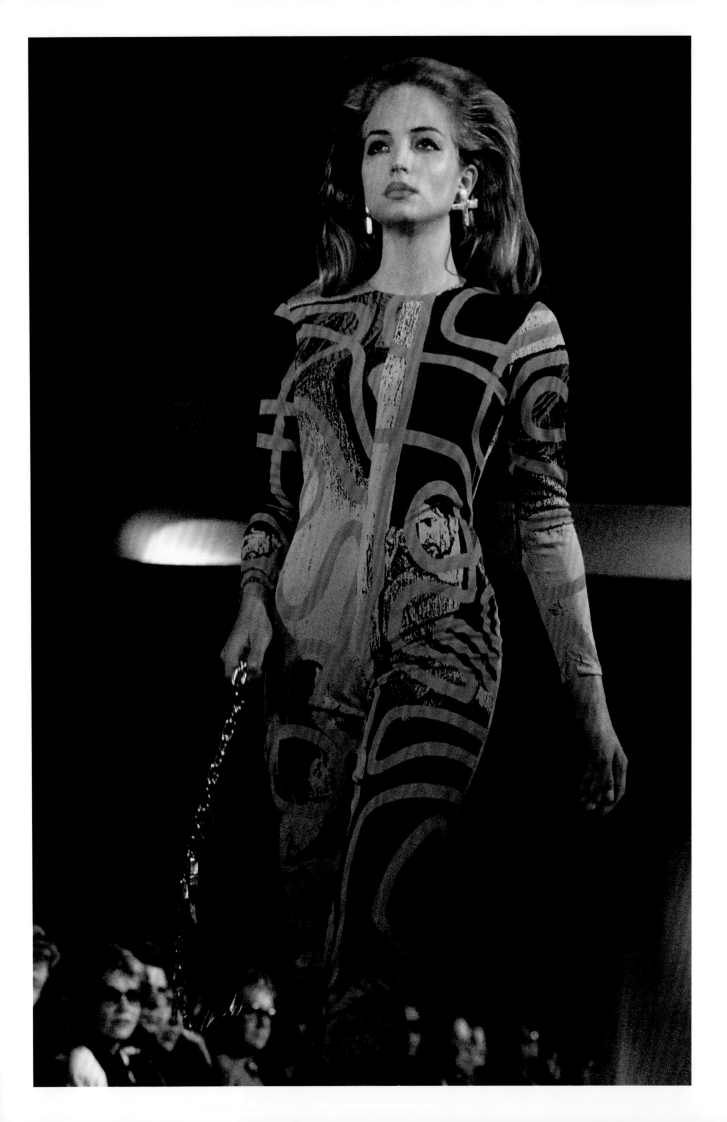

Stephen Sprouse
Autumn/Winter 1988
New York

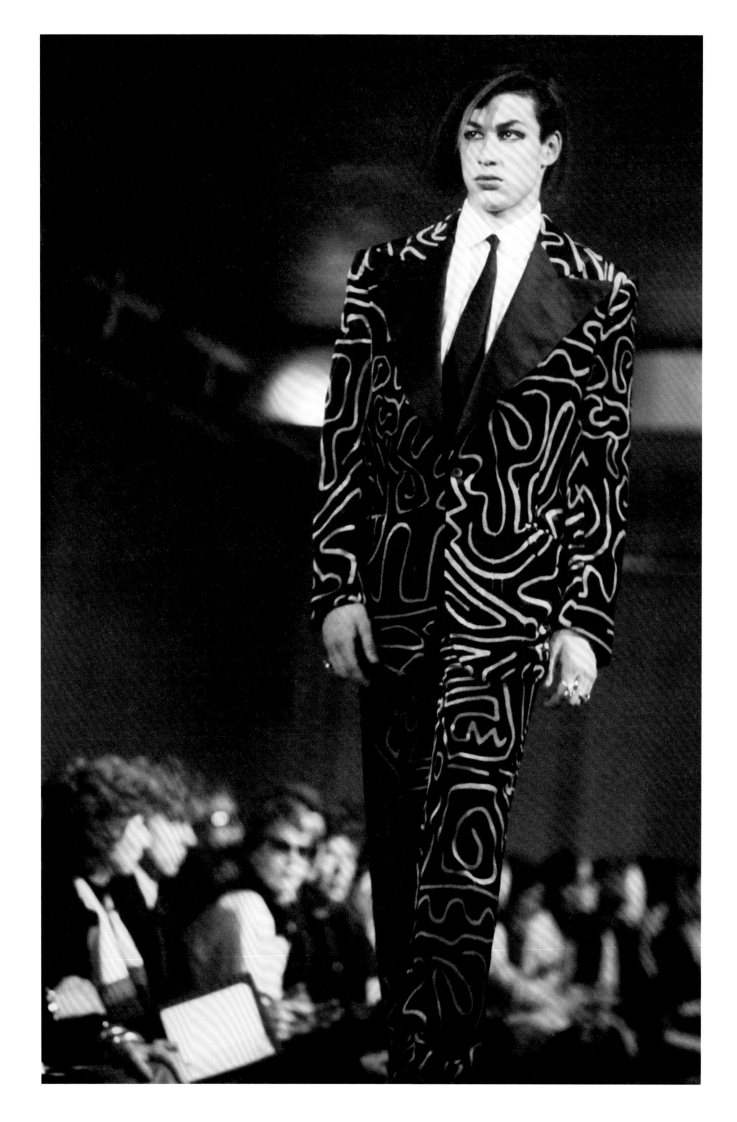

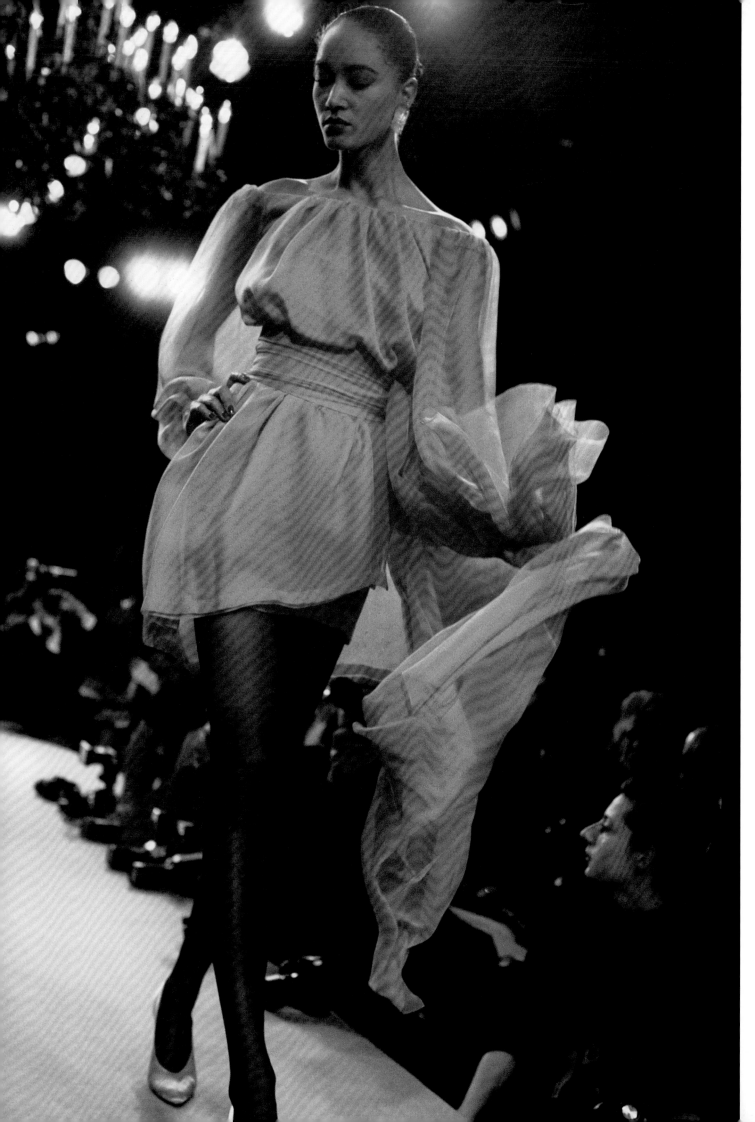

Left:
Yves Saint Laurent
Spring/Summer 1988
Haute Couture, Paris

Opposite:
Dolce & Gabbana
Autumn/Winter 1988
Milan

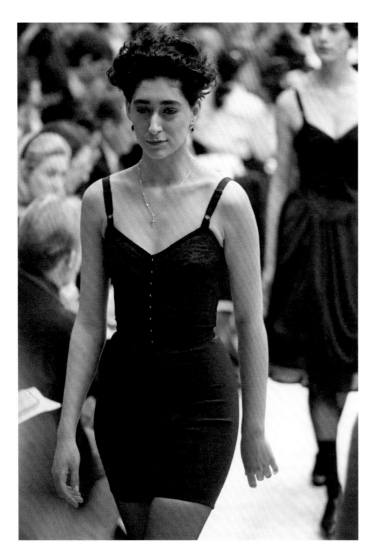

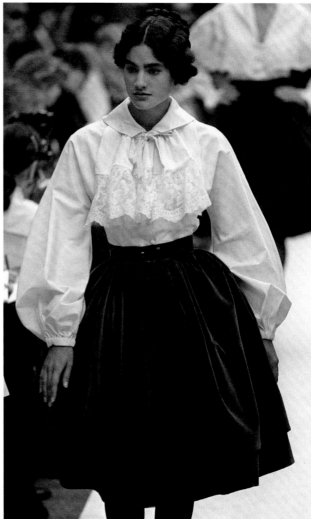

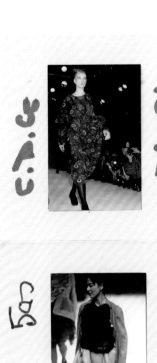

C.D.G.

FW84

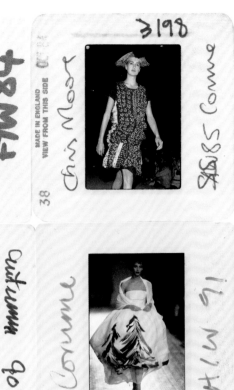

3198

Chris Moore

S/S 85 (comme)

38

MADE IN ENGLAND
VIEW FROM THIS SIDE

CDG AW86

S/S 89

COMME

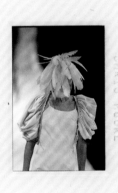

CDG

autumn 90

Comme

ils M/M

3198

9081/97

COMME DES GARCONS
SPRING/SUMMER 92

AW93

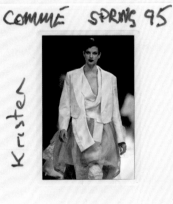

COMME SPRING 95

Kristen

AW 94

CDG

COMME DES GARCONS
SPRING/SUMMER 94
CHRIS MOORE

COMME DES GARCONS
FALL 95
CHRIS MOORE

Comme

COMME DES GARCONS
SPRING/SUMMER 96
CHRIS MOORE

J

0682

1386

CHRIS MOORE

FALL 96

Comme

3

COMME DES GARCONS
SPRING/SUMMER 97
CHRIS MOORE

G

8191 0682

3252

COMME DES GARCONS
SPRING/SUMMER 98
CHRIS MOORE

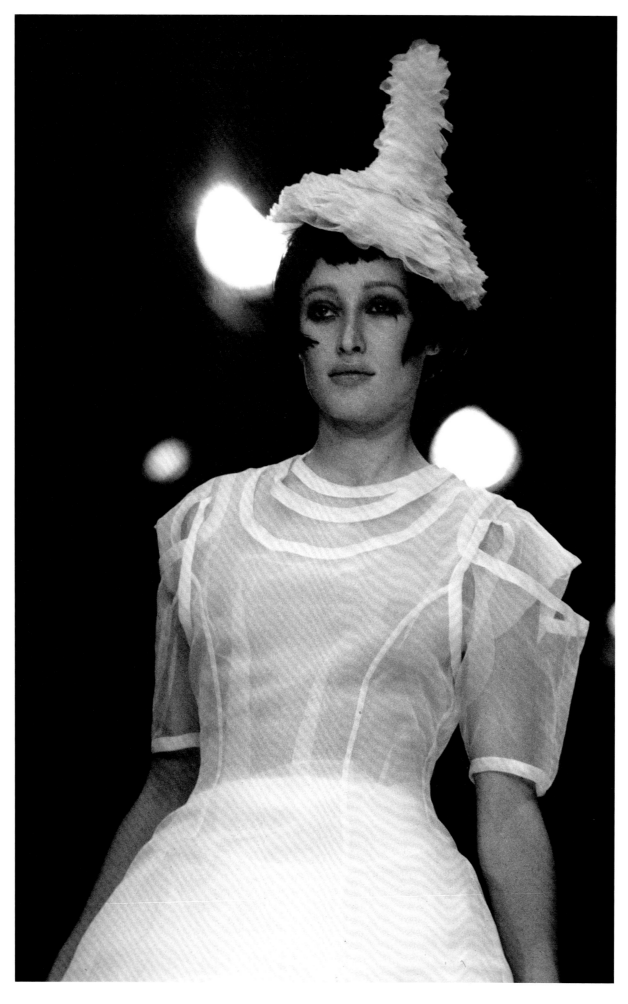

Comme des Garçons, headed by the cerebral, elusive designer Rei Kawakubo, exerted a phenomenal influence over 1980s fashion. It continues today. 'I always love Comme des Garçons,' says Moore. 'These clothes make amazing pictures. I could just go through the last six years of Comme, and I know that I would get it. It's astounding, she's a genius, really.' Kawakubo's Paris debut in 1981 consisted of shapeless black clothes, a look decried as 'post-Hiroshima chic' by fashion critics, but which became a template for the dress of the intelligentsia in the decade to come. Hers was one of the first high-fashion alternatives to be proposed, with styles that opposed not just the fashion conventions of the time, but also those of the West as a whole. Rather than the intricately cut and tailored clothes, created from specially shaped pattern pieces, that characterized occidental dress, Kawakubo cut flat and wrapped bodies in fabric. She added a different dimension to fashion, and her influence was seismic.

Comme des Garçons
Spring/Summer 1989
Paris

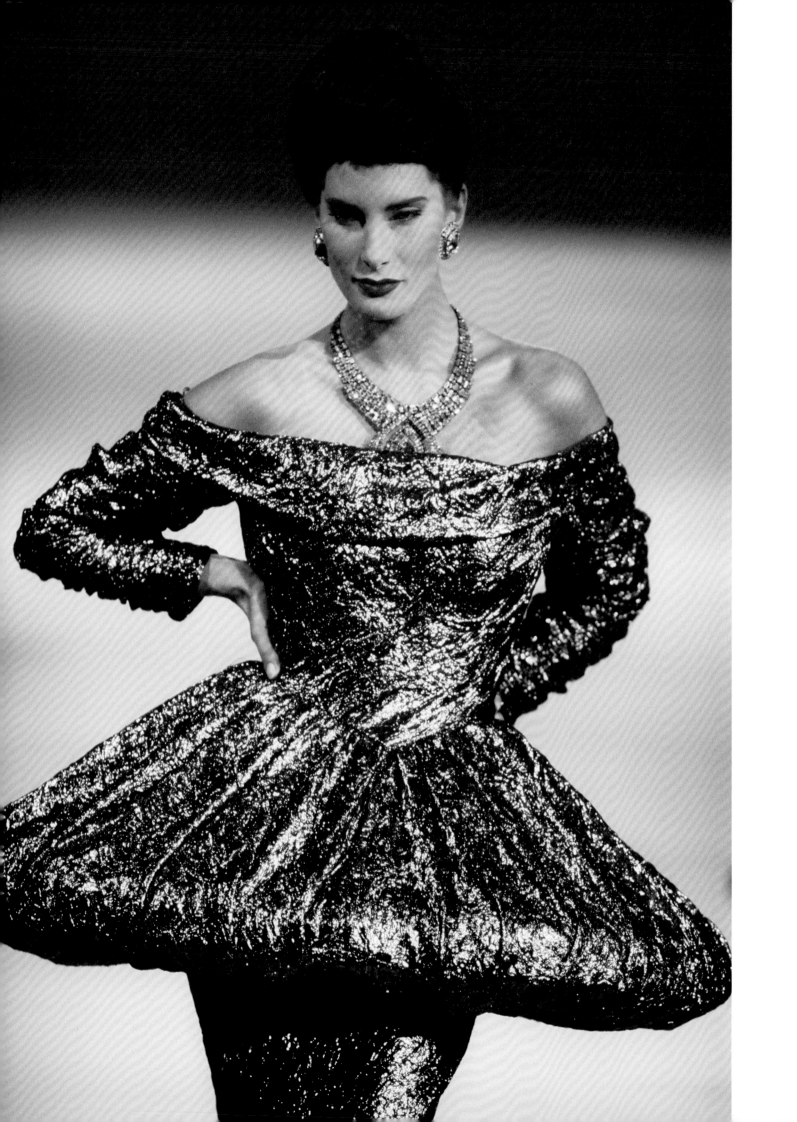

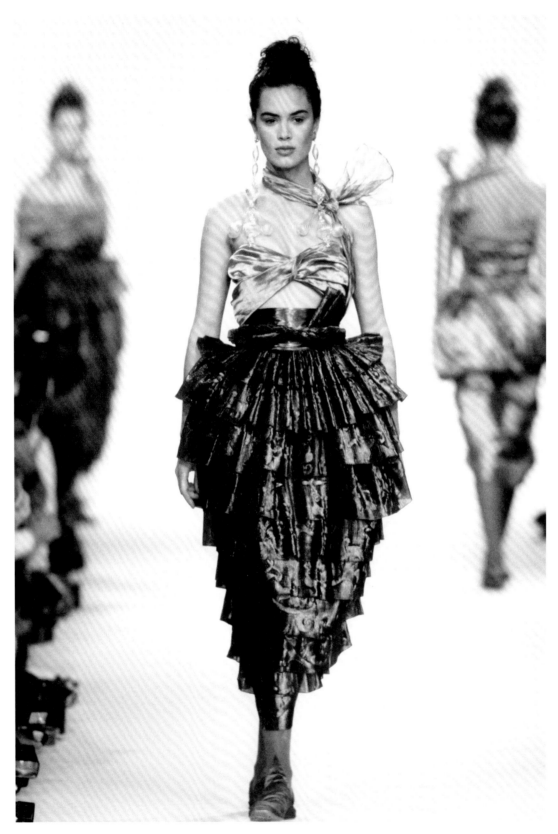

Opposite:
Antony Price
Spring/Summer 1989
London

Left:
Romeo Gigli
Spring/Summer 1990
Paris

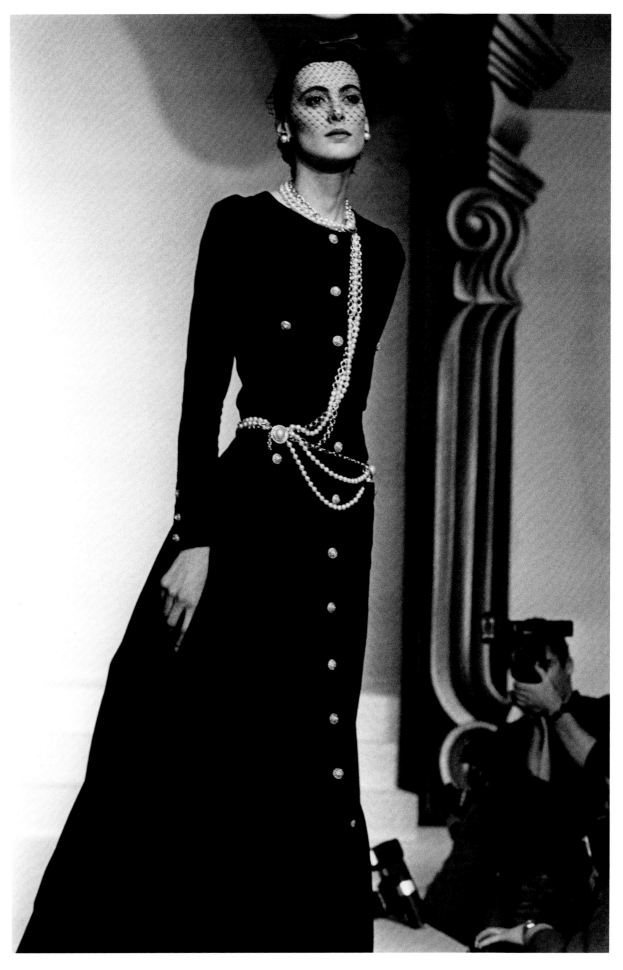

Left:
Chanel
Spring/Summer 1984
Haute Couture, Paris

Opposite:
Jean Paul Gaultier
Autumn/Winter 1989
Paris

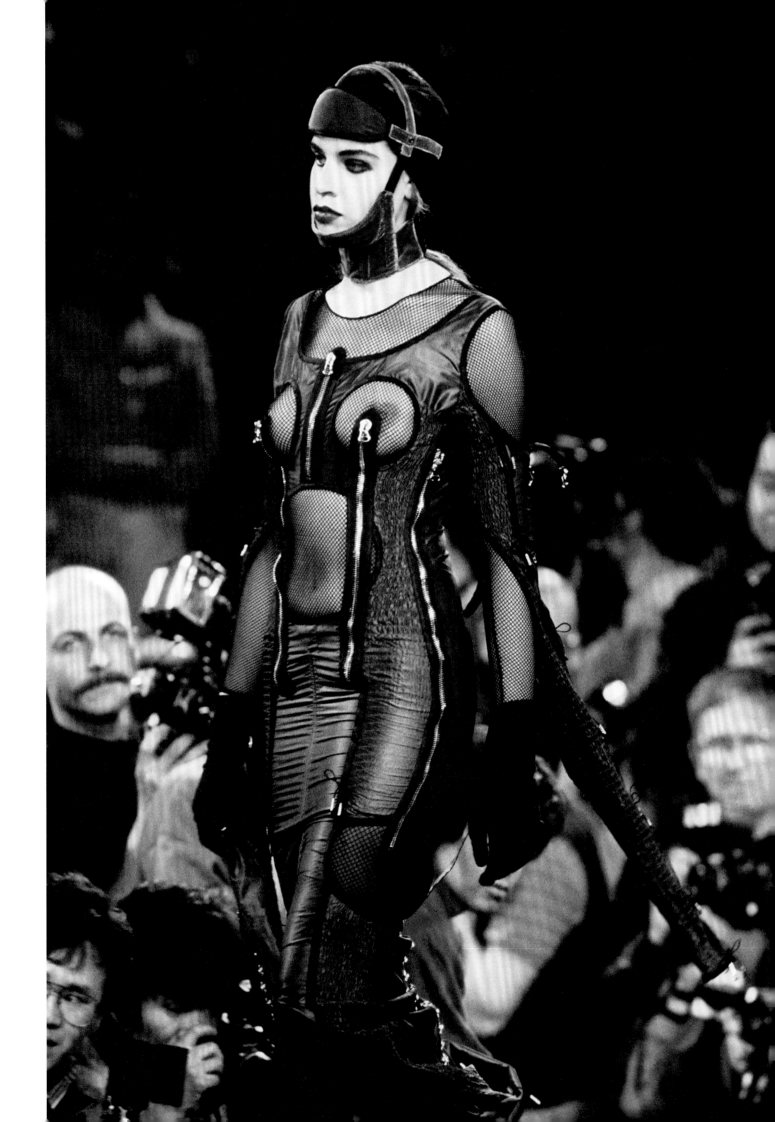

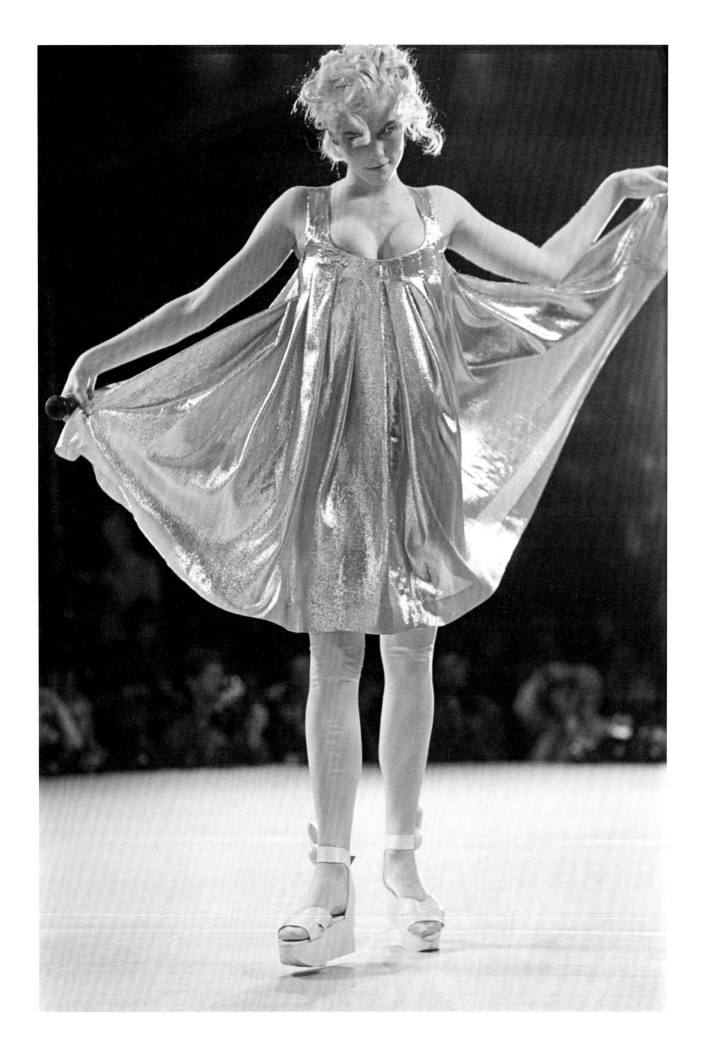

From punk, to pirate, to princess, and back again. Vivienne Westwood first took to the catwalk at the start of the 1980s to showcase her 'World's End' collection, often called 'Pirate'. By the end of the decade John Fairchild, the publisher of *Women's Wear Daily*, named her as one of the six most important designers in the world – and probably the most creative of them all. What Westwood did, in the 1980s, was to rebel against convention and propose startlingly new and original designs whose influence reached far wider than the clientele of her cultish London boutique at 430 King's Road. Westwood revived the corset and Scottish tweeds, sewed philosophical allusions to ancient Greece and Rome into her clothes, resurrected the platform shoe and invented the idea of underwear as outerwear. 'Vivienne's shows were great,' says Moore. 'Her clothes were like theatre, her shows were spectacles. And you could see her influence everywhere, across all the catwalks.'

Vivienne Westwood (left) and Sara Stockbridge backstage
Vivienne Westwood
Spring/Summer 1989
London

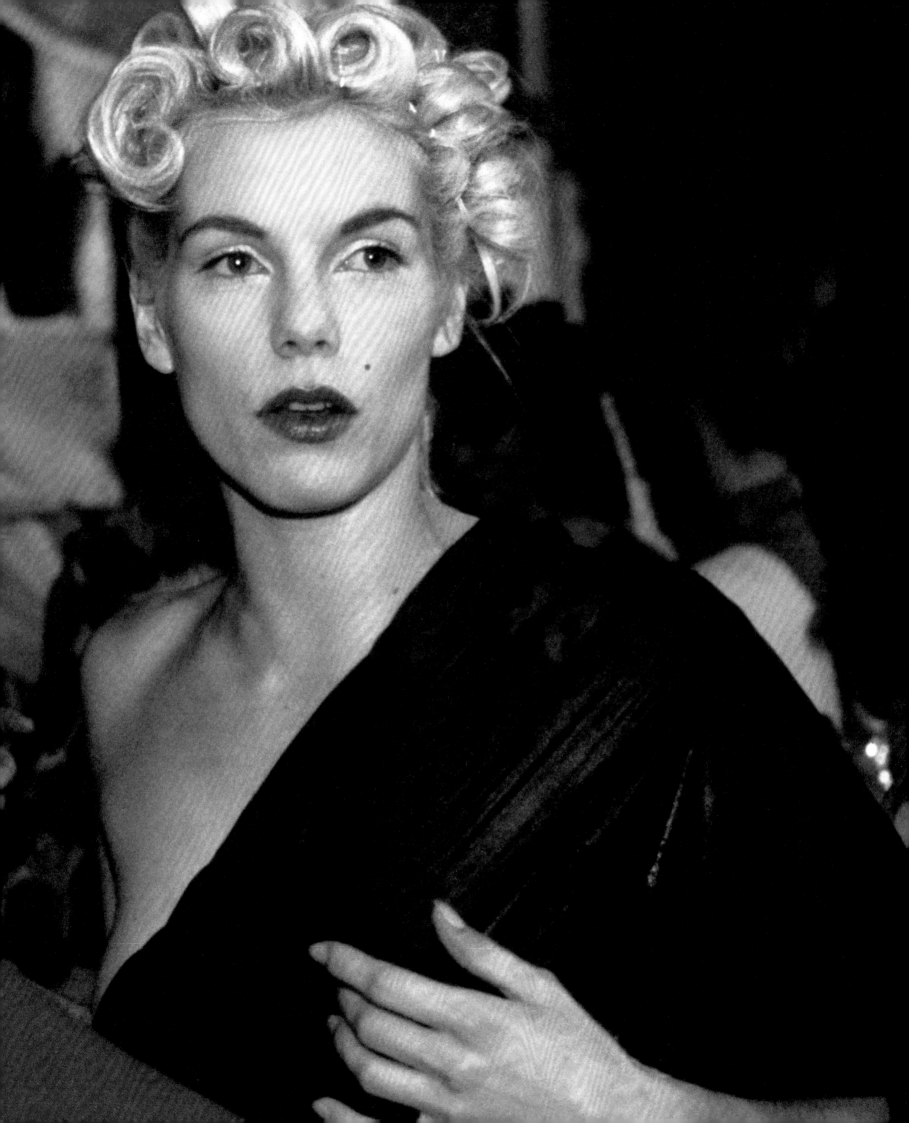

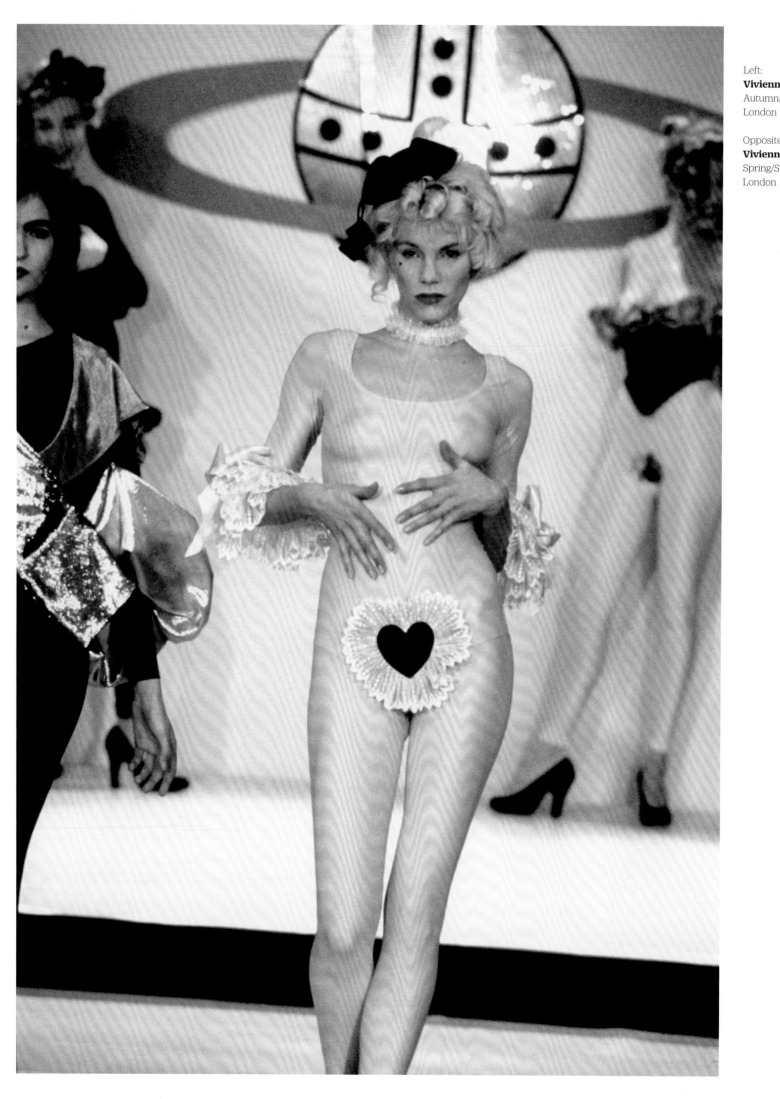

Left:
Vivienne Westwood
Autumn/Winter 1989
London

Opposite:
Vivienne Westwood
Spring/Summer 1989
London

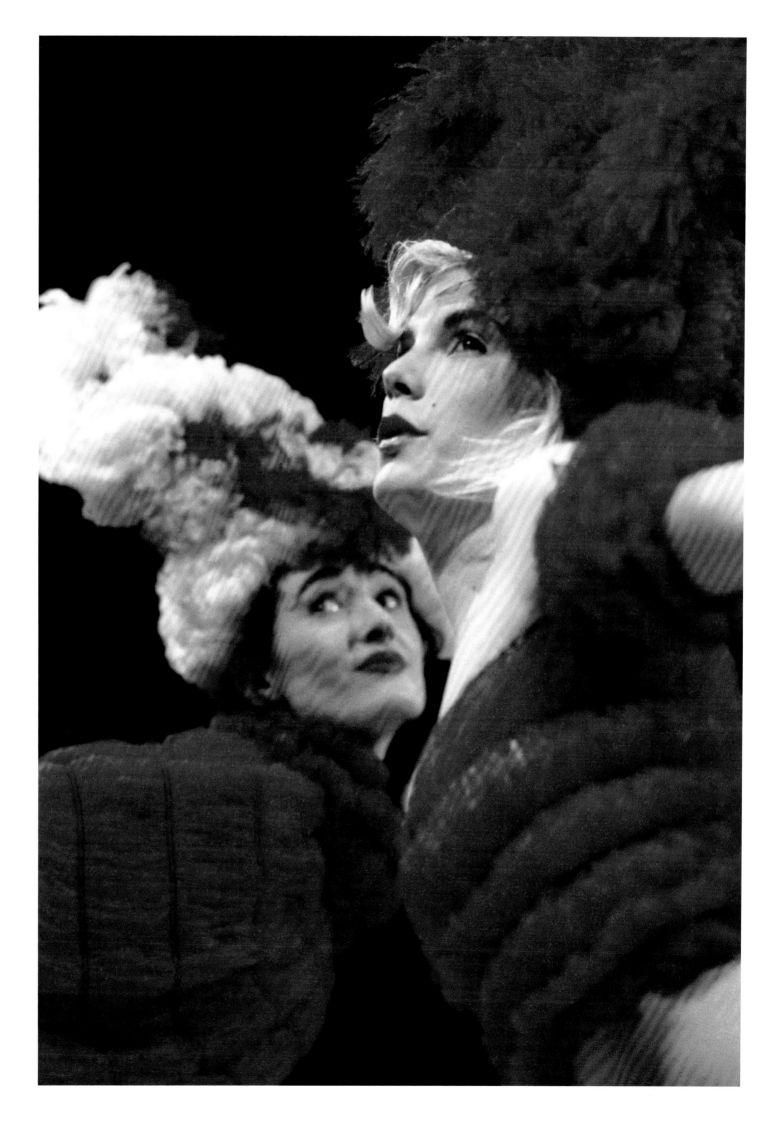

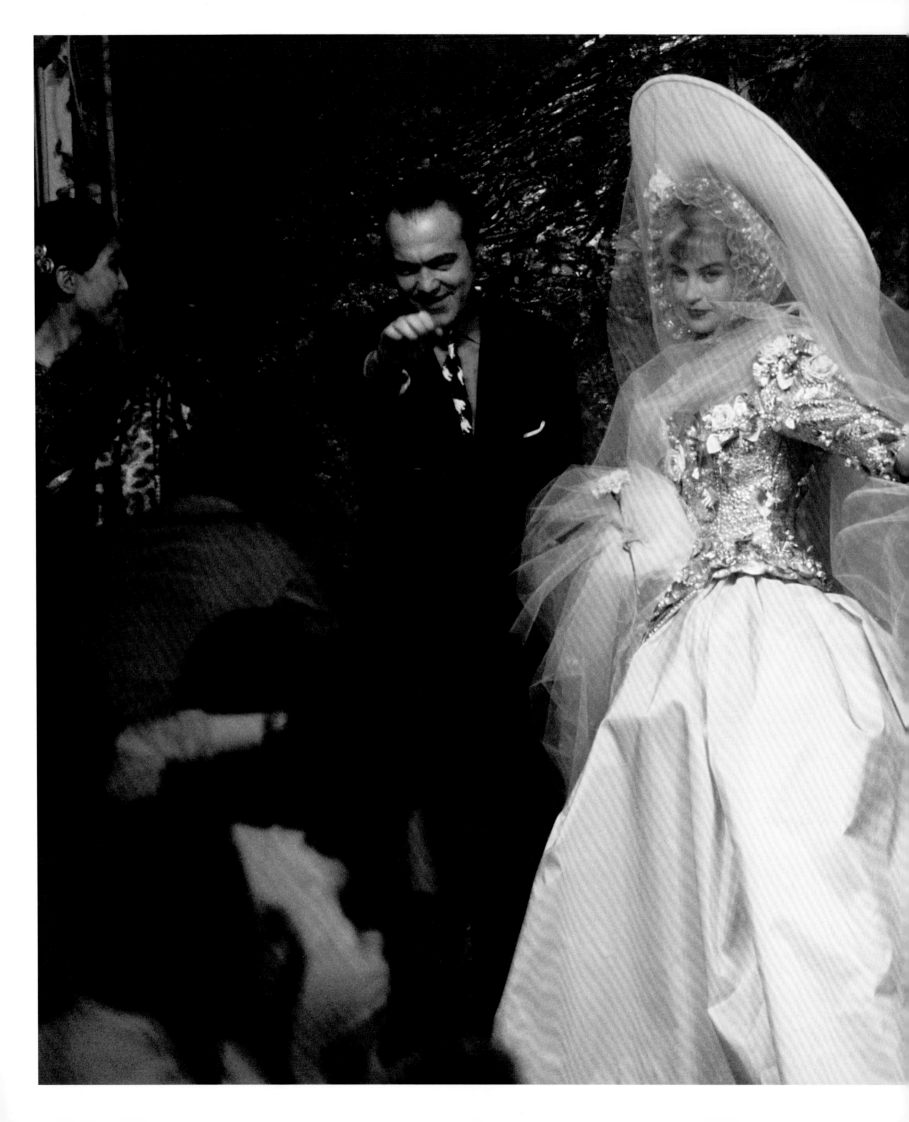

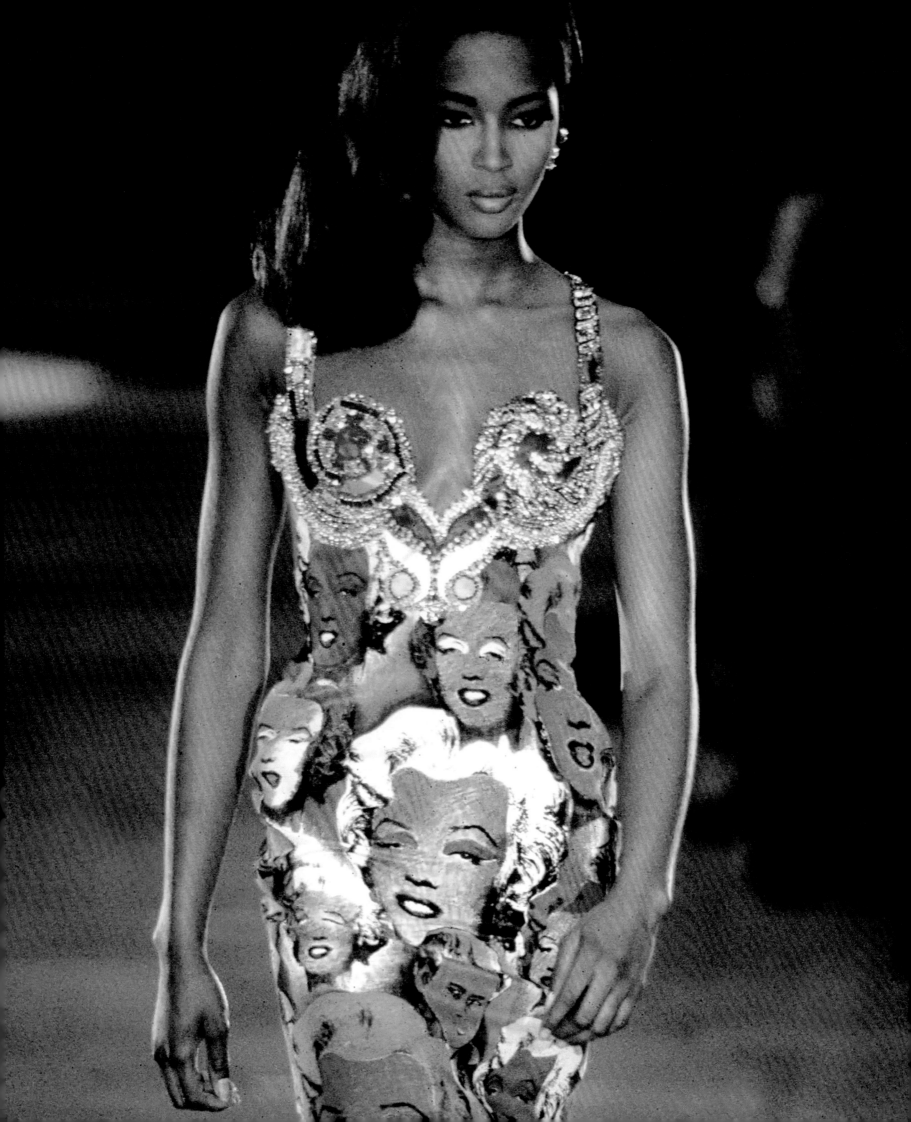

Supermodels and Supershows

1990–
1999

> *'A good model is an intelligent woman. People don't think that.*
> *They think, "Oh, she's just good-looking." No. It's more.'*

Chris Moore

As the 1990s dawned, the supremacy of the catwalk remained unchallenged – even by a global recession said to be the worst since the Great Depression of the 1930s. Perhaps that was, actually, key. By the early 1990s, fashion had occupied a space previously held by Hollywood – that of a dream factory, offering the masses escapism from everyday hardships. The catwalk was fashion's silver screen, the means by which its message was beamed to millions, via images in magazines and newspapers across the world.

No cultural phenomenon epitomized this process more than the supermodels, who rose to prominence in the late 1980s, but ascended to superstardom only at the start of the 1990s. Their numbers vary, including names such as Claudia Schiffer, Helena Christensen, Karen Mulder, Yasmeen Ghauri, Tatjana Patitz and, later, Nadja Auermann. But the four most consistently considered synonymous with 'super' are the British Naomi Campbell, the Americans Cindy Crawford and Christy Turlington, and the Canadian Linda Evangelista. Bar Crawford, they were collectively referred to as 'The Trinity', and alongside their sometimes-supermodel cohorts, they were fixtures on the decade's high-fashion catwalks.

Were the supermodels the most important story of 1990s fashion? In retrospect, perhaps not. But they attracted the lion's share of the decade's attention in a way achieved by no designer, silhouette or look, the traditional bellwethers of fashion change over the preceding century and a half. 'The models have become so important,' commented the American designer Geoffrey Beene – pejoratively – in 1992. 'They have become bigger than design.' Even Twiggy, the model whose gangly limbs and doe eyes are still shorthand for the 1960s fashion look, was born out of the fashion moment, rather than creating it. By contrast, the supermodels seemed to define fashion: their bodies demanded the clinging bandage dresses invented by Azzedine Alaïa, geared to pneumatic curves and popularizing the use of Lycra throughout fashion. Their personalities required the highly visible creations of designers such as Christian Lacroix, Thierry Mugler and Gianni Versace, whose clothes seem to represent an attempt to outshine the megawattage of the models inside by virtue of crystal strass and embroidery. Their star power necessitated bigger and bigger shows, staged like Hollywood movie productions, the better to frame their fame. Their inherent, intoxicating hyper-glamour can even be seen as a catalyst for such counterintuitive movements as deconstruction, Grunge and Punk revivals.

The supermodels were created entirely by the catwalk – namely, Gianni Versace's catwalk in March 1991. They had appeared on other catwalks before, of course, and on various international magazine covers. It was in American *Vogue*'s October 1990 issue that Evangelista infamously quipped, to the writer Jonathan Van Meter, 'We have this expression, Christy and I. We don't wake up for less than $10,000 a day.' It went down in history as the 'Let them eat cake' of the twentieth century. The same year, Evangelista

appeared alongside Campbell, Crawford and Turlington in George Michael's music video for his single 'Freedom '90'. A year later, Versace would reunite the foursome, marching a phalanx of supermodels along his Milanese catwalk mouthing along to the same song. It was this moment that cemented the supermodels in popular consciousness, and has been relayed more than any magazine cover, or even the original video. 'I'm sure it was Versace that brought the models on to the scene, the supermodels,' comments Chris Moore – reflecting the opinion of industry insiders and the general public alike.

Supermodels were, perhaps, the only constant on the catwalks of the 1990s, their presence – rather than a definitive shape or cultural thrust – the anchor of the decade. Supermodels appeared on the catwalks of Chanel and Comme des Garçons, on the covers of *Vogue*, at haute couture shows and at those of underground, unknown (but still, presumably, cool) designers. Many designers, unable to afford appearance fees that soared well beyond Evangelista's $10,000 (Versace once paid Turlington $50,000 to model exclusively), would pay their supermodels in clothes: they accepted this from designers with relatively small turnovers, such as John Galliano and Vivienne Westwood. It wasn't as strange a business decision as it might seem: despite their diminutive sales, designers like Galliano and Westwood packed a wallop when it came to press. Appearing on their catwalks ensured the omnipresence of supermodels across the decade's fashion. While designers slipped in and out of favour, the supermodels hedged their bets.

Unlike earlier decades, the 1990s cannot be summed up easily, even when restricted to fashion. An exhaustive round of revivals – 1960s, 1970s, even 1980s – scrambles our perception of the decade's identity. Segues into looks dubbed 'Kinderwhore' and 'Heroin Chic' are, perhaps, best forgotten; they were even questioned at the time. Suzy Menkes, then fashion editor of the *International Herald Tribune* (renamed the *International New York Times* on 15 October, 2013, and since incorporated into the *New York Times*), was one of Moore's most important creative collaborators, and he captured her sporting a badge bearing the epithet 'Grunge Is Ghastly', summarizing the split of opinion, even among industry insiders, about the various fashions on show. 'A typical outfit looks as if it were put together with the eyes closed in a very dark room,' sniped Menkes's counterpart Bernadine Morris at the *New York Times*, about a collection that is today seen as seismic in its influence. To focus on the decade's defining characteristics as seen on the looks that have proved to have lasting impact – on Maison Martin Margiela's deconstruction, the minimalism of Calvin Klein and Helmut Lang, or indeed Grunge, pioneered by Marc Jacobs – is to ignore the preened and pouting models wrapped in the highly constructed clothes of Mugler and of Versace, a designer who reached the height of his power and influence between his

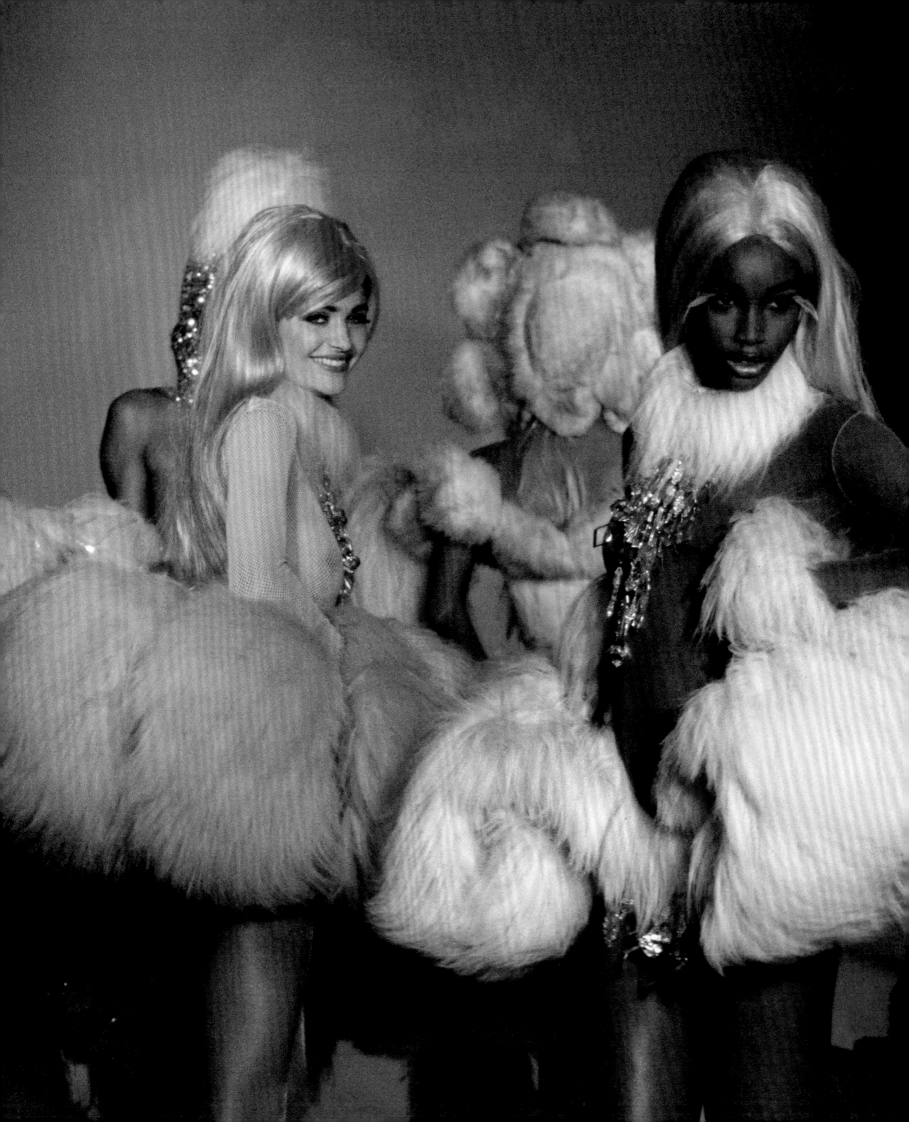

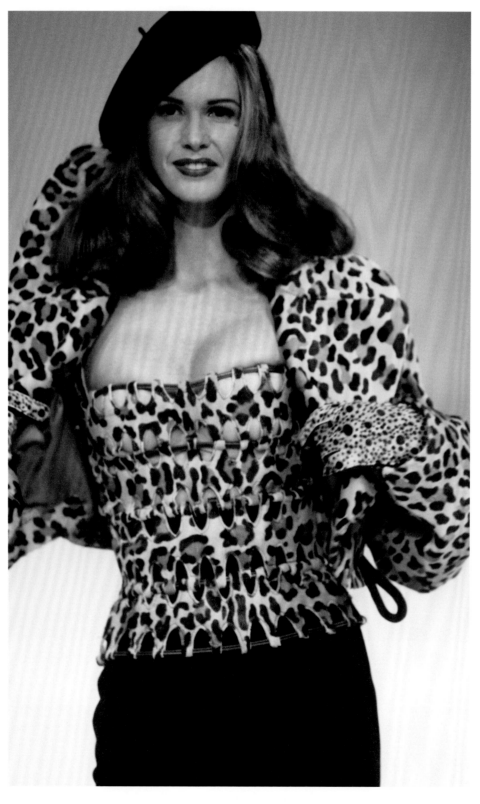

'Supermodel' shows of 1991 and his CFDA International Award – the first 'American Fashion Oscar' – in 1993. What about the new explosion of Italian fashion: Fendi's 'Baguette', Miuccia Prada's 'Ugly Chic' and pared-back, utilitarian luxury, Tom Ford's unexpected resurrection of the moribund Gucci?

Likewise, it is difficult to know where to slot in John Galliano and Lee Alexander McQueen, arch romanticist and renegade rebel respectively, whose clothes spectacularly revived two French fashion houses, and indeed haute couture as a whole. Individually, they can be linked with other overarching themes evident in 1990s fashion: McQueen is emblematic of the phoenix-like rise of London as a creative force once again, his debut followed by talents including the Turkish-Cypriot Hussein Chalayan and Stella McCartney, a Beatle's daughter, who did her first work-experience placement at Christian Lacroix during his debut couture season. Within two years of her Central Saint Martins BA graduation, McCartney was installed as the creative director of Chloé, an appointment by the brand developer Mounir Moufarrige that capitalized on both her instantly recognizable surname and the cachet of British fashion in the mid 1990s. The same year – 1997 – the March issue of *Vanity Fair* was dedicated to 'Cool Britannia', with Oasis singer Liam Gallagher and his then girlfriend Patsy Kensit on the cover, and inside lavish David LaChapelle-photographed spreads devoted to London fashion.

This Anglomania had already been rapidly exported across the channel: in 1996 McQueen had been appointed head of Givenchy, succeeding Galliano, who held the distinction of being the first British designer since the war to lead a French haute couture *maison*. In October 1996 Galliano moved to Dior, and was seen by many as the natural successor to Christian Dior himself: his debut collection, in January 1997 – marking the fiftieth anniversary of Dior's seminal 'New Look' – was a triumph, acclaimed internationally. On a larger stage, Galliano's work in ready-to-wear had pulled the focus back on to age-old haute couture techniques, such as complex tailoring, or bias cutting – a 1930s technique that created sinuous, moulded second-skin gowns, and which Galliano effectively reinvented for the late twentieth century. The theme of haute couture was also explored through the work of designers as diverse as Mugler and Westwood, whose pinched and padded clothes had a distinct air of mid-century *salons*. Westwood even christened a jacket 'Bettina' after the 1950s couture mannequin Bettina Graziani, on account of the gently folded fabric emphasizing the bust, and the emphatically flared peplum. In 1997 Mugler and Jean Paul Gaultier both launched haute couture operations, showing their first couture collections alongside the debut of McQueen and Galliano's opening act for Dior.

The technical prowess indicative of haute couture encouraged designers to explore grand gestures, rather than subtle nuances. The ousting of Hubert de Givenchy in favour of Galliano in the

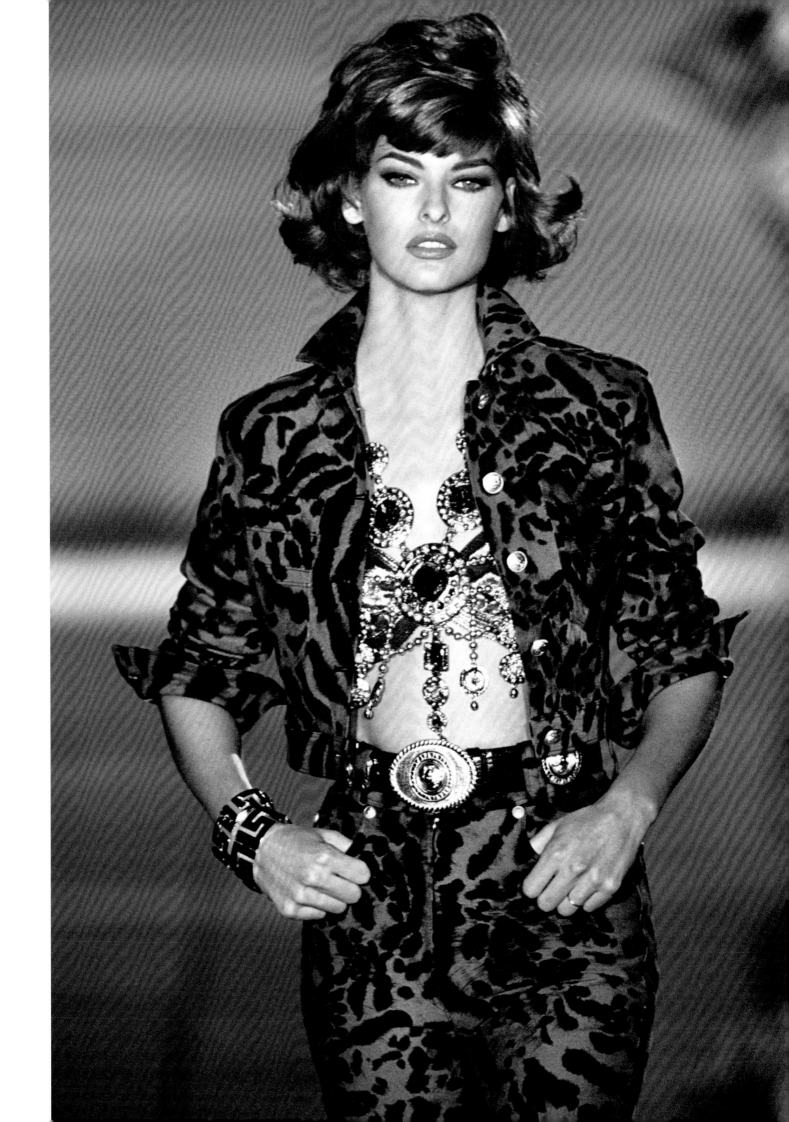

Page 196:
Versace
Spring/Summer 1991
Milan

Previous page:
Thierry Mugler
Autumn/Winter 1991
Paris

Right:
Versace
Spring/Summer 1992
Milan

Opposite:
Azzedine Alaïa
Autumn/Winter 1991
Paris

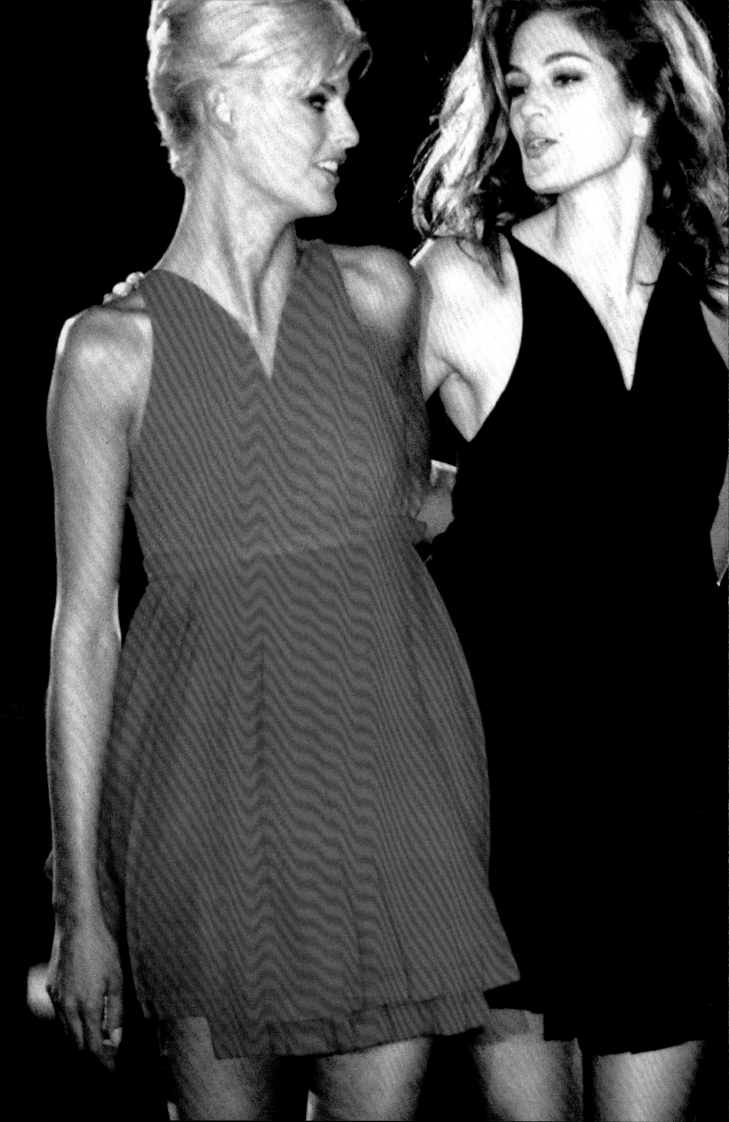

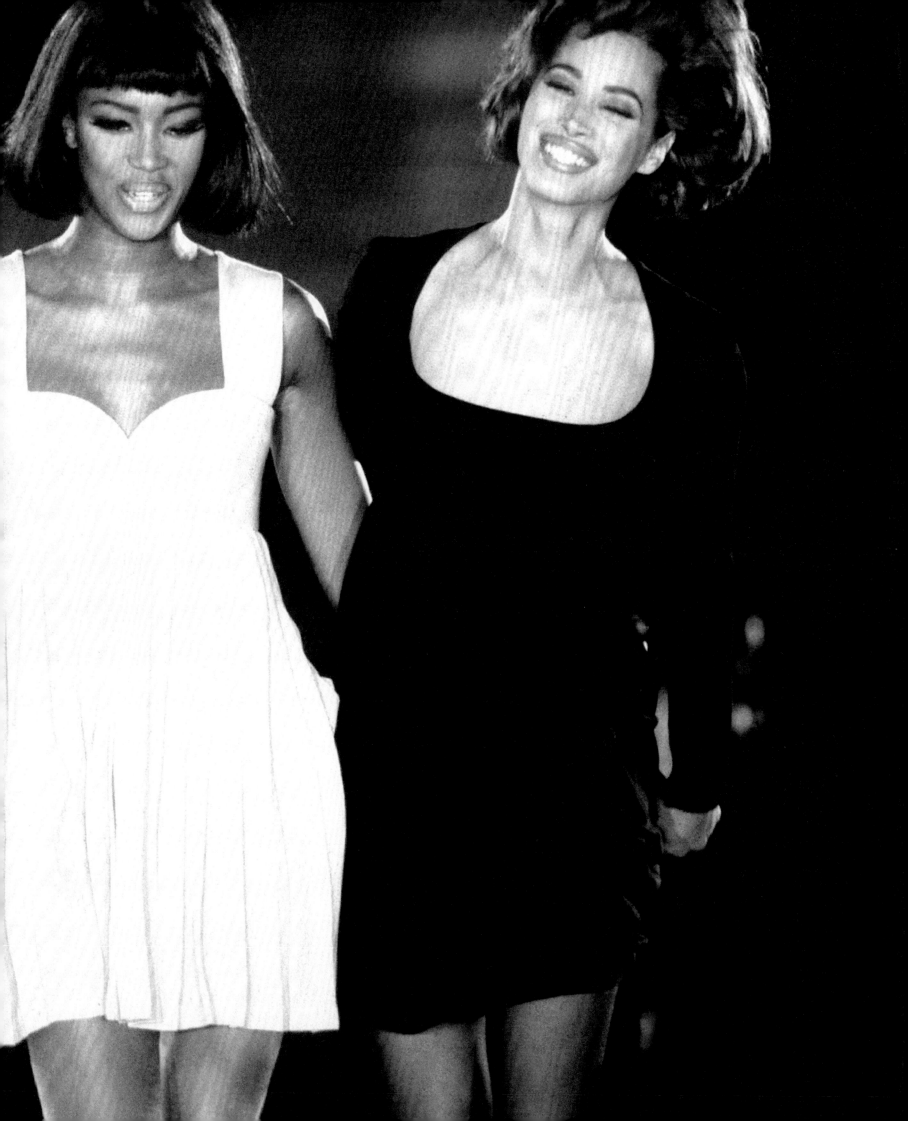

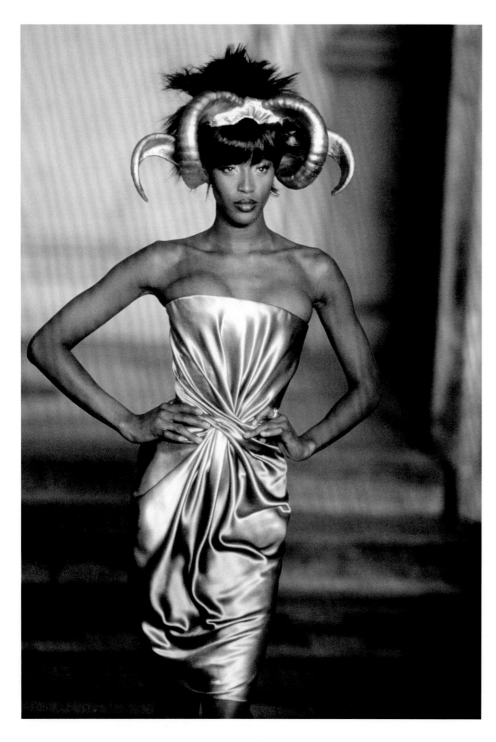

autumn of 1995 represented a victory of a new guard over the old school – if the latter was preoccupied with pleasing individual clients, on the profoundly private business of dressing the dwindling numbers of true haute couture clients (approximately 1,000 women worldwide by the mid 1990s), the former was focused on the bigger picture – namely, creating attention-grabbing spectacles and staging sumptuous shows that monopolized media attention. Although new to the couture circus, both Mugler and Gaultier had bestselling perfumes (Angel and Classique) to bank-roll the loss-leading business, while Givenchy and Dior plainly focused on sales of perfume, cosmetics, and 'entry level' products such as scarves and leather goods.

The resurrection of haute couture in the 1990s was in service of two things: the oversized creativity of the designers, and big business. Both Givenchy and Dior were owned by Bernard Arnault, CEO of LVMH – the biggest luxury-goods house in the world, whose annual sales stood at $5.9 billion in 1995. 'It's the perfume bottle and the handbag, and how to keep the attention there,' said André Leon Talley, then an editor at *Vanity Fair*. 'It's all about the media hype.' Catwalk images were fundamental in cementing that, in creating a dream on which to capitalize. It was this that made Galliano and McQueen push haute couture to the highest levels of fantasy: Galliano, in particular, staged outrageous shows, on railway concourses, in custom-built gardens in the Bois de Boulogne, or in the enclaves of the Palais Garnier at a reputed cost of around $2 million per show. The clothes themselves were equally extravagant: the Autumn/Winter 1998 Christian Dior haute couture collection (staged on that train platform) featured an outfit lavished with 2,000 hours-worth of handwork by the master embroiderer François Lesage. It was the most expensive piece Maison Lesage has ever produced.

Perhaps reflecting the profound uncertainty of a century drawing to a close – with the media dominated by apocalyptic tales of 'Millennium Bugs' that threatened to disable technology – many designers retreated into boundless fantasy. The pragmatism of designers such as Margiela and Lang – and even the gritty realism of McQueen's early collections, with their references to club culture, domestic violence and drug abuse, their use of cheap everyday fabrics and stark silhouettes – were quickly subsumed by theatrical urges. The seemingly endless round of revivals added to that sense of unreality: one season, fashion resided in the Mod 1960s, the next, Hippy-ish Haight-Ashbury or the retro formality of mid-century Hitchcock heroines. Designers proposed costumes, not clothing. Jacobs offered Grunge one year, the next, Isaac Mizrahi turned his catwalk into a film set, exposing the backstage goings-on through a scrim more commonly used for ballet. The same season – Autumn/Winter 1994 – at the March shows in Paris, the director Robert Altman filmed a poorly received farce of the fashion industry titled *Prêt-à-Porter*. The film featured footage of Altman's fake editors and fashion designers alongside the real deal, at the shows of Gaultier, Sonia Rykiel and Lacroix, among others; Vivienne Westwood loaned her collection to be featured. The merging of reality and make-believe could arguably never happen in another arena.Fashion, by the 1990s, was a fantasy factory. If make-believe wasn't its sole focus – clothes, after all, still needed to be sold – then it was at least the primary focus of the international catwalk shows of the 1990s. These shows were selling dreams, not dresses.

For Moore, the 1990s were a period of loss, and of gain. In March 1990 his first wife, Jackie, died in the Sheraton Heliopolis Hotel fire in Cairo. A memorial award was established in her name, and given to aspiring fashion journalists in the 1990s and early 2000s: the prize was to attend the Paris haute couture shows, the biannual event

**Alexander McQueen
for Givenchy**
Spring/Summer 1997
Haute Couture, Paris

Right:
**John Galliano for
Christian Dior**
Spring/Summer 1997
Haute Couture, Paris

Previous page:
Versace
Autumn/Winter 1991
Milan

Overleaf:
Sophia Loren during the
filming of Robert Altman's
Prêt-à-Porter, backstage at
Christian Lacroix
Autumn/Winter 1994
Paris

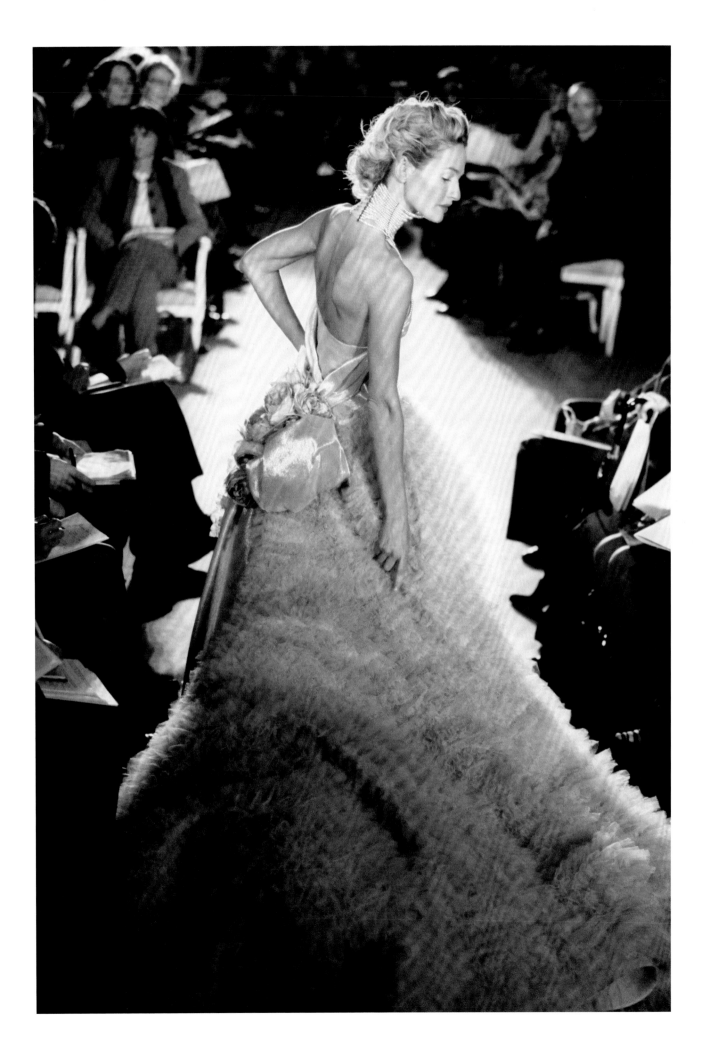

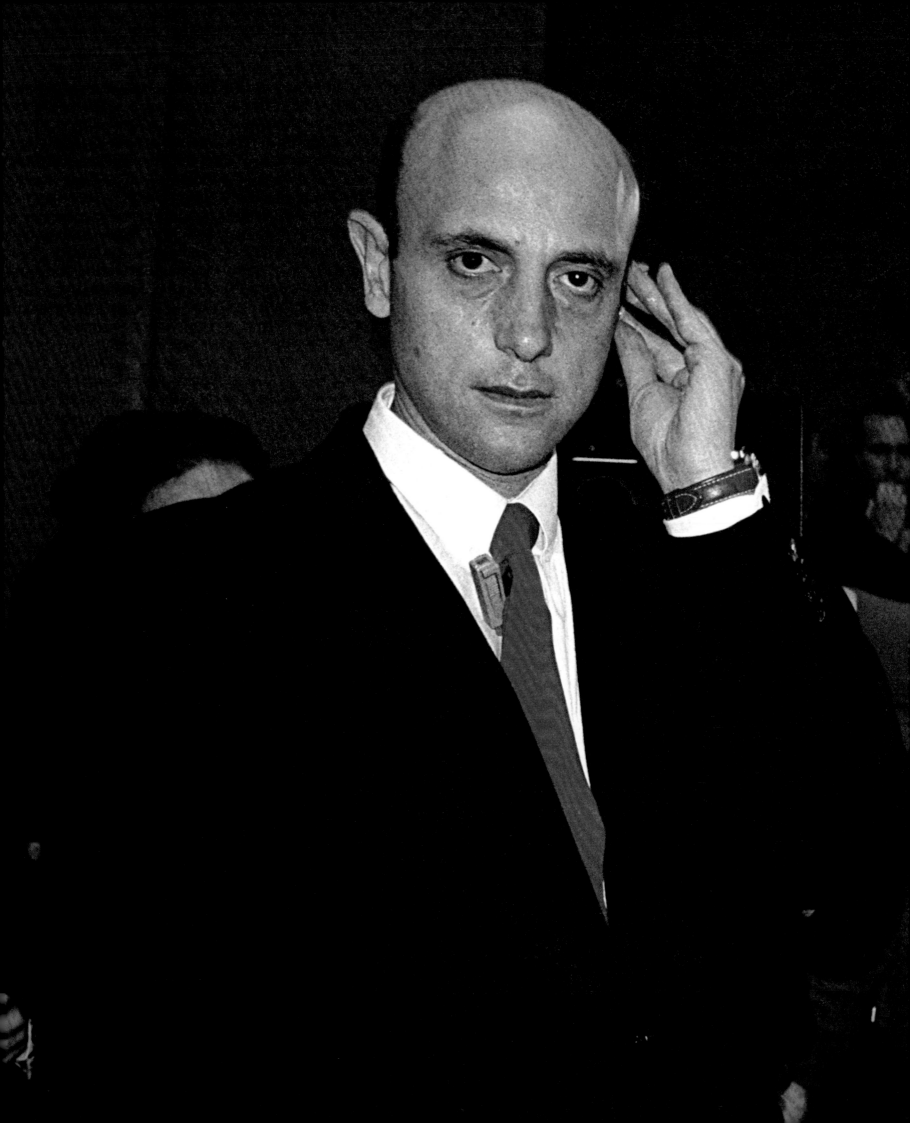

Below:
John Galliano
Autumn/Winter 1995
Paris

Opposite:
Maison Martin Margiela
Spring/Summer 1996
Paris

that had introduced Chris Moore to a new world of fashion photo-journalism 23 years earlier. But around the same time, Moore forged one of the key creative partnerships of his professional life: he began working alongside Suzy Menkes, providing catwalk coverage for the fashion pages of the *International Herald Tribune* from the ready-to-wear and haute couture shows. Menkes was (and is) one of fashion's most respected critics, and the newspaper carried enormous clout within the industry; Moore's images would be paired with her words for almost 25 years, shaping the public's perception of designers' successes and failures, and helping to form the landscape of contemporary fashion.

The relationship of Moore and Menkes was markedly close: they travelled together between shows, poring over contact sheets to select the correct images. 'It was a team, you were part of a team,' Moore recalls of this moment in his career. 'What would happen is, say, after Dior, she always had the car, which we travelled in. After Dior we would go to her car, with a computer, load up the pictures, go through the pictures, and she would choose. She always insisted on choosing the pictures. Very, very occasionally she'd leave it to me,' he smiles. 'That was always, as far as she was concerned, a terrible mistake, because I would pick the wrong ones.'

Bar the advent of the high-stacked podium, the other revolution in 1990s catwalks was the move to digital imagery – hence the fact that Menkes and Moore were poring over pixelated pictures on computer screens, rather than hastily developed photographs. This reflected a wider move, across the photographic industry as a whole, towards digital image-making. In 1990 Adobe Photoshop 1.0 was released, to be seized upon rapidly by photographers, particularly those working in the fashion industry. While Moore didn't retouch, the evolution of his craft – highlighted by his relationship with Menkes and the *International Herald Tribune* – moved inexorably from film to digitized imagery. 'There was a period when stuff would go to a lab, and Suzy would come and visit the lab, and we would look at it there.' These images were frequently black and white; they developed faster than colour, and the *International Herald Tribune* ran its fashion images in black and white. 'Then there came a period when we started to use two-hour labs – we had scanners, so we took scanners with us to the hotels, and set them up. We'd scan the negatives, turning them into digital. We didn't have digital cameras, but we digitized the film. It was a great relief when we were able to use a digital camera.'

The demand was, of course, for speed – more shows, more images, delivered faster and faster. In reaction, Moore cleared out his darkroom in 1995 to make way for a scanning suite; he relaunched his business under the name Catwalking in 1999, along-side his partner (now wife) Maxine Millar. They established a website – the first to be dedicated to catwalk imagery in the UK, and one of the earliest sites in the world (the Fairchild Media site Style.com launched the same year). Moore and Millar were stealing

a march on the rest of the industry: they were frequently required to shoot both colour negative and digital as a number of publications remained suspicious of digital, and demanded images via existing film processes. At the beginning, the digitized images – 'almost the same as Catwalking.com now', according to Moore – were viewed only by Moore's team, and Menkes herself.

The single uniting factor of 1990s fashion was its continuing focus on the catwalk show as the primary means of promoting the industry's various messages. However, after a decade in which designer labels refined the presentation format of the stereotypical raised walkway, with photographers placed strategically along the sides, a new generation of names began to challenge it. Key among these was Galliano, whose approach to fashion as storytelling rather than product placement had a seismic influence in the latter half of the decade. Even before his big-top shows for Dior, Galliano eschewed the formal runways of Paris – which, by 1994, were staged by rote in the Carrousel du Louvre, a specially constructed series of auditoriums underneath the famed museum – in favour of far-thrown, elegiac venues. His shows were staged in, for example, a disused doll factory kitted out like a circus tent, or a warehouse filled with fake snow and accessed through a wardrobe, like Narnia. Although such *mise en scène* was spectacular, Galliano pulled his audience in close, winding seating around complex sets to give every guest a near-front-row view, and inviting his models to camp it up like Hollywood B-movie actresses. It was theatrical in a different sense from the shows of Mugler and Montana that had defined the 1980s: more intimate, more detailed.

The same intention – with a radically different approach – emerged on the catwalks of Margiela and Lang, pillars of the decade's deconstruction and minimalist movements respectively. Both chose to show 'flat' – without the white catwalk of the 1980s. Margiela showed in down-at-heel neighbourhoods, in under-ground stations or children's playgrounds; unlike Galliano, he didn't transform them, but rather used their urban decay to challenge preconceived ideas about the luxury and preciousness of fashion. Lang's shows took place in raw concrete boxes, stripped to the bare bones. It wasn't a conceptual conceit, like Margiela's; it was merely a void, filled with clothes.

In all three cases, the mode of presentation was a challenge to the hegemony of that 1980s' catwalk. It's tempting to think that it was all aesthetic and ideological – breaking down the systems that had dominated fashion for almost two decades, to propose a brave new future. But there were also technical advances that allowed the catwalk to evolve into its new format. 'Now we have autofocus lenses – technology governs a lot of it,' says Moore, practically. He recalls one client in the early 1990s – W magazine, then at the height of its power under the legendary and draconian publisher John Fairchild – asking for shots from a static point at the end of the catwalk. 'At the beginning, when we had the longer lenses from the back, and they weren't autofocus, you had to concentrate very much to get them to shoot when the models were in focus,' recalls Moore. 'We'd get quite a number [of pictures] that were a little bit soft. Then, as techniques progressed, it worked very well. It does work very well.' Indeed, just as the catwalk survived, with few tweaks, for 20 years from the early 1970s, the position of photographers, piled high into a pyramid-shaped podium at the end of the catwalk, has been fixed since the mid 1990s. The full-length images this arrangement produced became the de facto representation of fashion, replacing the multiple angles of 1980s shots. It also corresponded to the decade's focus on accessories, since the full-length view threw a focus on the extremities of the silhouette, on the handbag as a model turned, or on the shoe as the completion of a look.

These new arrangements also brought logistical problems: given the restricted space at the head of catwalks, with photographers piled high on precarious stacks of camera boxes, safety was often compromised. Podiums collapsed at a number of shows, and a series of strikes were staged by catwalk photographers who said that working conditions were unsafe. At the Autumn/Winter 1999 Paris fashion week, Jean Paul Gaultier's show was boycotted after the house issued credentials to 80 photographers, despite the fact that there was reportedly space for only 20. Photographers refused to cross the picket line, and Gaultier had to issue in-house imagery to publications and television stations. A similar situation had arisen at Claude Montana's show in March 1995, when a CNN cameraman was manhandled by a private security force, resulting in photographers walking out.

Such shows were being staged at a cost of hundreds of thousands – even millions – so this sudden power shift to the image-makers must have been infuriating for many CEOs. The tension that Moore had previously identified between the fashion press and the photographers was now, more markedly, between the photographers and the staff of the fashion houses, who required photography to get their message across (and, most importantly, to sell their products), yet who seemed to hold the photographers in no high regard. 'There's always been antagonism,' allows Moore. 'Catwalk photographers are considered dogs, and are often treated as such. But at the same time, they want us there.' More than merely *wanting*, fashion houses by the 1990s *needed* the photographers there, to help get the message out to the increasing number of viewers poring over images in newspapers and magazines and on television, and to justify the inflated cost of shows that were used primarily as pyrotechnic promotion to sell perfume and licensed goods, rather than showcasing the goods themselves. And, as Moore and Millar correctly predicted, a new horizon was about to open – the possibilities not just of digital imagery, but of digital communication. The digital age was about to begin.

If the Tunisian-born, Paris-based designer Azzedine Alaïa helped to define the short-skirted, broad-shouldered look of the 1980s, his work invented the silhouette of the 1990s: body-conscious, curvaceous, flawlessly cut. In 1990 the designer moved to a 750,000-square-foot space in the city's Marais district, where he based his workrooms and flagship store, and also showed twice a year in the old couture fashion. Alaïa worked to no rhythm other than his own: his shows were often months later than those of every other designer. But everyone still came – including the supermodels, who worked for Alaïa in exchange for clothes.

Azzedine Alaïa
Autumn/Winter 1990
Paris

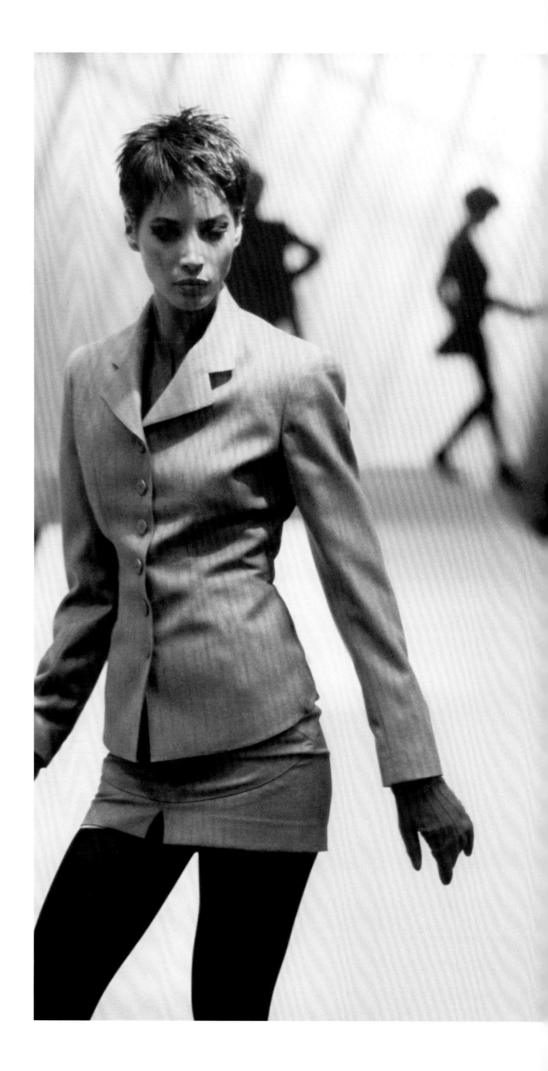

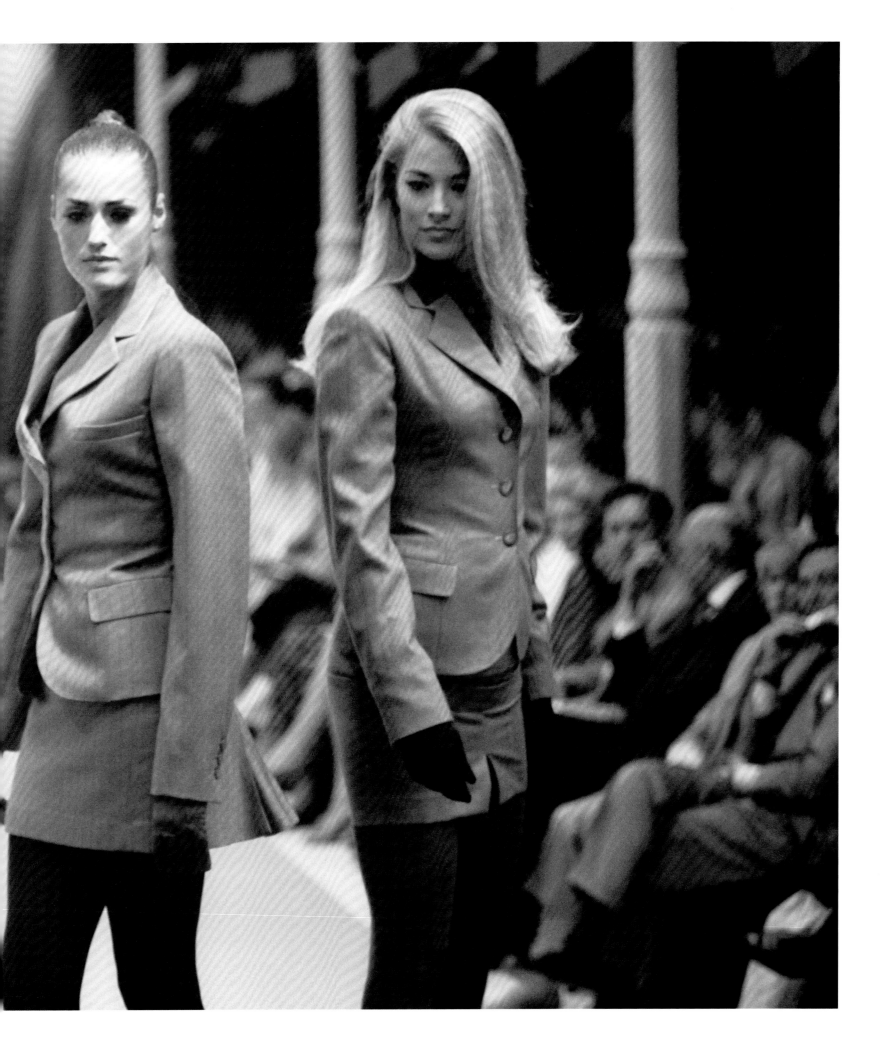

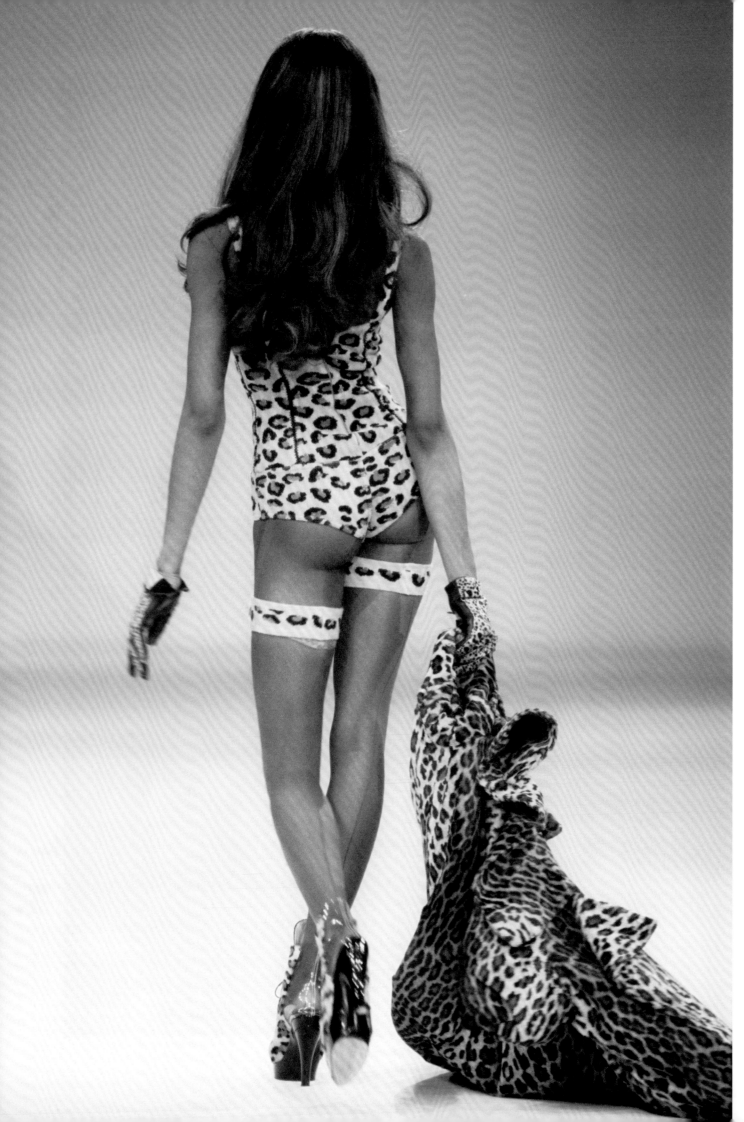

Left:
Azzedine Alaïa
Autumn/Winter 1991
Paris

Opposite:
André Leon Talley, the
then Creative Director
of American *Vogue*, who
stands 2 metres tall (six foot
seven inches), alongside
Azzedine Alaïa, who is
1.6 metres tall (five foot
three inches), photographed
at a party thrown for the
pop star Madonna.

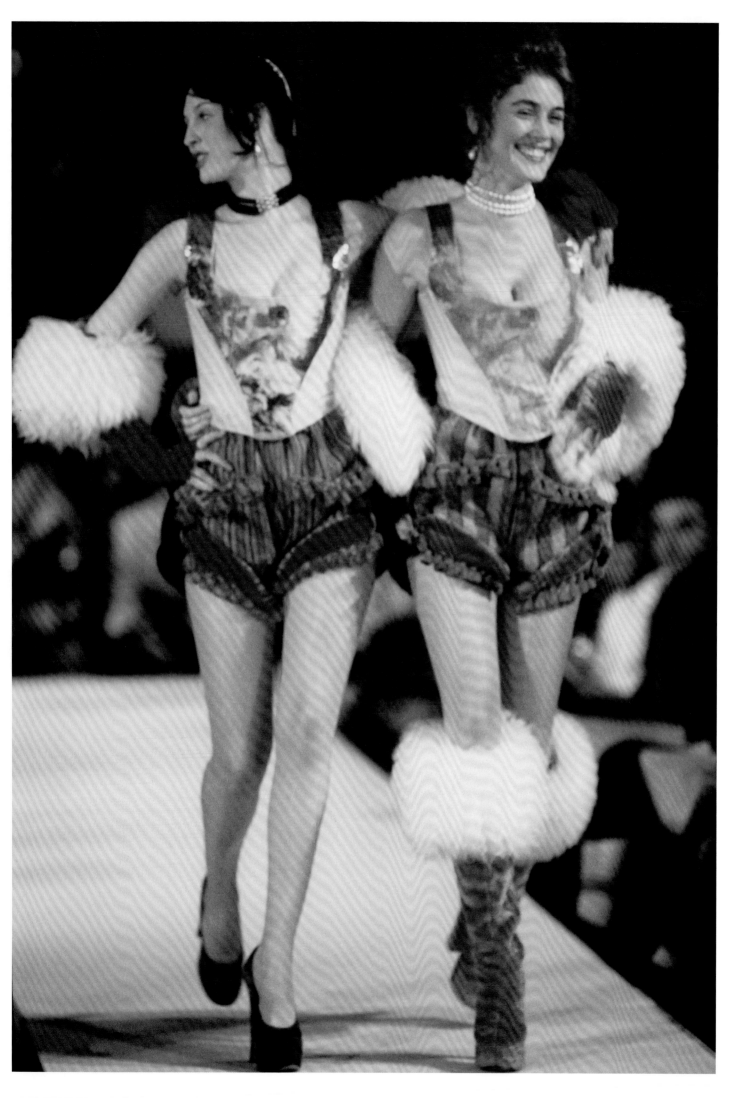

Left:
Vivienne Westwood
Autumn/Winter 1990
London

Opposite:
Yohji Yamamoto
Autumn/Winter 1990
Paris

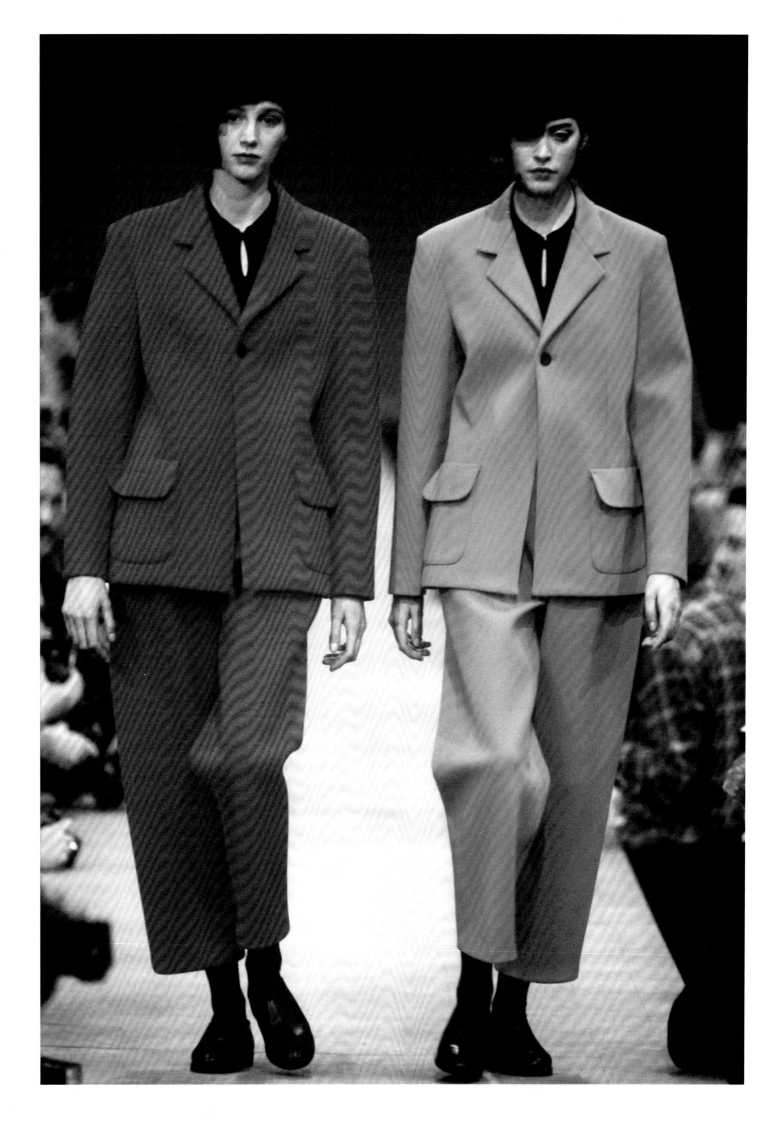

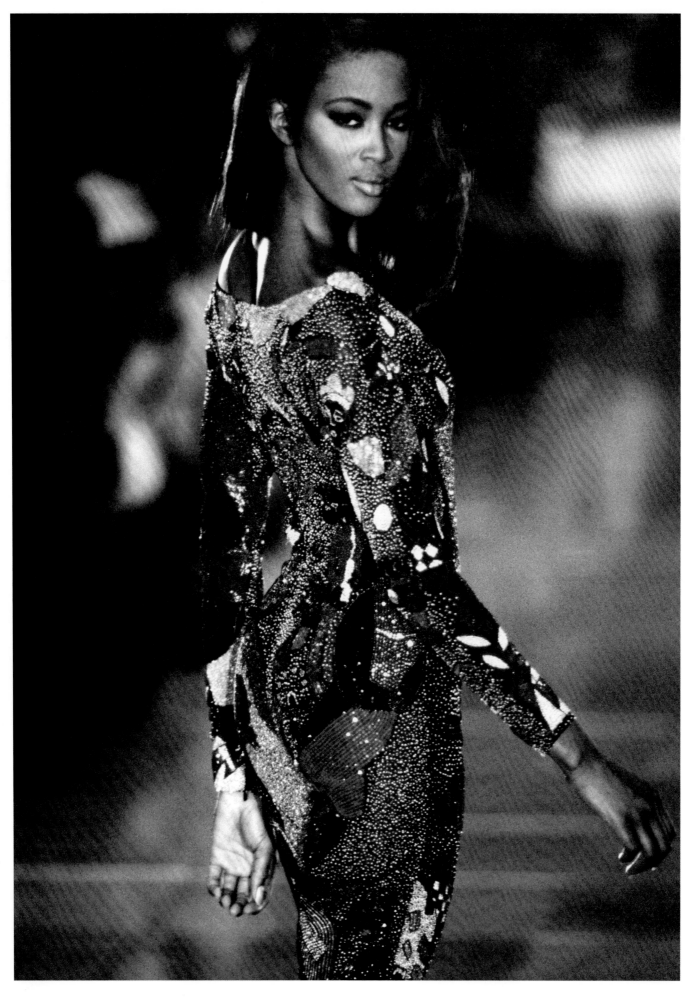

Gianni Versace created
the supermodels. He
paid the likes of Naomi
Campbell and Karen Mulder
astronomical fees, cut his
clothes to enhance their
already perfect physiques,
and featured them
prominently in high-octane
shows staged like rock
concerts with klieg lights
and thumping soundtracks
by Prince or George Michael.
The Milan-based designer
crafted the supermodel
myth through his catwalk,
and his name has been
inextricably linked with
theirs ever since.

Left:
Versace
Spring/Summer 1991
Milan

Opposite:
Versace
Autumn/Winter 1991
Haute Couture, Paris

Overleaf:
The designer Gianni
Versace surrounded
by supermodels.

Versace
Autumn/Winter 1992
Milan

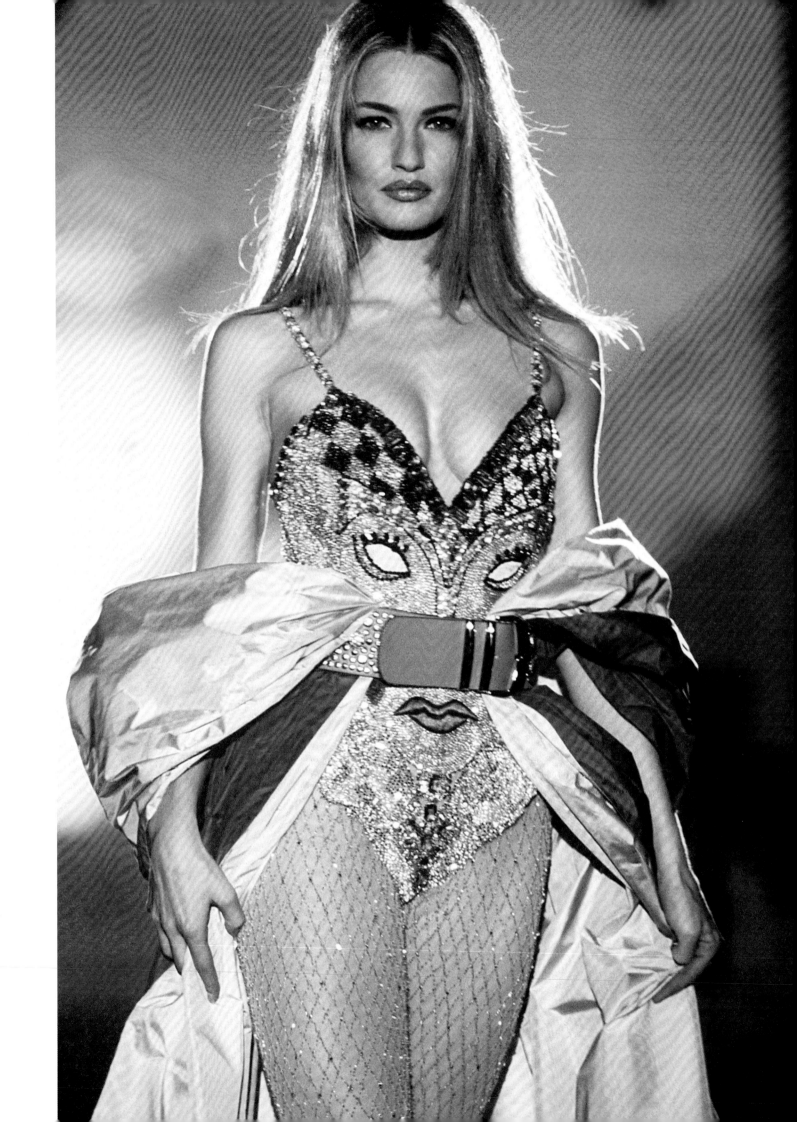

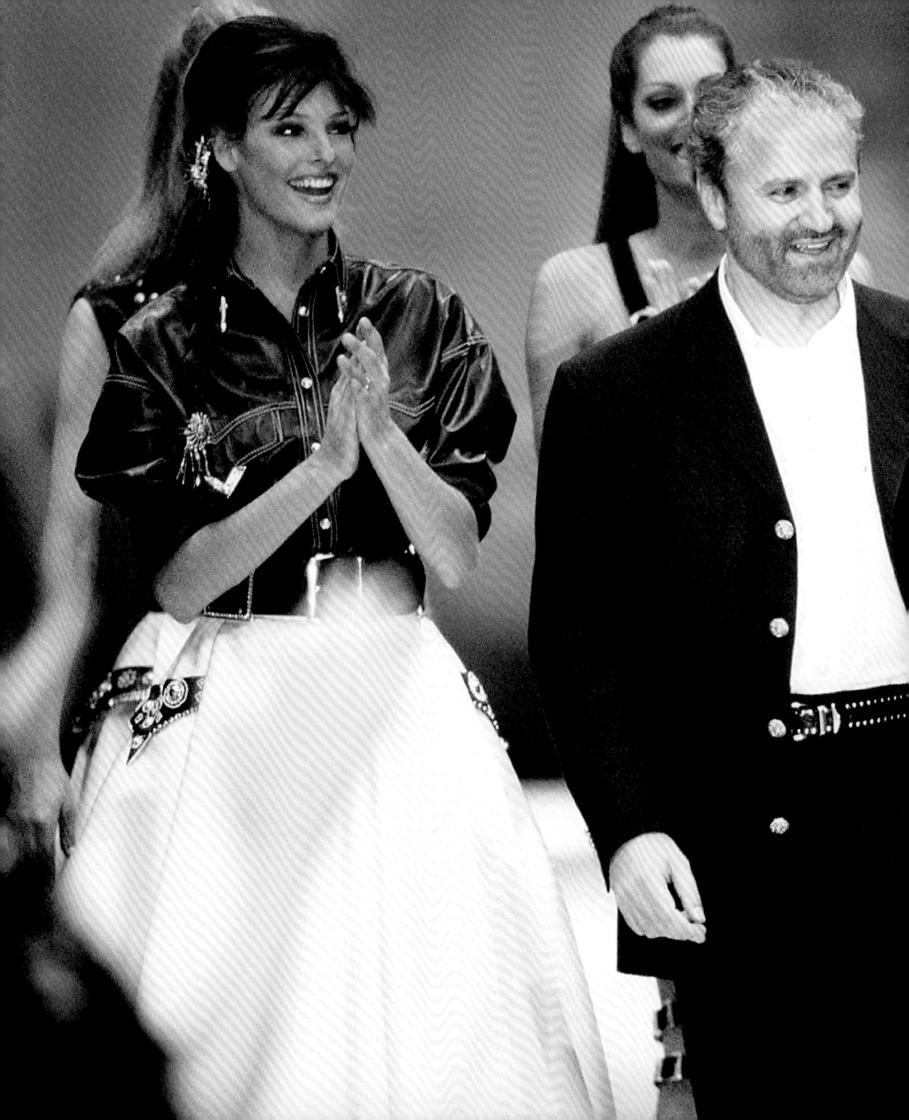

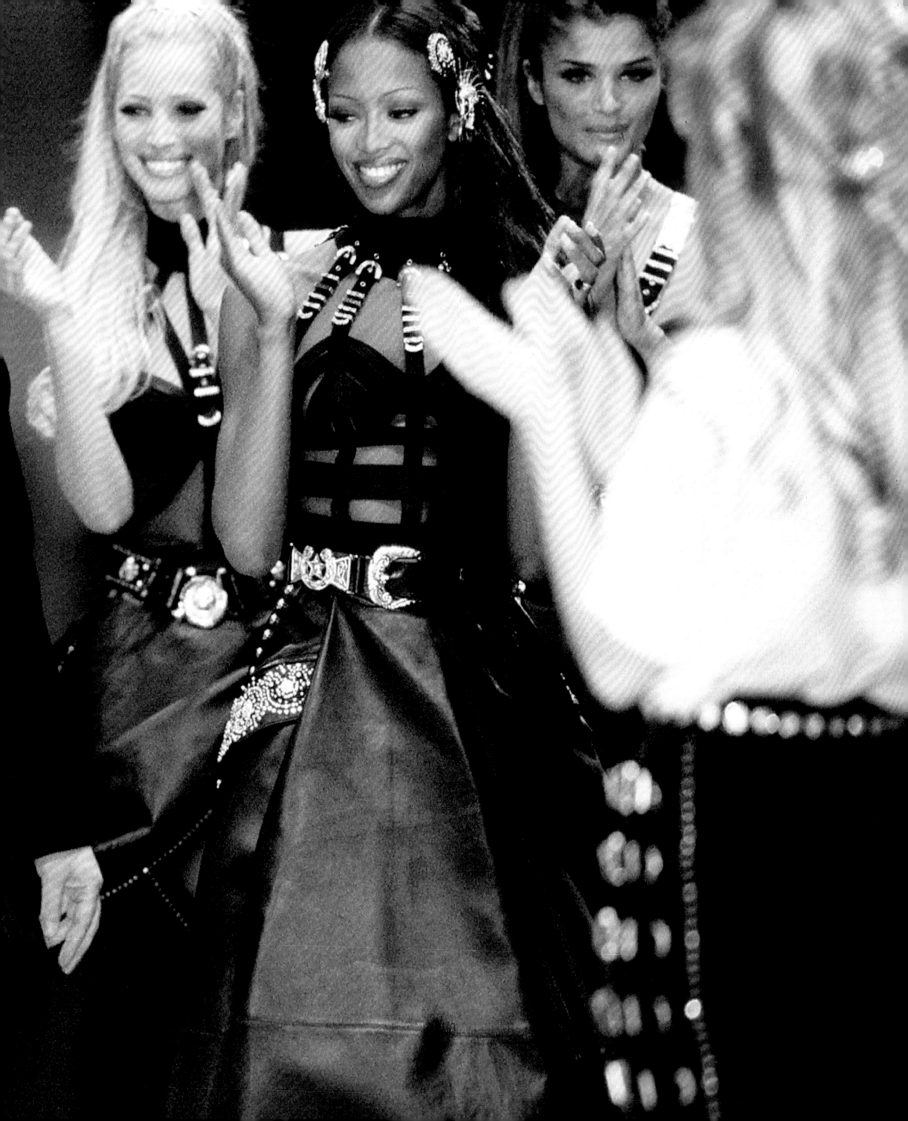

NAOMI

8186

ALISTAIR BLAIR 217

chris Moore

@CHRIS MOORE

NAOMI CAMPBELL 9089

@Chris Moore

@Chris Moore

2317 NAOMI

CHRIS MOORE

ANNA SUI SPRING 1996

CHRIS MOORE

0980

NAOMI

@CHRIS MOORE

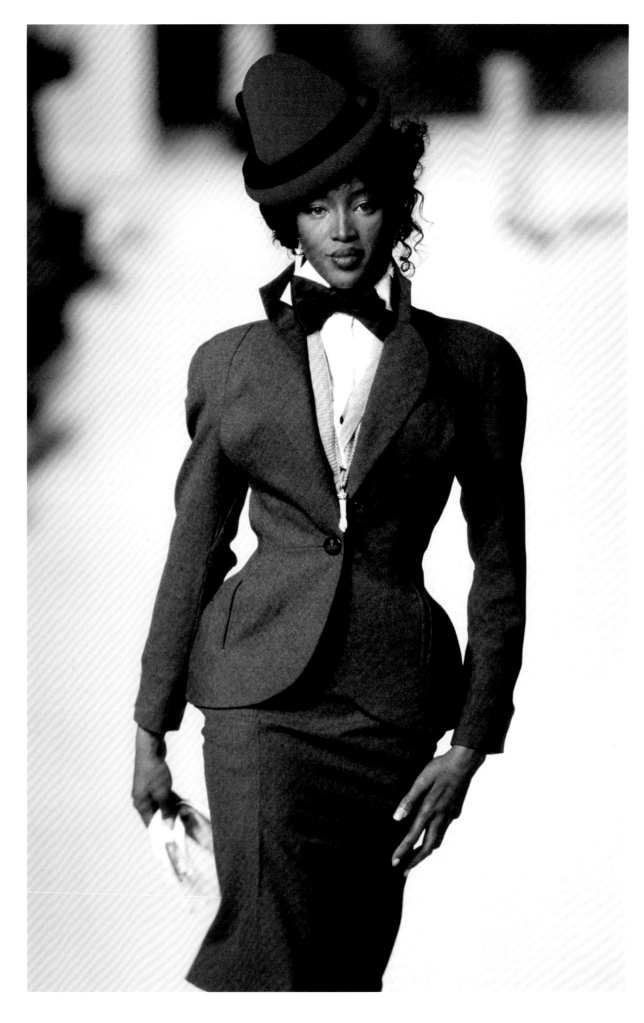

Naomi Campbell began modelling aged 15 and was on the cover of her first magazine within a year, shortly after her catwalk debut. Born in Streatham in South London, Campbell became known for a pneumatic, hip-swivelling, panther-like walk that proved immediately recognizable. 'You couldn't mistake Naomi for anyone else,' says Moore. 'She is one of a kind.' Campbell became one of the most high-profile supermodels, heavily associated with the clothes of Gianni Versace, Azzedine Alaïa (who designed a dress specifically for Campbell in 1987) and Vivienne Westwood, whose signature super-elevated nine-inch platform shoes famously caused Campbell to fall at the designer's show in March 1993.

Vivienne Westwood
Autumn/Winter 1995
Paris

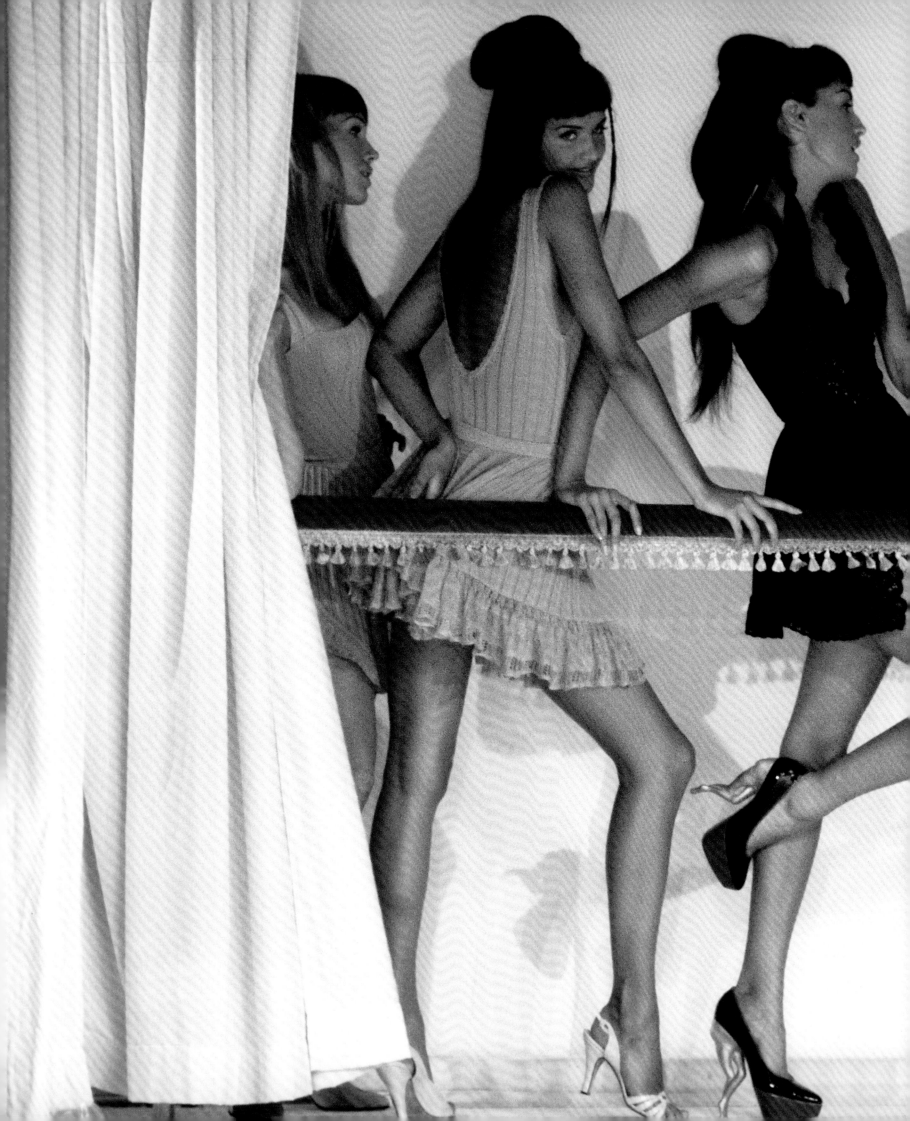

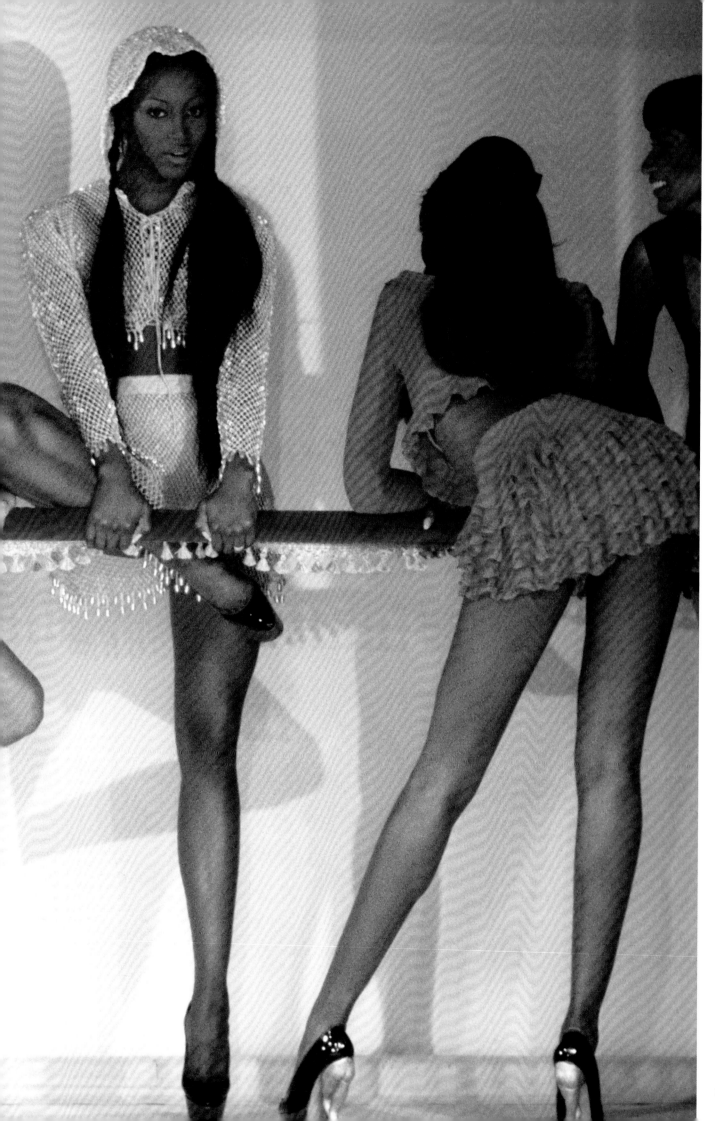

Azzedine Alaïa
Spring/Summer 1992
Paris

Christian Lacroix
Autumn/Winter 1991
Haute Couture, Paris

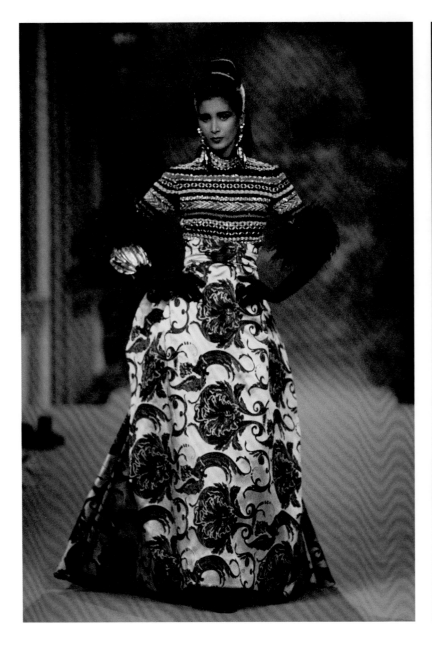

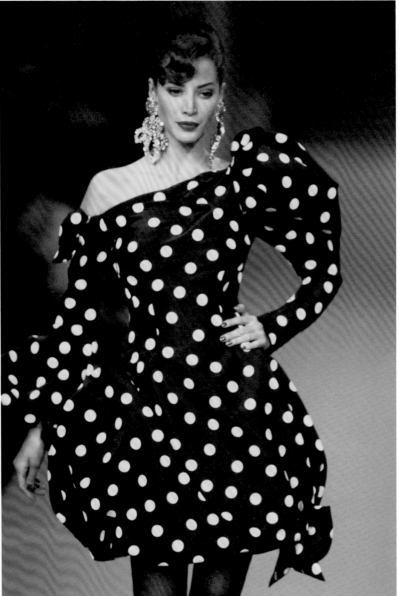

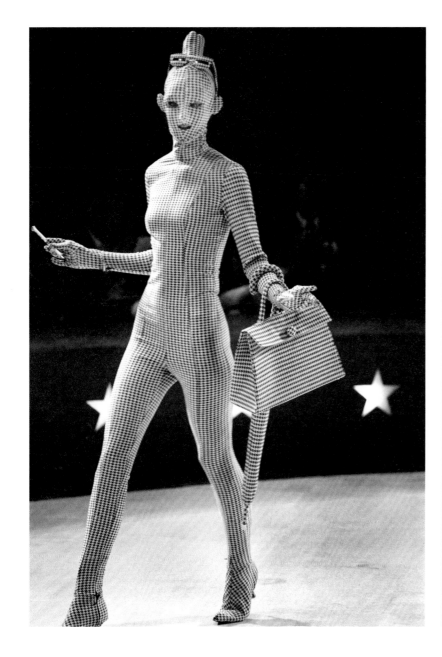

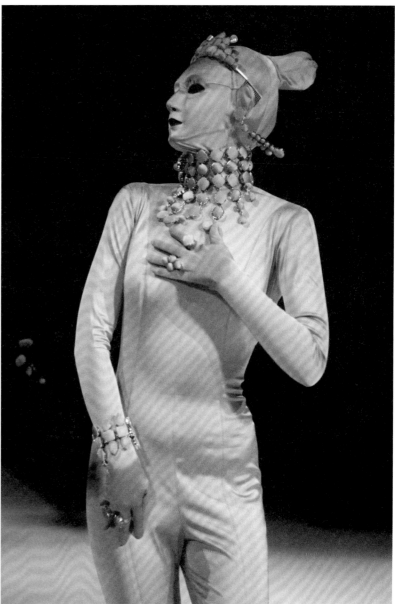

Moore was at hand to document the entire supermodel phenomenon: 'you know when it was the turn of the century – not this century, the last one – you had people waiting at the stage door of theatres, admiring the chorus girls?

Well, that feeling was very much there with the supermodels – they were these almost mythical creatures and people were desperate to see them. I think it's gone a bit now, but it seemed to be more so in the 1990s.'

Below:
Chanel
Autumn/Winter 1992
Paris

Opposite:
Chanel
Spring/Summer 1993
Paris

2813

Christy

DIOR HC 92

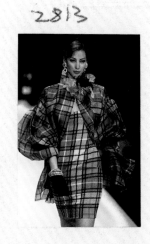

AW

9325

VERSACE H.C 92

CHRIS MOORE

CHRISTY TURLINGTON

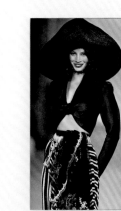

LACROIX
H.C S/S 93
CHRIS MOORE

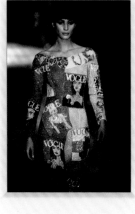

CHRIS MOORE

16. SS
VERSACE

Turlington — 0986. Tribal

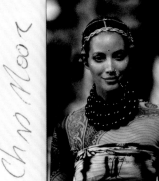

2001 NY

Gualtier SS96

Christy

FERRE AW93

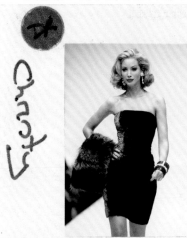

2911

CH. LACROIX
FALL WINTER 92

9325

AW 92

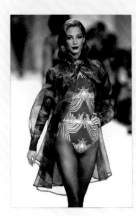

CHLOE

TODD OLDHAM
S/S 94

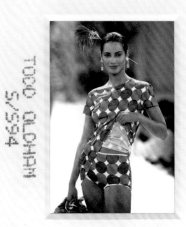

CHRIS MOORE

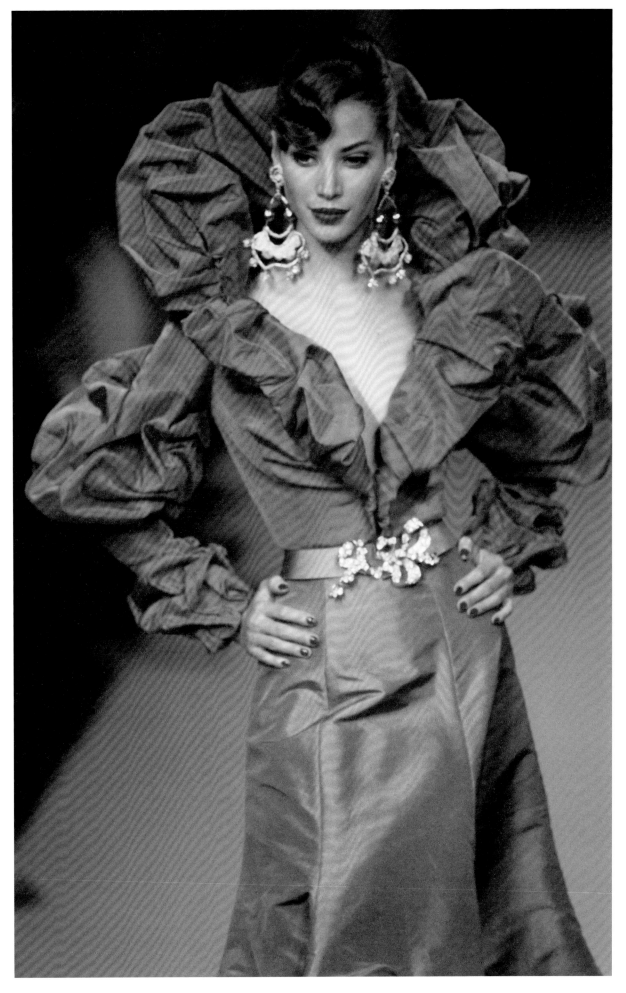

Christy Turlington rose to fame as a teenager in the 1980s, appearing in Duran Duran's 'Notorious' video in 1986, aged 17. By that time the Californian-born Turlington was already modelling internationally for a variety of designers and photographers. Her classic beauty ensured her career's longevity and versatility. 'Christy was my favourite,' says Moore. 'There is a relationship, between a great model and the catwalk photographers. We really work together.'

Christian Lacroix
Autumn/Winter 1991
Haute Couture, Paris

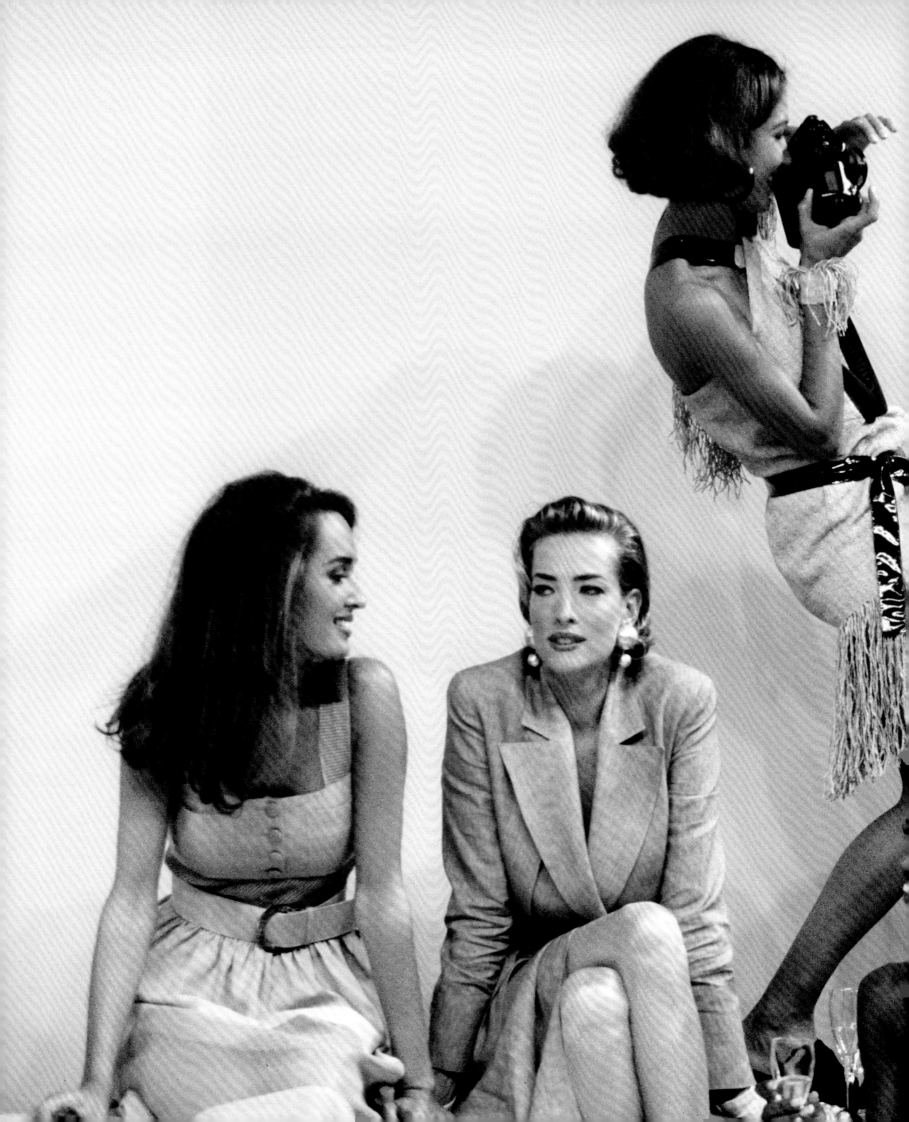

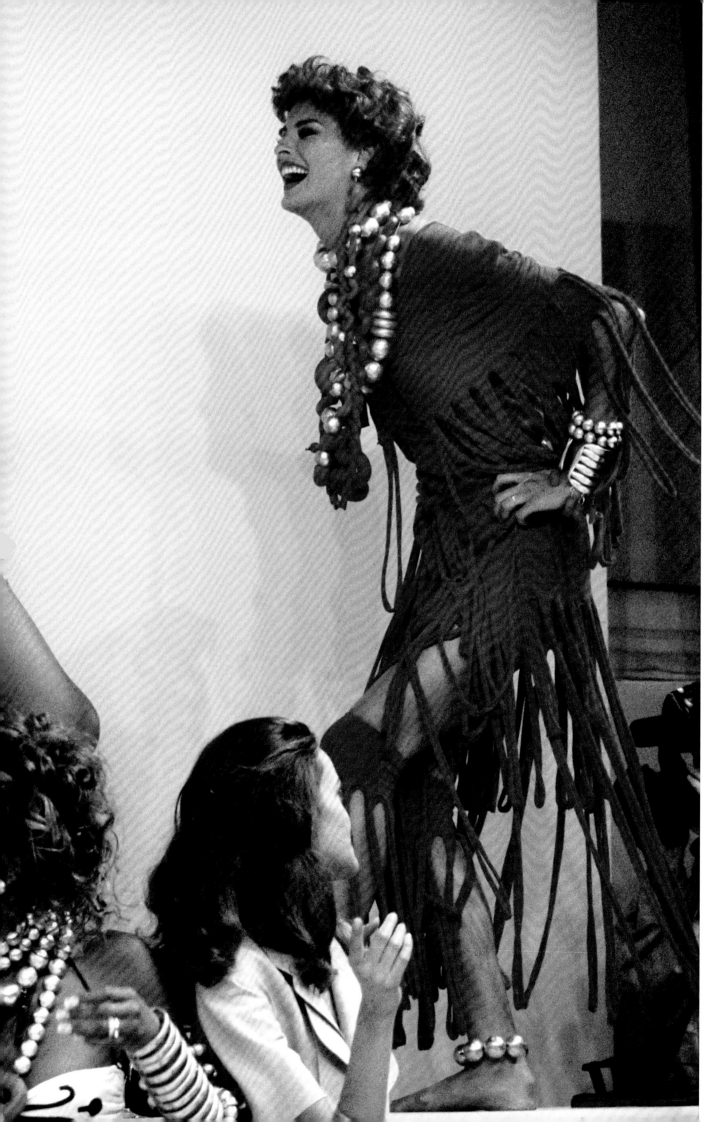

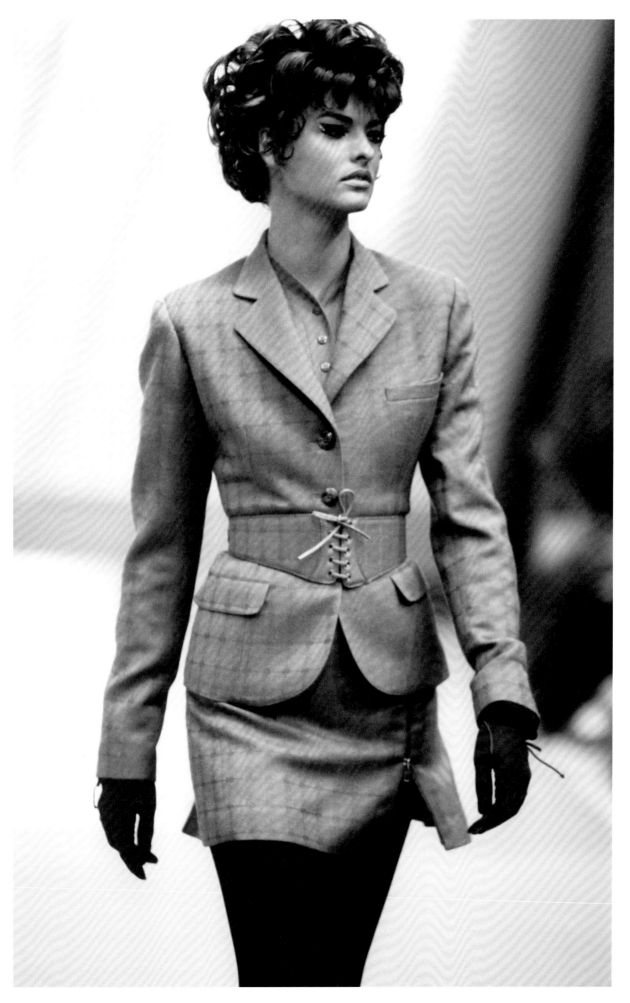

Linda Evangelista's career began in 1984, but by the early 1990s had reached stratospheric heights never attained by a model before. Alongside the other supermodels, Evangelista was afforded the status of a rock star or Hollywood actress, and she was a ubiquitous presence across the decade's catwalks and advertising campaigns. Karl Lagerfeld, who featured Evangelista frequently, once called her the modelling industry's Stradivarius – an instrument you could play like nothing else. The ever-transforming hairstyles of this Canadian chameleon commanded headlines of their own. 'The best kind of model is a performer,' says Moore. 'All the supermodels were actresses, really. They performed for us.'

Azzedine Alaïa
Autumn/Winter 1991
Paris

Moore recalls the struggle behind this remarkable shot, of Yves Saint Laurent and the actress and unofficial house mascot Catherine Deneuve: 'Suzy Menkes wanted me to get this picture, backstage after the show, but I was in the photographers' pen shooting the show. But she was the boss. So I had to get out of the pen, which meant I had to jump over a barrier and run backstage. Of course, all these agency guys were there before me, but as it happens, there was a table full of jewellery. I persuaded somebody to sweep the jewellery to one side and I got up on the table, so I was able to shoot down over the agency guys. I was just lucky enough to get this shot. It was a scramble of outsize proportion!'

Yves Saint Laurent
Autumn/Winter 1992
Haute Couture, Paris

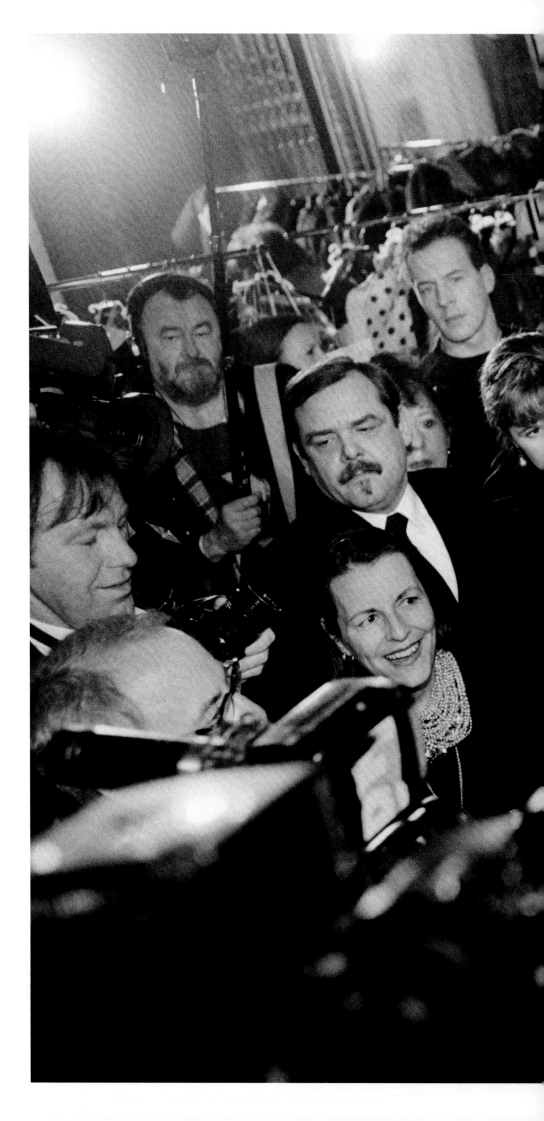

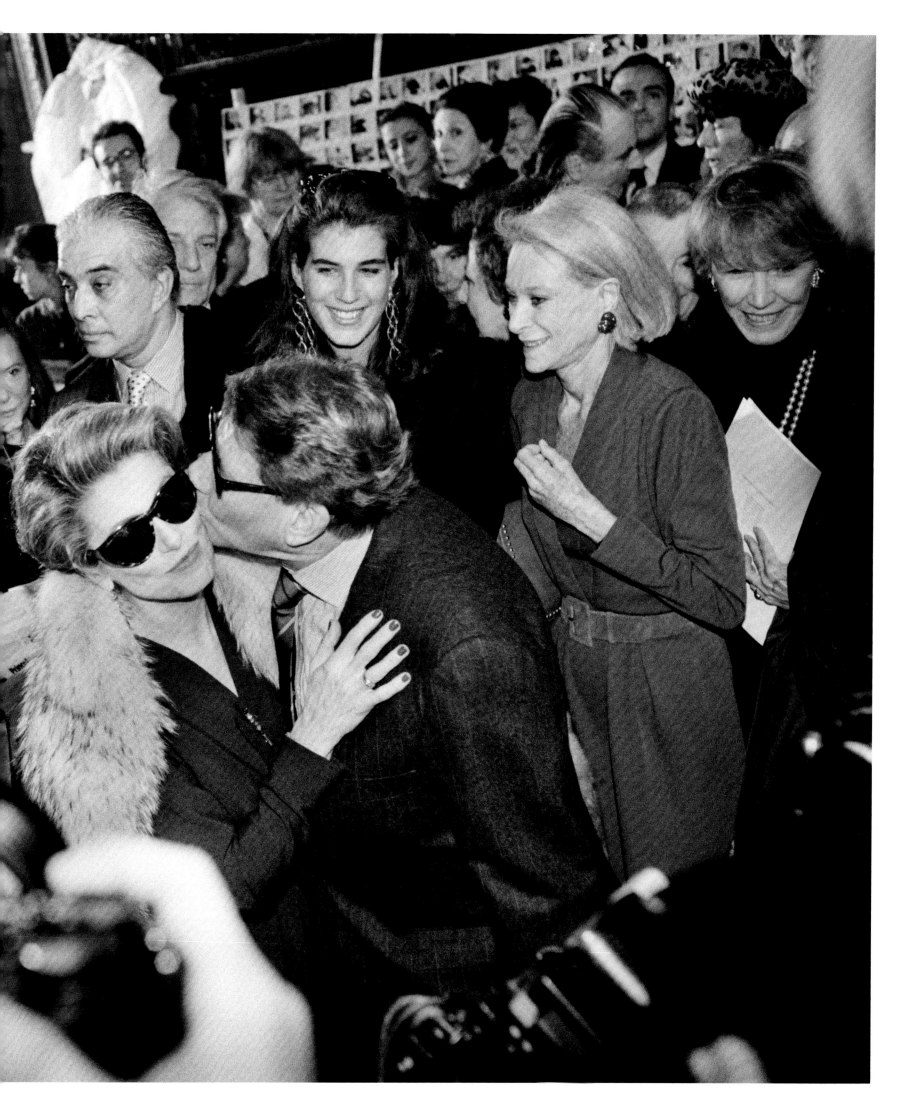

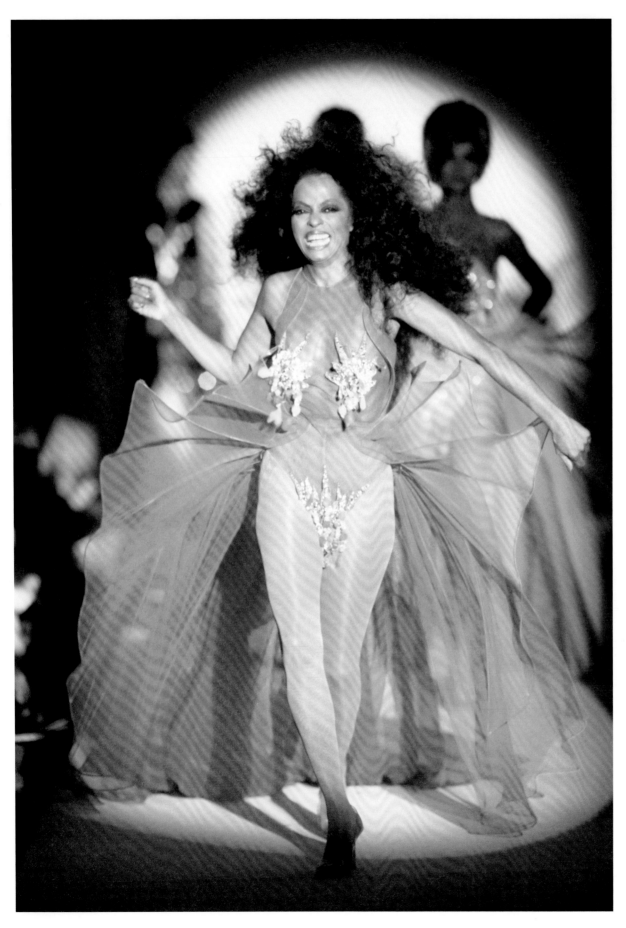

The obsession with noteworthy models could reach extremes. At Thierry Mugler's Spring/Summer 1991 show, superstars replaced supermodels: Diana Ross, Lauren Hutton and Jade Jagger took to the catwalk in front of guests including Madonna and Danielle Mitterrand, wife of the French President at the time.

Left:
Thierry Mugler
Spring/Summer 1991
Paris

Opposite:
Yves Saint Laurent
Autumn/Winter 1992
Haute Couture, Paris

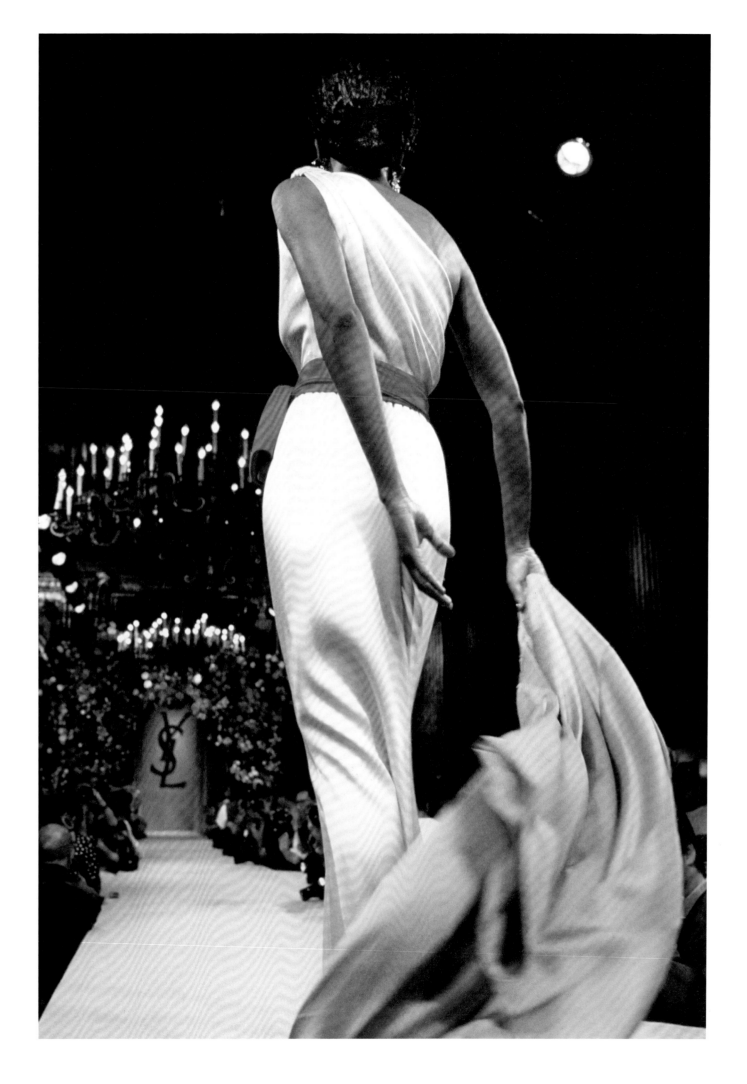

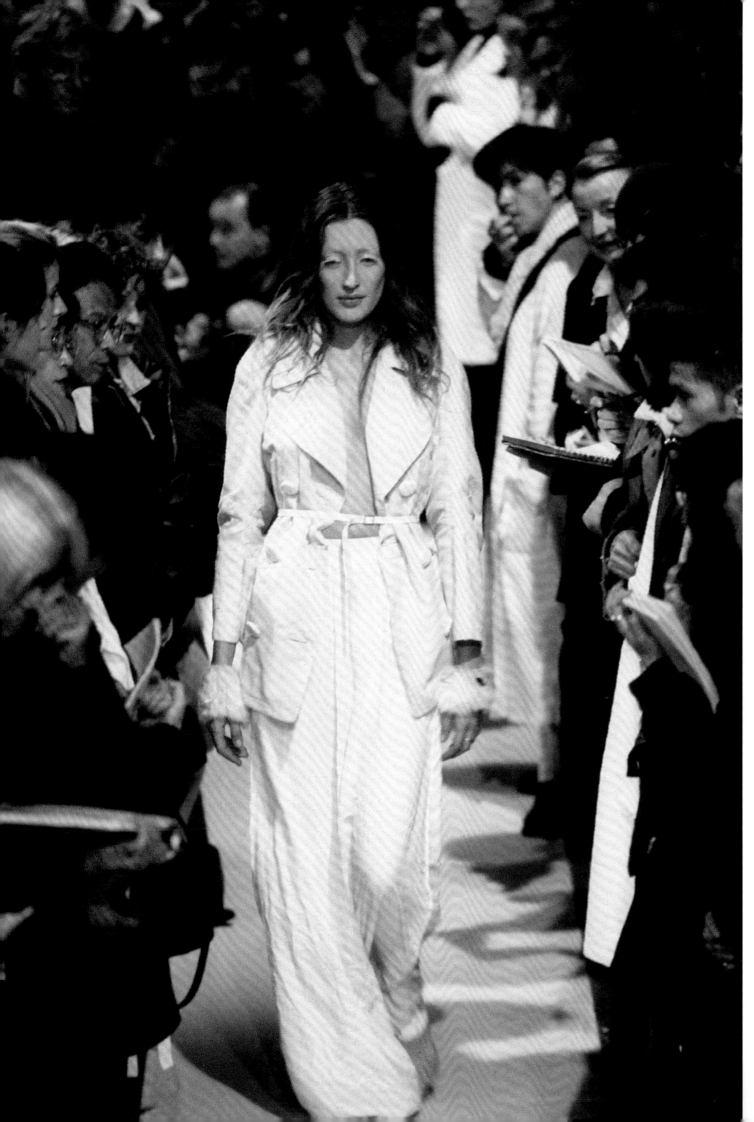

The work of the Belgian designer Martin Margiela was the antithesis of superstar designers like Gianni Versace, or Jean Paul Gaultier, for whom Margiela worked before establishing his label in 1988. Margiela himself refused to be photographed, and his label was a blank white rectangle. In a similar vein, his fashion shows featured clothes created from vintage garments or 'anti-luxe' fabrics such as cheap lining materials, or from plastic. Dubbed 'deconstruction' in reference to their artfully distressed appearance, Margiela's clothes offered an alternative, and highly influential, view of fashion at the turn of the twentieth century.

Left:
Maison Martin Margiela
Spring/Summer 1993
Paris

Opposite:
Maison Martin Margiela
Autumn/Winter 1992
Paris

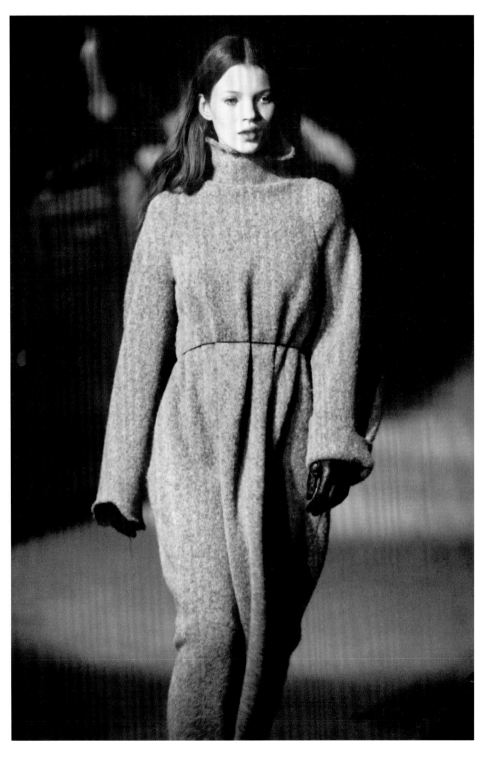

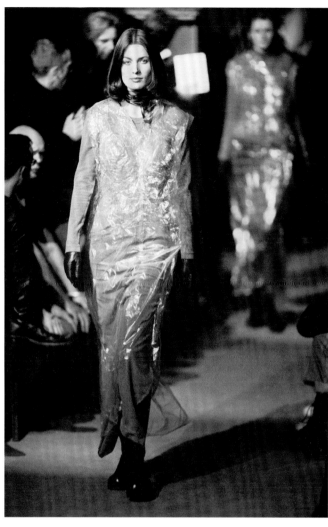

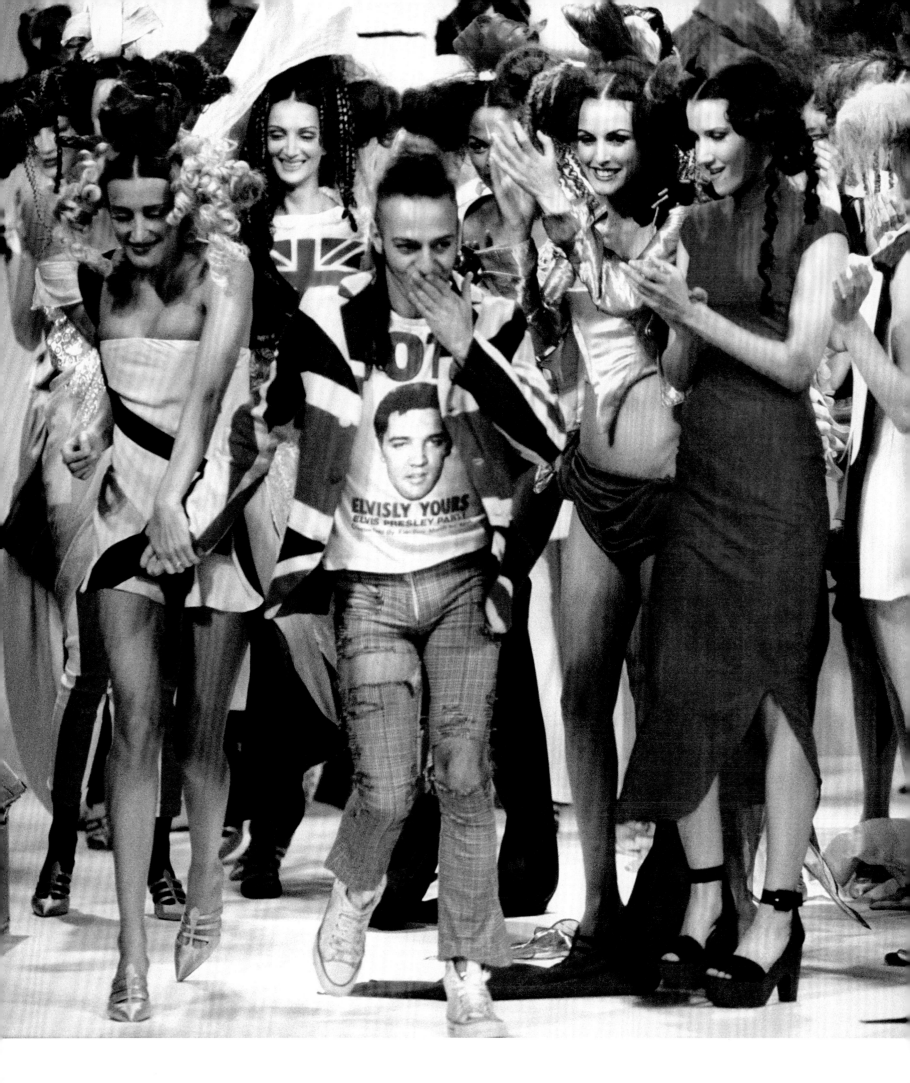

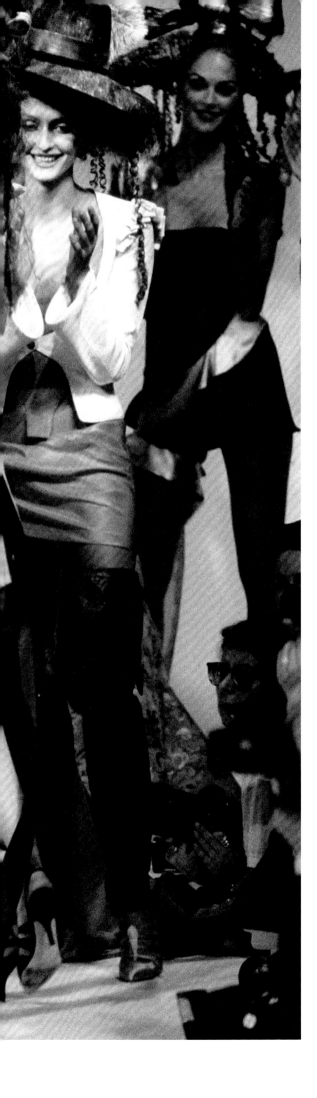

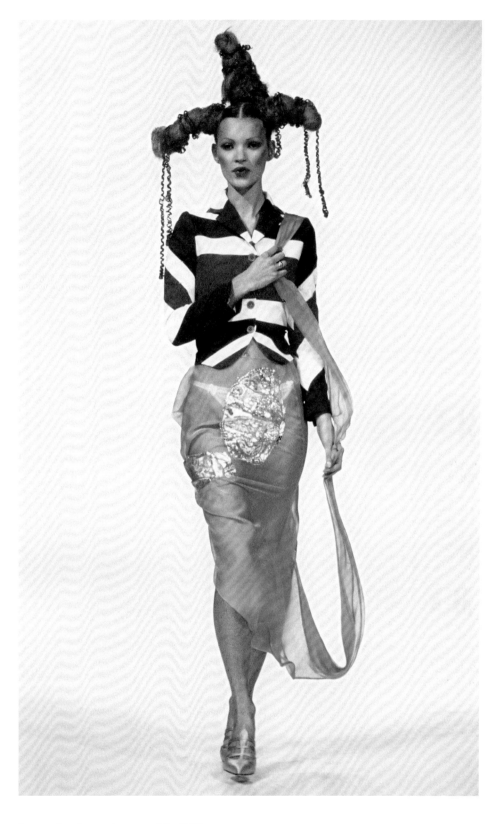

'It was a three-hour wait, that show,' recalls Moore of John Galliano's blockbuster 'Olivia the Filibuster' catwalk show in 1992. Thanks to the complex hair and make-up inherent in Galliano's vision, such delays were often inevitable. 'It was worth it. It was always worth it,' says Moore.

John Galliano
Spring/Summer 1993
Paris

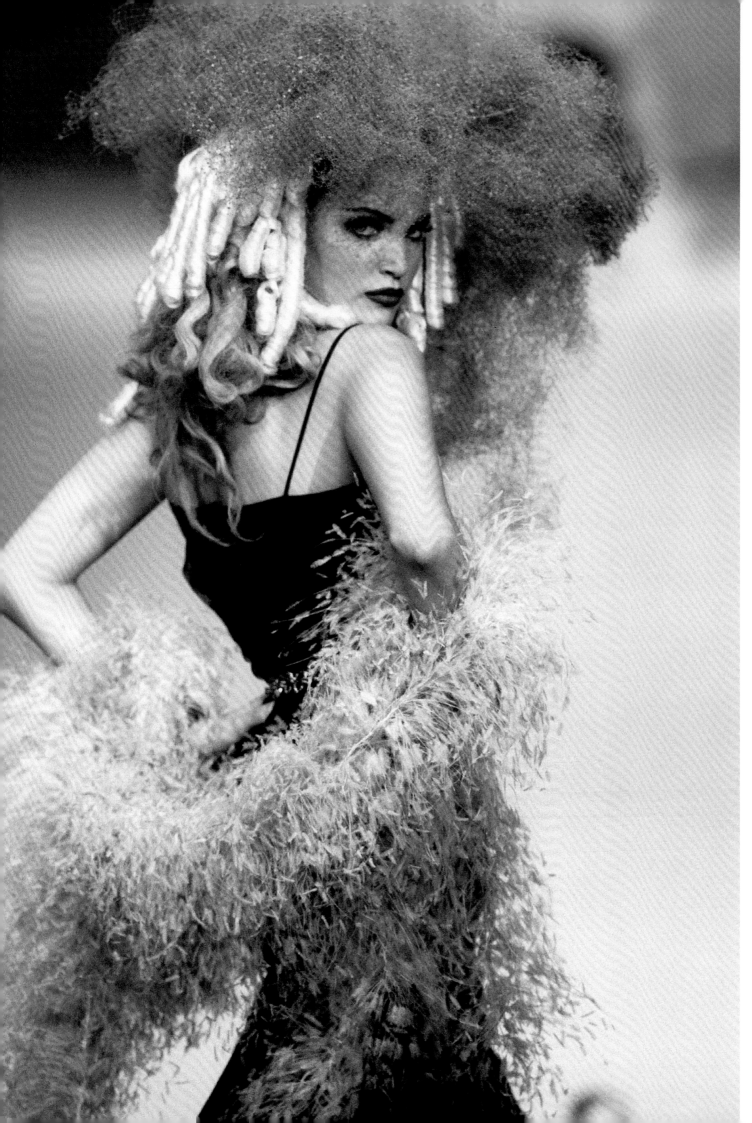

The dichotomy of fashion in the 1990s: glamour faced off with Grunge in 1992. In Paris, the haute couture shows continued to dominate headlines, despite minute sales. But, influenced by Maison Martin Margiela, a new mood of deconstruction had begun to influence fashion, as seen in New York designer Marc Jacobs's 'Grunge' collection for Perry Ellis, influenced by the Seattle music scene. Jacobs was fired after the show.

Left:
Chanel
Spring/Summer 1992
Haute Couture, Paris

Opposite:
Perry Ellis
Spring/Summer 1993
New York

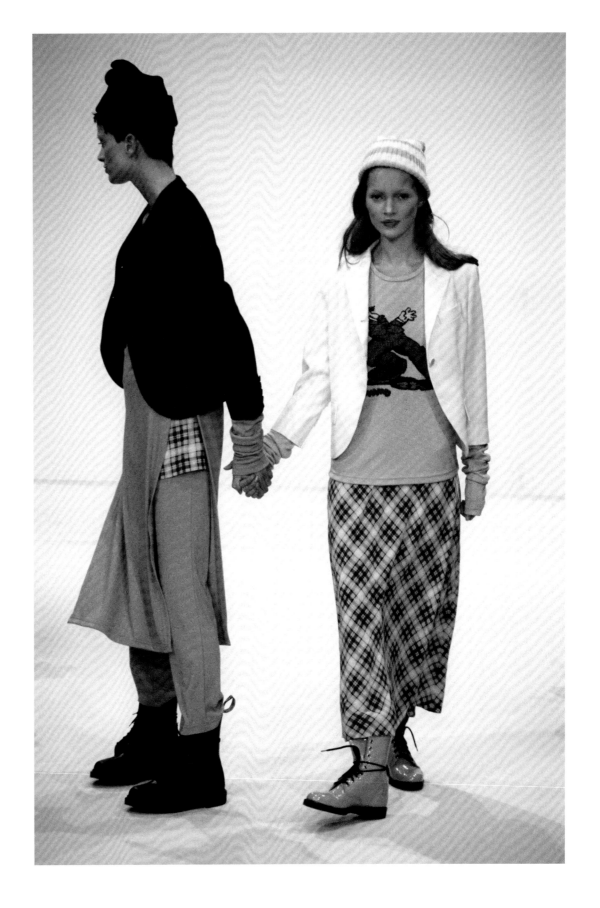

Left:
Jean Paul Gaultier
Spring/Summer 1993
Paris

Opposite:
Jean Paul Gaultier
Autumn/Winter 1993
Paris

Overleaf:
Christian Lacroix
Autumn/Winter 1993
Haute Couture, Paris

Alexander McQueen, the son of a London cab driver, burst onto the London fashion scene with his first show in 1993. His clothes frequently tackled extreme themes – sex and death, club culture mixed with contemporary references and emphasized by theatrical presentations – but were invariably impeccably tailored, a result of a teenage apprenticeship on Savile Row. He first raised eyebrows by lowering the waistband of trousers, a style he called 'bumsters' (a variation on the then fashionable hipster), which revealed the cleavage of the buttocks. 'McQueen's shows were audacious and irreverent,' says Moore. 'They spoke more to his public than to his buyers or press.'

Alexander McQueen
Autumn/Winter 1994
London

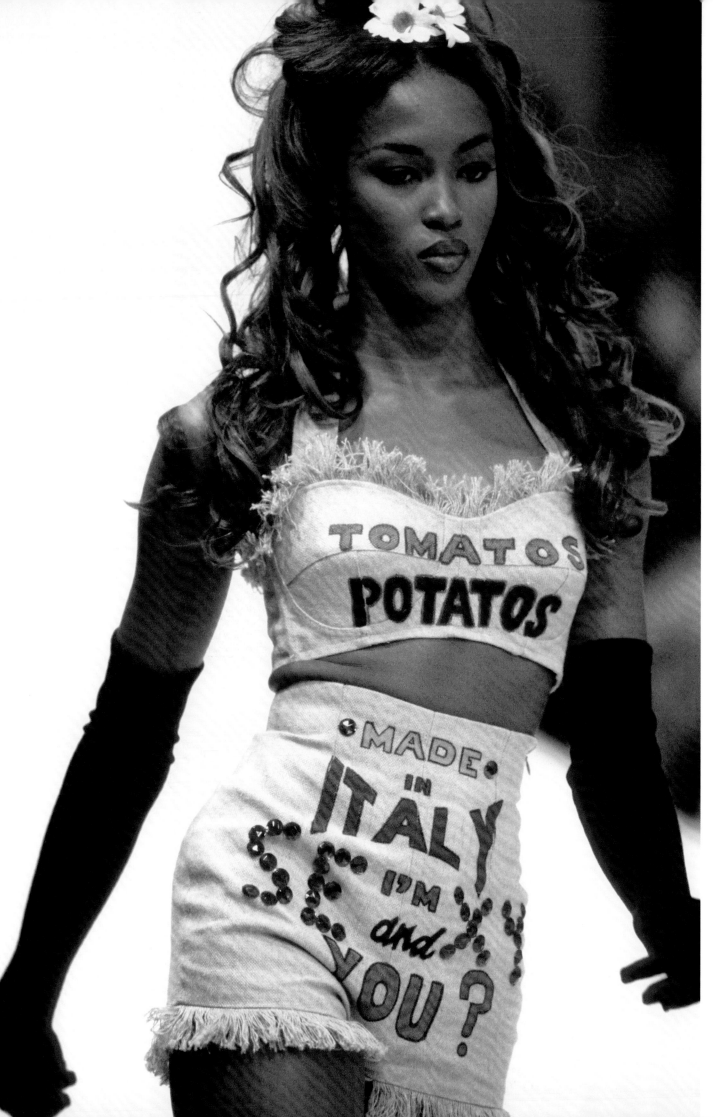

Dolce & Gabbana
Spring/Summer 1992
Milan

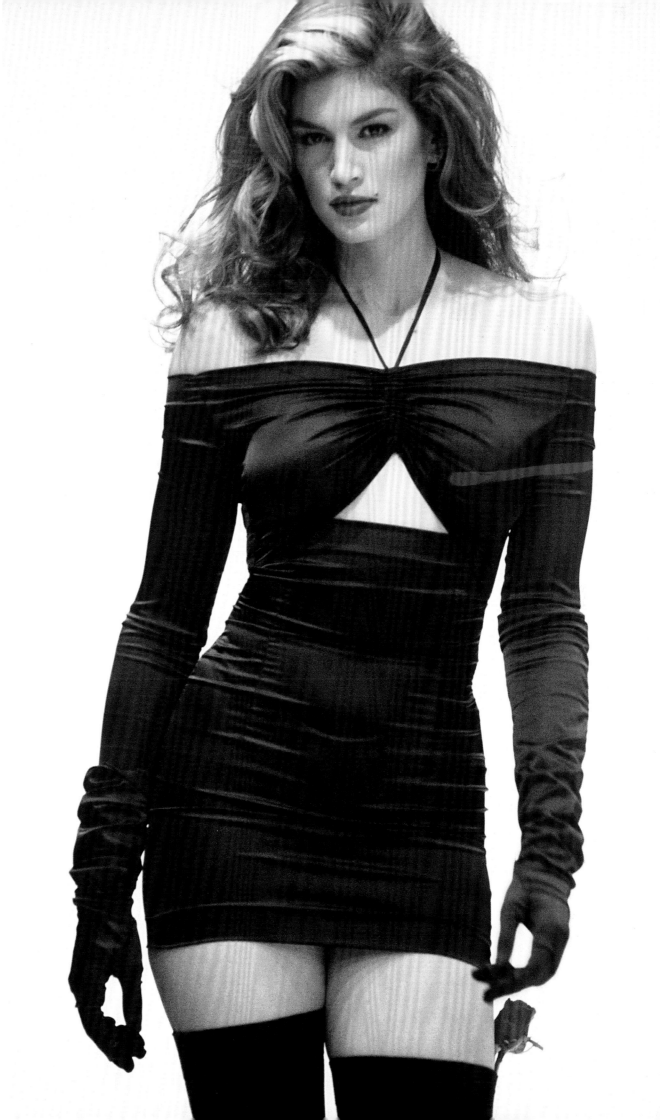

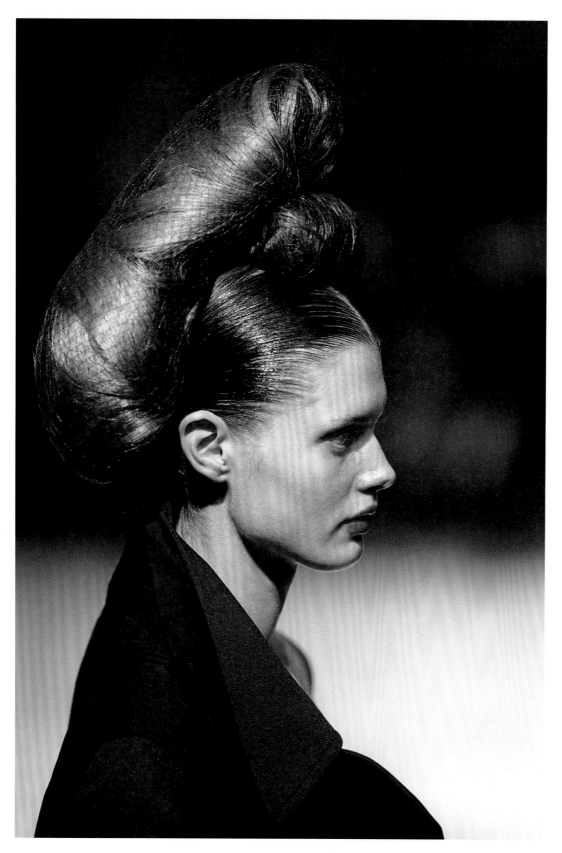

Left:
Comme des Garçons
Spring/Summer 1999
Paris

Opposite:
Comme des Garçons
Autumn/Winter 1994
Paris

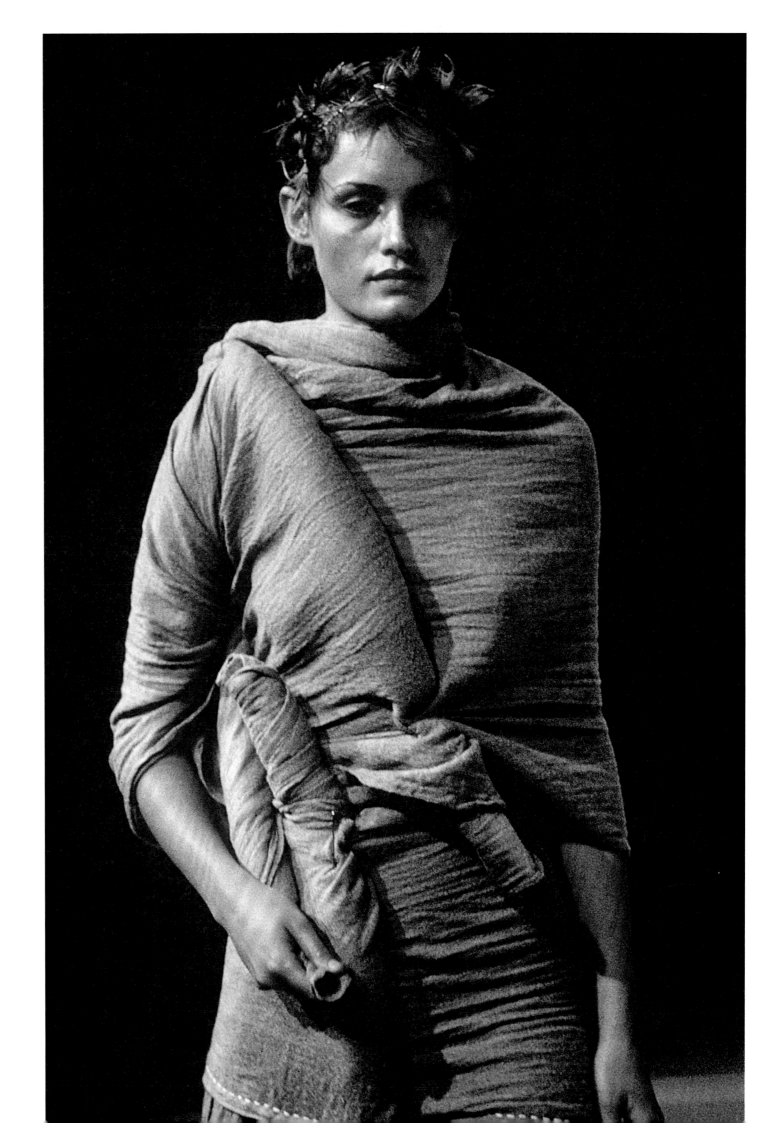

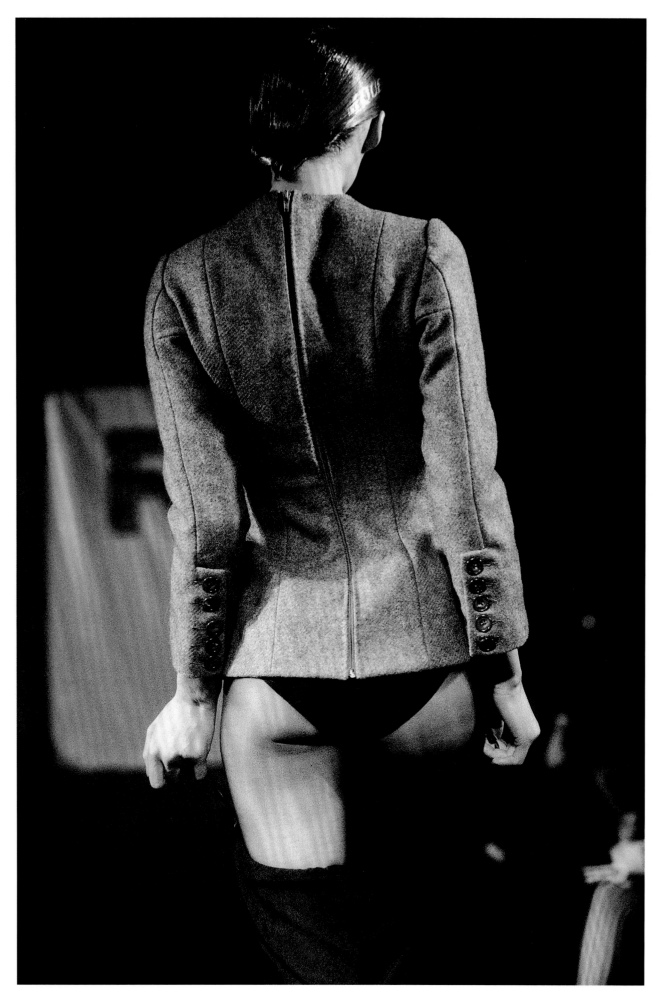

Left:
Alexander McQueen
Autumn/Winter 1994
London

Opposite:
Giorgio Armani
Autumn/Winter 1995
Milan

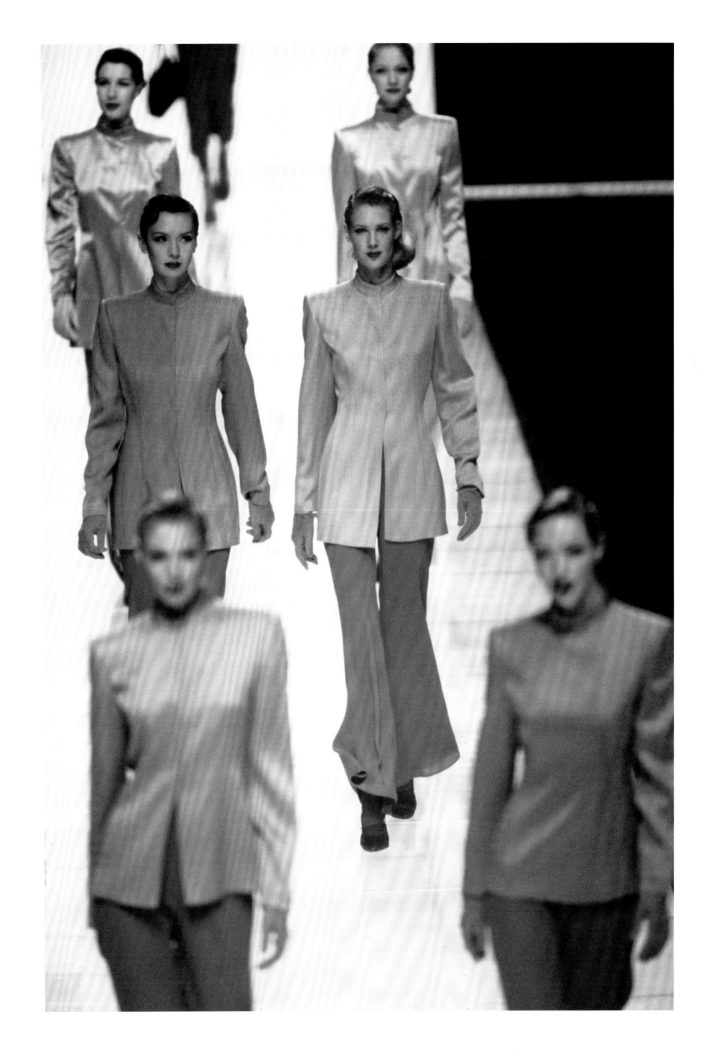

ISAAC MIZRAHI FALL 1994 — CHRIS MOORE

MIZRAHI AW 94 — CHRIS MOORE

CHRIS MOORE — MIZRAHI AW 94

ISAAC MIZRAHI FALL 1994 — CHRIS MOORE

CHRIS MOORE — MIZRAHI AW 94

ISAAC MIZRAHI FALL 1994 — CHRIS MOORE

MIZRAHI AW 94 — CHRIS MOORE

ISAAC MIZRAHI FALL 1994 — CHRIS MOORE

ISAAC MIZRAHI FALL 1994 — CHRIS MOORE

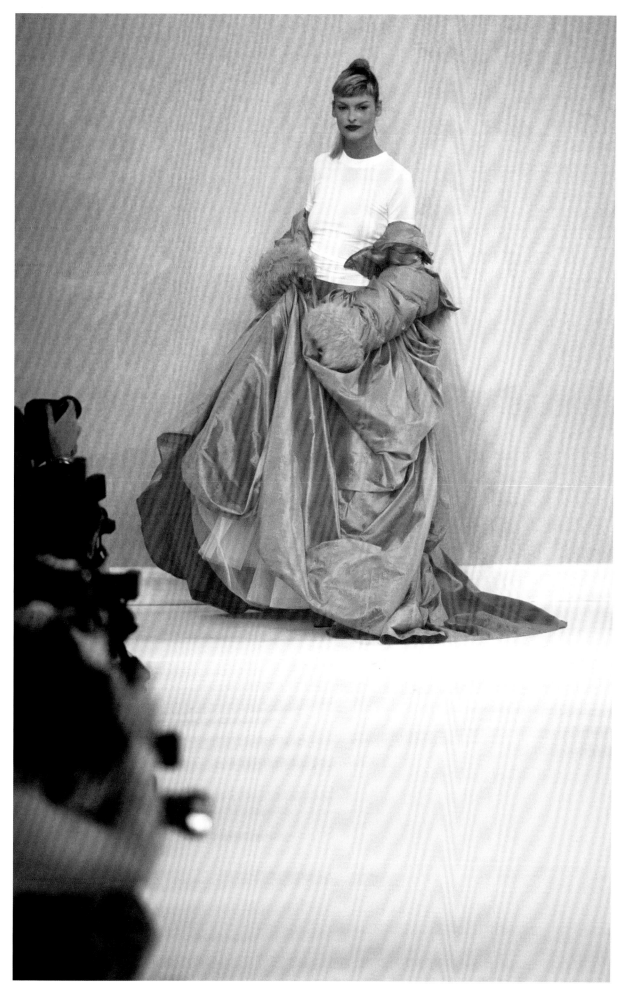

Isaac Mizrahi was a darling of 1990s New York fashion. While Robert Altman's ill-fated fashion-industry farce *Prêt-à-Porter* was filmed in Paris, across the Atlantic Mizrahi collaborated with his then boyfriend, the director Douglas Keeve, to chart the evolution of his Autumn/Winter 1994 collection via film. The always-on-camera ethos extended to the show, where supermodels were exposed, even while offstage, via a transparent theatrical scrim. Mizrahi brought backstage to centre stage, opening up a secret world up for all to see. Depicting events from the drubbing by *Women's Wear Daily* of his previous collection, through to the ecstatic next-day reviews of this, the resulting documentary was entitled *Unzipped*.

Left and previous page:
Isaac Mizrahi
Autumn/Winter 1994
New York

Chanel
Spring/Summer 1995
Haute Couture, Paris

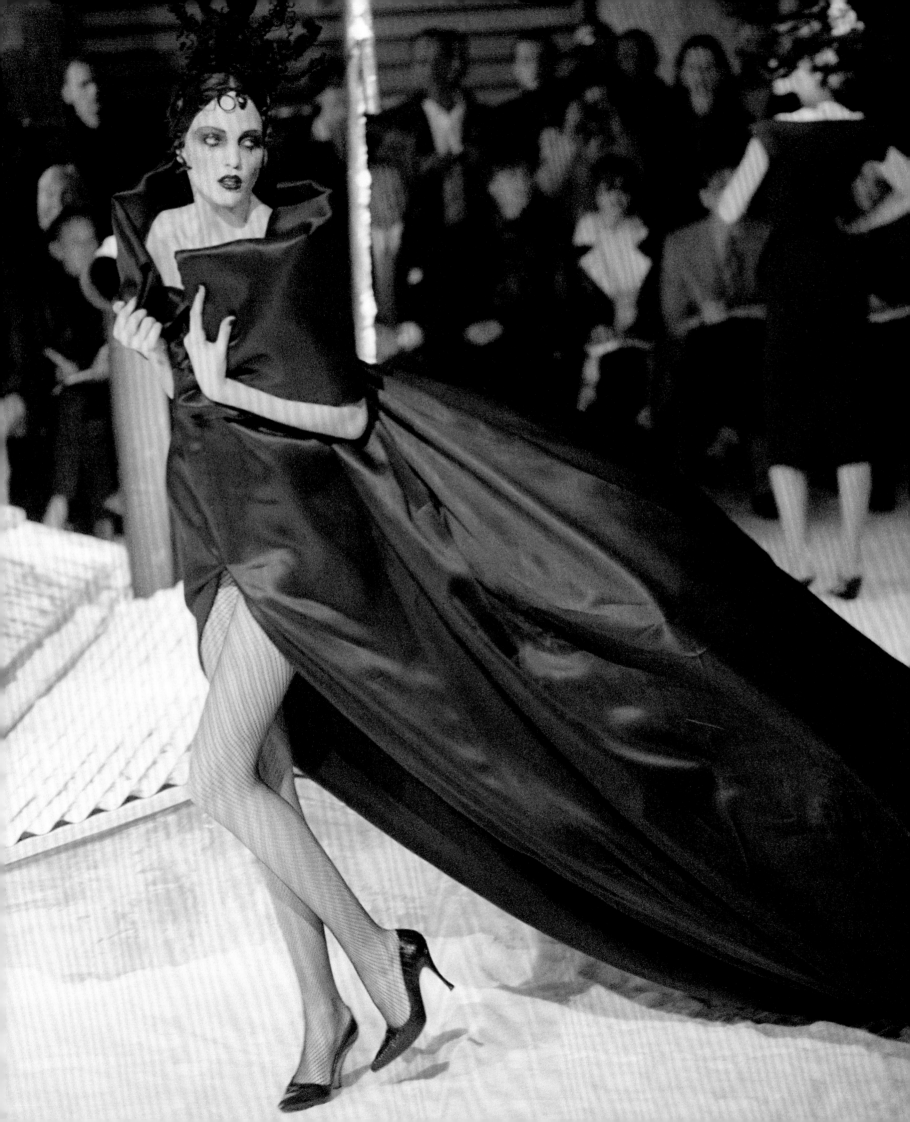

In the late 1990s designers transformed fashion shows into full-blown theatrical productions, employing sets, props and, sometimes, celebrities, from Madonna for Jean Paul Gaultier, to the actress Béatrice Dalle for Alexander McQueen. The ringmaster was John Galliano, who showed his clothes around increasingly elaborate *mise en scène* that included a circus big top, a tumbledown mansion and, for Autumn/Winter 1995, a re-creation of the snow-dusted rooftops of Spain built in a Parisian warehouse. The audience filed through a wardrobe to enter that fashion Narnia.

Left:
John Galliano
Autumn/Winter 1995
Paris

Overleaf:
Jean Paul Gaultier
Spring/Summer 1995
Paris

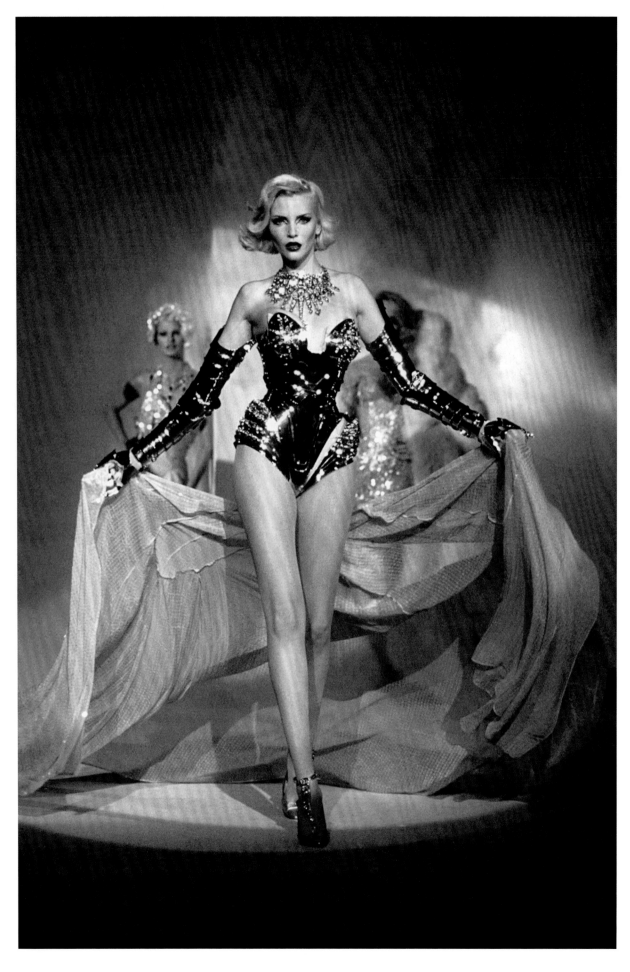

To celebrate his twentieth anniversary, Thierry Mugler put on a fashion show-cum-concert, a high-camp spectacular, lavishly staged at the Cirque d'Hiver with P.T. Barnum-esque chutzpah. Cameos by James Brown, Tippi Hedren and Patty Hearst were upstaged by clothes including cyborg corsets, latex hourglass suits and vast, egg-shaped satin skirts. The show lasted for more than an hour and was broadcast live on French television.

This page and overleaf:
Thierry Mugler
Autumn/Winter 1995
Paris

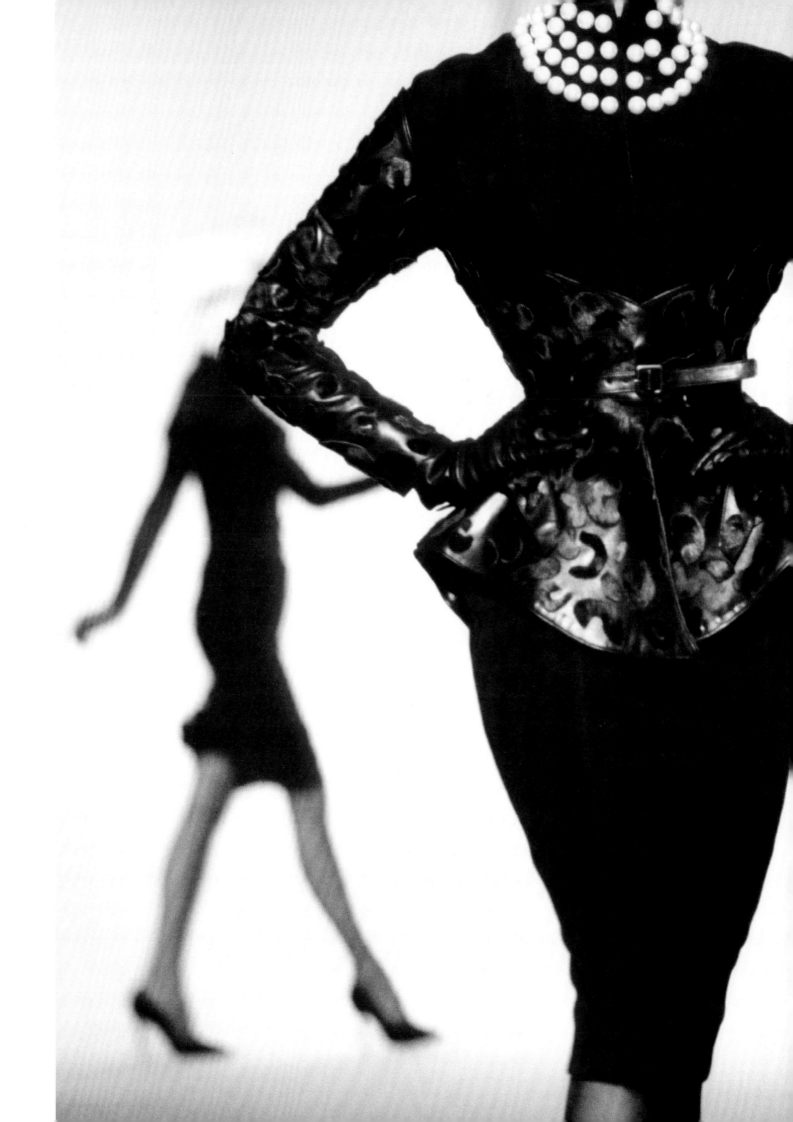

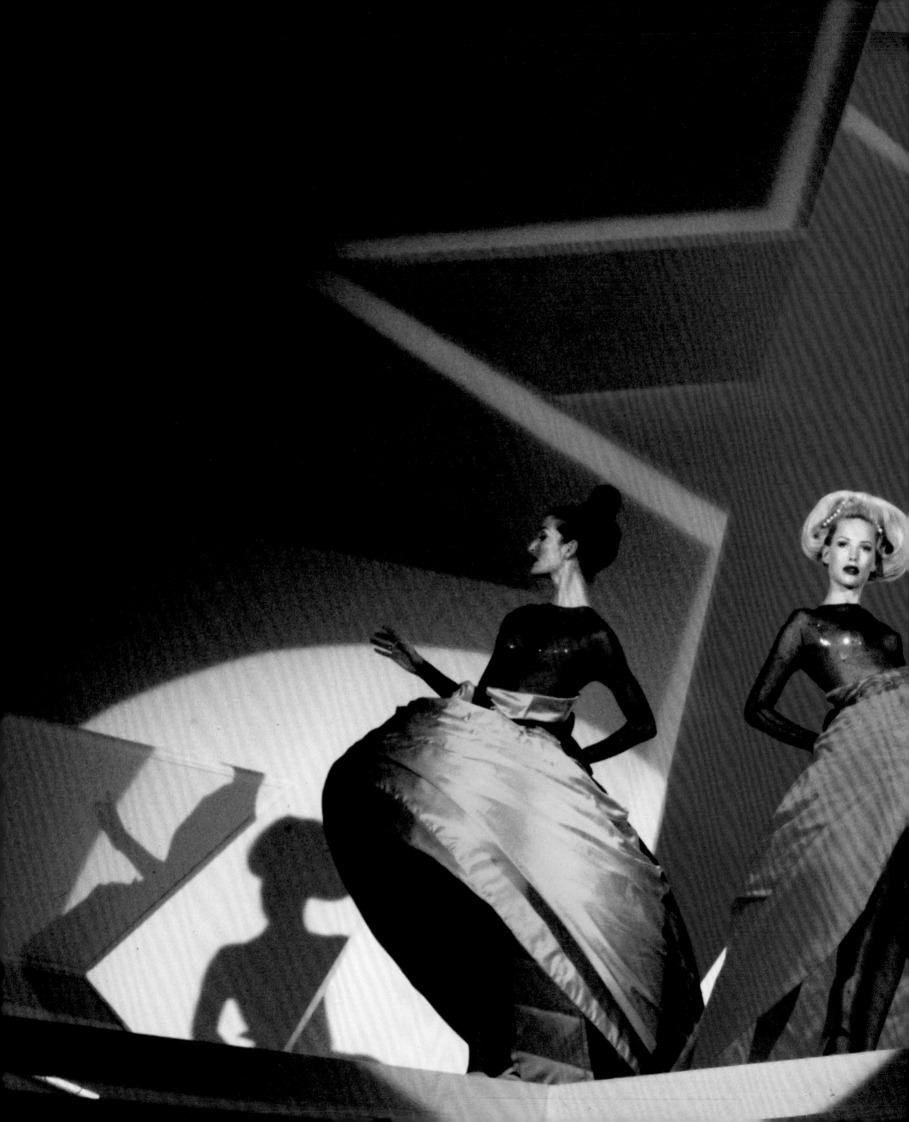

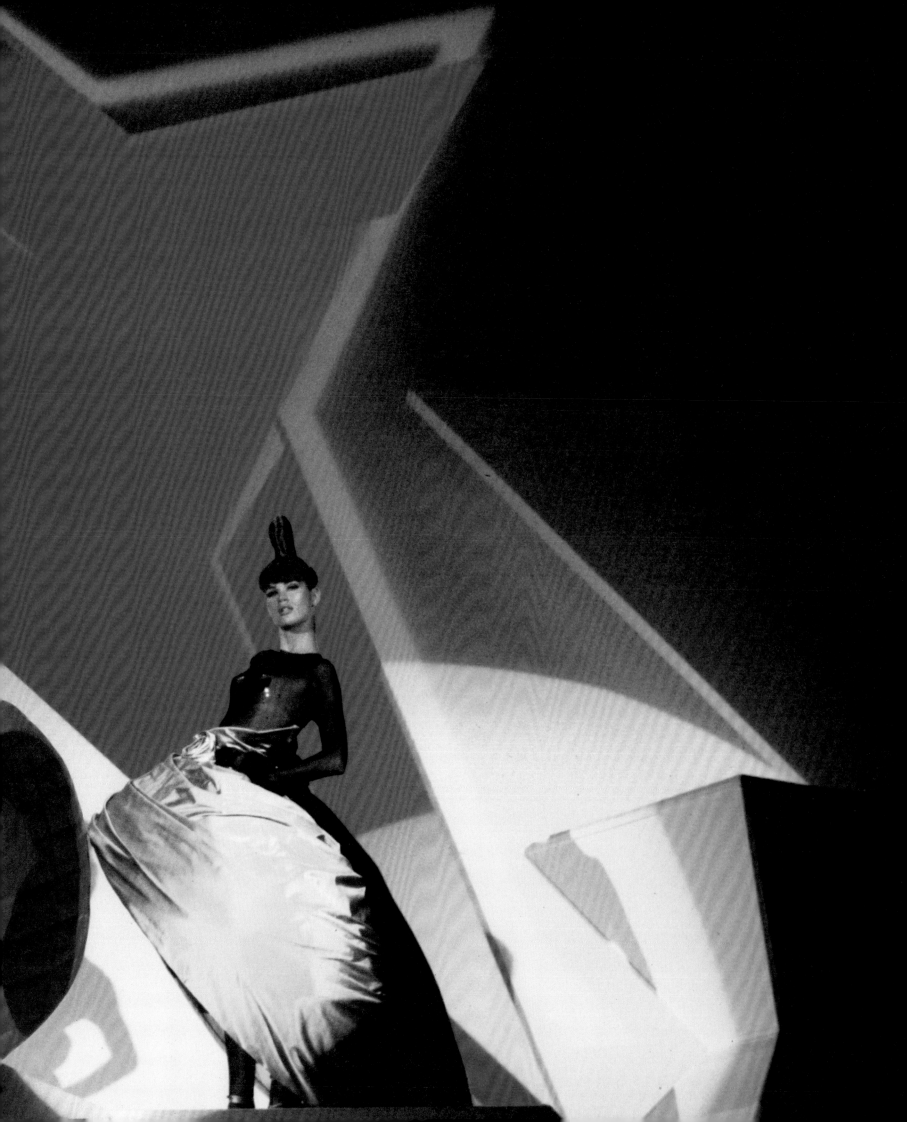

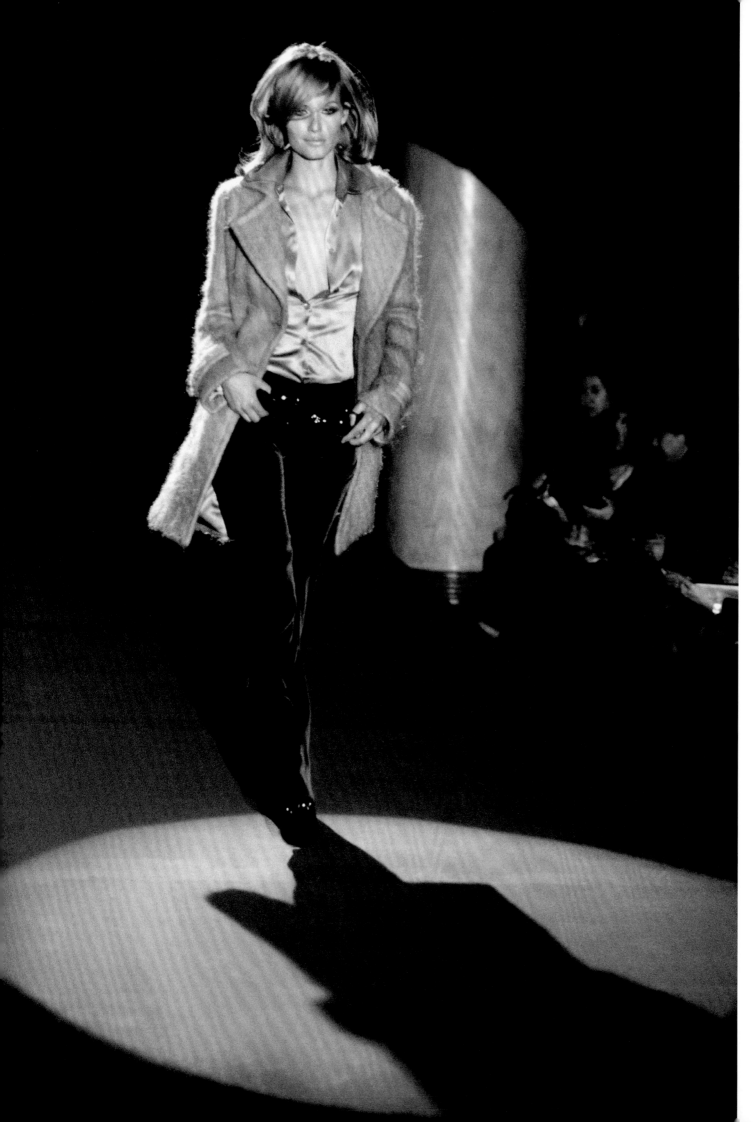

Tom Ford, a young Texan designer, took the reins of Gucci in 1994, having worked there as a behind-the-scenes designer since 1990. The company was nearly bankrupt, but under Ford as creative director, its profile and sales rocketed. He staged brazenly sexy shows, with models spotlit and frequently rakishly undressed, drawing on his own past as habitué of the legendary New York nightclub Studio 54 and on the slinky styles of the 1970s. His March 1995 show in Milan marked the debut of his seductive new vision, and a startling turnaround for Gucci. Between 1995 and 1996, sales increased by 90 per cent.

Gucci
Autumn/Winter 1995
Milan

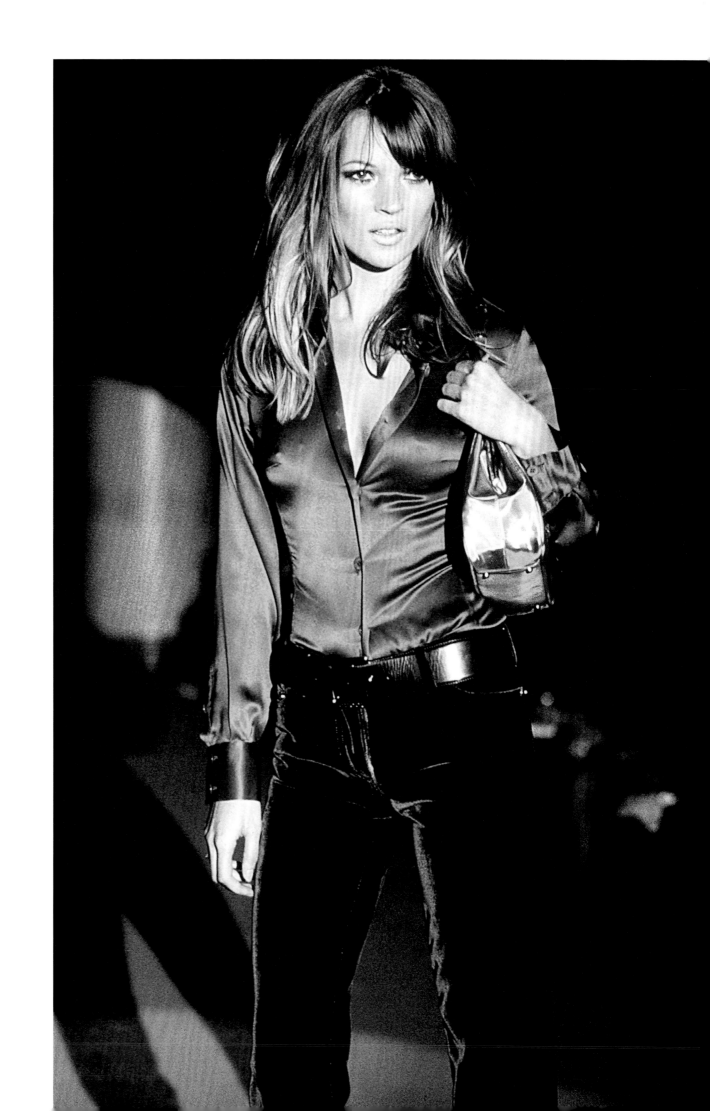

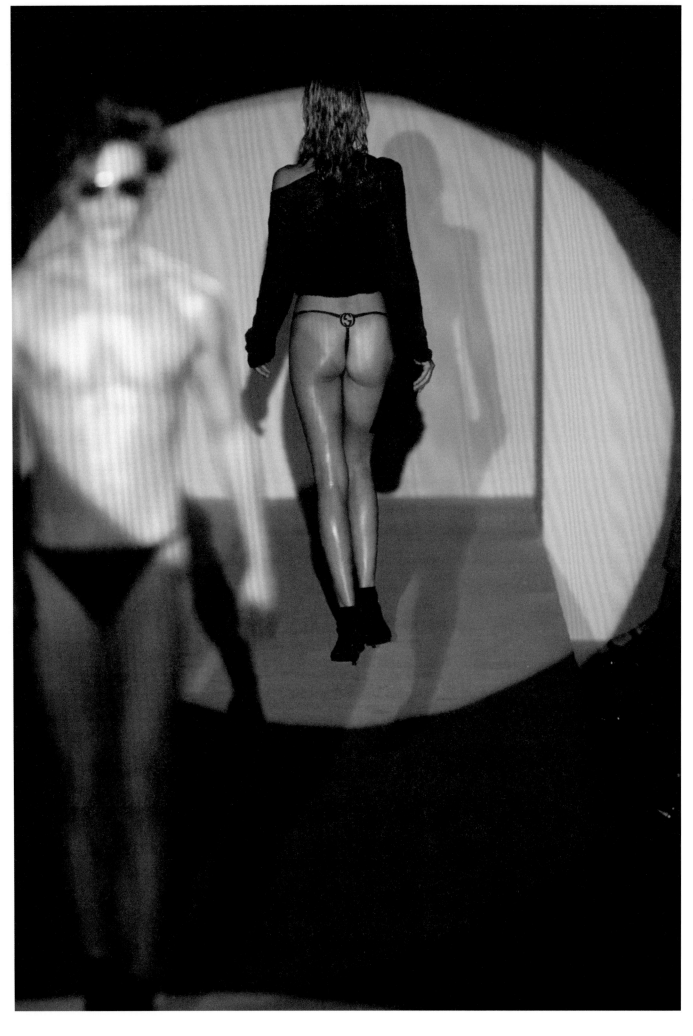

Left:
Gucci
Spring/Summer 1997
Milan

Opposite:
Chanel
Spring/Summer 1996
Paris

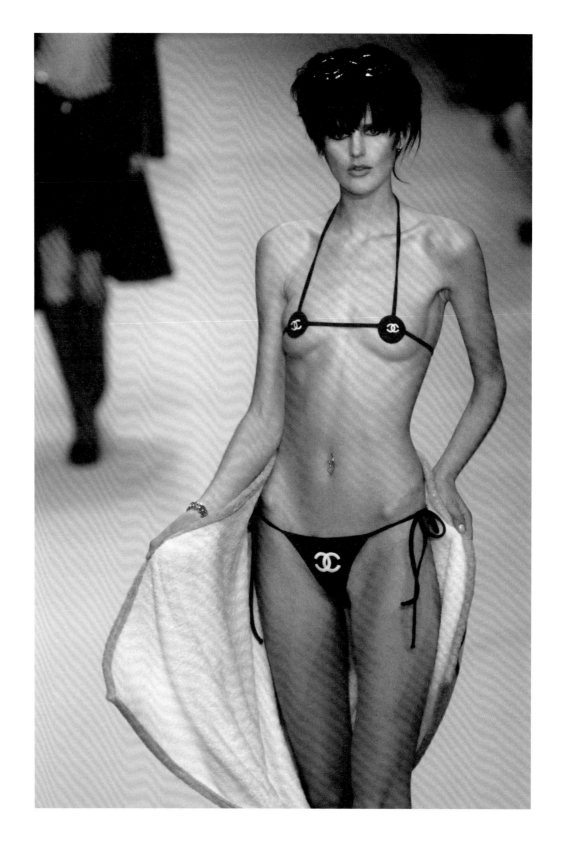

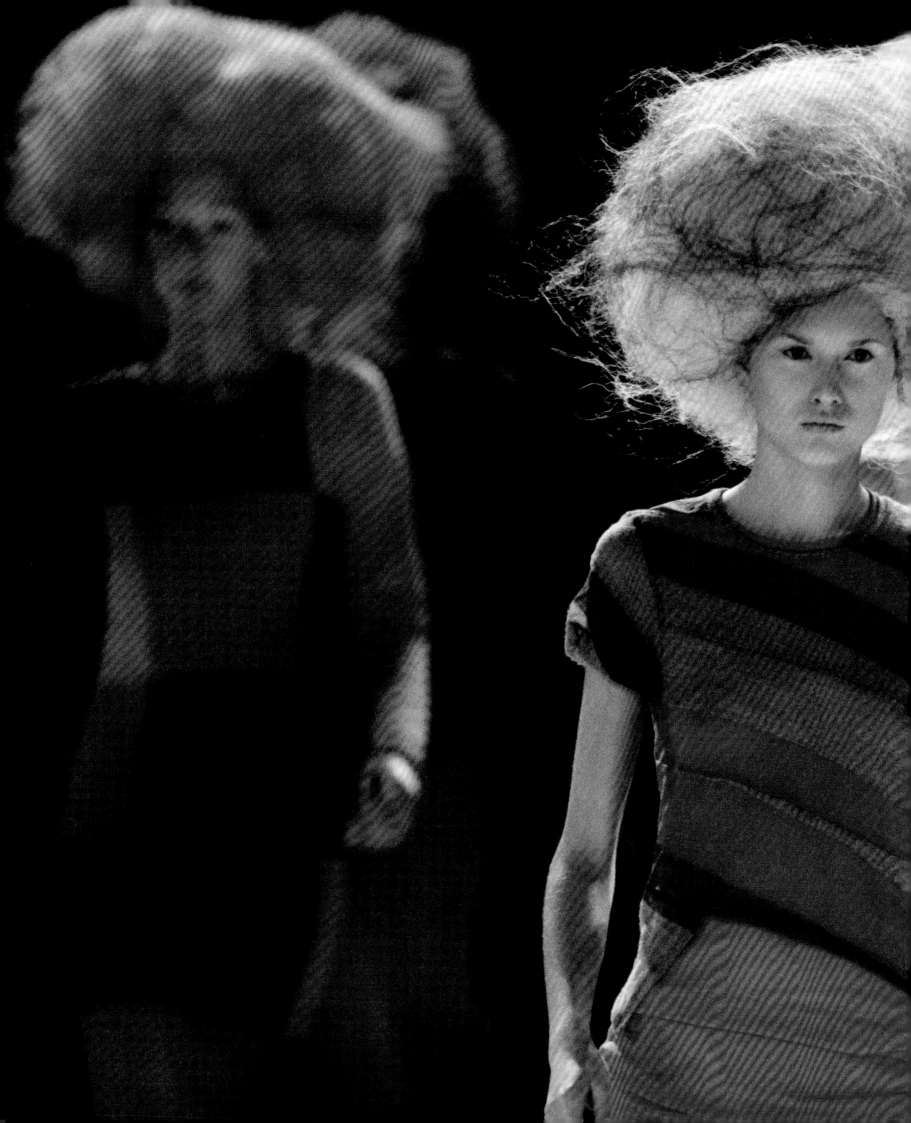

John Galliano
for Givenchy
Spring/Summer 1996
Haute Couture, Paris

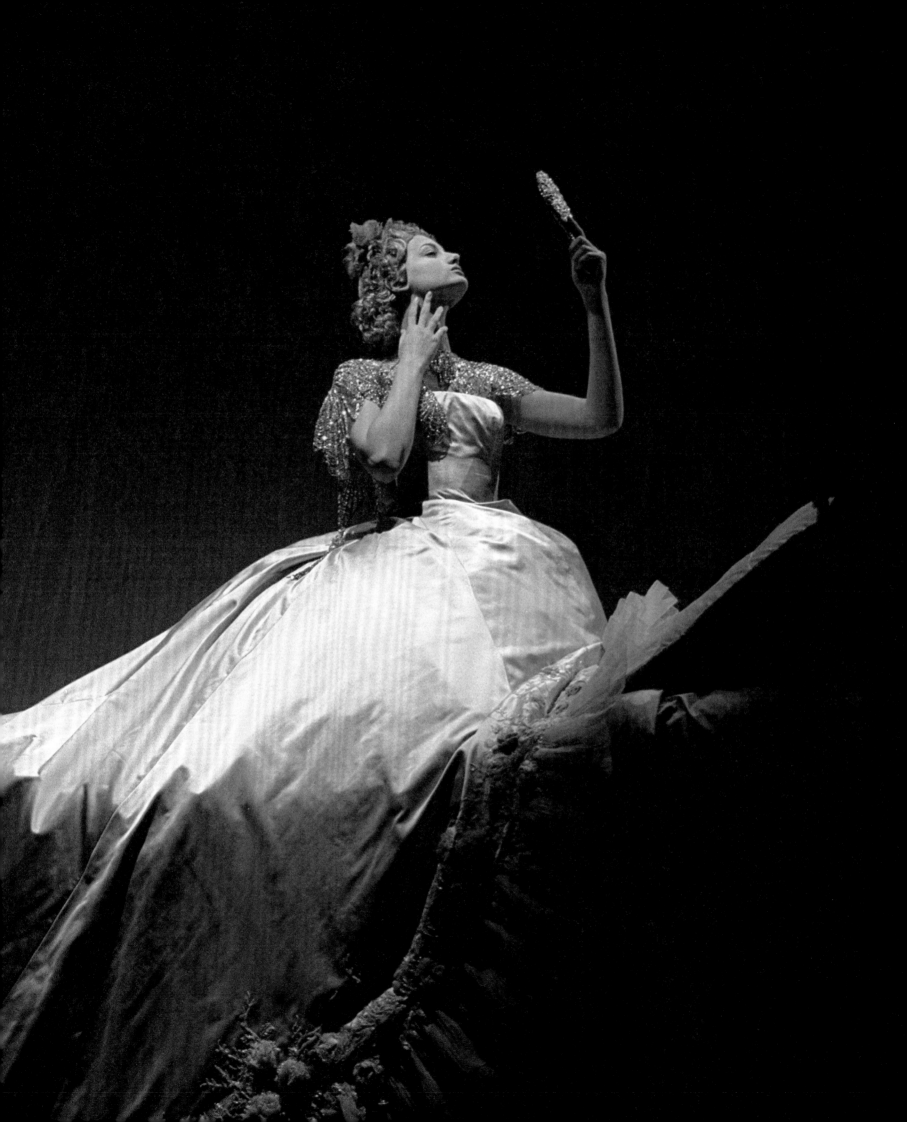

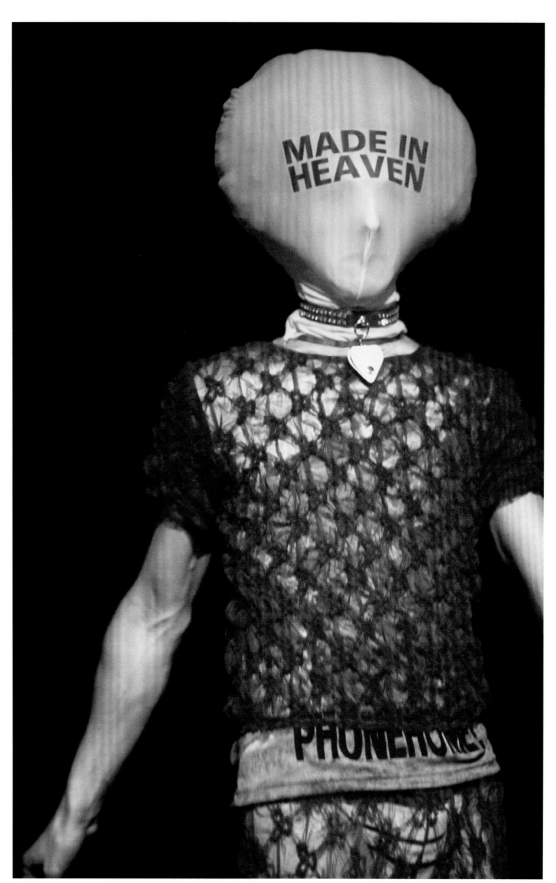

Opposite:
'Well, I have to say, the spring 1998 Walter Van Beirendonck show was one of the best shows I've seen' recalls Moore. 'There were three parts. They had people coming on on stilts, then suddenly the lights went out and then suddenly went on and then there were people dancing with green gas masks on. It's just so bizarre. Surreal, I suppose. You can't beat a bit of surrealism in the show. To hell with the clothes! But I thought it was fantastic.'

Walter Van Beirendonck
Spring/Summer 1998
Paris

Left:
'Then there was another year when he had a menswear show when the models had masks on', says Moore. 'They were shaped like bags, paper bags, but they had messages on them – and they kept falling off the catwalk. There was a moat between us and the models, and they fell into it.'

Walter Van Beirendonck
Spring/Summer 1996
Paris

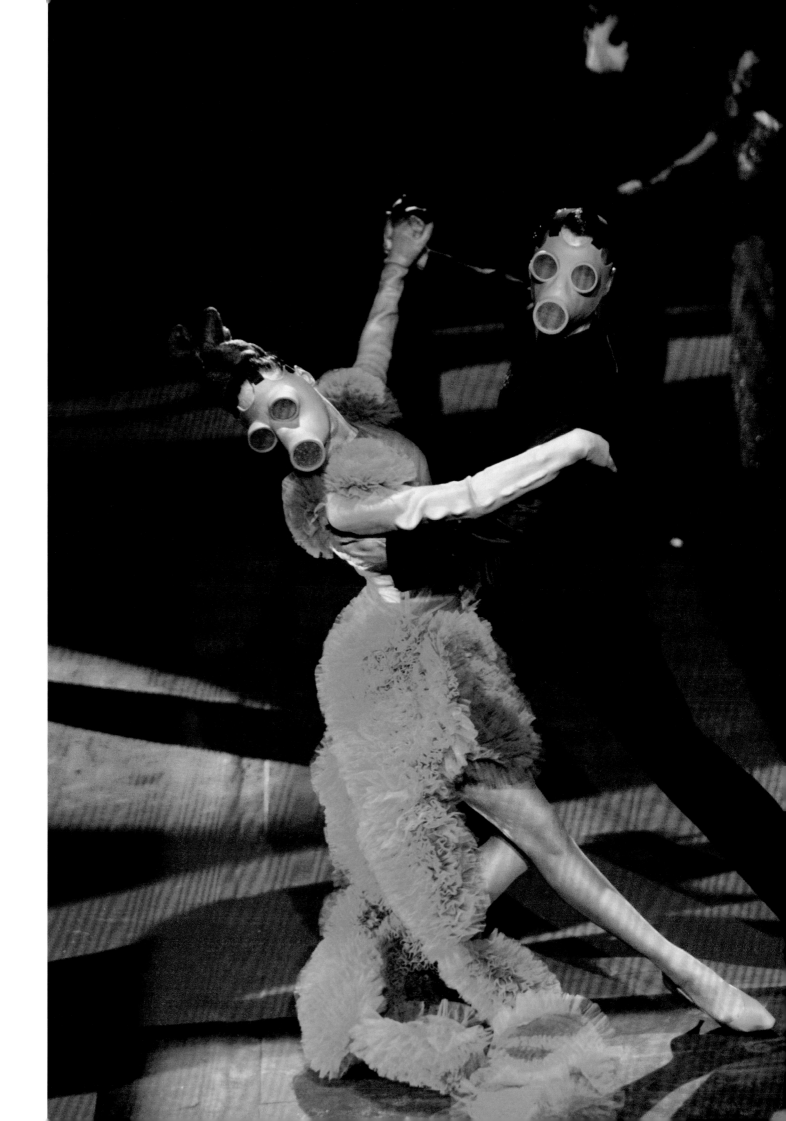

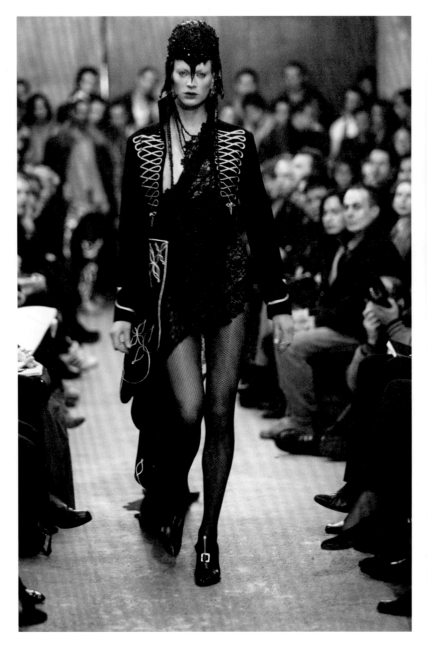

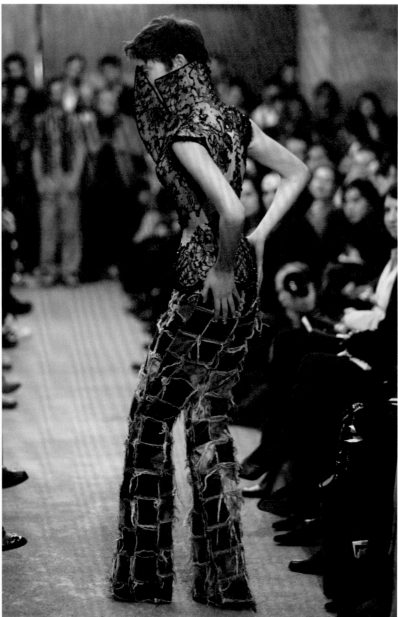

Right:
Alexander McQueen
Autumn/Winter 1995
London

Opposite:
Alexander McQueen
Autumn/Winter 1996
London

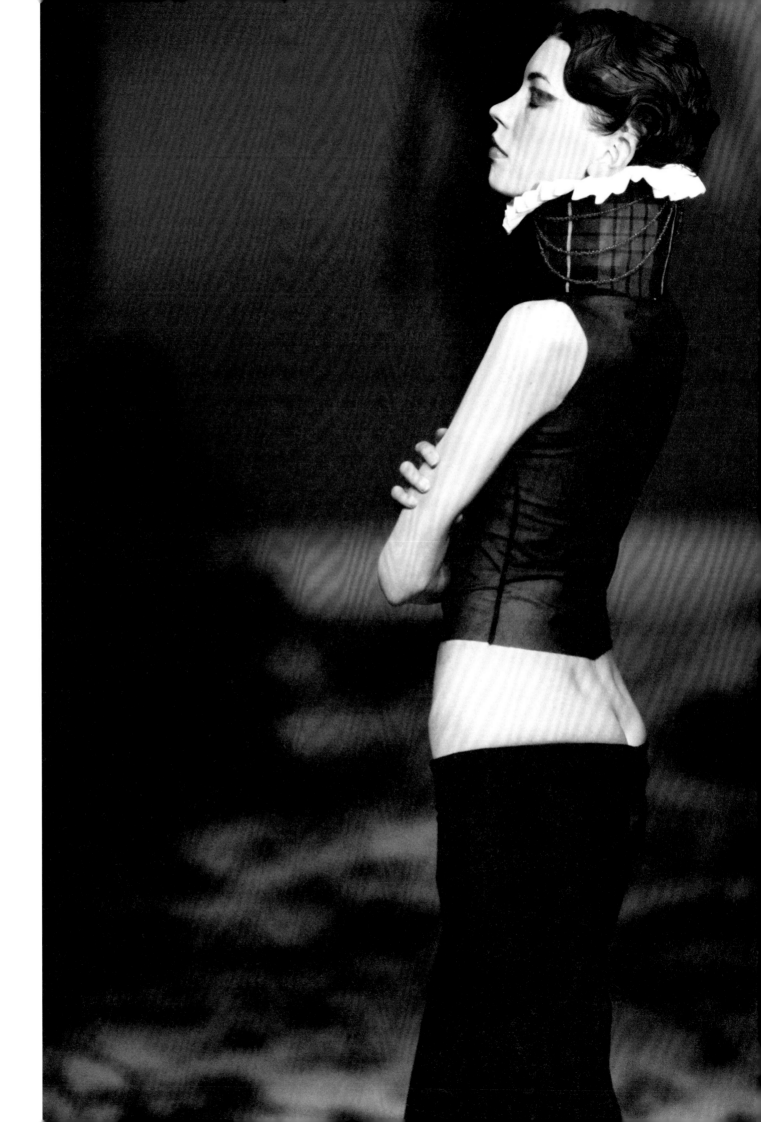

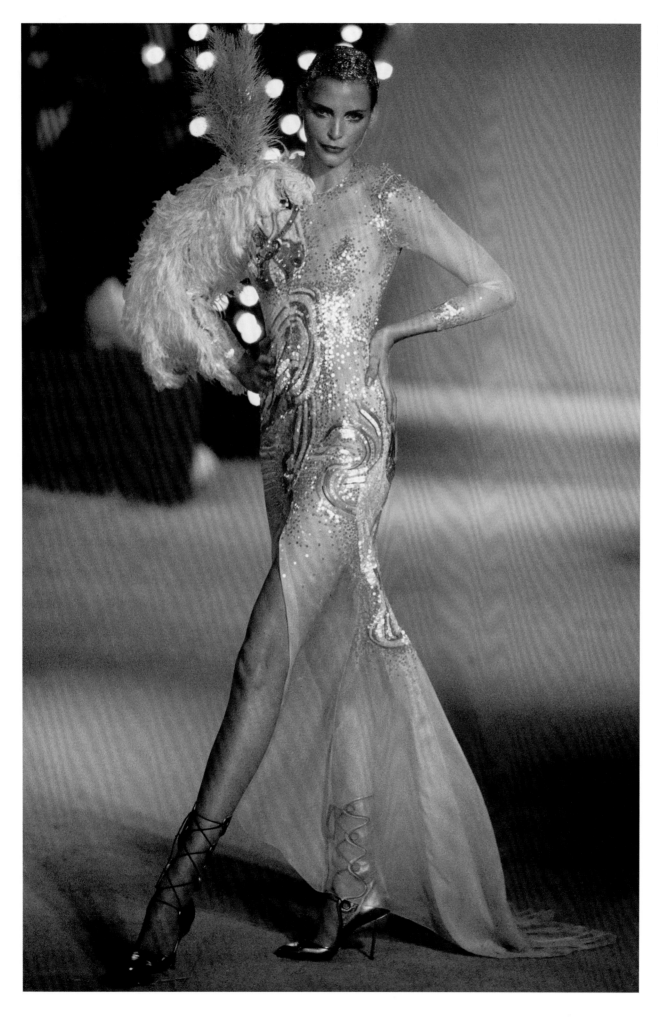

Left:
John Galliano
Spring/Summer 1997
Paris

Opposite:
Versace
Autumn/Winter 1995
Haute Couture, Paris

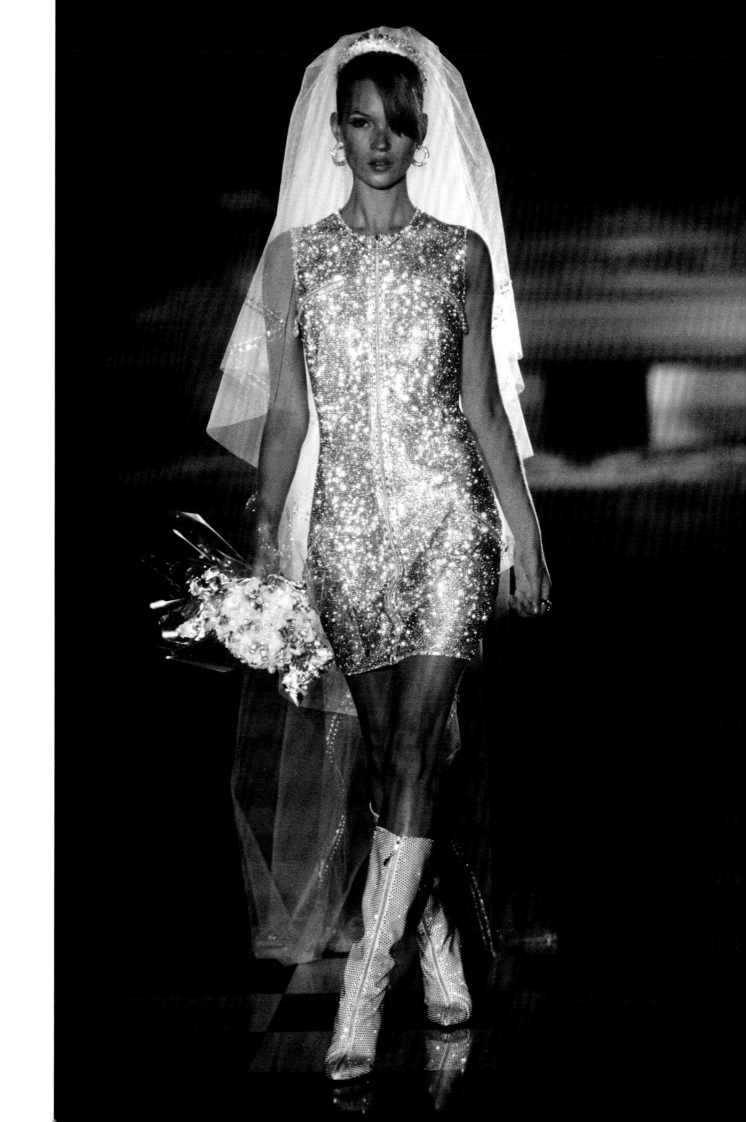

Below:
Chloé
Spring.Summer 1998
Paris

Opposite:
Philip Treacy
Autumn/Winter 1996
London

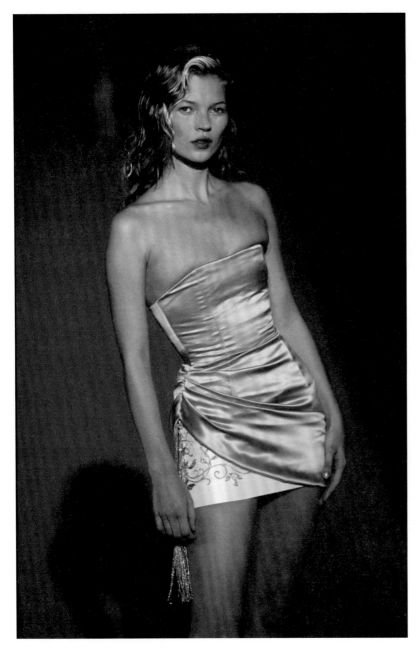
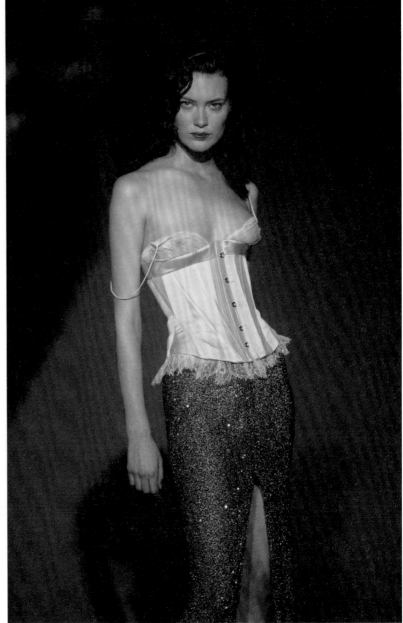

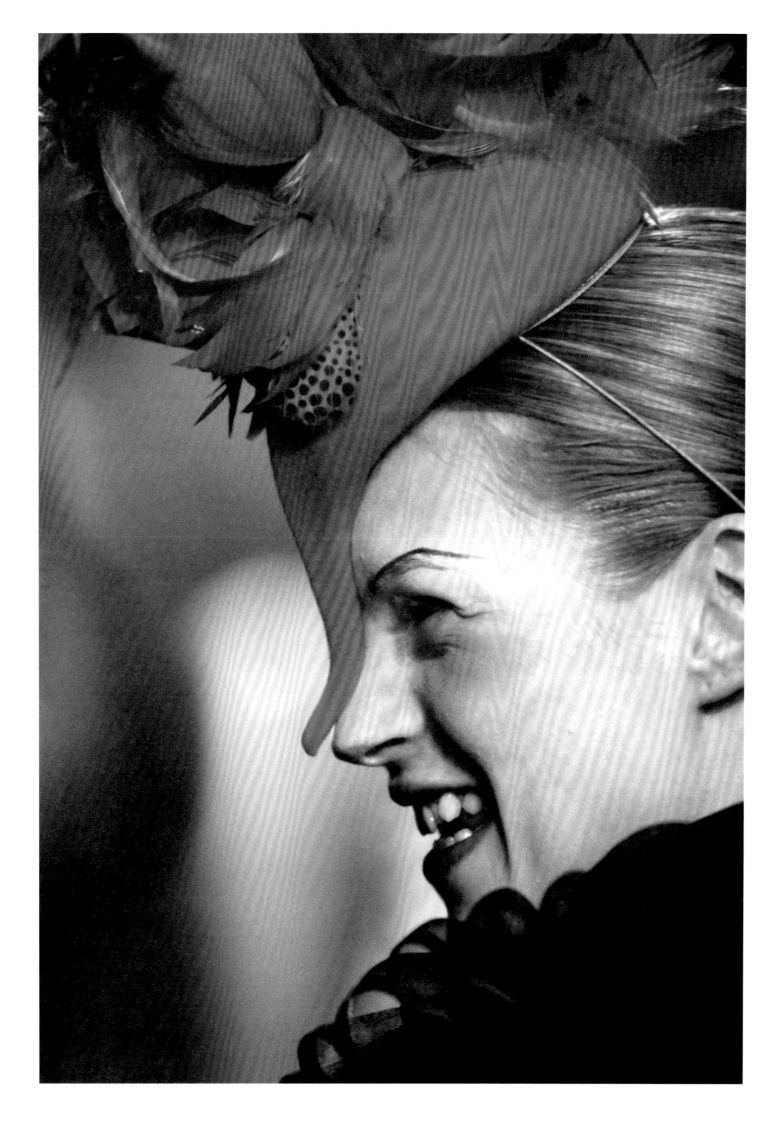

Prada AW90

Prada
©CHRISTOPHER MOORE LTD

Prada AW 92

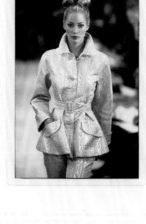

PRADA A/W 91

2831

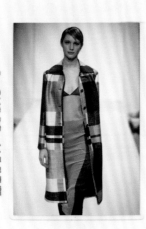

PRADA

Spring 92

LINDA

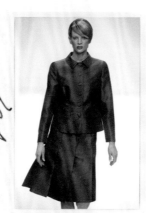

25A

PH. CHRIS MOORE
PRADA FALL 96

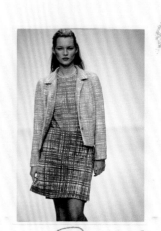

SPRING 1996

CHRIS MOORE

PRADA

33

1030

PRADA FALL 96 @ CHRIS MOORE

Chinese

© CHRIS MOORE
PRADA 5/97

343

33

4520

© CHRIS MOORE
PRADA
SP. 99

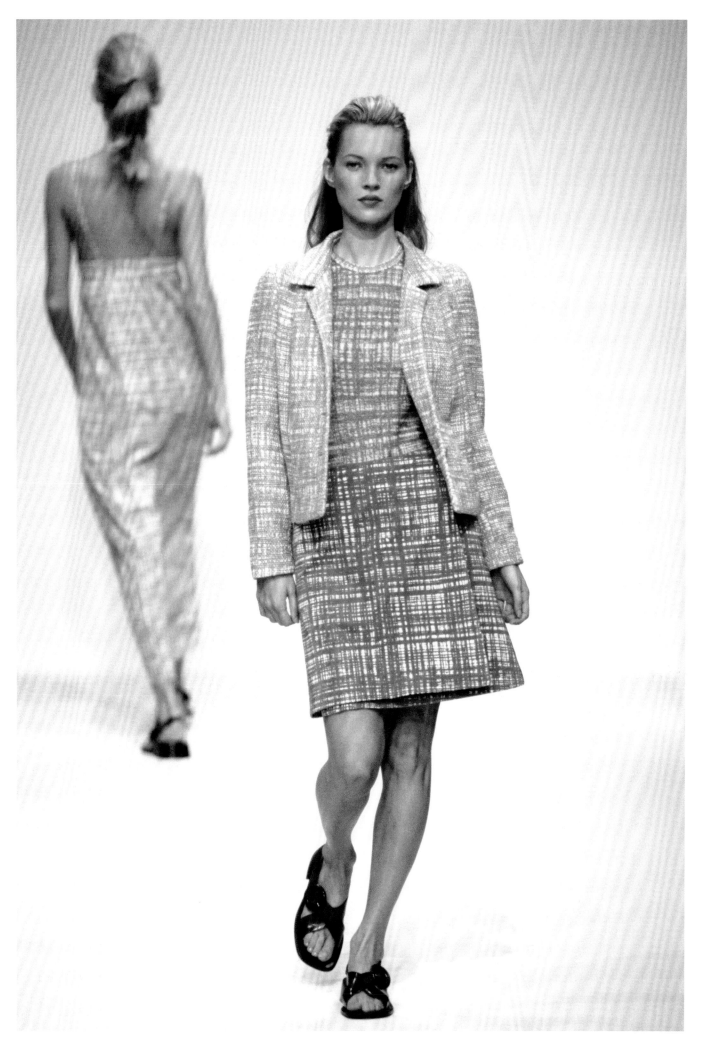

Miuccia Prada inherited her family's luggage company in 1978, and a decade later she showed her first womenswear designs, lambasted by the press but indicative of the future. In 1984 she had designed a striking new line of handbags using military-grade nylon, making the functional and utilitarian fashionable for the first time. The 1990s were her decade; the look Prada pioneered in the 1980s became the definitive fashion statement of the time, keyed to the dominant modes of minimalism and retrospection. Prada added her own new ingredient: ugliness. Her Spring/Summer 1996 'Ugly Chic' collection – coloured in sludgy 1970s shades of green and brown, and patterned with prints taken from Formica and wallpaper – was seminal, examining the notion of bad taste and reinventing it for the first time as a status symbol.

Prada
Spring/Summer 1996
Milan

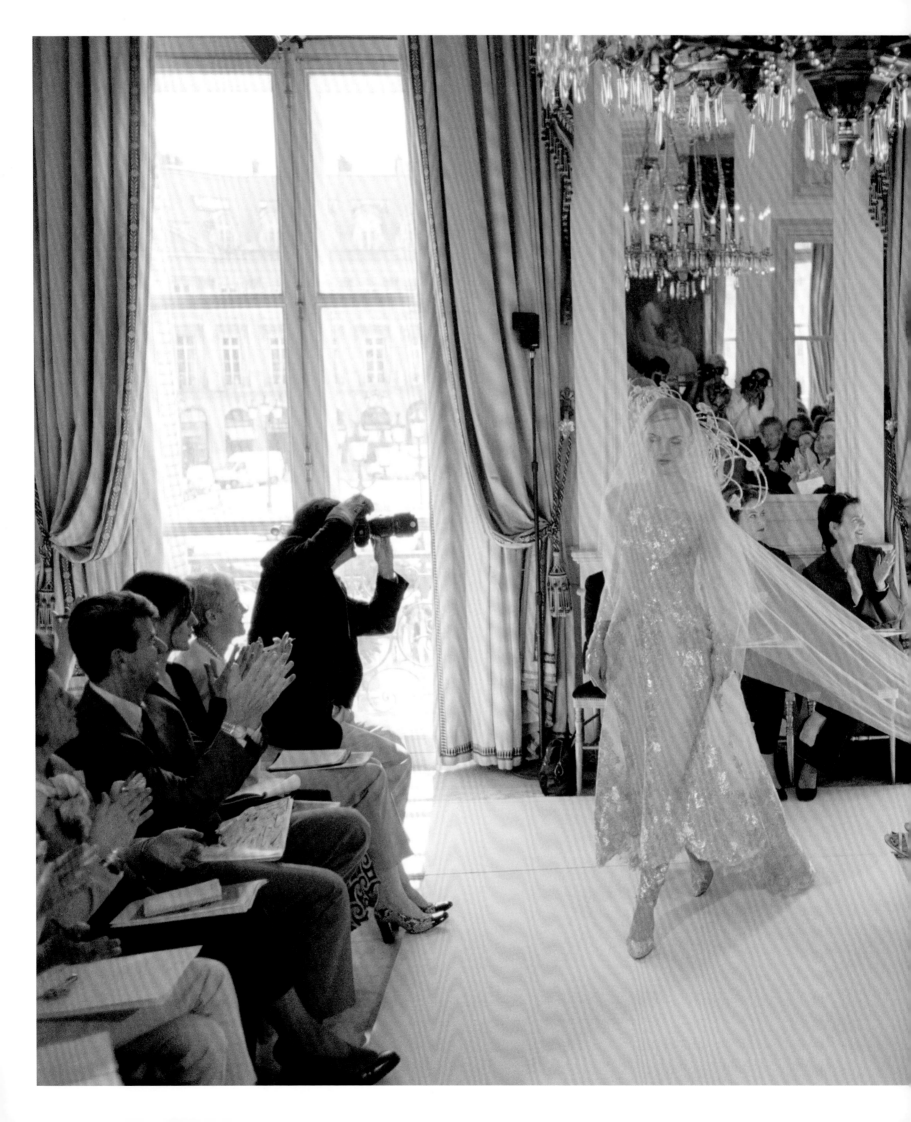

This page:
Chanel
Autumn/Winter 1996
Haute Couture, Paris

Previous page:
**Alexander McQueen
for Givenchy**
Spring/Summer 1997
Haute Couture, Paris

In 1997 Alexander McQueen and John Galliano presented their debut haute couture collections for the houses of Givenchy and Dior, respectively. In that year, too, Jean Paul Gaultier and Thierry Mugler showed their first own-label couture collections. These theatrical visions, often unwearable but always unforgettable, prompted a grand revival of interest in the age-old Parisian craft of made-to-measure clothes. For Galliano's debut season at Dior his haute couture and ready-to-wear collections mixed characteristic elements of the house with influences as diverse as the Maasai tribe of Africa, Mitzah Bricard, the Far East and the Hollywood actress Jayne Mansfield

Left:
John Galliano for Christian Dior
Spring/Summer 1997
Haute Couture, Paris

Opposite:
John Galliano for Christian Dior
Autumn/Winter 1997
Paris

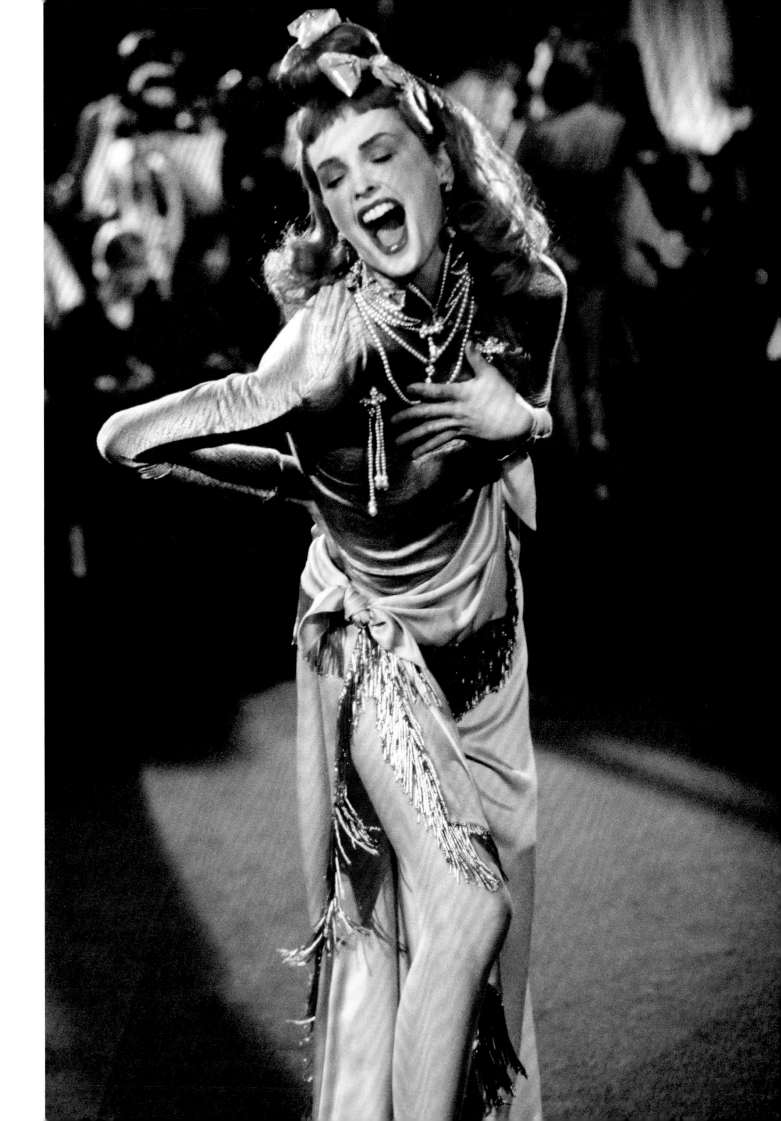

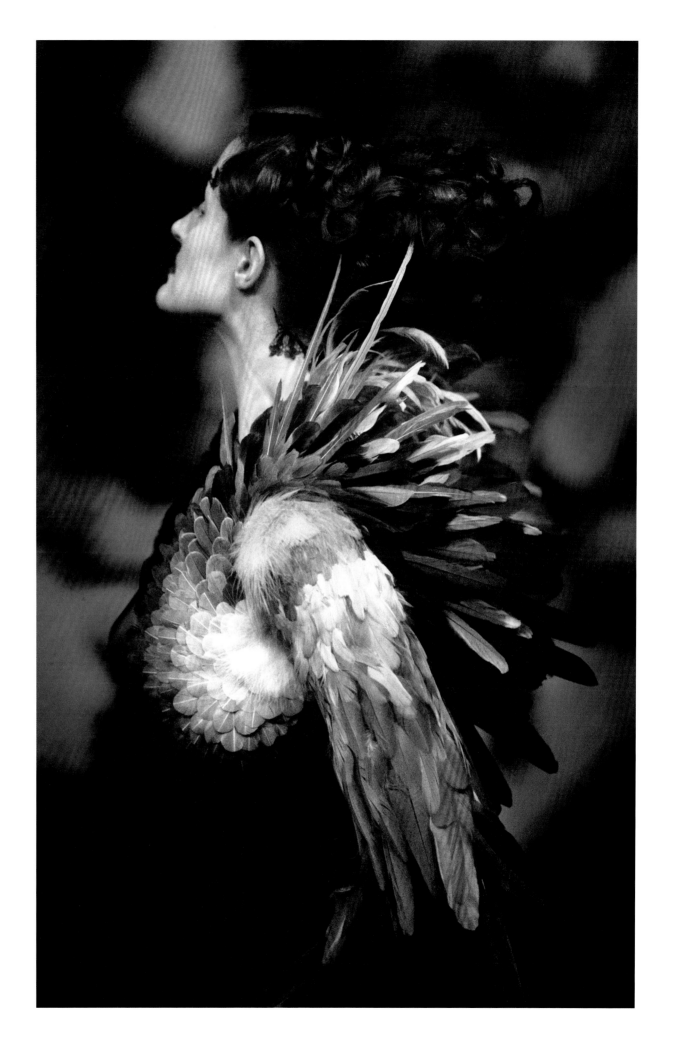

Below:
Comme des Garçons
Spring/Summer 1997
Paris

Opposite:
John Galliano
Spring/Summer 1996
Paris

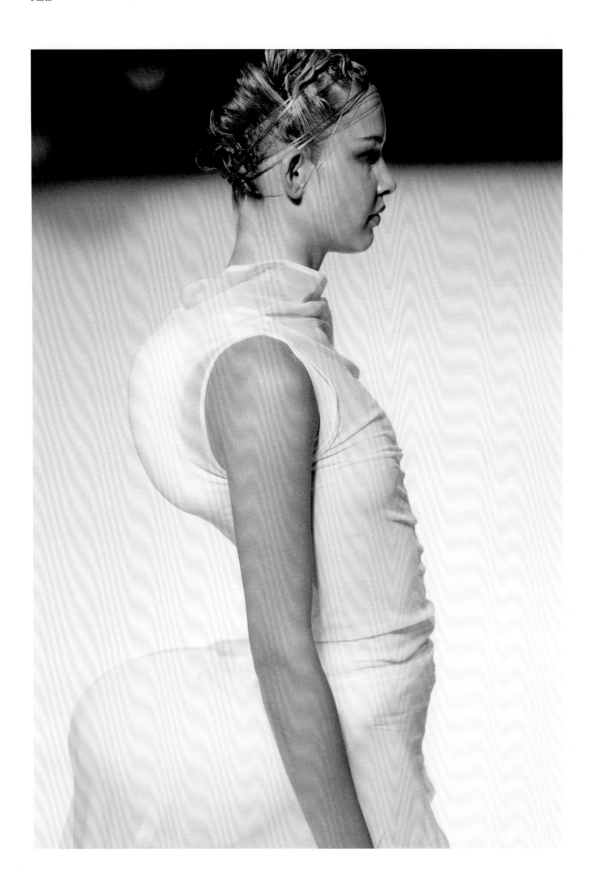

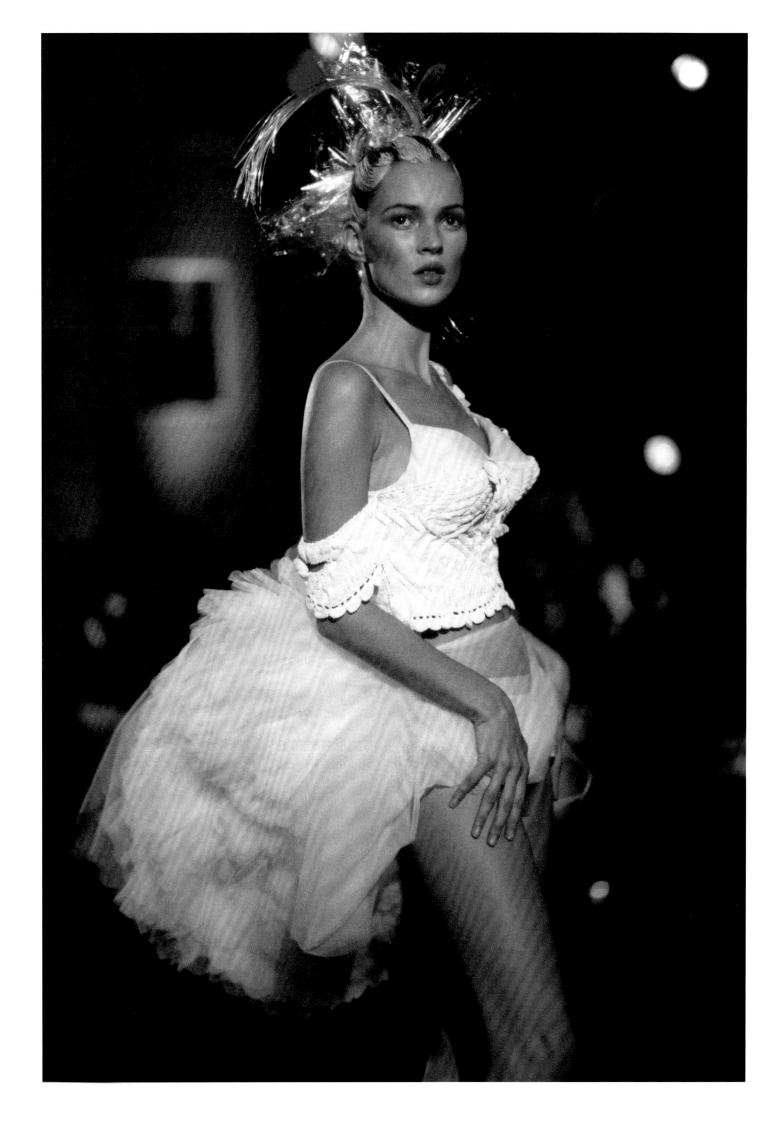

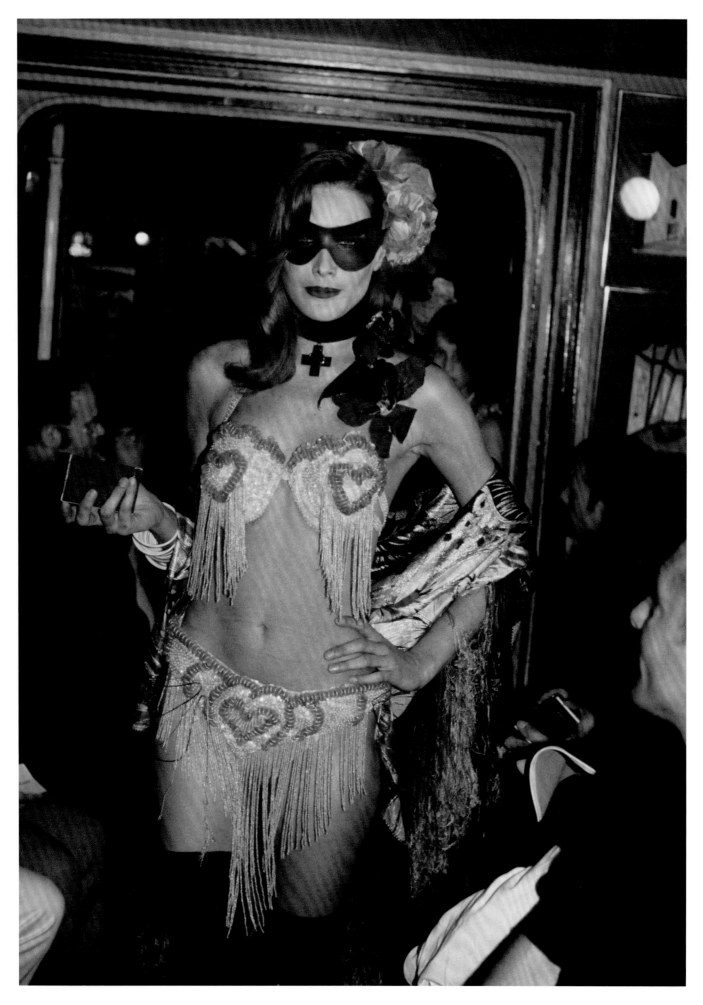

Left:
Jean Paul Gaultier
Spring/Summer 1997
Paris

Opposite:
Helmut Lang
Autumn/Winter 1997
New York

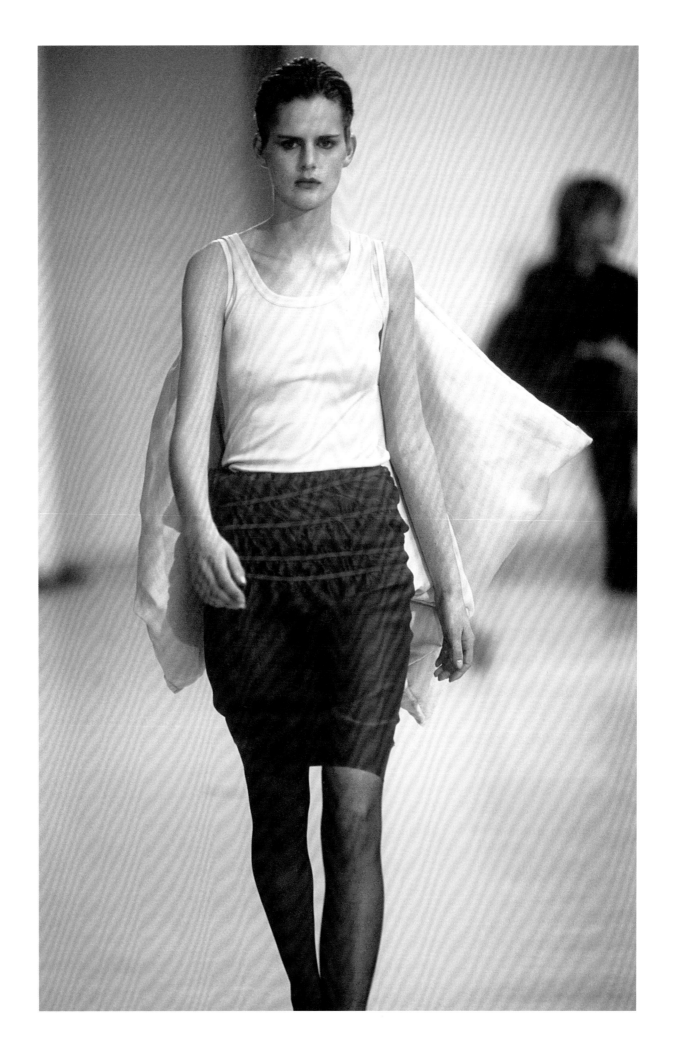

For his January 1998 show, Karl Lagerfeld returned to 31 Rue Cambon, where Gabrielle 'Coco' Chanel had founded her haute couture house, for the first time since his debut in 1983.

Chanel
Spring/Summer 1998
Haute Couture, Paris

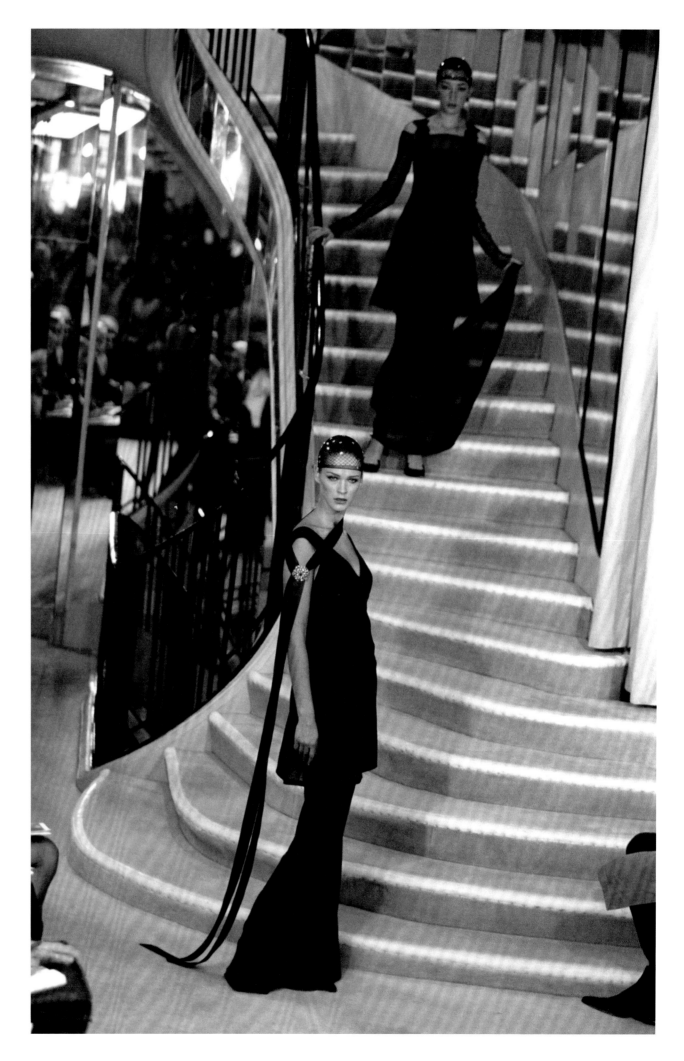

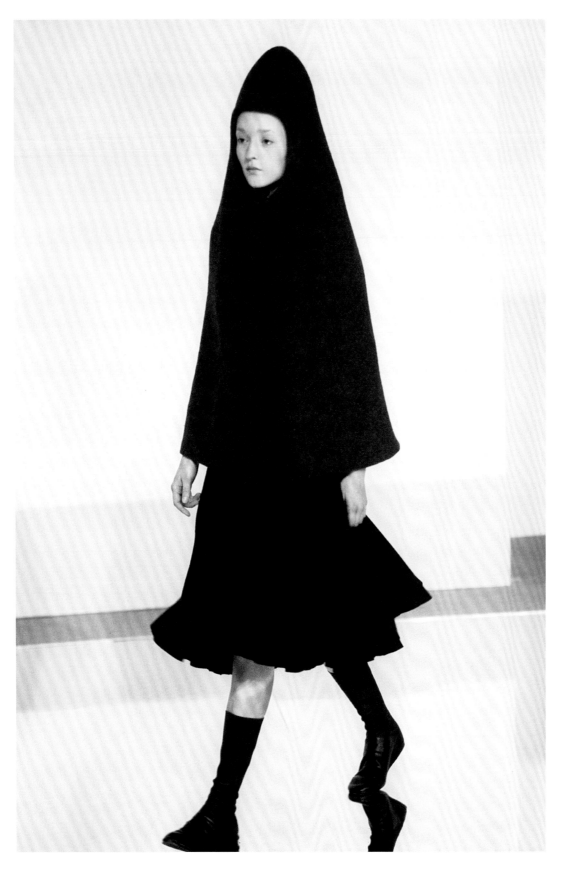

The cerebral creations of Hussein Chalayan were often contemplative, and his shows more akin to performance art than fashion. His work explored ideas of identity, religion and cultural difference, and, as the millennium closed, represented a fascinating expounding on the effects of technology on the body. Chalayan offered a quiet alternative to the pyrotechnic displays favoured by other designers, most evidently his London counterpart Alexander McQueen, but both proved influential to new generations of fashion students. 'With Alexander McQueen and Hussein Chalayan's productions, I felt the catwalk changed forever,' says Moore.

Hussein Chalayan
Autumn/Winter 1998
London

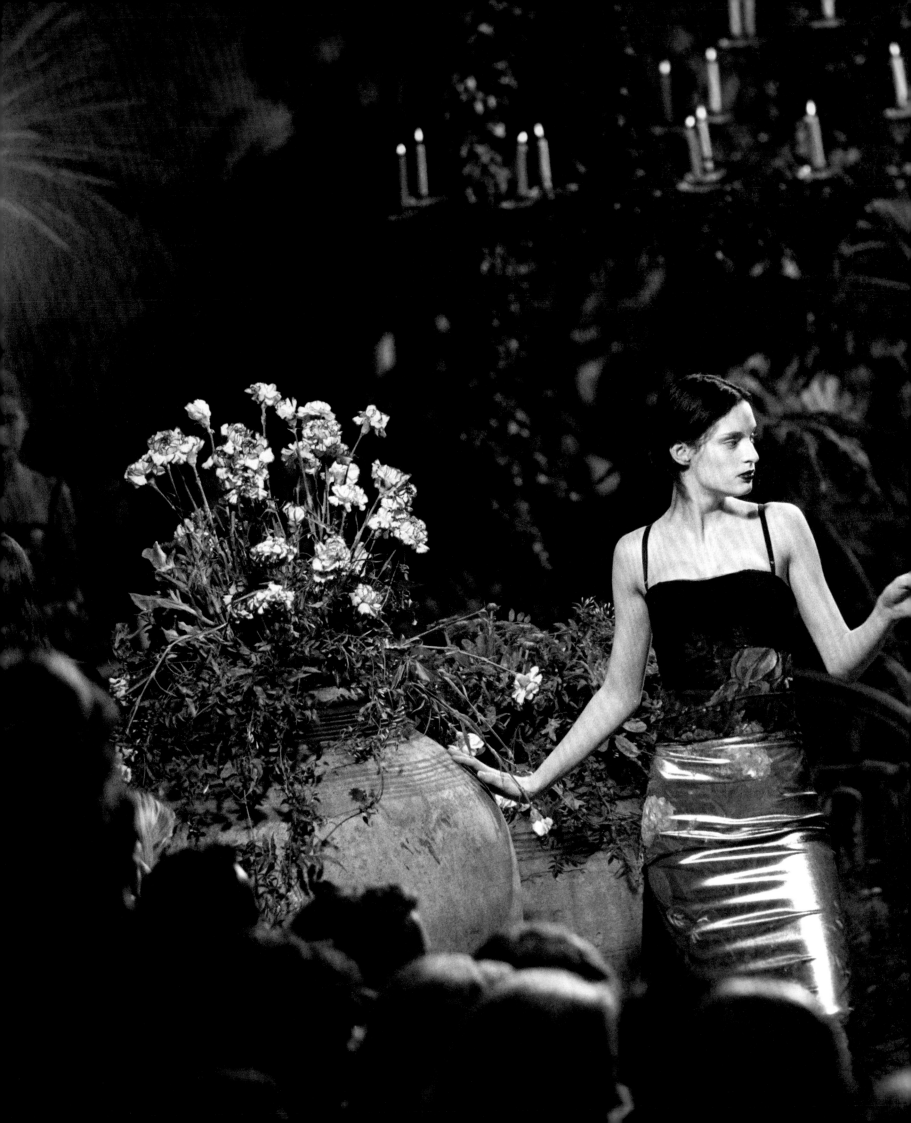

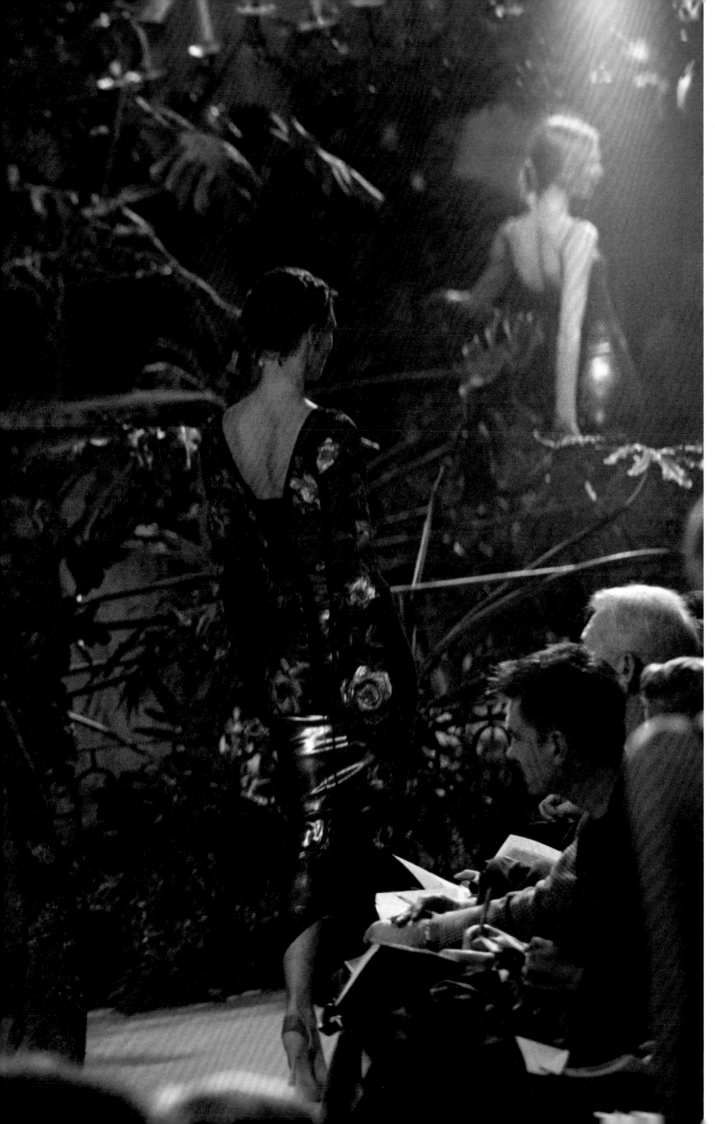

LANG AW 92 — Cecilia

HELMUT LANG SPRING/SUMMER 93

HELMUT LANG — AW 93

SPRING/SUMMER 94 — CHRIS MOORE

Moore — LANG AW 94 — 60%

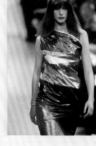

HELMUT LANG SPRING/SUMMER 95 © CHRIS MOORE — Linda

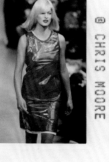

HELMUT LANG SPRING/SUMMER 95 © CHRIS MOORE

SPRING/SUMMER 96 HELMUT LANG CHRIS MOORE — AMBER

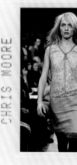
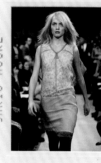
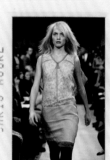

Helmut Lang S/S 97 — PH: Chris Moore

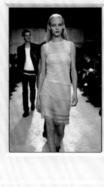

HELMUT LANG SPRING/SUMMER 97 CHRIS MOORE — 27

CHRIS MOORE — HELMUT LANG FALL 96

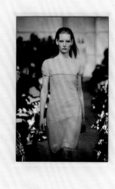

Helmut Lang A/W 97 — 95/2 — Stella — CHRIS MOORE

H. Lang — Spring 98 — Angela

LANG SS 98

Angela Lindval — AW 99/H. Lang

LANG — M/S 99

Helmut Lang is a designer whose work defies easy categorization. Blurring menswear and womenswear, combining synthetic and natural fabrics, cheap with expensive, high with low, he created minimalist, futuristically tinged clothing during his heyday of the 1990s, which helped to define the prevalent silhouette and general 'look' at the close of the twentieth century. His shows were staged in anonymous concrete spaces, mixing menswear and womenswear together, reflecting a stylized view of reality. He was often tagged as a 'deconstructionist' because of his affinity for humble fabrics, particularly nylons, polyester and denim, although his clothes were a world apart from the wilfully distressed designs of Maison Martin Margiela. Trying to sum up Lang's aesthetic in one word, one comes back most frequently to 'modern'. Lang was the first designer to forgo a catwalk show and present his collection on the internet, back in 1998. Austrian-born, but showing in both Paris and New York during his career, he had a global outlook. He eschewed references to other cultures, to art or historical styles, and simply made great clothes.

Helmut Lang
Various collections
1992–1999
Paris and New York

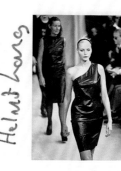

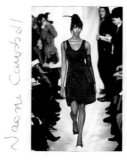

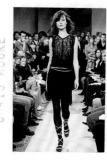

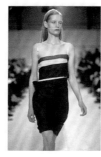

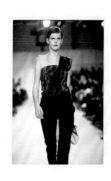

John Galliano staged his Christian Dior Spring/Summer 1998 haute couture show at the Palais Garnier in Paris, on a scale of extravagance unseen for almost a century. The show itself was staged among tango dancers and velvet-clad tables groaning with food and drink, recreating the atmosphere of the costume balls thrown by the Italian aristocrat Marchesa Luisa Casati in the 1900s. The clothes were overblown and wildly theatrical. Here Isabella Blow, the British stylist and talent-spotter credited with discovering the designers Alexander McQueen and Hussein Chalayan, the milliner Philip Treacy and the model Sophie Dahl, is captured in conversation with André Leon Talley before the show began. She wears the clothes of Jeremy Scott, another designer whom she championed. American *Vogue*'s editor-in-chief, Anna Wintour, is seen at the far left and Grace Coddington is to Blow's immediate right.

This page and overleaf:
John Galliano for Christian Dior
Spring/Summer 1998
Haute Couture, Paris

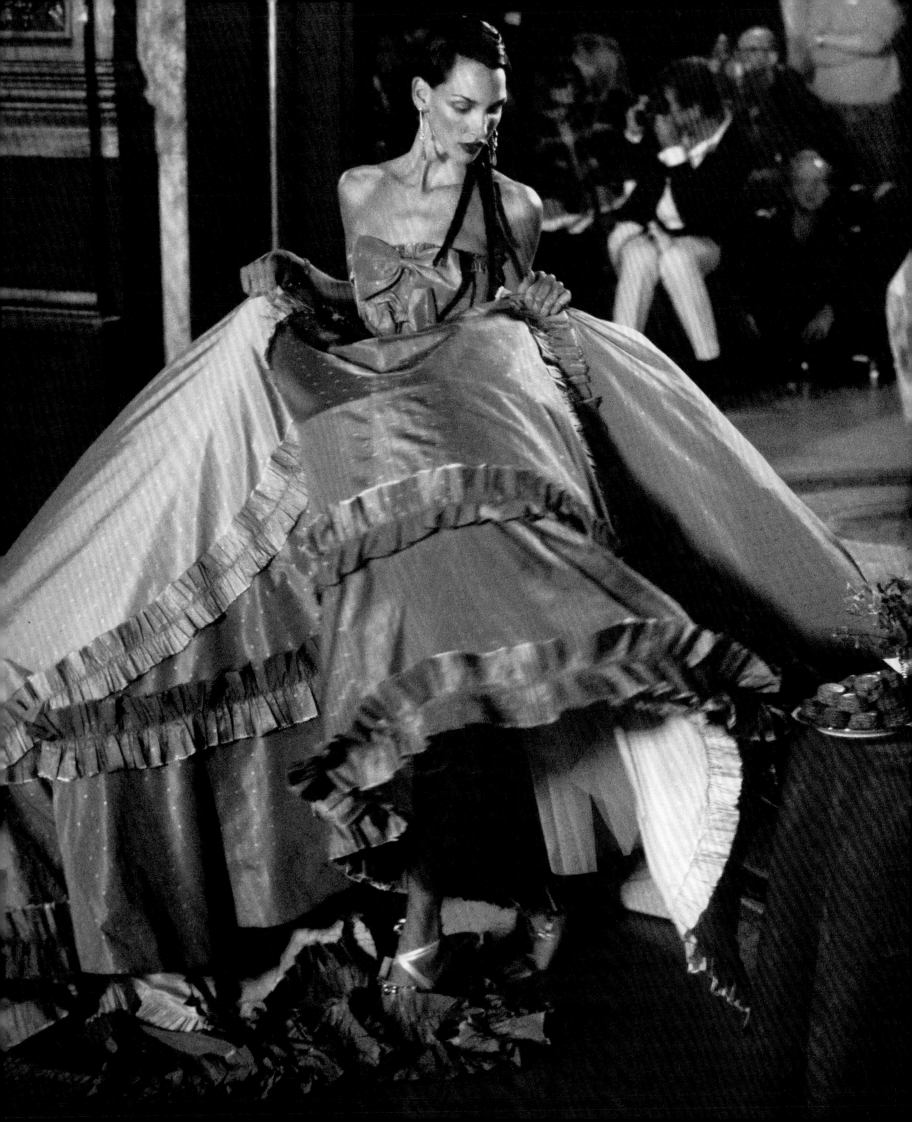

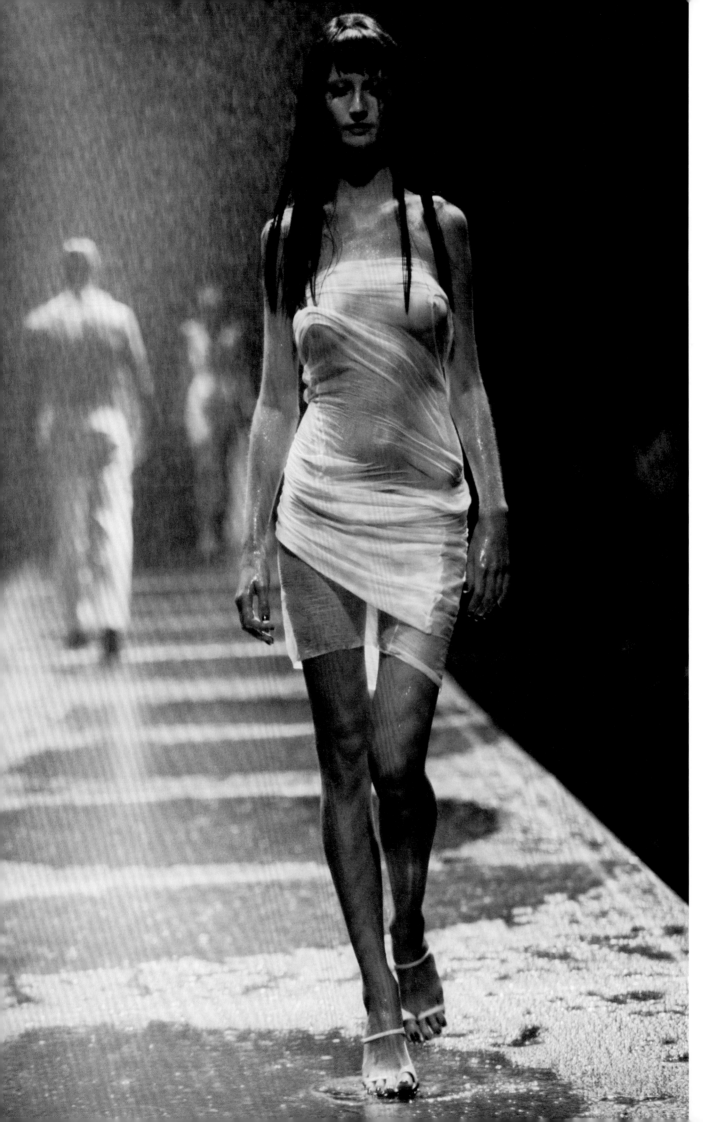

In contrast to the romantic, historical vision of Galliano, McQueen's shows – for both his own label and Givenchy – were hard-edged and contemporary. He wanted to call his Spring/Summer 1998 show 'The Golden Shower', in reference to the practice of urinating on a sexual partner, but his sponsor, American Express, baulked at the idea. The show was instead called 'Untitled', like a work of art. For the show's finale, models dressed in white walked beneath a shower of water while Ann Peebles's song 'I Can't Stand the Rain' played.

Left and opposite:
Alexander McQueen
Spring/Summer 1998
London

Overleaf:
**Alexander McQueen
for Givenchy**
Autumn/Winter 1998
Paris

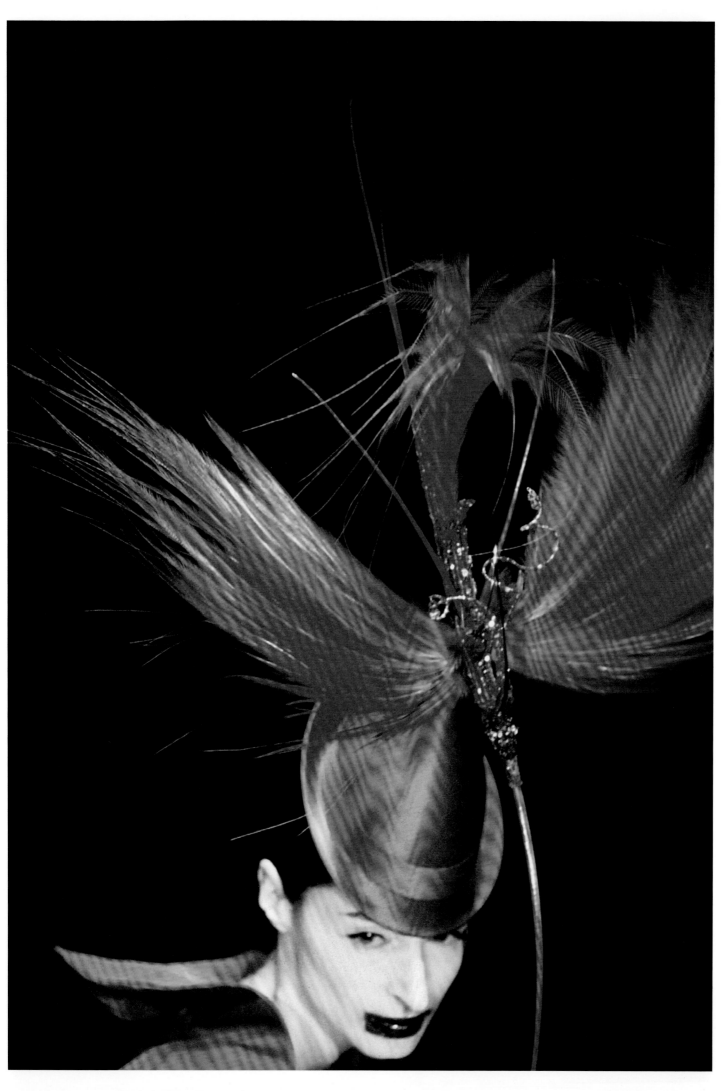

Left:
Philip Treacy
Autumn/Winter 1998
London

Opposite:
Versace
Autumn/Winter 1998
Milan

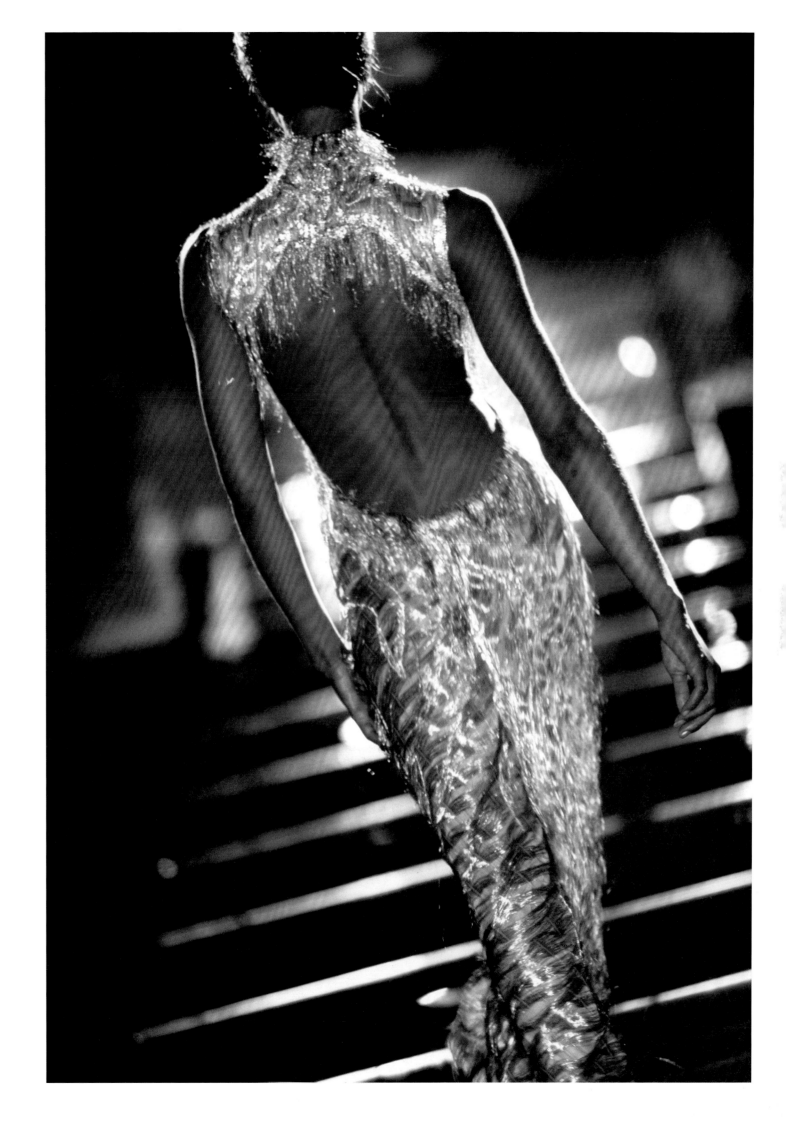

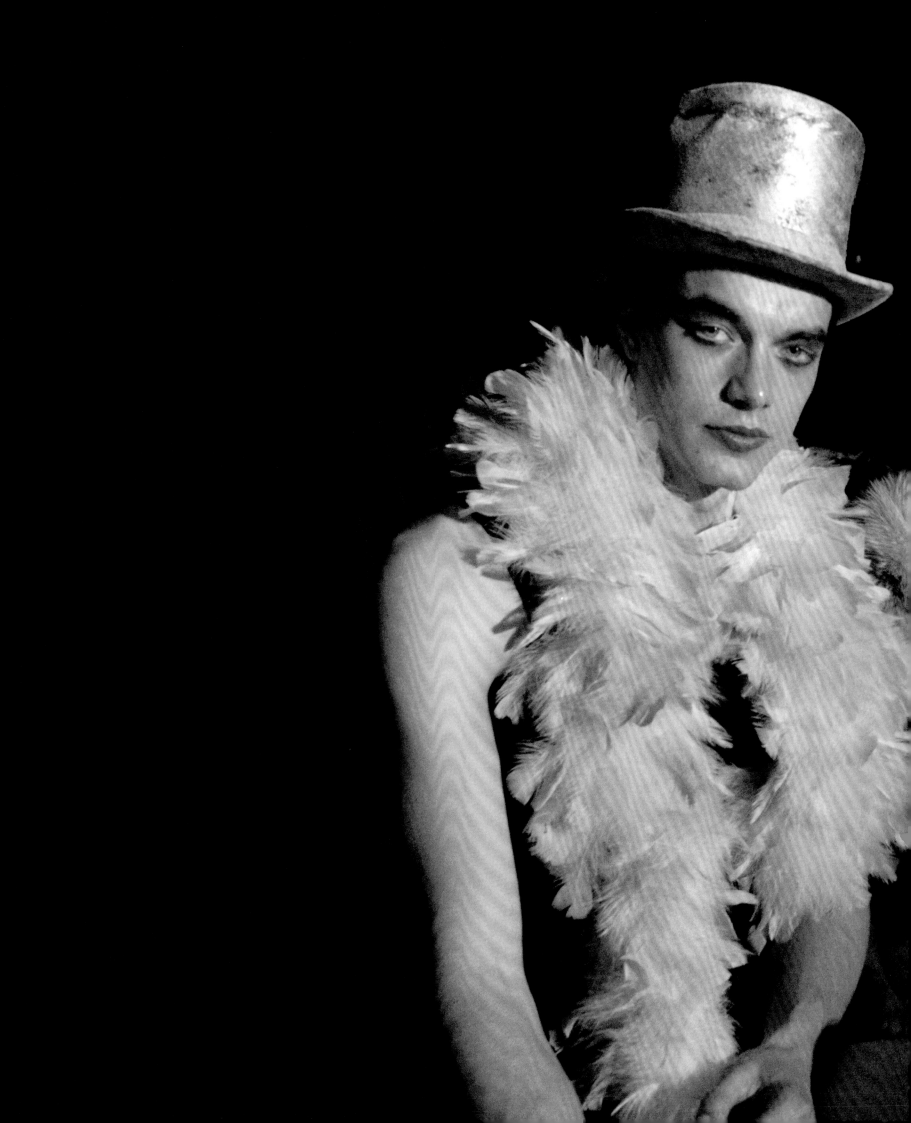

John Galliano's theatrical vision was all-encompassing, and audience members were often invited to participate in the fantasy. For Autumn/Winter 1998, the cinematic set designer Michael Howells re-created a Weimar-era Berlin cabaret in the Parisian suburbs of the Bois de Boulogne, complete with cross-dressing extras. The fashion press and buyers sat among the set and players as the models wound their way through.

John Galliano
Autumn/Winter 1998
Paris

Julien Macdonald
Spring/Summer 1999
London

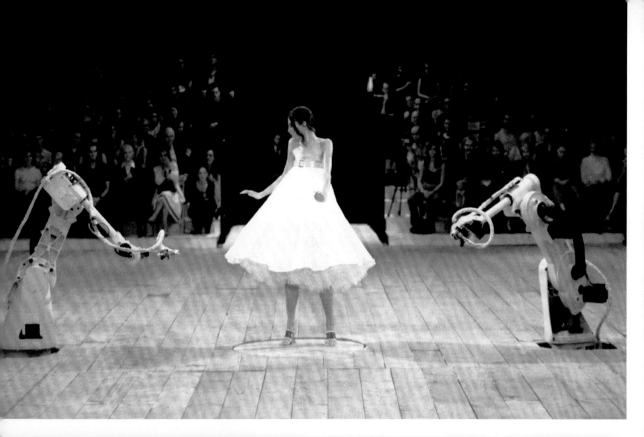

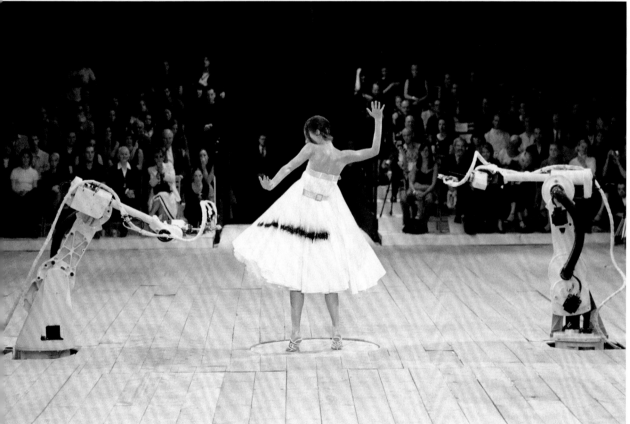

Alexander McQueen staged his Spring/Summer 1999 show at a warehouse on Gatliff Road, London. The set, created by the warehouse production designer Joseph Bennett and the producer Sam Gainsbury, was based in part on *High Moon* (1991), a piece by the artist Rebecca Horn in which two shotguns fired blood-red paint at each other. McQueen replaced the guns with the machinery used to spray-paint car chassis, and placed the model Shalom Harlow between them in a white dress. McQueen later said that this show was the only one that had ever made him cry.

Alexander McQueen
Spring/Summer 1999
London

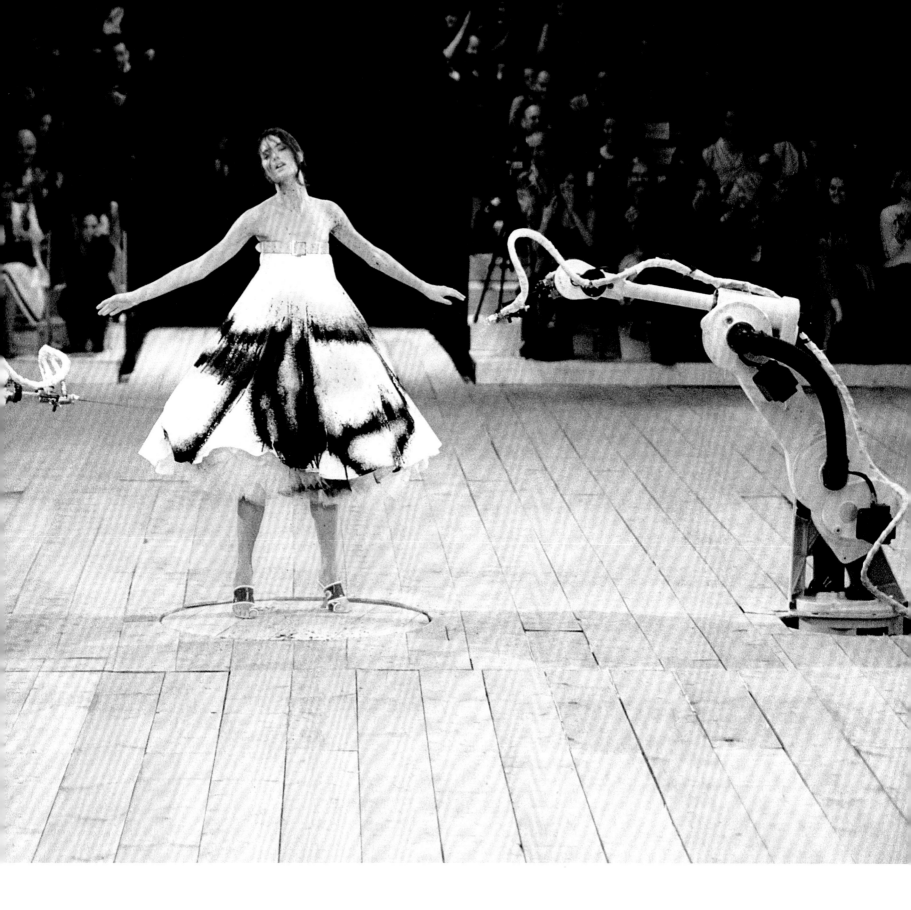

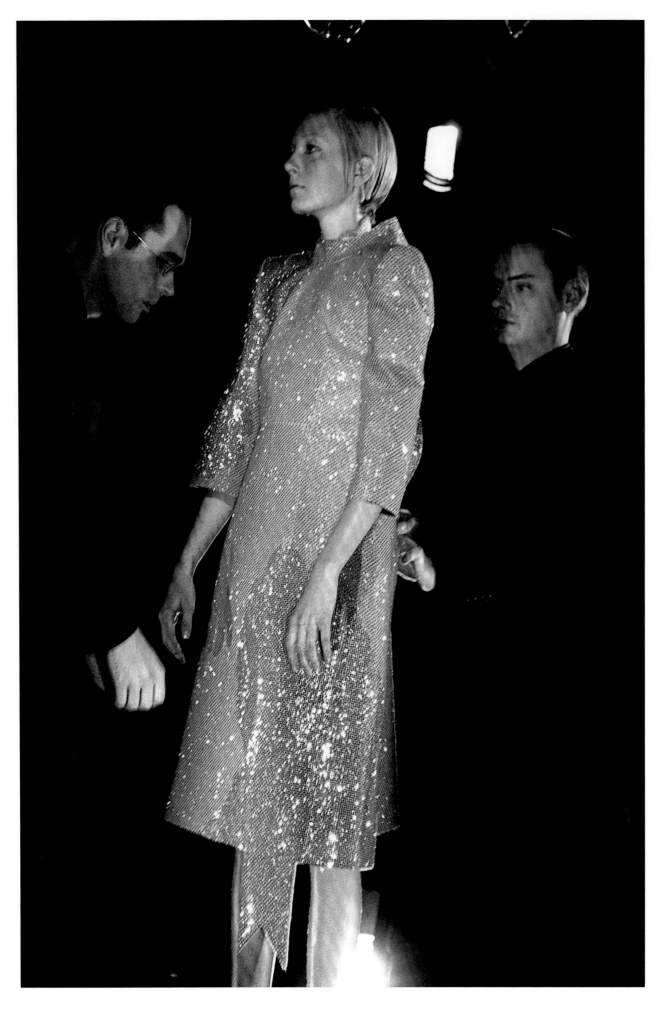

Two approaches to winter fashions: Viktor Horsting and Rolf Snoeren piled layers of clothes on to the body of the model Maggie Rizer as though she were a Russian matryoshka doll. Eight outfits were custom-made to fit one on top of the other. Meanwhile, in London, Alexander McQueen created a collection in homage to Stanley Kubrick's film *The Shining*, and sent his models ice-skating inside a Perspex box (overleaf). Halfway through the show, a snowstorm began.

Viktor & Rolf
Autumn/Winter 1999
Haute Couture, Paris

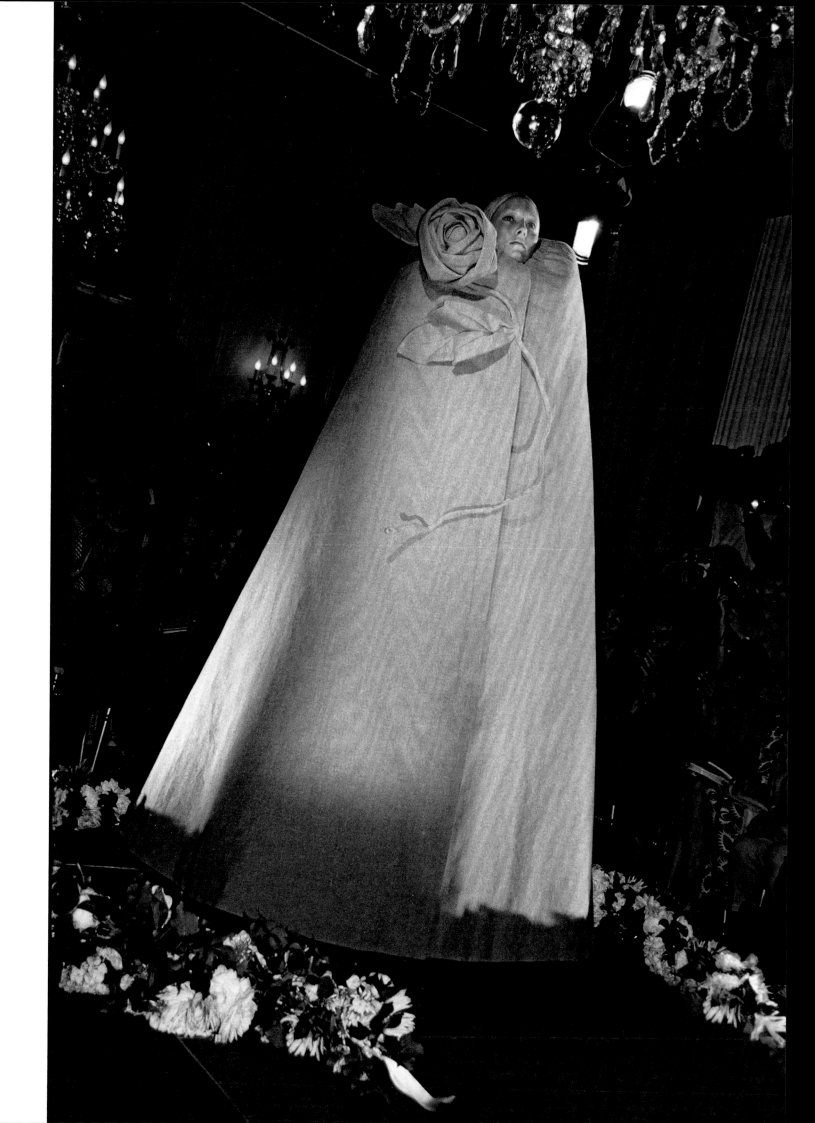

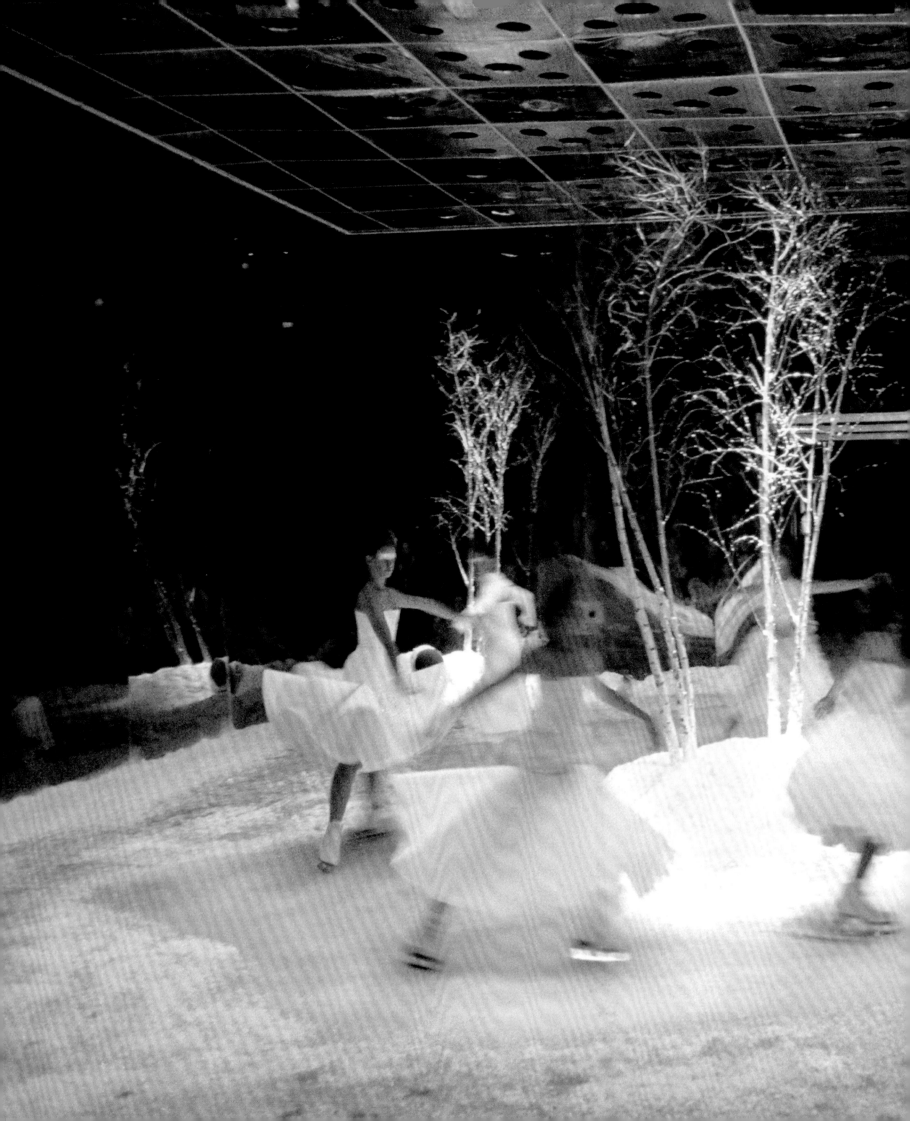

Alexander McQueen
Autumn/Winter 1999
London

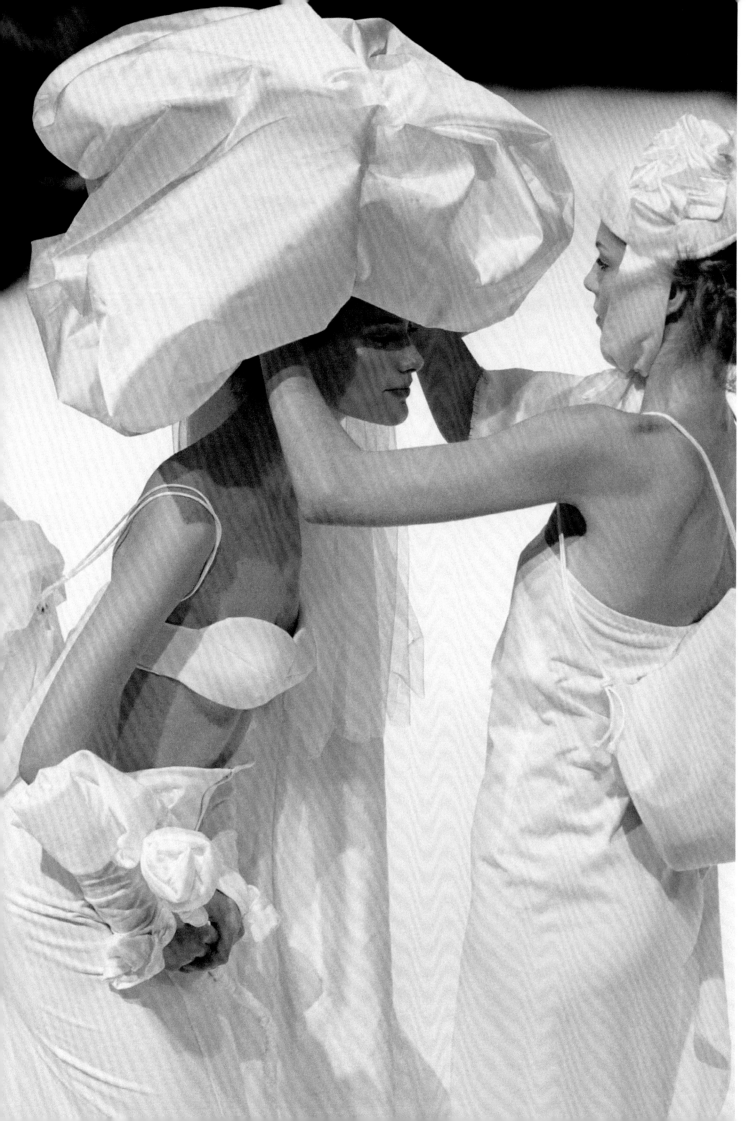

'I loved this show where the models dressed each other,' recalls Moore. His camera captured tender scenes of Yamamoto's models interacting, delicately changing garments and adjusting hats, producing pictures that were unlike any fashion-show images captured before.

Yohji Yamamoto
Spring/Summer 1999
Paris

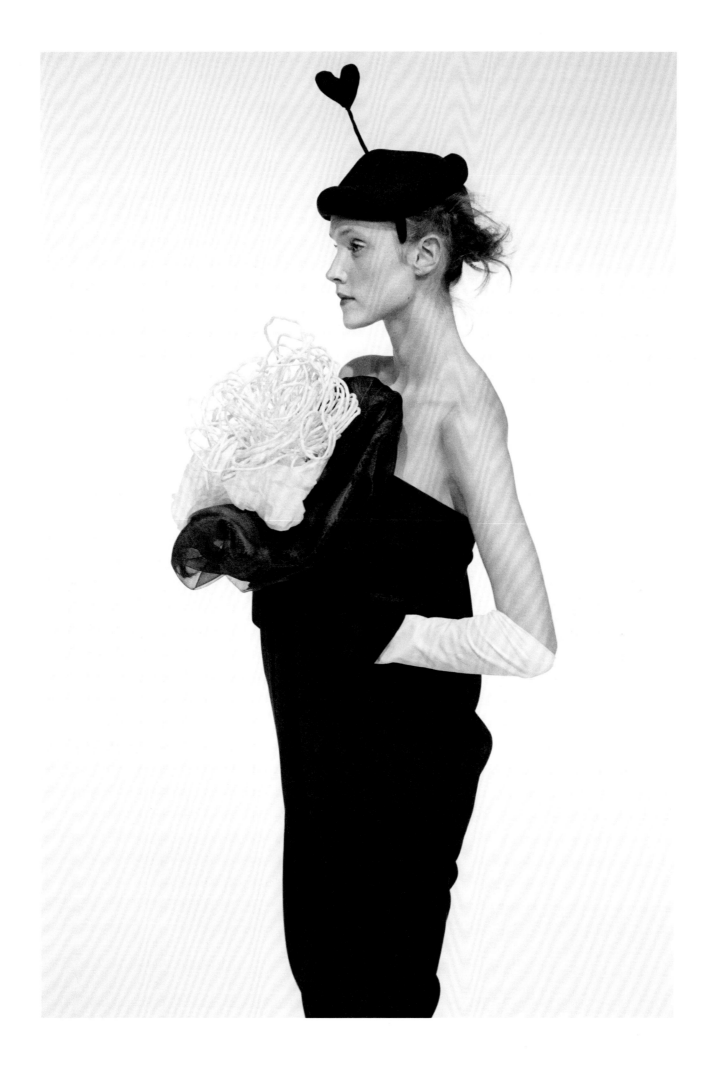

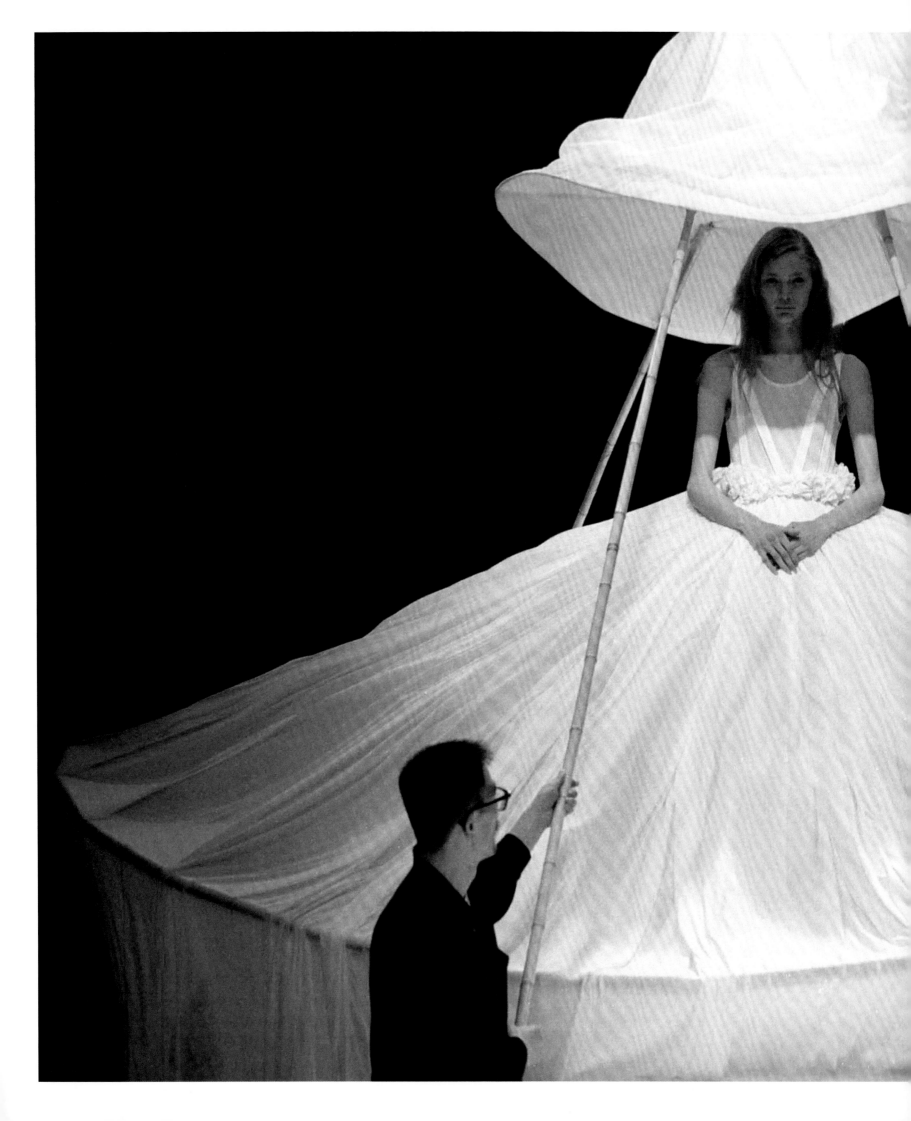

Yohji Yamamoto's work of the late 1990s consciously referenced mid-century haute couture and created odes to the work of Chanel and Dior. Here Yamamoto exaggerated the crinoline skirt of the model Jodie Kidd to such a width that it swept along the faces seated in his front row. It was an alternative view of the theatre of fashion.

Yohji Yamamoto
Autumn/Winter 1998
Paris

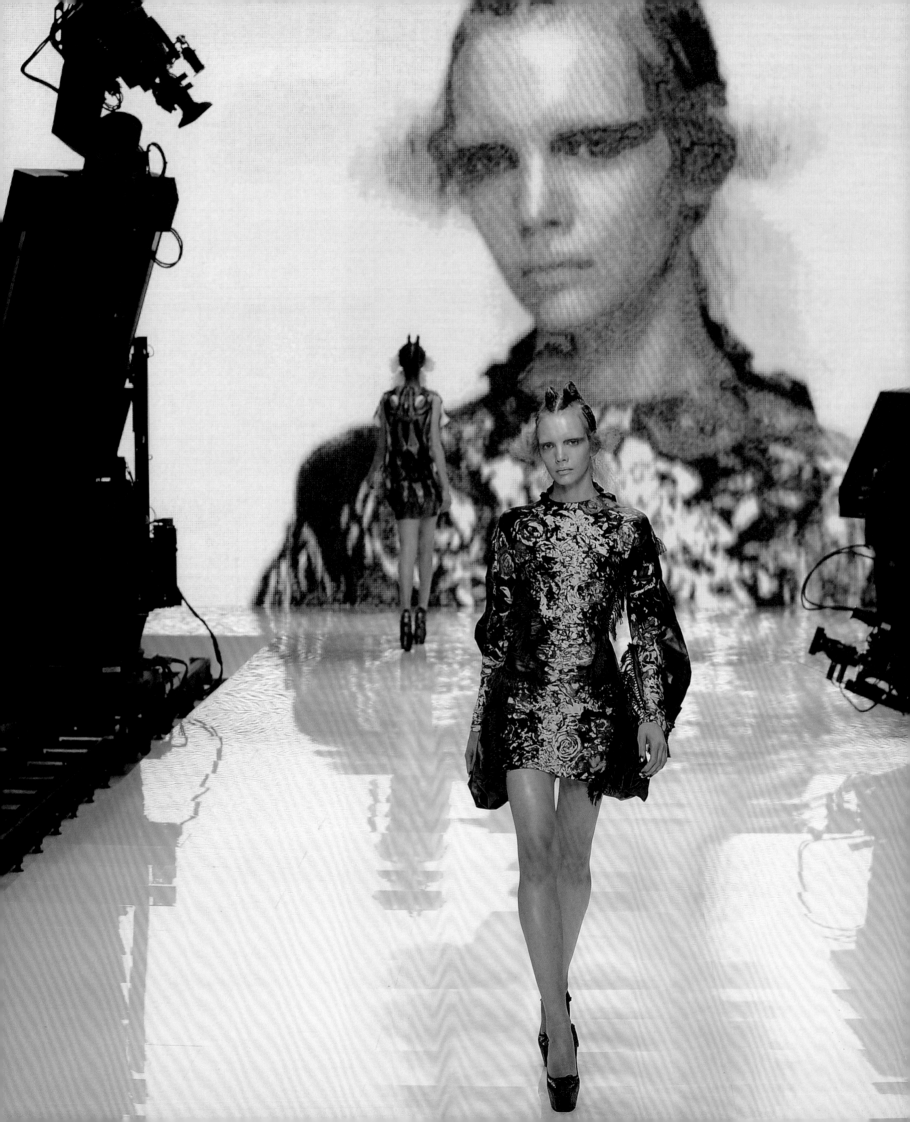

The Millennium Bug

2000–2009

'It's all got to be instant. It's all about speed.'

Chris Moore

On 22 January 2002, Yves Saint Laurent staged his final show. He retired in October that year. 'I tell myself that I have taken part in the transformation of my times,' he said – and, just as Cristóbal Balenciaga's retreat from haute couture in 1968 proved a bellwether, so did Saint Laurent's 34 years later. An era was at an end; and, more importantly, a new one had already dawned. Oddly enough, Saint Laurent's final show represented not the past but the future, namely the new media mood of the new millennium. Rather than being shown to a cosseted, privileged few at the Hôtel Intercontinental, it was staged with aplomb at the Pompidou Centre, to more than 2,000 guests. Outside, thousands more gathered to watch the show on enormous video screens. Within 24 hours, the entire collection was posted to Style.com – in 278 images.

Immediacy, mass appeal and spectacle orchestrated for an outside audience rather than the happy few who attend the show, or even wear the clothes – that was the new mood of the twenty-first century: not only to welcome a vast audience, but also to court them outright. Eventually, shows would be staged primarily for their benefit, with front-row seats allocated to cameras representing thousands of online observers, rather than members of the fashion press.

By the year 2000, Chris Moore had moved Catwalking online, launching the first UK website dedicated to catwalk imagery mere months before the new millennium began. Later, in 2000, Net-a-porter.com became the first online sales portal for designer clothes; shortly afterwards, LVMH launched the now defunct Eluxury.com. As the dot-com bubble burst elsewhere, in fashion it had only just begun to inflate. In August 2001 the encyclopaedic catwalk show website Style.com introduced an $11 million media campaign – in print magazines – to celebrate both its presence and its rapidly rising prestige. The web portal was originally conceived as the umbrella site for Advance Publications' flagship fashion brands, *Vogue* and *W* magazines. Tellingly, neither of them maintained their own websites. In fact, in 2001 most major fashion magazines still eschewed a web presence, and the majority of fashion houses viewed the medium with trepidation and suspicion.

The same was true of catwalk photography, particularly as it began to shift from clandestine, cloistered contact sheets to being visible to all online. 'They put some of us in prison,' says Moore. 'Do you know about that?'

This may sound like something from the 1940s, when the Chambre Syndicale de la Haute Couture could have counterfeiters imprisoned, and when photographers – and even sketching – were banned in the salons of the haute couture houses. But Moore refers to the twenty-first-century imprisonment of the photographers Don Ashby, Marcio Madeira and Olivier Claisse, who were arrested on 13 March 2003 following the Chanel Autumn/Winter ready-to-wear show. Ashby and Madeira were photographers for the website Firstview.com, the first to be devoted to publishing fashion-show imagery on the internet; it went online in 1996. (At the time Madeira, based in France, had been shooting the collections since 1978; Ashby, a New York resident, began in 1984.) By 2005, Firstview.com supplied catwalk imagery to around 400 publications in the United States – including Style.com – while its own site received more than a million hits daily. However, under French law, the ownership of imagery belonged to the designers rather than the photographers – and neither the fashion houses involved (a litany of leading Paris names) nor the Fédération Française de la Couture du Prêt-à-Porter des Couturiers et des Créateurs de Mode (the governing body of French fashion that had evolved from the Chambre Syndicale) had provided permission. Firstview.com was charged with 'counterfeit by distribution or representation of intellectual property in violation of copyright', between 6 and 10 March. Ashby, Madeira and Claisse were imprisoned for two days. Françoise Benhamou, the head of judicial affairs and intellectual property at the Fédération, dubbed the act an 'illicit traffic'. Didier Grumbach, the Fédération's president, clarified on French radio that the problem was the selling of images, not the journalistic process – namely, that images had been mutually agreed by fashion houses to be used in specific publications only, not on Firstview.com. The argument was ownership: whose images were they, anyway?

The case went to court in June 2005, when Ashby, Madeira and Claisse offered a portfolio of images that, their legal representatives argued, were a distinct work – an art unto themselves – as a result, the photographers should have ownership rights. In July the French courts ruled in their favour (although a fine was issued in the Paris Court of Appeal in February 2008).

The convoluted legality of the Firstview.com saga illustrates a number of points. Firstly, it underlines the power of the new media – of views in the millions, and images being used by hundreds of news sites. Second, it illustrates the suspicion that lingered in certain corners of the industry. The democratization of fashion began with ready-to-wear in the 1960s; now it was that democratization of fashion imagery that was causing a furore, and which fashion houses wished to control. By 2003, reports of clients using online imagery to request specific outfits from retailers was becoming commonplace. Many designers assumed that it would also result in speedy counterfeiting of their goods, hence the urge to restrict the publication and dissemination of imagery.

'I can remember when we first set up Catwalking.com, I was terrified that we'd have problems,' Moore recalls. 'But I was amazed that designers were actually delighted that they were on Catwalking. We have designers who, if we don't go and photograph, do say "Can we be on Catwalking?"' He allows that, even today, some French houses try to restrict the use of their images. But they are in the minority.

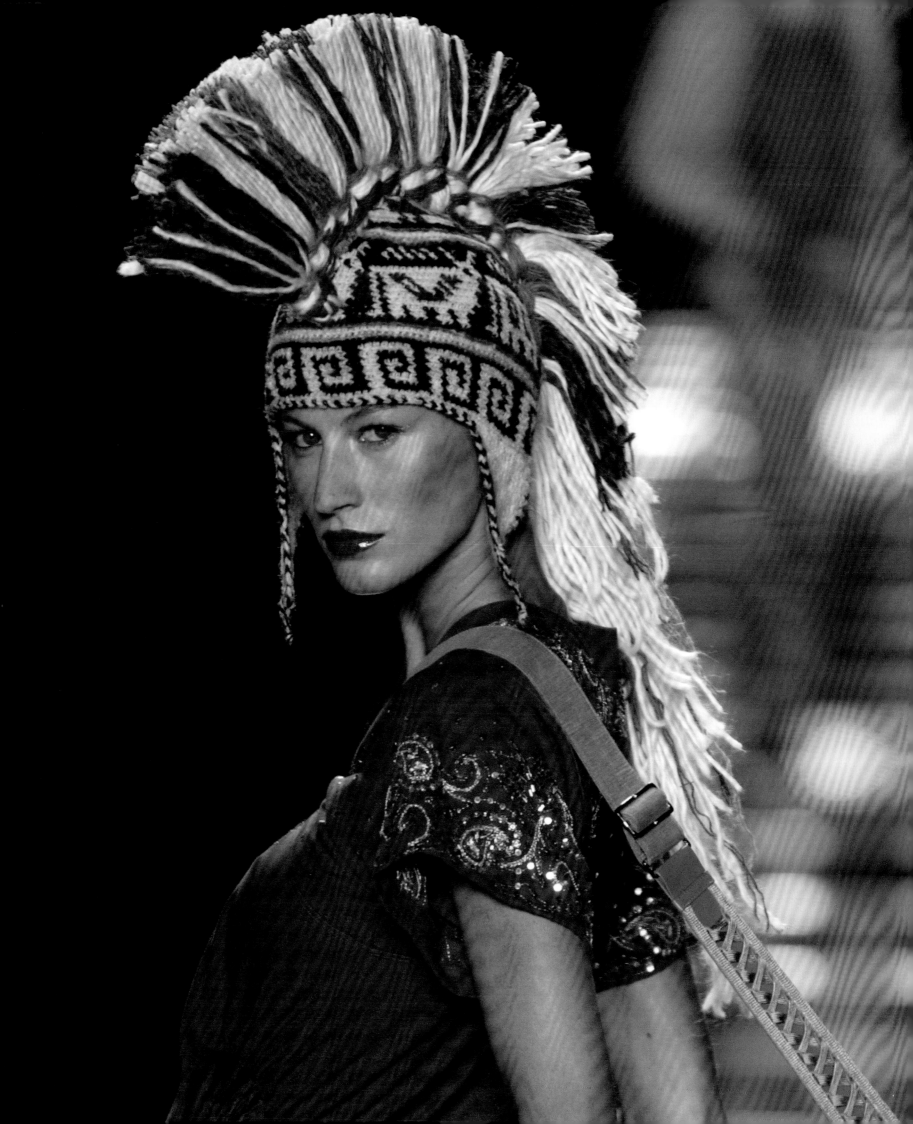

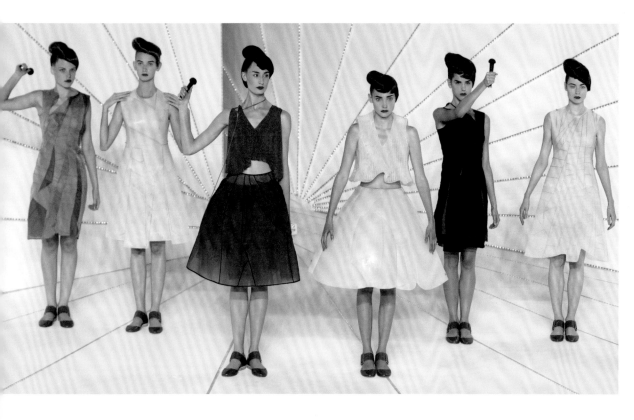

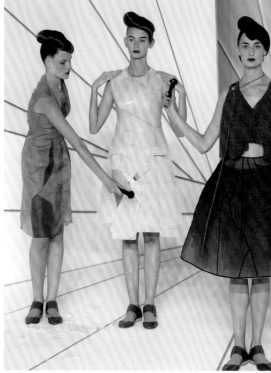

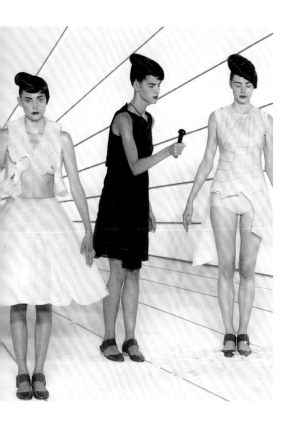

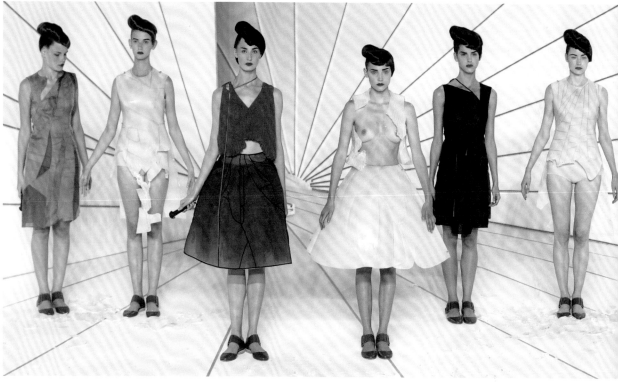

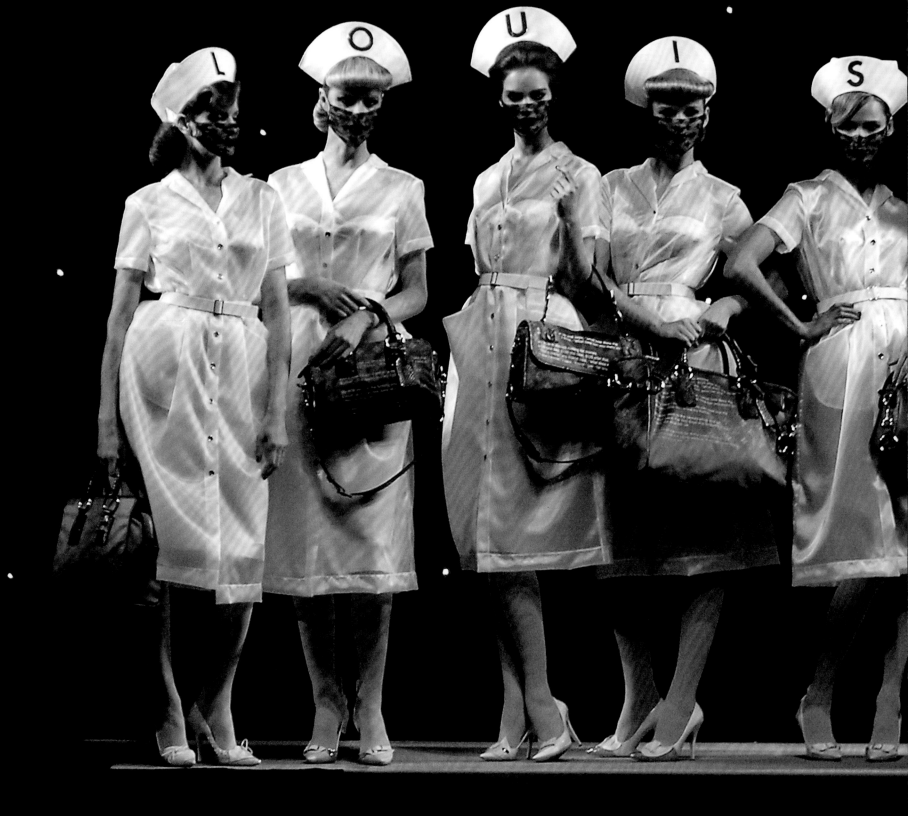

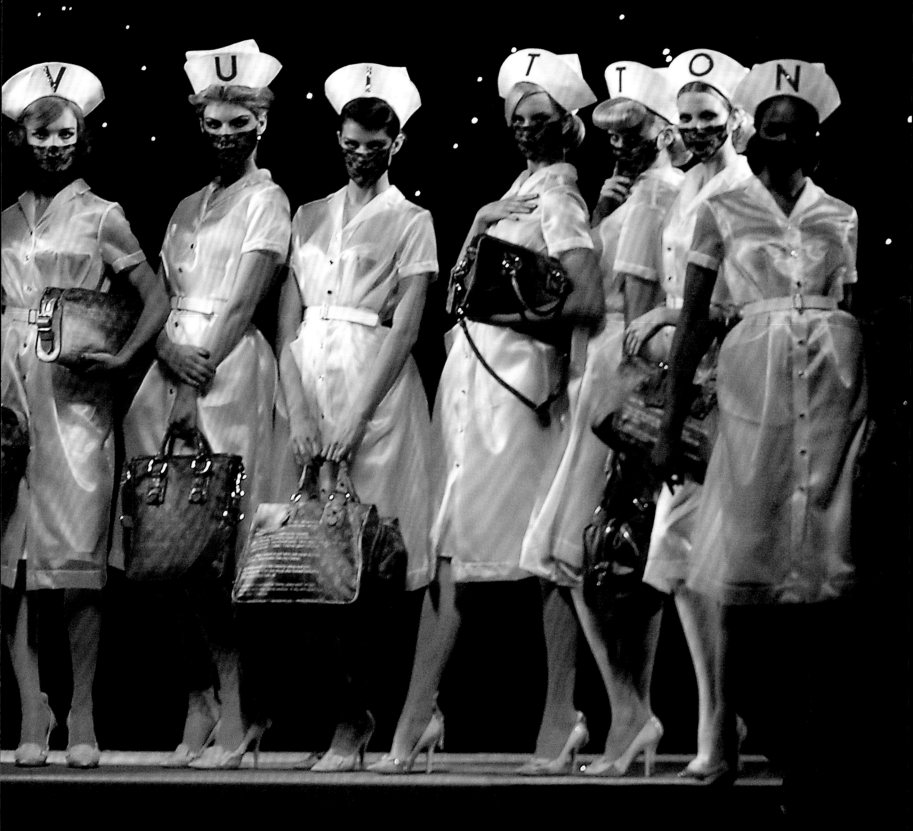

Below:
Miguel Adrover
Autumn/Winter 2000
New York

Previous page:
Louis Vuitton
Spring/Summer 2008
Paris

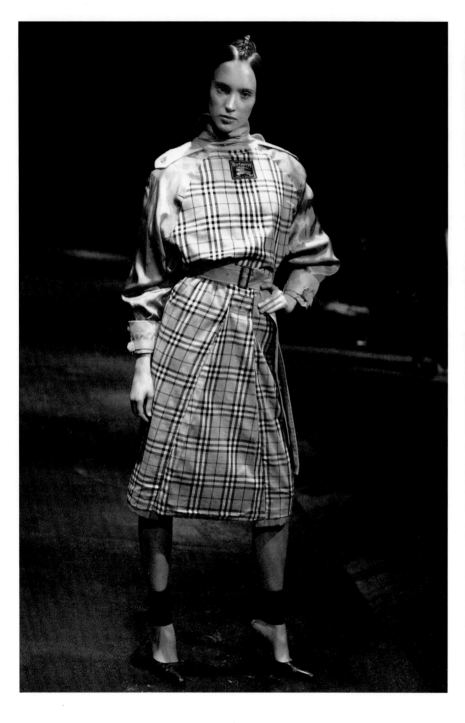

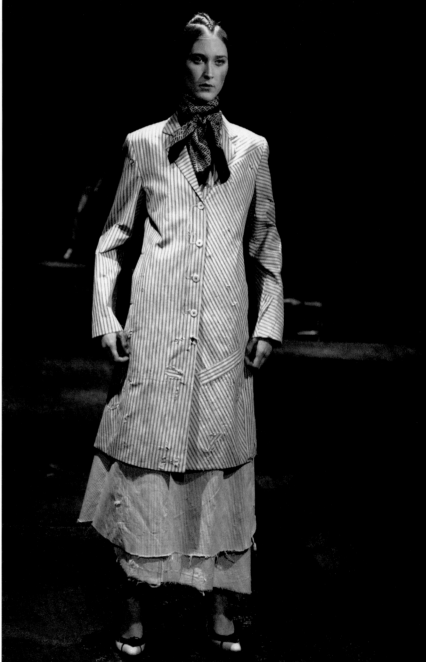

Regardless of the new digital world dawning around it, the fashion show in the twenty-first century did not change. It still consisted, somewhat archaically, of models walking in clothes, before a static audience of observers, and the ever-present bank of photographers. A few designers chafed at the restrictions, and proposed alternatives – with varying degrees of success. Lee Alexander McQueen presented his final Givenchy haute couture collection of the twentieth century on plexiglass dummies, raised and lowered through trapdoors; Jean Paul Gaultier showed his Autumn/Winter 2004 collection on puppets (as Maison Martin Margiela had done back in 1998). Hussein Chalayan abandoned catwalk shows for Spring/Summer 2008, opting instead to show via a film created with the fashion photographer Nick Knight – who founded his own fashion website, SHOWstudio.com, in 2000, as a way of exploring 'representations of fashion online.' Generally, though, fashion was represented online via the catwalk image, in the full-length, straight-on format established in the mid 1990s. The main point of difference was that, by the middle of this new decade, more images were being seen by more people than ever before. Those Style.com advertisements that unfurled across magazines throughout the autumn of 2001, bore the tagline 'Runways are everywhere.' It had never been truer.

The expansive possibilities of the internet were reflected, in a broader scale, by a sheer surfeit of fashion. The rise of the luxury conglomerate continued unabated: Prada, the Gucci Group – later Pinault-Printemps-Redoute, now Kering – and Richemont followed LVMH and bought controlling stakes in a number of different fashion houses, installing new designers and staging extravagant shows. Gucci's Tom Ford took the helm of Yves Saint Laurent; McQueen was ousted from Givenchy after he sold his namesake brand to the Gucci Group. Outside that murky corporate bubble, the sense of disparity and expansion was expressed through radically different proposals of how men and women should look, and even what clothing should be.

The latter is, possibly, the easiest way to summarize the work of a radical group of designers, pushing against the borders of what clothing could mean. The Cypriot-born Chalayan was at the forefront, staging a sequence of fashion shows at the turn of the new millennium which transformed the way we considered both clothes and the fashion show. Chalayan's shows – specifically a trio, 'Before Minus Now' (Spring/Summer 2000), 'After Words' (Autumn/Winter 2000) and 'Ventriloquy' (Spring/Summer 2001), staged at Sadler's Wells Theatre in London with production values that approached performance-art installations – proposed radical ideas about the function of clothing, and hence about the fashion show as a whole. Clothes were remote-controlled, clad in rigid plastic or magically expanded when plugged into electricity; topiary shapes were carved from tulle by sculptors, rather than sewn by dressmakers; in 'Ventriloquy', avatars of models were projected in a virtual-reality world before the show commenced; in 'After Words', a table magically unfurled into a skirt. Pieces of fashion theatre and technical ingenuity, they nevertheless raised questions about the very purpose of the garments we wear. Should we be able to carry our home around with us? Will garments always be sewn? Can technology begin to control the clothes on our back? The last question, posed a decade before the iPhone made the mobile computer an everyday reality rather than a pipe dream, is emblematic of Chalayan's forward-thinking design ethos. But, when it came to fashion shows, Chalayan's London presentations were old-fashioned and distinctly British, of the school of wonder and make-believe. His table transformed into a skirt not to the hushed awe of an art-gallery crowd, but to riotous screams and tumultuous applause. 'It was extraordinary', recalls Moore. 'He's a visionary.' The fashion critic Cathy Horyn dubbed 'Before Minus Now' 'one of the best shows seen anywhere in the last few years'. It couldn't have been, if the clothes weren't great.

Questioning clothing didn't always mean the sci-fi stuff. The work of Miguel Adrover in New York was decidedly low-fi: his first collection repurposed a Louis Vuitton Monogram handbag as a skirt; his second featured an inside-out Burberry raincoat worn back-to-front as a dress, and a suit cut from the mattress ticking of the recently deceased Quentin Crisp (Adrover's neighbour). It was born out of necessity – namely, that Adrover, as a young designer, was penniless and working with found fabrics and objects (Crisp's mattress had been thrown out on the street). But it also tied in with other designers subverting traditional codes of luxury, such as John Galliano showing a Christian Dior haute couture collection inspired, in part, by the homeless people seen on the banks of the River Seine (Spring/Summer 2000), or Nicolas Ghesquière inventing a new, twenty-first century identity for the house of Balenciaga without any overt reference to its archives or storied history. Later, Marc Jacobs would pick up on Adrover's brutalized Vuitton skirt when he asked the New York artist and fashion designer Stephen Sprouse to graffiti across Louis Vuitton's canvas handbags. Commercialized, they sold for four-figure sums. What it all added up to was a sense of confusion, even anarchy. Of designers challenging norms – of design, of marketing, of value, even of the idea of fashion itself.

Fashion is always new in contrast with that which has just ceased to be fashionable. Four years after presenting his 'Homeless' haute couture collection, of exquisitely handworked rags and trousers printed with newspaper pages from the *International Herald Tribune*, Galliano devoted a Christian Dior haute couture collection to the nineteenth-century Empress Elisabeth of Austria. His models preened and camped it up, towering on a mirrored catwalk atop platform shoes, hair piled high above gowns tightly corseted and vastly skirted, the surfaces of their clothes festooned with embroidery re-creating

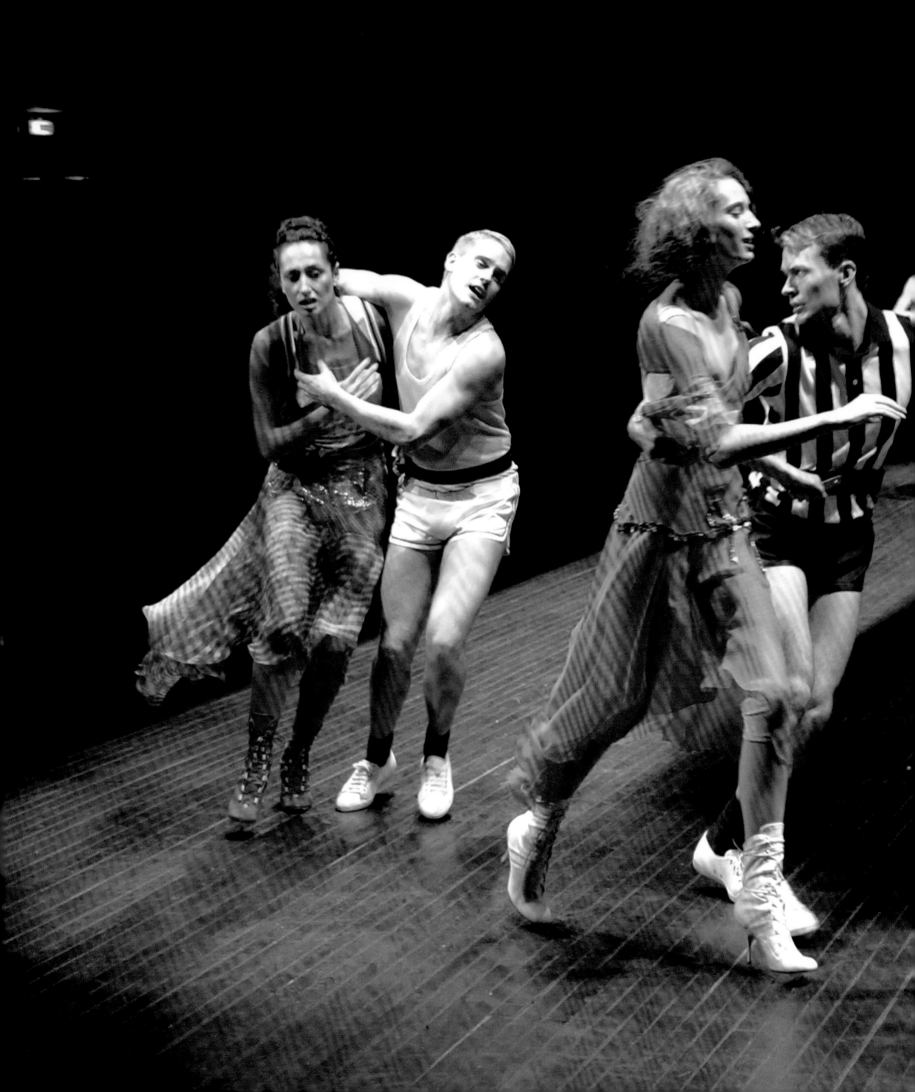

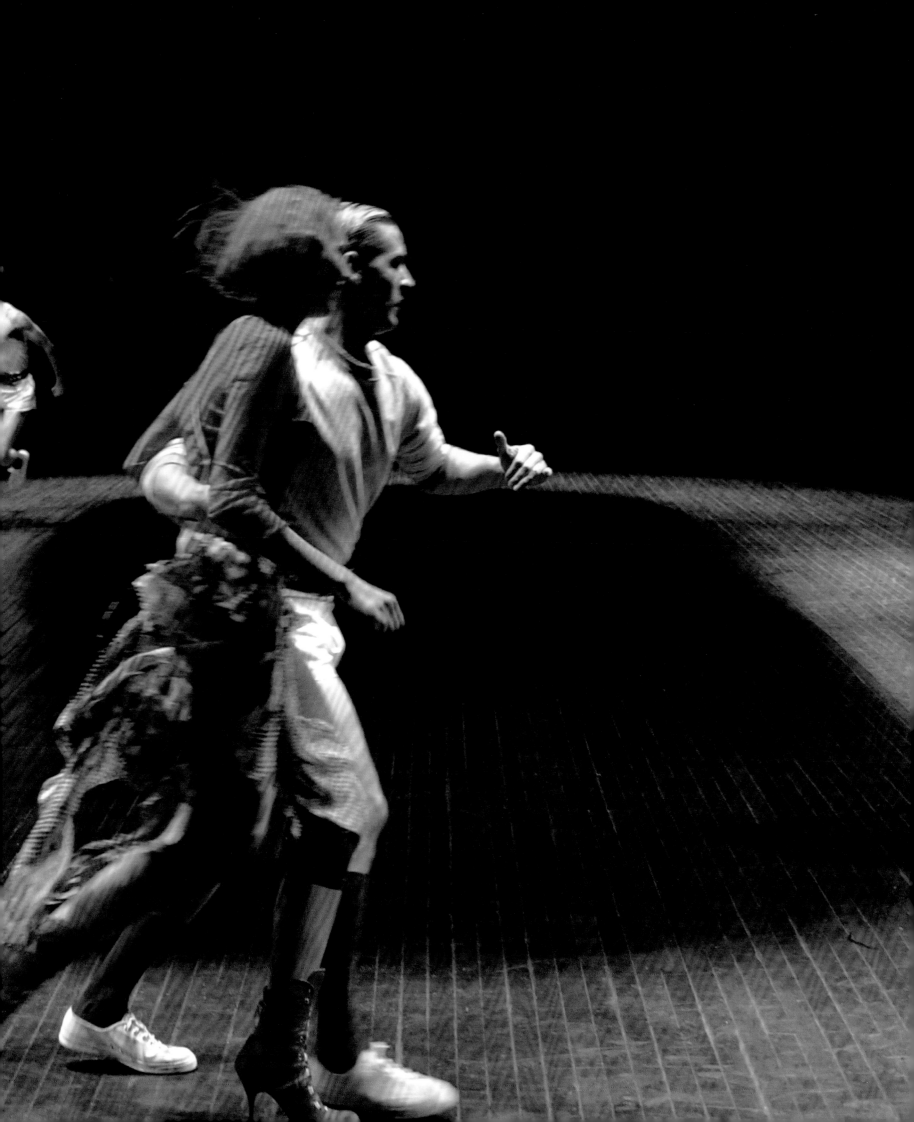

the gilded ormolu and chortling putti of an imperial palace. The pendulum had swung away from questioning the meaning of luxury, instead glorying in its excess, championing its traditions. Galliano's example – like his clothes – is extreme, but it demonstrates a general shift. In 2006 Ghesquière created a collection in overt homage to Cristóbal Balenciaga, with high-domed pillbox-style hats, curvilinear tailoring and heavy, almost cloven-hoofed footwear. It was conceived while Ghesquière was preparing for a Balenciaga retrospective at the Musée de la Mode et du Textile in Paris in July – hence its unusual, backwards-slanting take from one of fashion's foremost modernists. The collection was highly influential: over the next half-decade, designers across the industry would create their own 'homages' to Balenciaga – old, and new.

That wasn't the only story. If the supermodels were the anchor of the 1990s, it seemed nothing held the 2000s in place, as designers bounded from futurism to revivalism, from high-tech to haute couture. Did any of it, ultimately, matter? Unlike previous decades, the real importance of the fashion decade running 2000–2009 was not the transformation of the clothes, but their communication. It wasn't what we saw, but rather the way we saw it that made fashion in the 2000s remarkable – the fact that Galliano's punks and princesses alike were viewed online, blearily pixelated at first, and in crisp high-definition by the end of the decade. Moore and Catwalking.com were instrumental in that shift, helping to demonstrate the power and impact of showcasing fashion via the internet. As never before, audiences could see not just edited highlights of collections, but shows in their entirety, from multiple angles, in minute detail. It was, arguably, better than being there.

Despite their earlier reticence, by the end of the decade the fashion houses had taken control of their imagery – and hence their image – online, namely via real-time internet broadcasts – 'live streams' – of fashion shows. Helmut Lang was the first; he showcased his Autumn/Winter show online in March 1998. Internet bandwidth didn't yet support video streaming, so Lang uploaded 81 images to his website, Helmutlangny.com, and sent editors a CD-ROM of the images and a video.

'This is the first step in the future,' Lang said at the time. He cancelled his planned New York show with just a week to go. Few understood the significance. 'In terms of the broader context of the industry, we made in the same season the entire collection available on a public platform, allowing consumers for the first time to get an unfiltered view of my work,' Lang stated, retrospectively, in 2016. 'It was a shock to the system, but a beginning of the new normal.' It took other designers more than a decade to catch up, but that notion of fashion unfiltered proved seductive for many designers. Rather than relying on the visual storytelling of Moore through any number of publications, houses decided to go it alone – under their own control. They used the digital sphere to craft their own universes. And, unlike Lang's earliest attempt, the resulting revolution would be televised.

The requirements of this demanding new global audience had an impact on fashion. Perhaps even more so than in the 'supershows' of the 1990s, designers were playing to a public gallery, expanding far beyond the reach of any newspaper or magazine, even in their heyday. During the course of the decade, the spectacles staged by Galliano and McQueen grew ever more lavish, and were documented with a newly frenzied ferocity. Karl Lagerfeld and Chanel also leapt into the fray, staging shows on a larger scale than ever before. From 2006, they have shown – mostly – in the Grand Palais des Champs-Élysées, a gargantuan Beaux-Arts exhibition hall constructed for the Exposition Universelle of 1900. The space enabled Chanel to construct near enough anything at its epicentre – from a towering spiral staircase to nowhere, to a 23-metre (75-foot) model of a Chanel jacket, braid and all, in cement. The clue is in the name of the venue: grand, like fashion's twenty-first-century ambitions, to put on one hell of a show.

'Usually communication is done through entertainment media like film and music,' commented McQueen in 2009. 'But fashion is part of that ... Whether I like it or not, my shows are a form of entertainment.' If Chalayan reimagined shows as performance art, McQueen staged shows as sheer performance: his Spring/Summer 2004 show, 'Deliverance', was inspired by the dance marathon in Sydney Pollack's film *They Shoot Horses, Don't They?* (1969) – and models choreographed by Michael Clark danced their way through the whole thing. Clark had choreographed shows for the British design duo BodyMap in the 1980s; he danced a Scottish reel for Vivienne Westwood's first menswear show, in June 1990. Neither gained the kind of exposure afforded to McQueen, although both were comparatively cult names in their respective periods. Neither, however, had the power of the internet as a tool for marketing their image. Indeed, rather than just marketing, the internet began to define the image of these fashion shows: they became engineered not for the few hundred in attendance, but for the scores watching at home. If the 1970s marked the invention of the fashion show proper, and of the public being able to see fashion captured in its natural habitat for the very first time, the 2000s shifted the power. It was now about seducing the public, live and direct.

Interestingly, even the troubles of the outside world seemed unable to dampen fashion's enthusiasm. The financial crisis and resulting recession of 2007–2008 – considered by many to be the worst since the Great Depression – dented many designers' bottom lines. The collapse of Lehman Brothers on 15 September 2008 came in the midst of the Spring/Summer 2009 ready-to-wear shows. A year later the house of Christian Lacroix, an haute couture darling whose early promise never translated into mass success, went into administration. Lacroix was perhaps fashion's highest-profile casualty: the label never turned a profit in 22 years, and reported a €10 million loss in 2008.

But, paradoxically, Lacroix was the exception rather than the rule. During the 'Great Recession', fashion played a confidence trick at a time of profound financial hardship, and the shows of major brands were still dizzying in their extravagance. In October 2009 McQueen staged what would be his final show, 'Plato's Atlantis' – an extravaganza of pixelated videos and roving robotic cameras 'dissecting' the models and broadcasting them, immediately, on to a 18-metre (60-foot) LED screen behind the catwalk. Under the direction of Nick Knight – who has filmed music videos for Björk and Massive Attack, as well as cinema-screened perfume commercials for Christian Dior – the whole spectacular was, of course, live-streamed, against a soundtrack by Lady Gaga. But, most tellingly, the show, with its roving cameras, back projections and integrated video footage, was articulated not for the audience (in a sports stadium in Bercy, on the outskirts of Paris), but for online viewers.

As the stream began, the McQueen website immediately crashed, owing to the sheer number of viewers online – over half a million – attempting to access it at the same time. Knight estimated that the video was seen by 40 million people in the ensuing few weeks. The internet upped the audience, and therefore the ante, exponentially.

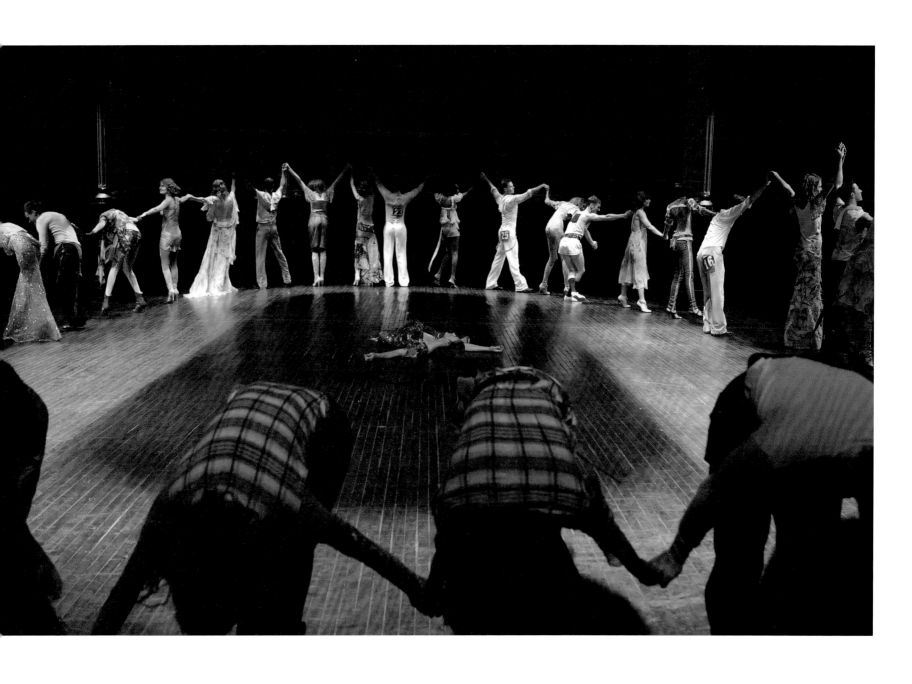

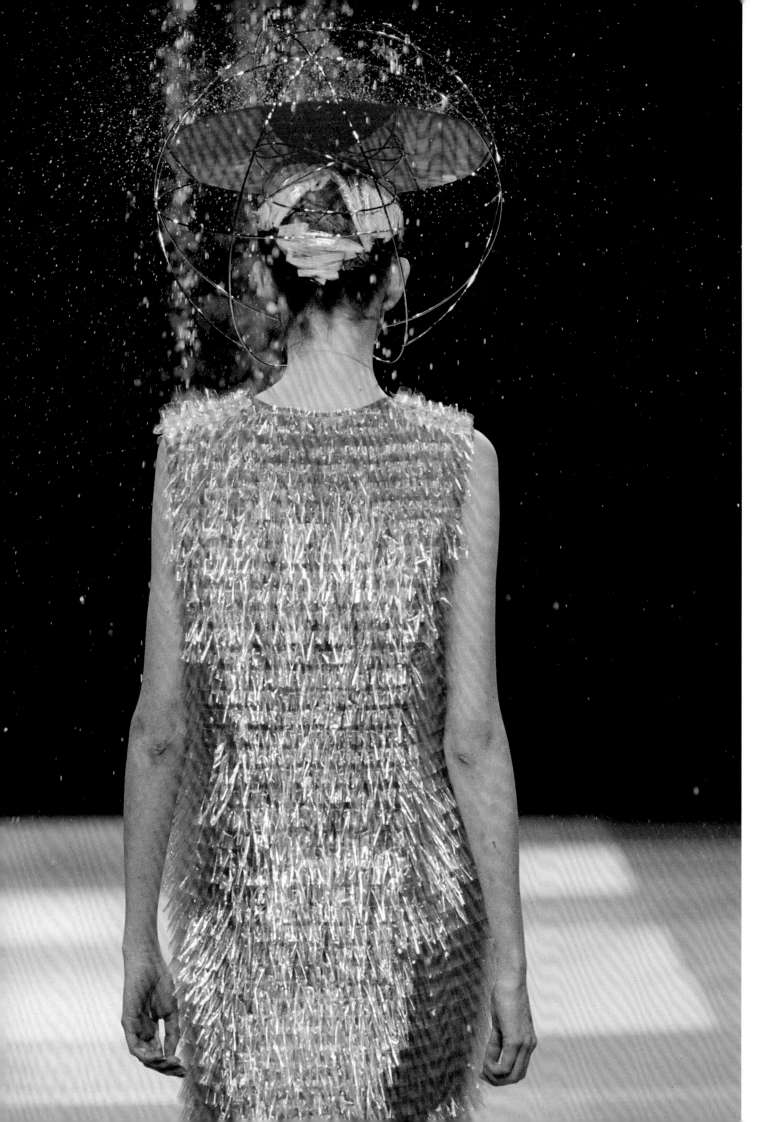

Left:
Junya Watanabe
Spring/Summer 2000
Paris

Opposite:
Maison Martin Margiela
Spring/Summer 2000
Paris

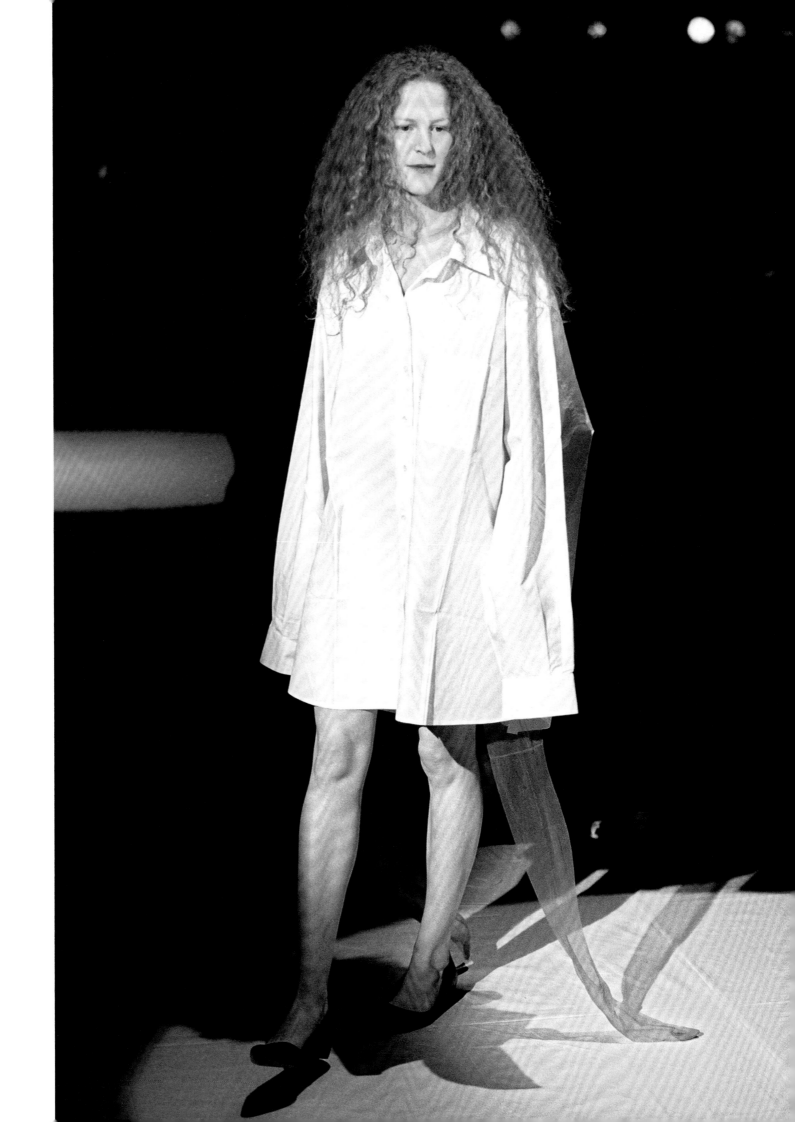

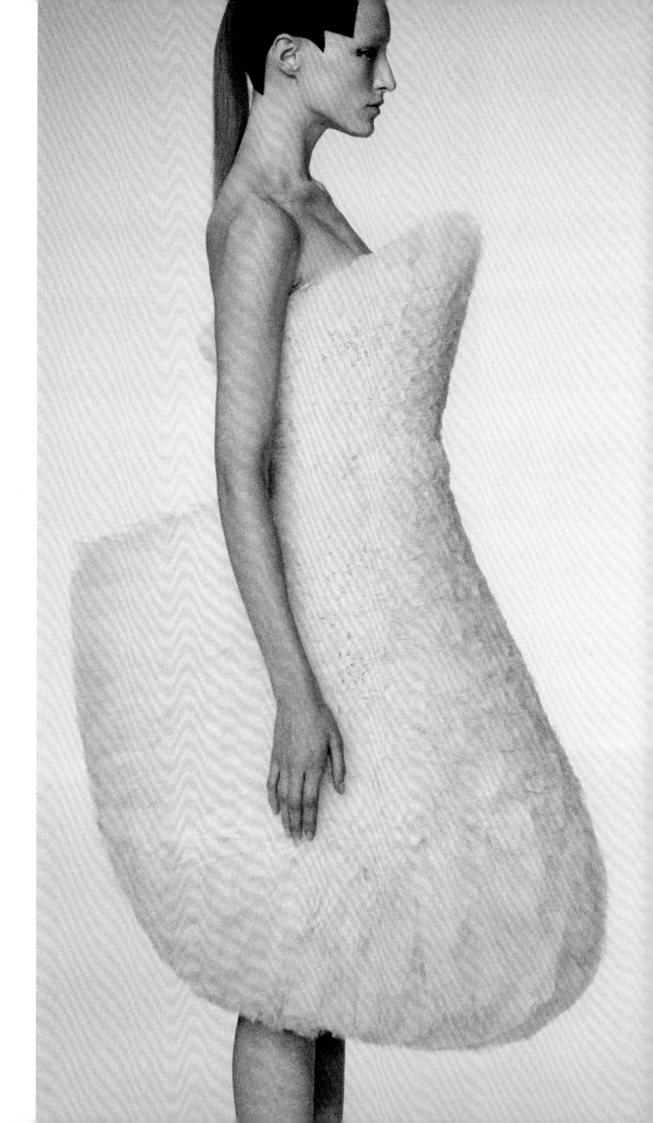

Hussein Chalayan
Spring/Summer 2000
London

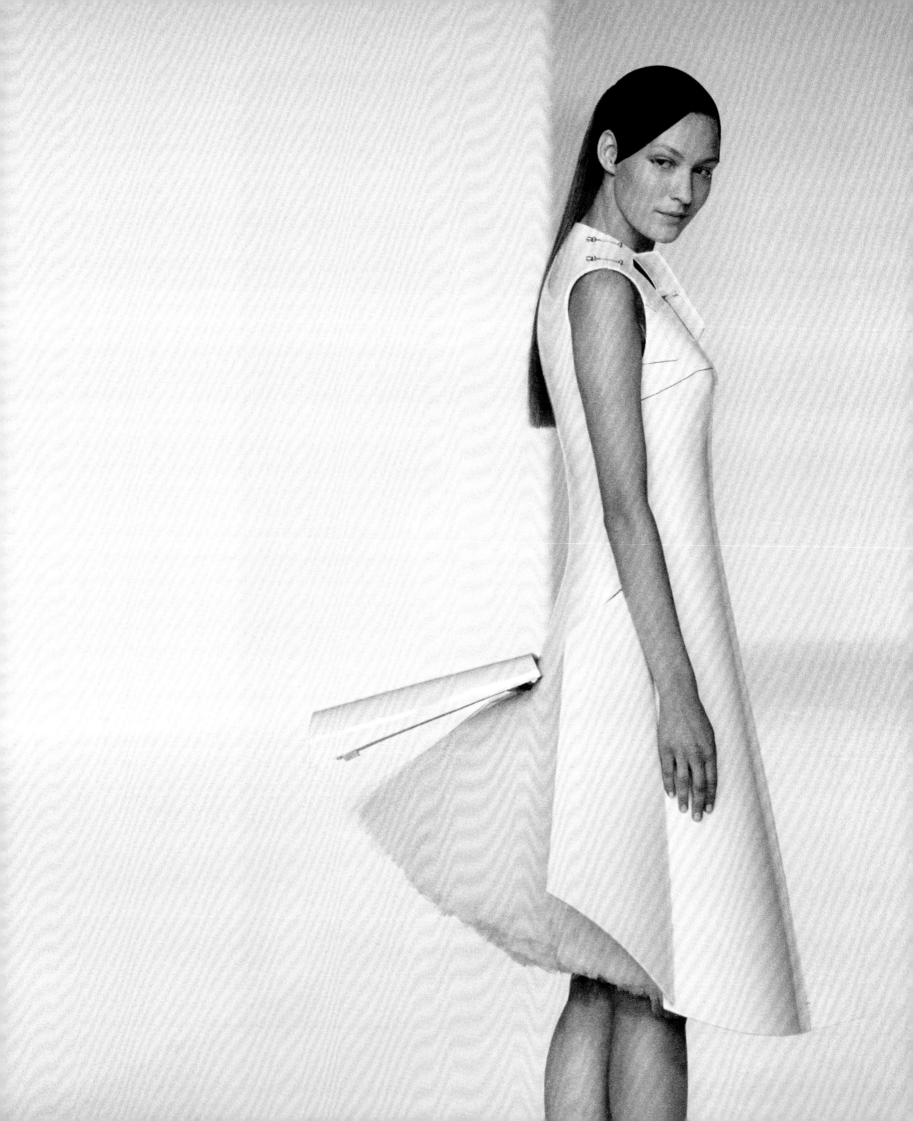

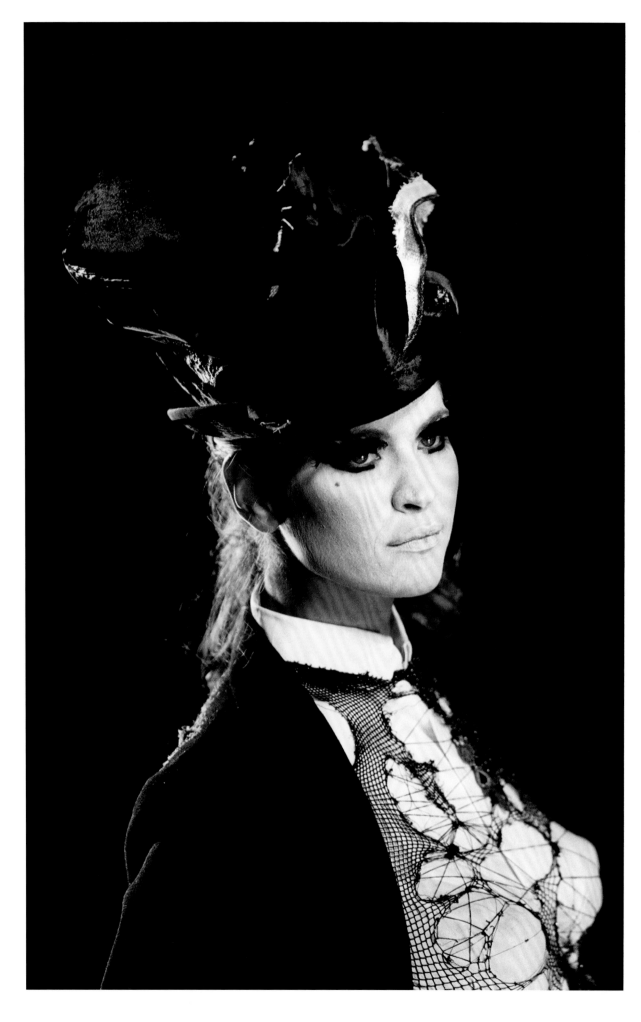

For his first haute couture collection of the new millennium, John Galliano turned the venerable house of Christian Dior on its head with a collection inspired by the homeless, as well as by the photography of Diane Arbus and the paintings of Egon Schiele. The homeless references were what stuck; the collection came to be known as 'Les Clochards' ('Tramps'), and Dior's headquarters were picketed. The house was forced to issue an apology. Contrasted with the overt, 'Ghetto Fabulous' luxury of the period by designers such as Dolce & Gabbana (overleaf), Galliano's Dior still feels like a revolution.

John Galliano for Christian Dior
Spring/Summer 2000
Haute Couture, Paris

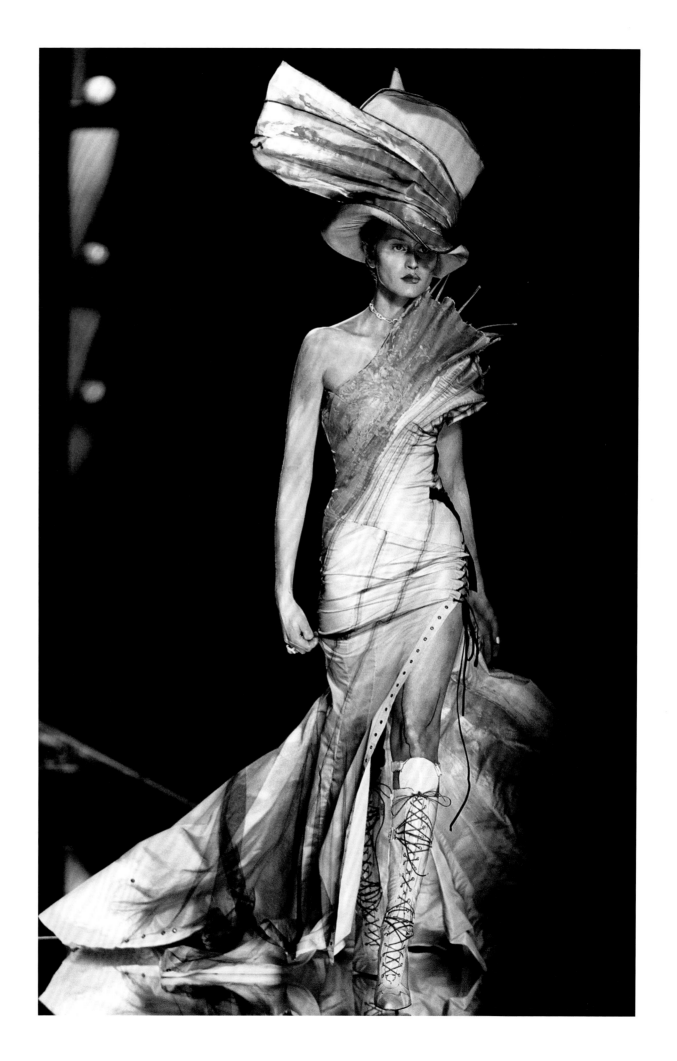

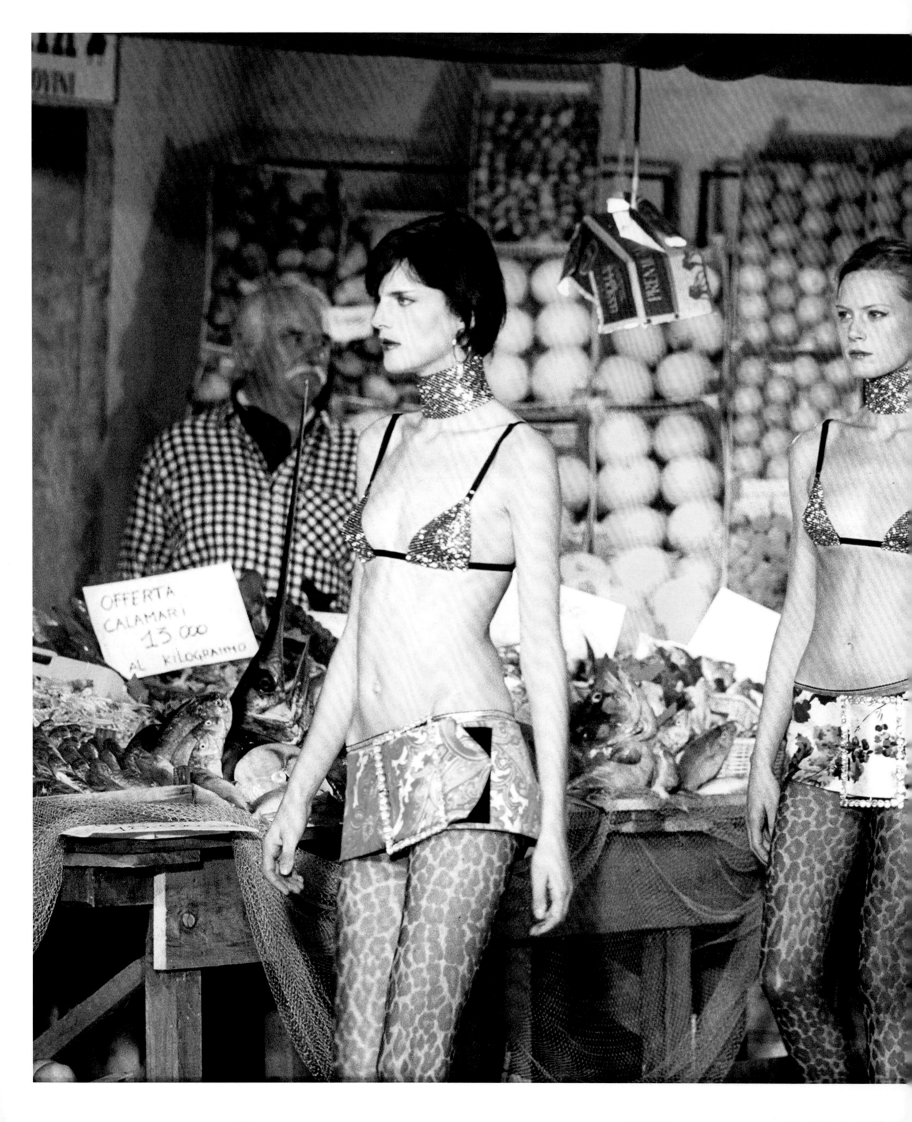

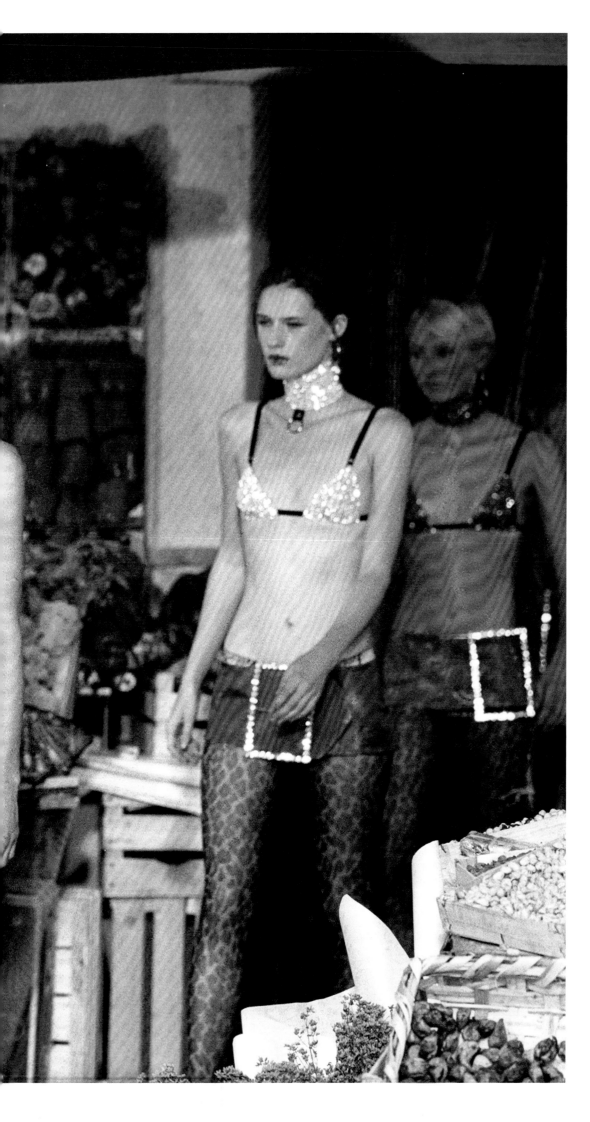

Left:
Dolce & Gabbana
Spring/Summer 2000
Milan

Overleaf:
Chanel
Spring/Summer 2000
Haute Couture, Paris

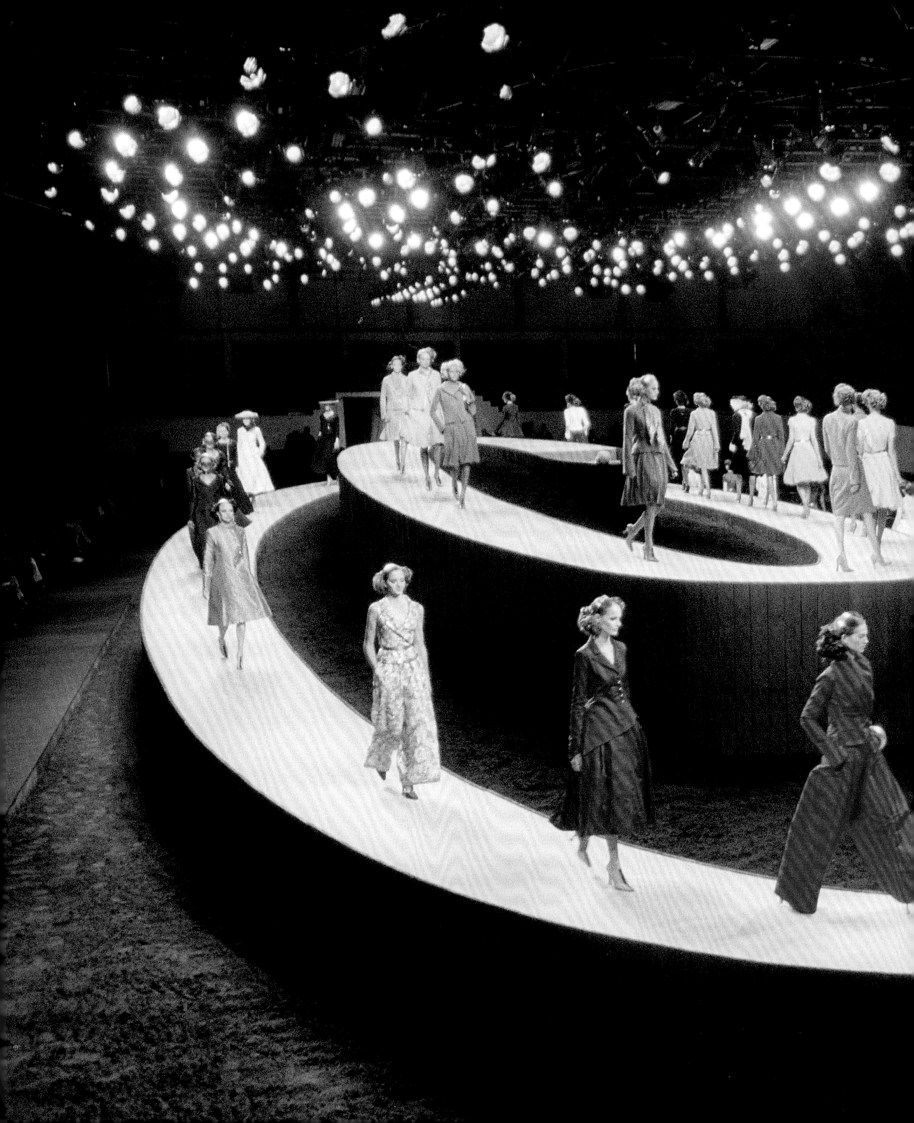

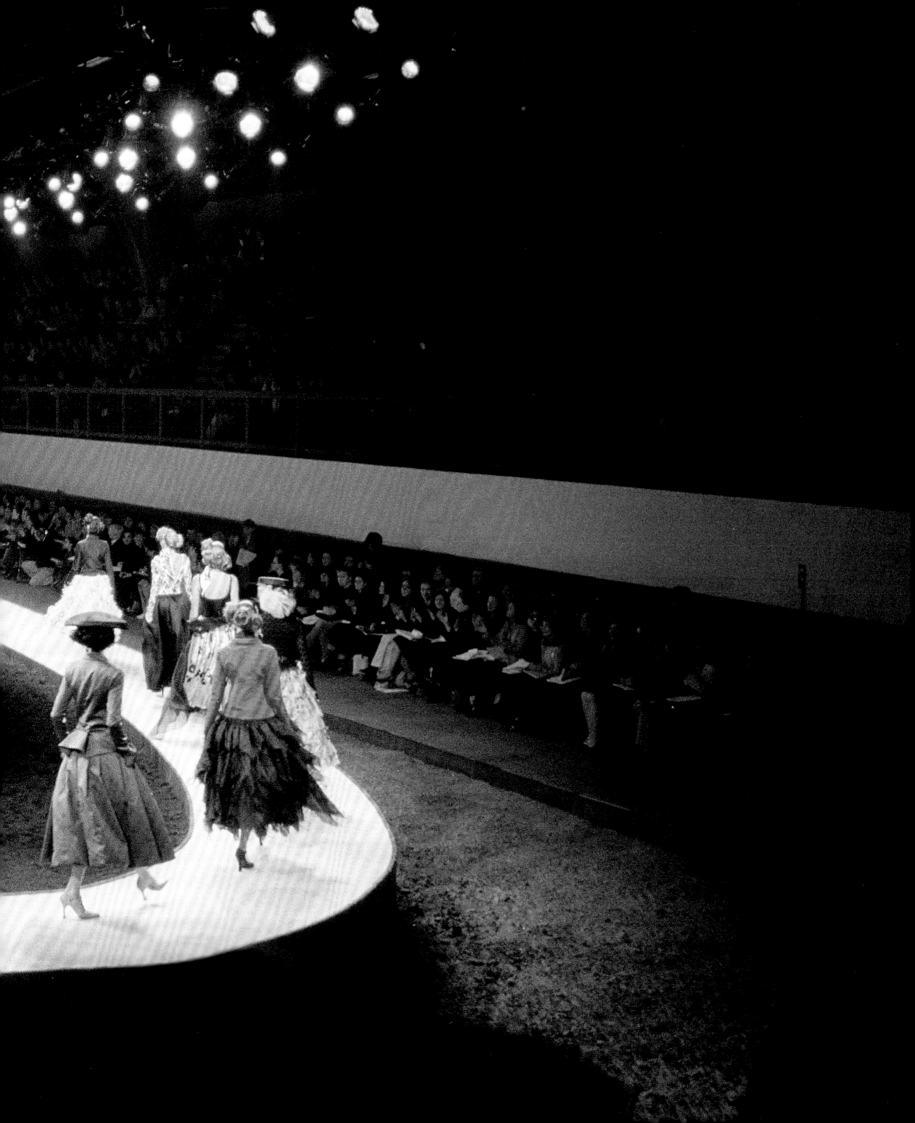

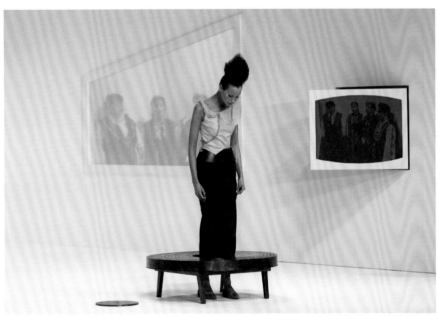
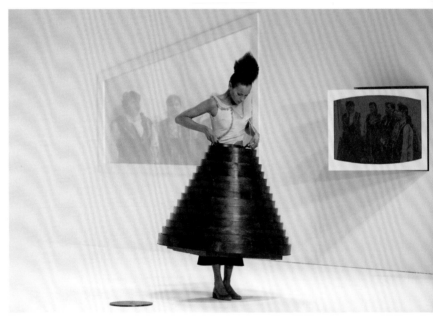

Inspired by wartime impermanence and displaced peoples, Hussein Chalayan staged his Autumn/Winter 2000 collection in a domestic setting, where every object could, in some way, be transported via the clothing. Garments featured pockets designed to hold specific objects, such as vases, while the furniture itself – four chairs and a table – were transformed on stage by the models into wearable clothing. At the finale a coffee table, created by the Scottish product designer Paul Swan Topen (a frequent Chalayan collaborator), telescoped into a cone-shaped skirt. When worn by the model, it left the entire room bare. 'It was extraordinary,' recalls Moore. 'So beautiful I was quite choked with emotion.'

Hussein Chalayan
Autumn/Winter 2000
London

Overleaf:
Alexander McQueen
Autumn/Winter 2003
Paris

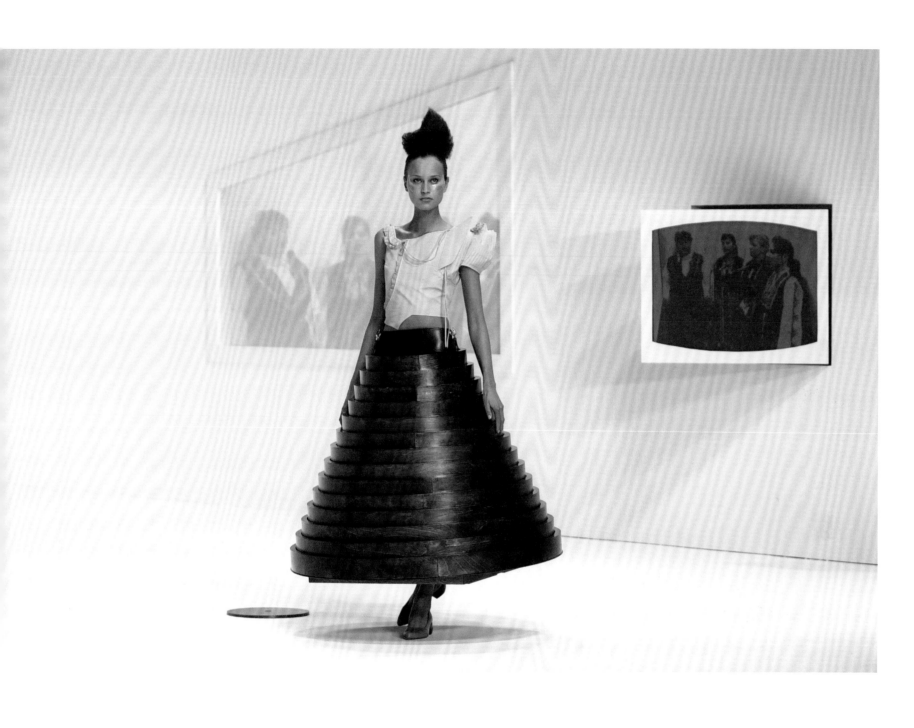

Yohji Yamamoto
Autumn/Winter 2000
Paris

Underlining a new transgressive challenge to luxury, Marc Jacobs subverted the Louis Vuitton Monogram, originally designed in 1896, by inviting the New York designer and artist Stephen Sprouse to 'graffiti' over the logos and quatrefoils with his signature marker-pen scribbles. Jacobs himself described the designs as 'anti-snob snobbism'. More than merely a clever take on an emerging trend, the Vuitton Sprouse collaboration marks the ever-higher profile accessories would earn on the catwalk as the decade progressed.

Left:
Louis Vuitton
Spring/Summer 2001
Paris

Opposite:
Boudicca
Autumn/Winter 2000
London

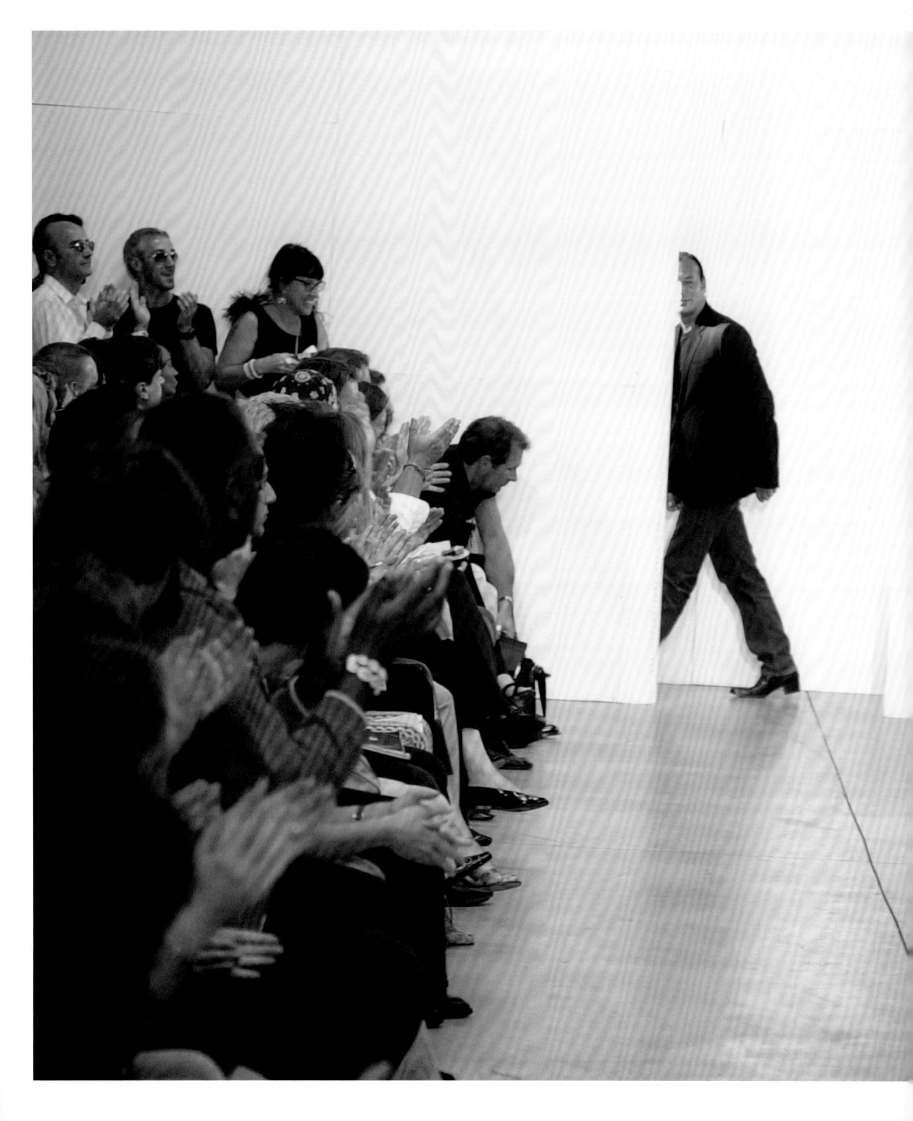

The traditional end to a fashion show, a designer's bow can be theatrical, perfunctory, or even non-existent. Here, the designer Helmut Lang – with whom Chris Moore had a long working relationship – is caught in profile as he dives backstage following his bow at his September 2000 show, entitled 'When Love Comes To Town'.

Helmut Lang
Spring/Summer 2001
New York

Moore was the house photographer for Alexander McQueen, and, as such, he would capture the shows for the fashion label's own archives. This permitted unprecedented access. 'Lee [McQueen] would talk to me, and say what was going to happen,' says Moore, of the unexpected finales that were the designer's trademark. 'There was the McQueen show where the glass box exploded, and all the moths came out, for instance. Lee told me about that and we had a special camera set up that captured the whole thing in sequence.'

This page and overleaf:
Alexander McQueen
Spring/Summer 2001
London

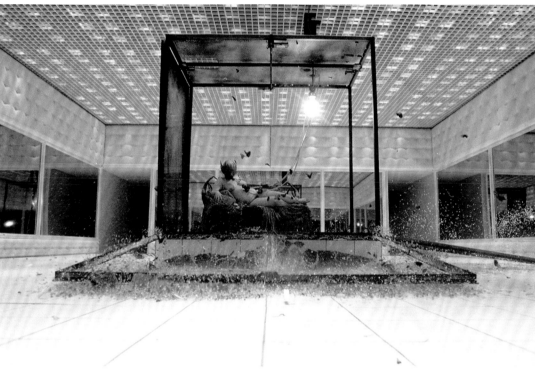

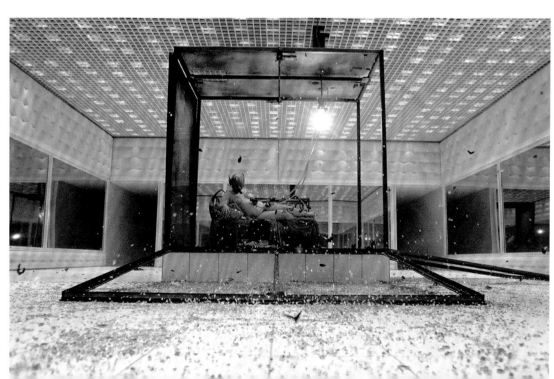

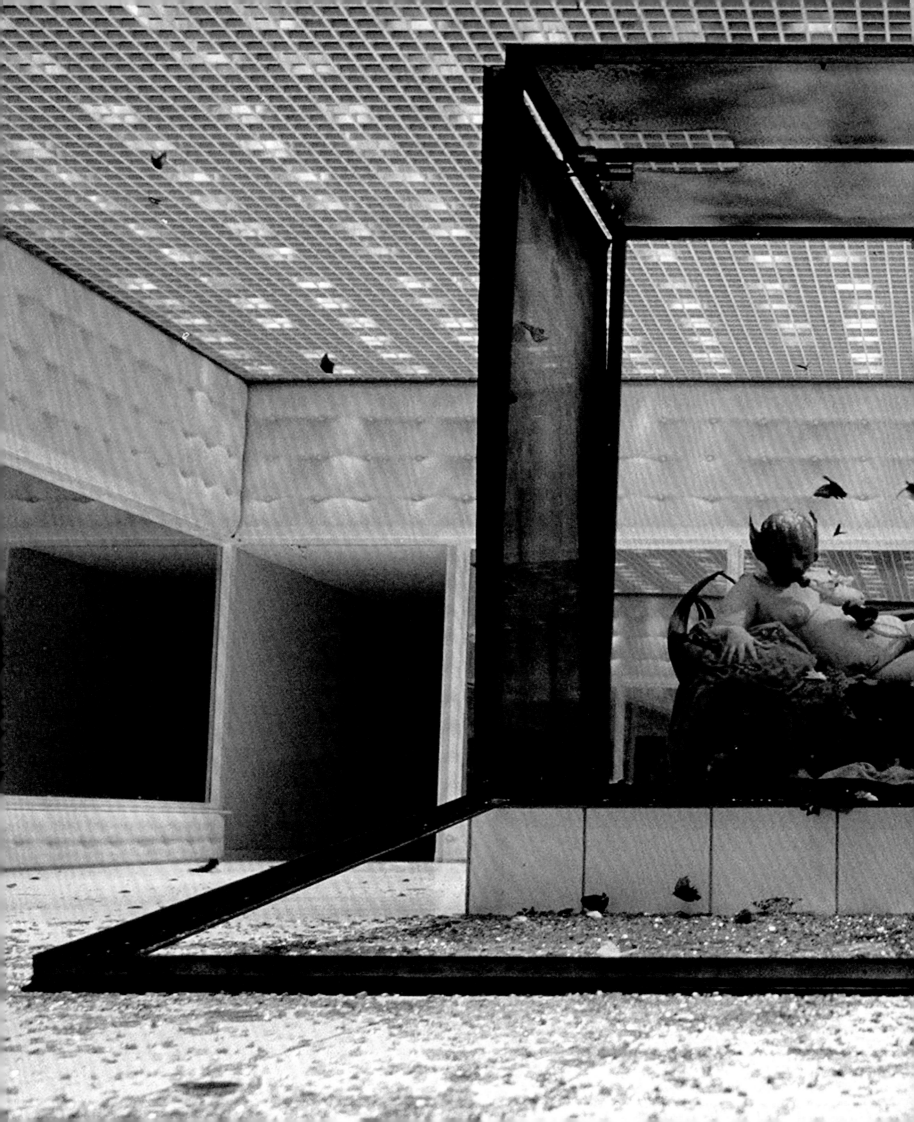

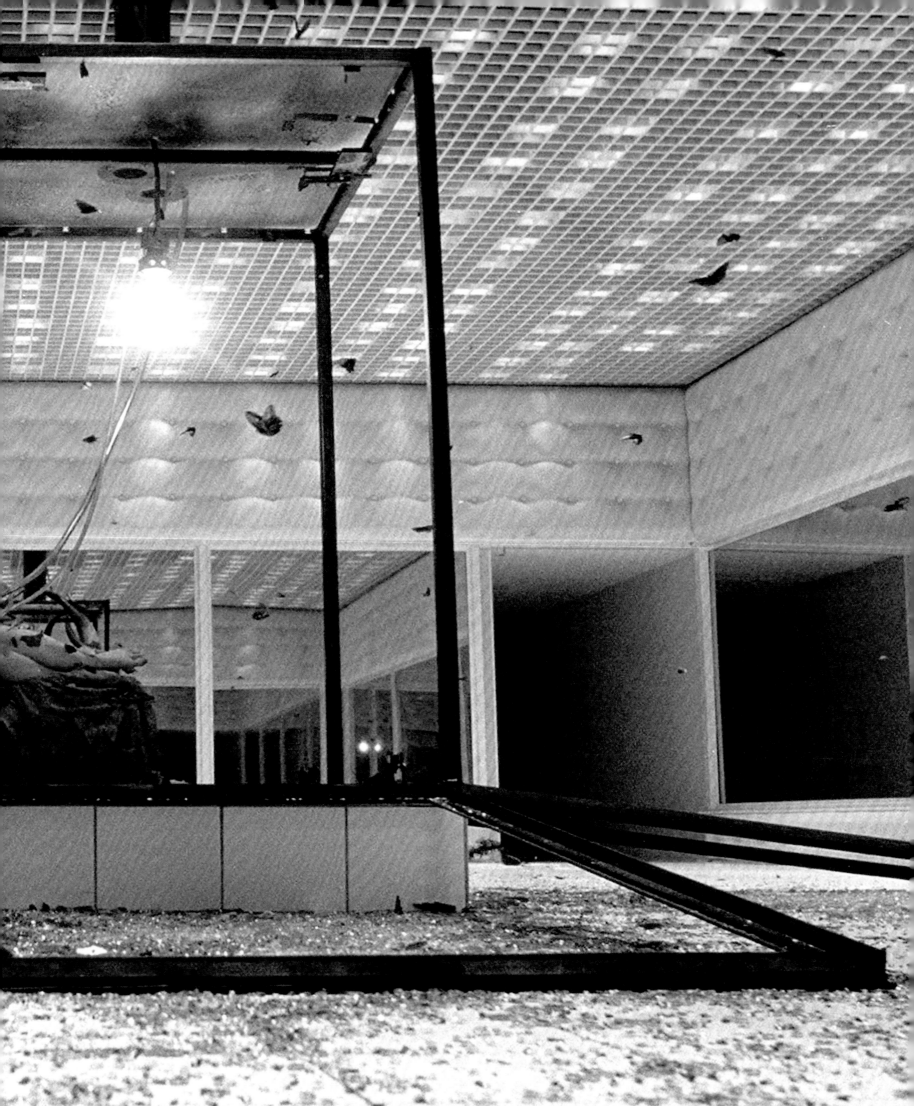

A new regime, and the end of an era: in 2000, the American designer Tom Ford took the reins of Yves Saint Laurent's ready-to-wear line, showing his first collection in October in a giant black tent in the gardens of the Musée Rodin. Less than two years later, in January 2002, Yves Saint Laurent himself would retire and close the haute couture branch of his eponymous label.

Left:
Yves Saint Laurent
Spring/Summer 2001
Paris

Opposite:
Yves Saint Laurent
Spring/Summer 2002
Haute Couture, Paris

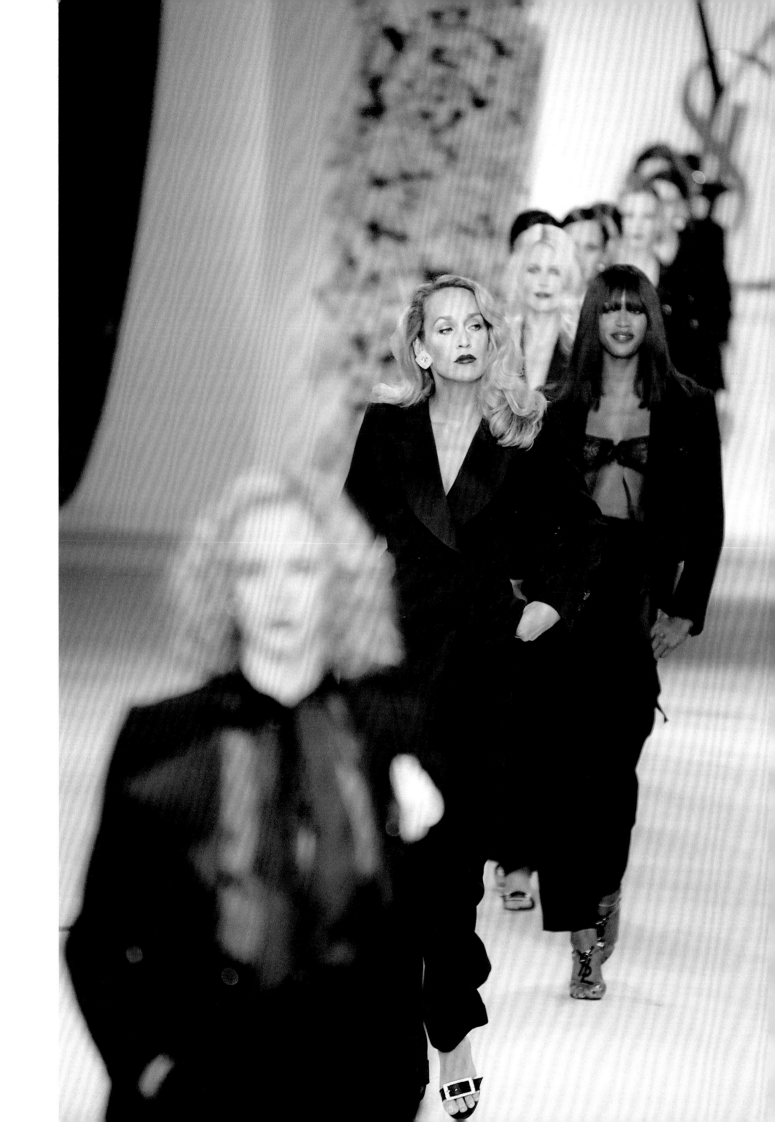

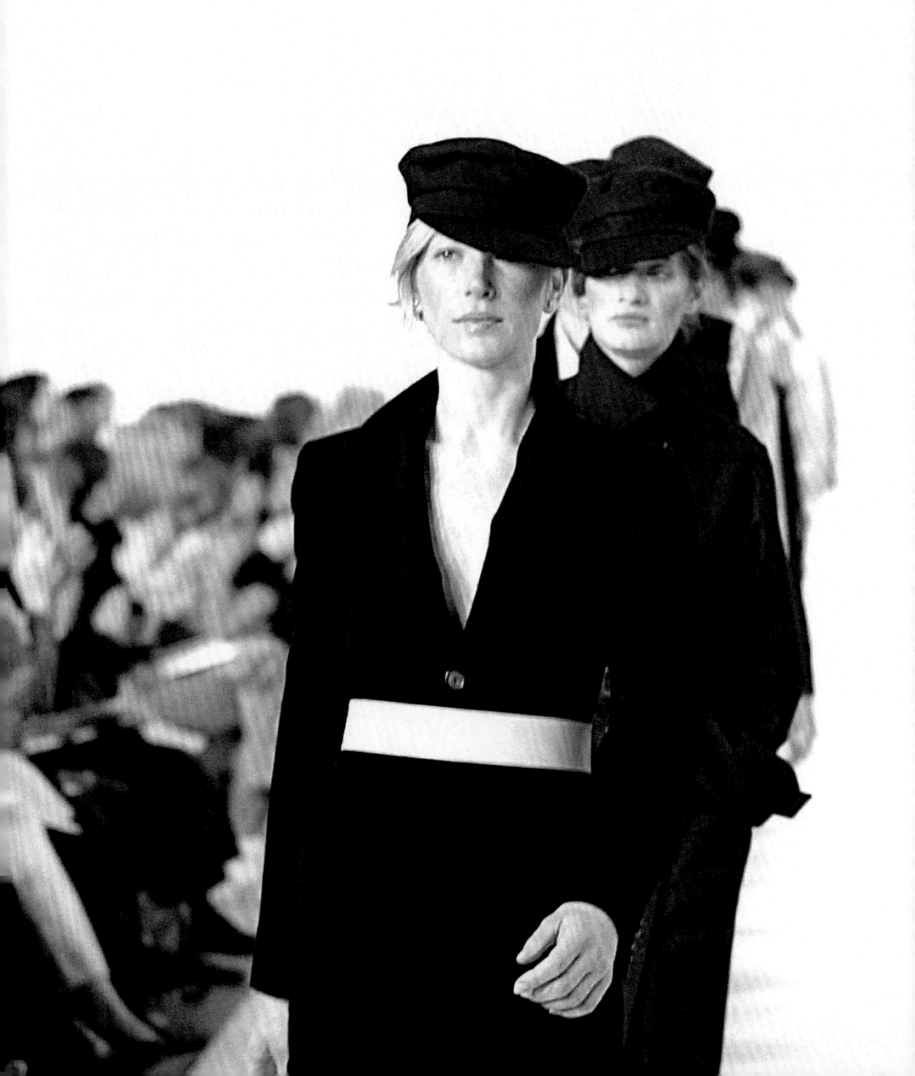

Moore doesn't believe
spectacle is necessary for
great fashion. He has been
documenting the work of
the British designer
Margaret Howell for more
than 40 years, in resolutely
quiet, low-key shows. 'I think
she's a woman of taste.
That's the word I'd use with
her. Taste,' he says. Howell's
approach is quintessentially
British – as is John
Galliano's, although the two
could not be further apart.
In 2003, while Howell was
presenting her crisp white
shirts and classic suiting,
Galliano devised his
collection as an homage
to the London nightclub
impresario Leigh Bowery,
dousing his models with
coloured powder inspired
by the Hindu spring
festival Holi (overleaf).

Opposite:
Margaret Howell
Spring/Summer 2002
London

Previous page:
Margaret Howell
Autumn/Winter 2001
London

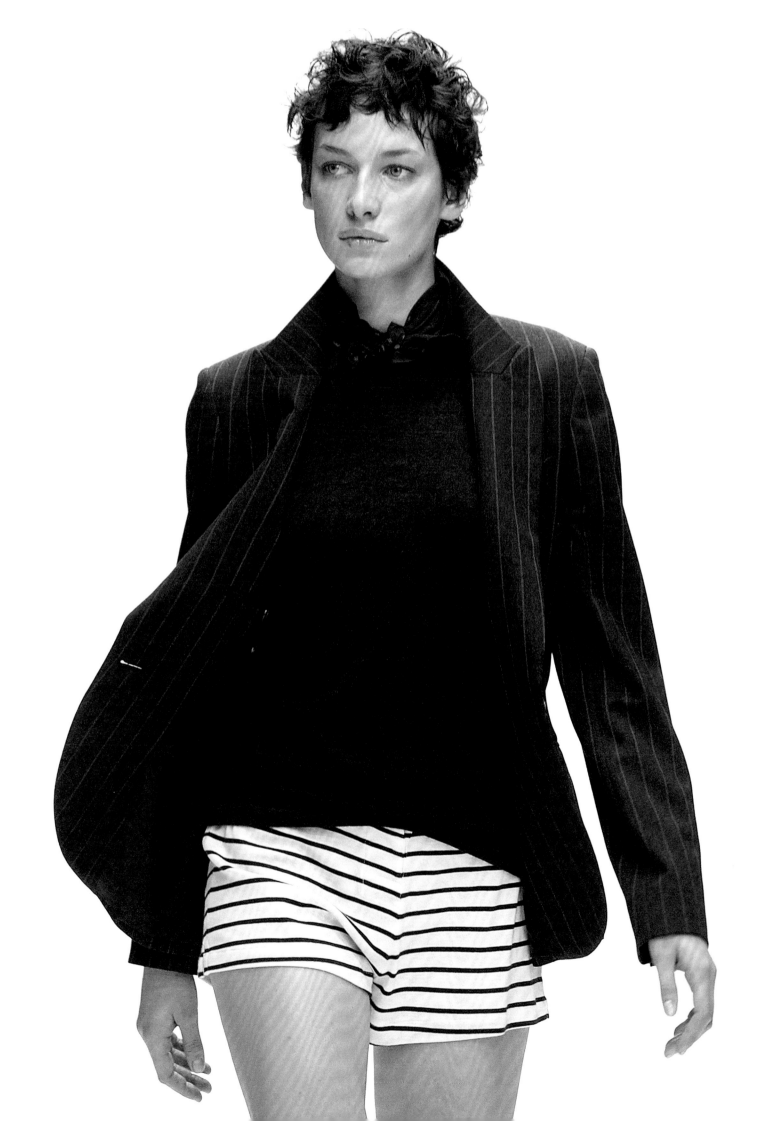

John Galliano
Spring/Summer 2003
Paris

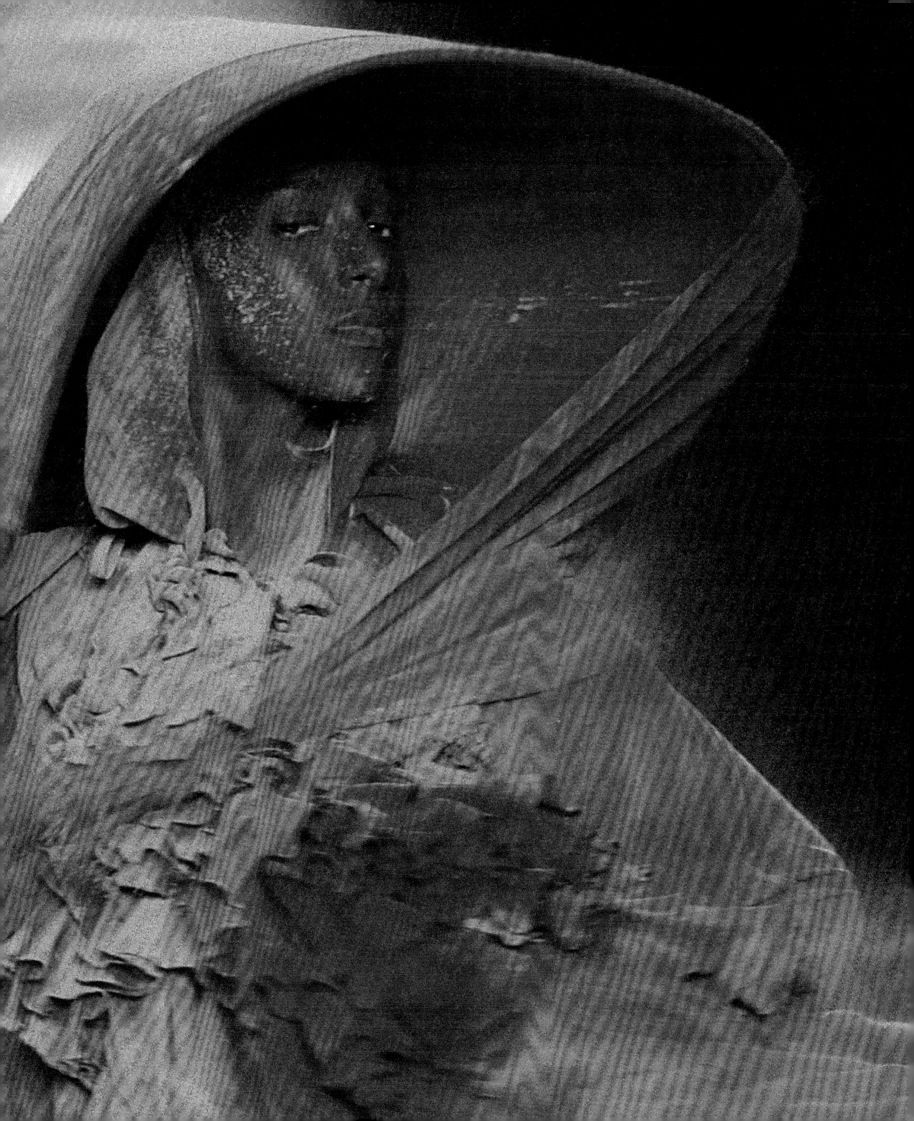

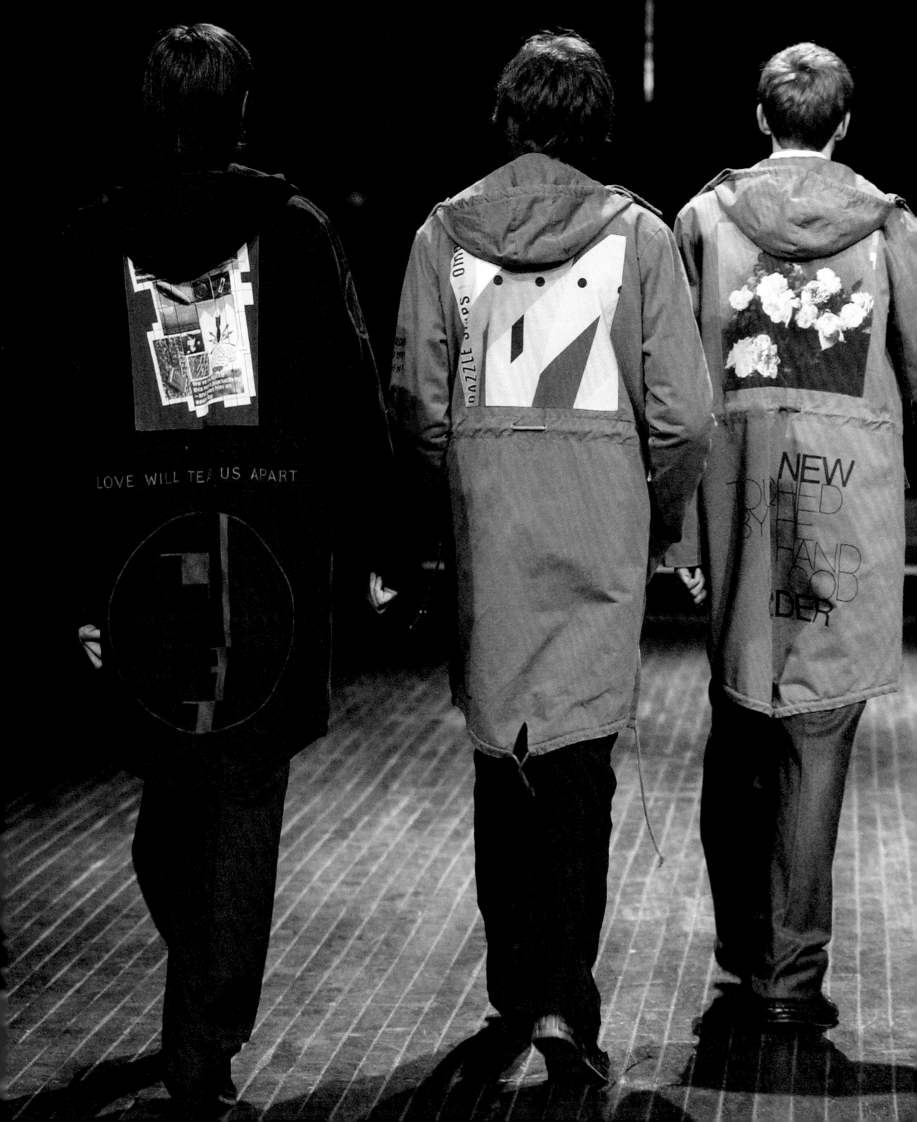

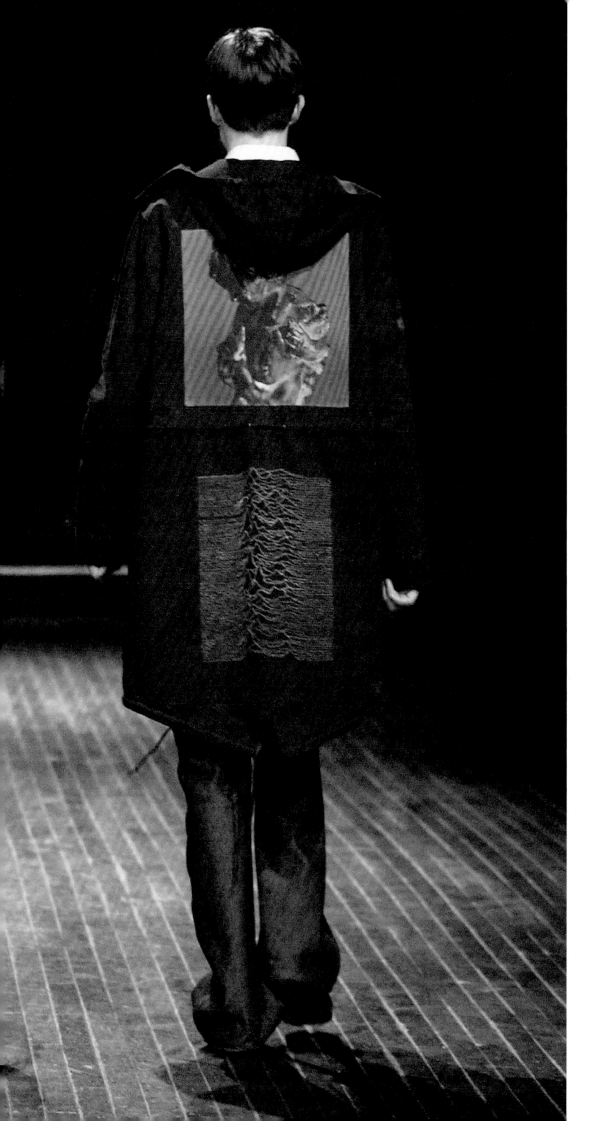

Raf Simons
Autumn/Winter 2003
Paris

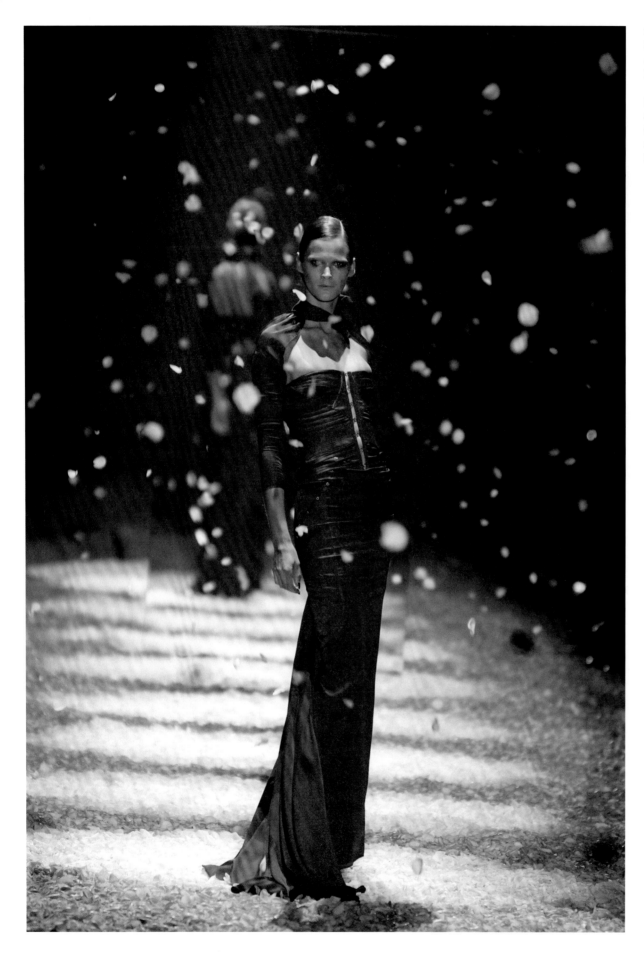

Left:
Gucci
Autumn/Winter 2003
Milan

Opposite:
John Galliano for
Christian Dior
Autumn/Winter 2004
Haute Couture, Paris

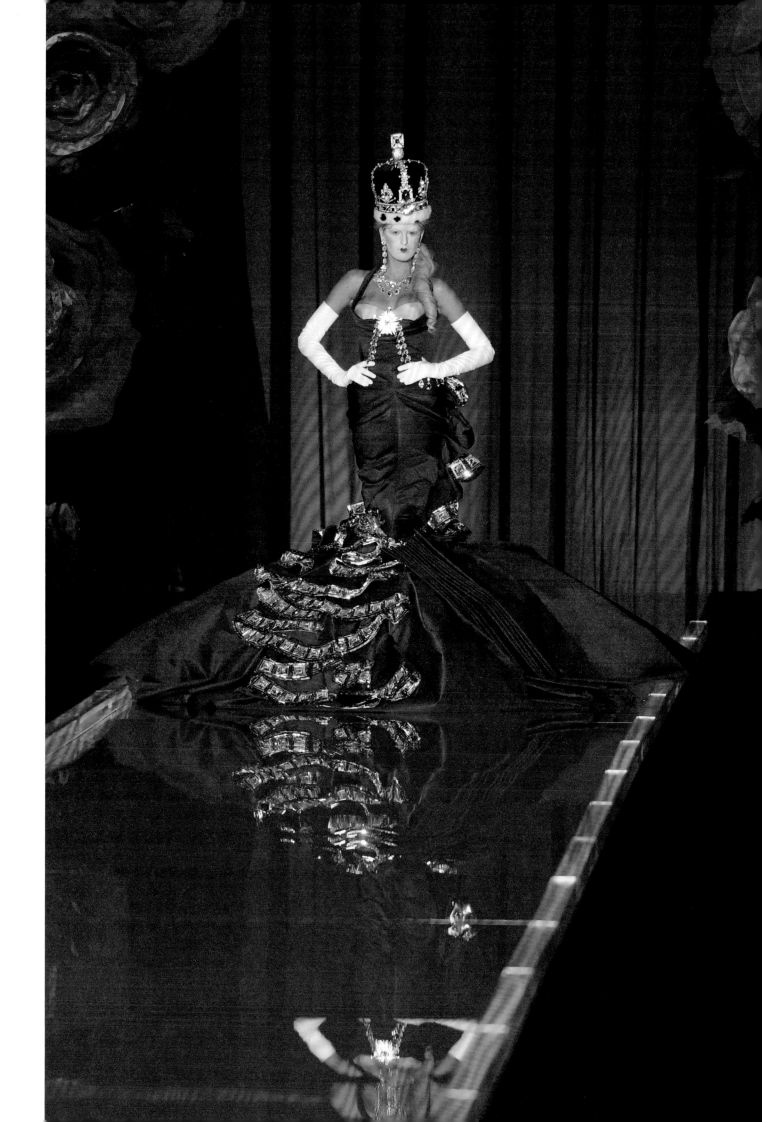

The Millennium Bug

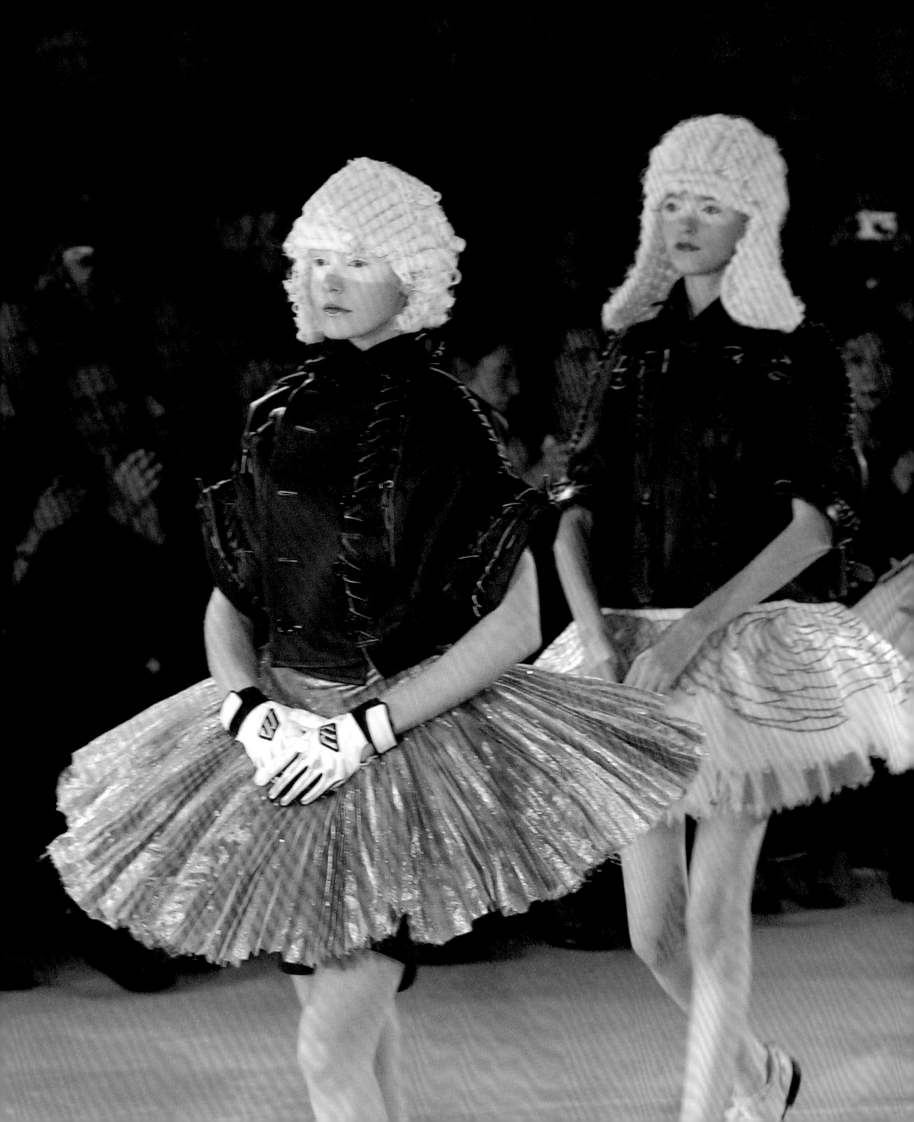

Two strikingly different visions of the modern catwalk: the stripped-back show spaces of Rei Kawakubo for Comme des Garçons are blank concrete spaces – even if the models' clothes are extreme. The space is a blank canvas, focussing attention on the designs. By contrast, the theatricality of John Galliano's work for Christian Dior made the set a vital part of the creative expression. In an ode to the hundredth birthday of house founder Christian Dior, his Autumn/Winter 2005 show was staged as a series of historical-inspired vignettes (overleaf). The model Erin O'Connor can be seen through the window of a carriage, dressed in a reinterpretation of Dior's mother's Edwardian attire.

This page:
Comme des Garçons
Spring/Summer 2005
Paris

Overleaf:
John Galliano for Christian Dior
Autumn/Winter 2005
Haute Couture, Paris

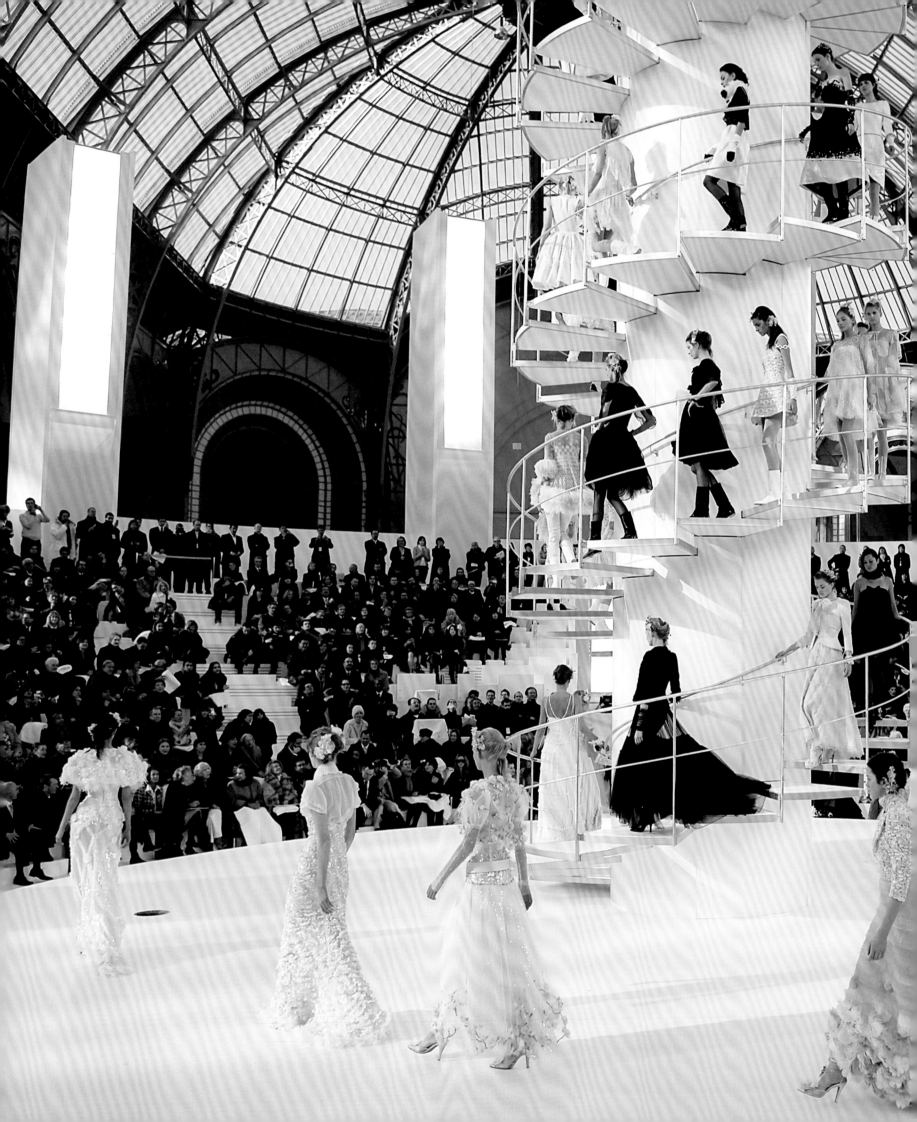

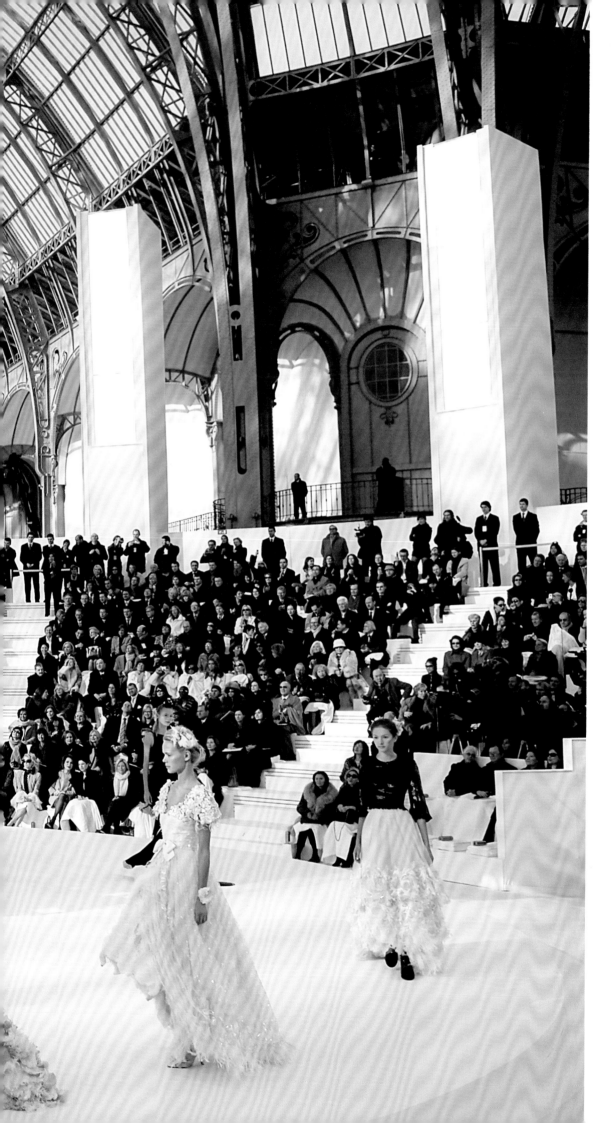

This page:
Chanel
Spring/Summer 2006
Haute Couture, Paris

Previous page:
Marc Jacobs
Spring/Summer 2006
New York

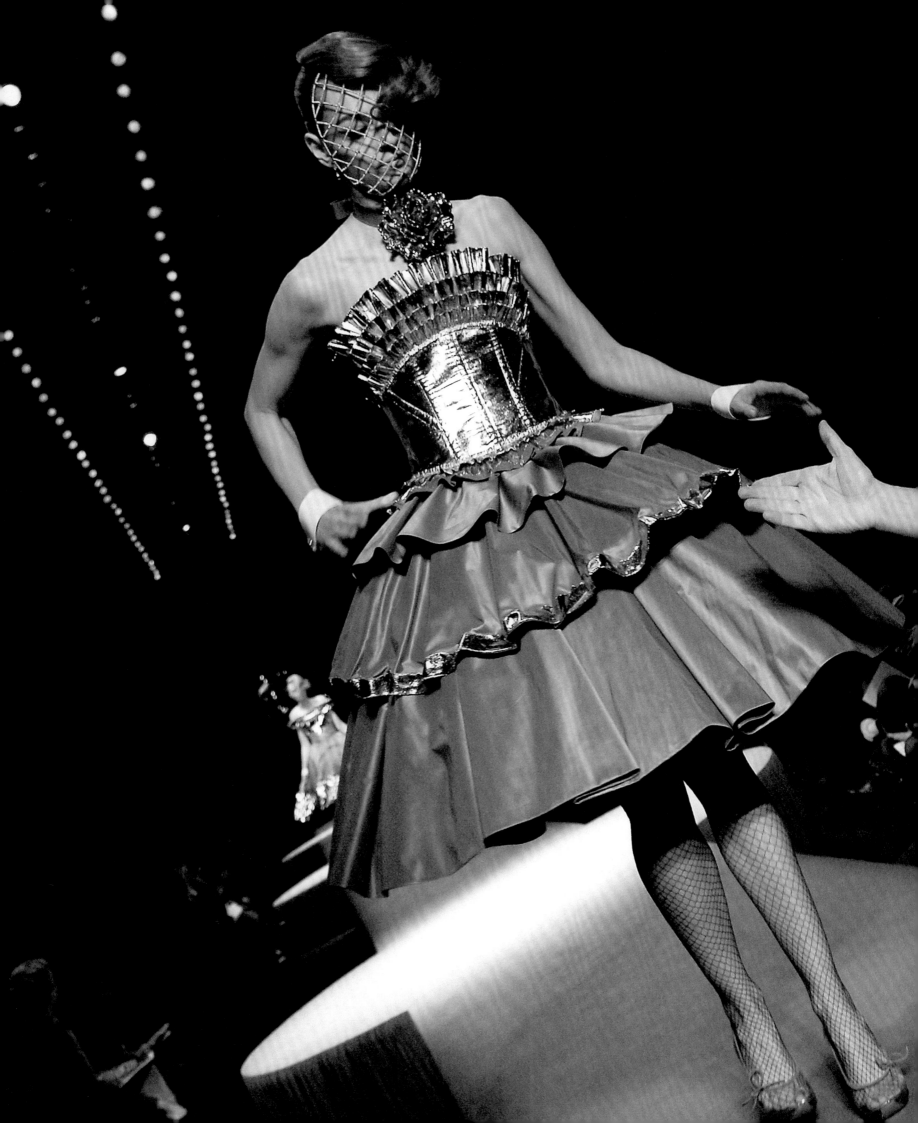

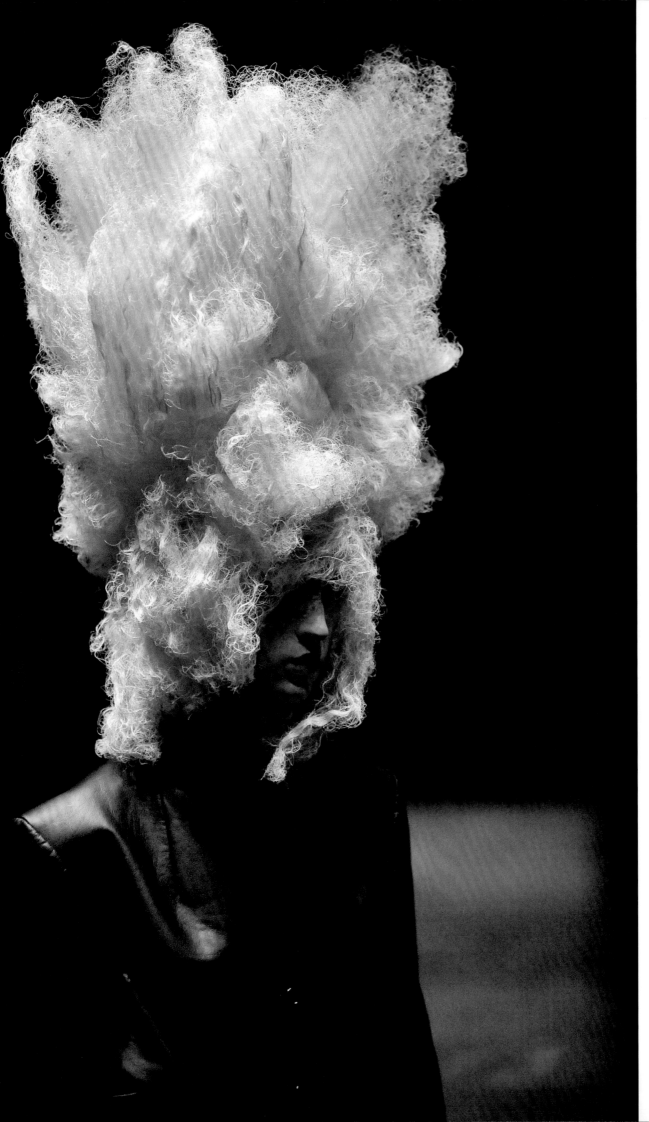

Left:
Comme des Garçons
Spring/Summer 2009
Paris

Opposite:
Gareth Pugh
Autumn/Winter 2006
London

Previous page:
Viktor & Rolf
Autumn/Winter 2006
Paris

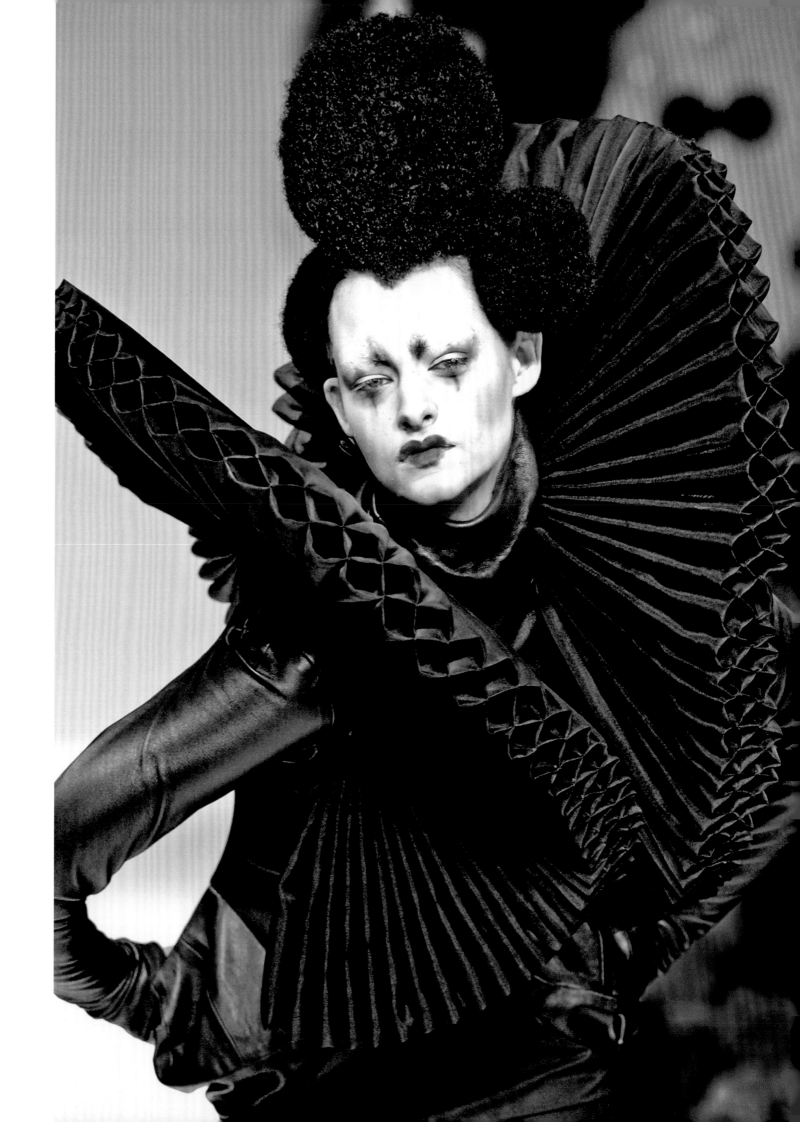

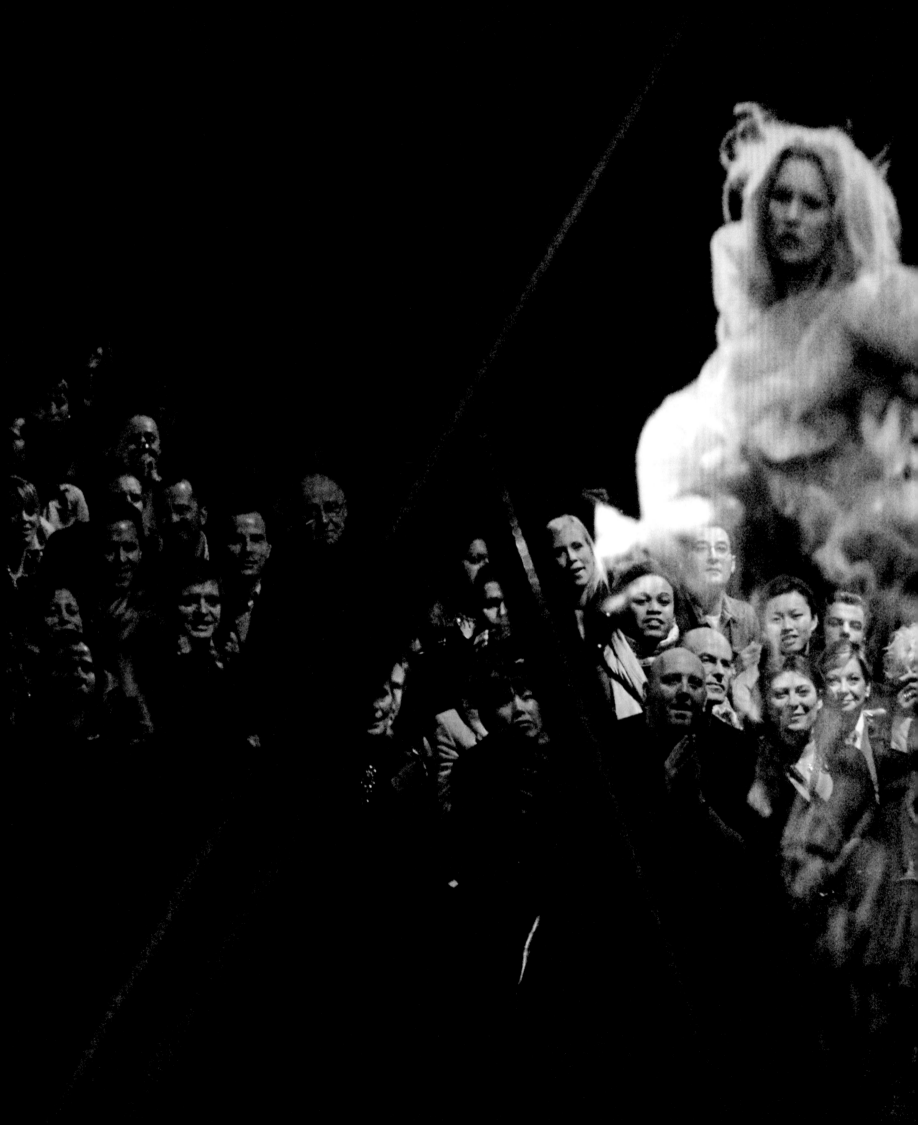

In 2006 McQueen staged a show both titled and dedicated to the Widows of Culloden, a reference to the battle in 1746 that ended the Jacobite uprising. Weaving history with modernity, the show ended with a technological masterpiece: a hologram created by the video-maker Baillie Walsh of Kate Moss, which appeared as if by magic in a glass pyramid at the centre of the show (in a vast sports stadium, the Palais Omnisports de Bercy, Paris), using the nineteenth-century illusionist trick known as 'Pepper's Ghost'. 'Alexander McQueen did amazing shows,' says Moore. 'I felt very emotional seeing them. How could you not?'

Alexander McQueen
Autumn/Winter 2006
Paris

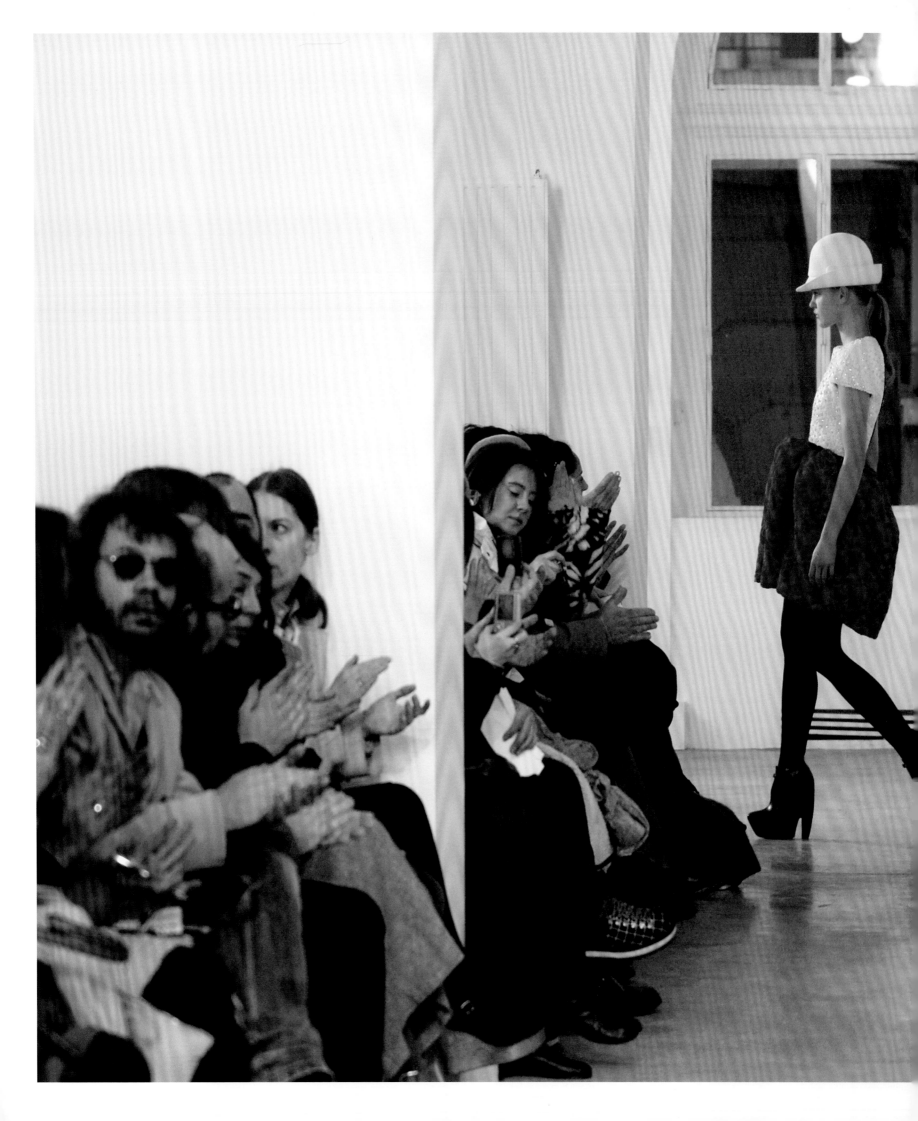

Nicolas Ghesquière became chief designer of the house of Balenciaga in 1997. His eye for proportion and a sense of contemporary ease resurrected the house, and Ghesquière led fashion in the 2000s, just as Balenciaga had in the 1950s and 1960s, influencing mass-market and high fashion alike. However, he didn't look into the archives until 2006, when he created an Autumn/Winter show influenced by the bubbly volumes and firm fabrics of mid-century haute couture. 'I love what Ghesquière did at Balenciaga,' says Moore. 'He's an amazing talent – those shows were a dream to photograph.'

Balenciaga
Autumn/Winter 2006
Paris

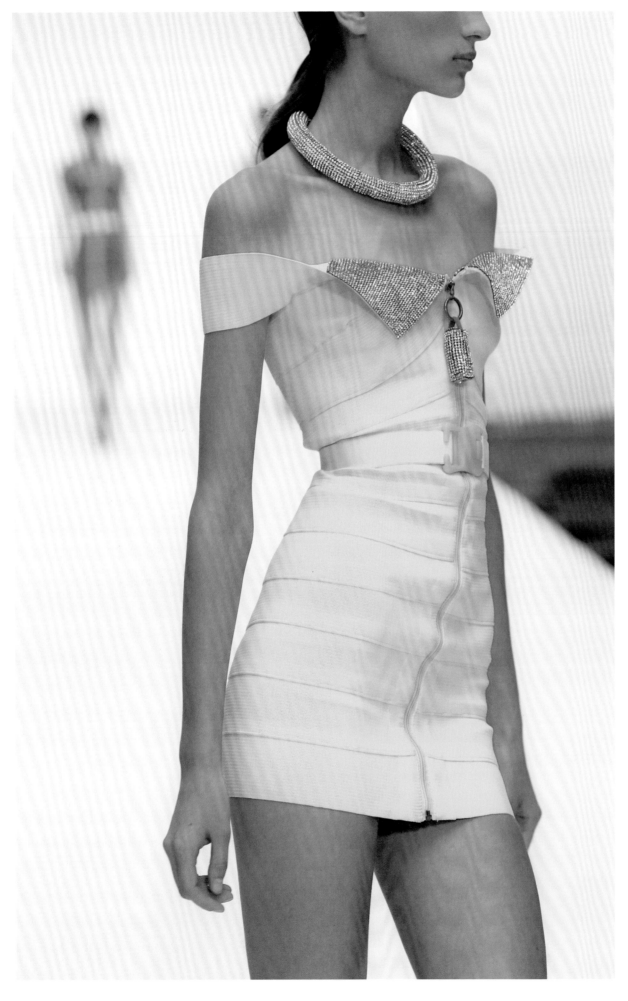

All eyes turned to London in the second half of the 2000s, mostly thanks to one man: Christopher Kane. His acclaimed Central Saint Martins MA graduation collection in 2006 was spun out into an entire collection for Spring/Summer 2007, and formed the foundation of his business. It consisted almost entirely of tight, sexy bandage dresses in neon shades of elastic and stretch lace, a silhouette that was subsequently ripped off and referenced by dozens of designers, high and low. Moore became the house photographer for Kane and captured his dazzling debut in every possible permutation.

Christopher Kane
Spring/Summer 2007
London

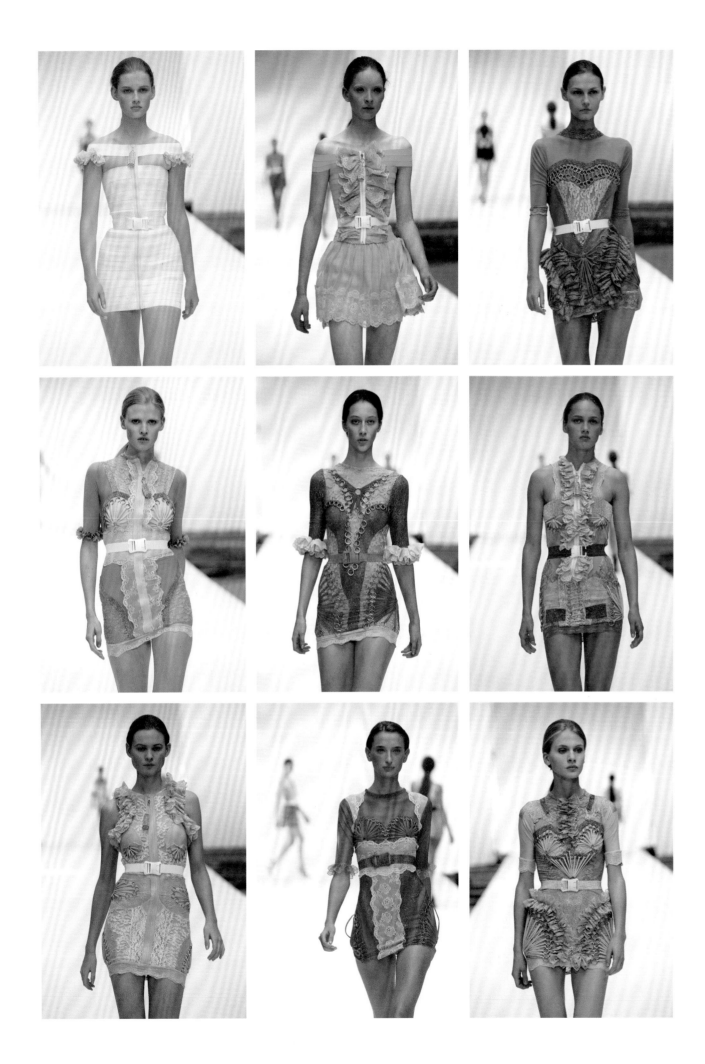

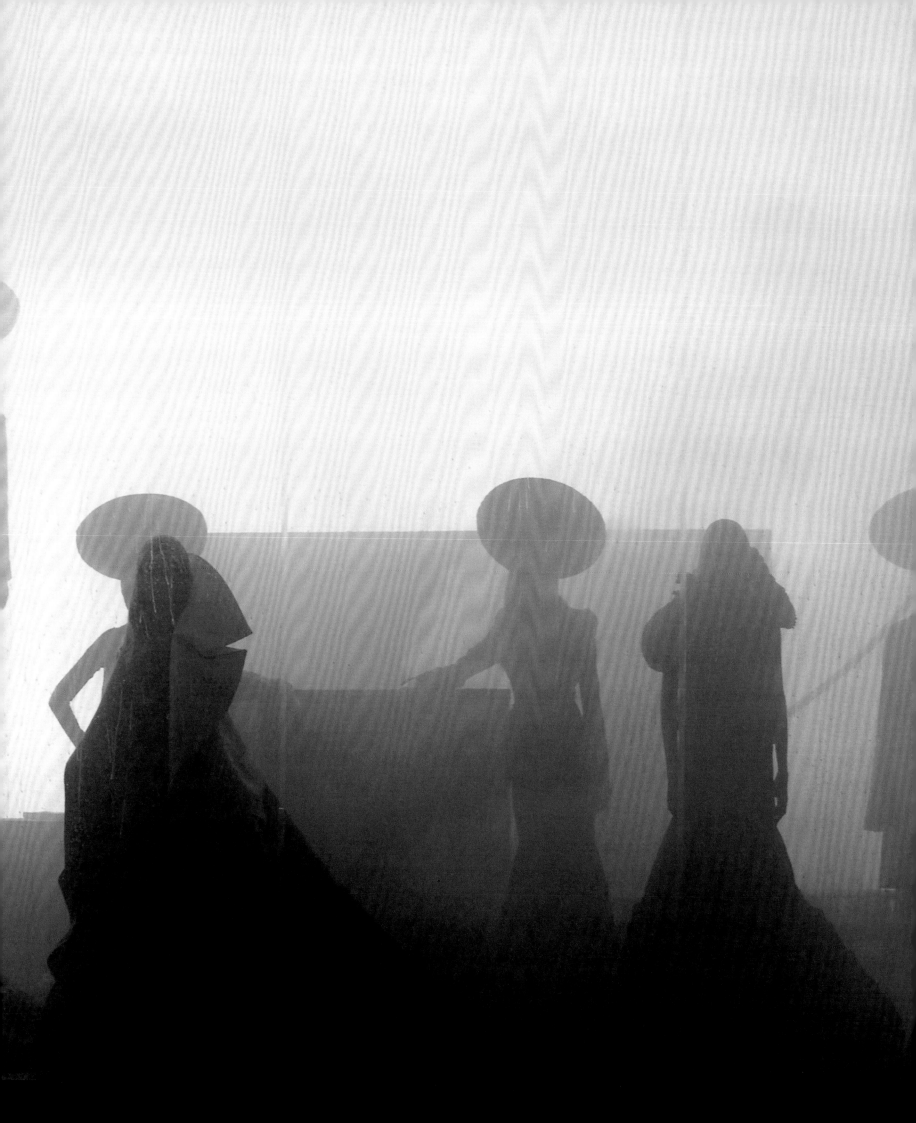

This page:
John Galliano for Christian Dior
Spring/Summer 2007
Haute Couture, Paris

Previous page:
Givenchy by Riccardo Tisci (far left)
Spring/Summer 2007
Haute Couture, Paris

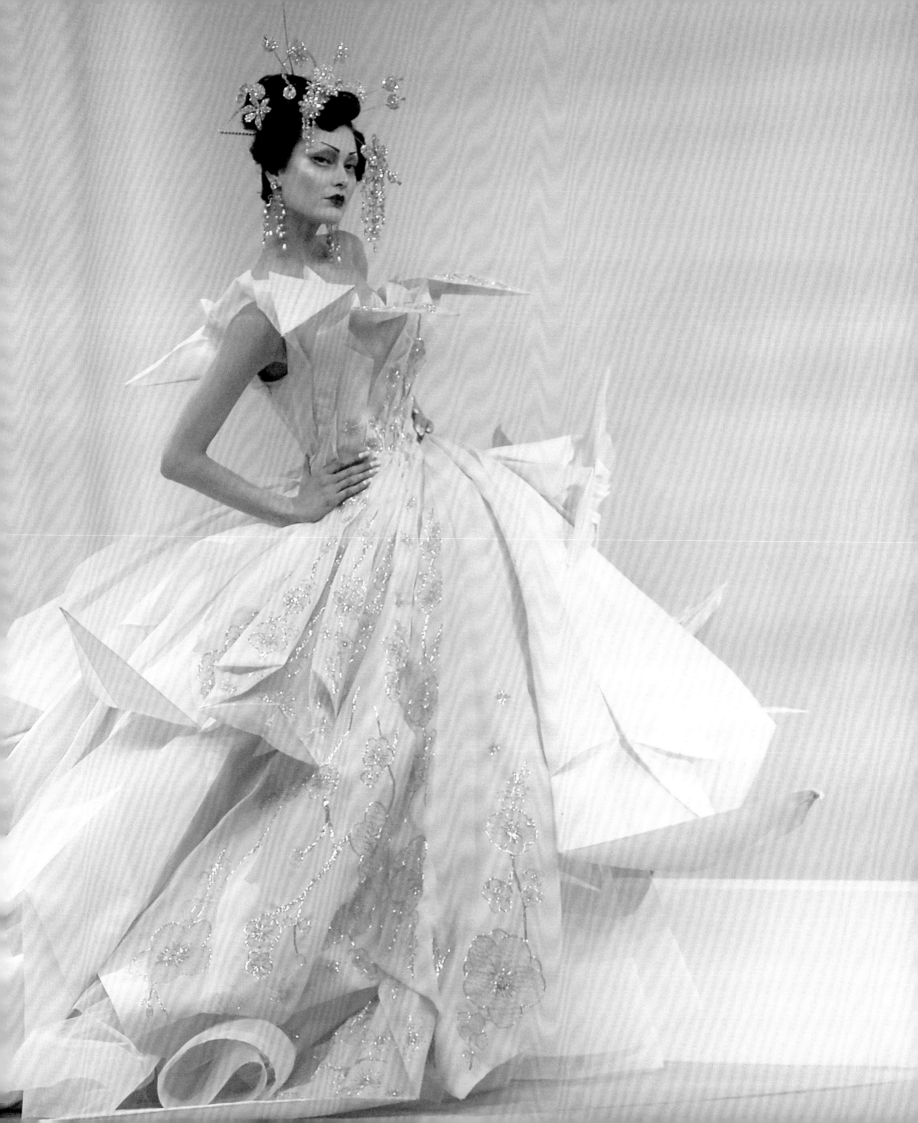

Often, Moore's eyes will be drawn away from clothing, towards the details of the physical catwalk itself as expressive of a designer's intent. 'Take Nicolas Ghesquière at Balenciaga,' he says. 'Very interesting fabrics, but did you notice, the floor became important? He always had an interesting floor, or an outrageously terrible carpet.'

Left:
Balenciaga
Autumn/Winter 2010
Paris

Opposite:
Balenciaga
Spring/Summer 2008
Paris

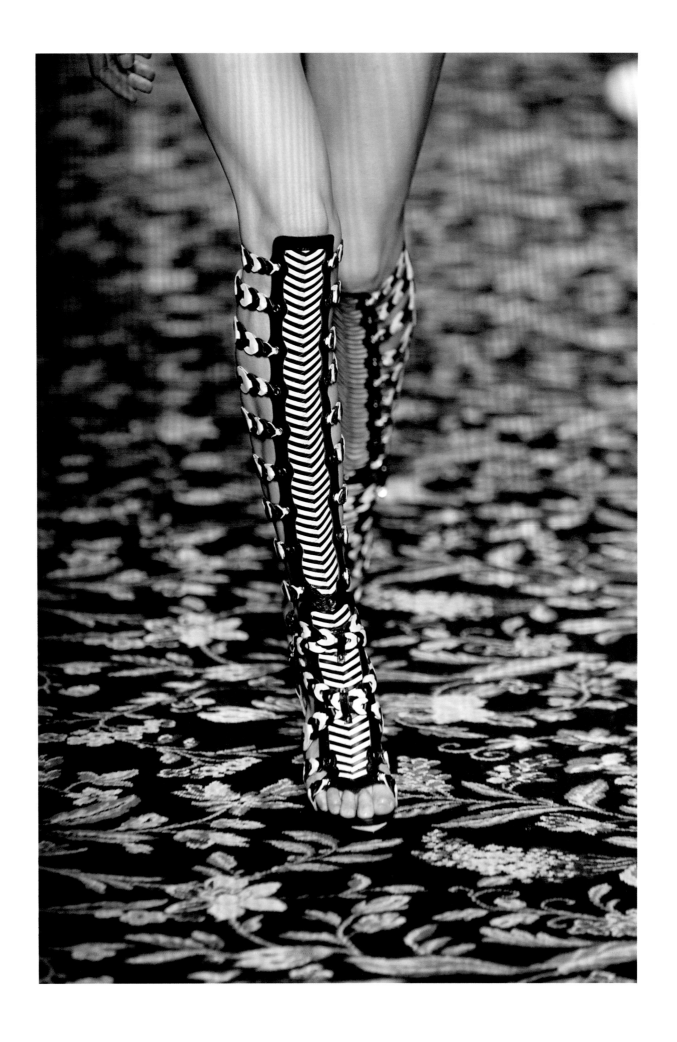

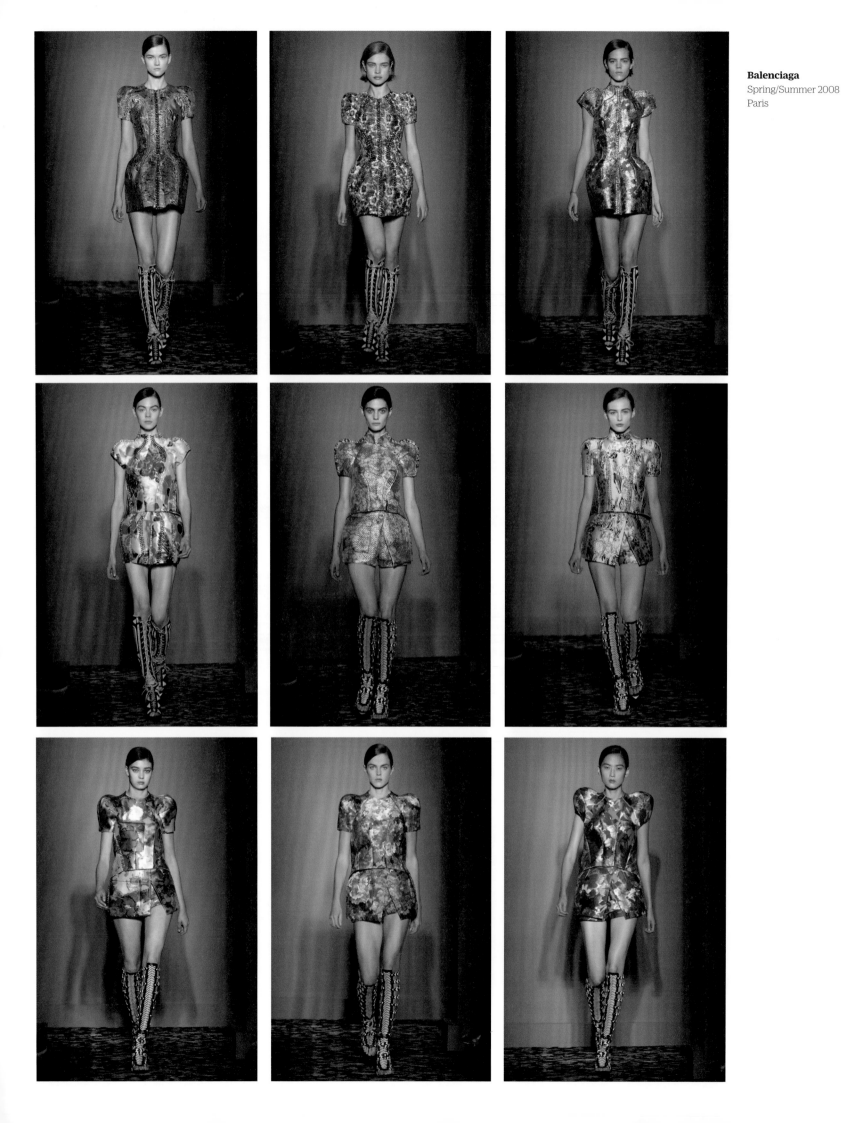

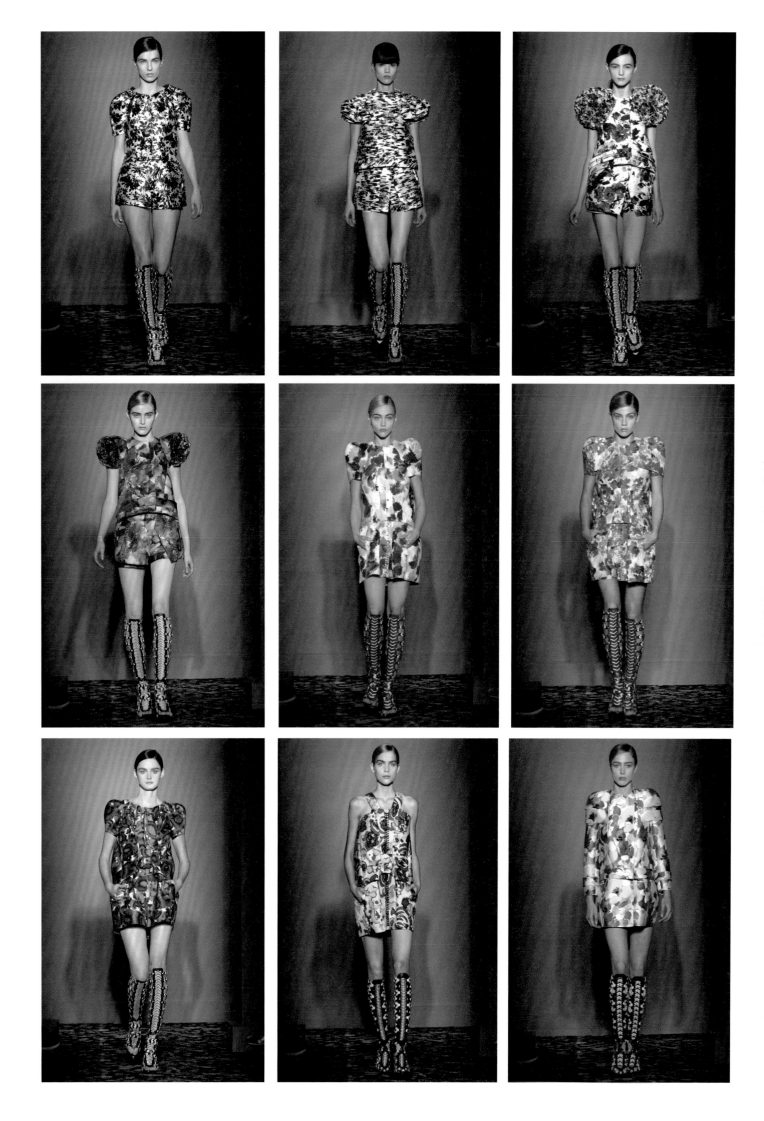

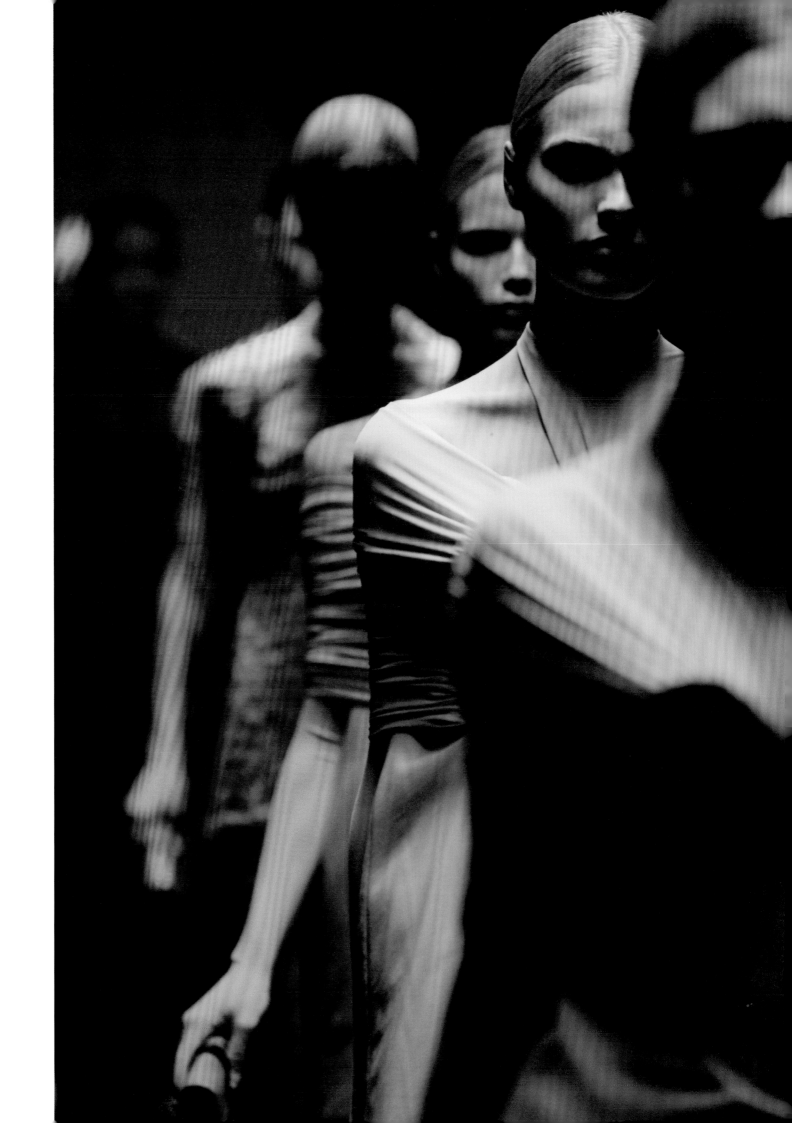

Designers responded in different ways to the financial crash and resulting recession of the late 2000s: Alexander McQueen created an apocalyptic Autumn/Winter 2009 show staged at the Palais Omnisports de Bercy around a gargantuan pile of rubbish, created from the sets of his career as a whole. His next show presented technology as a force both menacing and fascinating – possibly the end of the fashion world – or a new beginning. In between, Christian Lacroix showed his final haute couture collection (overleaf) before closing owing to financial problems.

Alexander McQueen
Autumn/Winter 2009
Paris

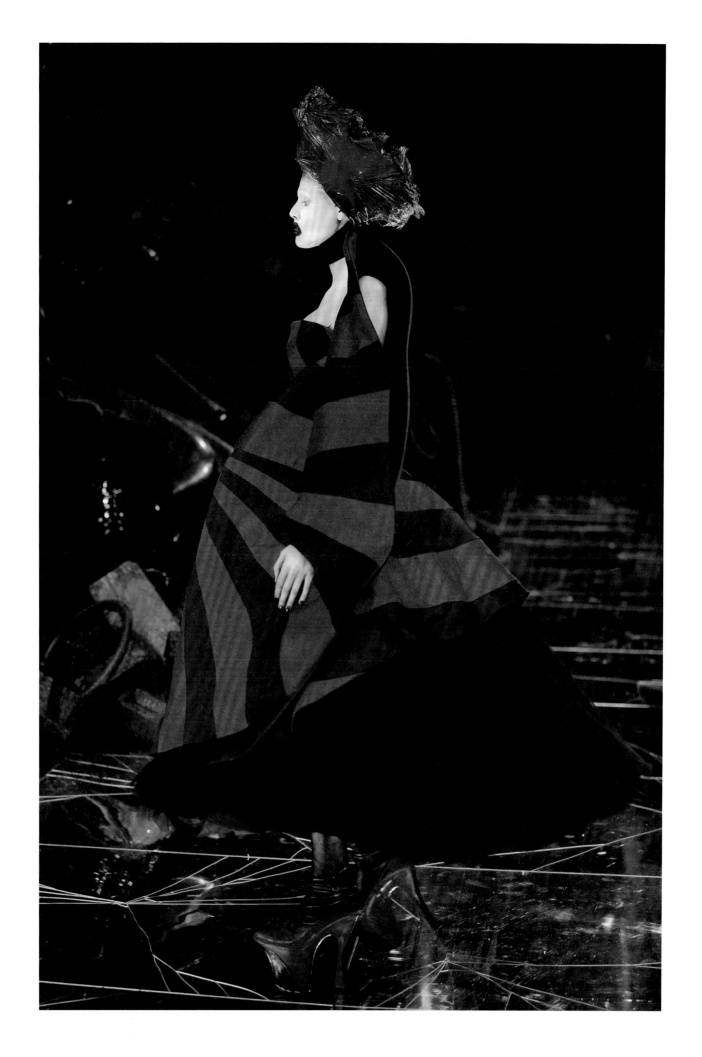

This page:
Christian Lacroix
Autumn/Winter 2009
Haute Couture, Paris

Overleaf:
Alexander McQueen
Spring/Summer 2010
Paris

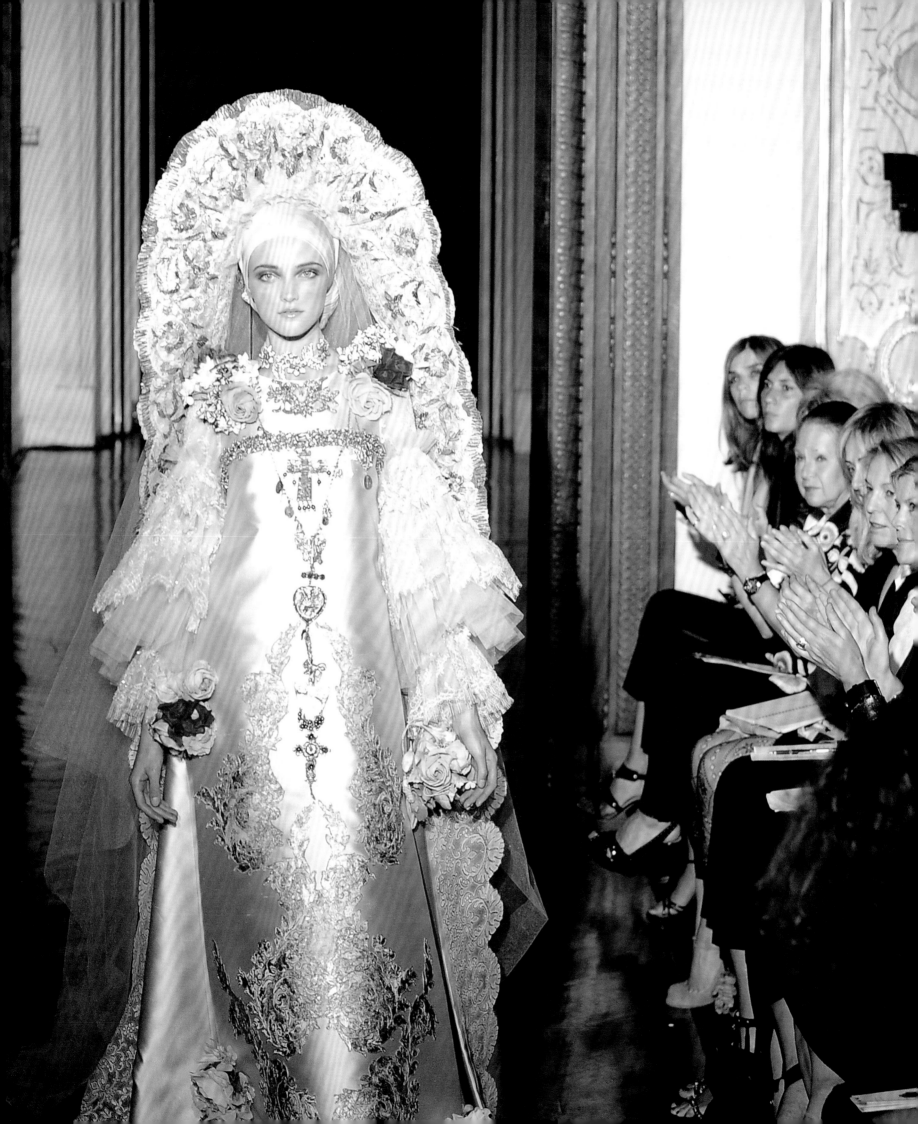

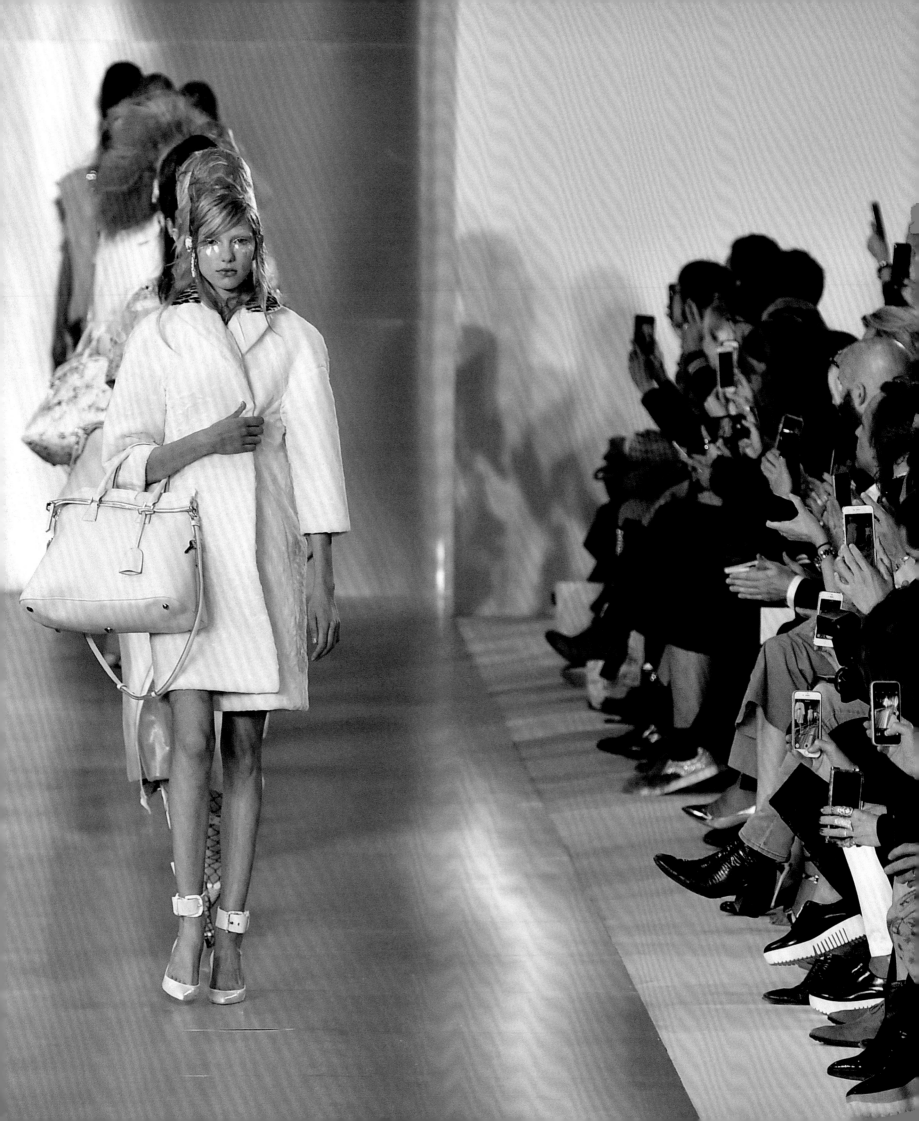

A Digital Revolution

2010–2017

'I embrace digital. I just think it's ... It's now.'

Chris Moore

Fashion loves a revolution. It's the allusions to upheaval and dynamic change that attract; the idea that, in one fell swoop, the world can be transformed. It's Dior's amnesiac, full-skirted New Look, Yves Saint Laurent's ready-made Rive Gauche, Charles Frederick Worth's chutzpah in daring to stick his name on a slip of fabric inside a gown destined for Her Imperial Majesty Eugénie, Empress of the French. The word 'revolution', though, has been woefully overused. Remember the verdict of the fashion photographer Jeanloup Sieff on the 'revolution' of Saint Laurent's 1960 'Beat' collection at Dior: a revolution in a teacup. 'But when you're in the teacup, it feels very important.'

The millennium didn't bring the 'bug' that many had prophesied would crash computer systems, scramble air-traffic control and generally derail modern society as we know it. But it did bring a revolution – and it wasn't restricted to fashion. It was a revolution across communication as a whole, one as profound as the invention of the printing press. That may sound grandiose and overblown – very fashion, in fact – but it's not. If anything, it's an understatement of the impact of the internet, which has revolutionized everything from politics, to pornography, right through to the clothing on our backs.

'You know what I think?' says Suzy Menkes, Chris Moore's journalistic partner throughout the early millennium. 'I believe that we live in one of these really exciting ages when everything is changing. I wasn't there at the turn of that other century when people were getting out of their carriages and taking off their grand hats, when the car was invented and everything became streamlined. But it's a similar sort of feeling now, that whole idea that everything in the world is changing. Certainly, the internet and all of its ramifications just makes you feel like that.'

The internet revolution began, for fashion, in the 2000s. By 2010, however, a major shift was palpable. The internet was no longer alien. It had become integrated into fashion, an essential part of it, and a vital part of life. A new breed of artists were dubbed 'postinternet', an ambiguous term that denoted a new generation raised in the constant presence of the internet, who reacted to it as 'something that pervaded existence in every way', Lauren Cornell, a curator at Manhattan's New Museum, said to the *New Yorker*. These artists responded to the internet, she continued, 'not as a new medium but as a mass medium'. This neatly summarizes fashion's own reactions, which, by 2010, were not about using a medium, but about living with it. In 2015 the Media award of the Council of Fashion Designers of America – presented in honour of the fashion journalist Eugenia Sheppard, of the *New York Herald Tribune* – was given to the social media company Instagram. Not a person, but a mobile phone app. Nothing could be more postinternet than that.

The New York designers Joseph Altuzarra, and Jack McCullough and Lazaro Hernandez of Proenza Schouler, created col-lections in the early 2010s inspired by the internet – by the random aesthetic associations thrown up by Google's image search, and the ceaseless scrolling of graphics on the microblogging platform Tumblr, respectively. But those clothes – and others – did not merely co-opt superficialities of the internet; they were fundamentally shaped by its freedoms and its restrictions. It wasn't about looking like a computer game; the digital age isn't a 'look'. It's an ideology that, as of 2017, has begun radically to affect the way fashion designers work, and create.

As Moore says, everything must now be instant – instant image relay, instant information, instantly available. By 2010, the live stream had become standard industry practice. Labels then began to experiment with the means of capitalizing on the exposure it created. Burberry's Christopher Bailey prioritized the brand's online interaction, on various platforms, including Twitter, Snapchat, Instagram and Periscope. When Burberry began to live-stream its shows in 2009, rather than presenting an impotent initiation into a six-month wait for product, it also began to offer entire shows online, available for immediate order. The strategy was picked up by other brands, notably Moschino under Jeremy Scott, appointed in 2014. A year later, retailers stated that 75 per cent of the brand's sales were made in the seven days following the show. The digital age is the age of instant gratification – otherwise, immediate obsolescence.

Underscoring the obsessions of the decade, the theme of an exhibition in spring 2016 at the Costume Institute of the Metropolitan Museum of Art in New York was 'Manus X Machina: the role of the hand and the machine in the creation of contemporary fashion'. It was sponsored by Apple – a company that shaped the physicality of fashion in the digital age to a far greater degree than any other. What Apple did – primarily through the iPhone, introduced in 2007 – was to remove the removal from online browsing. The iPhone turned the internet into something tangible, no longer confined to a screen placed inches away from your face. You touch the internet. You tap it. It moves in your hand. It's as tactile as a piece of clothing. With the Apple watch, first introduced in April 2015, it actually became an item of clothing itself.

How did all this affect the fashion show, and its communication into popular culture? It increased its speed, yet again, and made it available to many more people. Moore smiles wryly: 'The joke is, now all the journalists are all doing it on their phones.' The blurry camera-phone picture, captured from the side of the catwalk – the same angle Moore and his fellow photographers abandoned in the early 1990s – has become a new viewpoint of the fashion show, uploaded instantly and shared with millions. Some designers, naturally, have reacted against that proliferation of material. In September 2010, when Tom Ford staged his first own-label womenswear show, photography was banned, except for that by a single image-maker, Terry Richardson. The occasional

Alexander McQueen died on 11 February 2011; his Autumn/Winter 2010 show was staged in a series of small salon presentations in Paris, and Moore – a house intimate – was the single photographer permitted to document them: 'I was the only one who photographed the show after his death. There were shows all the way through the day, and I did them all. The music alone was enough to make me cry.'

Pages 423–427:
Alexander McQueen
Autumn/Winter 2010
Paris

Page 420:
Maison Margiela
Spring/Summer 2016
Paris

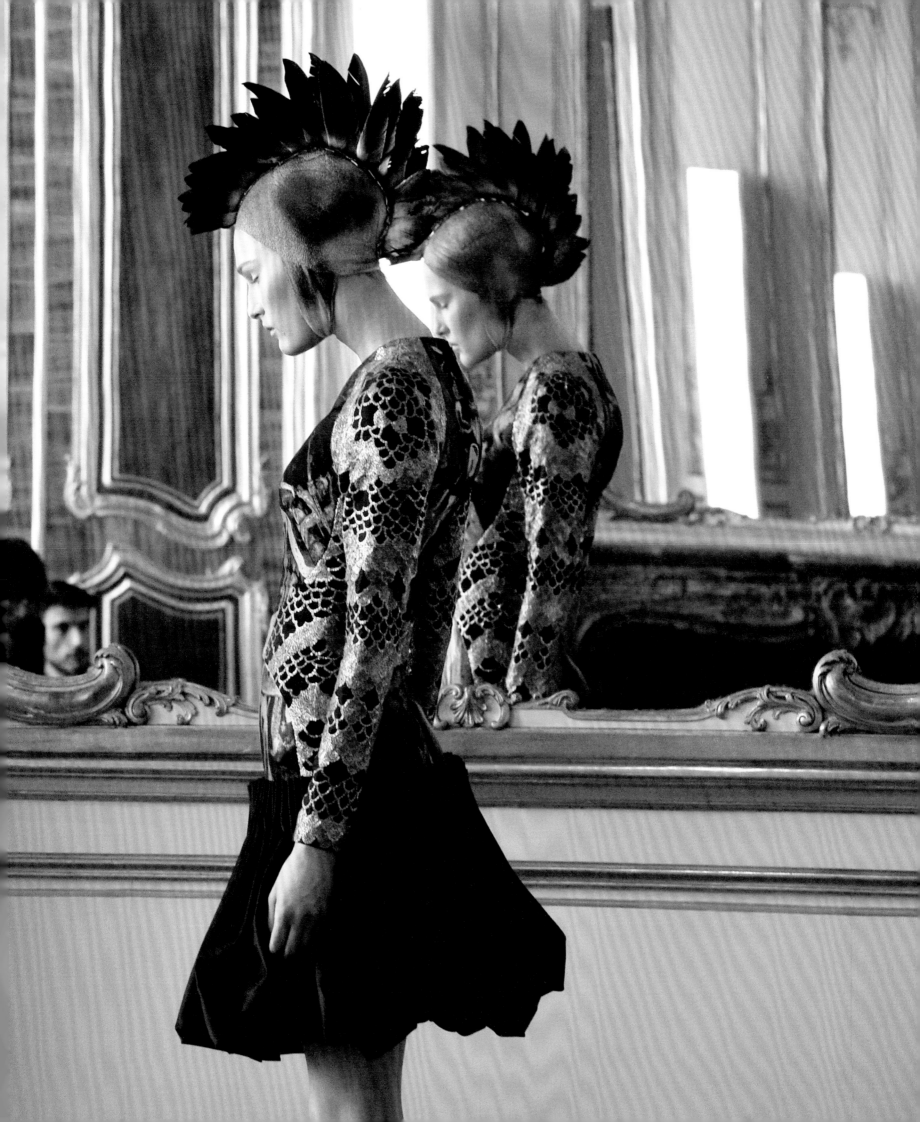

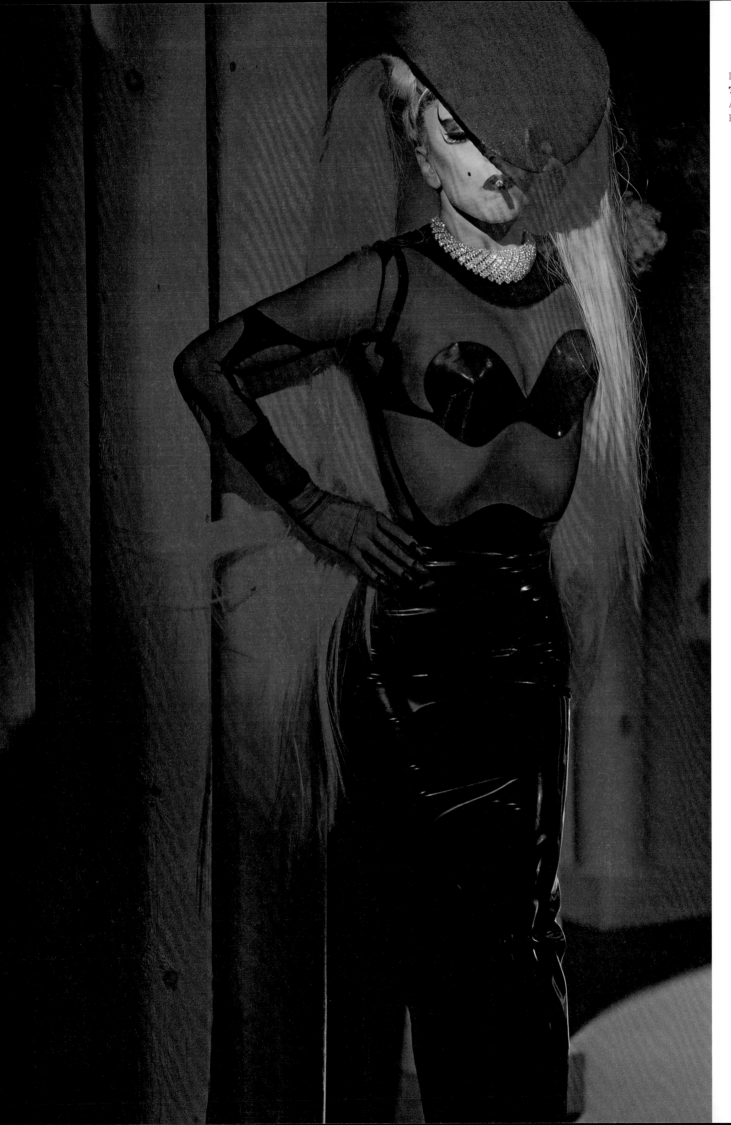

Lady Gaga at
Thierry Mugler
Autumn/Winter 2011
Paris

furtively snapped iPhone picture, however, made it through the embargo. There was, it goes without saying, no live stream. From a man whose high-octane Gucci shows and slick marketing remoulded the way fashion was seen and bought, it was a major stand. It was only for one season, though.

Ford's fight felt as though it was against the internet – or rather, against the digital age experience of the fashion show. Fashion, he said, had become overexposed. That was undoubtedly true. The tussle of the decade proved to be between the demands of accessibility and exclusivity – postinternet and pre-internet. These two notions were not necessarily irreconcilable, but they were often presented as such, as can be seen in Ford's withdrawal and, later, fashion-show audiences shrinking from thousands to hundreds – at least, in terms of witnesses to the live event.

A new debate was over whether fashion shows were obsolete, in an age when a digital space could offer greater possibilities for creative expression. By 2010, after tentative experimentation in the first decade of the century, industry voices vehemently argued the pros and cons of both sides – particularly as, with the rising importance of pre-collections, some of the largest fashion houses were staging six fully fledged catwalk shows a year. 'Is a fashion show really necessary?' was the flat-out question Menkes posed in 2010, a month after Ford restricted views of his, and as the experimental London-based designer Gareth Pugh used Paris's Bercy stadium, where Alexander McQueen's 'Plato's Atlantis' had been staged a year earlier, to showcase a film in place of a show for Spring/Summer 2011.

Moore is somewhat traditional in his view. 'What you see is going to be different from the live-stream pictures,' he says, pragmatically. 'If you are a designer, you need the full stop at the end of a novel. You need people to look at your work of art, to admire it. It is probably an ego thing. They've been saying it's going to stop, it's going to stop, it's all going to be video. It's rubbish.'

So what is Moore's opinion? That the fashion show is a collective experience in itself, not merely a vehicle for viewing clothes: 'You get the smell of it. The whole ambience. The music.' He sighs. 'I don't see this going away. I suppose it could, but I don't see it.'

In a sense, what Moore divines is a distinctly twenty-first-century search for authenticity. It can be seen in a hankering for pre-digital photography methods, a move away from the airbrushing and Photoshopping of the 1990s and 2000s, an embracing of imperfection. It shows in fashion's championing of the apparently anti-fashion fashion brand Vetements, whose lo-fi approach – one of chopped-up and recycled clothes and oversized layers – owes an obvious debt to the work of Maison Martin Margiela, who retired in 2008. Vetements staged its second show in Le Depot, a gay sex club in the Marais district of Paris; its third in a down-at-heel Chinese restaurant. The label garnered attention by pulling away from the digital polish of the contemporary fashion scene, by offering, simply, an alternative: an analogue option, in the digital age.

The notion, of course, grabbed attention. That proved the ultimate goal of fashion in the 2010s. Celebrities evolved beyond commonplace catwalk-side accessories at fashion shows; they launched their own fashion lines, most notably Victoria Beckham, Mary-Kate and Ashley Olsen of The Row, and Kanye West. Their pop-culture status arguably amplified the impact of their clothing designs beyond their individual merit. Perhaps that was also true of some fashion brands, who leveraged the power of digital media to promote themselves far beyond their usual scope of influence.

Designers are very aware of the means by which their clothes are consumed – visually as well as financially. For Spring/Summer 2011, Miuccia Prada created a menswear collection whose denouement was a trio of striped sweaters. They were pleasant enough at the show, but through the distorting prism of the internet those sweaters glowed, with each model reduced to a cut-out form on which the stripes bounced up and down in changing colours, like a GIF animation. Prada's clothes will be seen by 99 per cent of people that way: as a flat, glowing image on a screen. So that's the image she chose to fashion – because for some, image is everything.

It's more nuanced even than that. Those Prada outfits were fashioned to make the most of the grid-style layout of websites such as Catwalking.com or Style.com, the former a website whose name was born from fashion patois, the latter one whose URL became part of the popular fashion vernacular. (Style.com is now an e-commerce platform; the catwalk archives of the original website were absorbed into American *Vogue*'s Voguerunway.com portal in September 2015.) Online catwalk archives, such as those two sites, have transformed the way fashion designers themselves view their collections. Look at any show, and you're struck by the sequencing of the outfits. The London designer J.W. Anderson, for instance, reiterates garments in multiple variations of colour, hammering home a silhouette when seen in triptych, in an online layout. The internet here is not just another tool, a medium for a message. It has become part of the message itself. That is an indication of its all-pervasive power in fashion of the 2010s.

The computer scientist Michael K. Bergman has reasoned that an internet search is like dragging a net across the ocean: you may catch something on the surface, but there are fathoms you can't penetrate. He was speaking of the hidden levels of the internet, but the notion is also applicable to the effect the internet – and the digital age as a whole – has had on the human psyche. The internet has overhauled our notions of what we want, how we want it, and even why. In a business like fashion, built on desire and seduction, that equates to an elemental shift. The fashion show after 2010 is engineered for the internet not just via the broadcast of a digital image, but in the very fabric of the garment itself. The 2010s have proved to be fashion's first postinternet era. How this will affect future generations of design talent can only be speculated about. It is just the beginning of something truly new.

The campy appeal of
Marc Jacobs's Spring/
Summer 2011 Louis Vuitton
collection was underlined
by staging reminiscent of
1970s shows, with a raised
faux-marble catwalk and
multiple model exits.
They even asked Moore,
the house photographer,
to mimic the era's image-
making techniques. 'We had
to get all the photographers
to go back to the 1970s
and get round the catwalk,
jumping up to get the shots.
They wanted their images
to look different.' The same
aim is true of Chanel, on a
grander scale, with the giant
sets inside the Grand Palais.
For the Autumn/Winter
2010 collection, a golden
lion – representing Gabrielle
'Coco' Chanel's astrological
sign – rested its paw on one
of the house's signature
pearls (overleaf).

This page:
Louis Vuitton
Spring/Summer 2011
Paris

Overleaf:
Chanel
Autumn/Winter 2010
Haute Couture, Paris

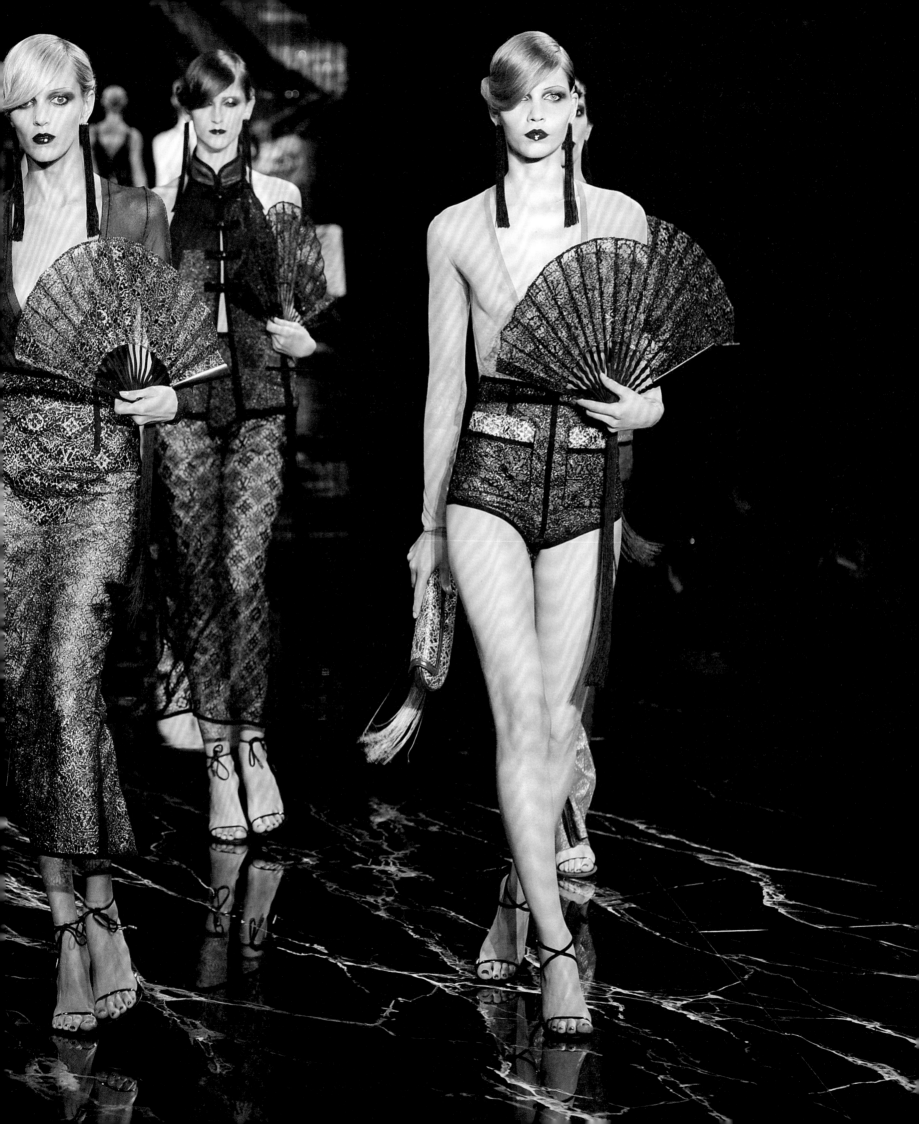

This page:
Junya Watanabe
Spring/Summer 2011
Paris

Overleaf:
Marc Jacobs
Autumn/Winter 2011
New York

An unusual sight: because of a seating malfunction, the benches of audience members at the Spring/Summer 2012 Balenciaga show began to crack and collapse before the show began. The entire audience was asked to stand, giving the show the appearance and atmosphere of a church service. 'It's funny, I don't know what the fuss was about. I haven't ever been offered a seat,' says Moore.

Balenciaga
Spring/Summer 2012
Paris

'I love everything that Miuccia Prada does,' says Moore. 'I love her shows. It helps that she has a big place of her own – and can change it, each time.' During the 2010s, Prada began to stage her shows on an ever-grander and more complex scale. Complex show sets were devised with AMO, the sister company to Rem Koolhaas's architecture firm OMA (Office of Metropolitan Architecture), and Prada's catwalk shows became complicated spectacles; the company's showspace on Milan's Via Fogazzaro was reconfigured entirely each time. For Autumn/Winter 2012, it was reimagined as a palazzo of ceremonies and laid with a giant 20-by-35-metre (66-by-115-foot) carpet in imperial purple, white and black (actually, three different carpets inlaid into one another). A similar carpet, in red, was used a month earlier at Prada's men's presentation. Given the logistics of arranging this, the original men's carpet was dyed purple for the later show.

Prada
Autumn/Winter 2012
Milan

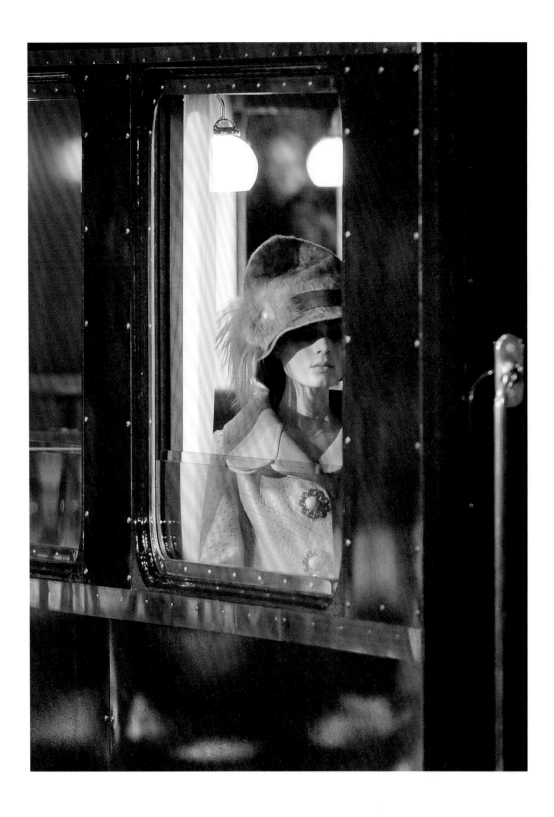

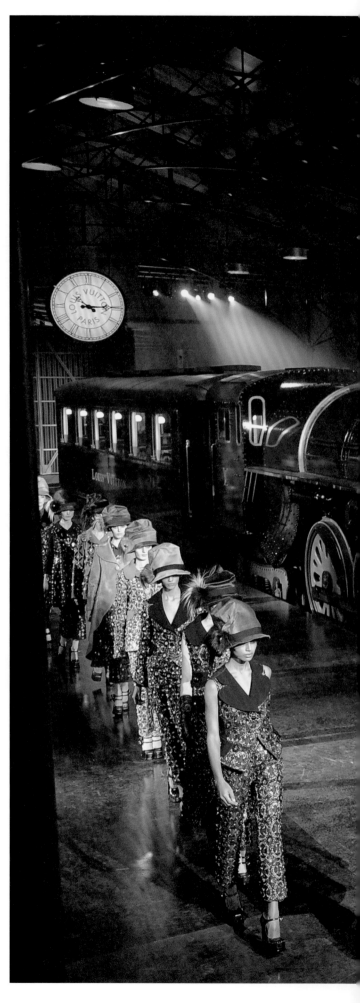

Designers continue to push the boundaries of expression through their shows. To equal the spectacle of Marc Jacobs's March 2012 Louis Vuitton show, you'd have to go back to the theatrical heyday of the 1990s – when John Galliano staged a Dior haute couture collection on a steam train. Jacobs chose to do the same, in a custom-built steamer that reputedly cost $8 million.

Louis Vuitton
Autumn/Winter 2012
Paris

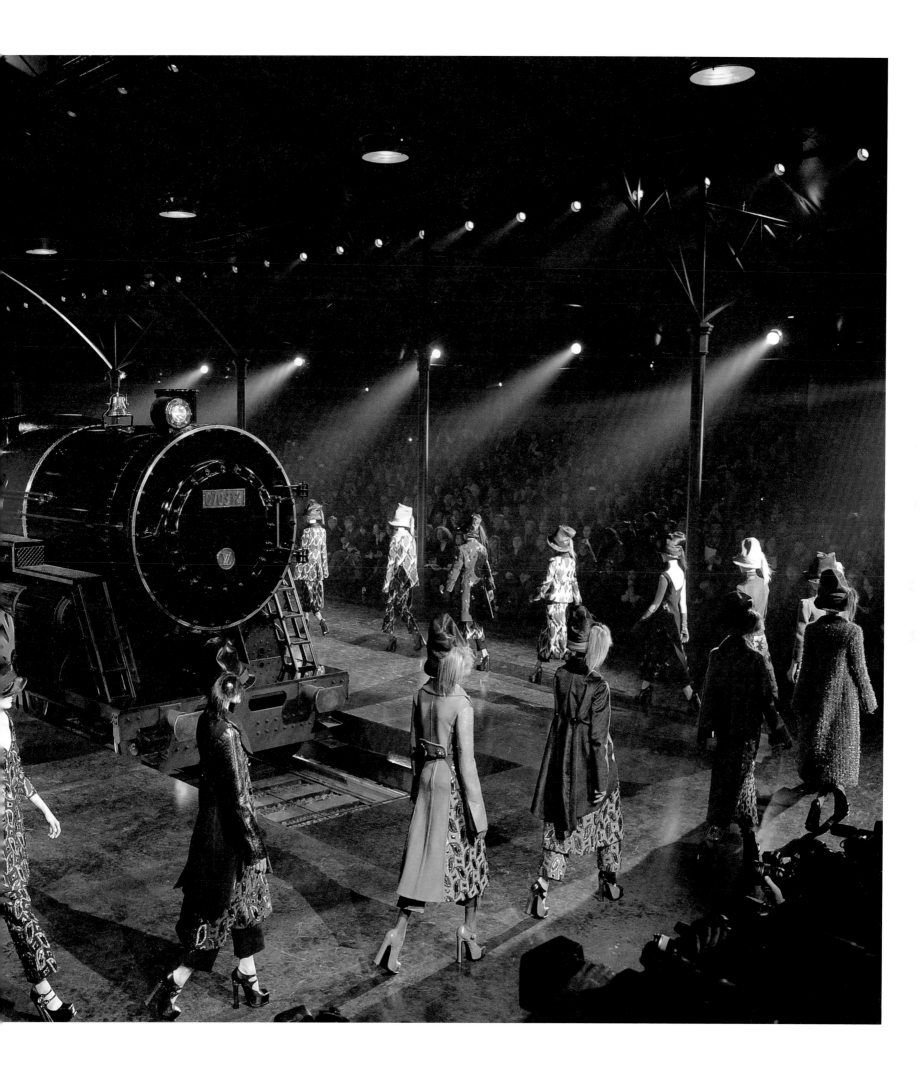

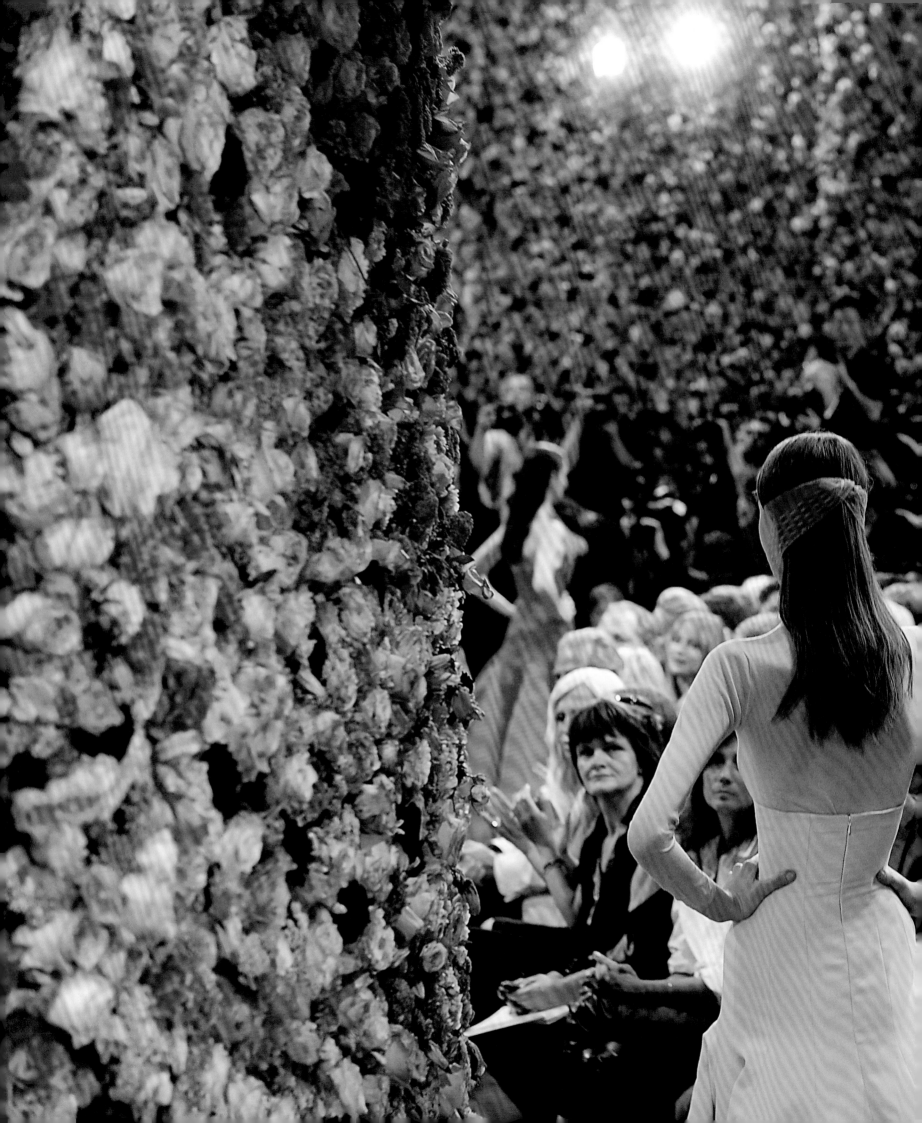

More than a million flowers were used to create the set for designer Raf Simons's haute couture debut for Christian Dior in July 2012, lining the walls of a *hôtel particulier* in Paris's 16th arrondissement. 'The smell was extraordinary,' recalls Moore. 'Fashion shows are an ambient experience – it's not just about what you see.'

Raf Simons for Christian Dior
Autumn/Winter 2012
Haute Couture, Paris

Below and opposite:
Lanvin
Autumn/Winter 2012
Paris

Overleaf:
Prada
Spring/Summer 2013
Milan

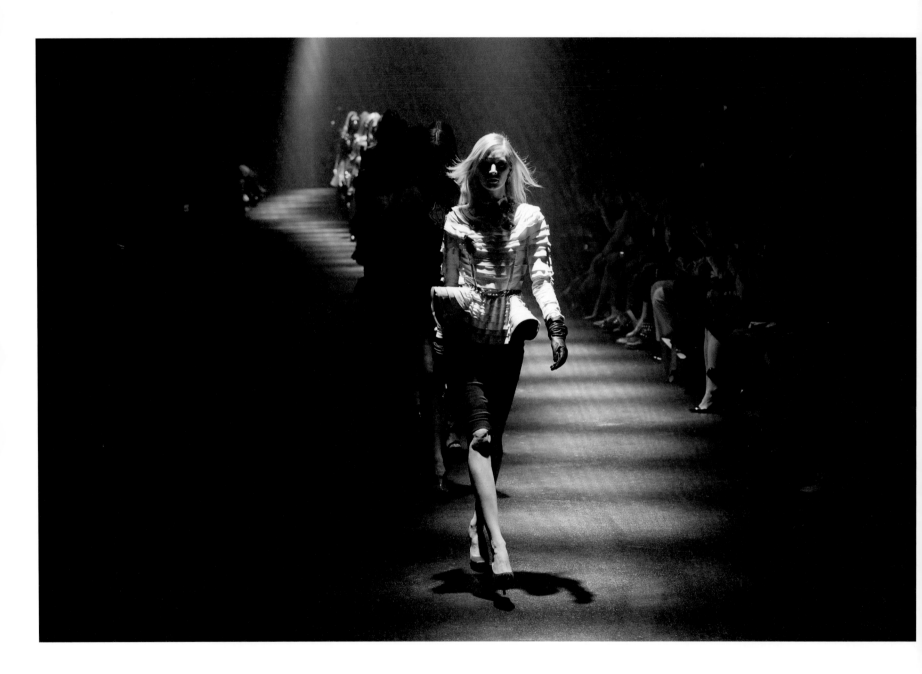

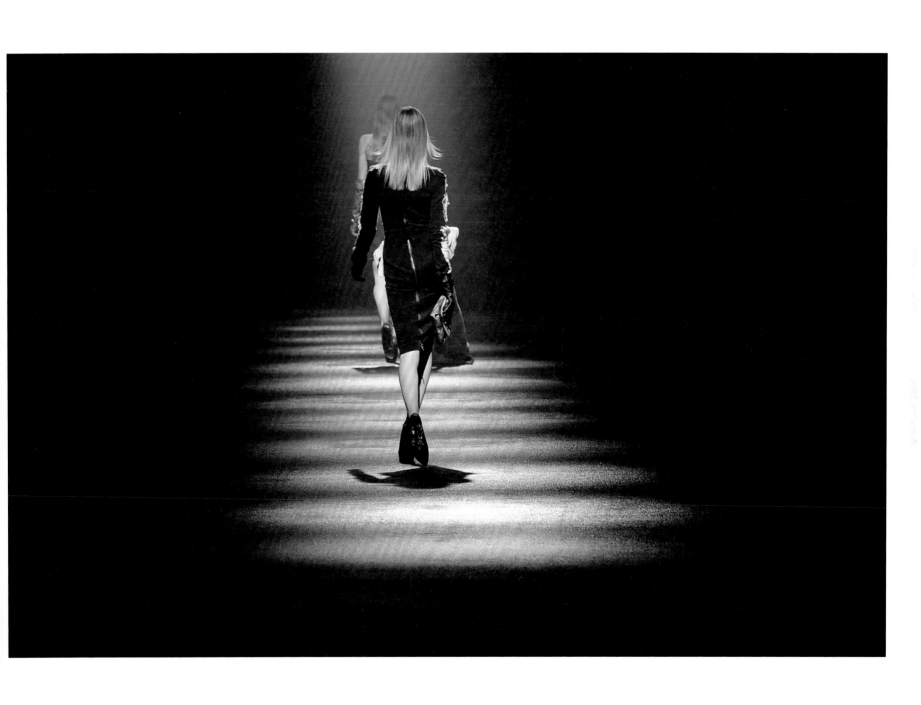

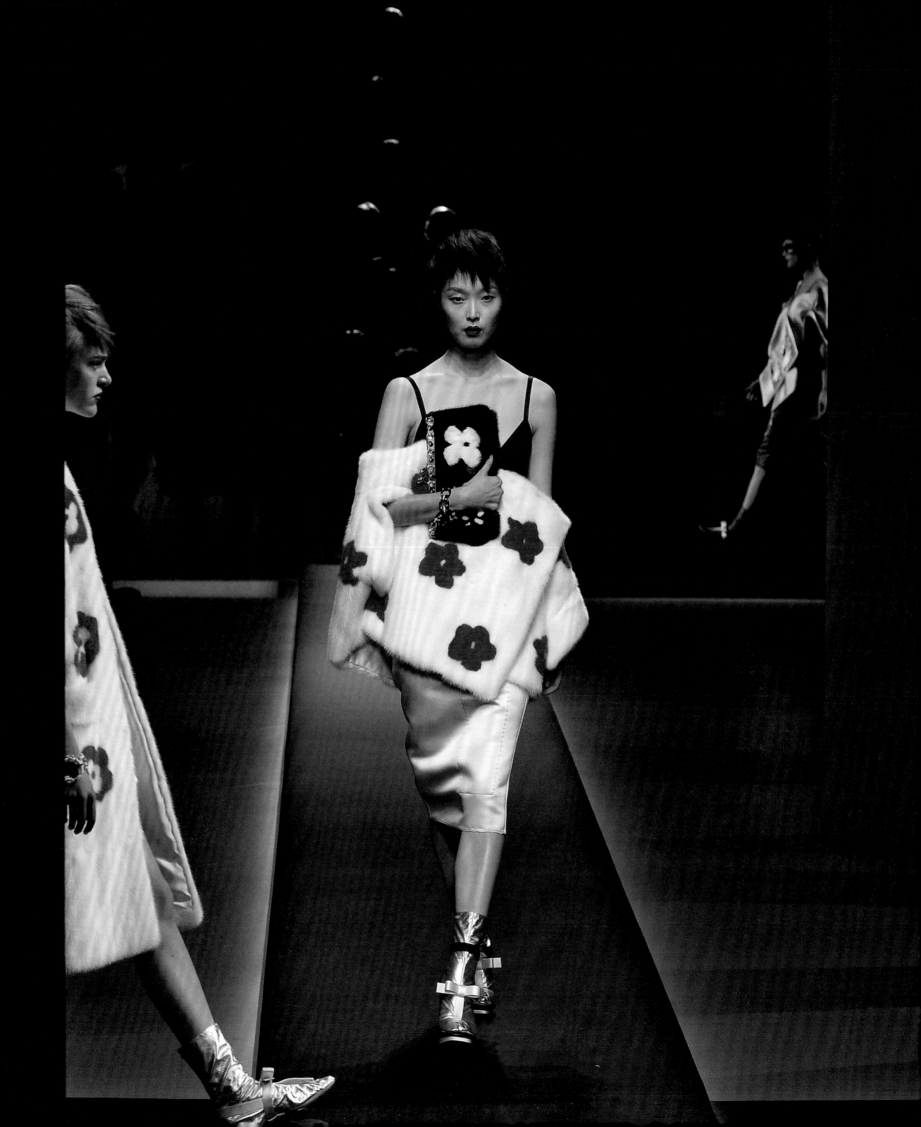

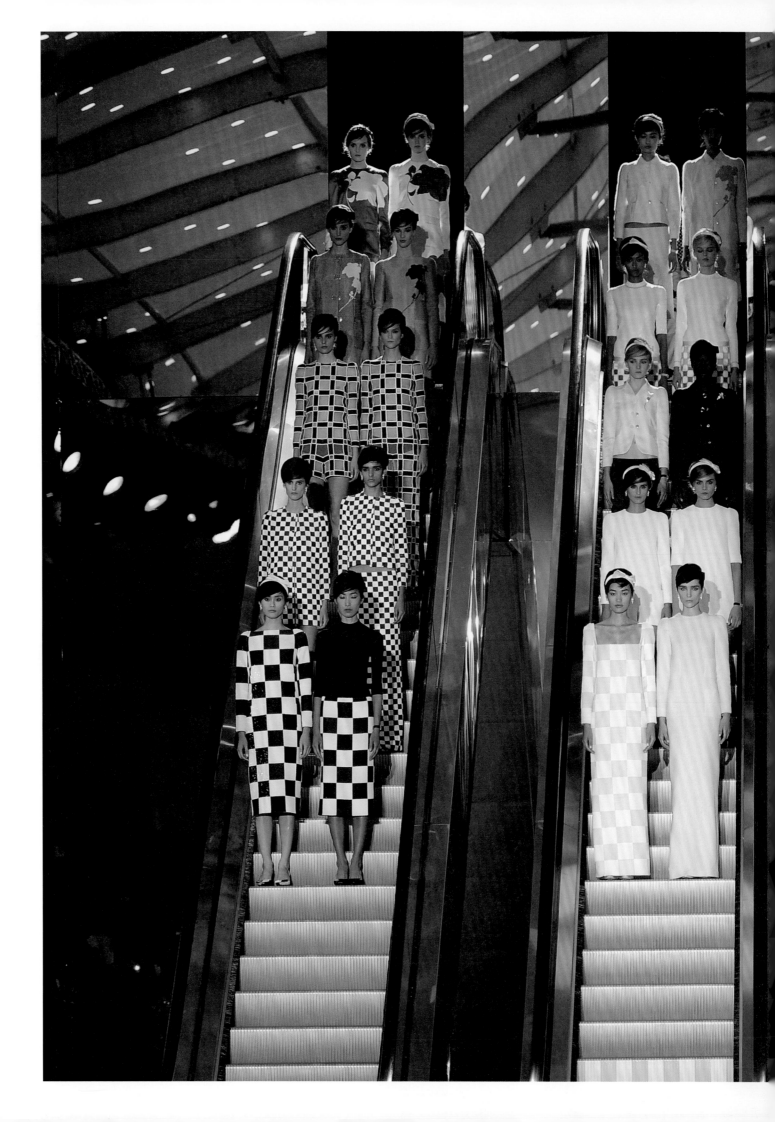

Fashion theatricality comes in different guises: Dolce & Gabbana's baroque indulgence, for example, versus the stark modernity of the Spring/Summer 2013 Louis Vuitton show (previous page). The Vuitton set was designed by Daniel Buren, the French contemporary artist responsible for *Les Deux Plateaux*, the installation of humbug-striped pillars at Palais Royal in Paris. The entire show, with its custard-yellow checks and ranks of escalators, was a Buren piece. And the clothes were specifically designed to match.

Dolce & Gabbana
Autumn/Winter 2013
Milan

'A fashion show is like a full stop at the end of a novel,' says Moore. 'You need to do it, for people to see it, to complete your vision.'

Miu Miu
Autumn/Winter 2013
Paris

There are well-worn
mechanics to a fashion
show, of course: the clothes
but also the theatrical
set pieces erected by
the designer – here the
American Thom Browne –
and then the hundreds of
photographers necessary
to broadcast that message
to the public.

Thom Browne
Autumn/Winter 2013
New York

Overleaf:
Thom Browne
Spring/Summer 2014
New York

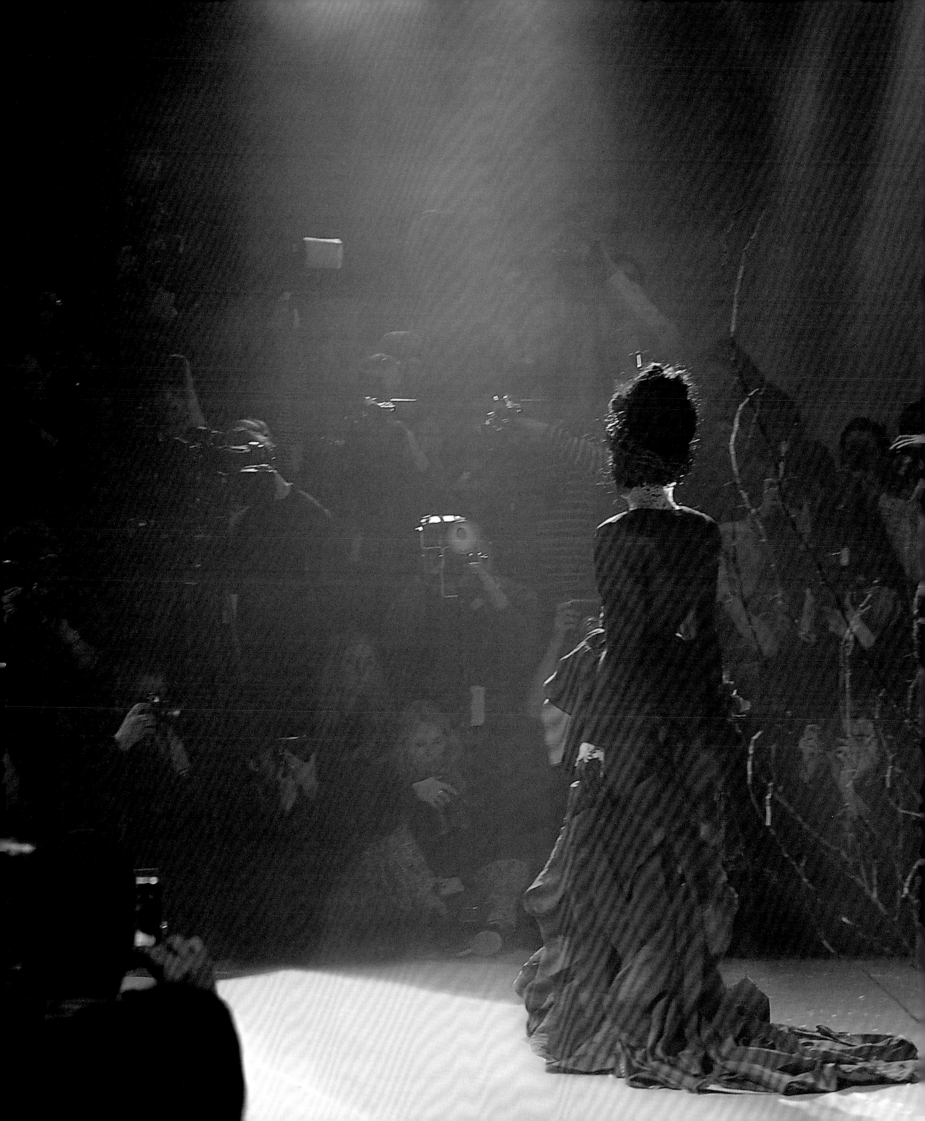

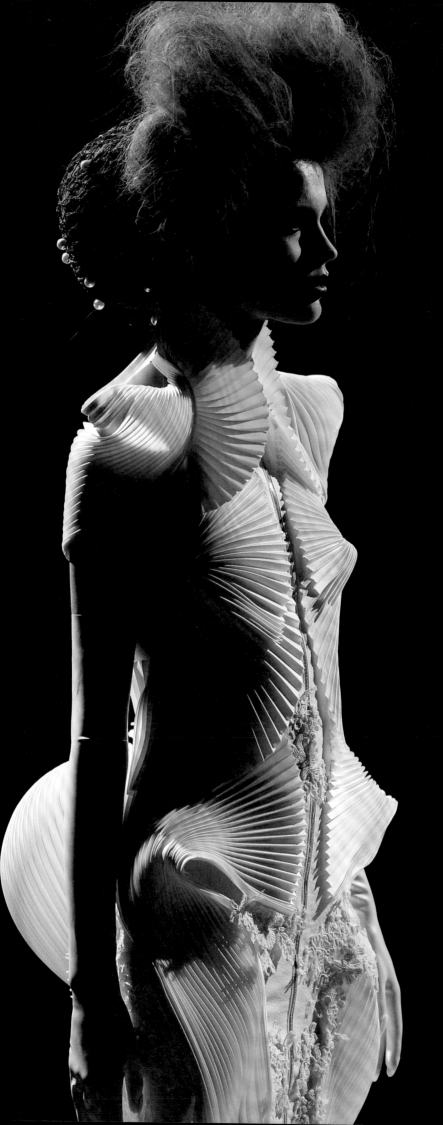

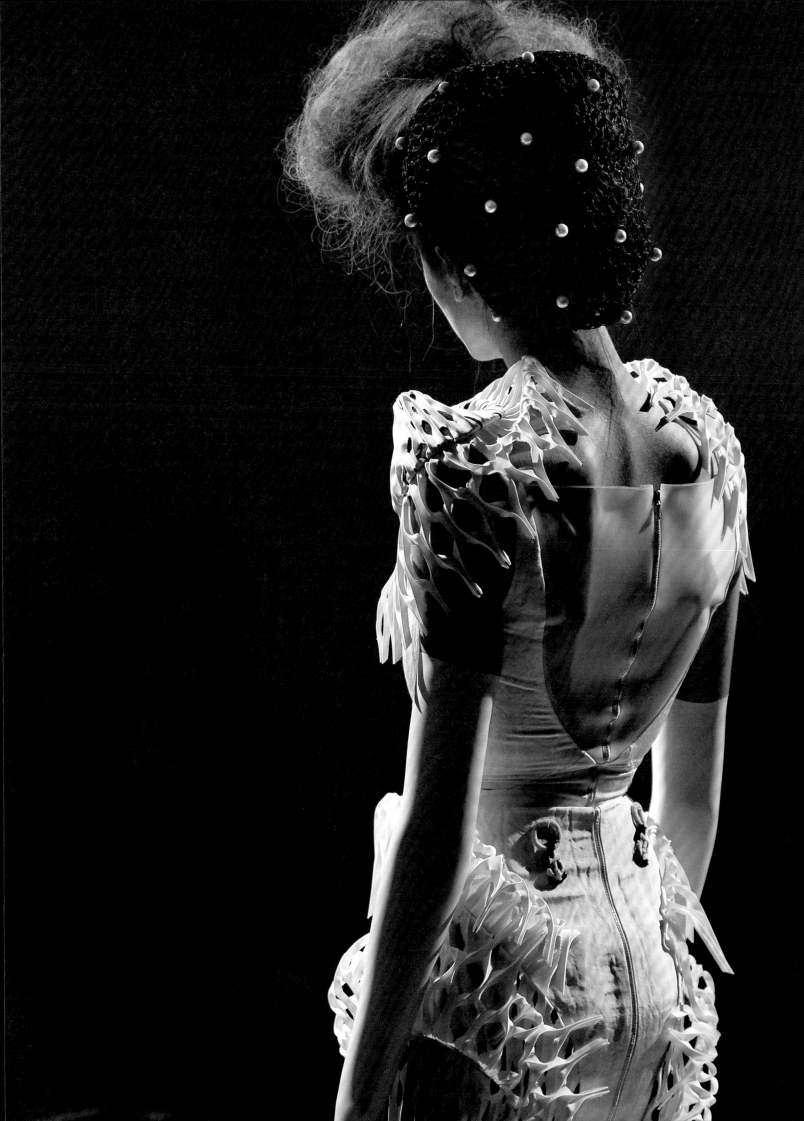

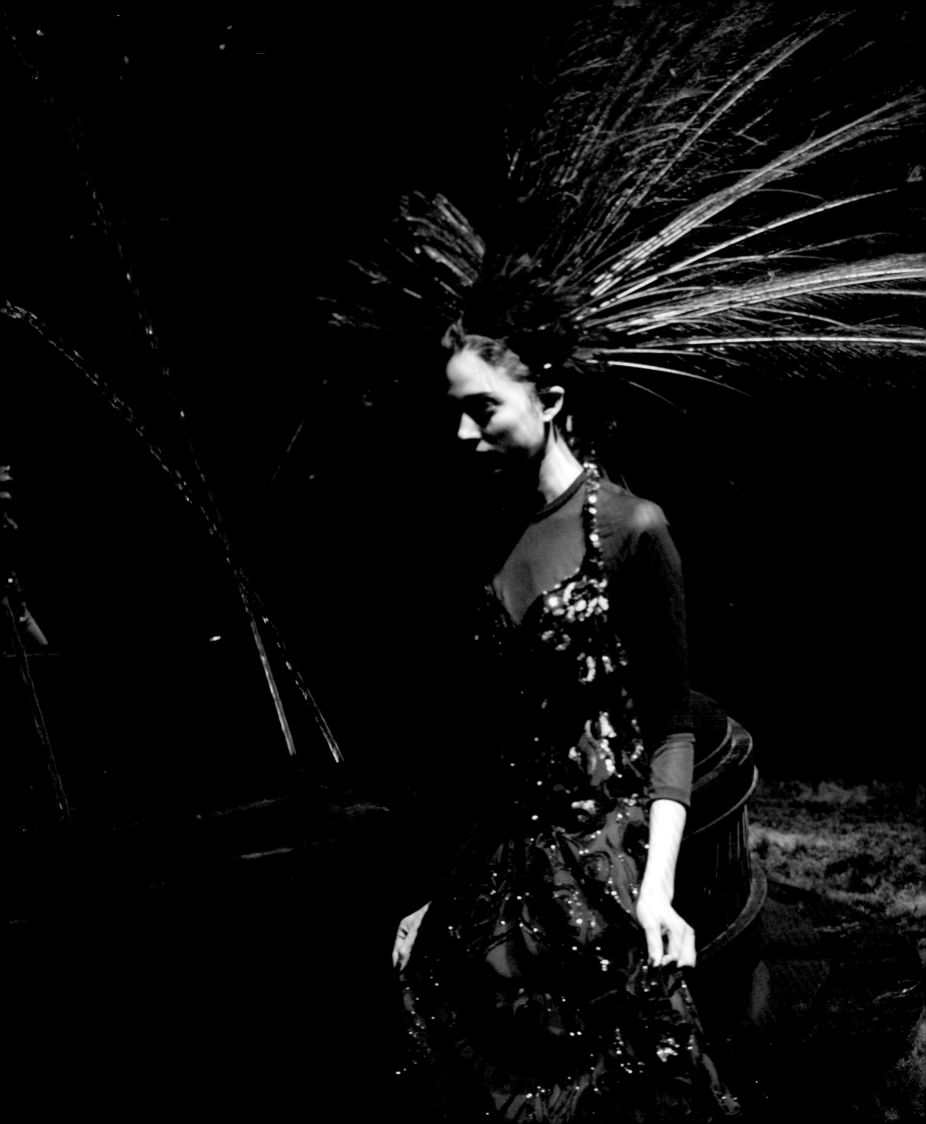

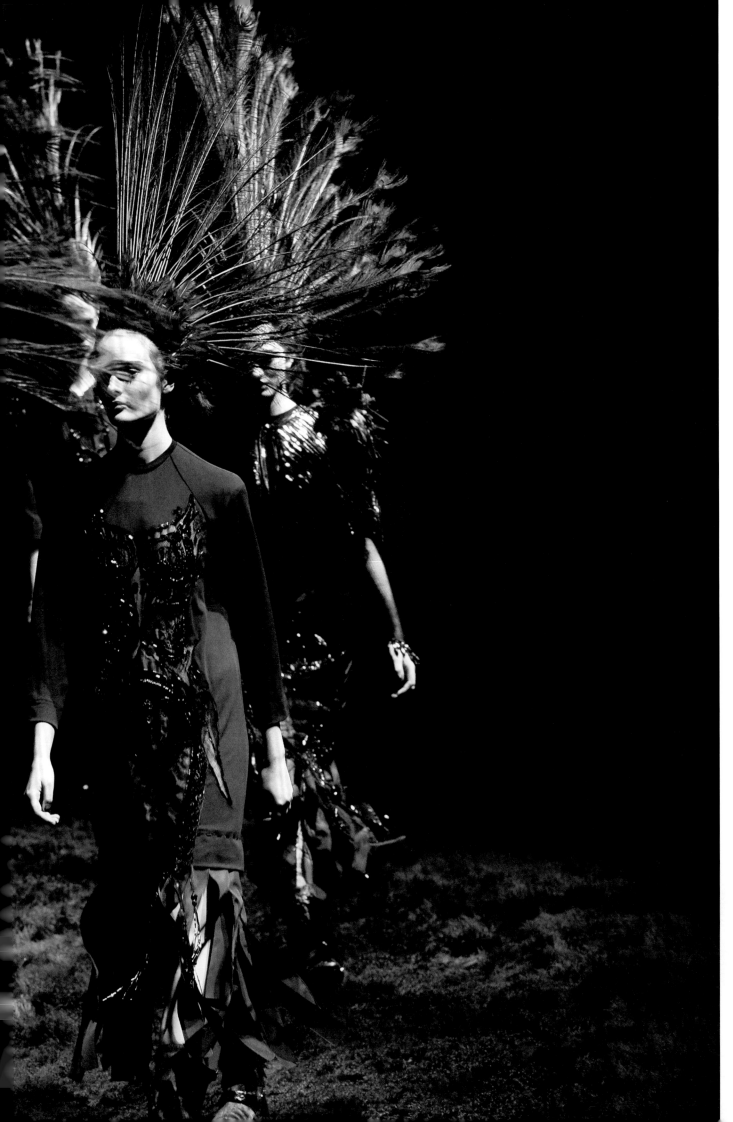

Moore vividly recalls the final show by Marc Jacobs for Louis Vuitton. 'My heart sank when I arrived,' he says. 'The daylight of the Cour Carrée du Louvre was all blacked out, the venue so sombre and dark. When the clothes came out it just got worse: the lights came up, but not much, and the clothes were almost all black. It was stressful, miserable and exhausting to shoot, but thankfully such occasions often return something visually interesting.' Such as this.

Louis Vuitton
Spring/Summer 2014
Paris

In March 2014 Chanel
erected a supermarket
inside the Grand Palais in
Paris, packed with house-
brand products, from
'Mademoiselle' doormats,
to 'Camellia' white paint,
to 'The Little Black Tea'
teabags. 'One thing I do
think was amusing: I asked
the PR at Chanel "Is this
like the supermarket Karl
Lagerfeld goes into?"'
remembers Moore. 'And
she said that he's never
been into a supermarket.'

This page:
Chanel
Autumn/Winter 2014
Paris

Overleaf:
Chanel
Spring/Summer 2015
Haute Couture, Paris

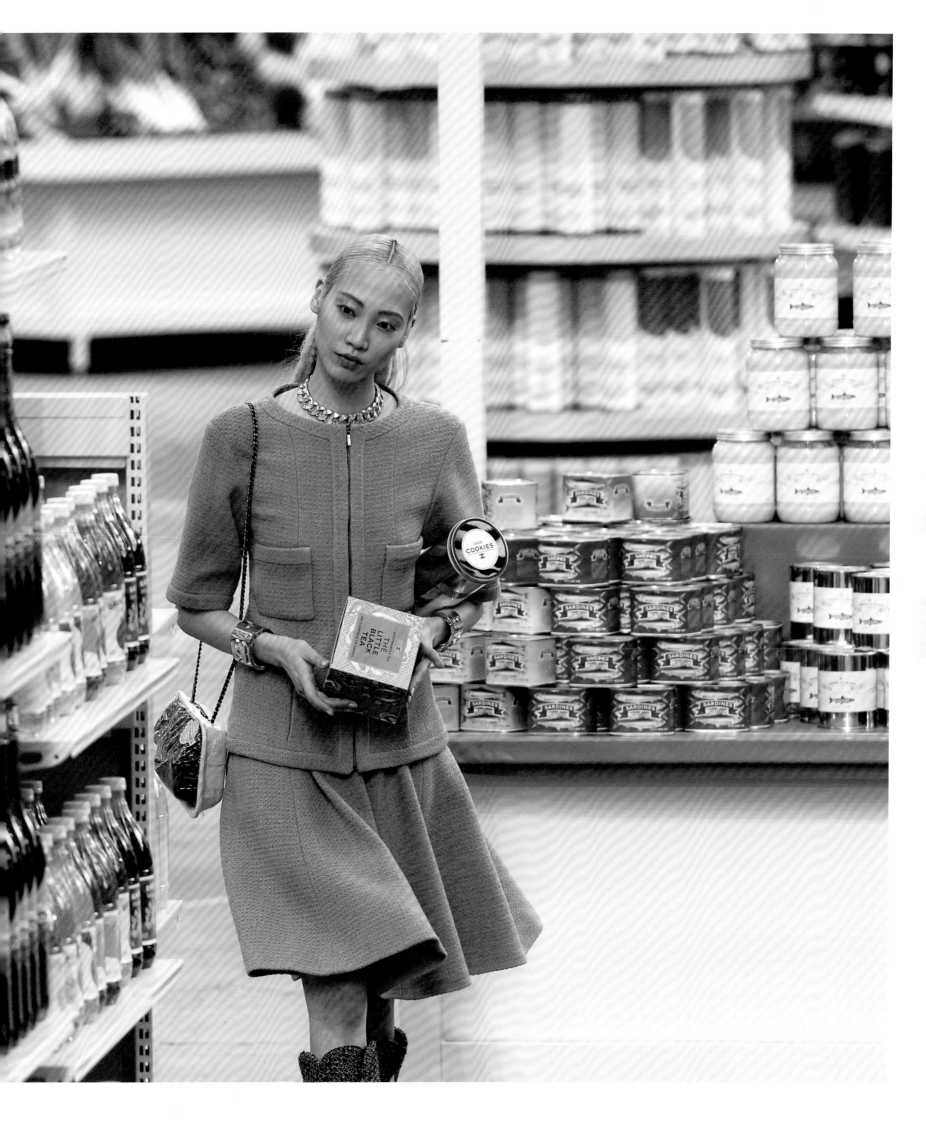

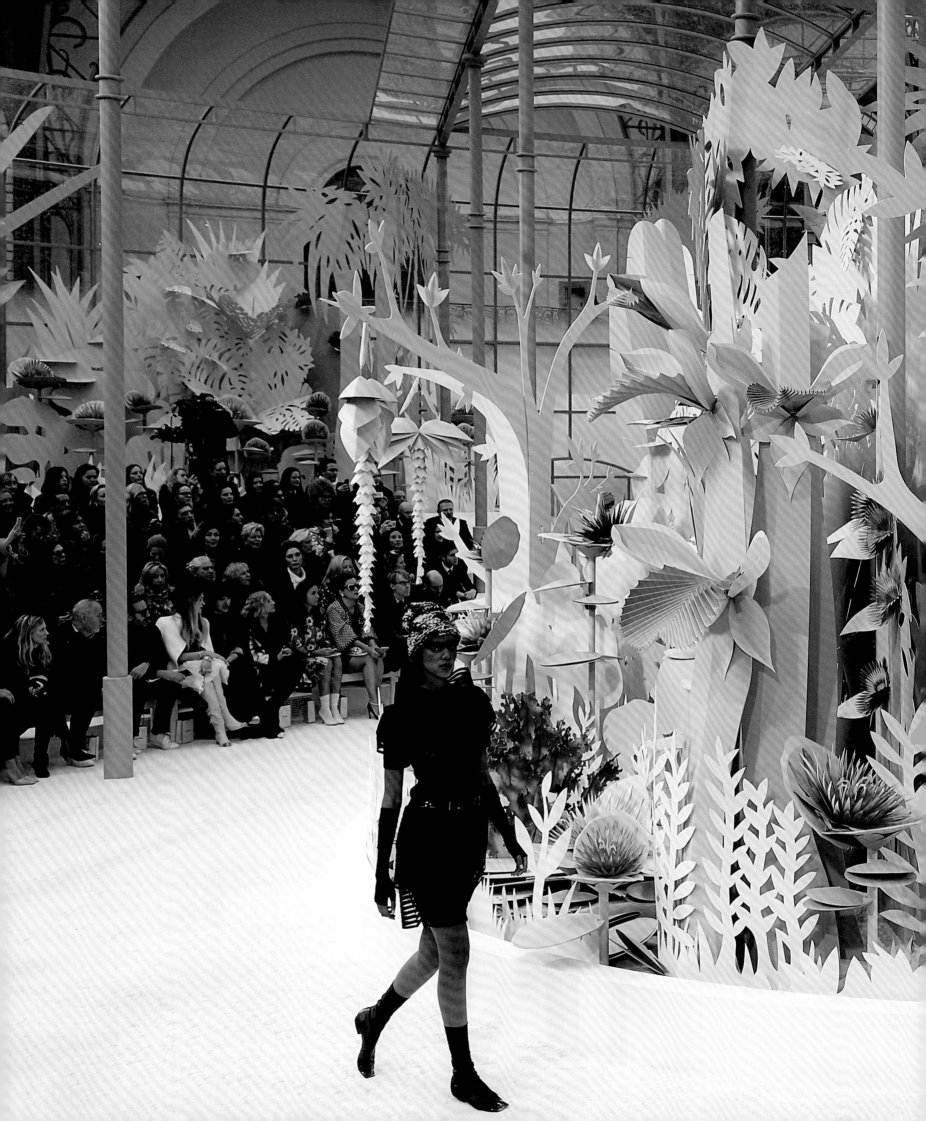

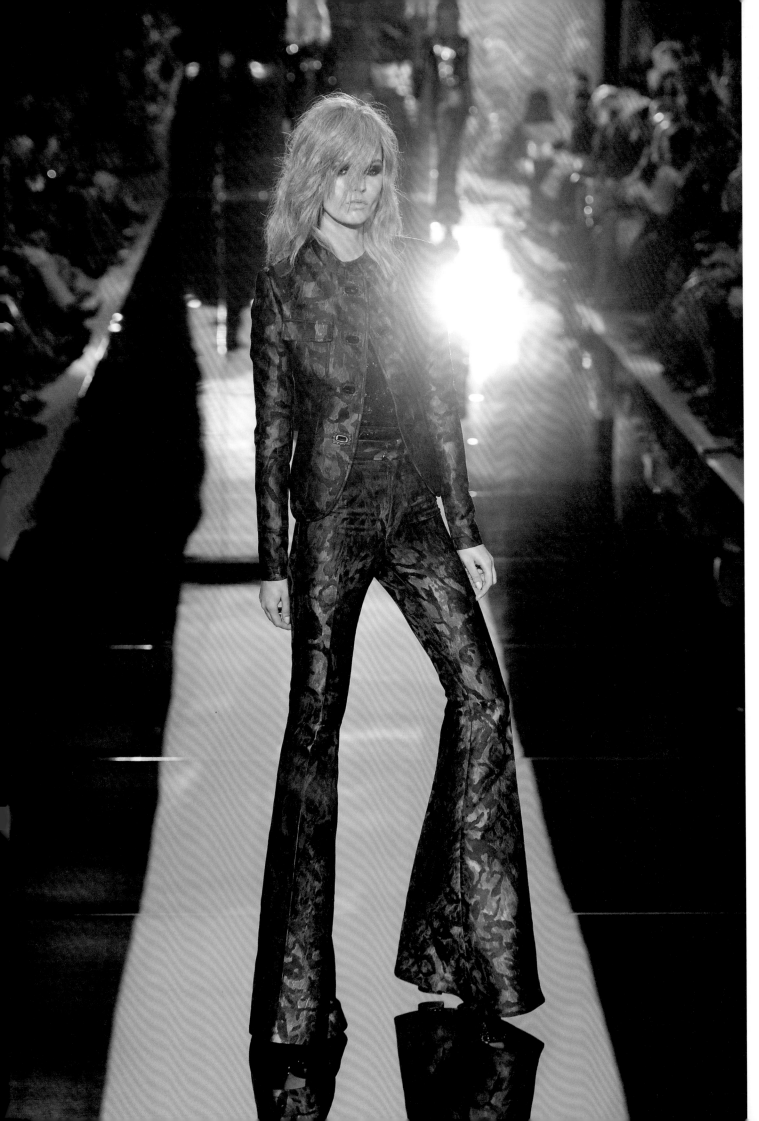

After a hiatus from the industry, the former Gucci and Yves Saint Laurent designer Tom Ford launched under his own name, quickly garnering a reputation for high-octane, highly-sexed outings that rivalled anything produced under his prior labels.

Tom Ford
Spring/Summer 2015
London

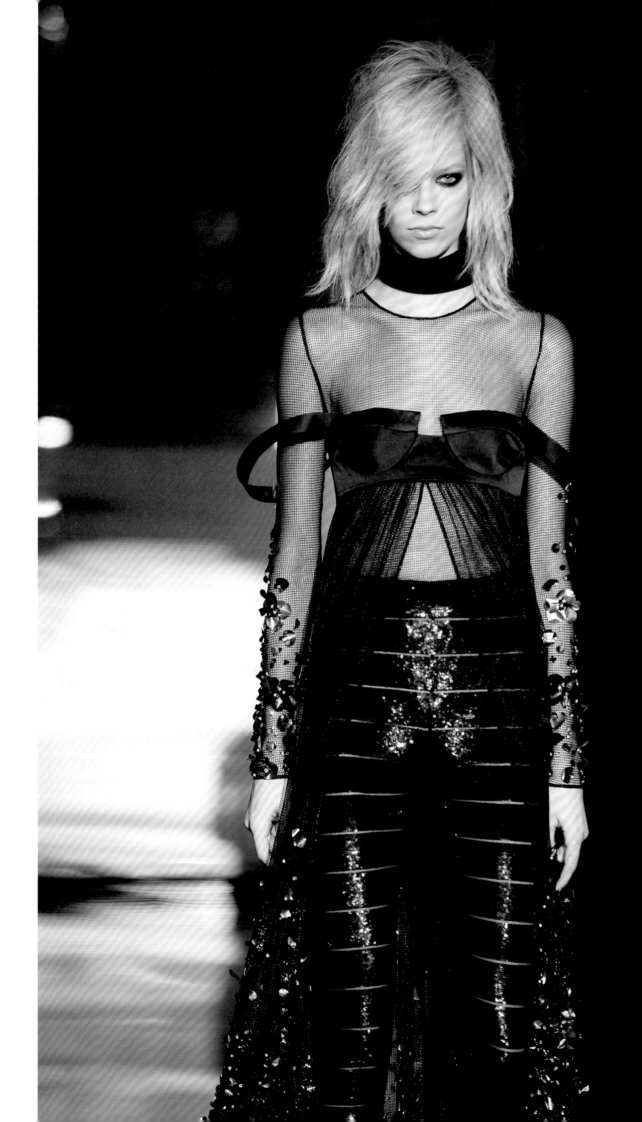

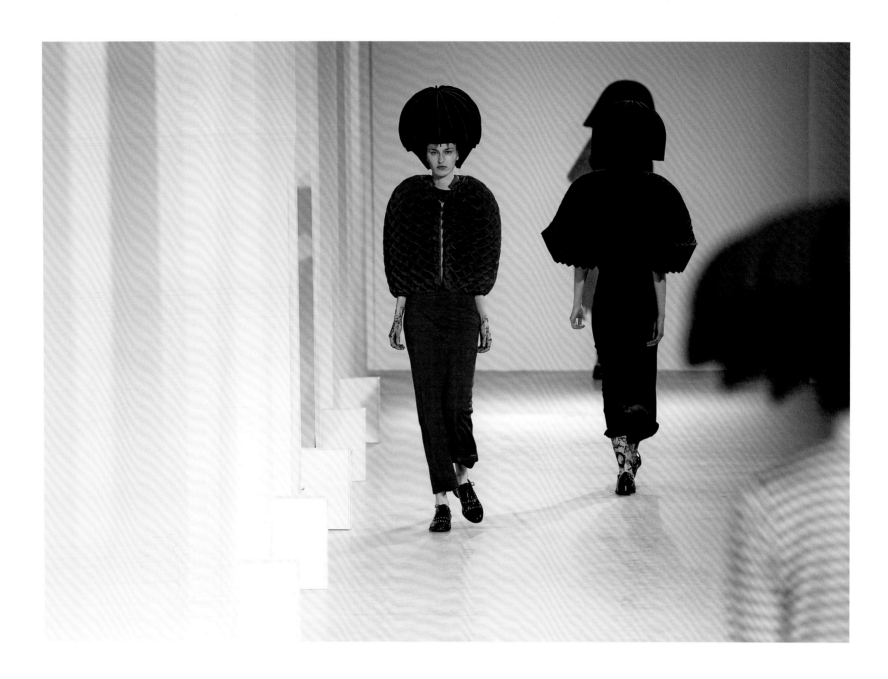

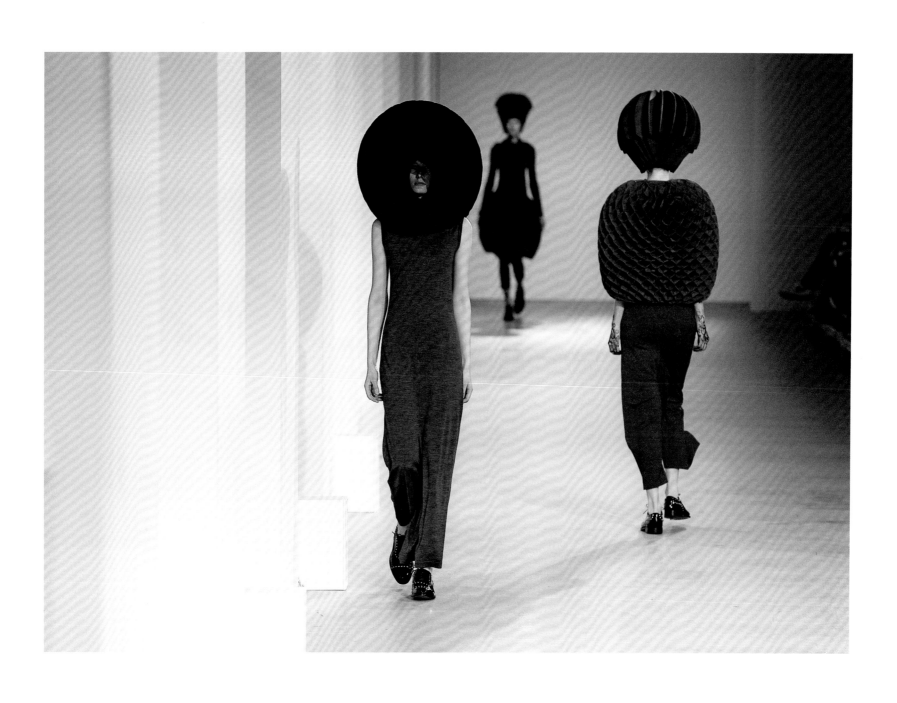

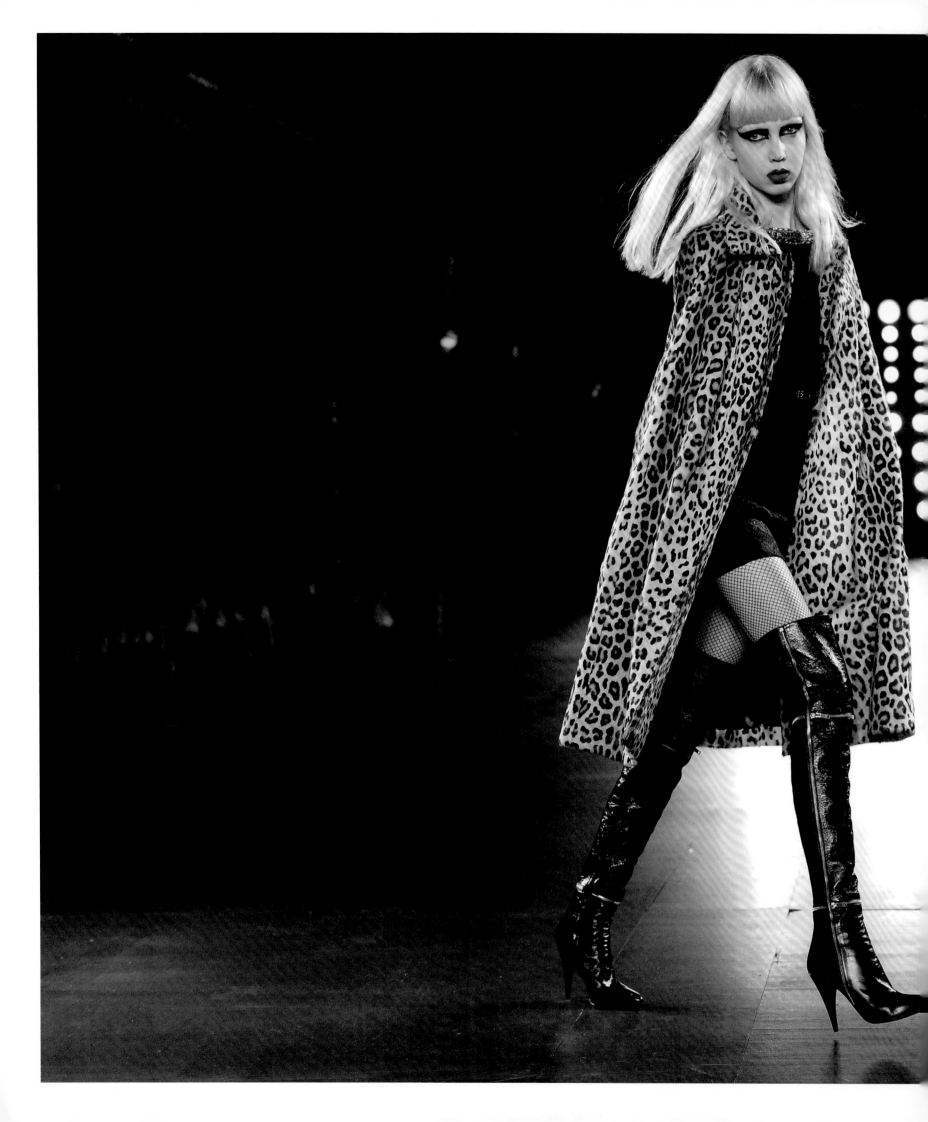

Comme des Garçons
Spring/Summer 2016
Paris

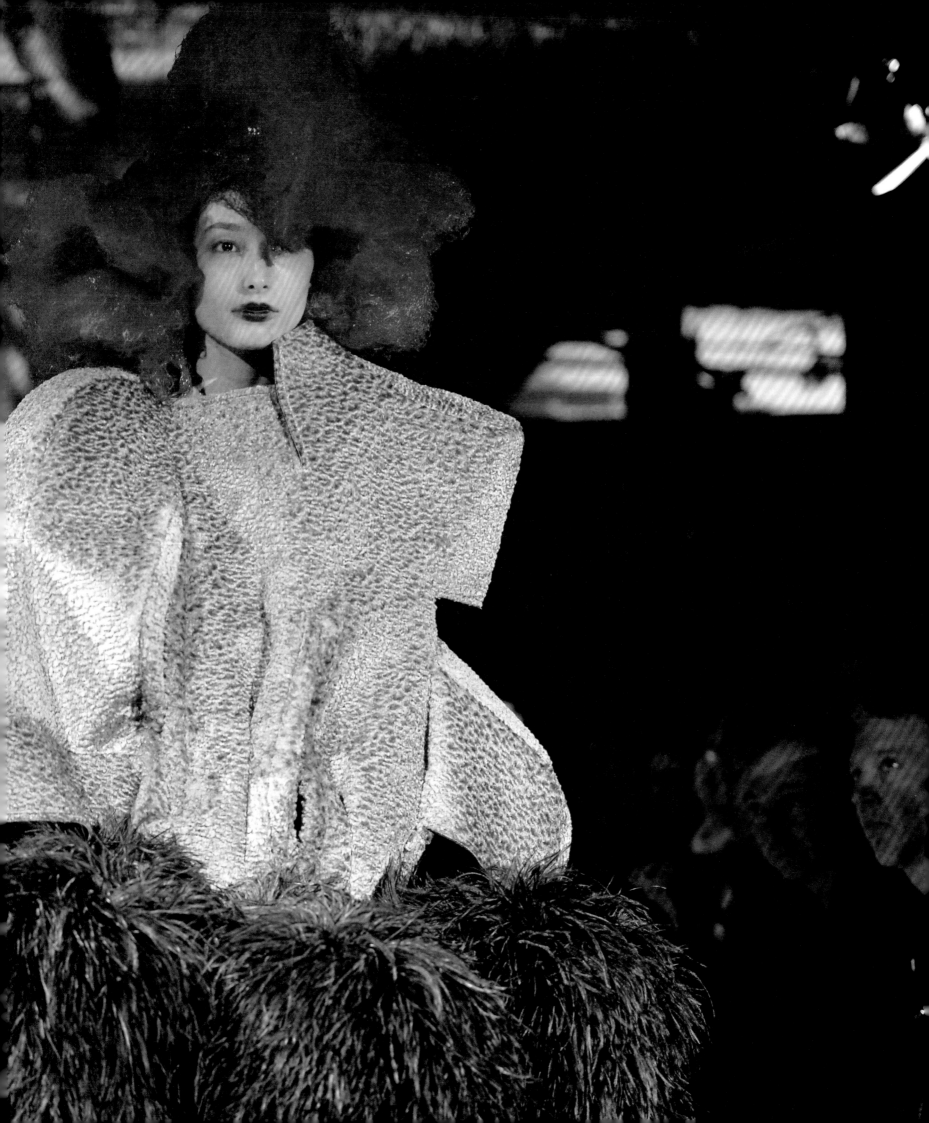

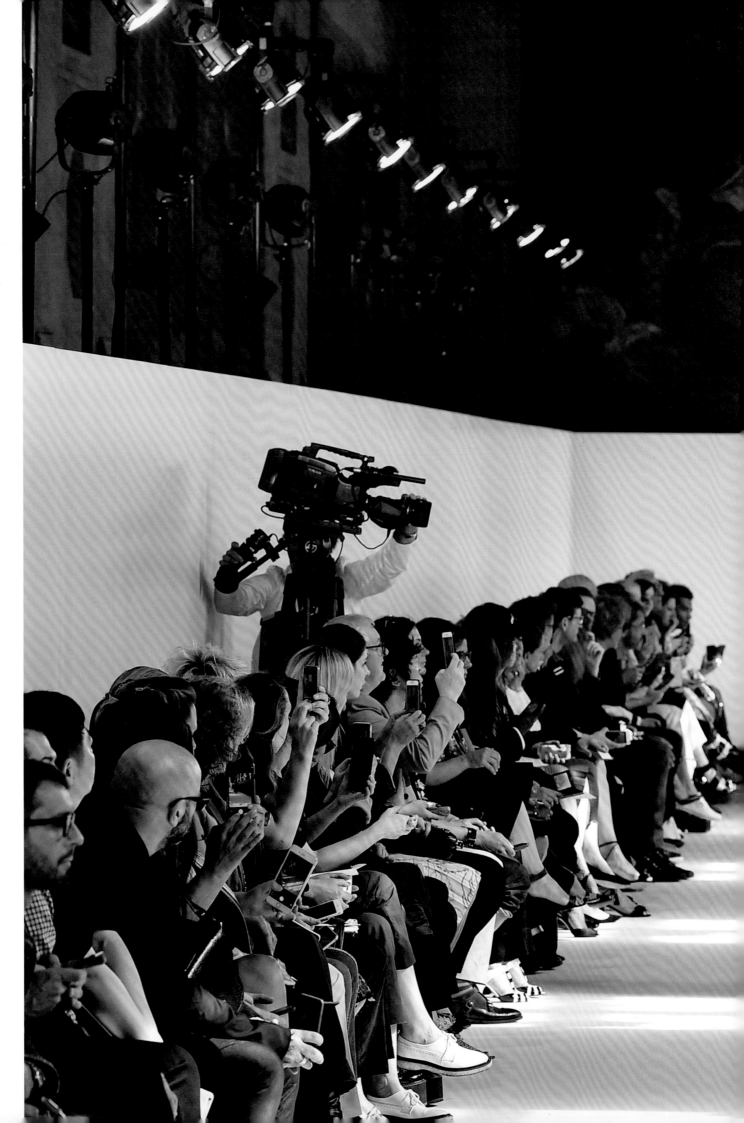

After being dismissed from his namesake line and Christian Dior in 2011, following a drunken outburst in a Parisian bar, designer John Galliano spent a period in rehabilitation. In 2014, he was appointed as the creative director of Maison Margiela (which dropped the 'Martin' from its name after Galliano's appointment). He opted to show his debut 'Artisanal' collection in London rather than Paris in January 2015. The show followed a striking new direction, melding Galliano's own style with that of Margiela in a bright, white catwalk space that has become a new signature.

This page:
Maison Margiela
Autumn/Winter 2016
Haute Couture, Paris

Overleaf:
Vetements
Spring/Summer 2017
Paris

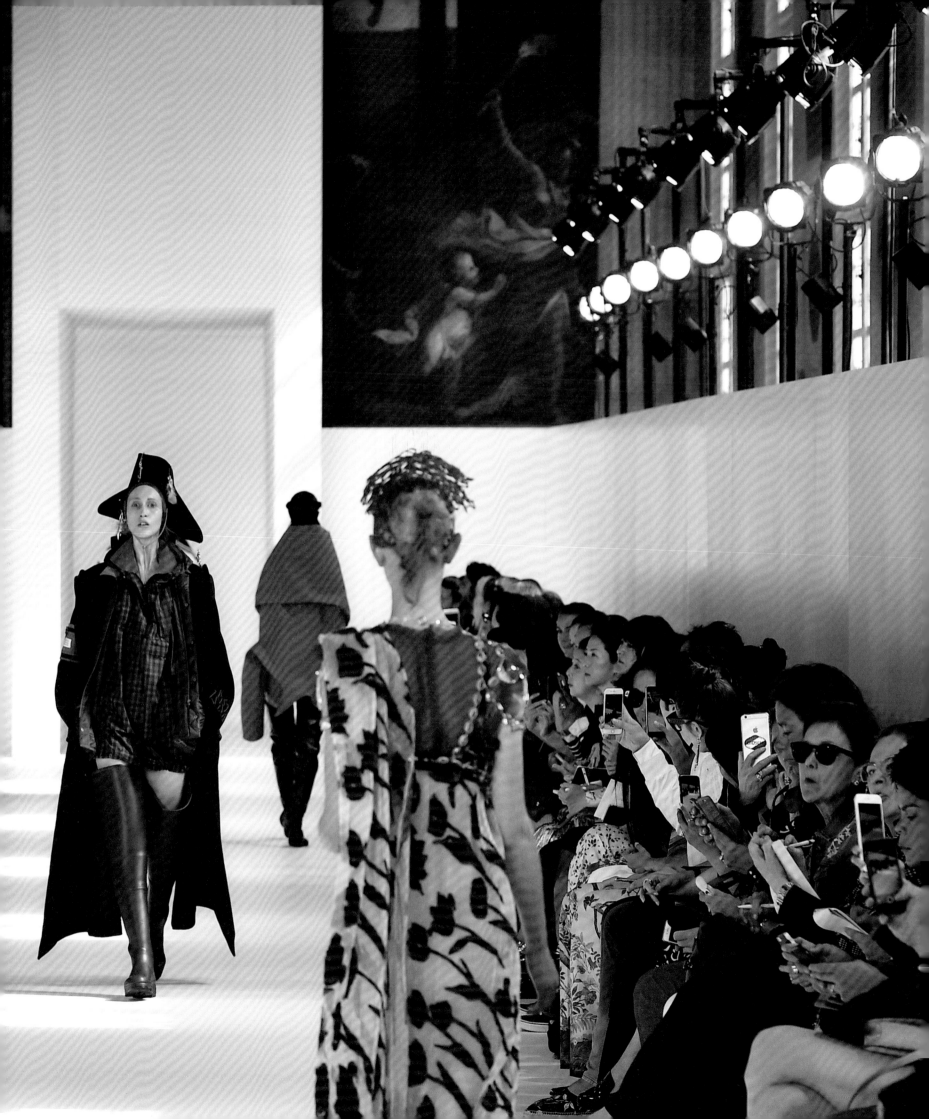

Asking Moore to pin down a favourite decade – let alone a favourite show – is tricky. 'Every decade has been so very different,' he says. 'Fashion is all about change, and it is because of this change that I never get bored. Each decade has pushed me in a new direction. I feel I am still on a journey.'

Comme des Garçons
Spring/Summer 2017
Paris

Gucci
Spring/Summer 2017
Milan

A Digital Revolution

Opposite:
J.W. Anderson
Spring/Summer 2017
London

Above:
Martine Rose
Autumn/Winter 2017
London

Overleaf:
Rick Owens
Autumn/Winter 2017
Paris

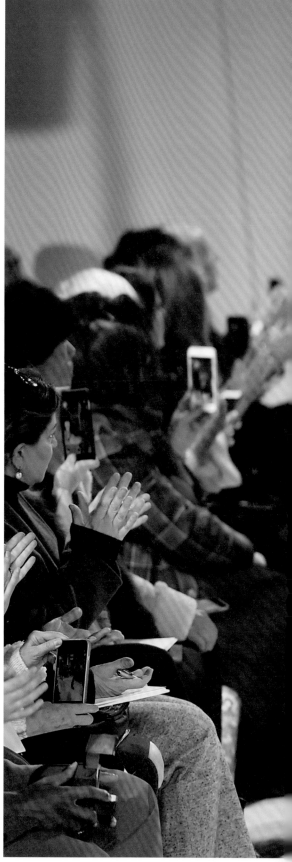

Above:
Oscar de la Renta
Autumn/Winter 2017
New York

Opposite:
Calvin Klein
Autumn/Winter 2017
New York

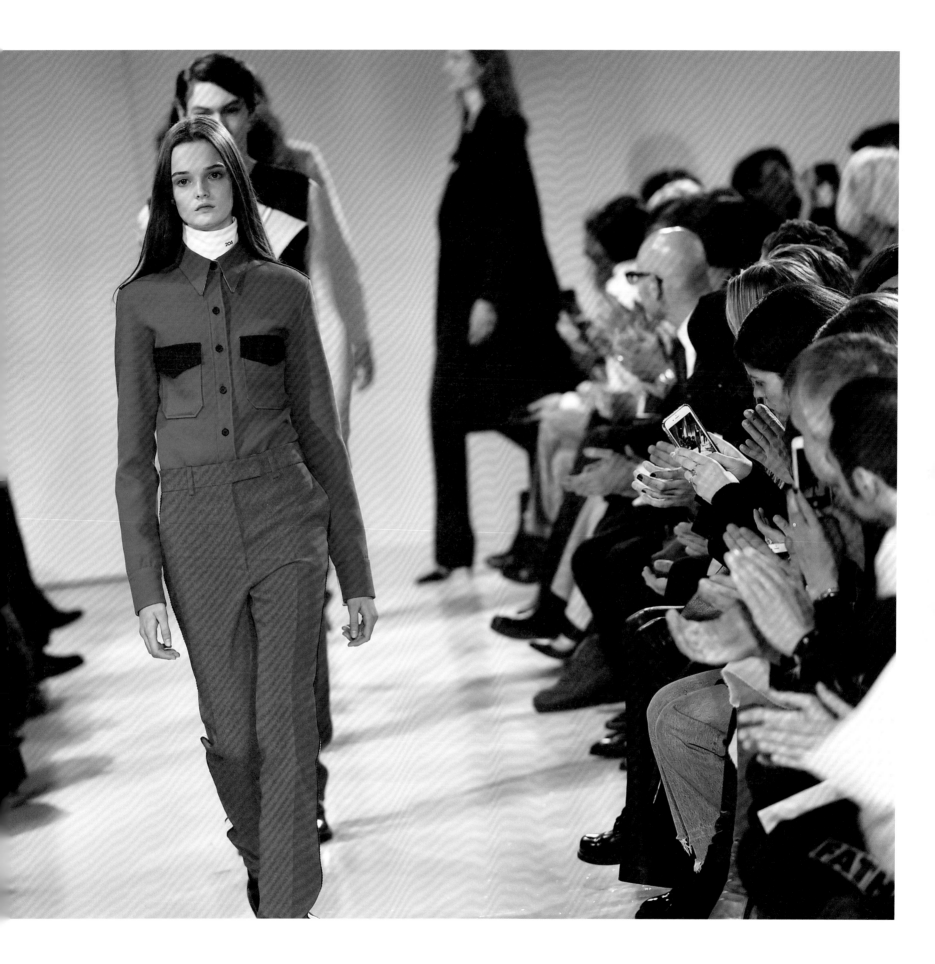

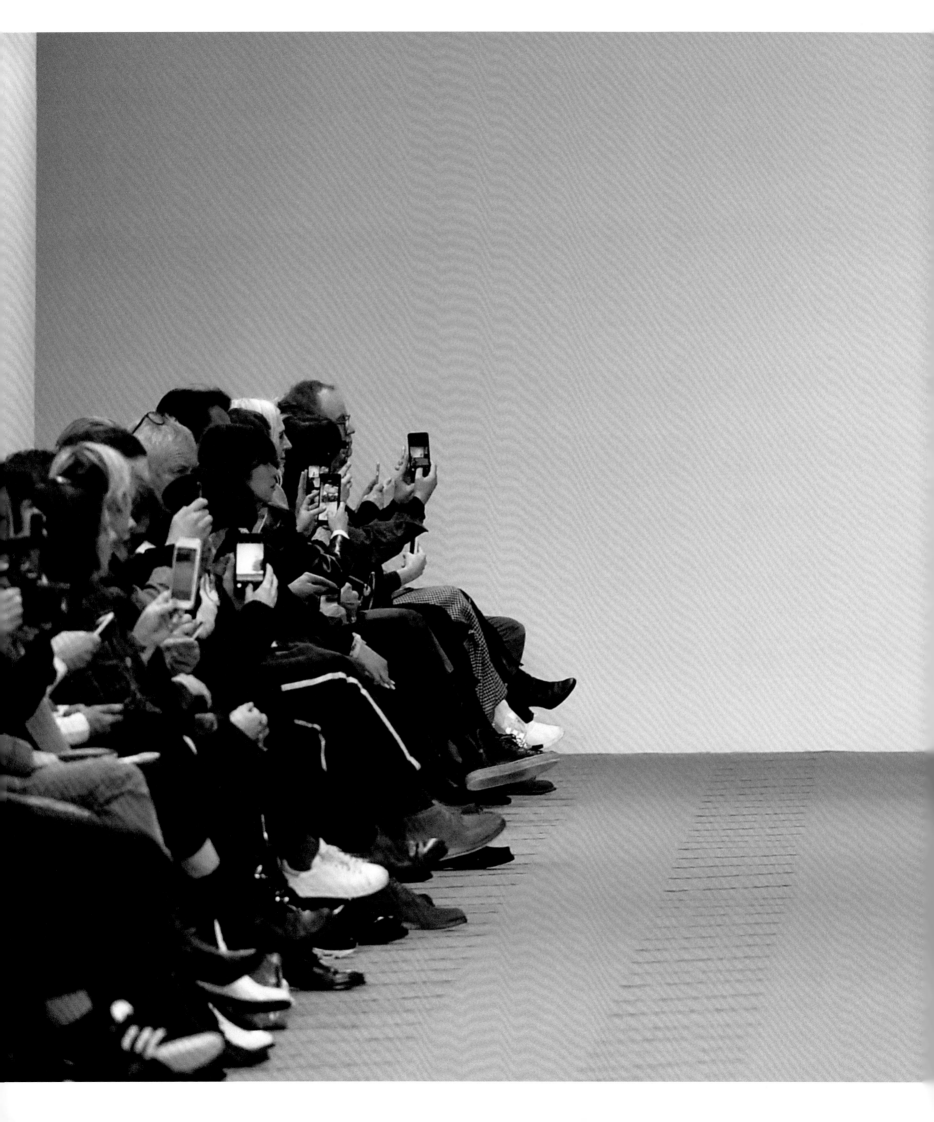

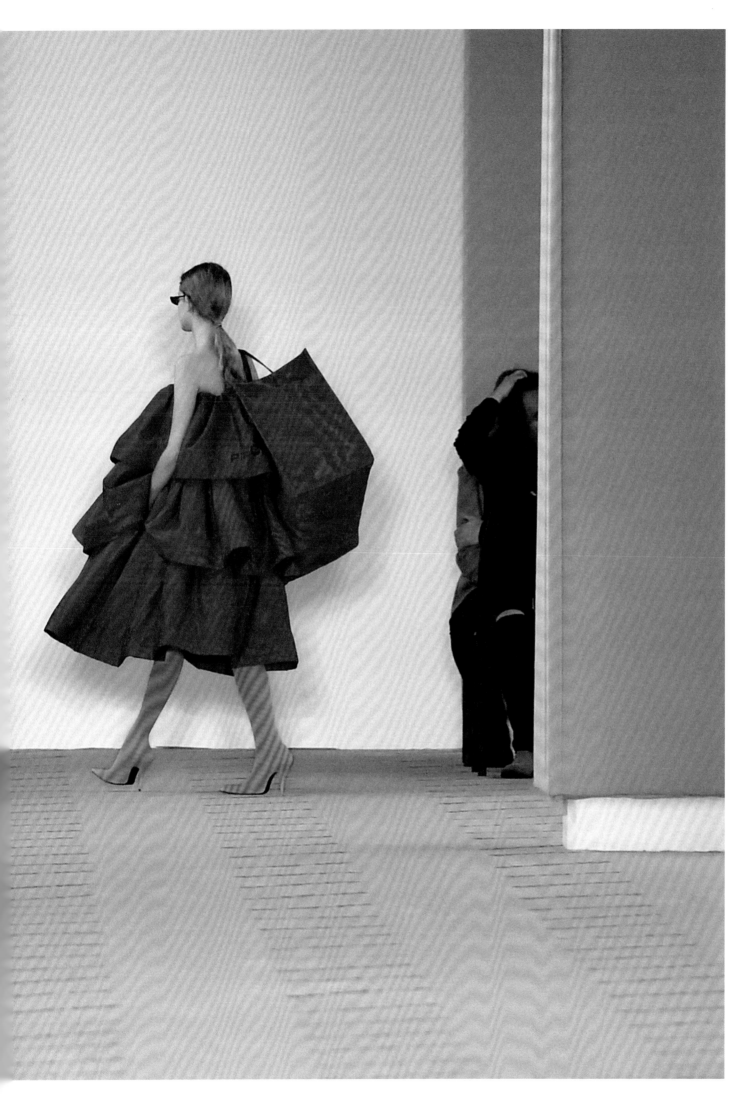

'Fashion is fascinating.'

Chris Moore

The year 2017 marks Chris Moore's 50th year photographing the international collections. At a conservative estimate, that means he has captured around three million images, of some of the greatest fashion shows ever staged.

How to condense that into a single volume? Nearly impossible. This book is not intended to be an exhaustive history of fashion – although it does provide an overarching view of the development of the industry, from the birth of ready-to-wear through to the advent of the internet. It charts the changing demands of fashion, of consumers and designers. Moore's images are not mere records; they were active participants in these fashion moments. His presence, as a photographer, caused a model to stop, pause and pose. The moment he captured is his, and his alone.

But there is more to Moore. As an insider, as the foremost chronicler of the catwalk, he captured things no other photographer could. The sheer span of his career is unparalleled and he provides a unique point of view, literally and ideologically.

This book is Moore's record of fashion – not of the industry's greatest hits. So while, for instance, the clothes of Phoebe Philo at Céline are trendsetting, extraordinarily successful, and remarkable in their manner of nailing the precise aesthetic obsessions of a particular moment, her fashion shows themselves – for all their dynamism – aren't about the theatre of fashion. They don't fascinate Moore.

Moore is British, and there is an undeniably English sensibility to his images, and to his choice of those images. The allegorical power of the work of designers such as Vivienne Westwood, John Galliano and Alexander McQueen are reflected in Moore's incredible imagery. His pictures tell a story – capturing an unusual viewpoint, a missed detail, a secret moment. They tell the story of modern fashion.

What I find striking is the multiple faces of the fashion show on display, the shift from quiet presentations to full-blown theatrical productions. The scope and variety, the endless permutations. These images can also say something not just about the insular fashion industry, with its lists of 'In' and 'Out', its hot designers and dud collections, but also about the state of the wider world, and our reactions to it. How extraordinary it is that, as the markets crashed in 1987 and 2008, designers simultaneously retreated into fantasy, to distract us from the horrors of reality. Why does fashion make us dream, when the world is a nightmare?

The ability of fashion shows to transport you to another time and place, another plane of thought is perhaps an argument for their continuation, as their validity is called into question by the advances of technology. That is something that even Moore's images aren't able to convey adequately – the need to experience, first hand. Moore's work bridges a gap between art and reportage. That makes his images picture-postcard records of these make-believe events less 'wish you were here', more 'wish you were there'.

Ultimately, the clothes aren't the point here. The focus of this book is the shows: the catwalks, the catwalking, the dream of the show, not the reality of the frocks.

Ask Moore what makes a great show, what fascinates him about fashion, and he replies, 'A bit of drama, I suppose. I like a bit of poetry, a bit of art to a show. Then I feel that this is a designer. It's not just a man making clothes. It's something else.'

Opposite:
Chris Moore's first step into fashion: his letter of employment from *Vogue* Studios, May 1954.

Overleaf:
The protective plastic is removed from the catwalk – the final step before another show begins.

Lanvin
Spring/Summer 2016
Paris

VOGUE STUDIO

THE CONDÉ NAST PUBLICATIONS LTD.
39, SHAFTESBURY AVENUE, LONDON, W.1
TELEPHONE . . GERRARD 1154-5

26th. May 1954.

Christopher Moore Esq.,
14 Whalebone Avenue,
Chadwell Heath,
Romford,
Essex.

Dear Mr Moore,

This is just to confirm that I will be expecting you at the Studio at 9 a.m. on Monday, 31st. May, to start here as an assistant. Your salary will begin at £6 per week. I can also confirm that it will be in order for you to take your holiday for one week at the end of August, as already arranged by you.

May I say that we are looking forward to having you work for us here.

Yours sincerely,

Patrick Matthews

D.P.L. MATTHEWS.

Studio Manager.

DPLM/mp

Sources

Introduction
(pages 10–23)
Author interviews with Chris Moore,
 June 2014, July 2016, August 2016
Lauren Cochrane, 'Photographer Chris Moore
 to be honoured at British Fashion Awards',
 The *Guardian*, 28 November 2014
Christopher Isherwood, *Goodbye to Berlin*
 (London: Vintage Classics, 1989)

The Early Years 1954–1969
(pages 24–53)
Author interviews with Chris Moore, June 2014,
 July 2016, August 2016
Román Alonso and Lisa Eisner, 'The White House',
 New York Times, 19 August 2001
Mary Blume, *The Master of Us All* (New York:
 Farrar, Straus and Giroux, 2013)
Diana Donovan, *Terence Donovan Fashion*
 (London: Art/Books, 2012)
Lesley Ellis Miller, *Balenciaga* (London:
 V&A Publications, 2007)
Gloria Emerson, 'Blinking Lights and Abstract Painting
 in Paris Boutiques, but not Chez Scott',
 New York Times, 10 October 1966
Valerie Guillaume, *Courrèges* (London:
 Thames and Hudson, 1998)
Didier Gumbach, *History of International Fashion*
 (Boston: Interlink Books, 2014)
Georgina Howell, *Sultans of Style*
 (London: Ebury Press, 1990)
Sarah Mower, *Chloe: Attitudes* (New York: Rizzoli, 2013)
Enid Nemy, 'A Run-Down on the Best-Selling Paris Copies',
 New York Times, 28 March 1966
Marie-France Pochna, *Christian Dior*
 (New York: Overlook Press, 2008)
——, *Dior*, (London: Thames and Hudson, 1996)
Alice Rawsthorn, *Yves Saint Laurent* (London:
 Harper Collins, 1996)
Claire Wilcox, *The Golden Age of Couture*
 (London: V&A Publications, 2007)

The Birth of the Catwalk 1970–1979
(pages 54–99)
Author interview with Pierre Bergé, January 2017
Author interviews with Chris Moore, June 2014,
 July 2016, August 2016
Anne Aghion, 'Practical Traveller: Getting a Seat at
 Paris Salons', *New York Times*, 12 July 1987
François Baudot, *Chanel* (London: Thames
 and Hudson, 1996)
Pierre Bergé, *Saint Laurent Rive Gauche –
 Fashion Revolution* (New York: Abrams, 2012)
——, *Yves Saint Laurent* (London:
 Thames and Hudson, 1997)

Hamish Bowles, *Yves Saint Laurent: Style*
 (New York: Abrams, 2008)
Alicia Drake, *The Beautiful Fall: Fashion, Genius and Glorious
 Excess in 1970s Paris* (London: Bloomsbury, 2006)
Robin Givhan, *The Battle of Versailles*
 (New York: Flatiron Books, 2015)
Jonathan Kandelloct, 'French Couturiers Are Flourishing in
 Ready-to-Wear Boom', *New York Times*, 23 October 1977
Bernadine Morris, 'Paris Couture and Its Ready-to-Wear:
 Will the Tail Soon Be Wagging the Dog?' *New York Times*,
 30 July 1970
——, 'Couture Alive, Pulse Fading', *New York Times*,
 28 January 1972
——, 'At the Paris Shows, Lots of Smoke but. Not Much Fire',
 New York Times, 3 April 1973
——, 'Fashion Talk', *New York Times*, 23 January 1975
——, 'Paris at Ready-to-Wear Time: Lots of Jostling,
 Lots of Trends', *New York Times*, 6 April 1976
——, 'Paris Versus New York', *New York Times*, 6 March 1977
——, 'Reporter's Notebook', *New York Times*, 10 April 1977
——, 'The Mood Is Playful at Shows in Milan', *New York Times*,
 5 October 1979
Enid Nemy, 'Saint Laurent Revising Way He'll Show
 and Sell Couture', *New York Times*, 10 August 1971
Alice Rawsthorn, *Yves Saint Laurent*
 (London: Harper Collins, 1996)
Agnès Rocamora, *Fashioning the City: Paris,
 Fashion and the Media* (London: I.B. Taurus, 2009)
Ginette Sainderichin, *Kenzo* (London:
 Thames and Hudson, 1998)
Sonnet Stanfill, *The Glamour of Italian Fashion Since 1945*
 (London: V&A Publications, 2014)
Kin Woo, 'Chris Moore, catwalking.com',
 Anothermag.com, 12 September 2014
'A Couture House Pulls Back', *New York Times*,
 23 October 1971
'Paris Trek', *New York Times*, 18 April 1971
'Whither Couture?', *New York Times*, 11 August 1971

Four-City Circus 1980–1989
(pages 100–195)
Author interview with Christian Lacroix, July 2013
Author interviews with Chris Moore, June 2014,
 July 2016, August 2016
Author interview with Junya Watanabe, August 2016
Author interview with Vivienne Westwood, June 2015
Rebecca Arnold, 'Vivienne Westwood's Anglomania', in
 Christopher Breward, Becky Conekin, Caroline Cox (ed.),
The Englishness of English Dress (Oxford: Berg, 2002)
Roland Barthes, *The Fashion System* (London: University
 of California Press, 1983)
François Baudot, *Christian Lacroix* (London: Thames
 and Hudson, 1996)
——, *Yohji Yamamoto* (London: Thames and Hudson, 1997)
Jean Baudrillard, *The Gulf War Did Not Take Place*

(Sydney: Power Publications, 1995)
——, *The Consumer Society* (London:
 Sage Publications, 2002)
Julie Baumgold, 'Dancing on the Lip of the Volcano:
 Christian Lacroix's Crash Chic', *New York Magazine*,
 30 November 1987
Nicholas Coleridge, *The Fashion Conspiracy*
 (London: Heinemann, 1988)
Steven Connor, *The Cambridge Companion to
 Postmodernism* (Cambridge: Cambridge
 University Press, 2004)
Marielle Cro, *Claude Montana* (London:
 Thames and Hudson, 2011)
Guy Debord, *The Society of the Spectacle*
 (New York: Zone Books, 2004)
John Fairchild, *Chic Savages* (New York:
 Simon and Schuster, 1989)
Pamela Golbin, *Valentino: Themes and Variations*
 (New York: Rizzoli, 2008)
France Grand, *Comme des Garçons* (London:
 Thames and Hudson, 1998)
Gene Krell, *Vivienne Westwood* (London:
 Thames and Hudson, 1997)
Colin McDowell, *Jean Paul Gaultier* (London:
 Cassel & Co., 2001)
——, *McDowell's Directory of Twentieth Century Fashion*
 (London: Frederick Muller, 1987)
Patrick Mauriès, *Chanel: Catwalk – The Complete Karl
 Lagerfeld Collections* (London: Thames and Hudson, 2016)
——, *Christian Lacroix: The Diary of a Collection* (New York:
 Simon and Schuster, 1996)
Bernadine Morris, 'From Japan, New Faces, New Shapes',
 New York Times, 14 December 1982
——, 'Miyake and Montana Give Dash and Variety to the
 Shows in Paris', *New York Times*, 26 March 1984
Jane Mulvagh, *Vivienne Westwood: An Unfashionable Life*
 (London: Harper Collins, 1998)
Roger and Mauricio Padilha, *The Stephen Sprouse Book*
 (New York: Rizzoli, 2009)
'Reshaping the Classics at the House of Chanel',
 New York Times, 12 December 1982
Hugh Sebag-Montefiore, *Kings on the Catwalk*
 (London: Chapmans, 1992)
June Weir, 'Has Success Spoiled Milan?',
 New York Times, 20 June 1982
Claire Wilcox, *Vivienne Westwood* (London:
 V&A Publications, 2004)

Supermodels and Supershows 1990–1999
(pages 196–333)
Author interview with Azzedine Alaïa, July 2015
Author interviews with Chris Moore, June 2014,
 July 2016, August 2016
Prosper Assouline, *Alaïa Livre de Collection*
 (Paris: Editions Assouline, 1992)

François Baudot, *Alaïa* (London: Thames and Hudson, 1996)

Andrew Bolton, *Anglomania* (New York: Metropolitan Museum of Art, 2006)

Stella Bruzzi, Pamela Church Gibson, *Fashion Cultures: Theories, Explorations and Analysis* (London: Routledge, 2000)

Farid Chenoune, *Jean Paul Gaultier* (London: Thames and Hudson, 1996)

Bill Cunningham, '2 Rebels Making Paris Debuts', *New York Times*, 19 January 1997

Caroline Evans, *Fashion at the Edge* (London: Yale University Press, 2003)

Alexander Fury, *Dior: Catwalk* (London: Thames and Hudson, 2017)

Amy de la Haye, *The Cutting Edge* (London: V&A Publications, 1996)

Marion Hume, 'McQueen's Theatre of Cruelty', *Independent*, 20 October 1993

Harold Koda, *The Model as Muse: Embodying Fashion* (New York: Metropolitan Museum of Art, 2009)

Colin McDowell, *Galliano* (London: Weidenfeld and Nicolson, 1997)

Richard Martin, *Gianni Versace* (New York: Abrams, 1997)

Suzy Menkes, 'Galliano's Diorient Express Runs Out of Steam', *International Herald Tribune*, 21 July 1998

Bernadine Morris, 'Beene's Question: How Does It Move?', *New York Times*, 4 November 1992

Alistair O'Neill (ed.), *Isabella Blow: Fashion Galore!* (London: Rizzoli, 2013)

Ian Phillips, 'How We Met: Naomi Campbell and Azzedine Alaïa', *Independent*, 4 April 1998

Anne-Marie Schiro, 'Photogenic, but Out of Focus', *New York Times*, 20 March 1995

Amy M. Spindler, 'Zut! British Infiltrate French Fashion', *New York Times*, 15 October 1996

——, 'Among Couture Debuts, Galliano's is the Standout', *New York Times*, 21 January 1997

Jonathan Van Meter, 'Pretty Women', *Vogue* (US), October 1990

Bob Verhelst and Kaat Debo, *Maison Martin Margiela 20: The Exhibition* (Antwerp: MoMu, 2008)

Donatella Versace, *Versace* (New York: Rizzoli, 2016)

Constance C.R. White, 'Patterns', *New York Times*, 16 March 1999

——, 'Review/Fashion: For Couture, New Ways to Seduce', *New York Times*, 20 January 1998

Claire Wilcox (ed.), *Alexander McQueen* (London: V&A Publications, 2015)

The Millennium Bug 2000–2009
(pages 334–419)

Author interview with Suzy Menkes, September 2011

Author interviews with Chris Moore, June 2014, July 2016, August 2016

Laid Borrelli-Persson, 'Helmut Lang on His Industry-Changing Fall 1998 Virtual Show', Vogue.com, 9 February 2016

Chris Burkham, 'Behind the Limelight', *Financial Times*, 4 March 2005

Caroline Evans (ed.), *Hussein Chalayan* (Rotterdam: Nai Publishers, 2005)

Susannah Frankel, *Visionaries: Interviews with Fashion Designers* (London: V&A Publications, 2001)

Alexander Fury, 'Paris Womenswear S/S 10 Alexander McQueen', SHOWstudio.com, 6 October 2009

Robin Givhan, 'Firstview.com, Sharing the Runway View', *Washington Post*, 9 September 2005

David Handyman, 'At a Time When Many Dot-coms are Failing, Style.com Opens Its Campaign with a Flourish', *New York Times*, 13 August 2001

Cathy Horyn, 'Backers Line the Dock as a Ship Comes In', *New York Times*, 4 April 2000

——, 'Balenciaga Transports Modern to a New Century', *New York Times*, 1 March 2006

—— 'In London, the Rebels Find Their Causes', *New York Times*, 28 September 1999

——, 'McQueen: Leaping Lizards', *New York Times*, 6 October 2009

——, 'Now, Even Rebels Are Looking Ladylike', *New York Times*, 8 February 2000

David Kirby, 'Hey Kids, It's Showtime!', *New York Times*, 29 March 1998

Olivia Ledbury, 'Chris Moore Catwalking: A Celebration of the London Catwalk,' *Daily Telegraph*, 1 December 2011

Suzy Menkes, 'London Crowns Its Fashion Kings,' *International Herald Tribune*, 22 February 2000

——, 'Techno Revolution', *International Herald Tribune*, 7 October 2009

Michael Specter, 'The Fantasist', *New Yorker*, 22 September 2003

Constance C.R. White, 'No Crush: The CD-ROM Runway', *New York Times*, 1 April 1998

Claire Wilcox (ed.), *Radical Fashion* (London: V&A Publications, 2001)

A Digital Revolution 2010–2017
(pages 420–489)

Author interview with John Galliano, October 2016

Author interviews with Chris Moore, June 2014, July 2016, August 2016

Author interview with Miuccia Prada, July 2015

Author interview with Raf Simons, May 2014

Michael K. Bergman, 'The Deep Web: Surfacing Hidden Value', *Journal of Electronic Publishing*, Volume 7, Issue 1, August 2001, 26 November 2015

Adrian Chen, 'The Troll of Internet Art', *New Yorker*, 30 January 2017

Kati Chitrakorn, 'Role Call: Chris Moore, Runway Photographer', businessoffashion.com, 26 November 2015

Grace Cook, 'Chris Moore: A Retrospective', *Financial Times*, 17 December 2014

Susannah Frankel, 'Chris Moore: "I'm Just a Fly on the Wall"', *Independent*, 28 November 2011

Alexander Fury, 'A Life Behind the Camera', *10 Men*, Autumn/Winter 2014

Alexander Fury, 'In With The New', *Independent/i*, 8 October 2015

Pamela Golbin, *Louis Vuitton/Marc Jacobs* (New York: Rizzoli, 2012)

Taylor Harris, 'Model Call: Kel Markey', *Women's Wear Daily*, 13 March 2012

Cathy Horyn, 'Glamorously, Tom Ford Is Back', *New York Times*, 13 September 2010

——, 'Raid the Archives With Caution', *New York Times*, 29 September 2011

Suzy Menkes, 'Is a Runway Show Really Necessary?', *International Herald Tribune*, 29 September 2010

David Pogue, 'The iPhone Matches Most of Its Hype', *New York Times*, 27 June 2007

Acknowledgements

Chris Moore

A special thanks to all the people who have worked with me in my team over the years, their dedication and support has made and continues to make it possible for me to do what I do. So many names over 60 years but prominently among them have been Andrew Lamb, Andrew Thomas, Karl Prouse, Nathalie Lagneau, Daniele Schiavello, Roger Dean, Rosemary Lopez Castrillon, Nigel Thomas, Maxine Millar and Holly Daws.

Special thanks also to Suzy Menkes, whom I worked alongside for 25 years and whose relentless pursuit of excellence held me at the vanguard for so long.

Thanks to Tracy Le Marquand and Liberty's of London; Linda Watson and Northumbria University; Heather Lambert and The London College of Fashion; Peter Millican and Kings Place, who were the first to recognize the potential of my archive and present it in the wonderful exhibitions they arranged.

Thanks to The British Fashion Council, to all the designers in New York, London, Milan and Paris who created these amazing events, and to my son Nicholas Moore for not minding too much about the rainy weekends at Grandma's while I witnessed them.

To Camilla Morton, Jodi Simpson, Charlotte Selby, Sam Wolfson, Alexander Fury and Maxine Millar who have worked relentlessly to realize this volume.

Alexander Fury

Thank you, firstly, to Chris Moore, and to many hours spent poring over his archive, recalling fashion's glorious past with photographic accuracy. His images are the backbone of this book.

Huge thanks to Camilla Morton and the staff of Laurence King for their tireless work in bringing this book together.

Thanks to all the fashion houses for helping to pin down dates and designer details to bring these images to life, and to the various interviewees for their time and patience.

Special thanks to Susannah Frankel for her invaluable feedback and gentle but assured guidance, and to Antony Miles for his wise counsel and always sage advice. Although I frequently didn't listen to it.

Thank you, most of all, to Joseph Larkowsky, for everything.

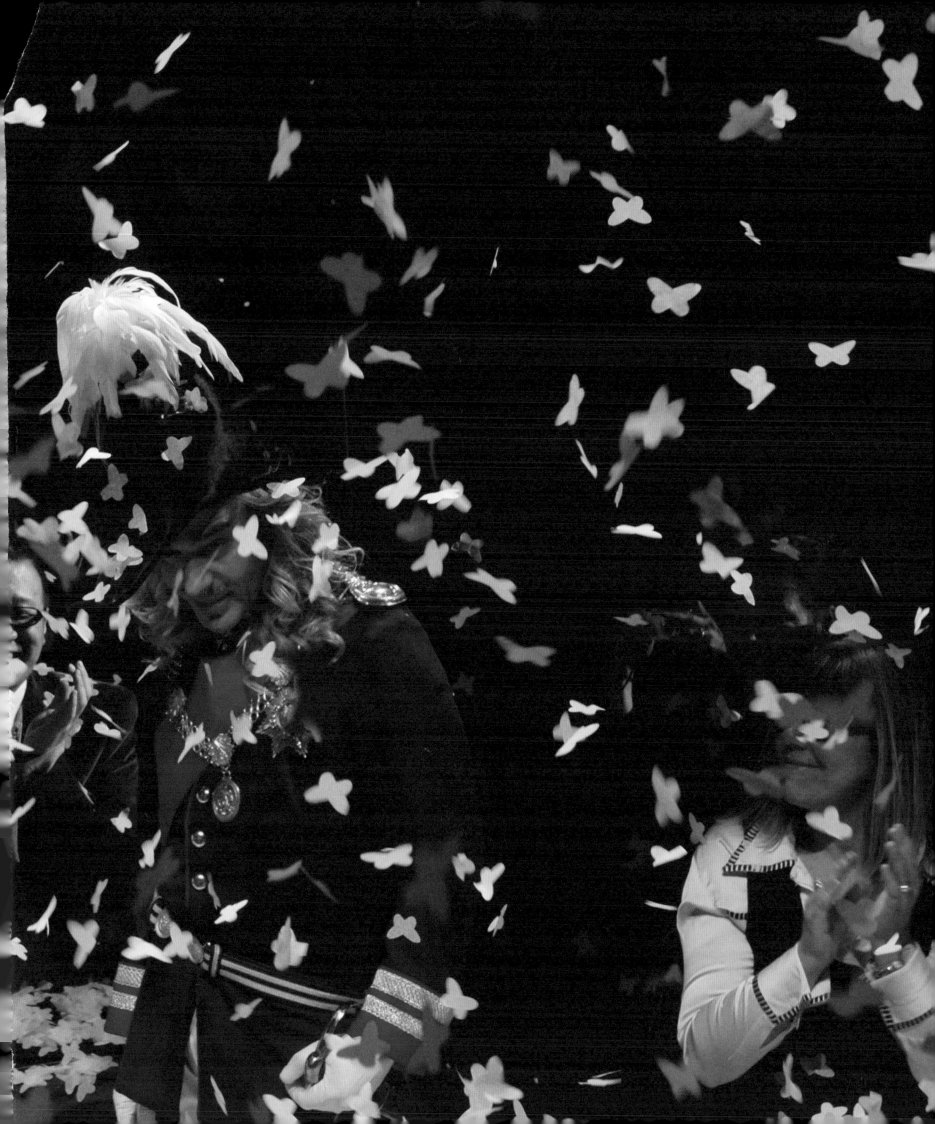

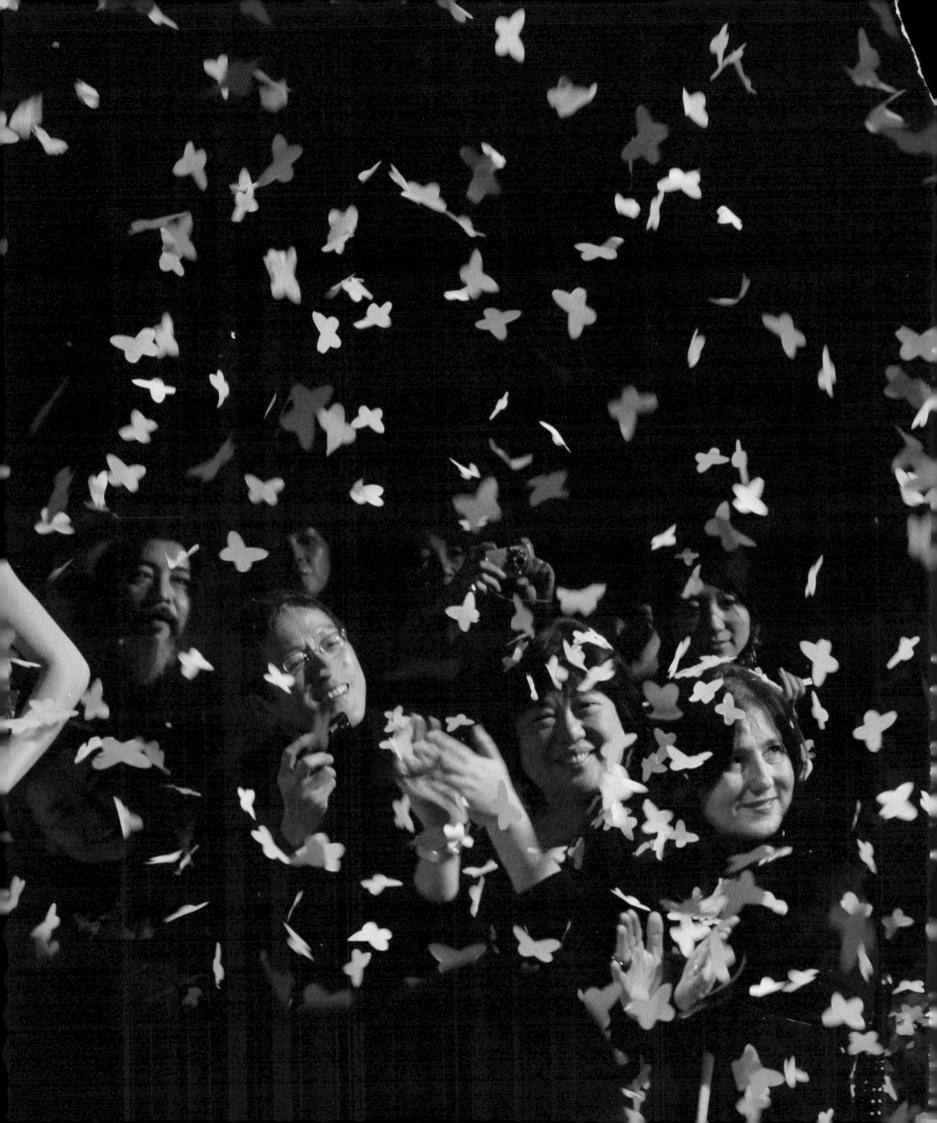